ISLINGTON

'A dazzling
and history, rema~ item on or before the last ~
of thought ... A major ach~~ ~rges. To renew an it~
so vast and volatile' **Robert Macfarlane**

'A deeply felt, richly observed and brilliantly articulated book ...
Alexandra Harris can't stop the rain but after reading *Weatherland*
no one could doubt that it and everything else meteorological that the
Earth throws at us has made us what we are. Prepare to be drenched
and delighted in equal measure by the best written downpour
England has ever witnessed' **Tim Dee**

'A splendid history of writers' and painters' reflections on the wind,
rain and sun ... its glory is in the detail, in its recording of facts and
lives, atmospheres and words, quirks of feeling and behaviour. ... on
every page is something precise and memorable' **A. S. Byatt, Guardian**

'Gathers all the written English centuries and sets them dancing to the
seasons on the head of its pin' **Ali Smith, Times Literary Supplement**

'Lie down in the grass and watch the clouds passing in the company
of some of our greatest artists ... Imaginatively vivid and freshly
surprising' **Rachel Campbell-Johnston, The Times**

'Wonderful, offbeat ... exquisitely produced ... delivers a deluge
of detail that will change the way you think about weather forever'
Claire Lowdon, The Sunday Times

'An ambitious, sweeping survey of British art and literature as seen
through the lens of clouds, skies, sunshine and drizzle. Carrying her
immense knowledge lightly, never emerging as didactic or pedantic,
Harris takes us across sodden fields and frosty meadows, through thick
mist – and into the English mind' **Andrea Wulf, The New York Times**

'I cannot love *Weatherland* enough. Exquisitely illustrated, it
has the wit and wonder of an exceptional literary work'
Philip Hoare, New Statesman

'Hugely ambitious, exhilaratingly written and handsomely produced'
Peter Parker, Times Literary Supplement

WEATHERLAND

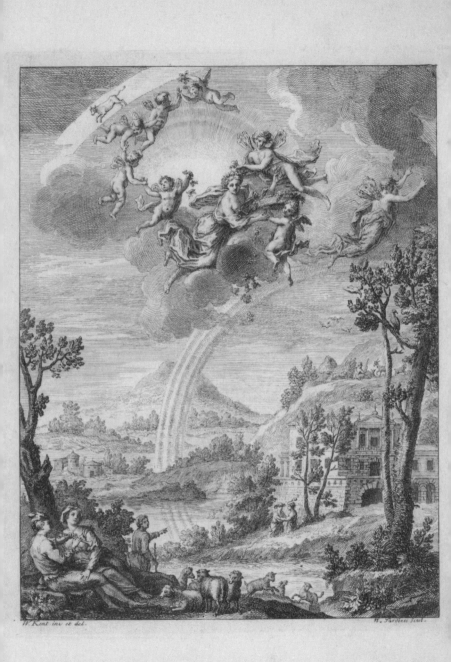

W. Kent inv et del. W. Jardieu Sculp.

ALEXANDRA HARRIS

Weatherland

WRITERS AND ARTISTS
UNDER ENGLISH SKIES

– *It will be rain tonight.*
– *Let it come down.*

William Shakespeare, *Macbeth*

With 59 illustrations

Thames & Hudson

For Hermione Lee, with love and thanks

Cover illustration by Stephen Millership
www.stephenmillership.com
Frontispiece: William Kent, 'Spring' for James Thomson's *The Seasons*, 1730

First published in the United Kingdom in 2015
by Thames & Hudson Ltd, 181A High Holborn, London WC1V 7QX

First paperback edition 2016

Book design by Lisa Ifsits

British Library Cataloguing-in-Publication Data
A catalogue record for this book is available from the British Library
ISBN 978-0-500-29265-5

Printed and bound in India by Replika Press Pvt. Ltd

CONTENTS

INTRODUCTION
A MIRROR IN THE SKY

*I hope you are better employed
than in gaping after weather.*

John Keats

It's December, the week before Christmas. I have rented for a few nights a sixteenth-century tower in the water meadows under the South Downs in East Sussex. The closest village is Laughton, which is not very near Lewes, though the lights on the edge of town become visible in the distance after dark, and every half hour a train goes along beneath the horizon. Leaning out of a high bedroom window, I have a better view of the ditches and sluices carrying water quietly away across the fields in the moonlight.

In the night I wake up damp with cold. Any movement, even to scratch my nose, creates a breeze. A hot-water bottle lies uselessly beside me, its heat long gone and the kettle which would rejuvenate it sixty-two steps down a spiral staircase in the kitchen. For two hours I lie awake thinking about our sensitivity to temperature, wondering whether people felt cold in this room four hundred years ago, one hundred years ago, twenty years ago. The new thermostat at home works doggedly to keep me at the same temperature all day long; however much I turn it down it flicks on again and wins eventually, insisting on temperate regularity. I am losing the capacity to be comfortably cold. I resist the hot-water bottle, try to enjoy the passing draughts, and fall asleep.

The morning is so triumphantly bright that when I wipe condensation from the window I can see the texture of the grass on Mount Caburn. It is the kind of sharp low light in which archaeologists can see field boundaries and lost villages, a light for seeking out long-buried things. Falling on a notebook by the window, it makes a furrowed landscape of a previously flat page. I proceed to spend most of the day rejoicing in the weather. At Alciston white light comes shafting through the plain church windows as if the pale sun itself had turned protestant; at Alfriston in the

afternoon the reed beds turn a tawny orange-grey, gently luminous beyond hedges of dark ilex and yew.

Weather is so mobile that it brings variance to tarmacked roads and concrete towers; a bare wall watched over time is interesting enough. In places where every surface is a different texture, where there are foregrounds and distances, shining berries, dense hollies, building stones which absorb the light in distinctive ways, there is almost too much to look at. I keep taking photographs, trying to catch each shading difference in colour as the afternoon goes on. You'd think I had never seen winter sun before.

Everything changes in the night: as I climb the sixty-two stairs the wind gets louder, and on each of the four floors, going up, I can hear the rain being thrown against the windows with more force. By dawn the meadows are flooded, leaving only small peninsulas of land. The sluice gate by the drive has been overwhelmed by what is now a fast-flowing river. There is no way of getting the car out but, since there seems to be a bit of footpath left, I cannot keep back the impulse to explore on foot. The aim is to collect a Christmas goose ordered from a farm about a mile away. Squelching and sinking, I make it across two fields before coming to a fast river I won't risk. It is still raining, and the water is going up. If I reached the goose, I'd never get it back. We'll have a vegetarian dinner.

I love this deluge. Flooding in towns can wreck homes and livelihoods, but here on the marshes flooding is supposed to happen in winter. These low fields have for centuries been taking the burden of the water. The flood laps up to the hawthorn hedges where a few hips show red against the grey. Clumps of brown rotting thistles keep their heads above water. While I've been gazing, local people have had the forethought to mark the edge of the submerged road with stakes so that it's possible to wade through without losing the way. They have also devised a plan for getting in the shopping. A car from the outside world is parked on the far side of the water with a boot full of festive food. Two bags at a time, our neighbour carries his supplies across the flood to his own car, a dock for the ferry's cargo.

In the evening, when the rain stops and the air is still, I go out again. There are small waves breaking gently on the inland sea. The stakes along the road are only beanpoles, but the wobbly verticals look dramatic. There is enough moonlight to see the outline of Caburn, which is now a cliff rising above water. Gulls have come in from the coast, claiming the levels as their own. Indoors, I find a set of postcards in a drawer, showing Laughton

under blue summer skies. There are deckchairs stowed in a cupboard on the stairs. It's a shock to see them: immersed in December I find it hard to believe in August. This is one of many strange characteristics of our relationship with weather: it is difficult to remember what it feels like to be in any conditions except the ones we're in. It is almost impossible to pack the right things for a different climate. I can't even imagine these floods going down.

But they do go down, very quickly. I drive away next day at low tide when the water reveals the land again. The sluice flows along innocently between its banks. The gulls have gathered on the last lake left to them, which sparkles in the sun. So that was my holiday. I have done nothing but watch the light and the water, and feel the cold, the wet, the wind, and afterwards the warmth. There are places where these things are so all-consuming that there's time for little else.

⌒

Weather is written into our landscape. I grew up near Coldwaltham in West Sussex, where at some point in the Middle Ages the identity of coldness was attached to the Old English 'waltham' (village in the wood). In the lee of the downs a few miles away, out of the wind, lies Coldharbour Farm (a harbour or shelter from the cold). Chalk Farm in London has its etymological roots in 'chalde' from Old English 'ceald'. Across England there are winterbournes, streams which rise when the water-table is high in winter and recede unobtrusively into the drier landscape of summer.[1]

Weather leaves its physical trace, but there are many aspects of weather which are insubstantial. As the anthropologist Tim Ingold observes, we can feel warmth but we cannot touch it. We can see where a cloud is and where it is not, but we cannot run a finger around its edges.[2] Shakespeare thought of clouds 'dislimning'. To 'limn' is to delineate, but weather is inimical to lines, dissolving them as soon as they are made. Meteorological phenomena are serially elusive. Winds and air-fronts reveal their characters only in the effects they have on other things. We learn the nature of wind by observing how far smoke drifts from the vertical, or by watching to see whether twigs are moving or just the leaves: the Beaufort Scale uses these signs from the visible world as a gauge for the invisible wind. We all have our personal variants on the official scale, the things we look to for clues, and we come to understand places through the marks the

wind has made on them. Emily Brontë described the wind at Wuthering Heights by reading the angle of its trees: 'one may guess the power of the north wind blowing over the edge, by the excessive slant of a few stunted firs at the end of the house; and by a range of gaunt thorns all stretching their limbs one way, as if craving alms of the sun'. These are the expressive signs of wind, though they are not the wind itself.[3]

This elusiveness, combined with tremendous power, means that in almost every culture the weather has at some stage been thought divine. It has in turn provided the imagery by which deities are known. The Christian God, everywhere present but nowhere visible except in His workings, is often represented as a figure emerging from cloud or air. Speaking out of a whirlwind to put Job in his place, God defines omnipotence through His command of weather. His speech, as translated in the King James Bible of 1611, poses some of the most beautiful and enduring questions in literature:

> Hast thou entered into the treasures of the snow? or hast thou
> seen the treasures of the hail, which I have reserved against the
> time of trouble, against the day of battle and war? By what way
> is the light parted, which scattereth the east wind upon the earth?
> Who hath divided a watercourse for the overflowing of waters,
> or a way for the lightning of thunder; To cause it to rain on the earth,
> where no man is; on the wilderness, wherein there is no man;
> To satisfy the desolate and waste ground; and to cause the bud
> of the tender herb to spring forth? Hath the rain a father? or
> who hath begotten the drops of dew?[4]

The secret workings of weather are here imagined in ways which are at once solid and elusive. Snow and hail exist in permanent states, stored up for the future. A 'way' must be made for the lightning because the Israelites believed the sky to be a solid layer between the earth and the heavens, through which channels were cut for the weather. The sky was often described as a sheet of metal, polished to reflect the light. The King James translators, working in a new age of mirrors, likened the sky to 'a molten looking glass'.[5] These images of the sky as a solid architectural structure are combined with lyric appreciation of the delicacy and diversity of weather. God's words to Job, though spoken in anger, describe the extent of His power in relation to dewdrops as well as lightning. The questions are presented rhetorically because it should be obvious to Job

that the answer in every case is God. But the point is also that these are great mysteries of the world, and so they have remained. Today, whether or not we find God in snow, we continue to feel wonder.

The Christian story proposes variable weather as one of the penalties brought down on humankind for its sins. In Eden there was moisture to nurture the abundant plants, and such warmth that Adam and Eve needed no extra layers. If there was 'weather' at all, it was steadily benign. The trouble began either immediately after the Fall or with the Flood. John Milton in *Paradise Lost* described the creation of weather as one of the dire 'alterations in the heavens and elements' set in train by God as soon as the apple was eaten.⁶ Winds were summoned to do battle in the air. Angels tipped the earth on its axis, subjecting it to the variability of seasons. Man would now have to cope with the unpredictability of a lopsided globe. The twinned genesis of weather and time is remembered in the French phrase 'les temps', Spanish 'tiempo' and Italian 'tempo'. Having lost the eternal stability of Eden, man must live in passing airs and hours.⁷

The worst of the Old Testament punishments came in the form of calamitous weather. The Flood demonstrated to Noah and to centuries of Bible-readers that rainfall is capable of wiping out human life. Later floods, gales, and freezes have been understood by many who suffered in them as sequels to those first, awful retributions. During the Middle Ages and the Renaissance it was commonly believed that the earth was yearly getting colder as it left temperate Eden further and further behind. This was easily conflated with the classical scheme in which Jupiter introduced the seasons after the perpetual spring of the Golden Age. We still ask ourselves on a daily basis if the weather is a curse or a blessing. We still see both horror and treasure in hail.

⌒

The immateriality of weather has made it a potent means of figuring not only our gods but the most immaterial parts of ourselves – our 'spirits' and our thoughts. The association between clouds and minds is so commonplace as to go unnoticed; in cartoons, for example, thought bubbles are cloud-shaped. The thought-cloud has become part of our sign language. There was a strand of early Christian mythology that imagined Adam's thoughts to have been fashioned directly from the clouds, and by the mid-tenth century this addition to Genesis was well established in

English and Irish writing. One Old English colloquy asks the question: 'Tell me the substance from which Adam was made', and the answer comes that he was made from eight pounds of material: a pound of earth made his flesh, a pound of fire made his hot blood, a pound of wind made his breath, and so on, including a pound of cloud, 'from which his unstable mind was made'.[8] The image is splendidly vivid: God takes a handful of cloud and shapes it into thoughts – except that, being cloud, the thoughts keep changing shape. In this very early example the cloud-mind idea implies a mistrust of both cloud and mind, a sense of their vapourousness. 'Unstaðelfæstnes' is the word in the Old English text.

For Shakespeare and the Romantics the comparison between thoughts and clouds becomes a means of expressing the miraculous abundance of human imaginations, which are constantly revising and replenishing themselves. The mind is a theatre, like the sky, in which whole cities can be built up and then dissolved. Even as he marks the end of the masque in *The Tempest*, Prospero unveils another vast panorama that flashes and fades in an instant, made from a single breath, leaving nothing more or less than a memory:

> These our actors,
> As I foretold you, were all spirits and
> Are melted into air, into thin air:
> And, like the baseless fabric of this vision,
> The cloud-capp'd towers, the gorgeous palaces,
> The solemn temples, the great globe itself,
> Yea, all which it inherit, shall dissolve
> And, like this insubstantial pageant faded,
> Leave not a rack behind.[9]

Our thoughts will be affected by the kind of weather we're in. Dark clouds are liable to engender gloomy feelings. The weather can be responsible not just for our own mood but for the mood of a whole town or country. Our weather-talk has a special grammar. 'What's it like today?' we ask, replacing the specific noun 'weather' with a cosmically generalizing 'it'. What is it like – the weather, the day, the world? Weather is one of the most powerful threads holding us together: it is what we share with everyone else who is in it, or under it. Rainy days turn people in upon themselves – hat pressed

down, chin tucked in – but there are common rhythms in the dodging and splashing and weariness. In the park on the first warm day of the year people of all kinds will be drawn into cheerful fellowship. When a bad day suddenly clears to late sun the thoughts of individuals all over a city, intent on thousands of different tasks, will take a momentary united leap.

Still, each among those thousands will feel something different. The thermometer may be the same whoever reads it, but our experience of weather is more than statistical. The naturalist Richard Mabey, a lifelong observer of the weather's effects on us, describes a 'complex weave of metaphor, ancient association, and real physical experience'.[10] Our weather is made up of personal memories and moods; an evening sky is full of other evenings; a mist may be given its identity by a line from a song or a half-remembered film. The weather is made for us partly by writers and artists who have set down permanently their response to a fleeting effect. This is all interwoven with the practicalities of being hot or cold, wet or dry, while the world around us is blotted out or lit up, a brass handle or a shopfront suddenly picked out by the sun.

Our common weather, then, is intensely personal and unpredictable. There is a moment in Proust's novel *The Guermantes Way* when the weather one morning has a transformative effect on the narrator:

> Although it was simply a Sunday in autumn, I had been born again, life lay intact before me, for that morning, after a succession of mild days, there had been a cold fog which had not cleared until midday: and a change in the weather is sufficient to recreate the world and ourselves anew.[11]

It is the combination of drama and nonchalance which makes this so truthful. *Of course* a foggy morning can make all the difference. This is just how our moments of revelation tend to come: on an odd Sunday morning, when the world is a new place because it's cold. Proust's narrator is only reborn in the fog, however, because he is ready, this particular Sunday, for something to change. Inner weather creates outer weather; we find the external image of the thing we need to express. If this is true of individuals, changing from moment to moment, it holds true in a very broad way for societies. It is possible for large groups of people to find certain conditions more meaningful than others. Cultures have climatic sensitivities, which may be consciously developed or which may evolve gradually and

unnoticed. Weather feelings can be shared by a circle of friends, or by one artist responding to another, or by thousands of people linked by a vast web of cultural influences.

The social scientist Steve Rayner, one of the most influential contemporary voices on climate policy, has quoted Proust approvingly: yes, the weather can recreate the world and ourselves. But for Rayner the creativity works in both directions. 'We could add', he says, 'that a change in ourselves is sufficient to recreate the weather'.[12] That belief is at the heart of this book. My subject is not the weather itself, but the weather as it is daily recreated in the human imagination.

～

My thinking about people and weather has been inspired from the first by Virginia Woolf. Her 1928 novel *Orlando* establishes the atmosphere of English life in different centuries by describing changes in the air. The turn of the nineteenth century brings with it the most dramatic meteorological alteration:

> the first stroke of midnight sounded. Orlando then for the first time noticed a small cloud gathered behind the dome of St Paul's. As the strokes sounded, the cloud increased, and she saw it darken and spread with extraordinary speed [...] As the ninth, tenth, and eleventh strokes struck, a huge blackness sprawled over the whole of London. With the twelfth stroke of midnight, the darkness was complete. A turbulent welter of cloud covered the city. All was darkness; all was doubt; all was confusion. The Eighteenth century was over; the Nineteenth century had begun.[13]

Life changes in accordance with this new weather: beards keep men's necks snug, skirts are worn to the ground and tablecloths follow suit. Damp-loving ivy grows in profusion; in the muffled gloom, evasions and concealments are bred almost as quickly as children.

Woolf's scene-setting is, in a sense, meteorologically accurate. Springs and autumns in the 1830s and 1840s were wetter than average. There was also the man-made atmosphere to contend with: industrial smoke generated its own black clouds. But Victorian England also saw plenty of fine weather and (in the 1850s) worrying periods of drought.[14] Measurable quantities of rainfall and cloud-cover were not really, I think, Woolf's point. Her method in *Orlando* had much more to do with a sense that, as cultural

preoccupations change, we find affinities with different kinds of weather. We find conditions to suit us, or from which we need to defend ourselves. Weather gathers association and, in a constant exchange of subject and object, our associations shape our experience of weather.

Woolf's sensitivity to cultural change over time came from astonishingly wide and deep reading, and in that reading she detected shifting meteorological emphases. In an optimistic moment, I wondered if I could observe these shifts for myself.[15] If I read straight forward through English literature, or at least if I tried to read in a roughly chronological way, would it be possible to feel the weather change? I was not serious about this until I spent a summer reading poetry and chronicles from the Anglo-Saxon period. There was seemingly no interest in warmth (except that of the indoor fire), whereas perceptions of winter were expressed with incomparable subtlety. The sun was nowhere to be seen, and I wanted to know when spring would come. In March 1913 Edward Thomas went out 'in pursuit of spring', walking west from London in search of the oncoming season.[16] I felt I was doing something like that – across time rather than space. It proved addictive. My travels were not across fields, but through books.

It amazed me to realize that there have been times when weather is all allegory and others when the numbers on a rain gauge count for more than a pantheon of aerial gods; there have been times for meteoric marvels and times for gentle breeze. It is hard to find a description of a rainy night in the early 1700s, but by the end of the eighteenth century the Romantics will take a storm, or even just a shower, as fit subject for their most probing meditations. At every stage I was tempted to stop, bed down, and spend the next ten years studying the Harley lyrics or William Cowper's letters. But I kept *Orlando* in mind: I wanted to experience a sense of time travel, and to see England (and English skies) as if filmed with a time-lapse camera.

༄

We have arrived, in the twenty-first century, at a critical juncture in the story of weather. Unless decisive action is taken very soon, the next generation will see the last of the weather we know. We will have written our own ending to the history of life in a temperate climate which has endured for about 11,500 years. Whatever the future holds, we are at a point of divergence. Either there will be substantial changes in the way we live, or there will be substantial changes in the climate – which will in turn

necessitate new ways of life. Things will not stay the same; we will never again stand in the same relation to our weather.

Now, at what may be an end-point, it seems appropriate to consider what English weather has meant. We hear a great deal of what may be to come and much less of what happened in the past. For obvious reasons, most discussions of weather and climate now operate in the future tense, illustrated by extrapolations and projections. Even the intricate work of historical meteorology (and how extraordinary it is that scholarship of different kinds converges to tell us what the weather was like in March 1321) tends often to be valued in terms of the precedents it can provide for what might happen next. But this is also a time to look back. I have tried to piece together episodes from the vast history of life in the English weather. What I offer here is just one very subjective version of the many histories that might be told of creative responses to a relatively stable set of climatic conditions in England over roughly the last thousand years. It is a version of the life story of a literary culture, and a portrait from many angles of the weather in which it flourished.

The rich weather-cultures of Scotland, Wales, and Ireland might fill many books, as might the shifting relationships between them. I hope that the imaginative weather-lives of other countries will be written, but I have confined myself to England, the part of the world I know best. The dialogue between here and elsewhere is constantly revealing. English culture is made up from eclectically imported ideas, many of which have needed adaptation to make them suitable for English weather. The umbrella ('little shadow') arrived from Italy as a sunshade and quickly turned into a rain-defence. In the eighteenth century, Palladian villas gleamed on drawing boards, and architects wondered what would happen to them in damp fields below heavy skies. A steady vein of satire has laughed at this chronic problem of classicism relocated northwards. Alexander Pope in the 1730s mocked the builders of fashionable mansions who 'call the winds through long arcades to roar, / Proud to catch cold at a Venetian door'. Angela Carter in the 1980s made revisions to *A Midsummer Night's Dream* on the basis that 24 June is no time to be outdoors in an English wood ('dripping bastard wood ... *Atischoo!*'): her fairies snuffle irritably through the chilly proceedings. Both these writers, and many in between, make their art from the change of scene.[17]

Contrasts in interest and sensibility are never so apparent as when you catch two people responding to the same thing. So I imagined Francis

Bacon and Robert Burton next to each other, looking at the sky. Shelley wanted to sublimate himself into a cloud while Ruskin, equally but differently obsessed, wanted to store the clouds in bottles. Compared with people like this I am the most amateur and faddish of weather-watchers. I cannot sit looking at the sky for very long without getting restless. I appreciate the *Sky Mirror* made by Anish Kapoor for Nottingham in 2001, installing the great cosmic cinema on the pavement and allowing us to study the clouds without craning our necks, but I would not choose to stare into it for months at a time. I need some sort of human scale and grounding. The effect of rain in a garden makes sense to me more than the great untethered cloud displays on which Shelley loved to meditate. So, by reading, I have tried to watch people watching the sky – and people feeling the cold, and getting wet, and shielding their eyes from the sun. Woolf talked about biographers hanging up mirrors in odd corners to reflect their subjects in unexpected ways.[8] I have tried to hang a mirror in the sky, and to watch the writers and artists who appear in it.

Tesserae

The voices of people living in the English weather can be clearly heard for the first time in the surviving literature of the eighth and ninth centuries. But even going back this far we are coming very late to the story. People had already been living for millennia with sea breezes along the west coast and snow on what we now know as Salisbury Plain. In spring 2013 tidal erosion exposed the earliest human footprints outside Africa. For a short time they were visible in the mudflats at Happisburgh in Norfolk: imprints made by a group of people walking on the shore nearly a million years ago. The prints have been dated to a temperate period between ice ages, probably either 840,000 or 950,000 years back. Traces of vegetation from the area suggest that summers in these interglacial periods were similar to the summers we know today, though winters were several degrees Celsius colder and may have forced a pattern of seasonal migration.[1] We can imagine, then, the weather in which these early humans lived, but we cannot know how they experienced it. They may not even have made fires. Briefly revealed for a few wet weeks, the prehistoric puddles filled with rain and were washed away.[2]

Thirteen thousand years ago, the ice came down again from the north, freezing over Scotland, freezing over Creswell Crags in Derbyshire where people had scored into the cave walls pictures of birds and bison. For another thirteen hundred years there was silence. Then hunters from France and Germany travelled north into newly temperate places, walking across Doggerland into southern Britain. There began again to be voices, buildings, pictures. Circular lakeside houses were built and maintained at Star Carr in Yorkshire during the 8500s BC. The land has not been empty again since then.[3] Millennia later, from about 200 BC, there were people living out their lives on Mount Caburn, high above the Sussex flood-plains.

Further west along the South Downs, near Pulborough, we come closer to recorded history. Bignor Roman Villa is upstaged by the much grander Roman palace near Chichester, so all the school parties march in crocodiles around Fishbourne while at Bignor visitors go round in ones and twos, walking on the edges of the mosaics, and then, if the tuck-shop window is open, getting a mug of instant coffee to sip on the grassy bank looking out across the hills. It always feels like a discovery, as if you had

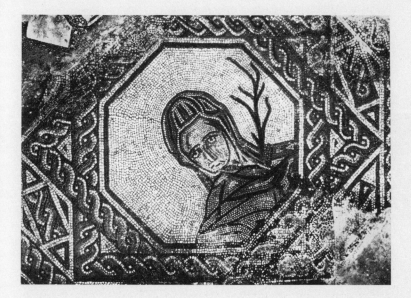

The cowled face of Roman Winter
at Bignor Villa in Sussex.

just turned up a Roman coin in a field. In fact, Bignor Villa was discovered by the farmer George Tupper while ploughing in 1811. He struck something hard, which turned out to be the edge of a fountain that once plashed in a Roman summer dining room. Now owned by Tupper's great-great-great-great-grandson, the floors are still sheltered by the Georgian thatched cottages Tupper built to protect them. The mosaics are impressive (a Medusa centrepiece, Ganymede carried off by an eagle, cherubs playing the part of gladiators waving tridents at each other in mock battle), but the image I love is one of the corner roundels of a floor on the west side of the villa. Each corner would have represented one of the four seasons, but now only winter is left. Winter is a lonely looking hooded figure, small and wan against a white-tiled background. Heavy brows and sunken eyes give the face its melancholy. A hand pokes out from swathes of woollen cloak to hold up a bare branch.

The mosaic does not tell us much about what January felt like in southern England when the month was called Ianuarius and the only light on a gloomy afternoon came from saucer-shaped oil lamps. 'The Four Seasons' was a popular decorative motif used in calendars, floors and paintings right across the Roman Empire. The basic imagery came as standard: young fertile spring, abundant summer, golden harvest, chill and elderly winter. The pictures evoked the conventional quarters of the turning year, mapped onto the stages of human life. There was no need for the imagery to be locally adapted or topographically specific. The mosaic designs laid down in Britain were probably brought over from the Mediterranean and copied from pattern books.[4]

No two seasonal images are quite the same, however. At Bignor there are two sets of seasons, the first dating from the third century AD, when mosaicists favoured simple geometric patterns in black and white.[5] The third-century Winter is as spare as they come: firmly contoured in black and red against a blank white ground, expressionless and with no accoutrements. In the fourth-century mosaic Winter has turned from pure symbol into a picture with feeling. There was once a Winter at Malton in North Yorkshire with a similarly muffled face, grimly set features and bare branch. The Winter who survives at Chedworth in Gloucestershire is more vigorous. He is well wrapped in leggings and tunic and a cape blowing out in the wind as he bears two seasonal totems, a dead hare in one hand and the essential branch in the other. At Chedworth and Cirencester we get a

sense of the repeated symbolism for all four seasons. Spring and Summer are naked or near-naked women, carrying flowers and wreaths. Autumn at Chedworth carries a basket while the Cirencester Autumn is draped in vine leaves and ready with a pruning knife.[6]

The people who walked over these floors knew, of course, that summer in Britannia was different from summers around the Mediterranean. Imperial geography placed Rome at the centre of the world while promoting the Italian climate as the most desirable and conducive to civilization. Places on the same latitude, in what was called the 'temperate zone', were much favoured; the inhabitants of 'torrid' and 'frigid' zones were pitied and regarded with suspicion. The first-century architect Vitruvius summarized the received Roman wisdom when he explained that 'the northern populations, infused with the thickness of the air and chilled with moisture, have sluggish minds'.[7] When Ovid was sent into exile in Tomis, on the eastern edge of the empire (now in Romania), he mourned what he perceived as an extreme change of climate. He was condemned to coldness and to uncultured remoteness, and the two things seemed to him inextricably related. In the anguished poems of his *Tristia* he wrote of beards glistening with ice, and frozen wine, un-pourable, which retained the shape of the jar. For a man whose society defined itself in relation to wine and warmth, there could be few more dispiriting prospects.[8]

Britain was at least as far from Rome in the opposite direction, and further north than Tomis. It was portrayed as a remote outpost; Britons knew that they were regarded as people at the end of the earth. In the first of Virgil's *Eclogues*, the shepherd Meliboeus speaks unhappily of distant places, including Britain, 'penitus toto divisos orbe', completely divided from the world. The historian Tacitus, whose father-in-law governed Britain, observed that 'the climate is foul, with frequent rains and mists'. There were, fortunately, mitigating factors: 'crops are slow to ripen but quick to grow – both facts due to one and the same cause, the abundant moisture of land and sky'.[9] The garrison soldiers up on Hadrian's Wall might have agreed with the basic assessment 'foul', or so W. H. Auden imagined in 1937. Auden himself was a lover of cold, but he could see that life might not have been ideal for a young man posted to Northumbria:

> Over the heather the wet wind blows,
> I've lice in my tunic and a cold in my nose.

The rain comes pattering out of the sky,
I'm a Wall soldier, I don't know why.

The mist creeps over the hard grey stone,
My girl's in Tungria; I sleep alone.[10]

The oldest written documents in Britain give some hints of life in the
north. The Vindolanda Tablets, the first of which were unearthed in the
1970s from one of many forts along Hadrian's Wall, are notes and letters
written in ink on sheets of wood (oak, alder, birch) during the first and
second centuries AD. Some are incoming mail: letters sent to soldiers on duty.
Others are drafts of letters sent out, household accounts, and lists of items
to order. Several are concerned with various kinds of clothing for keeping
out the cold. 'I have sent you [...] pairs of socks', writes one correspondent,
'two pairs of sandals, and two pairs of underpants'. Historians think the
half-legible number of socks may be 'viginti' – twenty – which seems a lot.
On another tablet Flavius Cerialis writes with a promise that tomorrow, 5
October, he will bring (or perhaps send the money for) supplies 'by means
of which we may endure the storms even if they are troublesome'.[11] Mail-
order catalogues from the ancient world, these tablets remind us that
the Romans in Britain were not draped in airy togas but wrapped up in
woollen undergarments and several layers of tunic.

Britannia, with its extensive pasture, was good at producing wool
and its products became famous throughout the empire. Cloaks included
the 'sagum' (which doubled as a blanket for bed), the 'paenula', the
'cucullus', and the 'birrus Britannicus', which was much in demand around
the cold, damp edges of Roman power. The birrus was like a duffel coat
with armholes rather than fitted sleeves. A relief carving from Housesteads
Fort – along the wall from Vindolanda – shows three figures (probably the
Romano-Celtic 'hooded spirits') wearing thick cloaks of this kind. These
garments, though not entirely reserved for otherworldly beings, were
luxury items and highly priced (6,000 denarii for such a cloak at the turn
of the fourth century).[12] Most workers in Britain had to do without such
robust protection from the rain. The appeal of steamingly hot baths in this
context is clear.

Roman builders thought carefully about temperature and light, often
orienting dining rooms towards the setting sun. Some of the guidance
given by Vitruvius was less than helpful. Houses built 'under the northern

sky', he thought, should always be angled towards warmer regions; it was as if a house might be improved just by facing vaguely in the direction of Italy.[13] Hypocaust systems came into their own in Britain, providing indoor warmth that would not be known again until the twentieth century. In Italy the expensive and labour-intensive system of underfloor heating was reserved primarily for bath houses, but in Britain it was much more widely used. Even small-scale villas often had a heated room. The air could be kept at a sauna-like 23°C, though to achieve this the floors were so hot that thick-soled sandals had to be worn.[14]

Archaeology has revealed much about the practicalities of Roman life in Britain – heating, woollens, climatically adapted farming – but it is difficult to gauge the imaginative response to wind and rain. The letters and manuals which survive do not mention whether storms carried messages from the gods, and there is little evidence of the reading matter which might have shaped feelings for landscape and nature. Virgil's *Georgics* were known by at least a few of the military families up at Hadrian's Wall; perhaps someone there read the catalogue of weather signs in Book 1 and wondered whether they applied in Northumberland. Virgil advises that 'rain need never take us unawares': 'high-flying cranes will have flown to valley bottoms [...] or else a calf has looked up at the sky and snuffed the wind.' After rain, 'mists hang low and crouch along the plain'.[15]

The people of Roman Britain must have had their own ways of talking about weather. They must have seen, felt, commented on, the mist coming in over Chichester harbour, the microclimate at Bignor which made it suitable for growing vines (and still makes it suitable today). Looking down on the cowled face of Winter may be about as close as we can get. If the designs were imported from pattern books, they were cut and laid in situ, and became cornerstones against which to measure the vacillations of the English year. It is hard not to think that this image is in some way shaped by life in this climate, on the slope of these hills, under these grey-white skies.

I

... sea-birds bathing, spreading their feathers,
frost and snow falling mingled with hail ...

'The Wanderer'

THE WINTER-WISE

English literature begins in the cold. The elegy now known as 'The Wanderer', usually dated to the eighth or ninth century, introduces the melancholy figure of an exile who finds himself completely alone in the world, adrift on an icy sea and haunted by memories of the life he used to lead.

> geond lagu-lade longe sceolde
> hreran mid hondum hrim-cealde sæ
> wadan wræc-lastas [...]

> *he must dip his oars*
> *into icy waters, the lanes of the sea;*
> *he must follow the paths of exile [...]*[1]

Whether or not he is actually out at sea, the Wanderer feels the solitude of a single oarsman alone with the elements and without any prospect of shelter. He was once part of a community, owing allegiance to a lord who in return gave warmth, protection, and loyalty. This man's lord is dead, 'covered by earth', and it seems that his comrades have been killed in battle, leaving one desolate survivor without home or human comfort. 'I left that place in wretchedness, / ploughed the icy waves with winter in my heart'.

'The Wanderer' works through contrasts. Where once there were gleaming cups and glorious princes, now there is the shadow of night. Each throws the other into relief. The cold is more bitter in comparison with the mead-hall fire; the shadows grow thicker as remembered cups shine brighter in imagination: 'For him are the ways of exile, in no wise twisted gold; / For him is a frozen body, in no wise the fruits of the earth'. The alliterative verse form, which had been used from prehistory by Germanic cultures and which endured as the standard metre of Anglo-Saxon poetry, specializes in these compressed contrasts. A single line can present a diptych: two images are held together by repeated sounds, but sometimes they evoke things which are painfully far apart. So the frozen body here clings to the bountiful image of the earth's fruits, and to its shining counterpart, the twisted gold. Frost and

gold are twined like strands in the intricate metalwork which haunts the exile's mind.

In the twenty-first century, psychologists are beginning to demonstrate correlations between temperature and mood. Researchers have found that feelings of exclusion regularly prompt a drop in body temperature, and conversely that people in cold conditions are likely to feel less socially attached than those who are warm.[2] Physiological evidence is emerging, then, for what the Anglo-Saxons already knew: that there are logical associations between loneliness and the cold. 'Winter in my heart' is Kevin Crossley-Holland's translation for 'wintercearig', literally 'the cares of winter'. It was a concept so powerful and well recognized that Old English, unlike modern English, had a single word to express it. The stock of other winter words in the language reads as a chilling list: 'winterbiter', 'winterburna', 'winterceald', 'wintergeweorpe'.[3]

The opposite of cold in Anglo-Saxon poetry is not the warmth of the sun, but the warmth of the communal indoor fire. Sunshiny days barely feature, and when the sun is mentioned at all it is often known as the 'candle of the sky'.[4] The image is curious in that it depletes the sun, likening it to melting tallow and vulnerable flame. The impulse of this culture is to favour the controlled, man-made, and essentially social space of the hall – lit by fire and candle. Exiles dream, not of airy fields, but of the dense, smoky atmosphere of a room where wooden benches are worn smooth and gold catches the light.

The outdoor winter world is dreadful by contrast, but it fascinates the poet of 'The Wanderer'; this is what he chooses to write about. While he sleeps, the exile dreams he is with his lord again. But he wakes to the truth:

> Ðonne onwæcneð eft wineleas guma
> gesihð him biforan fealwe wegas
> baþian brim-fuglas brædan feþra
> hreosan hrim and snaw hagle gemenged[.]

> *Then the friendless man wakes again*
> *and sees the dark waves surging around him,*
> *the sea-birds bathing, spreading their feathers,*
> *frost and snow falling mingled with hail.*[5]

How bleak that is: the gull's wing spread against the seascape of water, ice, and snow. It is monochromatic, with the addition of 'fealwe' suggesting the dun yellow of churned water. The poet is mesmerized by this cold expanse. The sense of horror is understandable, as is the tough resignation, but the highly developed aesthetics of cold might take us more by surprise.

Other Anglo-Saxon writing is explicit about the visual appreciation of cold. 'The Wanderer' survives in the Exeter Book, the largest anthology of Anglo-Saxon writing, and here, too, is a series of more than ninety riddle poems. One of these riddles describes an iceberg, and the poem is remarkable not only for its sense of the iceberg's witching menace and 'terrible laughter' (a whole soundscape of ice), but for its evocation of dangerous allure: 'A curious, fair creature came floating on the waves [...]'.⁶ In the 'Rune Poem', from the eighth or ninth century, ice is defined by its jewel-like quality. Thinking of it, the poet makes his line glitter – 'glisnaþ glæshlutter gimmum geliucost' – and icy ground gleams attractively in his mind as a frosted floor which is 'fæger ansyne', fair to see.'

The Wanderer's elegy sounds cold's lower notes, slower and darker than this. He appreciates something in the grey seascape which goes beyond the glint of an ice crystal. The poet makes a connection between nature being 'fettered' by winter (the sea is frozen: 'waþema gebind'), and his own grief bound up inside. He has kept silent about sorrows 'fæste binde' in his heart, and he adopts the austere seascape as the external image of inward feelings which are chilling in themselves and on which he has had to impose a cool self-discipline. Both water and emotion are arrested by ice, yet in the privacy of the poem the Wanderer allows himself to speak. His monologue becomes a controlled thawing, an 'unbinding' of his heart.

The grief unbound is both personal and universal. His own happiness did not last and nor, he realizes, can any happiness: he has seen the relics of those who went before him, whose solidly built societies have eroded away. 'Walls stand, tugged at by winds / and hung with hoar-frost, buildings in decay.' His own predicament is only a representative fragment of the larger human fate. When friends have died, when the fires have faded to dull ash, when the once-watertight buildings are derelict, what is left is the barren waste of winter:

and þas stan-hleoþu stormas cnyssað
hrið hreosende hrusan bindeð
wintres woma þonne won cymeð
nipeð niht-scua norþan onsendeð
hreo hægl-fare hæleþum on andan[.]

Storms crash against these rocky slopes,
sleet and snow fall and fetter the world,
winter howls, then darkness draws on,
the night-shadow casts gloom and brings
fierce hailstorms from the north to frighten men[8]

Some readers have suggested that this is an image of apocalypse.[9] Not only do all men – and all civilizations – reach the winter of their lives, and die, but the life of creation itself is finite and will reach an end. 'This world dwindles day by day', says the Wanderer. His own spring has passed and perhaps so too has the world's. This is the earliest literature in English, and as we look back across a thousand years we tend to think of it as a beginning. But the Anglo-Saxons thought they were near the end. The Wanderer's elegy is a poem of aftermath and it is about the plight of being aged, moribund, winter-bound. For its Christian poet there is only one place of certain warmth remaining, and that is the warmth of God in heaven. His Christian faith allows him to see his exiled coldness as the predicament of all men, salved by hope of the afterlife. In this context the Wanderer is no longer excluded, but representative: everyone on earth is wandering through winter.

⁓

This is not one poet's interest in cold, though that would be compelling enough; it is an abiding fascination shared by diverse and often warring tribes in a winteriness which is both literal and metaphysical. Wisdom and winter go together in Anglo-Saxon culture. There is a commonly used formulation, 'wintrum frod', which means literally 'wise in winters', possessing knowledge gained through many seasons of cold.[10] We still sometimes refer to 'a man of many winters', but the phrase sounds archaic and has lost its force. For the generations who lived in Britain from the fifth century to about the time of the Norman Conquest its meaning was vivid. Winter was an annual challenge to be met and endured; to come through a winter into spring was to achieve physical and spiritual maturity.

So it made sense to log the passage of time in terms of winters. They were the great measure of Anglo-Saxon life.

For Gildas, the first historian of Britain, writing in the sixth century, it seemed that the country was 'virtually at the end of the world', 'an island numb with chill ice and far removed, as in a remote nook of the world, from the visible sun'.[11] In this cold and darkness, he argued, the word of Christ was a form of light – if only the people around him would accept it. In the centuries that followed, Christianity was widely accepted, but winter on earth seemed no less pervasive. Poets mentioned warmth and spring with the briefest flashes of pleasure. Spring arrives in *Beowulf*, bringing 'wuldor-torhtan weder' (gloriously bright weather) and the brightness is glorious here in the sense that angels and heaven are also things of 'wuldor'. But almost immediately thoughts turn again to warfare.[12] There is no leisure for basking, and no lasting satisfaction in it. Many of the conventional ways of describing summer are based on ideas about the adornment of the earth with blossom and greenery; it is a costume, a surface effect, beneath which lies the real body of the world, made visible in the nakedness of winter. In 'The Seafarer', which also survives in the Exeter Book, there are hints of blossom and a cuckoo sings. But the poet mentions these things only to show that they mean little to him because the defining experience of his life is as an exile, 'fettered in frost'.[13] Here again are the desolate vistas of icy waves. The poem is partly a complaint, but the Seafarer seems to have chosen his exile. The greening of the meadows in spring urges him away to the wintry sea. It is on the 'whale's way', with the solitary sea-birds, that his mind is most free: 'My heart leaps within me, / my mind roams with the waves'.

In an intricate conceptual layering, these journeys satisfy the emphasis on fearless endurance in the heroic culture of the ancient Germanic nations while also fostering the Christian life of individual reflection and abnegation. For people who traced their genealogy back to northern Germany and Scandinavia there was an element of ancestral pride, even nostalgia, in going out into bracing air. So the cold could be associated with the heroic northern past, but it was also part of the Christian future. From the sixth century onwards it was common to hear of holy men who put themselves purposely in the hands of nature at its coldest. Cuthbert, Aidan, and Æthelwold on Lindisfarne, Columba and his followers on Iona: all went to the remotest parts of the British Isles,

fulfilling the Seafarer's urge to leave communal comforts behind for a life which was both meditative and heroic. They chose to be alone with a God who was manifest in the wind.

Saints' lives were part of the common hoard of Anglo-Saxon narratives, and weather was often part of the plot. When Bede wrote the life of Cuthbert, who lived as a hermit on Inner Farne for as long as his contemporaries would let him alone, he paused over an arresting image which clearly meant much to him. Bede described the saint's habit of praying all night in the sea, up to his arms and neck in water. This was a self-inflicted penance of cold, at the limits of bodily endurance. A fellow monk, wondering where Cuthbert went at night, followed him to the shore and watched at dawn as Cuthbert came out of the water and prayed on the sand, where otters gathered around him to warm his feet with their breath.[14] We can almost see, in the grey light of a morning on the wide Northumbrian beach, the wet gleaming fur of the otters, and their breath condensing as it rises.

The anonymous poet who told the story of the apostle Andrew in the Holy Land had more of a taste for action. He made his biblical Andrew an Old English warrior by emphasizing battles against any number of floods and storms. He was happy to borrow most of his material from Latin and Greek sources, but, at the point where St Andrew is caught in a tempest with little hope of survival, the poet saw his chance. 'The winds rose, the waves dashed, the floods were fierce, the cordage creaked, the sails were soaked', 'terror towered up over the ship out of the ocean's bosom'.[15] It is not necessary to the moral meaning of the poem to have quite so much bad weather. This is the English writer's own extra-strength dosage. St Andrew becomes a northerner, and the poet uses weather to make his material his own.

English summers could be as warm then as now, but Anglo-Saxon writing does not deal in warm Junes or bright Septembers. Perhaps they did not need to be discussed. In winter, the time of story-telling, easy warmth was an unreal memory. The painstaking work of historical climatologists suggests that, though there was a general warming and stabilizing of the weather after 900 – leading into the so-called 'medieval warm period' – the eighth and ninth centuries were cooler on average than during the Roman occupation and more often subject to storms.[16] 'The Wanderer' and 'The Seafarer' were probably composed in an England more prone to ice and flood than it is today.

Cuthbert prays at night in the sea and then sits on the beach at dawn while otters warm his feet. From a twelfth-century manuscript of Bede's *Life of St Cuthbert*.

Letters and chronicles hint at the tough conditions in which people farmed, built, and wrote. Sometimes the cold was articulated through a space on the page. At the Northumbrian monasteries of Jarrow and Monkwearmouth in the winter of 763, the scribes' hands were so cold that they could not write. They had been asked to produce copies of Bede's texts to be sent out after his death, but even these tough workers, accustomed to monastic draughts, had to stop. Abbot Cuthbert sent his apologies to Bishop Lul in Germany, explaining that ice, wind, rain, and storms had delayed their progress on the copying.[17]

Even when fingers had seized up, the canonical hours still had to be observed. The monks went to prayer three times each night, for compline, vigils, and matins, all in the frozen dark. At Jarrow there were glass windows in the church, made by glaziers brought specially from France. But the windows, and even more the glass, were exceptional features, reserved for one of the country's greatest ecclesiastical buildings. Windows were rare elsewhere, and might be covered with vellum if anything. 'Window' in Anglo-Saxon was 'eagþerl' or 'eagduru' – the 'eye-hole' or 'eye-door' through which to see out. The Norse word 'vindauga', or 'wind-eye', became the more common name, signifying what came in rather than the ability to see out. Windows let in the wind.

Most domestic buildings were single-room wooden structures, often sunk into the ground and with the earth itself as flooring, though cobbles or floorboards might sometimes be laid. If you wanted warmth you lit the fire, but fires make smoke. There were no chimneys (an innovation of the twelfth century and not common before the sixteenth), so smoke hung about in the rooms before slowly filtering its way out through the thatched roof. The air inside would be heavy with soot, making eyes itch and bronchial linings swell; archaeologists are used to finding damaged lung tissue and traces of sinusitis in human remains from the period.[18] Anglo-Saxon remedy books, noticeably well stocked with medicinal suggestions for the treatment of rheumatic and other damp-related ailments, tell us by implication about a world of aching bodies beset by inflamed joints, sore backs and persistent coughs.

Much of the day, at all times of year, was spent outside. The average routine of agricultural work rarely finds its way into books written by the learned in monasteries, but a few lines here and there evoke whole ways of life. In a Latin textbook written by the educator Ælfric in the

late tenth century and used as a primer in monastery schools, there is a sample discussion with a ploughman. It is a simple question-and-answer exchange, like the role-play scripts in language textbooks today. 'I work very hard', says the ploughman: 'I go out at dawn, drive the oxen to the field, and yoke them to the plough. There is no storm so severe that I dare hide at home, for fear of my lord.' The teacher asks if he has a companion out in the fields. 'I have a boy to urge on the oxen with a goad; he is now hoarse on account of the cold and his shouting.'[9] If his words are only guessed at by the learned Ælfric, the guess could not be far wrong: the start before dawn, leaving home in the dark to harness reluctant oxen, the expanses of mud making each step that bit more depressing, the trudging up and down, hour after hour, in clothes that never quite dry out.

FORMS OF MASTERY

In the Anglo-Saxon world the cold outside gave meaning to the mead-hall fire. Though saints might seek solitary exposure, most people preferred the idea of the communal hall. In stories it is the symbol of civilization itself, resisting the chaos of the unpredictable world beyond, where dragons appear in the sky and raiders come ashore at night. Winds and wild beasts may try the edges of the door, but they will not be admitted. In the confines of the hall the lord presides, his people talk and eat, the fire burns, mead is poured, another story is told.

The greatest surviving poem in Old English begins with the violation of such a place. The epic scope of *Beowulf* grows out of one central battle, which is specifically a hand-to-hand combat between the warrior Beowulf and the monster Grendel, but which is also a representative battle to safeguard the civilized human life of the mead-hall against forces that rise up out of the wild. The poem was composed somewhere in England, probably in the eighth or ninth century, but it looks back to Denmark in the sixth century. It is period drama: a poem of ancestors and origins, meant to feel satisfyingly archaic. The wild weather in *Beowulf* is both Danish and English weather, so that the dampness and frost of the Scandinavian setting feel familiar to anyone who reads it in the marshier lowlands of England.

There is the hall, Heorot, home to a society of sophisticated Danes. Then there is Grendel, who prowls the borderlands, shrouded in mist.

Waiting in the darkness, hearing the sounds of feasting and singing, Grendel is a jealous outsider. The poet makes him a descendant of the first exile, Cain, cast out by God as well as by men. Breaking into the hall, throwing his shadow across the place of light, Grendel seeks revenge for his exclusion. He is all that is untamed and inimical to taming. The poet's means of expressing this wildness are to invoke the foulest weather and environment. In important ways Grendel *is* the weather of the 'windswept crags' and 'mistige' moors from which he emerges. A 'shadow-stalker' ('sceadu-genga'), moving stealthily, he is more like a ghostly mist than a savage animal, and his shape is always indistinct. He moves below the clouds, 'wan under wolcnum'. In Seamus Heaney's translation, which gestures to the wideness of the landscape, he moves under 'bands of mist' ('misthleoþum'). It is true that Grendel is at least partly flesh and blood: when Beowulf wrestles off the monster's arm the poet displays before us a gory bit of clawed anatomy, and Grendel leaves a trail of bloody footprints behind him when he goes. He is said to look like a man. But if he is momentarily corporeal, he is more often intangible, a 'dark death-shadow', a thickening of air and light.[1]

These are the weather conditions and this is the eerie atmosphere that will characterize, centuries later, many of the great English ghost stories. Henry James's *The Turn of the Screw* and the East Anglian tales of M. R. James occupy these places of grey occlusion. 'The dampness of the insular air is crucial', observes the contemporary writer Peter Davidson of these fictional revenants: 'mists and vapours, afternoons darkened by rain, the proximity of lakes and meres, still, black, mist-generating water'.[2] It is a long cultural journey from heroic *Beowulf* to the muted psychological tensions of the late nineteenth and early twentieth centuries, but all through that time the forms of anxiety take shape in the mist.

The mere which Grendel inhabits with his mother is a black cauldron of chaos. It is primal in the sense that God's orderly creation has not reached this far. There is ice, but there is also – in accordance with the biblical inferno – a fire burning over the water. It is an outpost of the hell vividly imagined by Anglo-Saxon writers as a persecutory mixture of too hot and too cold. One biblical translator described how fires burn all night in hell, 'and then in the dawn the east wind comes, a frost tormentingly cold'.[3] The fire is hard to imagine in English marshland, but Grendel's mere is frightening because it is so nearly familiar. The poet's careful

topographical details of frozen woods, knotted roots, and dark pools bring certain boggy woodlands to mind.

This landscape of horror in *Beowulf* may have influenced, or been influenced by, a similarly grotesque scene which was conjured up by a vehement priest one September day in the tenth century. His sermon, which is now among the Blickling Homilies, explained to an Anglo-Saxon congregation somewhere in England what St Paul saw when hell appeared before his eyes. Paul looked north, and saw the souls of the dead hanging from the branches of trees along a cliff edge and then falling for miles into dark waters where they are seized by monsters. The setting is one of rimy woods ('hrimige bearwas') and dark mists ('þystro-genipo').[4] The weather conditions are intensely realized as part of the drama, their effect heightened by the fact that this sermon was delivered at Michaelmas, the hinge between summer and winter in the Anglo-Saxon year.

That invocation of the frosty wood was meant to hold the congregation in its grip as they sat safely in a church, just as those who recited *Beowulf* intended the audience around the fire to feel, for a moment, their blood run cold. This acute sense of the inside versus the outside will shape English lives and literature across the centuries. If the Anglo-Saxons are in many ways remote to us, they are in this way very close. Their sheltered indoor spaces are treated with a kind of sanctity.[5] Their art evokes the thrill of relief that still attends the drawing of the curtains on a dark winter evening, or the shutting of a door against the wind.

⌒

The Anglo-Saxons used art of many kinds to assert mastery over the outdoors. In a poem such as *Beowulf* they imagined physical conquest of all that was monstrous in mist and mere. In their metalwork, too, they wrought objects of defiance. The goldsmith made things that were immune to pain, time, and weather. The hoard of treasure uncovered by Beowulf at the end of his life has been in the earth for perhaps a thousand winters, in the poet's estimate, and will outlive even the dragon which guards it. The gold objects brought out from the Sutton Hoo ship burial in the 1970s gleam, likewise, in the British Museum, more than a thousand winters after their making. The famous Sutton Hoo helmet, with its moustache and eyebrows incised into the metal, is a life-mask preserving the features of a face and solidifying them into permanence. Not merely a defence

against enemies but a defence against all time, the metal body outlives the flesh.

In July 2009 the rings, belts, and purses of the Staffordshire hoard rose up, muddy but still glistening, from the earth of what was once the kingdom of Mercia. It was a resurrection of the undead. The people who owned these things in the seventh century knew that the damp earth would not erode them. Once made, they refused to die, which may be why a gold cross was forcibly bent double in an effort to disempower it. 'In the gloom', wrote Ezra Pound, in another context but using an alliterative Anglo-Saxon line, 'the gold / gathers the light against it'.⁶ The gold still gathers the light.

Wrought, jewelled, inset, interlaced, the productions of the gold-smith posed a challenge to poets. Could their art, likewise, be so woven as to defeat the weather? It may be that the most effective form of armoury is language itself, and the forms of imagination it permits.⁷ To name the weather, to say it and repeat it, to tell stories about it, all these are efforts to take control. It is comparable with the philosophy of the tragedians: tell the worst in a way you can manage, take possession of it. Render in art all that terrifies you.

The very earliest forms of written language among the Anglo-Saxons, derived from runes used in Scandinavia and Frisia, included symbols for weather. The Anglo-Saxon rune alphabet, or 'futhorc', was a system of hieroglyphs used in a culture that was otherwise illiterate. Each rune corresponded to a concept or thing – horse, man, tree, food – so that the full sequence of between twenty-six and thirty-three runes constituted the essentials of ancient life in England, beads of existence falling into different combinations. Three of the runes were weather signs, denoting hail, ice, and sun. The first impulses of language were to express these things. The 'Rune Poem' weaves ideas around each letter. So for 'hægl': 'Hail is the whitest grain. It comes down from high in the sky, the wind hurls it in showers, then it turns to water.' The poem is close to a child's alphabet song, yet its concerns are conceptual and aesthetic in that what matters here is the mutability of hail and its duality with grain. 'Ice glistens, clear as glass, just like jewels'; sun is 'looked forward to by seamen'.⁸ Runic writing typesets the weather into words.

The Anglo-Saxons were fond of riddles in which objects speak. A tree or a cup or a bookcase will cryptically describe itself and ask, 'Who am I?'

The weather talks too: winds and clouds are given voices. In the seventh century, perhaps at Malmesbury where later he would be appointed abbot, the monk Aldhelm wrote a series of a hundred Latin riddles amounting to a quizzical encyclopaedia of the world. The second puzzle is not difficult to solve:

> No-one can see me nor grasp me in his hands; I quickly spread the shrill sound of my voice through the world. With my terrible-sounding strength I am able to shatter oaks. I touch the lofty skies and pass through fields.[9]

This is the wind speaking. The riddle makes the wind pause for a moment to speak and tease, visible in script on the page and held in the hand. In the next riddle a cloud tells its life story. It changes colour (again, as with the glistening ice floor, the visual is prioritized), it drops rain, and – wonderfully – it is an exile, floating between earth and heaven, a solitary with no place to call home. A millennium and more before Wordsworth, the cloud was conceived as a lonely wanderer.

The first three riddles collected in the Exeter Book (sometimes read as a single poem) are also about weather. They are less aphoristically brilliant than Aldhelm's, but the poet has expanded the terse riddle-form to accommodate fulsome drama. His subject is a storm, which travels over land and under the water. As playwrights in later times will write words for their stage villains, here the riddler gives the storm a rousing soliloquy as it revels in its power:

> I roar loudly and rampage over the land,
> sometimes causing havoc [...]
> > Smoke rises
> ashen over roofs. There is a din on the earth,
> men die sudden deaths when I shake the forest [...]

The storm talks on, now describing how it whips up the sea:

> Sometimes I swoop to whip up waves, rouse
> the water, drive the flint-grey rollers
> to the shore. Spuming crests crash
> against the cliff [...][10]

Rushing through the sky, the storm smashes clouds against each other. This is the sky as imagined in a warrior society: it is a battlefield and the storm takes its spoils. It should not seem remote to us. In the early twentieth century, meteorologists from the Bergen School in Norway proposed the movement of air masses by analogy with the advance and retreat of battle-lines in the First World War. Warm and cold 'fronts' took their name from the front lines of the trenches.[11]

In the riddle, the weather is a marauding army and it causes the same kind of devastation. The poet is the potent eye of the storm. He is for a moment in control and on the victor's side, except that, looking from the storm's point of view, he realizes that the storm itself is not all-powerful. The weather is only a servant of God, allowed out to do God's work and then (as the storm tells us later in the poem) imprisoned again under the earth. Winds were understood to come up from the earth (and earthquakes were caused by subterranean winds trying to get free). Though Aristotle's *Meteorologica* was not known to the Anglo-Saxons, his theories of winds breeding inside the earth were passed down through encyclopaedists like Pliny and later Isidore of Seville to be deployed in the natural history writing of Aldhelm, Ælfric, and Bede.[12] These thinkers were all trying to understand the giant natural process around them, and the riddle is part of that quest. It asks what the weather is *like*, who it is, whose rules it obeys. The storm is subdued by the end of the poem and rendered as a figure of sorrow. Only God remains in charge. Not until Shelley evaporates himself into a cloud will there be a comparable leap of imaginative empathy with the air.

IMPORTED ELEMENTS

The English are known today for their obsession with the weather, and it is tempting to suppose that the Anglo-Saxons might have been similarly renowned. Yet many of their weather descriptions were not distinctively English at all. Anglo-Saxon speakers and writers borrowed eclectically to build up the hoard of imagery they needed. England is geographically a middle ground between north and south, so its weather-culture takes ideas from both directions. This is manifestly evident in the twenty-first century: summer pavements fill up with continental café tables which have to

be dried after every shower, while in winter we buy Fair Isle or Swedish jumpers for which it is rarely cold enough. We cannot decide whether to invest in snowploughs or in open-air arenas. Some of that betwixt-and-between quality shows itself in the earliest English language and literature.

The icy wind blowing around the Wanderer's head comes, predictably, from the north ('norþan onsendeð hreo hæglfare').[1] The cold in *Beowulf* is northern too. Thinking of monsters in the chill night, the *Beowulf*-poet imagines his way back to the Germanic homelands of his ancestors; his story of the misty and monstrous outdoors belongs in his mind with the old country, Scandinavia, the north. The runes for 'hail' and 'ice', the whole Old English vocabulary of sleet and rime, the word 'weder' itself, all have Germanic origins.

The Norsemen, or north-men, who raided the coasts and took over northern and eastern England in the ninth and tenth centuries, brought with them a vast mythology that had been developing for nearly two thousand years, and which was predicated on struggles between fire and ice. Even if the old gods were no longer worshipped by the time the Vikings settled in England, the myths from the cold countries were hard to forget. In the beginning there was ice on one side of the universe and fire on the other, and a place in between called Gunningagap where ice comes into contact with warmth and begins to melt.[2] As it thaws, the ice forms strange beings: the great frost-giant Ymir and the holy cow Auðumla. With its large tongue the cow licks out a shape from the ice. Warm and rough, the cow-tongue works on the smooth ice, melting and sculpting it. The shape comes to life. This new being, born from the interaction of cold and heat, is a human. Life germinates too in the warmest parts of the frost-giant's body. His armpits become fertile, producing a man and a woman. In the Jewish and Christian scriptures from the desert places of the Holy Land, man is made from dust.[3] But here, in the northern account, man is fashioned from melting ice. At the point of thawing, that magical juncture at which solid becomes liquid, life emerges.

The first men and women immediately set about murdering Ymir the frost-giant (or rime-giant, 'Hrimthurse'). From his body they fashion a world for themselves:

> From Ymir's flesh was earth shaped,
> The mountains from his mighty bones,

From the skull of Frost-Cold was the sky made,
The salt-sea from his blood.[4]

Imagine looking out at a winter landscape and, at some level, understanding it through these myths. The white dome of the sky is the curving skull of a great iceman, whose blood once ran as cold and grey as the punishing northern seas. In some accounts Ymir's brains are thrown into the air where they form clouds. The Norse myths look back to a wintry creation, and forward to an apocalypse that comes in the form of eternal cold. Ragnarök (the 'Fate of the Gods') will be heralded by three years without summer. During this Fimbulvetr ('Great Winter') snow comes from all directions, darkness reigns, people wage war in their desperation. Then come the battles of the gods themselves, and at last the sinking of the ice-bound earth into an overwhelming cosmic sea.

It is terrifying and magnificent. Yet there is scant evidence of the Norse gods surviving as powerful figures for very long in England.[5] The Vikings converted rapidly to Christianity. The Gosforth Cross in Cumbria is rare in being carved with images of Ragnarök and of Thor fighting the World Snake – and even here the pictures are contained within a framework of Christian imagery. In the nineteenth and twentieth centuries, devotees of the northern myths would argue for a long affiliation between English and Norse cultures; W. H. Auden, for example, would insist on his Viking genealogy and respond to Norse literature as the most important part of his cultural inheritance. But the myths he loved had only ever taken a fragile hold on English ground.

Many Old English ideas about weather appear to derive instead from the work of Greek and Roman writers. The cold comes from the south as much as the north. Bede described the eagerness and urgency of Latin learning among the monks at Jarrow, the research trips and book collecting, the busy to-and-fro between Northumbria and Rome.[6] When scholars came back laden with books acquired on their forays to the Mediterranean, they were importing – along with much else – ideas about nature, the weather, and the seasons. The imagery of ice 'binding' and 'fettering' was a standard formulation in classical (but not in Germanic) poetry. The icy beards of the wanderers also have analogues, if not sources, in Ovid and Virgil.[7] It is possible that the Anglo-Saxon poets of exile were invoking the exile literature of the classical world, harnessing the power of Ovid's *Tristia*

to their own native experiences. They share in the basic Roman idea of the cold extremities lying out on the frontier, far from the warming centres of civilization. And they turn classical pagan work to Christian use in evoking the exile of life on earth, awaiting the ideal climate of heaven.

Some major ideas settled so naturally into English culture that it is hard to imagine things being any other way. There seems to have been a time, for example, when the English year was not understood in four distinct seasons. In a seminal book called *The Seasons of the Year*, the Finnish philologist Nils Erik Enkvist described a 'primitive dualism between day and night, summer and winter', which structured the year for centuries before gradually ceding place 'to a universe of gradations and to a world of four seasons'.[8] Others have shown how the two- and four-season patterns coexisted. There was the ancient Germanic year, hinged across the middle, which is what we find in 'The Seafarer', for example, where the poet uses the kenning 'corna caldest' ('the coldest grain') to describe hail. Corn and hail, gold and white, summer and winter.[9] But in Latin writing, or Old English which has come under Latin influence, the four seasons appear and the year takes a different shape: 'lencten' (the season of lengthening days) swells into 'sumer', which yields gradually to 'haerfest' and 'winter'.[10]

The relationship between two of the seasons in the classical four-part year is intriguingly set out in a late eighth-century Latin poem attributed to the learned and well-travelled Alcuin, who worked both in England and at the court of Charlemagne. 'The Debate between Spring and Winter' is the earliest example of a 'debate' genre, the *conflictus*, which would remain popular for centuries ('The Owl and the Nightingale' is a later, more famous example). It dramatizes the contrasts between different seasons or times of day – their birds, plants, moods, and associated activities, the ways of life which they encourage and for which they seem to stand. In Alcuin's poem the enthusiastic character of Spring anticipates the first cuckoo, while Winter explains why he dreads the cuckoo's coming. Winter is strikingly different here to the one in the Old English poems. He stays indoors, lying in 'torpore', resentful of the work and outdoor action that will come with good weather. He has no interest in the icy land or seas, and no sense of heroic 'wintering'. Spring, who is barely mentioned in Old English, has equal status here with Winter, and is chosen by a jury of shepherds as the winner of the debate: 'Let the seeds burst luxuriantly into bud on our hills, / May there be pasture and sweet repose in the fields for the flocks'.[11]

Just sometimes, the 'sweetness' of spring finds its way from Latin sources into an Anglo-Saxon text. The ninth-century writer of 'The Phoenix', translating and elaborating images from a Latin poem, imagines the climate of paradise in terms of light, flowers, and delicate scents.[12] The poet is keen to show that it is very different from the familiar bad weather on earth. No, he says, his subject is not snow or hail or winter sleet (the subjects of the Old English elegies); he wants to write about this place of blossoms where the phoenix renews itself like Christ and like spring. In the 'warm breath' of this poem, observes Enkvist, we find an example of 'Christian Anglo-Saxon poets struggling to break away from the terrible winters of the heroics to the ideal climes of the paradise long celebrated on the continent'.[13]

⌒

In 'The Old English Calendar Poem', or 'Menologium', we get a glimpse of what the English year felt like, through its full cycle of seasons and months, for a common-sensical writer in the eleventh century recording the important liturgical dates against the backdrop of nature and weather. It is not a great work of imaginative literature, and the poet certainly does not count himself among the 'learned men', but for just that reason it gives a sense of the year as it might have been experienced in villages all over the country. Oral and learned, Norse and classical forms are all bound together here. The Latin names for the months are used alongside the Anglo-Saxon names (which Bede had thought were ancient history about three hundred years earlier).[14] May is also 'Thrymilce' (when the cows were milked three times a day); October is also 'Winterfilleth', the month when the full moon marked the beginning of winter, a season which, in the old order, would last for half the year. The poet gestures cheerfully to 'sun-brightsome days, / warming weathers' when 'the meads bloom with blossoms, and the bliss mounts up over the earth', though the most energetic lines belong to winteriness, which extends right through the New Year into March. 'March the fierce one, / Haughty Hylda', 'crusted with hoar-frost and hailstorms'.[15] This is someone who is not just following seasonal conventions (which might designate March as the temperate start of spring), but who knows the fierce potential of a month that often comes in like a lion, even if it goes out like a lamb. The sense of the turning year in the 'Menologium' is culturally eclectic, but the weather is recognizably ours.

It is worth noting that there are no comparably specific representations of weather in the visual arts of this time. Where figures are shown against an outdoor background, it is definitely not 'sky'. In a mid-eleventh-century calendar preserved in the British Library (in a manuscript known as Cotton Tiberius B.v), there are coloured scenes showing outdoor work, but the sky-spaces are flat blocks of yellow, red, and blue, filled in purely for decorative contrast and with no intention of imitating cloud or rain. The poetry, on the other hand, is acute in its perception of air and temperature. The visual effects of mist in *Beowulf* are integral to the story. 'Flint-grey' in the 'Storm' riddle is not a modern translator's approximation: the Old English is 'flintgraegne', a compound rich in the precise knowledge of the sea's dark opacity, its sheen, and its stony coldness.[16] Such discrepancies between art and literature are reminders that we cannot hope to guess what anyone in the ninth or eleventh centuries really saw when he or she looked at the sky. But there is no doubting the conceptual interest in weather which will endure in English thought across the centuries.

One piece of writing in particular sums this up. It is an account of the Fall as told by an Anglo-Saxon poet adapting a Saxon version of Genesis. When he realizes that Eden is lost, Adam's first thoughts are of the weather. Anticipating life in the fallen world, seeing earthbound days stretch out before him, it is the weather that he imagines most vividly. 'Hail will come pressing from the sky', he says: 'it will come mingled with frost, which will be sinfully cold. At times the bright sun will shine, blaze hot from the heavens, and we two will stand here naked, unprotected by clothes'.[17] This is man's fate as an exile from paradise. 'Nothing will shield us', writes the poet, invoking in that moment all the shields which humans will make for themselves, weak substitutes for God's protection: clothes and walls, coats of mail, the consolations of philosophy, the consolations of poetry itself.

WEATHERVANE

Someone looked up and wondered how the weathervane felt. The eighty-first riddle in the Exeter Book is narrated by a cockerel attached to a pole and stuck in the air. This being an Anglo-Saxon poem, the weather is cold and the weathercock is horribly exposed to it: 'I suffer misery', he says, 'hoar-frost attacks me and snow half hides me'.[1] He is proud, and flourishes

his tail, but it is hard being all alone, high above the rooftops. The poet imagines this poor cockerel, cold and battered, as a suffering figure of exile. Like the Wanderer, the weathercock stresses that he must keep his woes to himself. So he sits in the air, inscrutable and silent. We do not know who wrote this cunningly ventriloquized cameo of coldness. Whoever it was had a shrewd sense of humour, and enjoyed parodying the conventions of the frozen exile to propose the weathercock as a kind of hero.

There are no surviving weathervanes from the Anglo-Saxon period, though this riddle and other references suggest that they would have been a common enough sight in the ninth and tenth centuries. Legend has it that in the ninth century Pope Nicholas sent out a decree that churches all across Christendom should bear the cock as a reminder of how Peter denied Christ. The evidence is extremely thin, but it is a plausible explanation for the sudden profusion of roosters. Across Europe they were hoisted onto towers and steeples: cocks carved from wood and cast in metal. They were eye-catching reminders of denial and repentance, looking down on us all from above.[2] If the papal story is true, churches bore cockerels before they bore weathervanes, though the two functions were soon combined. The birds blew in the wind, their high feathered tails acting as flags in the breeze. In a doubling that seems eloquent of the linked histories of faith and meteorology, the weathercocks were both signs of God and signals of God's weather.

They quickly became icons worthy of enthusiastic celebration. When a gilded rooster was installed on top of the newly extended Old Minster at Winchester in the late tenth century, it attracted whole panegyrics. The cleric and writer Wulfstan devoted many lines of Latin verse to the praise of this golden bird:

> Raised aloft this noble fowl commands all other birds, and rules the western domain. It is eager to receive the rainy winds from all directions and, turning itself, it offers its face to them; bravely it endures the violent blasts of the wind, standing unafraid, tolerating gales as well as snowstorms. It alone sees the sun sinking into the western ocean, and likewise it sees the first rays of dawn. Someone coming from afar fastens on it, once in its vicinity, with his eye and, though still far off, fixes his sights in that direction.[3]

Turning into the wind, this bird was a warrior stoutly facing its enemy while also, like a good Christian, turning the other cheek. It was a shining beacon

A weathercock installed on the new Westminster Abbey,
as depicted in the eleventh-century Bayeux Tapestry.

drawing travellers from afar, and it was a kind of prophet, glimpsing the future as it looked out towards the dawn.

That was in 994. For centuries after this the vanes on great cathedrals and local churches alike would be messengers from the skies giving news of the wind. Whole communities referred to them, and when winds swept across the country they turned the vanes of church after church. In the mid-eleventh century a weathercock was erected on the rebuilt Westminster Abbey. The Bayeux Tapestry shows a workman balancing on a ladder to install it while a divine hand reaches down from heaven in affirmation. If this bird looked to the Channel it would have seen enemy fleets approaching. The Conquest of 1066 made England a province of Normandy. Old English became a language of the conquered; Anglo-Saxon literature and culture belonged to the dispossessed. Though the Exeter Book and its riddles survived through it all, few people turned the pages to read the poetry preserved there.

The oldest vane still working in England was made in the 1340s. A small, vulnerable-looking bird, on top of a high cross on the steeple at Ottery St Mary in Devon, it waves its tail in silhouette against the clouds. There are no compass points, but no one in the Middle Ages would have needed them. This is a cock who crows in the wind, having copper tubes which whistle as the air passes through.[4] Perhaps it whistles about cold exile and bravery, as in the Anglo-Saxon riddle. But it may be a different kind of tune. The wind had long since turned, and the weathervanes of Winchester and Ottery St Mary looked down on a different England.

II

Omnia tempus habent ...
(All things have their season)

Ecclesiastes

Anyone reading through an anthology of English literature will be aware of the light and temperature shifting. Turning the pages from the Anglo-Saxon elegies to the lyrics of the thirteenth and fourteenth centuries, the air begins to feel milder. Doors are thrown open; the poet is outside and it is spring. He sees the blossom and he hears the birds:

> Bitweene Merch and Averil,
> When spray biginneth to springe, / *branches come into leaf*
> The litel fowl hath hire wil / *little bird is happy*
> On hire lud to singe.[1] / *in her own language*

Copied into an anthology of poems owned by the Ludlow family at Stokesay Castle in Shropshire in the 1340s, these are the first lines of an anonymous song about a beloved 'Alison'. They are similar to the first lines of hundreds of other medieval lyrics. Again and again we see the 'spray' unfurling and hear the song of the 'litel fowl'. The rhyme between 'spring' and 'sing', joyously repeated as often as possible, expresses an association between natural growth and human creativity. Usually there is love involved, sometimes religious though often secular – either the delight of lovers in tune with the natural world or the pain of parted lovers whose melancholy is accentuated by contrast with the season. With all the regularity of the Anglo-Saxon poets describing ice, medieval poets evoke a world springing and singing its way into new life.

What looks from a distance like a pleasant change of temperature was in fact the result of the myriad complex, radical, variously subtle and violent negotiations by which England became Anglo-Norman. A lifetime could be spent in exploring the relationships between, on the one hand, spring descriptions as they began to be used by native English speakers, and, on the other hand, spring songs from France, of which there were many interacting types ranging from the *reverdies* (or 're-greening' songs) of the Provençal troubadours to the highly stylized spring passages in the *Roman de la Rose*.[2] Both Henry i and Henry ii, and their queens Matilda and Eleanor, were patrons of the arts and sponsored troubadours at their courts – poets like Bernart de Ventadorn, who was in England in the 1150s, singing of melancholy lovers in blossoming woods.

A generation later, Marie de France (who lived in England and defined herself by her Frenchness, claiming that her stories came from Breton minstrels) wrote of spring in 'Laüstic' as the season when 'amur' comes from every flower.[3]

In just a few lines from an Anglo-Norman lyric, reminiscent of a lovelorn troubadour song but composed in an anglicized version of Old French that flourished in London, the most populous and advanced French-speaking city in the world, we glimpse some of the many literary cultures which coexisted in the polylingual England of the twelfth and thirteenth centuries. Here is the sensual longing with which a poet anticipates twelfth-century spring:

Quant le tens se renovele
E reverdoie cy bois,
Cist oysials sa père apele
Celé cum a pris a choys;
Lur voil chanter sur mun peis [...]

When the fair weather is renewed
And the woods again grow green
Each bird calls its mate,
The one whom it has chosen;
Then will I sing my grief [...][4]

We might wonder that spring culture could involve such crosscurrents of artistry. It seems fairly obvious, even instinctive, that you might sing a song when the sun comes out. But the fact that the Anglo-Saxons do not seem to have sung about happy birds or the pleasure of sunshine indicates that the desire to do so is by no means universal. Nor are the surviving medieval lyrics particularly 'natural' or even attentive to nature. Written celebrations of particular green landscapes do exist (St Aelred, in the mid-1100s, described Rievaulx Abbey in Yorkshire as a 'second paradise of wooded delight', where 'the branches of lovely trees rustle and sing together'), but they are rare in comparison with the standardized birds and blossoms.[5] Most lyrics are not spontaneous reactions to spring, the literary equivalent of *plein air* paintings (an idea that would have made no sense in the thirteenth century); they are close weaves of conventional images and appropriate emotions.

To sing a spring song in England was not necessarily a gesture of Frenchness or Norman allegiance, since every Latinate country had its literary seasons. English spring had been evolving since before the Conquest, influenced by literature from all over the continent, like the mid-eleventh-century 'Cambridge Songs', brought originally from Germany and including much talk of 'gentle Zephyr'. There existed for several centuries 'a vast lost world of English song' which has left little trace, though some lyrics appear to have been less polite, less keen on artifice, and altogether more raucous than those of the troubadours.[6]

It is likely that, in the 1260s, a monk in the chill quiet corridors of Reading Abbey had a catchy song on his mind: 'Sumer is icumen in, / Lhude sing cuccu!' It starts off with the usual meadows blooming, but then: 'Bulluc sterteth, bucke ferteth, / Murie sing cuccu!" The bullock starts and the buck farts, the music ascends almost a full scale to mark a climax, and all the sexual force of nature is in play. Nor is the cuckoo just another sweet-sounding bird. Cuckoos lay their eggs in other birds' nests, and for that habit they have long been associated with adultery – which, like the cuckoo, was thought to be most prevalent in spring. Cuckoo led to 'cuckold', and cuckoldry lurks in that insistent, addictive chorus: 'sing cuccu!' The fun of the rhyme is on the side of the bucking, farting, and cuckooing, and since this was written to be sung repeatedly as a round (it is the oldest example of English polyphony) it could all go on for some time.

This song, which calls out with joy and transgression, can still be sung from the same manuscript as in the thirteenth century. The score has survived, written out on vellum with the lyrics underneath each line. In fact there are two sets of lyrics, making the score suitable for all occasions. The 'murie' spring song is accompanied by a sober alternative in Latin for when loud cuccuing would not do. All this was bound together with other music and poetry in a book which also contains a calendar for Reading Abbey and is inscribed by its owner 'W de. Wint'. The most likely candidate is the Reading monk William of Winchester, who was, by all accounts, prone to lusty feelings, and might well have enjoyed the cuckoo song as a change from the sacred music he ought to have been contemplating on his way into mass.[8]

In the eighth century, Alcuin and other Latinists had articulated the *conflictus* between winter and spring. Now spring was certainly ascendant, the taste for it so keen that even in February 'St Valentine's day poems

'Sumer is icumen in':
words and music from the 1260s.

began with spring descriptions'.[9] For two centuries, from the early 1200s to the mid-1400s, it was the season that made people sing – of love and loss, of feelings sacred and profane. Yet, intriguingly, they had no distinct name for it. 'Spring' was used as a verb ('spray beginneth to springe'), but it did not become the name of a defined season until the 1500s. 'Lencten' served well enough to denote the period from Ash Wednesday to Easter, and 'Somer' encompassed both our spring and summer.[10] Such linguistic changes remind us that seasons have to be invented, and this particular season was invented with verve. Impatient for its flowering and regretful of its passing, medieval writers made it last from February right through to July.

Spring was the time for poets to leave their books and go into the fields, as Chaucer observed in his *Legend of Good Women* in the 1380s. 'Bokes for to rede I me delyte', he says in his persona of reclusive year-round bookworm; but he makes an exception for spring:

> whan that the month of May
> Is comen, and that I heare the foules synge,
> And that the floures gynnen for to sprynge,
> Farewel my bok and my devocioun!

Though he bids farewell to his book for a moment, his enjoyment of spring is enhanced by all the reading he has done. Once the blossoms have faded he will doubtless be busily composing spring songs for the rest of the year. Soon after this, Chaucer wrote what would become the most famous spring in English literature. For many people today the prologue to *The Canterbury Tales* is associated with rote learning at school and the guttural sounds of a language not theirs. Read it again, and Chaucer's delight becomes addictive:

> Whan that Aprill with his shoures soote
> The droghte of March hath perced to the roote,
> And bathed every veyne in swich licour
> Of which vertu engendred is the flour;
> Whan Zephirus eek with his sweete breeth
> Inspired hath in every holt and heath
> The tender croppes, and the yonge sonne
> Hath in the Ram his half cours yronne,
> And smale foweles maken melodye,

That slepen al the nyght with open ye
(So priketh hem nature in hir corages),
Thanne longen folk to goon on pilgrimages [...]"

We have to keep reading because Chaucer won't let us stop: he holds back the subject and verb of the sentence until the twelfth line, so that the momentum builds and builds. The reader quickens as he gets short of breath, until the release comes at last: '*Thanne* longen folk to goon', and by this time we feel the longing too.

An epic poet in the classical world would have begun by seeking inspiration from the muse. The muse would speak through the poet, and so his words would have her divine sanction. As he set out on the *Aeneid*, Virgil asked the muse to tell him what took place. Chaucer makes a seasonal substitution as he sets out on his own journey, replacing the muse with the gentle airs of spring. Zephyr, the west wind, has 'inspired' the tender crops, and by association he gives breath to Chaucer.[12]

Showers can be inspiring too. The 'shoures soote', like ample beer at the Tabard Inn, ease the poet and pilgrims into song. April is statistically no wetter than March, but poetry has made 'April showers' a phenomenon.[13] It is appropriate that the first literary epic of English life should begin with rain. This first soaking is an alluringly sensual one, piercing the earth, finding its way into every bodily 'veyne'. If Mediterranean writers found their hot dry climate conducive to love songs, the English were not going to miss out on the competing erotic potential of rain.

There is much that is classical, literary, and learned in Chaucer's spring song: the mythological Zephyr, for example, and the plotting of time in relation to the sun's path through Aries. There are conventional literary details, like the singing of small birds, which no self-respecting *reverdie* could be without. But it is the mixing up of convention with observation which makes this spring distinctive. Chaucer is idealized but also down to earth, all in the space of twelve lines. He adds to the customary 'small fowles' the arresting detail that they sleep with open eyes. Suddenly, from the generalized landscape, we find that a duck is staring out at us. Chaucer's 'small fowl' might be many kinds of bird (modern editors point out which species have transparent eyelids), but mallards are especially good at sleeping with one eye on the watch. Once

we have registered that 'open ye' there is no forgetting it: all nature is wide-eyed and on the alert.

The mood of spring got into every field, street, and cloister. Yet the whole character of the season was shaped by its coincidence with the period of Lent. This time of blossoming was also a period of fasting and sobriety in preparation for Easter. The eating of meat was forbidden. Couples could not marry during this time; nor, more to the point, were they supposed to have sex. It may be that this six-week abstinence, demanded by the church at just the time of year when all nature seemed fertile, explains a little of the pining and dreamed-of release in the spring songs. 'Lenten is come with love to toune', begins one poem, but love in Lententide had also to be controlled and contained.[14]

The period of fasting ended with the celebrations of Easter, followed not long afterwards (the latest date for Easter is 25 April) by the varying festivities of May. Anyone who has been out at dawn on May morning in England knows that it is liable to be damp and cold, so the practice of walking through meadows required determination. The historian of folk rites Ronald Hutton makes the nicely debunking observation that the demographic evidence (at least for the Early Modern period) shows no May-time rise in the number of conceptions. 'The boom [...] came later in the summer', when things had warmed up. Still, there were certainly games and dances, and a ritual gathering of vegetation. We still know hawthorn blossom as 'may'.[15]

We can imagine poems being read or sung at Stokesay, half castle half domestic manor house, with the air a little claggy from the moat, and the River Onny running in the distance between the Shropshire hills on its way to the Severn. 'Lenten is come' celebrates the renewal of nature by day and night, looking across the whole greening landscape, and letting the eye rest on small birds and plants:

> The mone mandeth hire bleo,
> The lilie is lossom to seo,
> The fenil and the fille.

> *The moon gives out her light,*
> *The lily is lovely to see,*
> *The fennel and the chervil.*

The power of these lyrics comes from their sense of a brief charmed interval. Each year the blossoms faded, the intensive labour of harvest came round, days shortened, the animals needed to be brought in from the cold, and winter settled in. Then summer would be a memory, as in this lyric from the 1220s:

> Mirie it is while sumer ilast
> With fugheles song –
> Oc nu necheth windes blast
> And weder strong.
> Ey! Ey! what this nicht is long,
> And ich wid wel michel wrong
> Soregh and murne and fast.

> *Merry it is while summer lasts*
> *With birds' song –*
> *But now draws nigh the blast of the wind*
> *And bad weather.*
> *Oh! Oh! this night is long*
> *And I with so much wrong*
> *Sorrow and mourn and fast.*

A singer might cry out for spring to come sooner. One of the most expressive of all the surviving lyrics looks forward to the warm west wind that was synonymous with spring:

> Westron wynde when wyll thou blow,
> The smalle rayne downe can rayne –
> Cryst, yf my love were in my armys
> And I yn my bedde agayne![6]

It is not known whether these words (which survive in a songbook from about 1530, though they are likely to be medieval) first occurred to a man or a woman, or whether they came on a winter day when the world seemed barren and unloving. The sentiments are immediately familiar: 'I want to go back to bed!' But these four short lines are delicately ambiguous.

Though it is possible that the speaker is out in the wet and fed up with it ('the smalle rayne downe *can* rayne'), this grumpy observation feels out of keeping with the tone of the lyric. If the point of the line is to evoke wetness then the specific reference to 'small rain' is an odd way to do it.

Most readers have preferred to add a silent conjunction: 'Westron wynde when wyll thou blow, / [*So that*] The smalle rayne downe can rayne'. The meaning shifts at once from exasperation to sensuous yearning.[17] In this reading the rain is desired; it seems now to carry associations of fertility, warmth, and gentleness. The interpretation would be more convincing if we knew that 'small rain' was often thought to accompany soft springful Zephyr, and there is some evidence for this. In Deuteronomy, as it was later translated, the word of God 'shall distil as the dew, as the small rain upon the tender herb'.[18] Small rain may well have been welcomed by the poet as a sign of fertile goodness. With this rain comes the memory of love, which might be mixed with mourning for a lost partner or with anticipation of summer nights to come. The seasons of the year and the seasons of love are closely folded.

MONTH BY MONTH

Spring was the time for love, or for longing, but every part of the medieval year had its associations and appropriate activities. The court and nobility had their seasons for hunting, hawking, travelling, jousting in tournaments, fighting in battle. For the people who worked the land – the great majority – there was the constant round of agricultural labour, from fencing, ditch-digging and logging to ploughing and threshing, every task vital in ensuring the supply of food and fuel. In the medieval calendar all these tasks, high and low, were brought into step with the liturgical timetable of the church so that periods of ploughing and sowing were marked out in relation to the high days and holy days (red-lettered in the almanacs) that punctuated the church year as hours punctuate a day.

The cycle of work, play, and worship in relation to the seasons was recorded in medieval art and literature more devotedly than ever before or since. Calendar illustrations appeared in richly decorated books of hours and workaday manuals, in wall-paintings, stained-glass windows, and carvings. The names of the artists are not known, but the ritual mapping of the year was among the great communal creations of the Middle Ages.

The idea of depicting the months in the form of symbols or personifications was popular in the classical Mediterranean, and gradually from late antiquity there emerged a tradition of illustrating the twelve

months in terms of typical activities. It was a logical development from the figures shown in the mosaics at Bignor and Chedworth, going beyond the general attributes of 'winter' and 'autumn' to depict specific things you might do at each time of year. The practice had reached England by the early eleventh century, and the earliest sequences to survive anywhere are English ones. The twelve fluent line drawings in the manuscript known as 'Cotton Julius A.vi' were made before the Norman Conquest, probably during years when the Danish kings Sweyn Forkbeard and his son Canute had control of England.[1] The drawings are not concerned with kings or conquests, but with life on the land. In March all hands are at work in the fields. One man digs, another sows seeds, another uses a harrow (and the scribe shows where each prong is attached to the plank). In June a man swings his axe to fell a tree, another bends vigorously to cut the logs, a third loads them on to a cart. These ink drawings seem to have been the model for the pictures in the 'Tiberius B.v' manuscript (illuminated in about 1040) where Anglo-Saxon fieldwork suddenly appears in full colour, arrestingly vivid.Though these pictures were made in England, it seems clear from the timing of the agricultural tasks that neither of the calendar sequences was actually conceived in this country. Over the next four centuries, however, English images came to synchronize with the English farm year. Drawn, painted, carved, cast, the 'labours of the months' would be recognized by everyone.

The village of Burnham Deepdale is on the north Norfolk coast, where fertile farmland gives on to saltmarshes and mudflats through which small rivers and footpaths run out to the sea. St Mary's church, with its round flint tower, contains a square Norman font carved in low relief with one of the earliest and best-preserved sequences of labours. Sometime in the late twelfth century, a mason surveyed this block of stone (Barnack stone from Lincolnshire), planned out the design, and took up his chisel. The style he used has all the sober dignity of the Romanesque. Each of the twelve months has its own panel with a smoothly arched top, running four panels to a side in a long colonnade around three sides of the font. The fourth side has always stood too close to the wall for any intricate pictures to be properly appreciated and so it bears instead a simple pattern. Everything about the design is well proportioned and carefully planned, and that is part of its meaning: here is a year, and the repeated, accumulating years of life itself, marked out and arranged with everything in its rightful place.[2]

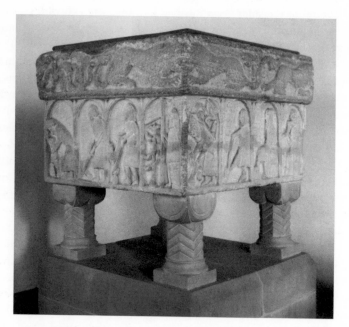

The twelfth-century font at Burnham Deepdale in Norfolk, carved with
the labours of the months. January with his horn is visible on the right,
and the sequence moves round to August, on the left, binding his sheaves.

We read through the year by following the scenes from right to left. (At a time when literacy was exceptional, it was just as natural to read images from the right as from the left, and it was better to follow the direction of the sun rather than move 'widdershins', against it.) The sequence begins, not with a labour, but with a pleasure. January is represented by a man sitting in a chair and drinking from an enormous horn, welcoming the New Year, as we do today, by raising his cup. This picture is a licence to fill the long nights with warming wine. February is an indoor month as well. The figure here is still sitting on his seat, but now, very sensibly, he wears a hooded coat (like the 'birrus Britannicus' from centuries before) and is warming his feet on a hearthstone.

The outdoor work of the year begins in March, with digging to make the ground ready for planting. The man has left the fireside and is thrusting out a leg from under his cloak to push a long-handled spade into the soil. Next comes April and the pruning of vines (which, in the twelfth century and up to the 1320s, were widely grown in England). May involves the holding of a banner, probably in celebration of Rogationtide, forty days after Easter. This 'labour' is a religious one, but it is crucially connected to the land because Rogation was the time for marking out territory, defining exactly the limits of each person's fields as a procession 'beat the bounds' of the parish and asked blessing on all it produced.

June returns to work in the fields, where unwanted thistles have sprouted up in the corn. The figure holds big two-handled pincers and is engaged in the major task of weeding, though the thistle in front of him looks so sturdy that it might fight back. Next comes mowing in July, and the corn harvest in August. With the crops brought in, we round the next corner of the year. The figure for September is threshing. October may show either the grinding of corn with a quern, or wine being poured through a funnel into a cask (these things can look surprisingly similar when carved in low relief). In November a pig is being slaughtered. December is the only panel with more than one figure. A party has gathered – four people crowd at a feast table laid with plates, knives, and bottles. A whole community is needed to personify the festive end of the year.

It is amazing that all this has survived. When the church was restored in the eighteenth century, the font was moved and somehow, in the process, it was broken. The fragments of stone were set aside as waste before being salvaged by the rector of Fincham, thirty miles away. He hated to see such

ancient workmanship cast out by 'the busy lovers of novelty', so he installed the damaged font in his garden in 1807, exposed to wind and weather, but at least receiving 'only the waters of heaven'. That might well have been the end of the months at Burnham Deepdale, but antiquaries argued for the rescue of the font. It was brought back to the church in 1842. The rector of Fincham set up a rain gauge in his garden to fill the gap, and in Burnham Deepdale the local children were once again baptized as they had been in the 1170s, welcomed into an established way of earthly life.[3]

Warming, pruning, weeding, reaping, threshing, feasting: the labours went on in the historiated letters of the Shaftesbury Psalter in the 1120s, around the Romanesque doorway at St Nicholas's Hospital in York (now the door to St Margaret's Walmgate), around the walls of St Agatha's Easby, also in Yorkshire, and on the big lead font now at Brookland in Kent. Each sequence has the idiosyncrasy that makes it a very human work of art. In the Shaftesbury psalter the February figure is all wrapped up in fur cape and bobbled hat; the March figure, rather than digging, is sounding a horn to start either the hunt or the day's work; and in May he is mounted on a good-looking horse, hawk in hand, ready for sport. These labours are for a courtly audience, those wealthy and literate enough to own a psalter. But courtly and humble activities go side by side: the economy and culture of the whole society depends on the work of the farmhands who swing their scythes, stripped to the waist in the heat. A row of labourers in July look up in proud exhaustion at the hay they have gathered.[4]

The Brookland font was probably made in France and imported: there is a French font with identical images, the lead having been poured into the same mould and cut to size. So the continental and English labours were sometimes interchangeable, but distinctive English traits did start to emerge, fitting the occupations to the local climate. English corn is not ready for harvesting in July, so the summer labours shown in continental art needed to be delayed a month. The answer was to insert a new labour in the early summer. Spot this and you know you are looking at a piece of English craftsmanship: look out for the man who is weeding. The English weeders get to work – as at Burnham Deepdale – performing a vital task in the cornfields and synchronizing the established traditions of European iconography with the local climate of England.

The pictures showed the activities of the year as they would ideally be carried out, weather permitting. The weather in the early Middle Ages usually did permit. The period from about 900 to 1300 is now referred to as 'the medieval warm period'. Historical meteorology suggests that average summer temperatures were about a degree Celsius higher than in the twentieth century, there were few frosts in spring, and conditions all year round were less extreme than in the periods before and since.[5] In the late thirteenth century, things began to change. All through the 1290s the winters were very cold, and the summers too dry to produce good harvests. The winter of 1309 was cold enough to freeze the Thames. Amazed Londoners walked, gingerly at first, from Southwark into the City. The anonymous compiler of the *Annales Londonienses* noted that even loaves of bread were frozen and had to be warmed before they could be eaten.[6] The bare image of inedibly cold bread articulates something of the daily struggle for millions of people living on poor diets alongside cold animals in unheated homes.

Disaster set in with the rains of autumn 1314, which went on and on. Archival work on manorial rolls and chronicles has made it possible to piece together what happened next.[7] The main harvest was in, but it was not a good one because the summer had been dry. It was difficult now to plant the winter crops of peas and beans. Fields sloppy with surface water would have to be written off until spring, though men worked urgently to maintain ditches and dykes. When the rain eventually stopped, the surface water turned to ice. The clouded puddles in the chalk districts and the deep squelchy puddles in the clay districts were now frozen. Doing what they could to work in the barns and mend tools indoors, people waited for the thaw. The ground was still hard with frost in April, and then, as the ice released its hold, the rains began again.

The harvests of 1315 were thin. There had been no time to prepare the land, though it wouldn't have done much good: the corn rotted in the waterlogged fields before it could be reaped. There were not many feasts to be had that Christmas, even for friends of the king. Abbot Hugh at St Albans Abbey tried to feed Edward II and his courtiers when they arrived, but there was just not enough to go round. In some areas peasants were already starving. Over the next two years, typhoid and dysentery took hold; a cattle plague spread among weakened animals, leaving meat and milk in dangerously short supply.[8] Other kinds of farm income were

jeopardized. In Hertfordshire there was sheep-rot. A reeve on the Bishop of Winchester's estates noted in the accounts for 1316 that there was no income from wool that year: the sheep had not been shorn 'on account of the great inconsistency of the weather and the summer'.[9] Sheep with no fleece might have died from cold.

For the people who lived through this drawn-out struggle, the bad weather was a punishment from a God so angry that he refused to answer their daily pleadings for respite. Bishops led nationwide prayers for forgiveness, encouraging everyone to atone for whatever sins must have aggravated the divine order. People were tired, cold, hungry; they had lost livestock, and often they had watched over relatives as they died, unable to give them the nutrition they needed. Through it all, they believed that it was their fault.

It was the beginning of what many historians now call the 'Little Ice Age'. The start was the worst of it; there was never again such prolonged rain, frost, and drought as in the years of the Great Famine of 1315–18. But the altered climate forced long-term changes in English farming. Though the average annual temperature fell by only a degree Celsius, it was a critical degree. It meant that certain crops (including vines) could no longer be grown and that thousands of upland farms had to be abandoned. More damaging than the general fall in temperature was the newly erratic character of the climate, which brought frequent storms and sudden freezes.[10]

The records of a reeve at Kinsbourne in Hertfordshire (modern-day Harpendenbury on the edge of St Albans), accounting in his orderly manorial rolls for income and expenditure on the farms within his demesne, must speak for the experience of thousands of medieval workers and their families. It was wet through the autumn of 1320, the pea crops flooded in 1321, the wheat seed was damp in 1322.[11] There seemed to be more weeds than corn: day after day in fields by the River Lea, where the Romans had farmed before them, labourers worked to pull out summer thistles from the crops; and then in autumn, in that frost-hollow where cold air settles over the water, they tried to plough before the winter took over.

The east coast in particular suffered at the hands of the violent storms that marked the early decades of the Little Ice Age. During the eleventh and twelfth centuries, Dunwich in Suffolk had been the biggest port along the busy coast of East Anglia and one of England's most important towns. It did not remain so for long. The sandstone cliffs were vulnerable to erosion

and already in the early 1200s workers had to keep clearing shingle from the harbour mouth. On New Year's Eve 1287 a savage storm broke off a slice of the town and washed it into the sea. Whole streets of houses – with families in them – were swept away. Forty years later the weather brought a second catastrophe. A storm blew across from the continent on the night of 14 January 1328 and another section of the cliff gave way, crumbling into the sea with the rubble of entire parishes on top of it. Around four hundred houses are thought to have been lost that night.[12] For twenty years the fallen buildings blocked the harbour. Churches were moored where ships were meant to be. Traders went elsewhere and those few who remained lived among ruins. A further storm hit in 1347, as if completing unfinished business. Across England it had long been customary to ring church bells during a storm, in the belief that they might frighten off evil spirits that rode on the wind. Many bells were inscribed with the words 'FULGURA FRANGO' ('I break the lightning'). But if something like the apocalypse had come, and the church bells were at the bottom of a crashing sea, little form of protection remained.

～

Through all this, artists kept producing the familiar images of the months, and their patrons still wanted them. No one called for stained-glass roundels showing flooded fields or trees bent over in the wind, or for calendars illustrated with snow on the ground in April or rotten corn in July. The labours went on productively, contentedly, in the appropriate months. Artists showed the rightful way of things, as if by force of will they could bring it about.

As an imaginative defence against the cold, the winter months were almost always represented by indoor scenes. Medieval artists were not drawn to the snowy landscapes which in later centuries would have magical appeal. As the historian Bridget Henisch strikingly puts it: '[Winter] was a season passionately detested in the Middle Ages. The traces of bare branches against a water-laden sky, the harmonies of black and grey and white, these were beauties still waiting to be discovered'.[13] The earliest painting of snow in Europe, at least the earliest we know of, is a mural at the Castello di Buonconsiglio in the Italian Tyrol representing January in a cycle of the months. It is a curious introduction of snow to art, depicting an energetic snowball fight between two solemn-looking

groups of aristocrats. The date is remarkably late – about 1400 – and the artist seems to be more interested in rendering a symbolic fight between theorists and experimentalists than in the aesthetic effects of snow.

Manuscript illustrators began to enjoy the winter landscape in the fifteenth century: in the late-medieval German and Flemish books of hours, snow sparkles in blue light. In an early sixteenth-century Flemish book, boys throw snowballs as puffy flakes float down around them. The famous Très Riches Heures (c. 1414) shows a winter scene both inside and out, with thick snow on the beehives, the hayricks, the log piles.[14] This is certainly not a common sight in English work, which held firmly to the tradition of showing a feast in December, wine to toast the New Year, and a warm hearth in February. These indoor images recall the safety of the mead-hall, though they are different from anything in Anglo-Saxon art: the medieval scenes are domestic and contentedly private, with all the off-duty feeling of the evening when you have taken off your shoes.

The shoes, in fact, are a feature. A typical February figure has pulled off at least one boot and is drying it out over the flames while toasting his toes.[15] Medieval boots often needed drying because they had soft leather soles which did not stay watertight for long. Pattens were sometimes worn by the wealthy to lift their feet above the mud, but for most working people it was normal to wear wet, chafing boots all day. William Langland, in *Piers Plowman* (c. 1370–90), summed up the suffering of the poor in terms of their feet: their breadless suppers in summer are bad enough, he says, 'and yet is wynter for hem worse, for weetshooed thei gange'.[16] For the very poor there might be no fire at which to get dry; trees belonged to landowners and so, therefore, did logs. All these troubles are overcome in the labours pictures, as the cheerful blaze flares up and perhaps a cooking pot is on the boil.

In the teens of the fourteenth century, while men and women struggled to cope with the strange weather, a scribe in London, or possibly in East Anglia, worked on an exuberantly illuminated book of psalms for a royal patron – probably Isabella of France or Edward II. He drew pictures of the months as they ought to be. Three men prune the vines in March, unaware that the days of English vineyards are numbered. Elegant ladies adorn themselves with flowers in April. In November men beat acorns from the oak trees to fatten the pigs foraging below – and down they fall, big ripe nuts in their cross-hatched cups, a kind of bountiful rain. February could

not be like this for many people: a young man sits on the end of his bed while his servants hand him stockings which have been nicely warmed by the hearth. The smoke from the fire goes up through a little chimney let into the border of the picture, and drifts off into the space of the page.

In the late 1330s a very different artist worked on a psalter for the Lincolnshire landowner Sir Geoffrey Luttrell, making images which are celebrated today as some of the most naturalistic depictions of outdoor life in the fourteenth century.[17] Every pulley and lever of the plough is inked in and shaded, the oxen strain in their harnesses, a woman pauses to stretch an aching back. The work is hard, but no one looks desperate and nature is never out of control. The harrow neatly criss-crosses the furrowed ground; the world is contained by well-made fences. Here and there a detail in the clothing gestures to the temperature. The ploughman wears a sturdy hat over his hood, while both he and his boy wear gloves. Were their voices hoarse with cold, as Ælfric imagined more than three hundred years before? The seed-sower needs a bare hand for scattering, while keeping the hand that holds his seedbox warm inside a mitten. Yet there is still no sign of actual weather: never a puddle in the path or an indication of the sky. The 'sky' under which these workers labour is the off-white of the parchment.

Precise evocations of weather are as rare in medieval writing as in pictures. Even Chaucer, who had so acute an eye for the cut of a coat or the tilt of a head, and who thought the best way to start a great work of literature was with a shower of rain, does not tell us much about the weather. His stories, if they are love stories, take place in spring when the sun shines. But it is an unchanging sort of spring, established in the opening lines and hung like a tapestry in the background. Evocations of weather are remarkable for their rarity. Fearful of going out through a night of 'smoky rayn' (the phrase suggests misty or murky rain), Criseyde spends the night at Pandarus' house, which gives Troilus the chance to attend her in her bedroom.[18] We can imagine (though Chaucer says no more about it) the rain pouring down all night while the lovers are warm in each other's arms. It is an example of the kind of weather-plotting that will be a favourite with Jane Austen and many novelists after her. The Franklin, telling his Canterbury tale, describes the pale winter sun as 'hewed lyk laton' ('laton' is French for 'brass'). Then he reverts quickly from observation to stylization, setting the scene not with the details of a particular winter day but with a quick sketch of Janus feasting by the fire:

Seed-sowing in the 1330s, from the Luttrell Psalter. The weather itself
is not depicted, though the hat and mittens tell us something of the cold.
The text is from Psalm 94, giving thanks for creation.

Janus sit by the fyr, with double berd
And drynketh of his bugle horn the wyn;
Biforn hym stant brawen of the tusked swyn, / *meat of the boar*
And 'Nowel' crieth every lusty man.[19]

It is a compact tableau, like a manuscript illumination or a roundel.[20] The imagery used to depict the labours had reached far beyond the illuminated capitals of a prayer book to shape the medieval experience of the year.

To learn the cycle of the months as a child (perhaps as a child baptized in a font like the one at Burnham Deepdale) was like learning 1,2,3. By the mid-1400s it was still possible to sum up the year in a little verse of rhyming couplets so simple that anyone could grasp it:

Januar	By this fire I warme my hands;
Februar	And with my spade I delve my lands.
Marche	Here I sette my thinge to springe,
Aprile	And here I here the fowles singe.
Maii	I am as light as bird in bowe;
Junii	And I wede my corne well enow.
Julii	With my sythe my mede I mawe;
Auguste	And here I shere my corne full lowe
September	With my flail I erne my brede;
October	And here I sawe my whete so rede.
November	At Martinmasse I kille my swine;
December	And at Christemasse I drinke redde wine.[21]

The couplets tick along: easy, inevitable, bound to raise a smile. Someone wrote this out on parchment, decorating it with zigzagging labels for the months drawn merrily in the margin, and a picture for each activity squashed in between the lines. Fire, spade, scythe, flail, cup: the stable iconography of the medieval year.

SECRETS AND SIGNS

The sequence of the 'labours of the months' answered to a profound desire for a repeating world. Medieval scholars, meanwhile, struggled to understand atmospheric processes that were clearly more complex and unpredictable than the pictures in their prayer books. Their chief

scientific advisor was Aristotle, whose *Meteorologica* was part of his great systematizing of the world in the fourth century BC. Fifteen hundred years after it was written, Aristotle's text was the springboard for the most advanced thinking in Europe. This was not as surprising as it sounds. *Meteorologica* may have been very ancient, but for many centuries after the decline of the classical world it had been known only in Arabic. When it was translated from Arabic into Latin it was like a new discovery being made. Today it can seem rather less exciting. Even the editor of the Loeb edition of *Meteorologica* warns readers about the 'intrinsic lack of interest of its contents'.[1] Here are a lot of theories, many of which turned out to be wrong. Yet schoolboys were for centuries educated in these theories and passed them on; the relationship set out here between earth and air is one that shaped the way our ancestors understood their environment.

The Aristotelian Earth is a giant lung, constantly breathing in and out. The air that surrounds it is made of 'exhalations' from the ground, some of which are moist and vaporous while others are dry exhalations, 'a kind of smoke'. The heat of the sun (produced by its rapid movement) draws these exhalations into the air. Vapours cool, turn to water, form clouds, and fall as rain. Dry exhalations are 'the origin and natural substance of winds'.[2] Heat and cold are discrete substances, and not (until the nineteenth-century discovery of thermodynamics) the energy or lack of energy in other substances. The *Meteorologica* includes in its remit many phenomena which today are not understood as 'meteorological'. There are chapters on earthquakes, the saltiness of the sea, shooting stars and comets. All of these are governed by exhalations. 'Meteor' in Greek means 'that which is raised up', and Aristotle's meteorology deals with all things raised up above the earth but below the moon. Above the moon, the heavens were thought to be constant. Only in the sublunary sphere was everything subject to change.

This was the system of hot and cold, moist and dry, inherited from antiquity by men like Robert Grosseteste and Roger Bacon, who worked in Oxford in the twelfth and thirteenth centuries.[3] They valued Aristotle's experimental method, and designed some experimental procedures of their own; both revised Aristotle's account of rainbows and questioned his view of winds. Looking out from his study in Oxford, Bacon could see the weather working in ways that made some of Aristotle's details untenable. But classical authority was so powerful that Aristotle remained the master.

The role of a medieval scholar, even one so bold as Bacon, was to provide commentaries, glosses and addenda in the margins of the master text. So the earth kept exhaling, water kept turning to air, and winds flowed like rivers for centuries to come.

One other book from Roger Bacon's thirteenth-century bookshelf suggests the framework of inherited knowledge within which medieval Englishmen tried to understand the weather. The *Secreta Secretorum* was not much of a secret by the time it had found its way into every good library in England, but it promised insights into a great many of life's mysteries: how to rule, how to keep healthy, and (crucial for both) how to read the skies. It appeared to be a book of advice composed by Aristotle for Alexander the Great, which is what medieval readers believed it to be, though in fact it was a tenth-century treatise composed in Arabia and drawing together all kinds of thinking from ancient Greece and the Middle East.[4] Roger Bacon thought it contained the greatest natural secrets man could acquire. Generations of readers, including Chaucer and Lydgate, understood the world as it was mapped out in the pages of this book.[5]

The *Secreta* lists the four seasons – 'veer' (the word is from the same Latin root as 'vernal' and '*reverdie*'), 'somer', 'hervest', 'wynter' – describing the character of each and the best way for men to live in harmony with it. The whole plan depends on the elaborate system of associations that was now established at the core of philosophical and physiological thought. It was a system of conveniently analogous 'fours': the four seasons corresponded to the four elements (earth, water, air, fire), the four 'qualities' (hot and cold, wet and dry), and the four humours thought to govern the human body: blood, choler (or yellow bile), melancholy (or black bile), and phlegm. The scheme of the humours had structured all understandings of physiology since the Greek doctor Hippocrates proposed it in the fifth century BC, and was given broader currency by the Roman Galen in the second century AD. By the Middle Ages it had infiltrated every aspect of life and featured alike in the work of the most intellectually advanced poet and the lowliest town doctor.

The scheme of 'fours' depended on precise correlation between the microclimate of the human body and the climate of the world beyond, which is why it was so central to ideas about the weather. Each season brought with it atmospheric conditions which corresponded to certain humours, and thus to particular forms of illness, emotion, and behaviour.

Spring is hot and moist and encourages the blood. Summer is hot and dry and stirs up choler. Autumn is cold and dry, the season of melancholy. Winter is cold and wet, the time of phlegm. Any medieval doctor needed to know this because his task was to balance the body's climate of qualities and humours with the climate outside. He must help the patient sustain his internally generated 'vital heat', but without overheating. He knew that a patient in spring was more liable to suffer from an excess of blood, and that it might therefore be helpful to drain some of it away. Horribly limited in the range of therapeutic techniques available, medieval physiology resorted by default to bloodletting and refined the practice to an art by focusing on the question of exactly when it should be done. Diets, too, were routinely prescribed in accordance with the weather. Summer food should be moist and cold to counter the dryness and heat in the air; autumn food should be dry and cold – 'chekons, lambe, wyne old and sotell, and swete grapes' were recommended.⁶ The philosophy of the *Secreta* is one of balance. The aim is always to maintain an equilibrium by countering an excess or compensating for a lack: good health is the temperate middle ground. This is a vision of a finely ordered universe in which illness and disaster are a temporary tipping of the scales.

For the medieval thinker, the weather was only one manifestation of a larger fate determined by the alignment of the planets and the stars decreed by God. To know the patterns of weather one must first know the movements of the heavens. Medieval meteorology was therefore inextricable from astrology, which ruled over all other forms of learning. Knowledge of such things was part of the basic equipment for a wisely lived life, as Chaucer knew when he taught his ten-year-old son Lewis to read an astrolabe. Few matters were of graver importance in fourteenth-century England than the effort to interpret the skies. This is why the prayer books that include the labours gave equal space to illustrations of the zodiac sign for each month. It is why the leaden font at Brookland showed Aries and Taurus, Cancer and Virgo, mapped out above pictures of the mowing and threshing. Even the unlettered villagers who did the weeding knew that their fate was connected with the constellations visible in the night sky.

The reeve or hayward of a farm often had access to astronomical tables that would help him plan for the year ahead. The little folding almanac now preserved in the Bodleian Library as 'Rawlinson D939/3' was designed to be worn at the belt, accessible at all times like a modern pocket

diary.[7] It comes from the Benedictine estates at Evesham in Worcestershire, and the best guess of bibliographers is that it once belonged to a hayward there called Harry who used it in the 1390s. It is packed with astrological information to be used in planning the work of the farm. Learning to read this almanac, we learn to read some of the patterns of nature through medieval eyes. A thunder prognostication chart shows what the year will hold if thunder is heard in a particular month. A harvest prophecy table displays the likely weather for the year ahead depending on the date of the first Sunday in January. If Sunday falls on the third day of January, read across through the hand-drawn icons and you'll find the weather forecast: the figure of winter has an ominous black hood and the figure of summer is shown in heavy rain. This will be a year to expect the worst.

The little pictures in these charts are the meteorological sign language of the fourteenth century (like the stylized clouds on our modern weather maps), representing wind and rain at a time when there were few direct visual depictions of atmospheric conditions. Mostly the weather is shown coming from the mouth of a seasonal personification. This is an animated world, in which the wind does not just blow but *is blown*. This is also a world that follows a predetermined course: when the New Year falls on a certain date the weather behaves accordingly. It was the work of medieval astrologers to discover these patterns, often by algorithmic calculation, and their findings reached far beyond the libraries to influence the practical life of men like Harry the Hayward. The prognostication charts might look today like an extravagant fantasy, but the Worcestershire almanac was, above all, a document to be used in the daily decision-making of ordinary working men.[8]

∾

There is very little in either the almanacs or the learned treatises that is based on empirical observation. People tended to think in terms of signs, symbols, stories. They learned from Hippocrates and Aristotle more than from the puddles in the street, for reasons which also meant that medieval illustrators painted personifications of the stars rather than any ordinary summer sky. No one, it seems, simply looked outside every day and wrote down what he saw.

No one, that is, except a parish priest in Lincolnshire who became known some five centuries after his death as the earliest weather diarist in

Europe. William Merle was a fellow of Merton College in Oxford, working in the tradition of Grosseteste and Bacon. But mostly he was on the other side of the country, in the remote village of Driby, where the wind comes off the North Sea. For seven years he kept a weather diary, noting the salient points each week, sometimes each day. He may have kept the diary for longer, but the record has been lost. All that survives is the little vellum book in which he wrote up, in fair copy, his records from 1337 to 1344.⁹ France and England were at war during these years; there were invasions along the coast. At Irnham, on the other side of Lincolnshire, Geoffrey Luttrell was bargaining for more land, overseeing work on his psalter and arranging for chantry masses to be sung for him in perpetuity. William Merle concerned himself with more immediate matters.

He took note of eventful weather, like the two continuous hours of thunder on 17 June 1337. More remarkably he took note of the mundane weather that went on most of the time. It involved a lot of rain. This is a translation of his habitual Latin: '1339. May: the third week was very rainy, and the fourth week was more rainy than the third. [...] September: the first, second and third weeks were rainy, and the fourth more rainy than the preceding weeks'. Necessarily, he developed ways of distinguishing levels of raininess, so in June 1340 there was not enough to hinder the workers in the fields, but by July they were 'hindered very much'. He noted how many times in a day the snow fell, and what kind of snow it was – 'magnarum parcium' on 12 December 1343: very large flakes.

Historians of science have celebrated this fragmentary document because it anticipates by hundreds of years the empirical methods of the Enlightenment. It is fascinating because it stands apart from its time. But we should not wish the observational methods of the eighteenth century on the people of the 1340s, and nor should we emphasize teleologically only those things from the past that seem to lay the groundwork for modern practices. Merle's other writings show him to have been an astro-meteorologist, and he probably intended to compare his diary observations with various astronomical tables. He was already linking the appearance of a comet in 1343 with the dry season that followed. Like his fourteenth-century contemporaries he understood the weather in Driby to be part of a cosmic narrative. He could not know that by the end of the decade the Black Death would have killed about half the population of Europe, and in retrospect all the hard-working prognostications of the early 1340s

look poignant.[10] Still, when William Merle walked across to Driby church in the snow, he believed that the snow was connected with the stars, with the ordering of society, with the make-up of his own body, and with the purposes of God.

A HOLLY BRANCH

The only surviving manuscript of *Sir Gawain and the Green Knight* is bound into a tiny volume with three other poems thought to be by the same late fourteenth-century author, whose identity we do not know but whose dialect can be traced to the north midlands. This little book has delivered to modern times some of the richest imaginative filigree-work of medieval culture. Ideas are so densely folded into each line of script, each parchment sheet, that the physical book ought by rights to be visibly shaking under the strain. *Gawain* is a calendar poem of a kind. It takes us through a full year, but all its action is in winter: it is about a New Year 'game' begun one January and concluded the next. If the labours have their focus in the months of outdoor productivity, and if the slow, warm rites of courtly love belong in May, the quest romance inhabits other times of year. This one will fill the long nights of Christmastide in Camelot. King Arthur calls for a game at the New Year feast and this is what he gets: a green knight on a green horse rides into the hall and dares one of Arthur's men to cut off his head. It is Gawain who takes up the challenge, and who cuts off the green head, only for its owner to pick it up by the hair, restate the terms of the wager, and depart as suddenly as he came. Gawain must now find the Green Knight at the same time the following year, and offer his own head for cutting.

At one level, in one of its many strands, this poem is about a form of midwinter ritual.[1] The Green Knight represents all greenery, though it is part of the poem's negotiation between the natural and the weird that its version of a fertility god is so creepily unnatural and witchily green-skinned. The Green Knight will not die, even when an axe strikes through his head; nature likewise will restore itself after what looks, in winter, like certain death. Gawain's beheading of the Green Knight is only a gardener's lopping of a branch from a tree, a seasonal pruning. Gawain inflicts one of the temporary winter deaths which allow nature to replenish itself.

Particular plants have always represented the continuity of nature because they keep their leaves through winter. The Green Knight associates himself with the king of evergreens: 'in his honde he hade a holyn bobbe, / That is grattest in grene when greves ar bare'.[2] There is a primal attraction in this holding of branches, something which reaches from the olive branch that survived the first flood to the bare branch held by the sad figure of Winter at Bignor, and which continues in the holly and ivy with which we still decorate our homes at Christmas. The branch is an ensign signalling the state of life itself, and here in the Green Knight's hand is a holly bob: gleaming, prickly, hostile, handsome, alive even in January.

The following winter, starting out on All Souls' Day in November, when the wall between the living and the dead has long been thought to be so thin as to be permeable, Gawain must go through his own ritual death. Riding through England in search of the Green Chapel, he takes on the role of the holly, alive alone in the dead woodland. Gawain undertakes the journey to the underworld necessary for all heroes, except that his Hades is the wintry country he finds as he travels from southern England, up through Wales, across the 'wyldrenesse' of the Wirral, on into Cheshire and probably Derbyshire. The poet overlays the mythic with the recognizably real so that we understand Gawain's journey as analogous with all our winter journeys. There are familiar place names, and identifiable topographies. Though this is a work of fantasy, allegory, and ritual, it is also a piece of nature writing.[3]

In the woods, hoary oaks and hawthorns are covered with moss (a thing one notices in winter when the branches are exposed), and birdsong has a plaintive note: 'byrrdes unblythe upon bare twyges, / That pitosly ther piped for pyne of the colde'. Gawain sleeps on bare rocks, 'ner slayn wyth the slete', while above him cold water runs and freezes, 'heghe over his hede in hard ysse-ikkles'. The conventional dragons of quest romance make brief appearances, but the poet is far more interested in Gawain's battle with the weather,

> For werre wrathed hym not so much that wynter was wors
> When the colde cler water fro the cloudes schadde,
> And fres er hit falle myght to the fale erthe.[4]

> *For war did not bother him as much as winter, which was worse*
> *When the cold, clear water fell from the clouds,*
> *And froze before it reached the pale earth.*

'Werre', here meaning wars with beasts but gesturing also to human battle, is a subject left for other poets. In this journey, the main adversary is weather and it is worse than war. It is dreadful, and yet the poet feels its challenging beauty.

The middle of the poem is set at a castle where Gawain passes Christmas, undergoes a secret testing, and awaits his fate. The atmosphere indoors is always contingent on what happens outside. While Gawain lies in bed all morning, light from the window falls across the wall. He 'lurkkes quyl the daylyght lemed on the wowes'. We seem to see a rectangular patch of cool winter light brightening and dimming as the morning passes, the slow-moving patch watched by anyone lying late in bed. Then, on the day he must set out to meet the Green Knight again, Gawain dresses before dawn, listening to the sounds from outside where the wind is rising. No one looked better this side of ancient Greece, observes the poet of Gawain in his armour.[5] The mention of Greece reminds us how English this poem is. The armour shines, not under a fierce sun, but by the light of a candle in a grey dawn.

The final miles of his journey take Gawain through high country where 'uch hille hade a hatte, a myst-hakel huge', an image which speaks from a time when misty hills were not yet 'sublime' and were more likely to be seen anthropomorphically, dressed in the weather's hats and cloaks.[6] If there are time-honoured and well-loved pictures from the calendar tradition in this poem (hunting, feasting, warming), there is also a serious interest in specific natural details of the winter landscape.[7] The Gawain-poet finds it worth recording the difference between wind in a valley and wind on the hills. He thinks as an allegorist and a naturalist at once and there is no discrepancy between the two. His attentiveness to pale light and freezing streams links him with the poet of 'The Wanderer' or 'The Seafarer', though he probably did not know their words.[8] Where the Old English poets twisted their ideas into the shapes of interlaced gold, symbolically resistant to weathering and decay, the medieval poet gives us his holly bob, a shining sprig of evergreen shaped like a book.

'WHY FARES THE WORLD THUS?'

Now and then, from amid a culture of orderly correspondences and calculations, there is simply a howl or a cry. Making noise in the cold is as

instinctive as shivering. The most common sound is the non-verbal 'brrrr', but that raw expressive energy can be shaped into language. Like the extravagant oaths that for centuries bore the brunt of human exasperation (until we settled for just a few repetitive expletives), weather-words can help to alleviate the misery. So what did a cold person in the fifteenth century sound like? Listen, for example, to the moans and groans of the shepherds in the *Second Shepherds' Play*, which forms part of the cycle of mystery plays once performed annually in the streets of Wakefield. Here is Coll, who appears on stage first and sets the scene:

> Lord, what these weders ar cold! And I am yll-happyd. */poorly covered*
> I am nere hand dold, so long haue I nappyd; */ nearly stupid*
> My legys thay fold, my fyngers ar chappyd.
> It is not as I wold, for I am al lappyd */ wrapped*
> In sorow.

Gib, the second shepherd, arrives with a feel for a good plosive and the iteration of 'wet' / 'sleet' / 'feet':

> Lord, thyse weders ar spytus, and the wyndys full kene, */ spiteful*
> And the frostys so hydus they water myn eeyne – */ frightful*
> No ly.
> Now in dry, now in wete,
> Now in snaw, now in slete;
> When my shone freys to my fete, */ shoes*
> It is not all esy.[1]

Whoever wrote this play understood the powerful commonality of numb hands, chapped fingers, watering eyes. He used it to make the Christian story feel knowable to the people from all over West Yorkshire who gathered in the city. At the end of the play the shepherds greet the newborn Jesus just down the road in Bethlehem, but it is quite clear that these are people whose lives are spent on the Yorkshire moors. Their local habits and their dialects confirm it, and shepherds in the Holy Land are less likely to have frozen feet.

The protest at the bad weather is simple enough, but, as so often in medieval literature, the state of the weather in the Wakefield play is inseparable from the larger state of things. Each shepherd's lament about the cold is bound up with complaints about other injustices.[2] The gentry

is corrupt, the taxes are high, wives are demanding and irritable: how has it all got so bad? 'Why fares the world thus?' asks Gib. The play's answer is a frenzy of transgressive practical jokes in which the Lamb of God is prefigured by a stolen sheep and baby Jesus is presented with a tennis ball. The official trajectory of the play, however, is to answer the complaints with the arrival of the Christ child; the songs sung early on by the miserable shepherds in the effort to keep warm become, at the close, songs of praise to a saviour who will put things right. When you are cold, runs the subtext, put your faith in Christ.

This movement from complaint to consolation is one of the shaping forms of medieval literature. The model for it came from sixth-century Italy where Boethius wrote his *Consolations of Philosophy*, a text which became one of the most influential in medieval Europe. Boethius wrote the book while a political prisoner in Pavia in the 520s, trying to answer that question, 'Why fares the world thus?' This is prison literature at its bravest and most affecting. Boethius in his cell, the victim of manifest violence and injustice, acknowledged his doubts about the excellence of divine creation. He did not know why a supposedly orderly universe had punished him like this. He wrote a dialogue between himself as prisoner and an imagined Lady Philosophy who visits him and offers comfort through explanation. For the suffering Boethius, Philosophy acts like a wind blowing away the 'wete plowngy cloudes' (as Chaucer expressively puts it in his English translation): clouds which have hidden the sun and stars. Lady Philosophy repeatedly uses examples of mutable weather to explain the 'hidden' laws of fate and justice. Steadfastness, she says, is not her way ('I torne the whirlynge wheel with the turning sercle'), and she likens the ever-moving but controlled wheel of fortune to the changing but finely balanced conditions of the year. 'It is certain and establissched by law perdurable, that nothing that is engendred nys steadfast ne stable'. Change occurs only within set limits; nature 'restreyneth alle thynges'.[3] This theory of restraint, this patient long-view of cosmic rightness, seemed to Boethius, and to many after him, consolation indeed. It was, at any rate, the only consolation they had.

In the humoral scheme, autumn was the season of black bile, or melancholia. The Stokesay lyrics attest the change of tone. 'Nou skrinketh rose and lilie-flour', begins one poem, evoking in its first breath the imagery of summer which fades before our eyes. The poet describes

himself wandering out from Peterborough, and his pleasure turns to grief at the realization that this dying season foreshadows his own death. His lady will die. He himself will die, and the sins of the summer will be judged. The spring lyrics of rhapsody turn to grieving winter prayers pleading for some kind of protection. 'Winter wakeneth all my care', begins another poem in the Stokesay collection:

> Now this leves waxeth bare;
> Ofte I sike and mourne sare / sigh / sorely
> When it cometh in my thoght
> Of this worldes joye how it geth all to noght.[4]

In misery, the oldest feelings are prone to reassert themselves. Here the Anglo-Saxon associations of winter and exile return: 'I not wider I shall nor how longe her dwelle' ('I know not where I will go or how long I shall stay'). Winter makes the medieval poet a wanderer.

One of the earliest descriptions of mental illness in English literature, written in 1420, begins with the disturbing effects of that most dangerous month, November. The poet is Thomas Hoccleve, a writer of startling psychological honesty, who describes in *My Compleint* how he lost his wits. For a period his 'memorie went to play' and then, just as suddenly, God returned it to him. But all is not yet well, as the poem acknowledges. The prologue establishes a framing scenario in which the 'broune season' stirs up old grief:

> Aftir that harvest inned had hise sheves,
> And that the broun sesoun of mihelmesse / Michaelmas
> Was come, and began the trees robbe of hir leves [...]
> And hem into colour of yellownesse
> Had died and doun throwen undir foote
> That chaunge sank into myn herte roote.[5]

The harvest is gathered, leaves have yellowed and died, and in the simple pivot from one line to the next all that sorrow is internalized, taken to heart. It is immediate, plangent, utterly recognizable in feeling. The effect of this prologue is sharpened by its invocation of Chaucer. Every line recalls in sadness the prologue to *The Canterbury Tales*. 'Whan that Aprill', began Chaucer, setting out on his journey. In Hoccleve all is secondary, as autumn follows summer. His own poetry comes second, following that of Chaucer;

he begins with the word 'after'. All Chaucer's lifting is here sinking, dying down. And where once the April showers 'pierced to the root' the growing crops outside, now all is turned inwards and the melancholy goes to the 'roote' of Hoccleve's heart.

Michaelmas falls on 29 September. By late November Hoccleve is lying awake at night, consumed by the 'thoughtful maladie'.⁶ Physiologically, as modern science has shown, the lack of sunlight can have serious effects on mind and body. Hoccleve's sense of the cause is a more philosophical one. Winter reveals to him truths that were masked by the blossoms of summer. Hoccleve associates his grief with autumn, whether or not autumn is actually part of its cause. The natural processes of death and darkening make fitting images for the feelings he needs to articulate. Turning for help to a book of philosophy, he finds the strength to perceive God's larger intentions.⁷ If God is testing him, it is so that he might emerge better. He bids sorrow farewell, casts it 'to the cok'. Though all the energy of the poem is in its expression of pain, and though we may not quite believe in the resolution, the carefully designed framework of medieval *consolatio* has put wintry distress in its place. 'All things have their season', and every season will pass.

III

I flamed amazement ...

Ariel, having acted the part of lightning,
in William Shakespeare, *The Tempest*

SPLENDOUR AND ARTIFICE

We must not expect Orlando in the Renaissance to behave as we do. The world was different then:

> The age was the Elizabethan; their morals were not ours, nor their poets; nor their climate; nor their vegetables even [...] The weather itself, the heat and cold of summer and winter, was, we may believe, of another temper altogether. The brilliant amorous day was divided as sheerly from the night as land from water. Sunsets were redder and more intense; dawns were whiter and more auroral. Of our crepuscular half-lights and lingering twilights they knew nothing. The rain fell vehemently, or not at all. The sun blazed or there was darkness.[1]

On one level, of course, this is knowingly ridiculous. There were dull days in the sixteenth century. It drizzled as much then as it does today. What made Woolf think the weather was different? A lifetime's reading in Renaissance literature made her think it. What she is describing is the climate as it emerges from the writing of the sixteenth century. A courtier would have noticed the dull days, and got wet in them, but he did not write about them, as the Anglo-Saxon did not write about summer. On the evidence of much Elizabethan art and literature one would think that this was a time of incessant storms, comets, frosts, and lightning strikes, broken only by the arrival each year of a prodigiously lovely spring. The Renaissance taste in weather was for heraldic suns and tempests that might be rendered in the woodcuts of an emblem book. Symbol and spectacle were the order of the day, and the skies seemed to be staging, for this most theatrical of societies, a tremendous cosmic show.

It was not until the later sixteenth century that the emphasis on meteorological drama really took hold. All through the 1500s the old songs continued to be sung. 'Westron wynde' was popular at court in the 1530s; it is possible that Henry VIII himself set it to music. In the crisis of the Reformation, among the violence and lies and double meanings of Tudor realpolitik, it must have been a release simply to sing the words: 'Cryst, yf my love were in my armys / And I yn my bedde agayne!' The song lived in the mind of the greatest Tudor composer, John Taverner, who used one of its settings as the basis for a mass. Christopher Tye

and John Sheppard followed him, so that there are three 'Western Wind Masses'.

The sentiments of the traditional *reverdie* inspired new poetry, as they always would. When the courtier Henry Howard, Lord Surrey, wrote about youthful unrequited love, he moulded spring to the shape of the sixteenth century's most favoured form, the sonnet.

> The soote season, that bud and blome forth brings,
> With grene hath clad the hill, and eke the vale:
> The nightingale, with fethers new she sings;
> The turtle to her make hath told her tale.[2]

'Soote season' is an adaptation of Petrarch's 'Zefiro Torna', but Surrey is more beguiled than Petrarch by the world outdoors, happy to let the whole sonnet roam through a summer field. In the work of the Italian poet the beloved woman is the subject and spring is a symbolic backdrop; in the work of the Englishman the season upstages the love affair and becomes itself the object of adoration. The buck flings off its winter coat; 'the fishes flete with new repayred scale', their supple movement characterizing the whole poem. Adder, swallow, and bee come one after the other with all the distinct detail of the *mille-fleur* tapestries popular at the French and English courts in the first decades of the century.

Surrey plays with the old iconography of the months and the zodiac. His fish grow scales, in which his contemporaries would have recognized the fish of Pisces becoming the scales of Libra.[3] And the medieval calendar tradition itself was undiminished. *The Kalendar and Compost of Shepherds*, translated from French to English in 1503, became a Renaissance bestseller. As a good compost should be, it was many things mulched together: an almanac, an encyclopaedia, a manual for healthy life rather like the *Secreta Secretorum*.[4] The medieval labours were all included, though transformed from unique manuscript illuminations to woodcuts printed by the thousand. January is still feasting, while Aquarius pours out her water. In the *Compost*'s instructions for behaviour through the year, we get a glimpse of what the passing months entailed in sixteenth-century England. Linen is recommended for summer, 'for of all cloths it is the coldest'; the light food and small ale of the hot months is followed in winter by 'strong wine', thick furs, and food to warm the body: 'all manner of venison, partridges, pheasants'.[5]

From the mid-sixteenth century, poems of the 'soote season' were increasingly joined by poems of 'winter woe'. Stylized descriptions of shivering branches and huddling birds were as familiar at the Tudor court as the spring blossoms had been for Chaucer, and they set the scene for introspective literature.[6] But this is mostly a story of continuity. The body was still controlled by humours; the air was still a mixture of vapours and exhalations. In Tudor writing the spring is always sunny and winter always icy, and the small daily variations in atmosphere go largely unrecorded. Giovanni Bellini in Italy saw that the sky appears lighter towards the horizon, and he painted it that way in his *Madonna of the Meadow*. He bequeathed his sense of subtle atmosphere to Giorgione, who painted enigmatic storm-light in *The Tempest*. But these Venetians were remarkable for trusting their own eyes like this. In England it was unusual to find anyone painting sky at all. The extreme naturalism with which Holbein depicted his sitters did not extend to their backgrounds. Like icons in churches – painted figures against flat gold leaf – the dramatis personae of the sixteenth century were usually presented against opaque blue or green. Landscape painting, which in later centuries would involve weather depiction, had yet to become part of English culture.

Some of the most expressive comments about weather came in the form of verbal complaint, as they had in the shivering speeches of the Wakefield shepherds. John Heywood, a Tudor dramatist with acute political intelligence (and the grandfather of John Donne), made weather complaint the ostensible subject of a 'dramatic interlude' for court performance in the early 1530s. His *Play of the Weather* is an 'interlude' worth pausing over because it combines the ordinariness of daily weather with the extraordinariness of the Tudor court.[7] The scenario is that the people of England are given the chance to choose the best possible weather. The question is broadcast far and wide ('At Gloucter, at Gylford and at Gotham / At Hartforde, at Harwych, at Harrow on the hyll'): what is the ideal climate? Like Chaucer's pilgrims, representatives of all kinds of trade and status come to make their requests. The Gentleman wants hunting weather: 'drye and not mysty, the wynde calme and styll'; the Ranger on the other hand wants 'good rage of blustryng and blowynge' to bring down the windfall in the woods. The wind-miller wants wind, the water-miller wants rain; the young beauty wants weather that will be

kind to her skin, the old laundrywoman wants weather that will dry her sheets. Youth and age, vanity and practicality, must battle it out. Moist faces or dry sheets? Heywood is a master of the comic ultimatum. He adds to the end of the queue a little boy who pipes up boldly in favour of frost and snow – frost to make his bird-traps more effective, and snow for the enthusiastic throwing of snowballs: 'O, to se my snow ballys lyght on my felowes heddys'.[8]

The controller of the weather is Jupiter, who has lowered himself from heaven and come to dinner at court (possibly Hampton Court) to take requests. Henry VIII may well have been in the audience and, if he was, he would certainly have recognized himself in the figure of Jupiter as the deity weighs up the arguments of his subjects. The play was meant to flatter Henry as a just king dealing wisely with crowds of bickering, badgering people intent on their own interests. The king is graced with the capacity to arrange matters better than any of his subjects 'can perceive or coude desyre'.[9] Everyone by the end goes home contented, and the little boy promises to give Jupiter some of his snowballs. Royal duty happily dispatched, it seems.

Heywood's wry twist is that Jupiter has done nothing at all. The weather, in all its variety, was as close as possible to ideal when he inherited it, and there was no need for all the fuss. Mery Report sums up the non-event: 'God thanke your lordship. Lo, how this was brought to pas! / Syrs, now shall ye have the weather even as yt was'.[10] This might be read as a satire on the English culture of complaint, gently consensual rather than radical because everyone in the end concurs that things should stay the same. Yet the play is also a celebration of meteorological moaning (elevated here to a national art form), and by extension a celebration of the strong tradition of political dissent. There are risky undercurrents, too, when we think of the context. Heywood portrays the king as a weather deity at a time when the weather in England was perceived as abnormally erratic. In the late 1520s, as Henry's dispute with Rome grew ever more tense and protracted, he and his counsellors looked for any sign from God that might serve as affirmation of his cause. The weather did not oblige.

It rained for months on end. The years 1527 and 1528 were the wettest anyone could remember, with sodden spring fields jeopardizing crops and breeding illness. The sweating sickness arrived in the summers,

apparently unleashed by the warmth; it reached epidemic proportions in 1528, inflicting hellish microclimates on its victims in their final hours. The winters were punishingly cold (the first signs of a downward temperature trend that would last thirty years); even the sea froze in 1528. It may have been too dangerous to stage *The Play of the Weather* in the bitter winter of 1534, the year of the final break with Rome. The frost held deep into the following spring, finally giving way to more incessant rain. It would have been treasonous to voice any straightforward interpretation of these signs; interpretation, in any case, was hardly necessary.

〜

Heywood was not a showy writer, but the society he lived in was developing a huge appetite for visual display. By the 1560s his *Play of the Weather* would have looked tame, with its interest in everyday conditions rather than extraordinary meteoric events. The popular press set the tone by publishing an improbable number of broadsides every time an unusual weather event occurred. The fascination with spectacular weather can be traced in the growing supply of meteorological handbooks, all of which commented in enthusiastic detail on atmospheric freak shows.

The ascetic puritan William Fulke was known as a scourge of excesses in church, but he revered the extravagant theatre of God's sky. His *Goodly Gallerye* of 1563 presented in book form an exhibition of sky-pictures to be admired: '*blasing sterres, shooting starres, flames in the ayre &c. thonder, lightning, earthquakes, &c. rayne dewe, snowe, cloudes, springes &c. stones, metalles, earthes &c. to the glory of God, and the profits of his creaturs*'. That is just the subtitle. It is the celebrity meteors (shooting stars, whole massed armies flaming in the air) that make the headlines, while rain and clouds come a long way down the list. Inside we find that plain old winds are delayed until part three, leaving space near the beginning for an array of 'dansyng or leaping Goates' and 'flying dragons' – like the one seen on May morning flying over the Thames to Stratford, where it landed and was arrested, put in the stocks, and discovered to be a devil with cloven feet. Fulke confidently gave six purposes of meteors: 'to make the earth fruitfull, to purge the ayre, to sett forth his power, to threathen his vengeaunce, to punyshe the worlde, to move to repentaunce'.[11] When it came to dramatic weather, the Elizabethan emphasis was very much on a reign of terror from above.

On the afternoon of 4 June 1561, a day of rain and high winds in London, the wooden spire of St Paul's Cathedral burst into flame. Almost certainly it had been hit by lightning. It was the most public of spectacles: a fire 150 feet above the city. The bells melted in the heat, leaving the great church dumb. People working in nearby fields (and there *were* fields close to St Paul's in 1561) reported a spear of fire followed by the smell of brimstone.[12] The blaze was immediately interpreted as an expression of divine displeasure. The following Sunday's sermons were all about repentance, warning that there would be worse to follow if people did not mend their ways. There were rumours that Queen Elizabeth would toughen the legal penalties for criminals.

Because the spire at St Paul's was never rebuilt, the maimed building became a memorial to that night. The playwright and pamphleteer Thomas Dekker, always alert to the symbols and showdowns of his age, gave the steeple itself a voice in the story. The steeple wonders whether its ambition 'in aspiring too high' caused it to fall, 'smote by the hand of heaven, defaced by flames, and shaken into the dust by the wrath of the breath Almighty'.[13] Here, in Dekker's playful parody of tragic drama, the wooden steeple plays the overreaching hero, punished for its aspirations and consumed by fire. It was a part that would be taken by some of the great human protagonists of the late sixteenth-century stage.

～

Christopher Marlowe, the most spectacular of all Elizabethan writers, made fiery meteors his province. He conjured exultantly hellish weather that Hieronymus Bosch would have been glad to paint. The ferocious eponymous tyrant of *Tamburlaine* (1587) takes command of the skies. As he steps on the conquered Bajazeth, using him as a footstool to his throne, Tamburlaine ecstatically declares himself the scourge of heaven. Imaginatively usurping the work of the gods, he casts himself as the sun, 'chiefest lamp of the earth', and also as lightning, striking fire in the clash of his sword against armour:

> As when a fiery exhalation
> Wrapt in the bowels of freezing cloud
> Fighting for passage, makes the welkin crack
> And casts a flash of lightning to the earth.[14]

The description of a meteorological process offers him an explosive analogy for the bursting out of his own power. The human body on stage shakes with the force it can no longer contain, until the words – like fire – find a passage through it and flash out. Tamburlaine not only conceives himself as a meteor but then enters into competition with the weather. His fantasy is that the bullets of his army might exceed thunderbolts and that his violence will make the whole sky 'wax as red as blood'.

The staging of the elements in *Tamburlaine* is outdone only in Marlowe's later play *Dr Faustus*. In the terror of his final moments, as he fantasizes escape from imminent damnation, Faustus imagines being drawn into and ejected from a thundercloud. Meteorological imagery does not get more grotesque than this:

> You stars that reigned at my nativity
> Whose influence hath allotted death and hell,
> Now draw up Faustus like a foggy mist,
> Into the intrails of yon labring cloud
> That when you vomit forth into the air,
> My limbs may issue from your smoky mouths
> So that my soul may but ascend to heaven.[15]

The limbs of a soiled and erring body are compacted into thunderstones and ejected as vomit from 'smoky mouths' which evoke the puffed, spewing faces of clouds and winds on Renaissance maps. Cleansed of its foul casing, the soul then rises up to heaven. It is a fantasy of evaporation, of becoming first mist and then pure soul. Sucking stars above are pitted against the mouth of hell below: Faustus must be consumed by one of them. The Renaissance theory of meteors was every bit as bodily as this, routinely couched in terms of sucking and exhaling and vomiting, but it took Marlowe to reinvigorate the metaphors. He might have applied them to himself. His plays were themselves like meteors, flaring out with pent-up energy suddenly released. Faustus' speech works at first through simile: he asks to be drawn up '*like* a foggy mist'. Then Faustus instinctively abandons that detachment to *become* the meteor. This is Marlowe at his most outrageous, but the evaporation of the human body will be a recurring fantasy in English literature.

～

Away from the dazzling, sweating, swearing theatre, a different kind of showiness characterized the culture of the Elizabethan aristocracy. This was a calculated and encoded drama, coolly intellectual even as it invoked the heat of the sun. The great 'prodigy houses' built by the richest of the nobility in the 1580s and 1590s embodied in glass and stone a new kind of performance, and revised ideas about the relationship between human beings and the natural world.

Approaching Hardwick Hall in Derbyshire, designed by Robert Smythson for the Countess of Shrewsbury, the first thing you notice is the windows. 'Hardwick Hall, more glass than wall' went the saying. Those who climbed the hill were amazed to realize that the whole structure was sparkling. Glass in the sixteenth century was a luxury and buildings wore their lights like diamonds. Conspicuous consumption was the motivation behind the windows, but there was more to it than wealth. Houses had always, until now, meant shelter. Their walls were as thick as possible to keep out the cold and, in violent times, the armies. Castle walls could be the breadth of a modern room, broken only by tiny slit-shaped windows, chinks in the armour only grudgingly permitted. Early Tudor manor houses let in more light than this but were still shaped by the needs of fortification. Often they faced inwards to a courtyard, closing in on themselves for protection. Elizabethan prodigy houses like Hardwick turned everything outwards, confronting the visitor not with strong defences but with equally formidable displays of confidence. Glass shatters so easily: these windowed walls seem to say, 'I dare you.'

Architecture like this entailed a new interplay between house and weather. A great chamber with floor-to-ceiling glass along one side was a kind of conservatory. By day the whole character of the room was conditioned by the quality of the light outside, the furnishings made pale and uniform when they reflected a white blanket sky, or sharpened and coloured in bright sun. From the outside, too, the façades seemed to be made partly of the sky itself. Grey, blue, shifting clouds – it all passed across the countenance of Hardwick. The architects intended the many panes to serve as mirrors, which was a characteristic ruse. Glass invokes transparency, and the house seems bent on candid self-exposure. But then you realize that windows can be one-way valves, which allow those inside to look out while those outside see only a wall of reflections.

At Burghley House near Stamford in Lincolnshire, where Elizabeth went frequently, William Cecil put the mirrors to dramatic effect. The

queen's procession would approach the west front, having travelled all day from London. In the late afternoon the light of the setting sun would flare up in the windows. On a clear evening the whole building would blaze. The light in the west was, figuratively, the light of the queen herself. She was the remote but beneficent star who would light up whichever house she visited. John Heywood had envisaged Henry VIII as Jupiter, meting out judicious shares of weather; Marlowe imagined the whole 'airy region' of the weather as the inside of Tamburlaine's head – and vice versa. The construction of Queen Elizabeth as a cosmic force was altogether more elaborate.

According to the mythology she sponsored, Elizabeth was 'England's Astraea': star-maiden, celestial virgin, goddess of the dawn, bringer of the golden age, 'Albion's shining sun'.[16] The source of all earthly goodness, wisdom, prosperity, hair flaming red, face bright white, she was the centre around which her courtiers were in constant orbit. One of the most celebrated paintings of her is the *Rainbow Portrait* (*c.* 1600), made in the last years of her life, probably by Isaac Oliver. A diaphanous lace ruff and wing-hooded cape frame her face like clouds just parting from the sun. Strands of hair fall in rays which point towards a glowing orange cloak. Then there is the rainbow itself: a translucent arc clasped in the queen's right hand. A motto in gold lettering makes the significance clear: 'Non sine Sole / Iris'. No rainbow without the sun. The bow in her hands is the proof of Elizabeth's sun-like status, and a symbol of the peace she has brought after storms. The rainbow is announced in the Bible as God's token, but here it is held by the divinely ordained ruler, to whom God has lent his most eloquent of signs.[17]

The cult of Elizabeth as a weather goddess had been shifting and intensifying for two decades. The *Armada Portraits* (there are three versions of the same image) show the queen between two windows. Through the first opening we see the arrival of the Spanish ships in fair weather; through the second we glimpse a scene of tempestuous destruction under a ferocious sky. This is the Armada 'before' and 'after'. On 19 July 1588 Spanish warships had reached the Channel and were poised to invade; by 9 August they were in retreat. Three weeks of manoeuvring and intense sea battles had intervened, but it was the final few hours that dominated public reports of the victory, hours in which an Atlantic storm blew the regrouping Armada into disarray and forced it to abandon the invasion.

Few doubted that such a decisive intervention was an act of God. News spread of a 'Protestant Wind' siding with England against the

Spanish. A commemorative medal was stamped with triumphant words around the edge: 'Flavit Jehovah et Dissipati Sunt'. Jehovah blew and they were scattered. It was the kind of sign Henry VIII had longed for in the 1530s and which had not come. The 'Protestant Wind' was greeted by many as divine sanction of the whole Reformation. The wind was from heaven, but in the *Armada Portrait* it is the body of Elizabeth which forms the hinge between the success and defeat of the invaders.

One of the fascinations of this mythology was that, while Elizabeth controlled and sometimes embodied weather, she was herself immune from weathering. She had made a pact between the cosmic and the cosmetic, her white-painted face being the token of her immutability. Every woman who could afford it adopted the fashion, displaying the mask of whiteness. The windows of their palaces might be great expanses of glass, confidently letting in the light, but the people inside would not be weathered. Their status put them beyond the elements.

The mask was meant to be unchanging. Elizabeth's face wrinkled, of course, and the white lead paste would have emphasized the creases (as well as slowly leaching poison into the skin). Thick ceruse makes deeper the shadows, but those who saw the queen pretended not to notice. An official order in 1563 banned the painting of royal portraits from life; artists were to render the mythologized Elisa as forever young, a figure of perpetual spring with the mythic power to establish a new golden age in England.

This, then, was the revised purpose of the spring song: to hymn the beauty and plenitude of Elizabeth herself. In the *Rainbow Portrait* she wears a dress embroidered with spring flowers, as if her body were a garden. Edmund Spenser, in his *Shepherdes Calendar* (1579), made Elisa the icon of April. Shepherdesses gather flowers to adorn her ('daffadowndillies / And cowslips and kingcups, and loves lilies') while Phoebus the sun peers out from heaven, sees her brightness rivalling his, and 'ne durst again his fiery face outshow'.[18] Yet this vision of fertility is framed by elegy. The paean for Elisa was composed by the *Calendar*'s central persona, Colin Clout, in former days, but he is now lost in unrequited love and it is left to his friend Hobbinol, mourning his absence, to sing Colin's song in the April eclogue. The joyous spring is at a distance, surviving only in lyric. Spenser is both the chief celebrant of Elizabeth's religion of spring, and the poet most troubled by its limits.

Spenser has not been particularly admired as a weather-writer. His snow is pure and white, his tears fall like rain, his thunder is hurled by Jove: 'this strictly literary meteorology gives Spenser's poetry a precious, hothouse atmosphere, so that even the *Shepherdes Calendar* and *Faerie Queene* never really get outdoors'. No reader encountering one of Spenser's tempests would feel, as Fuseli felt when looking at pictures by Constable, the need of an umbrella.[19]

But weather, for Spenser, is nevertheless the beginning of narrative. The Red-Cross Knight 'pricking on the plain' at the start of *The Faerie Queene* (1590–96) is wandering in no defined direction, his quest for Gloriana as yet uncertain. A lovely lady rides silently beside him, the Eve to his Adam. All life and all stories are latent in these two, but how are they to be unleashed? After a pause, the quiet before a storm, the sixth stanza brings the answer:

> Thus as they past,
> The day with cloudes was suddeine overcast,
> And angry Jove an hideous storme of raine
> Did pour into his Lemans lap so fast
> That every wight to shrowd it did constrain,
> And this fair couple eke to shroud themselves were fain.

The weather here is cosmic sex: Jove pours his fertile rain into the lap of the earth which is his 'leman', or lover. For the wandering mortals on the plain, the change has been made, the action begun. Una and the Red-Cross Knight seek shelter in a 'shady grove' which, as they walk, springs up around them to become Faerieland. This, then, is the second English epic to grow from the rain. With his 'hideous storme' Spenser is both honouring and rivalling Chaucer, 'old Dan Geffrey', whom he acknowledges as the 'pure well head of Poesie'.[20] 'Well head' is no casual metaphor: the same spring-water flows between them.

In the classical tradition, rain is a key ingredient for the making of man himself: Ovid suggested that Prometheus had mixed up a brew of rainwater, earth, and magic particles of the sky. Virgil, too, wrote about the watery creation that comes with every shower, and which had been going on since the first springtime of the world. In one of the most delightedly sensuous passages in the *Georgics*, he paused in awe to describe how

> almighty father, Air, marries the earth
> and penetrates her with prolific showers, and, their bodies joined
> as one, unbridles life's potential.

Virgil allowed this great union to 'unbridle' a whole panoramic description of natural life: woodlands echoing with birdsong and young plants reaching up to the sun. In Spenser's mind this landscape extended in every direction to become an endless forest of winding paths, no longer the setting for pastoral but for the self-perpetuating adventures of romance. Spenser's giant poem replenishes itself along the way by invoking 'a sudden shoure of raine, / That all the wretched world recomforteth againe'.[21]

Weather is change, but change within what limits? It was the question Boethius had asked of Lady Philosophy in the sixth century, and when Spenser asks it in 'The Mutabilitie Cantos', the final, fragmentary book of *The Faerie Queene*, he arrives at similar conclusions about the necessary but controlled changefulness of nature. First, a personification of mutability summons forth a great procession of her subjects: the four elements, the four seasons, the twelve months, one after the next. All derive their identity from their changefulness. The procession of seasons had been a literary set piece since ancient times, so Spenser had to do something distinctive. As his elements perform their orderly march-past they meet and merge. Water is defined in a sentence of phantasmagoric shape-shifting:

> Ne poole so small that can his smoothnesse holde,
> When any winde doth under heaven blowe;
> With which, the clouds are also tost and roll'd;
> Now like great Hills; &, streight, like sluces, them unfold.[22]

Like so many of Spenser's stanzas, poised between containment and spillage, this one can barely hold the energy of the things it describes. The long final line is a sluice gate, containing the flood and then, at the semicolon, releasing it.

Spenser's procession of seasons and months is no static and elegantly proportioned classical frieze but a rapturous display of plenitude, foraging in the well-stocked prop-room of European calendar tradition to give each month more accoutrements than it can reasonably carry. They trundle past like overloaded floats at a carnival: Winter with chattering teeth and

breath freezing on his beard, September laden down with the harvest, October tipsy with new wine, January holding a hatchet with numbed fingers while standing (precariously, one imagines) on a pot from which pours the water of Aquarius. It is the most excessive of calendars, unwieldy and improbable, greedy to encompass all human and natural life.

It is a fitting culmination to Spenser's 'endlesse worke', but Spenser needed to inscribe Elizabeth at the close, asserting her power over changefulness. She appears as the goddess Nature, presiding in judgment over the claims of Mutability. This is Spenser's endorsement of his queen and her promise of stability; but he has the queen acknowledge (in ways that the official Elizabethan propaganda did not) that Nature and Mutability must work in tandem, that Mutability is the source of the world's variety, and that change does not preclude perfection. Her decision about the correct cosmic order is carefully accommodating:

> all things stedfastnes doe hate
> And changed be: yet being rightly wayd
> They are not changed from their first estate;
> But by their change their being doe dilate:
> And turning to themselves at length againe,
> Doe work their owne perfection so by fate:
> Then over them Change doth not rule and raigne;
> But they raigne over change, and doe their states maintaine.[23]

With this diplomatic assessment, Spenser left Faerieland and turned his mind to eternity. He found he could not write about it. What was there to say? It was the problem Botticelli had faced in the 1480s when he tried to illustrate Dante's *Paradiso*. Botticelli drew a few roses on an otherwise empty sheet. Paradise was a blank. Spenser applied to God for a rest, a Sabbath earned in the seventh book of his poem as on the seventh day of creation. The end of mutability was the end of poetry. It was left to Shakespeare to brew up such storms as would make the world change again.

SHAKESPEARE: INSIDE-OUT

Standing in the pit of the Globe Theatre, or seated in the galleries, wherever you are in that famous 'wooden O', look up. The ceiling is the sky: an airy

ellipsis which rivals the jewelled blue and gold of the ceiling in the Chapel Royal at Hampton Court or even Correggio's vortex of inhabited clouds in the dome of Parma Cathedral. The competition between real and painted skies goes on even within the walls of the Globe: the stage is sheltered by a projecting canopy, a false ceiling painted midnight blue, decorated with stars and the signs of the zodiac.¹ It was referred to by actors as 'the heavens', and from these heavens many visions appeared. Openings in the ceiling stood ready to produce gods or portents at the required moment in the drama.

The real sky above the groundlings is remade by the plays on stage; words make the air warmer or drier, fresh or close. *Macbeth* generates 'fog and filthy air' with a thickness to it ('light thickens', night thickens), and voices sound in it other than the voices on stage. There are 'lamentings heard i' th'air, strange screams of death'. The play's atmosphere is in the quality of its air. Arviragus in *Cymbeline* asks, 'how / in this our pinching cave, shall we / Discourse the freezing hours away?'² It is the question from which all Shakespeare's plays, and perhaps our lives, set out. Here we are, pressed together in the cold. How shall we spend the time?

Shakespeare acknowledges that we make the weather up, and studies the ways in which we do so. Hamlet's exchange with Polonius about the clouds, apparently an incidental comic filler, concentrates into six lines the problem of our relation to the sky.

> H: Do you see yonder cloud that's almost in shape of a camel?
> P: By th'mass and 'tis like a camel indeed.
> H: Methinks it is like a weasel.
> P: It is backed like a weasel.
> H: Or like a whale?
> P: Very like a whale.

Polonius may be humouring a man he thinks has lost his senses, but the scene is appealing because Hamlet's observations are so recognizable. Our minds recoil from blankness, which is why it is hard to watch the clouds for a few minutes and *not* see creatures. We long for shape as we long for narrative. We also have a wonderful, dangerous capacity to see what we are told is there. This much was evident long before Wittgenstein drew the duck–rabbit diagram, which is a rabbit when one is told to see a rabbit and a duck when one is told to see a duck.³

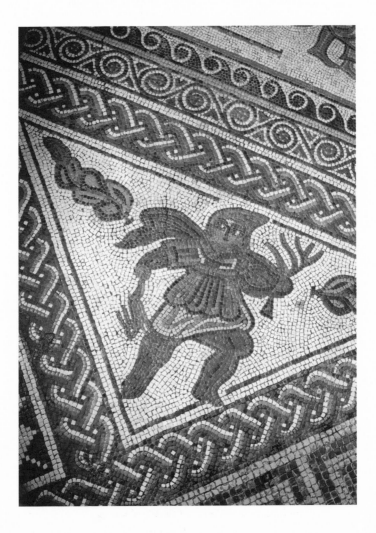

Winter at Chedworth Villa in Gloucestershire, holding
a dead hare and the season's customary bare branch.

Warming and forging in November, from a calendar illuminated *c.* 1040,
in the British Library's Cotton Tiberius B.v manuscript.

Calendar illustrations for February turn their backs on the cold outside
and focus instead on fireside comforts. Shaftesbury Psalter, *c.* 1120s (top), and
a mid-fourteenth-century picture from the Gregory-Hood Cartulary.

A thunder prognostication chart from an almanac made for Harry the Hayward in 1389. If thunder is heard in January (top left) there will be strong winds (mouth issuing big gusts), abundant produce (platter), and war (crossed swords). Thunder in December (lower right) augurs better things: abundant fruit (tree) and provisions (platter), and harmony among the people (figures hugging).

Pilgrims leaving Canterbury, from a manuscript
of John Lydgate's *Siege of Thebes*, c. 1457–60.

Marcus Gheeraerts the Younger, *Queen Elizabeth I* ('The Ditchley portrait'), *c.* 1592.
The Queen presides over earth and air, bringing light where she looks.
The sonnet on the right praises the 'prince of light'.

Anthony van Dyck, *Charles I and Henrietta Maria with
their two eldest children, Prince Charles and Princess Mary*, 1631–32

Quiet rivers and temperate air: Izaac Walton depicted
in a memorial window at Winchester Cathedral.

The mythological masques of the Renaissance presented gods and goddesses who inhabit the sky, blow the wind, and conjure lightning. The character of each was for the most part a fait accompli, handed down from an anonymous past, taken up by Hesiod and by Ovid, preserved by the decorum of literary convention. That was the schematic sky painted in the 'heavens' at the Globe and in every almanac you opened. But what Shakespeare does is different. The action begins at the point where the months can no longer be contained in roundels or staged in a pageant. The seasons go topsy-turvy, rivers overflow their banks, no category will do. 'Fair is foul and foul is fair', chant the witches in the storm at the beginning of *Macbeth*, in their 'sickening see-saw' antitheses which make fog from fresh air. Their meaning is double or triple. To the witches, foul weather is the most fair, but they also suggest that fair days will be fouled by deeds. Beatrice in *Much Ado about Nothing* says that 'not till a hot January' will she fall for Benedick. It is not much of a put-down because Januaries in Shakespeare might well be unseasonably warm. The most changeable months inspire some of Shakespeare's most beautiful images, as well as the most ominous and violent. Proteus in *The Two Gentlemen of Verona* (his name of course speaks change) sighs that his season of courtship, his 'spring of love', resembles

> The uncertain glory of an April day
> Which now shows all the beauty of the sun,
> And by and by a cloud takes all away![4]

It is a perfect evocation of ordinary English weather, mobile and delicate. This is a rare thing in sixteenth-century writing and sets Shakespeare apart from the makers of emblematic and personified weather. In Shakespeare's theatre (though there are intriguing exceptions) weather is not made of discrete, easily categorized events. The months cannot be consistently personified, just as characters who live in them can no longer be defined through single attributes as in the old morality plays. This is part of the 'uncertain glory' of the worlds he creates.

Though some of Shakespeare's plays were commissioned for particular feasts and are associated with certain times of year, all transcend the expectations of the season. *The Winter's Tale* is half a summer pastoral; *Twelfth Night* may have been intended for the end of the Christmas season, but it was performed at Candlemas in February (at the hinge between

winter and spring) and it invokes the festivities of May Day.[5] *A Midsummer Night's Dream*, so often chosen by directors for summer evenings in the park, promises no such thing as balmy entertainment. The play's imagery of midsummer is not headily hot but confusingly sodden. Titania, queen of the fairies, has expressed her rage at Oberon by tampering with the weather. A personal quarrel leaks out to become an atmospheric disturbance, legible in the winds and the cold and the rheumatic dampness of the air. Titania's instrument for climatic control is the moon, 'pale in her anger' – the moon's anger reflecting the fairy queen's. 'And thorough this distemperature', explains Titania, 'we see the seasons alter':

> The spring, the summer,
> The chiding autumn, angry winter change
> Their wonted liveries, and the mazèd world
> By their increase now knows not which is which.[6]

'Liveries' here reminds us of the costume drama of the seasons as displayed in the Roman mosaics, in Spenser's procession, in Ben Jonson's masques. Shakespeare muddles up the costumes and in the process brings us closer to the truth of seasonal weather which is liable to be unseasonable. There was foul weather from March onwards in 1594; the astrologer and diarist Simon Forman recorded that June and July were 'wonderful cold like winter', with people still sitting by their fires. Un-summery summers followed in 1595 and 1596, when *A Midsummer Night's Dream* was first performed.[7] So Titania was sketching a picture of contemporary England when she set before Oberon the results of their dispute:

> The fold stands empty in the drownèd field
> And crows are fatted with the murrain flock.
> The nine men's morris is filled up with mud.[8]

The words were topical, but universal too. We have all known drowned summers. We have all seen work and games thwarted, rotting crops, flocks and livelihoods lost to disease. There were classical models for describing the 'alteration of the seasons', but Shakespeare makes this disorder a practical affair and all the more disturbing for that.

At the same time he dramatizes the relationship between weather and mood. The bad weather stems from the quarrel between Oberon and Titania. Out of temper themselves, they change the temperature of the

world. Titania's word 'distemperature' refers to the disordering of the four elements and qualities, the incorrect 'tempering' of cold and heat, air and water. She would not have imagined the air as having a particular temperature (that meaning followed from instrumental measurement in the late seventeenth century), but meanings lost to us were rich to her. Her word had physiological implications, since the Renaissance body was characterized by the four qualities and humours tempered (in the sense of 'mixed') together, balancing each other to reach a temperate state. Even more than this, in the 1580s and 1590s 'temperature' was coming to mean state of mind as well as body; a medical textbook of 1583 referred to 'melancholie occupying the mind, and changing its temperature'.[9] So the tempering of elements in the body, dependent on elements in the air, was acknowledged as determining one's mood. Shakespeare took things a step further. He imagined what it might be if human tempers could alter the weather.

Not often in the plays, however, are the workings of weather so explicitly dramatized as in Titania's machinations. The elements for the most part remain a mystery. Lear gets no answer when he asks, as simply as a child, 'What is the cause of thunder?' In the Old Testament, God mocks Job with rhetorical questions: 'Who is the father of rain? Or, who hath begotten the drops of dew?' In Shakespeare there is no voice from God to claim authorship of the weather. Other contenders for the role emerge: the witches in *Macbeth* really can cook up winds, it seems, and Ariel, at Prospero's behest, can stage his or her own weather around the magic island of *The Tempest*. A spirit of the air, Ariel can temper its ingredients, producing the dramatic effects Prospero requires. He even tells us what it is like single-handedly to enact a lightning storm:

I flamed amazement: sometime I'ld divide,
And burn in many places; on the topmast,
The yards and bowsprit, would I flame distinctly,
Then meet and join.

It fascinates Shakespeare to become, for a moment, the 'I' of the storm. He relishes the thought of a body turned painlessly to lightning flame, not a 'bare, forked animal' but a forking streak of light, dividing and joining itself at will.[10] For the space of a dream, or a spell, the weather belongs to these

Shakespearean drama imagined as a weather event:
Macbeth, Banquo and the Witches, by Henry Fuseli, 1793–94.

magic beings – fairies, witches, aerial sprites. But there is no lasting answer to Lear's question. The origins of thunder remain unknown.

'I believe they are portentous', says a nervy Casca of the strange weather events in *Julius Caesar*. Thunder sounds around him; he has come through a 'tempest dropping fire'. Cassius rubbishes such superstition, and bares his breast to the storm to prove it. Both points of view remain valid through the plays. Portents retain their power not least because Shakespearean drama works through foreshadowings, and any theatre-goer must be alert to the signs. 'These late eclipses in the sun and moon portend no good to us', warns Gloucester in *King Lear*, and the next eclipses we see are the two circular voids where Gloucester's eyes once were.[11] The cause of this darkness, however, is human deed alone, and it is with the nature of men rather than the causes of thunder that Shakespeare is concerned.

Act 3 of *King Lear* is a study of a man, not a study of a storm. Commentators have for centuries been asking how far the weather triggers Lear's madness, or is merely coincidental with it, or is really an externalization of the storm in his mind. Shakespeare allows these possibilities to coexist. Lear incites the weather to maximum violence:

> Blow, wind, and crack your cheeks! Rage, blow,
> You cataracts and hurricanoes, spout
> Till you have drenched the steeples, drowned the cocks!

We see the Elizabethan map with the puffed cheeks of the winds around the edges. Immediately the image surges to life and blows itself apart, the map confused and drowned. Might Lear really be able to command the storm, bringing it down as a curse on his own 'white head' and on a whole unjust kingdom which deserves a second Flood? The tradition of kings as weather gods allows that he might. But this is not a midsummer dream, Lear is not a fairy or a god, and there is in this play no proof of supernatural or divine forces. Lear's address to the storm is a soliloquy: no articulate response comes back from a sky which shows no sign of knowing him.[12]

Lear fantasizes that the weather might be his accomplice, sharing his mood and matching his temper. Goading the storm to do its worst, he instigates a contest between man and sky. Because the storm is more powerful, Lear's encouragement of it is a form of self-excoriation: 'Why then let fall / Your horrible pleasure. Here I stand your slave, / A poor, infirm, weak and despised old man'. He is both diminishing himself before

the greatness of the weather and enlarging himself by making the storm an expression of his temper and an extension of his mind. Self-enslavement and self-release come erotically close as Lear presents his small body for flagellation. Persisting outside when everyone calls him to shelter, Lear feels both the sympathy and violence of a storm which works with and against him. The storm, of course, is not really doing either. It is just being a storm.[13]

The rain, which falls on everyone, extends Lear's sphere of thought from his own body to other bodies. He submits to a lesson in the sufferings of common men, whose vulnerability he suddenly understands:

> How shall your houseless heads and unfed sides,
> Your looped and windowed raggedness, defend you
> From seasons such as these? O I have ta'en
> Too little care of this. Take physic, pomp,
> Expose thyself to what wretches feel.

Lear is a patient undergoing medical treatment from the tempestuous physician. The scourging of his body is conceived as a cure for his mind – a mind diseased and limited by the material luxuries of kingship. Weather can be socially divisive, persecuting those most exposed to it while the rich in their watertight homes need scarcely notice its existence. But here the king realizes its potential as a leveller: if he stays outdoors he will feel 'what wretches feel'. At the height of his rage, 'the tempest' in his mind is a kind of anaesthetic, dulling the sensitivity of his flesh. Then, as he slows and reflects, the king begins to feel the weather, sensing it on his skin and acting upon his thoughts. He makes the same discovery as Duke Senior in *As You Like It*, who is pleased to experience in the forest something more real than the artificial climates and flatteries of court. Cold winds, the duke finds, can be 'counsellors / That feelingly persuade me what I am.'[14] Lear values the same natural counsel.

So the weather becomes Lear's tutor in both empathy and self-knowledge. The king's raging poetry turns to prose as he talks with the battered Edgar (disguised as Poor Tom the beggar), wondering in humility at the smallness of man against the elements. Thomas Hardy, describing another night on a heath, would invent the phrase 'prosy rain' for weather that just has to be endured; poetic rain is a grand force we invent to flatter our own significance. In prose Lear gets to the flat truth of things. 'Thou wert better

in thy grave than to answer with thy uncovered body this extremity of skies. Is man no more but this?' The natural force of the storm exposes the superficiality of coverings: 'Unaccommodated man is no more but such a poor, bare, forked animal as thou art', says Lear to the beggar before him, taking off his own clothes to expose the identity of king and tramp.[15]

'Unaccommodated man': he is the central subject of the storm scenes. All the play's talk of houses and retinues has been in preparation for this moment of acutely felt unhousing. 'Shut up your doors', Regan ordered as the storm approached. Left with only the shelter of clothing, Lear conceives fabric as a house – and the holes in a beggar's 'looped and windowed' dress as openings through which the rain gets in. His choice is to 'abjure all roofs', following the example of the storm which makes all accommodation seem petty. Power, on this wild night, is the breaking of bounds, hence Lear's first command that the winds crack their cheeks and that the thunder 'Smite flat the thick rotundity of the world, / Crack nature's mould, all germens spill at once'.[16] It is a curse on the Globe (a rotund world whose walls might be struck down), on the way to being more dreadfully a curse on the planet. The 'rotund world' is the womb as well, our first accommodation, from which Lear imagines all the seeds, or 'germens', of life being forcibly expelled.

These images are taken up in Shakespeare's next tragedy as Macbeth demands information from the weather-brewing witches. His speech is almost impossible to read silently: it asks to be let out, uncontained – though the extent of its flood is controlled by syntax which holds the storm in a subclause:

> I conjure you, by that which you profess,
> Howe'er you come to know it, answer me:
> Though you untie the winds and let them fight
> Against the churches; though the yeasty waves
> Confound and swallow navigation up;
> Though bladed corn be lodged and trees blown down;
> Though castles topple on their warders' heads;
> Though palaces and pyramids do slope
> Their heads to their foundations; though the treasure
> Of nature's germains tumble all together,
> Even till destruction sicken, answer me
> To what I ask you.

The stage directions demand 'thunder', but props are paltry beside words such as these. Though a 'real' storm is evoked on stage, all the exhilaration comes in the act of imagination. The witches (as was commonly believed) keep the winds tied in knots, ready to be unleashed when needed.[17] All human ways of tying up and making safe are here untethered with the winds. 'Navigation' in the sense of 'shipping' will be swallowed, but so too will all ability to navigate the world: our compass points, our charts, will all be drowned. As the pyramids collapse, the ancient systems of mathematics and geometry seem to founder. The subsequent history of meteorology will be one obsessed by measurement, but here Macbeth invokes a fundamental enmity between weather and human ordering. The weather overwhelms the very means by which we try to understand it.

Storm is the primal mess from which worlds are made. Reprising the original separation of light from dark, land from water, *Twelfth Night*, *The Tempest*, and *Pericles* all start in chaos and work towards order.[18] *The Winter's Tale* – which is two plays fused together, tragedy and pastoral comedy – needs a storm part way through to mark the join and the new beginning. It wipes out what is no longer needed and throws up like driftwood the constituents of the next act. In this case the storm is comically paralleled with a wild beast. As Antigonus exits, famously 'pursued by a bear', a storm besets the crew of the ship which has brought him to Bohemia. On land, the bear (as we are told by the amazed Clown in the next scene) chomps through the body of Antigonus, enjoying its dinner. At sea, the storm makes short work of the vessel and its sailors.[19] The bear as storm, the storm as bear: the association is a surreal probing of these different forms of wildness.

The Clown notes the convergence of water and air: 'I am not to say it is a sea for it is now a sky', and this fluid state, which will be the impetus for Turner's art, is much used by Shakespeare. Lear's imagined drowning of the weathercocks is a version of it, in which water floods land and sky. Sometimes, vertiginously, the earth and the heavens are flipped round, positioning the heavens below us. 'As flies to wanton boys are we to th'gods', observes Gloucester after the storm.[20] The image is much noted for its apprehension of divine indifference, but it is also a giddy inversion, placing the gods on earth and men in the air.

⌒

Through all the spouting, cracking, spilling, washing in Shakespeare's plays, the human body proves stubbornly solid. Shakespeare's characters do all they can to imagine it dissolving, but though their minds fly free their flesh stays put. Envious of the shape-shifting elements they urge their bodies into complicity with the weather. Surrendering his crown to Bolingbroke, Richard II laments that his body should outlast his kingship. It is indecent that he should still be standing there – and so, in his speech of grief, he dematerializes himself. His crown becomes a well, filled up with tears. The usurpation of his throne is marked, in his mind's eye, by an inky blot on the written page of history. Like this blot his own words well up and run, as he sees through watery eyes the washing away even of the name given to him in baptism. The water and the winters then freeze together to produce one of the play's most startling images, as Richard, with chill irony, wishes himself a snowman:

> O, that I were a mockery king of snow,
> Standing before the sun of Bolingbroke
> To melt myself away in water-drops![21]

Cast out from the sunlike position of kingship, Richard will be one of the frozen exiles who have inhabited English poetry for centuries, though he hopes not to endure the long, lonely fate of wanderer or seafarer. Better to melt, and for a moment we see it: the king built in snow, slumping and diminishing in the thaw, leaving behind on the ground (where we might now expect to find a scarf or grubby carrot) an unmelting, uncorroding crown. In the sixteenth century snowmen were intrinsically connected with mockery, built primarily as images of political satire. Accounts survive of fairs in which city streets were lined with snow-sculptures representing figures of contemporary notoriety.[22] Snowmen were not then the generic shapes of cuddly cartoon roundness we know today. They were ruthless caricatures sculpted with identifiable features. Richard imagines joining this parade of infamy and dying with it.

He wants to melt actively not passively. The regal sun of Bolingbroke may provide the impetus, but the old king will not be melted by his usurper. The capacities of the snowman, however, are beyond the capacities of the once-king. Flesh will not melt and he must try something else. He calls for a mirror and studies his face. 'Was this the face/ That like the sun did make beholders wink?' The glinting mirror is itself a sun, but glass is also

smooth and cold like ice. The mirror image will have to be his snowman, and he will shatter himself into 'a hundred shivers'.[23] Still it is only his reflection which has been broken and his body remains vexingly intact.

Richard's fantasies of dissolution are bequeathed to Hamlet, who longs similarly for the protean properties of water. 'O, that this too too solid flesh would melt, / Thaw and resolve itself into a dew!' Antony reconciles himself to death in *Antony and Cleopatra* by comparing himself with clouds. His body is not permanent, he tells his attendant Eros, but as easily and necessarily effaced as clouds. 'Sometimes we see a cloud that's dragonish, / A vapour sometime like a bear or lion'. These forms appear one moment and disappear the next, 'limned' and then 'dislimned':

> That which is now a horse, even with a thought
> The rack dislimns and makes it indistinct
> As water is in water.[24]

He knows his death will be a painful, messy, and unnatural one, involving swords and blood. But Antony imagines himself erased 'even with a thought', experiencing no agonies and leaving no more trace than a name limned in water.

∽

Auden observed that, in Shakespeare, the opposite of turbulent weather is music. He pointed out that, as King Lear revives in Act 4, the doctor calls for music, 'music that is a rich, full, sophisticated victory over the storm'. Turbulence resolves into the controlled breath of a singer or the wind issuing from the precisely shaped cavities of lute and recorder. In the same spirit, on the night of Othello's rage, Desdemona and her ladies try to keep the wind at bay by singing, gently, an old song. The agitating sounds of the night air are turned into the plangent notes of 'willow, willow, willow'.[25]

Desdemona is singing in advance her funeral dirge; for the mourners in *Cymbeline*, death is a release from the earthly struggles of which fierce weather is the most potent symbol. 'Fear no more the heat o' the sun', they sing, 'Nor the furious winter's rages'. After long exposure to the elements, at least the grave offers shelter. To live is to be weathered. One must endure it, and sing a song to help. There are many seasonal songs of the old sort in the plays, songs in the tradition of 'Westron wynde' and 'Sumer is icumen in'. Several seem to have been written by Shakespeare himself, who knew

their power in asserting that the seasons carry on, that the ploughboy is cold, the fire is warm, the holly is green in winter: 'Then, heigh ho, the holly! / This life is most jolly'. After the fluid metamorphoses of sea and sky, the drowning of weathercocks, the thundering portents, these songs restore to us an ancient and knowable version of the weather. Choruses of men and women gather at the close of *Love's Labours Lost* to sing of spring and winter. Antiphonally they answer each other, the cuckoo and then the owl, the meadow flowers and then the freezing time, 'when icicles hang by the wall / And Dick the shepherd blows his nail'.[26]

Feste stands alone on stage at the end of *Twelfth Night* and sings a simple song about life in the weather and the weathering of life.

> When that I was and a little tiny boy,
> With hey, ho, the wind and the rain,
> A foolish thing was but a toy,
> For the rain it raineth every day.

Another three verses take him on through the ages of man, until he comes finally to a beginning and an ending:

> A great while ago the world begun,
> With hey, ho, the wind and the rain,
> But that's all one, our play is done,
> And we'll strive to please you every day.[27]

The song is sometimes called a 'lecher's progress' because of the bawdy lyrics (thieves, beds, and drunkards) which appear in among the weather. It can be sung as a bit of drunken jesting, but more often it is sung in a way which mixes joking with melancholy, because it is both comic and tragic to accept this vision of life.[28] Shakespeare's feeling for the song is suggested by the context in which it is reprised: Lear's Fool remembers it in the middle of the storm, as the gale blows and Lear's wits 'begin to turn'. At a point of desperation, when everyone and the sky seem to have gone mad, the Fool remains sanely aware that the wind and the rain have been going on since the world began, and his song quietly proposes that human lives are all versions of the same humdrum effort to make one's way through the weather. And so it goes on:

He that has and a little tiny wit
With hey, ho, the wind and the rain,
Must make content with his fortunes fit,
For the rain it raineth every day.[29]

IV

Th'air shows such meteors, as none can see,
Not only what they mean, but what they be.

John Donne,
'The First Anniversary'

TWO ANATOMISTS

For a powerful sense of how people have understood the weather differently, try reading Robert Burton's *Anatomy of Melancholy* next to Francis Bacon's *Historia Ventorum*, works published within a year of each other in the early 1620s. On Burton's side the room is busy with ideas quoted from sources ancient and modern, sympathetic advice about keeping warm but not too warm, cross references to follow up later, an unstoppable stream of sayings and stories drawn from a fund apparently so limitless that there is no pause in which to notice that the air is cold and life is sad. On the other side, Bacon quotes no one and tells few stories. He asks us to look at things directly and make up our minds. He goes to the door and stands in the draught. He points to a windmill in the distance and asks what we can learn from it. These were both modern men in the 1610s and 1620s, gripped by new ideas. Both were 'scientists' before the word was used, yet their enquiries were of divergent kinds, and so were their experiences of weather.

A good deal of space in the compendious *Anatomy of Melancholy* is taken up with thoughts on air. Admittedly space is also taken up with lovers, magicians, and mandrakes, ointments, omens, and onions (the index alone is a cabinet of curiosities), but Burton understood air to have a special significance for melancholics. Medical tracts made it clear that, in the airy circulation system of the body, vapours produced by any of the organs might rise up into the brain. Or food might be the guilty party: cabbage, for example, 'sends up black vapours'. By many means the head becomes toxic with the body's exhaust fumes, as all the doctors attested. External atmospheres could also upset the balance of humours, though 'a change of air' could provide sure relief. Burton felt himself to be acutely air-sensitive. 'The air works on all men, more or less', he observed, 'but especially on such as are melancholy'.[1] So, in his daily, addicted reading, he took note of all that had been thought about air across the centuries.

As he ranged in imagination across continents and through the universe, he sat reading in the college library at Christ Church in Oxford, with its large ecclesiastical windows and row after row of numbered oak bookcases in what was once the refectory for the nuns of St Frideswide. The building still stands, reached through an unpromising blue door in the

cloister. Though the large open reading-room has long since been divided into student accommodation, there are still fragments of the old painted ceiling with its coats of arms. Some of the tracery windows remain, through which the changing light must have fallen onto Burton's page. Here he was safe from potentially dangerous weathers, and free to explore the climate of the world through books.

In the second part of the *Anatomy*, intending to consider medicinal climates, Burton embarked on a 'Digression on Air'. Having worked hard to anatomize causes of melancholy (bad diet, inheritance from parents, overmuch study, as well as bad weathers) it was time for a holiday: he paused luxuriously to survey 'these ample fields of air, wherein I may freely expatiate and exercise myself', and then he soared upwards, imagining himself as a 'long-winged hawk' flying from Eldorado to the Caspian Sea. Like Faustus commanding divine knowledge, he toured the heavens, and he descended below ground to conduct strange archaeologies. Burton studied maps and read his way, engrossed, through travellers' tales which told him, for example, of cool rains experienced in the equatorial 'torrid zones', which had previously been thought intolerably hot. He read of how, crossing Peru and Chile in the 1570s and finding 'moistening showers' in places assumed to be uninhabitable, José de Acosta had laughed at the faultiness of Aristotle's meteorology. The zoned areas, or *klimata*, into which the known world had for so long been divided, were being decisively broken down. Thousands of voices brought to Burton news of the world's airs. As for the air far above him, Burton thought some explorer ought to go and have a look. What colour is the sky when you get up close? Is there a reservoir of water beyond it? Burton was still sitting in Oxford, but his reading had made him an astronaut. Disappearing into the blue, or away over the horizon, he called back from a distance. 'But hoo!' he exclaimed at the far limit of his digression, 'I am now gone quite out of sight, I am almost giddy with roving about'.[2]

He landed safely back on earth and began his detailed analysis of healthy airs for melancholics. Others had drawn maps according to political divisions, agricultural produce, land ownership, population; Burton mapped the country in terms of the atmosphere liable to sit over each part of it. He couldn't see it, he couldn't measure it, but he believed good air to be the greatest quality a place could possess. Bad air was to be strenuously avoided. The Dutch physician Lemnius noted that 'in a

thick and cloudy air, men are tetric, sad and peevish'. The very worst air, Burton wrote with feeling, was 'a thick, cloudy, misty, foggy air or such as comes from fens, moorish grounds, lakes, muckhills'.[3] From all ages and across Europe he found testimony of spirits being lowered by these conditions.

Like most of his contemporaries, and with some accuracy, Burton believed air quality to be governed by topography; hence the horror of the fens as a place of damp-bred pestilence where the atmosphere was deathly. Shakespeare had used a range of extravagant curses involving 'fen-sucked fogs' as a form of poison, and Burton too was suspicious of any fog that came from the fenland east.[4] He issued his air-warnings for England: Romney Marsh, the Essex hundreds, coastal Lincolnshire. Not all his sources agreed: Plato stressed the capacity of fog to help the memory, and William Camden (in *Britannia*, his great survey of the nation) connected fog with the excellent memories clearly functioning in Cambridge. Still, Burton had no need to risk long exposure to Cambridge. Cautious to the last, he even distrusted Salisbury, Hull and Lynn: 'they may be commodious for navigation [...] but are they so wholesome?'[5] Far better to be on high ground, as at Sutton Coldfield in Warwickshire (where Burton went to school) or Cuddesdon (on a hill south of Oxford), or his own parish of Segrave in Leicestershire.

Previous commentators on air quality had warned about the dampness of moats, but Burton thought this could be mitigated with a good fire indoors. Wherever the house, moat or no moat, he reassured his reader that much could be achieved through the 'opportune opening and shutting of windows'. We might imagine him, then, opening and closing his own college windows to achieve maximum control of his atmosphere. Burton adored the world, but he also felt persecuted by it and was always on the verge of evasive action.

> The heavens threaten us with their comets, stars, planets with their
> great conjunctions, eclipses, oppositions, quartiles, and such aspects;
> the air with his meteors, thunder and lightning, intemperate heat
> and cold, mighty winds, tempests, unseasonable weather; from which
> proceed dearth, famine, plague, and all sorts of epidemical diseases,
> consuming infinite myriads of men.[6]

Life was an obstacle course, and Burton wrote the *Anatomy* in an attempt to steer himself and others around it with minimum injury.

⌐

While Burton was writing, the first concerted moves towards new kinds of scientific enquiry were being made. In 1622, just after the first edition of the *Anatomy of Melancholy* appeared as a volume of nine hundred pages (Burton would add many more over the years), Francis Bacon published his *Historia Ventorum*. This, too, was part of a giant project, a study of natural phenomena which Bacon proposed to write at the rate of one volume per month into the foreseeable future.

For both writers the air was an agent of discovery, opening up the world; but their methods of air travel differed. When Bacon called his book a 'history' he did not mean a chronology of ideas about wind – far from it. He meant 'natural history', the study of natural things, and not the cultural afflatus that had accrued around them. The immersion in classical scholarship which shapes every page of Burton's book seems to Bacon distracting and at worst misleading: 'what the ancients have told us about the winds [...] is confused, uncertain and for the most part untrue'.[7] In 1622 this was a kind of heresy.

Burton took pleasure in labyrinthine charts and was known to invent a false quotation if there was no literary authority to fit the bill. At times the content barely seemed to matter: the important thing for Burton was to keep writing and for the reader to keep reading. The aim was not so much to understand the world but to find prolonged distraction from it. Bacon, by contrast, went briskly to business. He wrote in Latin, the language of intellectual life, but his tone was that of the common-sensical man exasperated by flights of fancy. People ignore what is right in front of them, he complained. They do not see what is right by their feet ('quae ante pedes'), or in front of their noses.[8]

So he watched the movement of the air above his head rather than citing books about the air as witnessed in Greece and Rome. Ever the teacher encouraging further research, he asked that the reader do the same. 'See if one can see clouds standing still and motionless while down here on the ground stiff winds are blowing'. Yes, of course we see them (though the sight may be deceptive), and having seen for ourselves we need not take Bacon at his word. These empirical observations foster intellectual freedom.

'How narrow are the spaces into which winds can be squeezed?' We start prodding at the window frame to see how small a crack will let in a draught.'

This investigative method proceeded from Bacon's realization that he could not answer all the questions himself. One man has only so much ingenuity, and he can only be in one place at a time. This geographical limitation was a crucial factor in the study of weather because air travels and changes from place to place. To record its behaviour one must track it across space and time. 'If a strong northerly blew at York on this day or that day or hour,' Bacon asked, 'did it blow (say) two days later in London?' His question anticipated the modern study of weather as a dynamic process rather than the recording of isolated conditions.'[10]

Bacon wanted to know how every phenomenon related to every other, including the environmental effects of human activities like heather-burning and forestry. His imagery for this connectedness was often that of the formal dance: 'From the limits of winds the inquiry passes on to their succession', he writes, 'either among themselves, or in relation to rains and showers. For seeing that they perform dances, it would be delightful to know the steps.' This reminds us that Bacon, like most other Jacobean courtiers, enjoyed a masque, and that the rhythms of his mind were related to the steps of a pavane. He was a friend of Ben Jonson, the most influential dramatist of the 1610s and 1620s, whose court entertainments made allegories of the weather. From the personified winds in *The Masque of Beauty* (1608), to the various dancing meteors in *Chloridia* (1630), Jonson's air was a pantheon of mythic figures. Bacon, too, knew the myths of the sky, but when he thought of the wind it was not Boreas and Notus, Zephyrus and Eurus, that crowded his mind. It was common experience that mattered most to him. He saw the way trees 'bend and curve as if avoiding the sea breezes'; he watched the guttering of a flame or the movement of air wafted by a lady's fan. Even the shuttlecock fascinated him. He could not stop to analyse its arc and flick in a game of badminton ('I have no leisure to think about these things'), but he trusted the shuttlecock as an authority on wind more than he trusted Aristotle.'[11]

Around 1624, perhaps suspecting that he did not have much time left, Bacon began to write in Latin a passionately ambitious book about the future of science. An English edition came out in 1627, shortly after his death, and it has remained in print, inspiring new generations, ever since. *New Atlantis* describes a utopian society in which men strive to discover the

workings of nature, and use their discoveries to make life on earth healthy and fruitful despite its fallen state. The understanding of weather is high on the agenda in Atlantis. Bacon imagined meteorological laboratories, 'spacious houses where we imitate and demonstrate meteors'. He saw a future in which air could be 'qualified' and its temperature controlled. His contemporary Cornelius Drebbel had already demonstrated an air-conditioning machine at Westminster Hall, reputedly making the air so cold that James I left the room before he was frozen. Bacon anticipated 'Chambers of Health', where controlled or 'tempered' air could be deployed medicinally for 'the cure of divers diseases.'[12]

New Atlantis was never finished. As a student now scribbles bullet points at the end of an essay when running out of time in an exam, Bacon rapidly itemized the things he wanted to include. He had already appended to his *Novum Organum* in 1620 a catalogue of 130 'histories' yet to be written. Now the last pages of *New Atlantis* contained a list of desirable discoveries (from which this is just a selection):

The prolongation of life
The restitution of youth in some degree
The mitigation of pain
The increasing and exalting of the intellectual parts
Making rich composts for the earth
Impressions of the air, and raising of tempests
Greater pleasures of the senses
Artificial minerals and cements.[13]

Weather was one interest among many, but it was certainly there on the syllabus. The word 'impressions' referred to all atmospheric phenomena, while also carrying the sense of air pressure and influence.[14] Bacon was lifting the weather out of the realms of astrology and mythology, placing it firmly in the realm of the discoverable. He knew he had not fathomed the nature of winds (he had only allocated one month's study to the *Historia Ventorum* after all); he could not answer for himself the question of how wind works, but he was the first man to have complete confidence that one day someone would.

Bacon died as he had lived, in the pursuit of knowledge – or so the legend goes. His first biographer, John Aubrey, told the story as it had been related to him by Thomas Hobbes. It was April 1626 and there was

still snow on the ground. Bacon was in a coach near Highgate with the physician Dr Witherborne.

> It came into my Lord's thoughts, why flesh might not be preserved in snow, as in Salt. They were resolved they would try the Experiment presently. They alighted out of the Coach and went into a poore woman's house at the bottom of Highgate Hill, and bought a Hen, and made the woman exenterate it, and then stuffed the body with Snow, and my Lord did help to doe it himselfe. The Snow so chilled him that he immediately fell so extremely ill that he could not return to his Lodging [...][15]

Bacon sought refuge at Arundel House, though his friend the Earl of Arundel was away. The room he used was cold and damp having long been empty, and this (Hobbes told Aubrey) depleted his health. He was dead within three days from the phlegmy 'suffocation' of a severe cold. So Francis Bacon died, apparently, in an effort to understand refrigeration. His quest for methods of preservation hurried the process of his own demise.

More circumspect modern biographers have pointed out that Bacon was already ill when he drove through Highgate. The chicken may or may not be apocryphal. Bacon himself told Arundel (in a letter which was dictated because he was too ill to hold the pen) that he had been 'conducting an experiment or two, upon the conservation and induration of bodies'. These were probably more sophisticated experiments than stuffing poultry with snow. He had been thinking for some time about 'the prolongation of life', and it has been suggested that the business from which he was returning that fateful day was the inhalation of nitre or opiates in the hope that he might preserve himself.[16]

One man tried to prolong existence; the other had had enough. Burton, it was rumoured, took his own life in his college room in Christ Church. If this is true, the date makes sense. He died on 25 January 1640, well past the encouraging feasts of Christmas, at a melancholy time of the year.

SKY AND BONES

What did people see in the morning when they opened their shutters in the mid-1600s? What did they feel when they got outside? It seems impossible to know. Modern diarists will often record the weather as a

matter of course and as the background to their day. Writers of journals and letters in Stuart England said very little about it. When the weather in the 1660s determined his movements, Samuel Pepys would make a note of it, as on Boxing Day 1661: 'it was most foule weather [...] and so we went into an alehouse'. He might stay talking in bed with his wife on a long rainy morning or doze off outside in the sun. John Evelyn kept his diary voluminously all through the 1640s and 1650s without saying much of wind and rain. Sometimes he would sum up a whole season as particularly warm or cold, but weather was not part of the daily texture of his recorded life until the 1680s. From that time, in Evelyn's papers and elsewhere, there begin to be comments about warm days, groans about rain, a sense of how weather affects one's clothing, work, and spirits. By the 1710s Jonathan Swift would be keeping up a running commentary in his letters, 'fine cold sunshiney' one day, 'slobbery' another.[1]

Weather-consciousness in writing grew very gradually. Celia Fiennes, hardy traveller that she was, described all her lengthy side-saddle tours of England in the 1680s and 1690s with barely a reference to the weather, though she must have been blown about on hilltops day after day, and bogged down in the various soils over which she rode. All she saw fit to mention was that Derbyshire was windy, and that after a fierce hailstorm in Cornwall her 'dust coate' dried off quickly. This was characteristic of her time. Orlando, usually so weather-conscious, spends most of the seventeenth century indoors, writing tragedies 'at dead of night', meditating on bones and ashes, reading Thomas Browne, 'a Doctor of Norwich, whose writing on such subjects took his fancy amazingly'.[2]

No painter in this period would have taken an easel outside. The portraitists of the century – Van Dyck at the court of Charles I in the 1630s, William Dobson for the Royalists during the Civil War and Robert Walker for the Parliamentarians – were all devotees of sky as a dignifying backdrop. But their skies were indoor constructions, as if they were paintings of trompe l'oeil murals. Invariably there was a column and curtain to one side, showing that the subject is contained by noble architecture. The sitter was not affected by the weather behind him, and that weather belonged with the apparatus of fabric and marble. So Van Dyck shows Charles and Henrietta Maria enthroned against a massive stage-set sky, cloud bubbling, primrose light matching the silk of Henrietta's skirt.[3] The stout Englishmen painted by William Dobson stand, for all their daylit idiosyncrasies, in

front of the same vaguely brushed-in skies which never for a moment persuade us they are real.

It is rare to feel the movement of air in seventeenth-century writing, though when we do it is with distinctive clarity. The clergyman Ralph Josselin, who kept a farm at Earles Colne in Essex, commented regularly on the weather in the weekly (sometimes daily) diary entries he made for nearly forty years. His records of frosts and fine spells were inseparable from his records of his family's health, the well-being of his parish, the progress of work on the farm, and – above all – the whole community's relationship with God. When he wrote about clement days, he was making himself stop and give thanks for them. In late April 1647, he prayed for a let-up in the rain: 'the weather was very wett, the season very sad and had continued so very long, I earnestly entreated god for faire weather' – and when fair weather arrived a few days later, he registered his sense of divine goodness. He was a close and appreciative watcher of very ordinary weathers, even when there seemed little to remark upon. 'This weeke was wonderfull dull and malincholly weather', he wrote on Tuesday 31 December 1654, while struggling with a cold and hoping it would not go to his chest: 'the sun shone not, but on Monday morning, the 30 a litle glimmering one glance or two'.[4]

Such regular weather-writing was unusual in the mid-seventeenth century, but in just a phrase here and a note there, deep feelings for weather become movingly apparent. The Puritan minister Henry Newcome often made brief records in his diary about the 'sad blustering rain' that might hinder a journey, and sometimes he paused to say more than this, as when, in October 1666, he found himself remembering the weathers of his early life:

> I was this day put in mind of some of the sins of my childhood
> by the weather, a softly rain. It made me freshly remember how
> at this time of the year, on the Lord's days ofttimes, in just such
> rainy days, we have played eagerly at bandy-ball. We counted it
> fair enough for that sport [...][5]

The appeal of 'a softly rain' was well understood by Izaak Walton. *The Compleat Angler*, first published in 1653 and repeatedly enlarged until 1676, is a fishy pastoral which inhabits all winds and weathers. Walton loves the calming and sustaining influence of ordinary English days. He

appreciates cool, clear air as much as the cool rivers into which he casts his line. All weathers are good for fishing, he assures us, except for deep frosts and east winds. He is one of the earliest writers to articulate that optimistic appreciation of all kinds of light and dampness which Ruskin summed up when he said that 'there is no such thing as bad weather, only different kinds of pleasant weather'.[6]

Showers for Walton are agreeable intervals in which the fisherman might retreat for conversation under a tree. His breaks for reflection are shaped by interludes of rain, as are his fishing tutorials: 'now, scholar, my direction for flie-fishing has ended with this showre'. *The Compleat Angler* takes its structure from the rhythms of an uncertain day. Walton has no taste for elaborate description, but the odd word reveals his naturalist's perception. When he watches from under a sycamore a 'smoking showre' he evokes the faint humidity of a warm day turned damp.[7]

Part of what Walton responded to in the poetry of his friends was this same feeling for the mild and well watered. So, in tribute to quiet friendship in divisive times, *The Compleat Angler* included quotations from Henry Wotton on the pleasure of fresh mornings, and George Herbert on a 'sweet day, so cool, so calm, so bright'.[8] Both poets had died before the outbreak of the Civil War, but to remember their tranquil weather was, for Walton in the 1650s, a token of peace. The poet and fisherman Charles Cotton celebrated Walton's friendship in weathered terms. Inviting Walton to stay in Staffordshire, he looked forward to mild days of amicable spring fishing:

> A day without too bright a beam,
> A warm, but not a scorching sun,
> A southern gale to curl the stream,
> And (Master) half our work is done.[9]

A fond observer of all seasons, Cotton would often play on allegorical habits, setting the old gods in real English air: in one poem he puzzles at the incongruity of classical statues in the snow, frozen naked with discus or amphora. His pastoral quatrains on the different times of day combine the standard language of 'blushing Aurora' with vivid appreciation of small natural things. In the 'cool air' of his 'Evening Quatrains' we watch a world of charm and strangeness:

> The shadows now so long do grow,
> That brambles like tall cedars show;

> Mole hills seem mountains, and the ant
> Appears a monstrous elephant.[10]

The picture forms in the mind like a woodcut worked with intricate cross-hatching to form inky shadows of comical and just slightly unnerving shape. Cotton looks at the English evening with all the attentiveness others might reserve for an exotic elephant. Wordsworth, Coleridge, Charles Lamb – and later Benjamin Britten, who set it to music in his 1943 *Serenade* – would all admire Cotton's good-humoured directness.

But Cotton's work was not typical of the intricate symbolic apprehension of nature in the metaphysical writing of his teachers and seventeenth-century contemporaries. Walton's most revered friend, John Donne, had inhabited a world very far from cool streams and rainy mornings. He had made mutability the subject of his lifelong study, and his poems set in motion state-shifting processes of distillation and deliquescence; but his weathers were always those of body and mind. His sun was a lover, a human mistress, to whom the burning star in the sky was 'a lesser sun'. Vapours were those given off by the loving heart; rain was the feverishly imagined liquefaction of flesh and soul. Donne's territories were the inner chambers of the human heart, or bowels, or grave. In the bedroom he wanted no interruption from the weather carrying on outside, hence the brilliant conceit of his most famous love poem 'The Sun Rising', with its mock chastisement of that 'busy old fool' bringing daylight where it is not required:

> Why dost thou thus,
> Through windows, and through curtains, call on us?
> Must to thy motions lovers' seasons run?[11]

The reprimand to the sun later became a genre of its own. In the mid-1660s, the puritan intellectual Lucy Hutchinson replaced Donne's chamber of sensual love with a place of private grieving in her elegies 'To the Sun Shining into her Chamber' and 'Another on the Sun Shine'. Deep in mourning for the death in prison of her republican husband, she resented the sun as a 'gaudy masker' peering in on her grief. This 'gay courtier' in the sky was mocking their ruination.[12] The language of courts and masquing invoked a political meteorology from before the Civil War, when Charles I had been the sun around whom libertine courtiers performed their gilded

dance. John Hutchinson had signed the king's death warrant in 1649, putting out that artificial light. Now, after the Restoration, the sun was at court again.

Lucy Hutchinson's opposition to the 'gaudy masking' of royalty made it a political act for her to write the weather in more natural terms. In her long poem on the Creation, *Order and Disorder* (1679), she celebrated the clouds as pictures more masterfully composed than any artist's painting. In an extended meditation on cloudscapes she marvelled at their capacity to change from mountains to ships to forests. No lavish expenditure could buy such art:

> Scorn, princes, your embroidered canopies
> And painted roofs: the poor whom you despise
> With far more ravishing delight are fed
> While various clouds sail o'er th'unhousèd head.

Nevertheless, Hutchinson's comparison of natural weather to indoor art has the effect of showing us how closely she associates the two. Even as she stands looking up, defiantly unhoused (the word recalls Lear's 'unaccommodated man'), she is thinking of ceilings and curtains. She uses the traditional image (from biblical cosmogony) of the firmament as a solid roof, and she imagines 'windows' through which God looks through it to the earth. 'His liberal hand' can stretch through the sky's window-openings to water the land with rain.[13] Hutchinson's ways of thinking about the atmosphere are solidly architectural, and have little to do with the experience of actually being outside. There is an indoor, emblematic, and un-weathered quality which, though her ideas are radically different, she shares with Spenser in his pageant of seasons, with Jonson in his masques of dancing wind-personae, and with Donne as he closes his curtains against the sun.

◦⟩

Outside the light was failing, or so it seemed to those who believed that all life was drawing to an end. The idea of decay was the corroding foundation over which all Donne's poetry was built. It urged him to analyse the world as a chronically ill body of shrinking flesh and protruding bone. It is one of the central motifs of his poetry that only love is constant in a dying world: 'All other things to their destruction draw, / Only our love hath no decay.'

Thomas Dekker was telling his readers what they already knew when, in 1628, he diagnosed sickness in each of the elements: barrenness on the earth, and 'mortall poyson' in the air. Thomas Browne in 1658 observed sadly that ''Tis too late to be ambitious. The great mutations of the world are acted, our time may be too short for our designes'.[14]

There had always been theories of decline. Hesiod, eight centuries before Christ, itemized the ages of degeneration from gold to iron. Virgil in the first century BC assumed in the *Georgics* that the world 'forces all things to the bad'. For the Anglo-Saxon poet of 'The Wanderer', singing sadly that 'this world dwindles day by day', it was too late to be happy.[15] It was always already too late. To live in modern times (at any time up to the eighteenth century) was to inhabit a pallid and elderly version of a universe once sparkling with life. The governing trajectory was not of progress but of decay. Imperfect weather, which is almost all weather, was understood for centuries as part of this great sickening.

Talk of decline was at its most intense in the early seventeenth century. In his popular account of the Creation, the French poet Du Bartas mentioned in a subclause (because it was so well known) the fact that 'th'earth, degenerate / From her first beauty [...] becomes less fruitful every day'. Donne's 1611 elegies for his patron's daughter, Elizabeth Drury, proposed her untimely death as a symptom of impending doom. It was an aberration, but proof of cosmically aberrant times in a world which did 'from the first hour decay'. The divine framework was 'quite out of joint' he wrote, as if it were a carpenter's damaged construction. Donne could not begin his poems with fertile springs as Chaucer had, for spring in the seventeenth century was a funeral for springs as they once had been. The world was a menopausal mother, liable to bear few children and sickly ones. Since women's fertility declined with age, it was logical to suppose all nature similarly finite. 'And now the springs and summers which we see, / Like sons of women after fifty be'. These 'sons' are suggestive of summer 'suns', so that we seem to see in the mind's eye both a white human face and the pallid disc of a weak sun in the sky.[16]

Donne thought that the sun itself, the source of energy, was weary and faded. The colour seemed to be going out of life, and even summer was a season dully dressed: 'summer's robe grows / Dusky, and like an oft dyed garment shows'. People looked paler and shorter, and their intellects seemed to dwindle within shrinking skulls: 'we are not retired,

but damped; / And as our bodies, so our minds are cramped'. Damp, here, refers both to moisture and the deadening effect of it on sounds and flames, the life-spark dampened down. Damp was extinguishing vitality. The overall diagnosis for the world was desperate: ''Tis all in pieces, all coherence gone.''[17]

This idea of deterioration did not affect everyone so viscerally as it did Donne. Burton, for example, mentioned it as a truism, and carried on being energetically melancholy about other things. But it was hard not to believe that something was awry when the poets kept writing about death, the priests gave impassioned sermons on bad weather as the proof of God's displeasure, and hundreds of pamphlets circulated with news of demonic lightning or shooting stars that heralded apocalypse. The focus of attention was much less on processes of temperature change and air circulation than on extraordinary 'meteors'. Wind and rain went on in the background, but, as the scholar Vladimir Janković has shown, 'it was *excess* and *oddity* that interested meteorologists'.[18] Little was said about temperate days, while every flood and storm prompted lurid and often fantastical narration.

The atmosphere of dread was understandable since the weather could be dreadful. This was one of the coolest periods of the Little Ice Age, with temperatures falling too low for winter wheat and summers bringing flooded, rotten harvests. The historian Geoffrey Parker has amassed a huge body of written and archaeological evidence to show how bad the weather was in the seventeenth century and how frighteningly it affected people right across the world. The long-term climatic changes of the Little Ice Age were exacerbated by the frequency of El Niño episodes (twenty of them between 1618 and 1669), which brought summer wind and rain to England, and on top of this came a decline in sunspot activity.[19] There were years when July and August came and went without much sign at all of warmth or brightness. The years 1628 and 1675, particularly, were remembered as having passed without summers. 'From Mayday till the 15th September there were scarce three dry days together', wrote John Oglander on the Isle of Wight in 1648, sure that the war on earth must have offended the heavens. The deposed King Charles, imprisoned at Carisbrooke Castle, wondered if the weather was always this bad. 'His Majesty asked me whether that weather was usual in our Island. I told him that in this 40 years I never knew the like before.' The Civil War in England,

and contemporary episodes of widespread violence on every continent, have been linked with the poverty and illness caused by bad weather.[20]

No wonder, then, that weather events are fearful things in the period's writing. Strange fires burn through the atmosphere of seventeenth-century literature because (as modern astronomers now confirm) there were unusual numbers of comets around.[21] The facts of the weather are clearly important, but the facts can be perceived in different ways, and sensibility matters a great deal here. This was a culture which had been intent on ideas of decay well before the decline in solar energy, and a culture which staged fiery spectacles in theatres and in books even when there was not much to be seen in the sky. This was a period fascinated by 'oddity', and it was partly because people were constantly looking for oddities that freakish meteors were witnessed in overwhelming numbers.

Year after year through the seventeenth century, popular broadsides and pamphlets carried reports of 'prodigious' events in the sky and called on the nation to repent. Fire balls and brimstones, strange lights and castles in the air: all seemed to be appearing with such frequency as to suggest the coming of the end. Some believed that the air was writhing with devils. Burton thought that 'aerial spirits' could 'tear oaks, fire steeples, houses, strike men and beasts, make it rain stones, as in Livy's time, wool, frogs etc., counterfeit armies in the air, strange noises, swords'.[22] It was like living on the stage of *The Tempest*, except that the spirits were less tricksily benign than Ariel.

Less and less was said of airy sprites, however; more was said, and more gravely, about the wrath of God. The weather events were understood by most commentators, not as the playthings of mischievous devils, but as the purposeful language of heaven. This was God, as Dekker put it in 1628, 'Holla[ing] in our Eares'. The hollering might take watery form, as when the River Severn flooded in 1607, overwhelming villages all along the Bristol Channel, drowning people and livestock in Wales on one side, and across Somerset and Gloucestershire on the other. These 'wonderfull overflowings of Waters', said the pamphlets, were worse than anything seen before, 'our punishment greater, because our treason against God is more horrible'. At other times God's hollering came in the form of hissings and cracklings before a fiery stone plunged to the ground. In 1642, near Woodbridge in Suffolk, there was thunder like a drum which beat on and on, and then, cued by this cosmic fanfare, a stone dropped from the

The VVonders of this
windie winter.

By terrible stormes and tempests, to the losse of liues and goods of
many thousands of men, women and children.

The like by Sea and Land, hath not beene seene, nor heard of in
this age of the VVorld.

Punishment from the skies: the title page of a pamphlet
reporting on the great storms of late 1612.

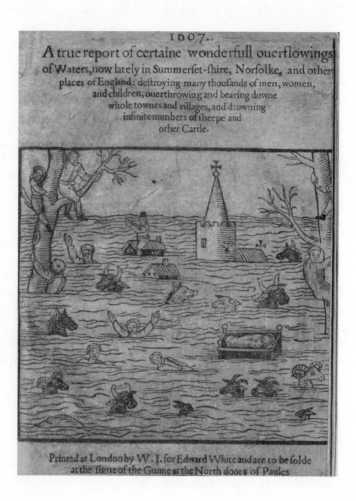

A pamphlet describing the 'wonderful overflowings' of January 1607, when floods overwhelmed the land around the Bristol Channel and Severn Estuary.

sky. Over the following days this cannonball from heaven was weighed and measured, and conveyed to the House of Commons to be 'read' as a message for the nation.[23]

Since every strike of lightning articulated God's intent, it was incumbent on anyone caught in a storm to bear witness to what happened. He must ask why a certain building had been targeted, or what could be learned from a storm's human victims. A 1641 pamphlet moralized on the death of a 'rich miserable farmer' struck by lightning in Abingdon in Berkshire.[24] A religious dispute between 'three maids' in 1652 was thought to have been resolved by the ultimate authority when the catholic maid was struck dead by lightning and the two protestants were left standing unharmed. This was among a litany of terrors catalogued by Charles Hammond in 1652 in *A Warning-Peece for England*. God's words to the prophet Joel kept turning in his mind, and he printed them on the front page of his pamphlet: 'And I will shew wonders in Heaven, and in Earth, blood and fire, and Pillars of smoake. The Sun shall be turned into darkenesse, and the Moon into blood, before the great and terrible day of the Lord come'.[25]

As with the 'Protestant Wind' which had helped defeat the Armada, the weather during the period of the Civil War and the subsequent Commonwealth was understood as taking sides. In 1658 a storm was quickly followed by news that the Lord Protector was dead. 'Oliver's Wind' would be remembered long afterwards. Some said it was a storm of devils taking Cromwell down to hell. Others claimed that the whole sky lamented to see his passing. The Royalist John Evelyn held on to the story of an infernal wind escorting the Protector to his burning end. From now on, Evelyn would watch anxiously at state occasions for signs in the sky.

Reading Evelyn's diary in the 1920s, Virginia Woolf was struck by the succession of 'marvels' he was always witnessing:

Nature, it seems, was determined to stimulate the devotion of her seventeenth-century admirers by displays of violence and eccentricity from which it now refrains. There were storms, floods and droughts, the Thames frozen hard, comets flaring in the sky.[26]

Yearly there were new meteors requiring interpretation; cautionary woodcuts showed shooting stars with faces and thunder from aerial cannon. Historians have pointed out that those who interpreted bad weather as punishment rarely pointed to good weather as a sign of

divine satisfaction.[27] To read through some of the period's 'exhortations to repent' is to gauge the pitch of anxiety at which ordinary people lived in these dangerous years. They were forced into sectarianism, they were forced into war, they were damned as heretics by everyone who did not hold the same beliefs. When news arrived of marvels in other countries it seemed probable that the whole world was actually coming to an end. Of all the generations on earth, this would be the one to suffer the fires of the apocalypse. People were taught to believe that they had deserved it: that for all their repentance they were the most ungodly of men. It begins to seem less odd that they so seldom recorded the balmy warmth of a summer evening or the briskness of a late autumn day. In this context, too, Walton's and Cotton's determination to write about temperate air takes on an ideological meaning.

∽

It required extraordinary independence of mind to think outside these narratives of providence and eschatological fear. Francis Bacon had asked scholars to concentrate on what they could see to be true. René Descartes, working in The Netherlands in the 1630s, argued in a similar spirit that there was far too much 'wondering' going on, too much trembling before 'marvels'. He urged philosophers to interrogate the causes of what they saw, rather than standing back in awe. He published *Les Météores* in 1637 as an addendum to his *Discours de la méthode*, and in it he was explicitly concerned to challenge the culture of wonder that dominated discussion of the skies. 'It is in our nature to have more admiration for things above us than for those which are on our level, or below':

> Because we must turn our eyes toward the sky to look at them
> [the clouds], we fancy them to be so high that poets and the painters
> even fashion them into God's throne, and picture Him there, using
> His own hands to open and close the doors of the winds, to sprinkle
> the dew upon the flowers, and to hurl the lightning against the rocks.[28]

Descartes specialized in shaking himself clear of assumptions, and in this case the assumption seemed to him unfounded: he could see no reason why things above were any more 'wonderful' than things on the ground. Part of his motivation, then, in trying to determine the causation of various meteors was his declared aim of demystifying the sky:

> If I explain the nature of the clouds in such a way that we no longer
> have occasion to wonder at anything that can be seen of them, or
> anything that descends from them, we will easily believe that it
> is similarly possible to find the causes of everything that is most
> admirable above the earth.[29]

Find the causes of everything! He made it sound so simple, and that was part of the point. His writing in French rather than Latin, his testing of clear hypotheses, was all directed towards this calm, unamazed investigation of things. If the dominant attitude to seventeenth-century weather was summed up in the title of Dekker's 1628 pamphlet *Look Up and See Wonders*, Descartes articulated a powerful alternative when he hoped that readers of *Les Météores* would in future see no occasion for wondering at the sky.

At the same time, a voice from the ancient world was increasingly attracting attention. The text of *De rerum natura* by the Roman poet Lucretius had been rediscovered in the fifteenth century, but its moment of greatest influence was in the 1650s. At least three translators were working on the text in England, and no writer was unaware of the Lucretian debates going on. Following the Greek philosopher Epicurus, Lucretius had understood the universe as an infinite number of particles in blind motion. By 'blind' he meant invisible to the human eye, but the word was also linked potently with his belief in a nature which is not consciously designed by an all-seeing divinity and not moving towards a foreseen end. He believed that gods existed, but not that they created the world. Nor did he think the gods had any providential interest in humans. We inhabit a universe of particles moving through space, and we are ourselves conjunctions of those particles. The gods have no power over this process, and thus we have nothing to fear from them.

To accept any part of this, or merely to visualize such an order of things, was to adopt a radical position in the seventeenth century. The 'Epicurean moment' involved tense negotiation.[30] Descartes denied that he was an atomist, primarily because he did not believe in the void through which Lucretius thought particles moved. But the same frustration with 'wonder' united them. Both paid attention to weather events because they were a prime cause of unnecessary terror. 'Storm and lightning flash must be my song', wrote Lucretius,

> Lest senselessly you tremble at the sky
> Divided into parts and speculate
> Which one the flying fire came from or to which other
> It went, and in what way it penetrated
> Through walls of buildings [...]

He might have been directly addressing the seventeenth-century commentators who measured the angles of lightning strikes and collected witness statements, elaborating horrors that would make readers tremble towards repentance.[31]

Freethinkers of many kinds were drawn to these ideas of liberation from self-punishing tyranny. Lucy Hutchinson, devout Puritan though she was, worked for years in her thirties on the first complete English translation of *De rerum natura*. She made English poetry from Lucretius' imagery of atoms dancing in space like dust-motes in the sun. She translated his injunctions not to marvel and fear, and his explanations of how lightning is produced by clashing clouds, like the sparks produced when flints are rubbed.[32] Did she for a moment suspect that lightning might be no more providential than a fire lit by flints? Her manuscript was never published, and by the 1660s Hutchinson was dissociating herself from the project. Such 'atheisms and impieties', she wrote in 1675, had been merely the product of youthful curiosity. And yet she was writing this in a covering letter to a learned friend, for whom she had just had a new copy of her complete translation made.[33]

MILTON'S TEMPERATURE

If, on a sunny day in the 1660s, you took a stroll outside the walls of the City of London, along Artillery Walk towards Bunhill Fields, you might have seen John Milton sitting in his doorway. He was by then immersed in the 'great work' which would be *Paradise Lost*. Early biographers reported that 'he Us'd to Sit in a Grey Coarse Cloath Coat, at the Door of his House near Bun-hill Fields Without Moor-gate, in Warm Sunny Weather to Enjoy the Fresh Air'.[1] He could not see the blue sky, being by this time completely blind, but he liked to feel the warmth. There is something surprising about the image of Milton, in his puritan's plain coat, sitting outside in summer. In the literary culture of his time the weather is so fierily erratic,

or so insistently emblematic and cerebral, that a peaceful chair in the sun seems incongruous. It is not in any case a very promising place to meet the prophet of heaven and hell, the spokesman for democracy, the divinely inspired interpreter of God's ways to men. Finding Milton by his door, you would not want simply to talk about the weather.

Nonetheless, he was a great weather-writer in an age when weather (as opposed to meteoric wonders) was not much written. A century and a half later, when the Romantic poets rejoiced in the sublime effects of mists and sun, it was Milton's words they remembered. Wordsworth would come to think the storm in *Paradise Regained* was 'the finest in all poetry'.[2] Turner would take Milton's evocation of sacred mists as the cue for his own creation of vaporous worlds. When, in 1798, he exhibited a painting of early sun on the misty Coniston Fells, he had the frame inscribed with words from the 'Morning Hymn' in *Paradise Lost* offered up in ecstasy by Adam in Eden. Though Turner never showed much concern for God, 'the world's great author', this hymn of praise set the syllabus for Turner's lifelong celebration of the steaming, dusky, sun-gilded natural world:

> Ye mists and exhalations that now rise
> From hill or steaming lake, dusky or grey,
> Till the sun paint your fleecy skirts with gold,
> In honour to the world's great author rise [...][3]

Milton wrote about the weather because he felt its effects. There is evidence to suggest that he worked more easily in some seasons and weathers than in others, and certainly he believed that climate influenced his creativity. 'From spring comes genius', he wrote in an early Latin poem, though later his nephew understood him to say that 'his Vein never happily flow'd, but from the *Autumnal Equinoctial* to the *Vernal*'.[4] The early sonnet may have been an expression of conventional springtime revival rather than an admission of his personal sensibilities; the fact that in later life he made frequent reference to seasonal creativity suggested that his own habits were unusual enough to be worth remarking on. If he was a winter writer, at his most productive from the autumn equinox to spring (and this would link him with Cowper and Wordsworth later), he also found winter a worrying time and wished that England weren't quite so cold.

Milton subscribed, more or less, to long-established theories of climatic determinism which linked the qualities of nations with their prevailing weathers. Since cold was associated in the humoral scheme with phlegm, northern societies were frequently deemed prone to dullness of mind. Every great Englishman in history was an argument against such sweeping characterization by latitude, but traditional judgments were not easily forgotten. Milton could still remark near the end of his life that a nation short on sunlight had better import its civil virtues from warmer places, along with its wine and olive oil. Sunshine, he wrote, ripened 'witts as a well as fruits'. That was reason enough to sit outside when the sun broke through.[5]

The effects of temperature even extended to qualities of speech. Proposing a new curriculum for English students in his 1644 essay 'Of Education', Milton recommended lessons in elocution:

> their speech is to be fashioned to a distinct and clear pronunciation,
> as near as may be to the Italian, especially in the vowels. For we
> Englishmen, being far northerly, do not open our mouths in the cold air
> wide enough to grace a southern tongue; but are observed by all other
> nations to speak exceeding close and inward [...][6]

In 1644 this was not a ridiculous suggestion. Temperature was understood as a factor in all realms of thought, art, intellect, and patterns of social interaction. Milton warned that muffled speech could easily make the wrong impression at a time when the English needed to dissociate themselves from phlegmatic coldness. He wanted the new English republic, when it was finally established, to pronounce its identity with confident Italian clarity. Milton's allegiance to the south was clear to see in his Latinate vocabulary and syntax, and he wanted it to be heard as well. Mouths must be opened, vowels enunciated, England's temperature defied.

Because he was a radical, looking ahead to a future of democratic liberty, Milton had a political duty to disapprove of cosmic pessimism. For the purposes of the republic, the future must be bright. But he could not shake off the sense of lateness that had so troubled Donne and which emanated from all the melancholy dust-sifting of his contemporary Thomas Browne. Cold and sadness came together in the winter of 1657–58, 'the severest winter that man alive had known in England', according to Evelyn, a winter when 'crow's feet were frozen to their prey'.[7] Milton's wife,

Katherine Woodstock, gave birth in October and seems to have contracted then the illness which worsened through the winter and killed her in February.

Years later, finishing the epic poem he had started around that time, icy notions converged in Milton's vision of his writing being frozen to a halt. He introduced Book 9 of *Paradise Lost* with a mixture of huge ambition and anxiety, expecting that his work would gain heroic stature,

> unless an age too late, or cold
> Climate, or years, damp my intended wing
> Depressed [...][8]

Dampened spirits and a dampened world: Milton's 'damp', used verbally like Donne's to mean 'stifle', invokes watery damp as well. Combined with 'cold' the damp turns icy and freezes the poet's soaring 'wing'; he falls from his flight, weighed down with the damp and with his spirits depressed. Cold seemed to encroach on him as age encroached, so Milton wrote with urgency, racing not only against the sandglass of his own time and the world's time, but against the dropping temperature. This was a man who had been imprisoned, whose books had been publically burned after the Restoration, who lived in blindness and enforced retreat; but the thing he feared was cold.

He wrote himself back into the gentle mildness of a paradise passionately imagined. As Adam walks in the Garden of Eden, spring airs come to meet him. Had Adam ever known sadness this weather would be enough to cure it:

> so lovely seemed
> That landscape: and of pure now purer air
> Meets his approach, and to the heart inspires
> Vernal delight and joy, able to drive
> All sadness but despair: now gentle gales
> Fanning their odoriferous wings dispense
> Native perfumes, and whisper whence they stole
> Those balmy spoils.[9]

The 'gentle gales' (softer than our modern gale-force) provide music as well as scent, tuning themselves with the dawn chorus to provide 'airs, vernal airs, / Breathing the smell of field and grove'. All is precisely balanced, so

that Adam and Eve need do only so much gardening as will allow them to appreciate the breath of Zephyr on their bodies when they sit down to rest. Each season is as bountiful as the next. When Eve lays out a spread for the visiting archangel Raphael she piles up 'all autumn' for the feast. There is no need to conserve the harvest now for leaner months, since 'Spring and Autumn here danced hand in hand'.[10] Eve may be the only picnicker in history to remain completely free from concerns about the weather as she lays out her food on the grass.

The chaos of weather belongs in hell, for which there are no adequate similes. Milton imagines it to be more vile than a northern winter at its worst. Devils appear for a moment as 'a multitude, like which the populous north / Poured never from her frozen loins'. The historical allusion is to the invasions of the Roman Empire by Goths and Vandals, but these lines need not be pinned to history: they propose a gynaecological freezing in which a womb of ice melts only long enough to let devils pour out. Satan himself, that 'weather-beaten vessel', is defined by his long exposure to the climate of hell. With the Fall of Man, weathers previously known only in hell are unleashed upon the earth. Humankind is doomed, like Satan, to be weather-beaten. Milton describes in horror what happens as God and the angels reorganize the cosmos into a system of battling elements. The movement of the sun is changed, causing 'cold and heat scarce tolerable' on the earth; the planet, knocked awry, must now and forever suffer the changefulness of seasons.[11] It is as if Milton is writing the first chapter for a biography of weather. Parentage, date of birth, and tumultuous early life are all discussed.

The angels establish the winds in their four corners with instructions about 'when with bluster / To confound sea, air and shore'. The winds promptly storm the world like armies. The northerlies come equipped with ice and hail as weapons, but in Milton's scheme winds from all directions are equally unsavoury. 'Forth rush the Levant and the Ponent winds, / Eurus and Zephyr with their lateral noise'.[12] These are winds that people now go on holiday to find: the Levant and the Ponent blow from the east and west in the Mediterranean and are usually gentle; Eurus may have aroused fear as an unlucky easterly, bringing rains and diseases, but Zephyr was generally celebrated as the most pleasant spring wind of all. For Milton, however, these are signs of a warring world, and with their creation the end has begun.

Jan Janssonius,
Wind Rose, 1650

Such a catalogue of winds coming from all directions evokes the wind-roses used by sailors for navigation. Aristotle, in the fourth century BC, had described a twelve-point *rosa ventorum*. The octagonal Tower of the Winds in ancient Athens had been carved with portraits of eight winds in all their varying characters (the Radcliffe Observatory in Oxford is an eighteenth-century copy of it). The tradition had reached its peak with the elaborate wind-rose published in the Dutch cartographer Jan Janssonius's maritime atlas of 1650, showing thirty-two distinct winds gathered around the compass.[13] But where the wind-roses are models of order, Milton's vision is one of unpredictable wildness. A wind-rose tames the air: each wind has its section of the compass, each is neatly and helpfully labelled with a polyglot list of names, and each blows from the mouth of a puff-cheeked face. The wind-rose looks like an astronomical clock and it soothes the mariner by making the air seem to run like clockwork. Milton's point is precisely the opposite: the cosmos is now thrown off course, and will never be easily navigable again.

At the end of *Paradise Lost*, Adam and Eve walk tremblingly into a punishing weather-world. The cherubim who gather to escort them are conjured in an evaporating simile that offers a last glimpse of Eden, though one already changed. The angels come towards the outcasts,

> Gliding meteorous, as evening mist
> Risen from a river o'er the marish glides,
> And gathers ground fast at the labourer's heel
> Homeward returning.[14]

In this image, which eludes like mist all attempts to catch it, luminescent angels are brought into association with a murky night drawing in over the marshes. 'Homeward returning', writes Milton pointedly, though Adam and Eve now have no home to which they can return and no protection from the mists that will gather at their heels. It is the mist of night, and it is the mist that will forever obscure human sight of the divine.

The dank marsh-world they enter will be the fenny breeding ground of English literature. Grendel will come stalking, down through the mist-bands. Dickens will turn the 'marish' into the shadowy Kent wastes of *Great Expectations*, which will in turn become the 'marsh country' of Graham Swift's *Waterland*. Clinging and closing over the earth, the mist

will foster sorrows and secrets. But it will have a thousand other moods. Evaporating in the morning sunlight it will come to be an image of hope in an expansive world.

In late October 1810 Dorothy and William Wordsworth saw Milton's paradise appear before them. They were sitting on a crag at Little Langdale and William was reading aloud Milton's 'Morning Hymn'. Looking out at the mists, they understood that what Milton had described was not theological speculation: it was there in front of them. The paradise dreamed by Milton was Cumbria as the Wordsworths saw it. Milton himself, they realized, was a superlative nature writer. Dorothy described the scene in a letter to her friend Catherine Clarkson:

> William read part of the 5th Book of the *Paradise Lost* to us. He read
> *The Morning Hymn*, while a stream of white vapour, which coursed
> the valley of Brathay, ascended slowly and by degrees melted away.
> It seemed as if we had never before felt deeply the power of the Poet,
> 'Ye mists and exhalations, etc. etc!'[15]

Etc. etc. indeed.

A Pause: On Freezeland Street

Sometimes, in deep winter, life seems to pause. Snow falls silently, and it muffles the usual sounds. The cold air is very still and clear. Darkness never quite falls: all night there is the faint glow of moonlight reflected from the white ground. Even in cities the tempo changes. A new kind of frost-time takes hold.

In December 1683 the River Thames stopped flowing. To begin with, ice formed at night along the shallow edges. Chunks of it broke off to form strange white islands, which were carried on the tide downriver. At London Bridge they knocked against the stone pillars, trying to get through the narrow archways. They caught and stuck there so that gradually the bridge became a dam. On either side, water washed up against the ice and froze. Boats moored on the river that night were stuck fast. Within hours there was a solid surface from Southwark to Westminster. The great highway of London was at a standstill.

Over the next few days an alternative world formed on the ice. People climbed down into it on steep ladders, as if they were boarding a boat, except that there were no boats to board. Ferrymen, out of a job, asked a fare from those who came onto the ice: a toll for entry to Freezeland Street.[1] Visitors came in their thousands as word spread about the greatest Frost Fair in English history. Booths were set up in double rows from Temple Stairs to the South Bank, each one rapidly constructed from the unused oars of riverboats hung across with blankets. There was every kind of food and drink on offer (especially warm spiced beer to keep the cold at bay), souvenirs to buy, games to play in new and slippery ways adapted to the ice. Visitors volunteered for the dizzy experience of being spun round in a boat tied to a pole. Roll up! roll up! for 'the whirling sledge' or 'Dutch whimsie', as the boatmen called it, the Dutch having introduced the game on their own more reliably frozen canals.[2] This was a 'whimsie' that would never go out of fashion: it was improved in the Frost Fair of 1740 to become something like a carousel, with carriages fixed to a circular wooden platform spun round on the ice. Every roundabout in modern playgrounds is a descendant of the 'whirling sledge' on ice.

A wonderfully detailed engraving survives as an A–Z of the 1683–84 fair, with each attraction alphabetically labelled: 'The Beef Booth', 'The

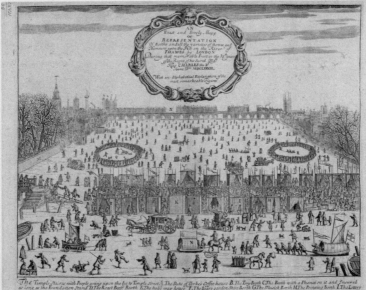

A labelled map of the Frost Fair, 1684. 'R', upper right, is the sliding
chair going round and round; roast beef is a available at booth 'E'.

Abraham Hondius,
The Frozen Thames, 1677

Bear Garden', 'The Lottery', 'The Chair sliding in the Ring'. Roadways were laid down, so that you could tour the entertainments without too much risk of falling over, or simply get from one side of London to the other. John Evelyn, always keen to see what was going on, tested the ice on 9 January:

> I went crosse the Thames upon the Ice (which was now become so incredibly thick, as to beare not onely whole streets of booths in which they roasted meate, & had divers shops of wares, quite [a]cross as in a Towne, but Coaches & carts & horses passed over) [...][3]

There had never before been a whole town on the ice, but accounts of how the Thames had frozen in previous centuries were passed down in fragmentary records and popular stories. The river seems to have frozen several times under Roman occupation, and five or six times in the Anglo-Saxon centuries. There was tell of stalls on the river in 695, when Bede was a young man and London was in the kingdom of the East Saxons.[4] Carriages ran across the ice in 1092 and 1150. In 1282, according to the Elizabethan chronicler John Stow, 'men passed over the Thames, between Westminster and Lambeth [...] dry-shod'.[5] The first really vivid record comes from 1309, written by an anonymous chronicler who recorded that 'bread wrapped in straw or other covering was frozen hard'. The frost began at Christmas: 'and it lasted so long that people indulged in dancing in the midst of it near a certain fire made on the same, and hunted a hare with dogs in the midst of the Thames'.[6] To walk across the river was strange enough, to light a fire and dance around it was extraordinary. By the time the hunt was underway ('in the midst of the Thames', says the recorder again, emphatically) it must have seemed that almost anything was possible on ice.

The chronicle records are suggestive, but they do not take us much beyond the bare facts. Nor can we turn to the visual arts for a sense of how this cold world was experienced since there are so few English medieval depictions of snow or ice. But there are clues to suggest that a medieval winter could be fun. In the lower margin of a fourteenth-century Flemish psalter are two tiny figures.[7] One of them is skating along the bottom of the page, arms held out for balance. His skates would probably have been made of animal shin-bones, tied on to normal shoes with length of leather. The other figure, on a sledge, propels himself along with sticks, in a snowy

variant on rowing. Perhaps the Thames in 1309 was crowded with people like them, and perhaps the scene was repeated on rivers and ponds across the country. But their laughter is very distant now.

There were at least two Thames freezes in the fifteenth century, and four in the sixteenth. In 1537 Henry VIII and Jane Seymour crossed the Thames on horseback to Greenwich Palace. Holinshed records that in 1564 boys were playing football on the ice 'as boldly there as if it had been on dry land'.[8] By the time the river froze again in 1608, there was a tradition of icy spectacle in London. The history of the city could be told as the history of freezes; the elderly could think back through the fairs they had seen.

The most evocative account of the 1608 winter is to be found in an anonymous pamphlet that would have been forgotten had not the Victorian scholar Edward Arber included it in his anthology *An English Garner*. Arber guessed that Thomas Dekker was the author, and he was right. The pamphlet has all Dekker's appealing mix of the striking and the common-sensical, and the frost was a characteristic subject for him.[9] *The Great Frost: Cold Doings in London* takes the form of a dialogue between a Londoner and a Yorkshireman (in a plain holland ruff and a kersey stocking), who has come from the country to see the Thames. They settle down in a tavern, these two old men, their hoary hair the colour of the frost, and go on talking, generously and carefully, about 'how we spend the days of our frozen age'.[10] *Cold Doings*, like most pamphlets, offers its readers news, opinion, and a bit of sensation. But there is also a slow beauty to it, and a pervasive sense of melancholy as the two men talk about the basic struggle to survive the winter. Like the fair, Dekker's writing is both raucous and reflective, taking place in an unexpected interval between the acts of life.

The Londoner describes the Thames as 'a very pavement of glass' dressed in its 'freeze-coat' for more than a month. The countryman thinks of the trapped fish beneath with 'thick roofs' above their heads. He is enchanted by the idea of the ice (hence his journey from Yorkshire to the capital in treacherous conditions); he can recite a whole history of frosts since the Conquest. This is his heritage, and part of his sense of England. But he comments, too, on the hardships of winter. 'The poor ploughman's children sit crying and blowing their nails', while the cattle, 'our nurses that give us milk', go hungry.[11] Those mixed feelings speak across the centuries, attesting to the magic of winters which are often, also, times of sadness.

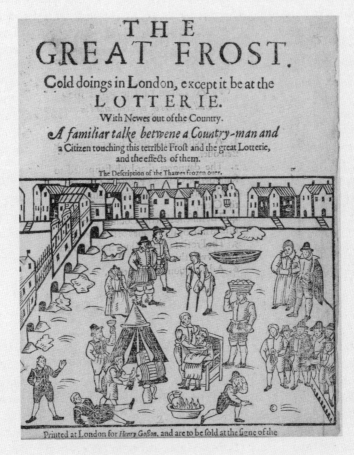

Shaving and skittles on the frozen Thames, as shown on the cover
of *The Great Frost: Cold Doings* by Thomas Dekker, 1608.

On the frozen river, hogs roasted and the spectacle went on. A remarkable ferryman named John Taylor was in the crowd. An entrepreneur and opportunist, he would become famous for eccentric stunts like navigating the Thames in a homemade paper boat. In 1608 he was probably dreaming up all kinds of money-making entertainments to tide him over until he could take passengers on his ferry again. He stored up his memories, and years later, when he reinvented himself as a 'water-poet', he published an account of the frost. Three titles were better than one, so he called it *The Cold Tearme: Or the Frozen Age: Or the Metamorphosis of the River of Thames*. 'It was the time' he began, 'when men wore liquor'd bootes [...]'.[12]

Taylor pressed all kinds of wild and homely metaphors into his couplets as he tried to catch the atmosphere of Freezeland: 'The liquid Thames each where from shore to shore, / With colde bak'd Paste, all pastycrusted o're'. Pastry was in short supply for impecunious ferrymen so he pictured Charity on a cake of ice, quivering and shivering in the midst of a raucous surfeit – which Taylor loves to describe – a world of 'Spic'd cakes and roasted Pigs / Beere, Ale, Tobacco, Apples, Nuts and Figs'.

It was, of course, bitterly cold. Himself the son of a barber, Taylor associated barbers with the vicious north wind, and in his poem the wind becomes a blade:

> When Boreas (all with Isickles bedight)
> Worse than a Barber, 'gan to shave and bite,
> Turning *Thames* streames, to hard congealed flakes,
> And pearled water drops to Christall cakes.

The reference was apt because barbers had set up their stalls on the Thames and vouched that even on ice their razors would not slip. It was all a kind of dare. Taylor watched the visitors play on: 'Some, for two Pots at Tables, Cards, or Dice: / Some slipping in betwixt two cakes of Ice'. That last was a sore point. He added a little note in the margin: 'Witnesse my selfe'.[13]

No wonder Taylor slipped, since movement was more a question of sliding than skating. Though skates had been known in England in the twelfth century, they were little used in modern times. As late as the 1660s, Londoners were taken by surprise at this novel form of locomotion. Evelyn was fascinated by the skaters in St James's Park on 1 December 1662. He watching in delight as elegant courtiers whizzed down the canal 'with Scheets, after the manner of the Hollanders': 'with what swiftness

they pass, how suddenly they stop in full career upon the ice, before their majesties'. Samuel Pepys went to the park that day as well, and thought the skating 'a very pretty art'. He was there again two weeks later, while the frost still held, and worried when his patron the Duke of York insisted on skating out over broken ice.[14] Neither Evelyn nor Pepys, it seems, attempted 'sliding' for themselves, though by all accounts the Duke of York did fine.

It was usually Dutch visitors, long accustomed to skating on their frozen canals, who demonstrated the swift and elegant art while the flat-soled English wobbled and looked enviously on. Abraham Hondius, a Dutch painter living in London, depicted the English bravely adventuring on the craggy ice of the 1677 freeze. With a gently satiric flourish he painted, in the foreground of *The Frozen Thames*, a mock-heroic cameo of a frock-coated man who balances on an icy crag for just long enough to throw a snowball.

Hondius' painting, with its feeling for panoramic landscape, fading light, and changing sky, is of a kind that was new in seventeenth-century England, where artists and their patrons tended to concentrate on portraits, houses, maps, allegorical emblems, and material *things*. The point of a picture was to flatter a woman, make a record, or teach a lesson. Many painters working in England, however, were immigrants from the Low Countries, and brought with them a love of landscape 'views'. Like his Netherlandish contemporaries Jacob van Ruisdael and Aelbert Cuyp, Hondius was interested in the spread of clouds above a low horizon. He focused his attention on wide spaces of air and the fall of light on ice. So, while Englishmen produced diagrammatic engravings of the Frost Fairs, labelling the attractions, Hondius produced an essay in atmosphere. His expansive sky, worthy of the Netherlands, is flushed with the apricot pinks of a winter sunset.

Hondius found beauty in the glinting Thames. But it also set him dreaming of places he had only read about: he kept fantasizing about the Arctic. His 1677 painting *The Frozen Thames* plays tricks with perspective to make the scene grander, larger, more unknowable. This is Hondius' vision of an Arctic waste in the middle of a city. At around the same time, he painted *Arctic Adventure*. It shows a ship foundered in pack ice near Greenland. Dimly visible in the foreground, ragged explorers take shots at a polar bear. The Thames was a noisy, busy river, but in its frozen state it transported Hondius to the desolate edges of the world. This was a hint

of the icy sublime which might just, with half-closed eyes, be experienced among the fair booths and taverns.

It may have felt like the Arctic, but London in the 1680s was not a scene of pure whiteness. Evelyn's 1661 *Fumifugium*, the first published tract on air pollution, had already drawn attention to the unpleasant effects of the fumes from thousands of city chimneys. Now, in the still cold air, London 'was so filld with the fulginous steame of the Sea-Coale, that hardly could one see crosse the streete, & this filling the lungs with as grosse particles exceedingly obstructed the breast, so as one could scarce breathe'.[15] It was fun to whirl in a skidding boat – cheeks burning, hair flying – but many people felt a constraining tightness of the lungs.

In a monochrome world of greys, then, with here and there a fire blazing out, hundreds of figures, wrapped and hooded, picked their way through a puzzling, alluring, sometimes threatening world. Like those who fell 'betwixt two cakes', slipping as John Taylor slipped between islands of ice, the fairs fell betwixt and between the mapped territories of London. The ice was a temporary ungoverned place, both wonderful and hellish. 'Laws they count no more than *Esops* fables', raged Taylor, keen to distinguish the honesty of watermen like himself from the thieves who operated in the giddy crowd. But he liked the fact that social hierarchies were all but abandoned on the river. For Dekker in *Cold Doings*, part of the spectacle was the mixing 'of all ages, of both sexes, of all professions' on the 'common path' of the Thames. Kings enjoyed the same sports as commoners, as became clear when Charles II visited the 1683–84 fair on the last day of January. Respectable citizens found themselves feeling wary but compelled. Evelyn thought the deep cold was an awful judgment from God and worried about the 'bacchanalia, Triumph or Carnoval on the Water', but he couldn't help going to look at it. Then going back again.[16]

'Behold the wonder of this present age / A Famous River now become a Stage'.[17] This was how one rhyme summed up the scene in 1684. The poet and playwright John Dryden may well have crossed the ice and witnessed this winter theatre. That year he started work on the libretto for an opera which would contain one of the most brilliant renderings of frost in musical history.[18] *King Arthur*, with words by Dryden and music by Henry Purcell, was first staged at the Queen's Theatre in 1691. The 'Frost Scene' in it was not strictly necessary to the story. It was a spectacular diversion in the tradition of the court masque, but now with more

Baroque extravagance, the work of a poet and a composer inspired to present a frozen world on stage.

Like Ben Jonson before them, whose masques had conjured dancing winds and rainbows indoors, Dryden and Purcell had a taste for elaborate meteorological tableaux. In the wake of the great Frost Fair they challenged themselves to invent a kind of ice music. They wanted to freeze and melt the human voice, dramatizing in the process the freezing and melting of the heart. Purcell knew that Jean-Baptiste Lully had staged for the French court a 'shivering chorus' as part of his opera *Isis*; now he wanted to explore for himself the soundscapes of cold.

The Frost Scene in *King Arthur* appears suddenly and is associated (like the ice on the Thames) with both showiness and sorcery. It is a fantasy summoned up by the evil Saxon king Osmond as a ruse to make Emmeline love him. With the mere tap of a cane on the ground he conjures 'a prospect of winter in frozen countries'. His masque of coldness is designed with guile to demonstrate that an icy heart can be warmed. In the frosty stillness, the 'Cold Genius', the spirit of the place, starts to stir. The characterization of Cold as a tired old man owes much to the tradition of the year as a human life, changing from youth to decrepitude. Here, in the ancient context of Arthurian legend, Cold seems to have been sleeping since the beginning of time.

Tremolando strings play in C minor, elected as the coldest key. Cold sings as if his were the bass voice of the earth itself, pained at this interruption to its frozen sleep. Slowly, achingly, the words come:

> What power art thou who from below
> Hast made me rise unwillingly and slow
> From beds of everlasting snow?

A fluttering soprano cupid answers in glee: ''Tis I, 'tis I, 'tis I that have warmed ye'. Then comes the 'Chorus of Cold People', the inhabitants of this country, who sing in a stuttering staccato that mimics their shivering. We seem to hear them hop with cold. The chattering of teeth had been one of the vivid attributes of the cold months since Lucretius, taken up by Dante in *Inferno* as the constant sound of a freezing hell.[9] Here in *King Arthur* the chattering reflex movement of the jaw, an involuntary tremor, is rendered in a conscious feat of superlative art.

The whole frosty country on stage is a picture of Emmeline's heart. The strings of the orchestra are Emmeline's heart strings, unwillingly played upon and producing involuntarily glorious harmonies. At the same time this country is the landscape of Osmond's scheming head, cooler than Emmeline's heart. Temperature as a metaphor for emotion is given a life of its own. Dryden and Purcell are virtuosos in this interplay of outward show and inward feeling. The whole masque revels in this dance of opposing symbolism. It reveals the beauty of cold, but only by animating it with warmth; it is a celebration of ice, but puts an evil magician in charge of the proceedings. Its composition is a triumphant moment in the art of frost.

⌒

The formation of ice, which the Anglo-Saxons had conceived as static and binding, came in the period of the great Frost Fairs to be associated with the fertile, the licentious, and the fantastic. No one saw that more clearly than Virginia Woolf in the 1920s as she imagined her way back into the seventeenth century. She read Dekker's *Cold Doings* in her copy of Arber's anthology and knew that Orlando, in his early life as a Jacobean courtier, must go to a carnival on the Thames. It was a brilliant ruse to incorporate freezing into a book with a hero who lives four hundred years. The joke was all the better for the fact that refrigeration is determinedly not Orlando's own method of preservation. Warm-blooded Orlando meets each century full of life and vigour, but the Great Frost sees many of her contemporaries – human and animal – turned solid. Woolf took flight with her descriptions, taking her cue for each detail from Dekker and exaggerating it to surreal effect:

> Birds froze in mid-air and fell like stones to the ground. At Norwich
> a young countrywoman started to cross the road in her usual robust
> health and was seen by the onlookers to turn visibly to powder and
> be blown in a puff of dust over the roofs.[20]

In a novel full of metamorphoses to rival Ovid, people are struck stock-still in mid-movement, as if they had pulled faces when the wind changed. Through the clear river ice shoals of fish are visible, caught in a trance. Life being on pause, the country is a series of tableaux, tragicomically poised between death and suspended animation. It is poised, too, between fantasy and reality. In January 1940 Woolf would see

her invented frost come true: birds were frozen mid-flight, and died in falling to the earth.[21]

Like Dryden and Purcell, Woolf thought of the warm passions that might flourish in contrast to the cold. Orlando's love affair with the Muscovite princess Sasha is sudden and hot. In accordance with Woolf's understanding of human sensibility in this age of 'suddenness and severity', there are no moderate temperatures in between. The lovers, lying together on the river, 'would marvel that the ice did not melt with their heat'.[22] But this love, born in the frost, lasts only as long as the ice stays firm. The first raindrops of the thaw strike Orlando in the face with a blow, like the slap of a hand waking a dreamer from sleep, or the tap of Osmond's cane which brings the masque in King Arthur to an end, making it vanish in a puff of dust that might blow away over the roofs.

~

The last Frost Fair on the Thames was in 1814. Old London Bridge, with its many piers impeding the river's flow, was demolished in 1831, and the new Embankment of the 1850s made the river deeper and faster-flowing at its edges. Freezeland Street would be no more. What was left of it? An assortment of relics. Each time they felt the thaw coming, tradesmen had rushed to dismantle their booths and save all they could. Then the detritus of their floating towns had sunk down to the riverbed. Cups, pots, signs, lost hats and gloves, animal bones. Human bodies.

Thaws could come suddenly and dangerously. Courtiers rushed to the windows at Whitehall to see the unfreezing of 1684. 'The thaw began at two in the morning', remembered the Earl of Ailesbury: 'out of the King's bedchamber windows we saw a waterman in the middle of the river [...] and in most places the heaps of ice were twenty feet high'. Orlando watches as the yellow water rushes downstream carrying people trapped on icebergs, shouting up to God for mercy. 'Many perished clasping some silver pot or other treasure to their breasts.'[23]

Luckier visitors took home their souvenirs. The appeal of the fairs lay in their transience, but people wanted mementoes. There were long queues for stalls at which printers would make you a personalized card, 'printed on the ice' with your name and the date. When the ice broke, the ballad-singing watermen cheerfully remembered all those who had made a living on the frozen river and who now disappeared back into the streets of the city:

Let the printers have their due,
Who printed your names,
On the river Thames,
While their hands with the cold look'd blue.[24]

It was sixpence a name, Evelyn tells us. The printers were charging a premium for the chilblains in their blue hands. Charles II's card survives, more than three centuries after it was printed by G. Croom on an icy Monday, 31 January 1684, with the names of everyone in his party and Princess Anne of Denmark's unborn baby. A later card also survives, from the fair of 1740, printed with the name of 'Trump'. William Hogarth had taken his dog along and bought him a keepsake of his own.[25]

Another souvenir is in the Victoria and Albert Museum. It is a tiny glass mug, with mould-blown ribbing around the bottom, and a silver rim at the top engraved in careful letters, 'Bought on ye Thames ice Janu: ye 17 1683/4'. Slightly frosted, the glass itself looks like ice, and equally fragile. Silent and beautiful, it evokes a world of abstract whiteness, but the lettering hints at another story – of a busy craftsman in a noisy tent, tired of his cold feet, stopping sometimes to warm his hands on the brazier, looking up to see the crowds of footballers cheering and friends drinking, a child slipping, a man losing his hat.

V

... sudden sun
By fits effulgent gilds the illumined field ...

James Thomson,
The Seasons

METHOD AND MEASUREMENT

In the spring following the Great Frost of 1683–84, John Evelyn walked sadly around his estate at Sayes Court in Deptford. The garden was his great passion, with its medicinal herb beds, clipped box hedges, formal parterres, avenues, orchards, and a grove of beloved trees. This April there were many branches which remained leafless. Evelyn could now be sure which plants had survived the dramatic winter, and which were its casualties. He looked in sorrow at his long hedges of rosemary, all dead. The cypress trees, some of them clipped into topiary pyramids, were brown and lifeless; ancient hollies were 'drooping and doubtful'. He knew that all across England the oak trees he loved were under strain, with gashes torn through their ancient trunks by the expanding frost. It was, he said, a 'sensible affliction' and he felt it deeply.[1]

Though Evelyn was in elegiac mood that spring, he was keen to put his botanical observations on record and to suggest what might be learned from them. The image of a gardener in his mid-sixties counting his losses after a bad winter is not the obvious exemplar of what would become known as the 'scientific revolution'. But the new investigative spirit characterizes Evelyn's writing in the aftermath of the frost. He was a founder member of the Royal Society, which had been formed in 1660 to promote 'experimental learning'. This emphasis on experiment involved paying attention to the material world ('quae ante pedes', as Bacon had said), and Evelyn certainly did that. He wrote his diary at extravagant length because he was a compulsive observer of life and believed in the value of what he saw. So, in 1684, he recorded his garden findings in a careful letter which was then published in the Royal Society's journal, the *Philosophical Transactions*.

He listed plants which had survived unscathed – acacia, phillyrea, serratifolia – giving details so that 'Gentlemen who are curious may take notice what Plants they may trust abroad in all events'. As for the greenhouse, where the oranges, oleanders and myrtles appeared to be nearly but not quite dead: do not despair, 'cut them to the quick, plaster the wounds', and replant them in a warm bed.[2] Widening his reach, he gathered information from correspondents like the Earl of Chesterfield and Sir William Fermor who reported devastation of trees in different

parts of England. Evelyn was working towards a study of hardiness, testing conditions in which plants do and do not survive.

In concluding his letter to the Royal Society he had another observation to make. His tortoise, which he counted as a kind of 'plant-animal' and therefore included in this report on his garden, had not fared well in the frost. 'My tortoise [...] hapning to be obstructed by a vine-root, from mining to the depth, he was usually wont to inter, is found stark dead'.[3]

References to the weather became more frequent in Evelyn's diary through the 1680s and 1690s. This may have been partly because he was writing up his days regularly rather than in retrospective chunks. Partly too, perhaps, it was his age; the weather affected him more. Sometimes in summer the heat 'inclined [him] to sleepe'. In the hot June of 1699 he dozed off in church and missed the meaning of the sermon. More importantly, he wanted to work out the pattern of God's judgments. In the winter of 1689–90 he worried continually about what the weather might portend. It had been 'wett, warme, & windy', he reflected nervously, 'such as went before the death of the Usurper Cromwell, which was in a stormy day'.[4] But even as he dwelt on the providential messages of storms he was well aware of the Royal Society's efforts to make sense of 'warme and windy' times, not by reference to providence, but by collecting and analysing natural data.

The early work of the society marked the coming of a new era in the understanding of weather. 'Authority' was now to be found pre-eminently in the material presence of the observable world rather than in the texts of the classics. In his 1665 *Micrographia* the prodigious Robert Hooke, 'curator of experiments' at the Royal Society, complained that scholars had for centuries been ignoring the things in front of them:

> The Science of Nature has been already too long made only a work
> of the Brain and the Fancy: It is now high time that it should return
> to the plainness and soundness of Observations on material and
> obvious things.[5]

Even the language Hooke used was of a new kind, without allusions or ornaments. His own careful, lens-amplified study of insect eyes and plant cells was an influential example of the plain, sound observation he advocated. So too was his work on the weather, though few things could be less 'material and obvious' than the movement of air. Wind will not stay still under a microscope to be examined, so Hooke worked energetically to

refine new measuring instruments that would make the unseen conditions of the air apparent on a clearly legible scale.

Galileo had taken the first steps towards a thermometer, finding that liquid inside a tube will rise and fall depending on the temperature of the surrounding air. His pupil Evangelista Torricelli had developed what might be called the first barometer in the 1640s – a glass tube upturned in a dish of quicksilver. The weight of the air pressing down on the mercury in the dish affected the amount of liquid pushed up into the tube. This was a phenomenal discovery: not only was it clear that air could be weighed, but that the weight of air in any one place was constantly subject to change.

The development of the weighing instrument was complex. The hardest thing was to make the vacuum in the upturned tube; in the end it was Robert Hooke in London who designed the necessary air pump. By summer 1664 (in among all the dozens of other experiments he had on the go) he had a barometer set up, complete with a scale of measurement. He sent reports of his progress to his old employer Robert Boyle in Oxford, alternating sober qualifying clauses with almost audible shouts of triumph:

> I have also, since my settling at Gresham College, which has been now full five weeks, constantly observed the baroscopical index [...] and have found it most certainly to predict cloudy and rainy weather, when it falls very low; and dry and clear weather when it riseth very high, which if it continue to do, as I have hitherto observed it, I hope it will help us one step towards the raising a theorical pillar, or pyramid, from the top of which, when raised and ascended, we may be able to see the mutations of the weather at some distance, before they approach us.[6]

He is *almost* there, and knows it. Hooke's mind is full of images of conquest and triumph: pillars, pyramids, great heights. He is a mountaineer gaining a view into the distance, and not only the distance but the future. He can see the weather coming.

The word 'barometer' appeared in print for the first time the following year in Boyle's *New Experiments and Observations Touching Cold*. Even the title was evocative: 'touching' meant 'concerning', of course, but Boyle was investigating cold as if he could touch it. Over the next two decades Boyle avidly gathered information for a *General History of the Air*, a project so limitless that it was no wonder he left it unfinished.[7] After Boyle's death,

A domestic weather-station with thermometer, hygrometer and barometer. Engraving after Benjamin Martin, in *The Young Gentleman's and Lady's Philosophy*, London, 1759.

John Locke edited and published this vast anthology of eclectically gathered observations. To read through the *General History* today, with its hurried paragraphs written variously in English, Latin and French, with gaps left for filling in later, is to feel some of the energy of the quest for knowledge. Everything is potentially relevant: barometric readings at various stages up Old Sarum Cathedral, the condensation on staircases in Buckinghamshire, the gravity acting on a hygroscope at Boyle's house in Stanton St John. The air is no longer treated as an ineffable mystery; it is a substance with springiness, dynamism, magnetism, and weight.

⁓

The future of weather-watching, however, would not belong to scientists alone. Instrument-makers began to produce relatively affordable barometers with standard scales of measurement, which made it possible for amateur observers in different parts of the country to make comparable recordings. A rector in Cheshire could take the same measurements as a gentleman in Kent. Hooke saw very early on that this geographical spread would be important in understanding the movement of air. No one yet knew how far air masses travelled; no one experiencing a gale in London had any clear sense that it might have begun in the Atlantic and come towards them. The whole science of dynamic meteorology was still ahead. So too was the effort to trace climatic patterns over long periods of time. People had always compared this year to last year, and claimed one winter or another to be the coldest in living memory, but the problem was summed up by Ralph Josselin: 'I observe how apt we are to account a harsh time the hardest we ever felt and mild the best letting slip out of our mind what was formerly'.[8]

For all these reasons, the growth of record-keeping across the country laid the groundwork for new relationships between the English and their weather. It was the tireless Hooke who got the observations going. On Wednesday 7 October 1663, at Gresham College in Bishopsgate, he read out to the Royal Society his 'Method for Making a History of the Weather'. His idea was that people 'in severall parts of the world, but especially in distant parts of this Kingdom', should adopt a standard practice of weather observation, recording on a convenient chart (arranged so that a whole month's weather would be visible on one sheet) the position of the sun, the moon, the direction and strength of wind, the temperature, the humidity,

the pressure, the 'appearances of the sky', and, after all that, 'the notable effects'.[9] He was setting up an experiment, and everyone was being asked to take part.

The 'Method' was published in Thomas Sprat's *History of the Royal Society* (1667), complete with sample recordings on a chart, pictures of the necessary instruments, and instructions about what, for example, you might look for in clouds: 'whether the underside of those clouds be flat or waved and irregular, as I have seen before thunder'. Since the 'appearances of the sky' were not easily converted into statistics, Hooke proposed a code where 'Hairy' signifies 'small, thin and high exhalations', 'Lowring' when dark clouds threaten rain, and so on. 'Let Water'd, signify a Sky that has many high thin & small clouds looking almost like waterd tabby, calld in some places a maccarell sky from the Resemblance it has to the spots on the Backs of those fishes.' Likening the untouchable sky to such knowable things as tabby silk and spotted fish, he was inventing a language of the sky.[10]

Despite Hooke's vivid words, there was no immediate rush of volunteers for this time-consuming work.[11] The people Hooke really needed, as he well knew, were not those rushing in and out to London meetings, but those who lived continuously in one place. Gradually, as more and more homes were equipped with the requisite instruments, regular recording spread. It may be that what mattered more than the availability of barometers was the urge to keep diaries, to save up lives, to watch and take daily note of the small details of the world. Weather-watching and diary-keeping would, from now on, be almost inseparable. The recording of weather and the writing of lives would occupy the same small notebooks.

Sir John Wittewronge, the ageing squire of Rothampstead Manor in Hertfordshire was among the early weather diarists. It was the winter of the Great Frost that compelled him to watch the weather more systematically. Like Evelyn he walked sadly through his garden, finding his rosemary and cypress trees all gone. From then on, for five years from 1684 to 1689, he would watch, measure, and record the daily moods of the weather. He kept his notes at the back of the household account book, which was appropriate since his weather observations were a daily keeping of accounts. Sir John often omitted to read his barometer, and the temperatures he noted were what he *felt* rather than what he read on the weather-glass scale. But for just this reason his 'Weather Book' is a beguiling one, and tellingly poised between emotional response and objective instrumental record.

A
SCHEME

At one View reprefenting to the Eye the Obfervations of the Weather for a Month.

Dayes of the Month and place of the Sun. Remarkable houfe.	Age and fign of the Moon at Noon.	The Quarters of the Wind and its ftrength.	The Degrees of Heat and Cold.	The Degrees of Dryneſs and Moyfture.	The Degrees of Preſſure.	The Faces or viſible appearances of the Sky.	The Notableſt Effects.	General Deductions to be made after the fide is fitted with Obſervations: As,
4 8	27	W. 2.9 3,12	3,2 4,2 2	5,29 ¼ 8	Clear blew, but yellowiſh in the N. E. Clowded toward the S. Checker'd blew.	A great dew. Thunder, far to the South. A very great Tide.	From the laſt quar: of the Moon to the change the weather was very temperate but cold for the feafon; the Wind pretty conſtant between N. and W.	
14 II 12.46	12 ☿ 9. 46. 8 Perigeü. 12,	3,16 10 W.SW.1,7	2 ½ 2	929 ⅛ 29 ¼				
15 II 13.40	4 28 6 ☿ 24.51.	N.W. 3,9 4, N. 2,8 1,7	2 2 ½ 2	8½ 29 ¼ 9 1029	A clear Sky all day, but a little checker'd at 4. P.M. at Sunſet red and hazy.	Not by much ſo big a Tide as yeſterday. Thunder in the North.	A little before the laſt great Wind, and till the Wind roſe at its higheſt, the Quickſilver continued deſcending till it came	
16 II 14.37	10 N.Moon. at 7. 25' A.M. ♊ 10. 8.	S. 1,10	1	1028 ½	Overcaſt and very lowring.	No dew upon the ground, but very much upon Marble ſtones, &c.	very low; after which it began to reafcend, &c.	
	&c.	&c.	&c.	&c. &c.		&c.	ſtones, &c.	&c.

Robert Hooke's 'Scheme' for observing the weather.
Published in Thomas Sprat's *History of the Royal Society*, 1667.

He developed his own descriptive language. The 22nd of February 1684 was 'a darck clowdy mizling day and warm'. The 5th of March was 'a sad cold day' and the 9th 'a sullen cloudy cold day'.[12] Though the barometer indicated 'fair', 'moderate' or 'changeable', Sir John found his own terms more evocative, and so they were.

Hundreds of other observers tried to put the weather into words. In the 1690s William Emes, the rector of Ash in Surrey, filled a little book with his round handwriting. 'Ye Hailstones near as big as Walnutts', he marvelled after a deluge in August 1693, 'some wth sharp points like needles, others with 4 feet like a stool'.[13] The imagery may be comical, but Emes is trying hard to register the precise qualities of these outlandish hailstones. His diary, which survives at Winchester College, is a register of this transitional moment in the history of our relationship with weather. Here was a man trying to see exactly the shape of hail, and making small-scale attempts to assess the validity of ancient weather-lore. He wondered, for example, whether the old legends about St Swithin's Day (15 July) could be relied upon:

St Swithin's Day if thou be fair
For forty days it will remain
St Swithin's Day if thou bring rain
For forty days it will remain.[14]

Emes decided to test it out. St Swithin's Day in 1691 was wet, 'and of ye 40 dayes following it rained more or less 25 dayes'. It was a miserable summer, but the rhyme was holding true. Then in 1692 St Swithin's Day was fair, which ought to have augured a fair month ahead. Sadly it was not to be: 'in ye fourty days following it rained more or less 24 dayes'. This was a tiny private fragment of a tremendous unfolding project.[15]

As for St Swithin's Day, meteorologists now know that the jet stream is usually settled into its summer position by mid-July. The medieval farmers knew their business as well as it was possible for them to know it. But the myriad other factors involved in determining our weather still mean that neither rain nor sunshine can be reliably predicted seven days ahead, let alone forty.[16] And as for St Swithin: there is no evidence that the historical Swithin, Bishop of Winchester in the 850s, had any interest in the weather at all. William of Malmesbury recorded in the twelfth century a story which would be retold for centuries. According to this

Nov. 11. 1692.
mr Hen: Beedel dyed.

Nov 28. 1692.
Sr George Vernon dyed

In ye beginning of ye
year 1693 was a very
great Earth-Quake in
Sicialy in wch 73680
persons perish'd.

London Gazet. numb. 2853

May. 1693.
The Chancell at Ash was
new painted. &c.
& Beautifyde

Aug. 8. 1693.
A great storm of Thundr
by Hail. ye Hailstones near
as big as Walnutts of
very irregular Figure.
some wth sharp poynts
like Needles, others wth
4 feet like a stool.

Aug. 13. 1693.
A very violent Tempest
of Thunder & lightning.
V.B. about 3 in ye morn.
For 3 years last past
violent Temp. h. hapned
on ye same Night, if not
in ye same Day on it

1692.
This year ye moneth of June
was so wett. & it rain'd al-
most continually for 3 weeks
togethr.
most part of July very
wett.

Aug 12. 1692.
A violent Tempest of
Thunder & lightning
at 11 or 12 & ye clock
at night.

1692.
This year tho for ye
most part so very wett)
yett then was a very
Fair & kindly Harvest

Anno 1691. St Swythins
day was a very wett &
rainy day. & of ye 40
dayes following it rained
more or less 25 dayes.
An o 1692. St Swythins
day was very fair, dry &
clear: & in ye fourty days
following it rained more
or less. 24 dayes.

'Hailstones near as big as Walnutts' and observations on
St Swithin's Day, from the diary of William Emes, 1692–93.

story, Swithin asked on his deathbed to be buried outside the walls of his cathedral, where his body 'would be exposed to the tramp of feet as people passed by and to the rain pouring down'.[17] The legend goes that when, a century later, his bones were taken into the cathedral itself and honoured as the relics of a saint, Swithin objected by sending a downpour. Alas, there is little in the way of fact to support this. Swithin was actually given a prominent burial in front of the west door, and if it rained at the time of his reinterment none of those who described the ceremony thought it worth mentioning.[18]

What matters more is that centuries of people have willingly believed the story, and one can see why. There could be few more fitting last wishes for an English hero than this request to lie out in the rain. There is the humility of it, and the sense of being in the midst of things, for life and rain can be synonymous and 'the rain it raineth every day'. There is also a touch of the Romantic in the legend of St Swithin. Here is not a saint to be cased up indoors, but a saint to be 'Rolled round in earth's diurnal course, / With rocks, and stones, and trees'.[19] Or, in a vision less violently mobile than Wordsworth's, a saint wanting to feel the fertility of the earth around him. Keats, who was mesmerized by the weather in Winchester, died far away during an Italian winter. But he imagined, as a last comfort, that he could feel the daisies growing over his grave.[20]

～

November 1703 put everybody's feelings about weather to the test.[21] From the middle of the month there were gales, and then on the evening of the 26th the wind grew unnerving. By midnight a hurricane was blasting across England, and there was no let-up until dawn. Fatalities were eventually calculated at about eight thousand. The greatest terror of the night was out in the Channel, where thirteen Royal Navy ships and their crews were drowned. On land barely a building survived intact. It remains the most violent storm recorded in England.

Evelyn was dumbfounded. 'I am not able to describe,' he wrote in his diary, 'but submitt to the Almighty pleasure of God'. After the first shock, he was able to add a little more, recording the tally of toppled trees, 'lying in ghastly Postures, like whole Regiments fallen in Battle'. The poet Anne Finch, writing at Wye College in Kent, imagined trees with individual hopes of grandeur, now dashed to the ground. In her ode 'Upon the

Hurricane' she considered the fates of birds, ships, buildings, and thought of man's exposure in this world that now lacked shelter. Even the poetic form she used, an irregular Pindaric metre, strained against coherence. A long stanza scanning the wreckage ends in the simple line: 'all defence has failed'.[22]

Finch understood this as a providential storm, akin to the whirlwind with which God once punished the people of Judea. She combined biblical precedent with sharp satiric cameos of contemporary society. Her wind is a prowling sleuth, uncovering iniquity, throwing down walls to find inhabitants in various compromising positions. She sketches scenes of a kind that would attract Hogarth in their enthusiastic itemization of vice exposed: a miser is caught and buried with his coins; there are 'men in wine, or looser pleasures drown'd', who reel in drunken giddiness as their mansions fall. This is how the storm carries out its judicial investigation of sinful times: 'Thus did your breath a strict enquiry make / Thus did you our most secret sins awake'.[23]

Among those in London that November night was a middle-aged businessman and journalist named Daniel Defoe. He was at home with his large family in his 'well-built brick House in the skirts of the City'. At about ten in the evening he checked the barometer, but did not believe what he saw: 'the Mercury sunk lower than ever I had observed it on any occasion whatsoever, which made me suppose the Tube had been handl'd and disturbed by the children'.[24] The pressure would sink so low in the next few hours that it went off the scale of most instruments. Next-door's chimneystack caved in, the house shook, and roof tiles flew across the garden. Defoe must have been cursing his bad luck for reasons different from those around him: until about six months earlier he had owned a successful brick and tile factory. Now here he was in a city that would immediately need re-roofing; never in the history of London had so many tiles been required at one time. Poor Defoe would not see a penny of the profits: his business had collapsed when he was sent to Newgate Prison for publishing politically inflammatory satires, so that by the time of the storm he was bankrupt, and not for the first time.

Over the next weeks and months, through the winter of 1703 and into the spring of 1704, Defoe's concern with the storm became an obsession. He wrote *An Essay on the Late Storm* (in verse), *The Lay-man's Sermon upon the Late Storm*, and his first full-length book: *The Storm*. What was it that

Plate 4 of *The Rake's Progress*, by William Hogarth, 1735. The lightning points at White's gaming house while the Rake is arrested for debt.

gripped him? He firmly disapproved of empirical attempts to understand the wind. He thought that students of natural philosophy were making 'prurient intrusions' on nature, uncovered 'even to her Nudities', and it was just as well that the wind had evaded them. It had defeated the Enlightenment investigators in a way that Defoe clearly enjoyed: 'Wind has blown out the Candle of Reason, and left them all in the Dark'.[25] He was sure that God had concealed the origin of winds, and kept them for his own providential uses.

Defoe's preoccupation, then, was not with the physics of wind but with the damage left behind. He advertised for information about how the storm had affected the rest of the country, and hundreds of letters arrived (unless Defoe made them up), reporting mangled weathervanes, flying lead stripped from roofs, people killed in their beds. For Defoe these were records of God's work, and every detail mattered. When he walked through a city of broken tiles and smashed windows, it was as if he were reading a version of scripture. His *Lay-man's Sermon* asked people to interpret the wreckage itself as a sermon: 'The trembling Habitations of an Unthinking People Preach to us', 'The fallen Oaks [...] Preach to us', 'The wrecks of our Navies and Fleets Preach to us.'[26]

This is the theological belief that would inform all Defoe's writing: the material world was to him a vast text to be examined. The invisible wind he would leave to God, but its legible writing on the earth was his domain and he would trace its every character. Facts were sacred in this context, so Defoe cherished statistics. He drew up charts to display the status of blasted ships. He calculated more than four hundred windmills overturned, seven steeples toppled, eight hundred houses ruined. His journalist's instinct to amass shocking figures was clearly at work, but there was a stronger urge here too. Something drove Defoe to count (or at least to say that he counted) the fallen trees as he rode through Kent. Not just the first fifty – the first seventeen thousand. It was as if this restless quest for evidence was a kind of atonement, and his counting, counting, counting a kind of prayer.

ے

Daniel Defoe, cataloguer of the storm-strewn world, went on to write what is usually considered the first novel in English. Few people now read his account of the 1703 hurricane, but everyone knows the story of Robinson

Crusoe, published fifteen years later in 1719. As Defoe counted fallen trees in 1703, Crusoe gathers statistics about the climate of his island. Though Defoe spoke derisively of the 'Candle of Reason', there was much in his work that connected him with the spirit of the scientific revolution. When in 1703 he appealed for witnesses to report on the effects of the hurricane across England, he was doing much as Hooke advised in the 'Method'. (One of those who provided Defoe with information was the devoted weather-observer William Derham, Fellow of the Royal Society, known for his sophisticated recording of the weather at Upminster in Essex.) The connection holds firm in *Robinson Crusoe*. When he has spent enough time on the island to observe its annual cycle, Crusoe draws up an orderly table of rainy and dry periods, working out the patterns so that he can plan the next year's farming.[27]

Had he made such a chart in England, Crusoe would doubtless have sent it off for inclusion in the *Philosophical Transactions* and compared his findings with those of others. But Crusoe is alone, and therefore can share his findings with no one but himself. On the island there is no optimistic community of experimenters working towards verifiable truths. There is only a single human consciousness prone to dreams and nightmares. Defoe reveals the terror (not too strong a word) of there being no external confirmation of one's own impressions. Crusoe erects a post in the sand and marks on it the passing days because he needs some external measure to grasp. His realization that he may have slept through a whole day, and thereby sent his calendar awry, is more profoundly frightening than the discovery of cannibals on the island. Later, symbolically, Crusoe gets lost in 'hazey' weather and returns to his post, the only landmark he can find in the mist.[28] No wonder he lavishes attention on the solid objects he has gathered around him (his clay pots, his table, his handmade gardening tools, the landmark post itself), stable things in the wilderness.

Yearning for solidity and clarity, Crusoe must defend himself against weather which might wash his solid objects away. In its extremes it is his enemy: the heat jeopardizes his rationalism and the rain threatens to submerge him. Both prevent him from the sane diversions of outdoor work. He therefore becomes expert in the art of building shelters. His temporary double-layered tent is succeeded by a sturdier 'fortification' complete with drainage to let the water out. He makes a fur hat 'to shoot off the rain' and, after much trial and error, he constructs a usable umbrella. 'It cast off the

Rains like a Penthouse, and kept off the sun so effectually', he explains, 'that I could walk out in the hottest of the Weather with greater advantage than I could before in the coolest'.[29]

Crusoe would never think to record the light changing on the beach or the smell after rain. His relationship with weather is primarily a long struggle to keep it out. By the end of the eighteenth century the aesthetics of weather would have become a national obsession: tourists would be making excursions to see particular effects of light; Gainsborough would be painting the breeze in a woman's hair. But Defoe is not a writer of breezes, and nor – in 1719 – was any other prominent author. In Defoe's world there is little pleasure to be found in watching the sky. Virginia Woolf pointed out that there are no sunrises and no sunsets in *Robinson Crusoe*, and perceived the significance of this fact.[30] Defoe keeps his eye focused on the solid thing in the foreground. His pleasure is in the dependable clay pot, not in the fugitive tints of clouds.

When Crusoe leaves his island, he takes away three things with him as souvenirs. One is the parrot which has been his constant companion; the other two are his hat and umbrella. These portable shelters are Crusoe's emblems. They are symbols too of a society which asserts civilization over chaos by making contained, controllable spaces which keep the weather out.

REASONING WITH MUD

When Orlando returns to England in the eighteenth century, following her stint as Ambassador Extraordinary in Constantinople, she finds her country changed. Seventeenth-century London, as she remembers it, 'had been a huddle of little black, beetle-browed houses [...] The cobbled pavements had reeked of garbage and ordure'.

> Now, as the ship sailed past Wapping, she caught glimpses of broad and orderly thoroughfares. Stately coaches drawn by teams of well-fed horses stood at the doors of houses whose bow windows, whose plate glass, whose polished knockers, testified to the wealth and modest dignity of the dwellers within. Ladies in flowered silk (she put the Captain's glass to her eye) walked on raised footpaths [...] Nor could she do more as the ship sailed to its anchorage by London Bridge than glance at coffee-house windows where, on balconies, since the weather was fine, a great number of decent citizens sat at ease [...][1]

Cleanliness, polish, flowered silks, fine weather, people sitting out on balconies: this is how things strike Orlando from the deck of a ship as she arrives, and her first impressions are partly correct. The new town-planners were clearing labyrinthine streets to make way for wide avenues; thousands of huddled houses were replaced, over the course of the century, with upright stucco terraces. Viewed from a boat, or down the telescope of time, England looked orderly. Flowered silk was the appropriate costume, for the weather was set fair. But, on closer inspection, Orlando finds things a little murkier. The carriage in which she rides with Alexander Pope is occasionally lit up by a street lamp, but mainly it rumbles along in darkness and falls into ruts.

Classicism was the order of the day. It has been suggested that the consistently warm summers of the 1720s and 1730s gave the architect John Wood impetus for his ambitious plans in Bath.[2] Queen Square (1728–36) and the subsequent terraces all looked their best on bright days when sunlight reflected off the pale stone and the polished doorknockers gleamed. The same was true of the great Palladian country houses: Chiswick, Houghton, Holkham, Woburn Abbey. In average English weather, however, high ceilings and open colonnades were considerably less appealing, which is why Pope mocked the followers of fashion who were 'Proud to catch cold at a Venetian door'.[3]

Palladians certainly sacrificed comfort for high style, though certain adjustments could be made when they anglicized their classical models. The miniature temples in landscaped gardens, for example, designed for the provision of shade in Italy, offered useful shelter from English showers – as visitors still often discover. Entering a grand eighteenth-century house, you might turn from a stone hall into a more welcoming room, as at Chiswick where Lord Burlington lined his walls with velvet. At Houghton, in Norfolk, rooms were carpeted and hung with insulating fabrics, which was a good thing in a place where the wind comes straight off the North Sea.[4] For the gentleman gardeners intent on growing the period's venerated exotics – oranges, pineapples, melons, and more melons – huge time and effort was expended on the hour-by-hour adjustment of greenhouses to mimic the climates of the south. Horace Walpole at Strawberry Hill in Twickenham was never more triumphant than in those rare summers when he could harvest abundant exotic fruits among the lush 'verdure' of England. His letters brim over with the pleasure of it.[5]

The protracted English love affair with Italy had implications for the wardrobe. Women's clothes caused more concern through each decade of the century as diaphanous dresses got flimsier and more exposing, plunging at the neckline and skimming the hips. Fashionable ladies were supposed to be emulating minimally draped Roman statues and Ovidian wood nymphs, which was all very well for a few hours in fine weather or a heated ballroom, but impractical if you wanted to be comfortable or get anything done. This was the heyday of 'catching a chill'.[6] With no more heating than a fire could provide, the eighteenth century could be, as Jonathan Swift said simply (and he had the benefit of a woollen coat), 'bloody cold'.[7]

By the end of the century Orlando is still looking rapturously on the façades of Enlightenment. Leaning out from a window high above London, she takes in the 'magnificent vista' of a cool city on a frosty night. 'Mayfair shone out in one clear radiance. Upon this serene and orderly prospect the stars looked down, glittering, positive, hard, from a cloudless sky.' In the clear air England is firmly defined. 'All was light, order, and serenity'.[8] It is just that down in the shadows, as Orlando has discovered, lie all kinds of doubts.

～

Weather kept threatening to upset the equilibrium of eighteenth-century writers. Heat was less often discussed than cold or damp, but it could be disturbing. Crusoe found on his island that heat went straight to the head and disrupted his work; few of Defoe's contemporaries welcomed a day in hot sun. Though it was acceptable for a gentleman to go to sleep in a grassy park (as Pepys had done when he was hot and weary in the 1660s), most carried on with their appointments, getting hotter and more bothered along the way.[9]

Swift was driven to distraction during a broiling week in 1711, and his daily letters to his lover Stella became a chronicle of desperate survival strategies. 'The weather is mad', he wrote. He slept with a single sheet over him; he put ice in his wine at dinner. Fantasizing about all possible sources of refreshment, he crept down to the Thames in his nightgown to look at the water. He couldn't quite find the courage to go in, but a few nights later he went again, took off his slippers, and stepped gingerly over the sharp pebbles on the foreshore. His description in the letters is so vivid that we

can visualize him there, bare feet on stone, a pale middle-aged figure in the dark, clammy with heat on a sultry city night. Longing for a 'cold bath', he plunged in, dived right under, and lost his cap. The conditions were less than ideal: when he went again the next evening, he was 'every moment disturbed by boats' and decided he would have to give up this nocturnal swimming.[10] By sunrise, in any case, he was hot again.

The sweaty discomfort Swift admitted in intimate letters was the kind of thing he might satirize in public. A reasonable man reduced to splashing in foul water: that was a subject for laughter. Much more than heat, it was rain and mud which threatened chaos in eighteenth-century England. Wherever the spirit of Enlightenment was invoked, there was a satirist close behind pointing to the chamber pot about to emptied on to the street from an upper window. Proud householders kept their stucco frontages clean, but visitors rode up to the entrance in spattered boots and coats. Few people could be complacent about progress when poets like Swift and Pope turned their attention to the kennels, or open drains, which ran down the middle of the road.

Mud in early eighteenth-century writing was often metaphorical, but it was always literal as well because England was unignorably muddy. The boggy roads were the most notorious aspect of the general problem. Never before had roads been so intensively travelled, and yet little was being done to maintain them. Country lanes rarely had any surfacing at all and became ditches after rain. Many rural routes remained impassable all through the winter, so that most people living in the country simply reckoned not to travel. They lived the winter months in a state of siege.

In the 1720s Defoe went on a series of journeys which he wrote up as *A Tour through the Whole Island of Great Britain*. He was not the kind of tourist who pauses over views. He was more concerned with material resources, trading links, and physical infrastructure. Structure? No, it was a great mess. Defoe wrote a treatise on road improvement as an appendix to the second volume of his *Tour*. Having waded slowly from city to city, he saw that the mud was holding Britain back. The clay was the worst, stretching across a crucial swathe of the Midlands. The Romans had made their roads properly, Defoe noted, building the causeway up above the level of the ground and with a camber: 'a rising Ridge in the Middle, gently sloping to the Sides, that the Rain might run off every Way'. This was the example to follow, and he was glad to see the new system of turnpikes

and tolls gaining favour. By this means the roads might be regularly maintained. But prospects of a dry journey were still remote. There were places with names like 'Foul Mire', which deserved their reputations.[11]

The tone of the period's literary mud-flinging was set in the wet October of 1710 when 'A Description of a City Shower' was published in the *Tatler*. Swift's poem moves from the warning signs of rain to the first drops and the rush for shelter ('Brisk Susan whisks her linen from the rope'), and then, in a great surge, the flood. Rain and effluent, dust and offal, the filth of all London converges:

> Sweepings from butchers' stalls, dung, gnats, and blood,
> Drown'd puppies, stinking sprats, all drench'd in mud,
> Dead cats, and turnip-tops, come tumbling down the flood.[12]

It is a dire panorama of the city, from the slaughterhouses of Smithfield to St Sepulchre near Newgate Prison. The rain dissolves polite boundaries, washing one thing into the next. It has been observed that 'shower' and 'sewer' were probably both pronounced as 'sure' in the early eighteenth century, so that linguistically, as well as physically, rainwater and effluence were one.[13]

It is a relief after reading the 'City Shower' to turn to *Trivia* by John Gay, who acknowledged that he owed 'several hints' for his poem to his friend Swift.[14] *Trivia*, like the 'City Shower', is an urban weather poem that turns down back-alleys and kicks through puddles. It is about aspects of city life that had not belonged in English poetry before, but which now came pouring in. Swift had described a deluge that seemed to presage the fall of civilizations, but Gay fusses more amicably over suitable head-wear and determines that civility will survive.[15]

Gay's declared subject is 'the art of walking the streets of London', though it is specifically the 'Winter Streets' he writes about. London means to him – as it meant to Swift and Pope, and later to Dickens – a world of sudden splashes and clinging fogs. The strategies he proposes for surviving London weather are strategies for life itself. Drop your guard for a moment and you may be left wiping from your forehead the dirt spattered by a passing carriage. There is seriousness, then, in Gay's apparently trivial discussion of clothes. The donning of the coat becomes the arming of a hero or knight errant on his way into the urban forest.

Shoes, walking cane, and overcoat must all be chosen with care. Gay, who once served as a draper's apprentice, has a tailor's eye for fabric and a mother's bustling concern for appropriate clothing: 'The Frieze's spongy Nap is soak'd with Rain, / And Show'rs soon drench the Camlet's cockled Grain'. These coats may look stylish when you set out from home, but they will make a fool of you in the rain. Correctly attired to the last button, Gay is the original flâneur – except that he refuses to cast himself as a fop or dilettante. He prioritizes practicality, and so rejects the showier kinds of coat. Far better the ample Kersey wool 'surtout' (brass-buttoned descendant of the 'birrus Britannicus'), in which a walker may 'brave unwet the Rain, unchill'd the Frost'.[16]

The 'unwet' is Gay's theme, and the word is more evocative than 'dry'. The wet is out there, the rain is coming down, but Gay and his reader are safe from it. We are a long way here from the spectacles of the Renaissance stage, where 'meteors' exploded like fireworks. Weather, for Gay, is a practical matter. He refers to the 'Paver's Art' because paving really is an art, creating order where once there was mud. He is drawn to different forms of shelter, noticing how the street lamp is a glasshouse for the flame, how a hat roofs over a wig, how the walls of buildings at the side of the street offer refuge from the middle of the road. Shoes seem to him symbols of civilization because they raise the human being up out of the mud. When he invents a story of mythological origin for the humble patten, he is ennobling rather than deriding it.

This most English of poems is constantly summoning up and refashioning its classical predecessors. Virgil's *Georgics* were poems of practical instruction about the cultivation of the earth, concerned with industrious means of living in an imperfect world; now shoes, coats, and canes are to the London walker what spade and plough were to the Roman farmer. Virgil appointed himself as a tutor, giving plain instructions; Gay sees his *Trivia* as a guidebook and manual, complete with an index for easy reference. Virgil had devoted a great deal of space in the *Georgics* to weather prognostications, which appealed to him as a set of intricate hieroglyphs, worthy of great poetry. In *Trivia* Gay advises us to read the weather signs of the city:

> From sure Prognosticks learn to know the Skies,
> Lest you of Rheums and Coughs at Night complain;
> Surpriz'd in dreary Fogs, or driving Rain.[17]

Swinging signs will creak; the cool stone of church monuments may be damp. The meteorology behind Gay's weather-lore is no more than common sense: watch out for rising wind and condensing moisture. What matters is that in the rush and clatter Gay looks for ways to measure these things. Attentiveness is, in this sense, a practical measure, as much for Gay in London as for the ancient husbandmen to whom Virgil ostensibly addressed his *Georgics*.

Trivia envisages the outside world as a place of threat. It is not so different from the murky unknown regions beyond the mead-hall in *Beowulf*. The Anglo-Saxon lines were interlaced like metal jewelry, bound up to last; the lines of *Trivia* glint with irony as they fall snugly into their couplets. They advertise their artfulness, pitting their wit against the mud. Gay is not entirely joking when he says he wants to be helpful, and when he calls on booksellers to hand out his poem gratis to passers-by. Gay and Defoe are in this sense linked: they set up the umbrella of art against the storm.[18]

It is part of the allure of Alexander Pope that he feels this ordering impulse deeply while also embracing the huge chaotic energy of the rain and mud. This is the central dynamic of his wild, disturbing mock epic *The Dunciad*, first published in 1728 and expanded – like a great swelling rain-cloud – to four books in 1742. London literary society, centred on Grub Street, is here imagined as a foggy weather-system circulating around the Queen of Dulness and settling over Fleet Ditch. Journalists and poets, the dunces who pay court to Dulness, are dim particles of the general grimy vapour. In *The Rape of the Lock* Pope had imagined Belinda's head as a cave with a microclimate of its own. We enter it like potholers, feeling the dank air when she has a headache, and the agitating east wind of spleen.[19] Visiting the interior worlds of the *Dunciad*'s dunces we find only dense cloud where intellect should be. The 'cave of poverty and poetry' is close to Bedlam (since writing is a form of madness), and it is a desolate place: 'Keen, hollow winds howl through the black recess, / Emblem of music caused by emptiness'. The books produced here grow like clouds and are equally vaporous. When their printed sheets rain down on London, it is as a tarnished sort of snow:

> showers of sermons, characters, essays,
> In circling fleeces whiten all the ways:
> So clouds replenished from some bog below,
> Mount in dark volumes, and descend in snow.[20]

The Dunciad, getting longer and more misshapen, delights to join in this snowstorm of writing. The words of the poem are threatened on the page by typographical clouds of obfuscatory footnotes, a persistent low fog of pedantic small-print.

Pope imagined bad writing as a kind of bodily discharge, a 'morbid secretion from the brain' which was all too analogous with secretions from other parts. 'As I would not suddenly stop a Cold in the Head, or dry up my Neighbour's Issue', he reasoned in his essay *Peri Bathous*, 'I would as little hinder him from necessary Writing.' Poetry could be as involuntary as a sneeze, and equally phlegmy. It poured from the flues or exhaust pipes of the microclimatic body: 'the same Humours which vent themselves in Summer in *Ballads* and *Sonnets*, are condensed by the Winter's Cold into *Pamphlets* and *Speeches*'.[21] Pope argued sarcastically that writing was crucial to bodily regulation; what he meant to expose, however, was a culture of literary incontinence.

In the *Dunciad* writers are uncontained and uninhibited, glad to let loose and dance in their effluent. In Pope's restaging of the Homeric games, dunces make rainbows from their arching urine and dive proudly into the foul river. This was what the Age of Reason looked like to Pope. This was the darkness he saw behind the rhetoric of a supposedly enlightened age. But it was also this that inspired and energized him. Pope's clouds spread across literary history; epics from the *Iliad* to *Paradise Lost* are invoked and then covered over by fog. Eighteenth-century readers, he suggests, wading in obscurity, could only look back on a grander past through a glass that was very dark indeed. James Thomson's *The Seasons*, published between the two versions of the *Dunciad*, loses its refined sensibility and freshness once it enters Pope's orbit. 'He comes! He comes!' writes Thomson of the 'philosophic melancholy' arriving on the autumn breeze. 'She comes! She comes!' writes Pope at the end of his poem, referring to his mock muse, Dulness, as she approaches her throne. Lights go out as she passes; art and philosophy fade.

> Lo! Thy dread empire, CHAOS! is restored;
> Light dies before thy uncreating word:
> Thy hand, great Anarch! lets the curtain fall;
> And universal darkness buries all.[22]

A LANGUAGE FOR THE BREEZE

For satirists like Pope, James Thomson's weather was worth invoking. Throughout much of the eighteenth and nineteenth centuries there was no poem better known by the English than *The Seasons* (1730). Children learned passages by heart at school and most literate households had a copy. As its fame spread through Europe, Haydn composed his grandest oratorio, *Die Jahreszeiten*, in response to Thomson's words. The poem is now hardly read, and competes only with *Pilgrim's Progress* for the most dramatic decline in popularity. But through those centuries as a standard text it had a huge influence on national thinking, talking, and writing about weather.[1]

The action of the first section is all in the uncertain transition from winter to spring:

> As yet the trembling year is unconfirmed,
> And Winter oft at eve resumes the breeze,
> Chills the pale morn, and bids his driving sleets
> Deform the day delightless.

Soon the spring air swells and stretches, no longer cramped with cold. The sense of atmosphere is different to that in any previous poem. The weather is the central character here, moving quietly then loudly, relaxing and contracting like lungs. Thomson breathes and feels in time with it. The 'infusive force' of spring seduces him into joining 'the general smile / Of nature'. Then again, he understands that miserable weather is sometimes what we need. 'Welcome, kindred glooms!' he writes, enjoying the coincidence of his own mood with that of nature. Thomson's subject is the air itself, which literally inspires him: 'I solitary court / Th'inspiring breeze, and meditate the book / Of nature, ever open'.[2]

Thomson's passionate courting of the wind was always connected with his childhood spent in Roxburghshire before moving to Edinburgh and then to London. There was more precedent among Scottish poets for describing weather; at least one poem by Thomson's tutor Robert Riccaltoun, 'A Winter's Day' (published in 1726), provided impetus for Thomson's work.[3] But it was the lengthy extravagance of natural description in *The Seasons* that made the poem so significant, and the sense of weather's inexhaustible mobility.

'Breeze' is among Thomson's favourite words. Even this small fact is suggestive of new kinds of weather perception, since only recently had it been used in the general sense of a light wind. 'Brisa' was Old Spanish for a tropical north-easterly, and 'breeze' in the seventeenth century meant a counter-current blowing from land to sea; it belonged to the precise terminology of sea-going.[4] The new sense, adopted and encouraged by Thomson, was less practical and better for evoking delicate movement, better for describing a natural world gently suffused with vitality. Towards the end of the century it would become an important word in the language of Romanticism.

The shift of emphasis came at a price. There were whole worlds of rural knowledge, practical weather wisdom, and seasonal festivals which were not part of Thomson's vision. He played his part in the long aestheticization of nature and landscape, turning England into a picture.[5] But he also brought revelations. No one had written so sustainedly about the moods of autumn, for example. Thomson knew there could be pleasure in autumnal melancholy, and he was the first to elaborate the aesthetics of a season that now seems more 'poetic' than any other. He sees the glancing effects of the low light:

> the sudden sun
> By fits effulgent gilds the illumined field,
> And black by fits the shadows sweep along [...]

He basks in the warmth reflected from an orchard wall. He marvels at the 'deeply tinged' blue of the sky, different now from any other time of year. He enjoys the falling leaves:

> now the leaf
> Incessant rustles from the mournful grove,
> Oft startling such as studious walk below,
> And slowly circles through the waving air.[6]

Thomson does not have much to say about 'autumn colour', one of the prime joys for a modern audience, but he takes the reader to the landscaped gardens at Stowe to 'catch the last smiles / Of Autumn beaming o'er the yellow woods'. Jane Austen would remember those 'last smiles' and allow her autumnal heroine Anne Elliot to feel their sad late beauty. Ninety years later, Keats's 'Ode to Autumn' and Turner's canvases of low

sunlight would show the formative influence of Thomson, whose poem looked out across miles of harvested country and then watched the land slip away under the gathering 'exhalations' of the 'cool, declining year'. Attentive as always to the movement of air, Thomson caught the double motion by which fog closes in while also spreading out:

> in deeper circles still
> Successive closing, sits the general fog
> Unbounded o'er the world, and, mingling thick,
> A formless grey confusion covers all.

If Thomson was a poet of sunlit 'enlightenment', he was also a poet of the 'huge dusk'.[7] His friend Patrick Murdoch remembered that autumn was 'his favourite season for poetical composition'. He was at his best in the 'desolated prospect' of the bare, twilit, autumn world.[8]

Thomson's central concern, though, was with a religious interpretation of the changing year. He gave a close-up view of suffering, and then drew back so that each episode takes its place in a longer view. The tragedy of a shepherd dying in the snow is absorbed into the ongoing cycle; God ensures that winter is always replaced by spring. This religious understanding of weather as part of a cosmic scheme was also a scientific understanding. Thomson's hero was Isaac Newton, whose discovery of the spectrum inspired Thomson to new appreciation of every view he saw. 'The setting sun and shifting clouds / From Greenwich [...] declare how beauteous the refractive law.'[9] Newton's theories of refraction, and the larger concept of a law-abiding mechanical universe, seemed beautiful to Thomson because they revealed richness and harmony in nature that extended beyond what was immediately visible.[10] The spirit of measurement was wholly compatible in Thomson's mind with ecstatic appreciation of the changing weather and with the free play of imagination. His own poetic work was a form of instruction, proposing new understandings of the beauty, science, and moral purpose of the seasons.

The Seasons is not in any straightforward way a naturalistic poem. It is shaped by the formality of early eighteenth-century culture and all nature seems to be engaged in polite rituals. Rain, for example, is a ceremonial gift-giving in which 'the clouds consign their treasures to the fields'.[11] William Kent's Baroque engravings for the 1730 edition appropriately showed the skies crowded with goddesses and zodiacal creatures; in his

plate for 'Winter' the weather gods are energetically engaged in emptying an urn of violent weather on to the earth below. For all this 'assemblage of poetic ideas', however, the response of Thomson's eighteenth-century readers indicates that the subject felt strikingly new. Samuel Johnson was nonplussed: 'The reader of *The Seasons* wonders that he never saw before what Thomson shows him'. Examining the 'state and faculties of man' in 1765, the Scottish philosopher John Gregory reckoned that Thomson had impressed the mind 'with numberless beauties of nature in her various and successive forms, which formerly passed unheeded'.[12]

The movement of clouds and sunlight must of course have been 'heeded'. People must have caught their breath at the beauty of cloud-shadows travelling quickly over hillsides or the 'huge dusk' gathering in a valley. But it is difficult to say what form that heeding took. Sometimes the history of visual perception can be gleaned only from hints and, more often, from what is not said. Evelyn and Swift often remarked on whether it had been hot or cold (and how this affected Evelyn's plants and Swift's general comfort), but neither described at any length the clouds or the light. Virginia Woolf noticed this in Evelyn just as she noticed the lack of sunsets in Defoe. It is part of why he feels remote to us, she reflected: 'Evelyn never looked at the sky'.[13]

The changing sky appears just occasionally in poetry before Thomson. Anne Finch's poem 'Nocturnal Reverie' evoked the beauty of a quiet evening in 1713. Finch dispatched the customary mythological references in the first few lines, and then proceeded without any 'action' or providential interpretation. The poem just asks us to sit still, watching and listening,

> Whilst Salisb'ry stands the test of every light,
> In perfect charms, and perfect virtue bright:
> When odors, which declined repelling day,
> Through temp'rate air uninterrupted stray;
> When darkened groves their softest shadows wear,
> And falling waters we distinctly hear [...]

Joseph Addison praised sunsets in his *Spectator* essays, concluding that 'we nowhere meet with a more glorious or pleasing show in nature'. Pope, too, was starting to think of light on landscape. He was too frail to go on the Grand Tour through Europe that would otherwise have been his finishing school, but in a sense he had no need of it. His 1713 poem 'Windsor Forest'

was his assertion of a native paradise not far from London. 'Here in full light the russet plains extend: / There wrapped in clouds the bluish hills ascend'.[14]

Addison and Pope (and the rereading of Milton's dewy paradise through Pope) introduced to English culture new kinds of landscape sensibility. They drew attention, for the first time, to vistas animated by shades and breezes. But it was James Thomson who really made the change. The appearance in 1726 of 'Winter' was a watershed. Few people before this would have sat down to write about landscape, and certainly not the changing visual effects on it of light and wind. Afterwards they could hardly be stopped.

⌒

It is not clear whether Thomson had the paintings of Claude Lorrain in mind when he described the effulgence of late sunlight gilding the fields, or the 'mild lustre of a blooming morn' reflected in the face of a shepherdess.[15] What is certain is that readers often associated the two, and that between them – the fashionable Scottish poet and the French old master – they came to define the English idea of natural beauty.[16] Claude's tremendous influence in the mid-eighteenth century could never have been predicted; few Englishmen had known his name when he died in Rome in 1682, years before Thomson was born. Yet for the art-lovers who discovered his work on the Grand Tour, and who were able to bring home prints even if they could not afford the prized canvases themselves, Claude set the standard for what a landscape might be.

Claude's pictures have mythological titles, but their real subject is light. If Echo and Narcissus lounge in the foreground it is only so that the small detail of their bodies will point up the expansiveness of glowing land and sky. Claude's views of glimmering seaports, rustic fetes, and dusky, enchanted castles carry the aura of the antique as if they have arrived from a great distance of time, but they also evoke fresh, slightly chilly air, as if the antique world were here and now. No other painter of the time had taken light as his subject in this way. Even Ruskin, who had mixed feelings about Claude, would affirm in the 1840s that he had given the world a tremendous gift: 'He set the sun in Heaven, and was, I suppose, the first who attempted anything like the realisation of actual sunshine in misty air'.[17] That so few people had seen fit to paint 'actual sunshine' before

this time is a fact that raises some of the most intriguing questions in the history of representation, but once sunshine and misty air had arrived there was no going back.

The English looked at Claude's Italian scenes with a thrill of recognition. There was plenty of misty air in England, and there was sometimes a low sun as well. With a little imagination Arcadia could be found at home. A small group of early English landscapists, laying foundations for what was still a very tentative school of national painting, looked across Hertfordshire, Worcestershire, Suffolk, and saw how these too might be sites of the golden age. John Wootton's view of *Cassiobury Park* (*c.* 1748) in Hertfordshire relegates the house itself to the background, leaving room to show how the fields slope down to the River Gade, smooth and spacious in a soft light which carries just a hint of dusky pink and which makes the trees (just turning?) look feathery against the sky. Wootton was best known for his portraits of pedigree horses, but after studying the paintings of Claude he gave Arcadian backdrops to his horses too.

George Lambert, the first English painter to devote himself primarily to landscape, transformed Chichester harbour into a little inlet on the balmy Italian coast and Rievaulx Abbey into a place of sunset enchantments. His friend Hogarth, always keen to cheer home talent, thought Lambert was just as good as Claude. The artist most in thrall to the Claudian ideal, however, was the Welshman Richard Wilson, who returned from Rome in 1757 ready to show that there were scenes at home to rival Tivoli. In one of his paintings a group pauses as the last sun illuminates the Dee valley. Few would have seen this Cheshire view as Wilson saw it, but a new generation of tourists looked at England with eyes trained by Claude. For just a moment, perhaps three or four times a year, the light across the Dee valley really did fall like this. Because this was the effect that people were learning to prize, they waited for it, captured it, remembered it just like this.

Help was at hand for tourists who could not wait all year for the few minutes when an English scene looked properly Italian. Imagination itself was the most powerful tool, but the 'Claude glass' was the gadget of the century as far as atmospheric appreciation was concerned. Instead of looking at the landscape you turned your back and looked instead at its reflection in a compact rectangular or oval mirror. The glass not only unified and framed the scene, but it could change the quality of light and air by

casting what William Gilpin, chief preacher of scenic virtues, called a 'soft, mellow tinge'. The poet Thomas Gray, a keen walker whose travels took him far from Stoke Poges churchyard, was transfixed by the pictures he caught in his glass as he made his way through the Lake District in 1769. Even when he tripped over (perhaps looking more at the glass than the ground) he was undeterred: '[I] straggled out alone to the Parsonage, fell down on my back across a dirty lane with my glass open in one hand, but broke only my knuckles: stay'd nevertheless, & saw the sun set in all its glory'.[18]

Most mirrors were backed with dark foil, but lighter versions were available for use on overcast days. The well-equipped tourist could also purchase a range of tinted glasses (transparent lenses rather than mirrors) through which to look at a view. You might try the blue glass for a moonlight effect, or the yellow for desirable autumn hues; within the space of ten minutes you might experience a landscape at sunrise, sunset, shrouded in mist (a light grey glass), and deep in snow. Given that so little had been said about the aesthetic effects of weather before the 1730s, the passion for atmospheric viewing which reached its height in the 1790s was an amazing development.

There were serious ideas behind all this framing-up. The most potent was the concept of 'sublimity', which had begun to be discussed in relation to landscape in the early 1700s. Addison had written in praise of wide views from rocks and precipices 'with that rude kind of magnificence which appears in many of these stupendous works of nature'. The dramatist and critic John Dennis not only described the sensations of 'delightful Horror' and 'terrible Joy' he experienced as he travelled through the Alps, but he tried to create sublime experiences in the theatre.[19] He invented loud and alarming weather-effects, 'a new set of meteors', designed to increase the 'magnificence' of his plays. His *Appius and Virginia* was closed down after a few booed performances in 1709, but it left a legacy. At a performance of *Macbeth*, Dennis realized that his new method of making thunder had been employed; the theatre was trembling with the sound of cannonballs rolled down a thunder-run. 'See how the rascals use me!' he was said to have cried. 'They will not let my play run, yet they steal my thunder.'[20] These theorists of sublimity wanted to talk about such grand things as Prometheus stealing the primordial fire, but their most memorable phrase emerged from a squabble about theatrical contraptions. It was oddly characteristic of eighteenth-century aesthetic debates.

Edmund Burke was the most influential of the mid-century writers who wanted to define the relationship between certain kinds of scenery and sensation. In his *Philosophical Enquiry into the Origin of Our Ideas of the Sublime and Beautiful* (1757), Burke tried to establish the ingredients that would combine to produce sublimity in a landscape, as opposed to the very different visual and emotional appeal of what he called beautiful. He acknowledged the major role of weather in determining these effects and proceeded systematically to question its workings, asking, for example, how a mountain affects us differently in sunshine and in storm. A gloomy mountain is grander than a sunny mountain, and night is more 'sublime and solemn' than day. 'Beautiful' weather is bright and mild; but the best weather for 'sublimity' is the worst weather of all. 'In nature', writes Burke, 'dark, confused, uncertain images have a greater power on the fancy to form grander passions than those which are more clear and determinate'.[21] His treatise, like Thomson's *Seasons*, marked a turning point in the effort to chart psychological responses to weather. It has been called 'one of the three or four most powerful ideas in the history of thought, because [Burke] wrenched aesthetics away from an insipid idea of beauty towards recognition of the full span of human sympathy'.[22] Part of its work was to bring attention to the diversity of atmospheric conditions and the human emotions they might prompt.

It was not long before landscape and weather appreciation became a cult. Tourists went en masse to stand in precisely the spots the guidebooks recommended. Gilpin advised that sheep were better arranged in odd numbers, and that asymmetry was desirable in the organization of hills. The poet William Coombe wrote satirically about an avid tourist called Dr Syntax, whose name advertised his liking for grammatical schemes such as the new, man-made grammar of landscape. The cartoonist Thomas Rowlandson smiled at the sufferings of landscape artists in their quest for views. The bedraggled touring painter in his *Artist Travelling in Wales* plods miserably though a downpour, though his next painting will presumably convert the dreary rain into conditions of stormy grandeur. The heroine of Austen's *Northanger Abbey* will learn from people of 'real taste' that 'a clear blue sky was no longer proof of a fine day'.[23] Such basic assumptions had to be reviewed: the definition of a 'fine day' was subject to change.

For all the potential silliness and the wilful artificiality, landscape was the centre of attention in England as it had never been before, and the

weather which changed that landscape and its buildings from moment to moment was being discussed as if it were a great artist. Eighteenth-century notions of classicism tended to cohere around ideals of smoothness, purity, and symmetry, but with the new category of the 'picturesque' came a legitimate framework within which to love all sorts of 'imperfect' things, from hummocky ground to lichened walls. The markings of time and wear were now deemed attractive. A cottage with damp-warped walls and holes in the thatch was now an appealing part of the scenery – for those looking at the view, if not for the cottager who wanted repairs done. The work of the weather on solid objects could certainly be eloquent, and though the word did not gain currency until the mid-nineteenth century, 'weathering' was a picturesque phenomenon. The enthusiastic Herefordshire landowner Uvedale Price, a practical gardener as well as an influential aesthetic theorist in the 1790s, asked his readers to 'observe the process by which Time (the great author of such changes) converts a beautiful object into a picturesque one':

> First, by means of weather stains, partial incrustations, mosses,
> etc. it at the same time takes off from the uniformity of its surface,
> and of its colour, that is, gives it a degree of roughness and variety
> of tint. Next, the various accidents of weather loosen the stones
> themselves; they tumble in irregular masses upon what was,
> perhaps, smooth turf or pavement.[24]

The 'irregular' works of weather had meant much to people in earlier times. The Anglo-Saxon poet who meditated on the frost in the lichened crevices of a ruined building (probably an abandoned Roman bath) was already reading the marks of time on stone.[25] But from the late eighteenth century onwards weathering would be an English passion. Today we wait impatiently for new buildings to 'weather down', watching with relief as uniform brickwork takes on a range of tones and textures. As with weathering, so with the 'irregular' English weather itself. The qualities of shadow and mist, and sun at different times of year, would from now on be enduring subjects of fascination.

Since refinement of taste could now be measured in degrees of responsiveness to landscape, society portraiture moved outdoors. At the start of Gainsborough's career, in the 1750s, the point of painting Suffolk gentry outside was to show off their extensive lands – hence the fertile

fields stretching to the horizon in *Mr and Mrs Andrews*. By the 1760s the focus had moved from the desirable acres to the naturalistic sensibilities of their owners. So Gainsborough's sitters are made to look at home in wooded glades. They sit on precarious tree roots with as much self-possession as if they occupied their own drawing rooms.

It was all a fantasy, and Gainsborough loved it. He was not very interested in commissions to paint real places, and much preferred the inventions 'of his own brain'.[26] His green-blue foliage was partly a gesture to the French Rococo painters he admired: Watteau, Boucher, Fragonard. But the Rococo goddesses have descended from their pink-edged clouds on the ceiling and from the swings of white-lit fairyland and are now out in blustery English winds, showing some gusto in their attitude to the weather. Everything is on the verge of movement in these outdoor portraits. Sometimes Gainsborough would tie his brush to the end of a long stick, which he held at one end so that paint reached the canvas in a quivering motion suggestive of an animating breeze. There could be no question of a fine lady being outside for hours, so the portrait sittings took place indoors. This is the magic of Gainsborough's woods: though the ground looks damp and ribbons fly in the wind, nobody is about to take a chill.

DR JOHNSON WITHSTANDS THE WEATHER

On Saturday 24 June 1758 the *Universal Chronicle* carried a particularly bracing edition of Samuel Johnson's weekly column 'The Idler'. Johnson had taken as his subject the extent to which the English are influenced by weather. He began uncontroversially, acknowledging that a general interest in the weather is a 'natural consequence of changeable skies'. Since we never quite know what to expect in the morning, it is reasonable to take note of the conditions we find. But Johnson was stern about those who let the state of the atmosphere govern their own tempers. 'Our dispositions too frequently change with the colour of the sky', he wrote, and he condemned it: 'Surely nothing is more reproachful to a being endowed with reason, than to resign its powers to the influence of the air, and live in dependence on the weather and the wind.'[1]

Today in Britain an estimated 3 per cent of the population suffers from Seasonal Affective Disorder, which can involve tiredness, lack of

Dr Johnson in his Travelling Dress,
by Thomas Trotter, 1786

interest, and severe episodes of depression during winter or summer.[2] Millions more are aware of moods that change with the seasons or from day to day as the weather changes. Few people look out of the window in the morning with perfect equanimity. The psychological effects of weather have been acknowledged in western culture for at least two thousand years. Though the scheme established by Hippocrates was revised over the course of centuries, the relationship between outer atmosphere and inner humours governing body and mind continued to be taken seriously. Hamlet had logic and Renaissance medical theory on his side when he claimed to be mad only in some weathers: 'I am but mad north-north-west. / When the wind is southerly I know a hawk from a handsaw'.[3] If Hamlet was mad, or feigning madness, he was close to good sense: a change in the wind can distemper the mind. But how far should we allow ourselves to be affected by the weather? How far do we have a choice in the matter? These questions were moot in the eighteenth century.[4]

As early as 1710, in his 'Description of a City Shower', Swift mocked the hypochondriac whose bodily pains give warning of a storm:

> A coming show'r your shooting corns presage,
> Old aches throb, your hollow tooth will rage.
> Saunt'ring in coffeehouse is Dulman seen;
> He damns the climate, and complains of *spleen*.

Corns, throbbings, toothache: it sounded like the talk of elderly women, and that was partly Swift's point. It was a bad state of affairs when this was what eminent Londoners debated in the coffeehouse. The fields of nourishing corn in Virgil's *Georgics* were downgraded by Swift to the corn on an aching man's foot. Addison, in the *Spectator*, reported on an (imaginary) group of gentlemen spending the summer in the country. One of the company boasts that he can tell by a pain in his shoulder that rain is coming. He gets his just desert: 'the president ordered him to be removed, and placed as a weather-glass'.[5] The aches and pains of the weather-prone were becoming notorious.

Doctors, however, were carefully investigating the relationship between climate and health. John Arbuthnot, friend of Swift and Pope, and a respected doctor as well as a leading wit, published in 1733 his *Essay Concerning the Effects of Air on Human Bodies*. It was a modern revision of Hippocratic ideas, adapted in line with the latest findings on the spread

of 'epidemical diseases' in particular kinds of atmosphere, and the way that blood and joint-fluids could change under different pressures. Here was an authoritative voice to back up the personal findings of those who suffered in cold or damp. 'In short', wrote Arbuthnot, 'some people find themselves much disorder'd in one sort of air and weather and perfectly well in another'.[6]

It was reasonable, then, to be affected by the weather. Or was it? Johnson insisted that if people were going to mind the weather they should at least keep quiet about it:

> If men who have given up themselves to fanciful credulity would confine their conceits to their own minds, they might regulate their lives by the barometer with inconvenience only to themselves; but to fill the world with accounts of intellects subject to ebb and flow [...] is no less dangerous than to tell children of bugbears and goblins.

Johnson finished with a manifesto for imperturbable consistency:

> To temperance every day is bright, and every hour is propitious to diligence. He that shall resolutely excite his faculties, or exert his virtues, will soon make himself superior to the seasons, and may set at defiance the morning mist, and the evening damp, the blasts of the east, and the clouds of the south. Every man, though he may not aspire to Stoicism, might at least struggle against the tyranny of the climate, and refuse to enslave his virtue or his reason to the most variable of all variations, the changes of the weather.[7]

There could be no more paradigmatic statement of the ideals associated with the Age of Reason. Johnson asserted the power of intellect and self-will over mind and body. He valued maturity over childishness, rationality over superstition. He invoked the language of current political debate to link his thoughts on weather with issues of good government and liberty. A culture fighting for political liberty, he implied, must free itself from the despotic rule of weather. Most of all, Johnson was concerned to promote stability over change.

Johnson's praise of consistency showed why the weather was never going to be an easy subject in the middle of the eighteenth century. In a culture which took its bearings from the stable symmetries of classical architecture and from the balanced weights of the poetic couplet, fogs

and storms were troublesome. In the face of such unruly forces, Johnson demanded that the thinking man make himself immune from 'the most variable of all variations'.[8] The façade of reason in the *Idler* essay, however, was erected on land hard won from unruly emotion. Every line betrayed the author's state of anxiety. From the beginning to the end of his writing life, Johnson kept on mentioning the weather.

Soon after his *Idler* essay, Johnson wrote a fantastical novel called *Rasselas* (1759), which features an astronomer who believes that he has sole charge of the weather. The young Ethiopian Prince Rasselas has sent his companion Imlac off on a world tour, interviewing people who might know the secret of happiness. Like many of his encounters, Imlac's meeting with the astronomer feels like a parable, though it eludes interpretation. The troubled astronomer admits his plight. 'Hear, Imlac, what thou wilt not without difficulty credit', he begins:

> I have possessed for five years the regulation of the weather, and the distribution of the seasons: the sun has listened to my dictates, and passed from tropic to tropic by my direction; the clouds at my call have poured their waters, and the Nile has overflowed at my command.

This is partly a story about being careful what you wish for. Johnson's astronomer finds that the climate cannot be improved. 'I have found it impossible to make a disposition by which the world may be advantaged.'[9] We have heard this before, in *The Play of the Weather* for example, where one person's ideal is revealed as another's disaster. Johnson's astronomer has thought through much larger questions of geographical diversity, and even the balance of planets across the solar system. But his conclusion is the same: no change. He must therefore try, with great anxiety and exertion, to maintain the distribution of weather as it was before; and he must bear in private the sole responsibility for the suffering caused when his system of 'regulation' fails.

Johnson's bizarre fable is partly about the dreams and the ethics of scientists. So much seemed possible in the eighteenth century that control of the elements was not an outlandish prospect. In *Gulliver's Travels* (1726) Swift had made a mockery of deluded scientists, touring the gimcrack laboratories of Lagado where experimenters earnestly tried to extract sunlight from cucumbers. Johnson, however, permits neither laughter nor cynicism. The case of the astronomer is a serious one because it

demonstrates the proximity of reason and madness. This man of learning, this devotee of empirical observation, has lost his hold on reality. His visionary scheme, which in one sense embodies the ambitions of the scientific revolution, is not a work of fact but of fiction. It is a product of what Johnson calls 'the dangerous prevalence of imagination', which leads in turn to melancholy and to madness.[10]

Johnson refused to laugh at madness because it was all too close to home. He spent much of his life in fear of it, bearing down hard on himself (and others) for behaviour that seemed to allow the irrational too much licence. It was not that he wanted to control the weather – that way madness lies – but he certainly wanted to control the effects of the weather on himself. Recording Johnson's every word, James Boswell noticed that 'the effects of weather upon him were very visible'. Boswell himself was sure that the 'influences of the air' were irresistible to people of fine sensibilities, and he regarded Johnson's denial of these influences as a strange quirk in a man resistant to quirks. He would continue to take careful note of developments, as when he recorded an apparently trivial conversation between the two of them one rainy night in the summer of 1763. They were waiting for their dinner at the Mitre in Fleet Street:

> I made some common-place on the relaxation of nerves and the
> depression of spirits which such weather occasioned; adding, however,
> that it was good for the vegetable creation. Johnson, who, as we have
> already seen, denied that the temperature of the air had any influence
> on the human frame, answered, with a smile of ridicule, 'Why yes, Sir,
> it is good for vegetables, and for the animals who eat those vegetables,
> and for the animals who eat those animals'.[11]

So they settled down to their rain-fattened meat and Boswell 'soon forgot, in Johnson's company, the influence of a moist atmosphere'.

The same 'smile of ridicule' plays around Johnson's *Life of Milton*. Not many biographers would scrutinize their subject's relationship to weather, but Johnson did. He examined the scattered evidence for Milton writing only at certain times of year, and raised an eyebrow at Milton's morbid fear that he would get too cold to write. Johnson commented reprovingly that it must all have been in the mind:

> The dependence of the soul upon the seasons [...] may, I suppose, justly
> be derided as the fumes of vain imagination. *Sapiens dominabitur
> astris*. The author that thinks himself weather-bound will find, with a
> little help from hellebore, that he is only idle or exhausted.

A good dose of botanical medicine (hellebore for melancholy) would
have done the trick for the idle poet. Johnson dismissed as a bit of 'wild
fancy' Milton's fear of climatic deterioration. After all, he noted laconically,
Milton's mind would only be as degraded as everyone else's, so no one
would notice the difference: 'among this lagging race of frosty grovellers
he might still have risen into eminence'.[12]

Did Johnson, reading Milton, recognize something that he shared?
In private he noted that the period between Easter and Whitsuntide was
'propitious to study' and set himself daunting tasks for this time of year.
(Boswell discovered this note later and wondered at his friend's contra-
dictoriness.) It is clear that Johnson found it very difficult to work steadily,
and was continually trying to learn the discipline he preached. His diaries
(or 'Annals') were punctuated by resolutions to concentrate better and get
up earlier, followed by notes of his failure to keep to the plan. In 1775 he
lamented his 'negligence, forgetfulness, vicious idleness', and determined
in future to be out of bed before eight. As part of this self-training he made
conscious efforts to appreciate particular times of year. A *Rambler* essay
from 1750 is a superb apology for winter written by someone not entirely
convinced. He persuades himself that winter brings invigorating changes:
'We are agreeably recreated, when the body, chilled with the weather, is
gradually recovering its natural tepidity; but the joy ceases when we have
forgot the cold'. The 'asperity of the wintry world', he says, is liable to
awaken in the receptive mind 'seriousness', awe', and 'terror'.[13]

Near the end of his life Johnson found that he was ready to relent.
He had tired of the struggle and he made an admission. 'I am now reduced
to think, and am at last content to talk, of the weather,' he wrote at the
age of seventy-four. 'Pride must have a fall.'[14] That was in August 1784. He
was ceding way to the next generation, whose veneration of the weather
would be its badge of honour, as Johnson's resistance was his. Johnson had
conceived the ideal man as a stable entity, hence his interest in epitaphs
that might capture his essence in a single, lapidary phrase. Boswell's con-
ception of character was quite different, which is why he needed hundreds

of thousands of words for his portrait of Johnson. A biography must be loose-fitting enough to contain a myriad shifts and contradictions. The glory of a human being is, to Boswell, the uniqueness of each act and each pronouncement. Fluidity, not solidity, is Boswell's ideal – in literary form, in personal conduct, and in atmospheric effects. Johnson's atmospheric responsiveness seemed to Boswell a further proof of the great man's genius.

Samuel Johnson had tried not to look very often at his barometer, though he possessed a very fine one. In his will he left it to the balloonist James Sadler, whose flights up into the clouds would open a new dimension in meteorological study and inspire the young Romantics who gazed up from the ground. On each of his ascents for the next twenty-five years (until an emergency over the Bristol Channel in 1810 when he was forced to throw it out of the basket) Sadler took the barometer flying.[15]

DAY BY DAY

Instruments were being tapped, temperatures taken, cloud-cover observations made. In the second half of the eighteenth century, right across the country, brass-edged dials in polished wooden cases were hung on the walls of parlours and studies to be inspected daily. Men and women filled notebooks with daily observations. The habit of weather-recording had grown and grown since the time of John Evelyn, John Wittewronge, and the first attempts of the Royal Society to gather reliable observations. For many people of enquiring habits, it was a point of both interest and pride to have at your fingertips a record of last year's rainfall and to compare the temperature of successive winters.

To store up the weather was a kind of collecting. The sky was elusive and untouchable, but it was possible to save up one's measurements of wind and rain as the period's many archaeologists and antiquarians saved up their finds. The two kinds of investigation might even go side by side: the new local histories presented the antiquities of a county alongside character sketches of its topography and climate.[1] To collect the weather was also to save up part of one's own life. Some observers included personal notes in the margins of their meteorological tables, while others added thermometer readings to their accounts of the day's events. Parson Woodforde, who wrote up the small details of his life in Norfolk through

forty years of weddings, funerals, cribbage, and very large, keenly itemized dinners, often sketched a portrait of the weather as part of a day's narrative. At the minimum he would record that 'A great deal of rain fell during last night. Dinner today boiled beef and a suet pudding'. The weather affected all his outings, and the size of his congregation; sometimes, too, it affected his spirits. On 28 January 1787:

After service I buried a Daughter of Harrisons an Infant aged only 5 Weeks – I think that I never felt the cold more severe [...] Snow falling all the time and the Wind almost directly in my Face, that it almost stopped my breath in reading the funeral Service at the Grave, tho' I had an Umbrella held over my Head.[2]

Constantia Orlebar said much less about her own life, though it was busy with travel and study. She determined instead to make a daily record of the weather at her home in the village of Ecton, Northamptonshire, a resolution which she kept for twenty-one years between 1786 and 1808. Each entry in her 'Weather Book' was a careful summation of a whole day's changes. On 27 February 1786: 'A misty sprinkling rain early – but soon cleared to a spring-like pleasant day – wind rose, and was a Blustering cloudy night'. On 30 September 1794: 'early very hasty rain, changed to be fine – cloudy sunset – wind arose and was a turbulent wet night'.[3] This kind of description involves a finely discriminatory kind of looking. Orlebar was like an artist making careful sketches, setting herself a daily task of disciplined observation.

Not many of the diary keepers were seriously expecting to make a breakthrough in understanding the weather, but anyone who looked at the latest issues of the *Philosophical Transactions* saw that advances were being made. Letters went back and forth with diagrams of improved hygrometers and air pumps. It seemed likely that one day soon the movement of winds would become clear. No one then could have foreseen that the weather would be beyond accurate prediction even with the help of supercomputers; knowledge felt within grasp. And a great deal of knowledge certainly was within the grasp of the ambitious, optimistic, multi-talented experimenters who turned their minds to the question of meteorology.

In Lichfield, Erasmus Darwin realized that, rather than check his barometer in the morning and again in the evening, it would be far more useful to watch what happened at the very moment when the wind turned.

Darwin quickly got around the problem of not wanting to hang around outside for the moment of action. On the ceiling of his study he fixed up a dial (probably made by his friend John Whitehurst) which was attached to the weathervane on the roof above.[4] From his desk, where he was engaged on many other projects, he could monitor the correlations between wind direction, temperature, and air pressure. 'The change in the direction of the wind evidently changes its tendency to absorb or give out heat', he had concluded by 1777. But what made the wind change? Soon he was thinking in terms of 'districts of air' which have boundaries and which meet other 'districts' with different qualities.[5] Not until the emergence of Frontal Theory in the 1920s would warm and cold fronts be understood in this way again.

'The theory of the winds is as yet very imperfect', Darwin wrote in 1788, as he launched into an enormous footnote on the subject in *The Botanic Garden*, a book-length poem which packs into its margins a complete analysis of meteorology to date. That same year, after bursts of work with air pumps and air guns, Darwin arrived at the first accurate theory of cloud formation. At the end of his paper on the expansion of air he allowed himself a moment's contemplation of the future: 'if it should ever be in the power of human ingenuity to govern the cause of the winds [...] I suppose the produce and comfort of this part of the world would be doubled at least'.[6]

⌒

Though Darwin's meteorological experiments yielded spectacular results, there was still much to be said for day-by-day observation. No sky in England was so closely watched as the sky above Lyndon in Rutland. Lyndon Hall is a handsome Caroline house with tall sash windows, and moulded cornices and lintels that give a hint of the Baroque. Thomas Barker was born here in 1722, into a family with an enthusiasm for science. By the age of eleven Thomas was taking thermometer measurements, and at fourteen he began the daily meteorological record that he would keep for the rest of his life.

For just over sixty years, Barker made daily observations of pressure, temperature, and rainfall. On 31 July 1759, to choose a day at random, he took full instrumental readings at 6.30 a.m. and 5.15 p.m. In between these times he watched closely enough to record that, after an early shower, it was a 'chiefly cloudy day; rainy most part of the afternoon, and a shower at 21. Wind SW to WNW'.

Top: Arcadian light in Hertfordshire:
A View of Cassiobury Park, by John Wootton, *c.* 1748
Above: Richard Wilson, *The Valley of the Dee,
with Chester in the Distance, c.* 1761

Thomas Rowlandson,
An Artist Travelling in Wales, 1799

A gentle animating breeze:
Mrs Richard Brinsley Sheridan,
by Thomas Gainsborough, 1785–87

Above: *Study of Cumulus Clouds*, by John Constable, 1822. Inscribed on the reverse: 'Sep 21 1822 past one o'clock looking South wind very fresh at East, but warm.'

Opposite, above: John Constable, *Weymouth Bay*, painted in the dark autumn of 1816
Opposite, below: John Constable, *Seascape with Rain Cloud*, c. 1824–28

Thomas Fearnley,
Turner on Varnishing Day, 1837

J. M. W. Turner,
Regulus, 1828, reworked 1837

Top: J. M. W. Turner, *Petworth Park: Tillington Church in the Distance, c.* 1828
Above: J. M. W. Turner, *Interior of a Great House, c.* 1830

The following winter, while others shivered ('sure you must be become a snow-ball', exclaimed Horace Walpole in a letter to his friend George Montagu, feeling too cold even to venture out to the opera), Barker calmly went out to his barometers. Barker's constant observation must have been almost automatic, like our awareness of our own bodies. Amid his busy family life (there were four children) he would look out of the sash windows, check the clock, and make a note. He had a reputation among friends for 'extreme Abstractedness and Speculativeness'.[7]

Scrutinizing his patiently amassed statistics for larger patterns, Barker was able to conclude, for example, that 'for the last 10 years the East winds have been often very wet' in comparison with east winds in the decade before that.[8] He would send yearly data, with analysis, to the Royal Society for publication in the *Philosophical Transactions*; and with his monthly tables appearing in the more widely circulated *Gentleman's Magazine* the public came to rely on the fact that weather data was available for given times. When the modern Met Office reports that it has been the wettest June 'on record', the reference is usually to the monthly gridded data-sets which began in 1910. But with Barker at work, the mid-eighteenth century can justly be called the time when records began. His statistics form a core body of evidence for the Central England Temperature record compiled by Gordon Manley in the mid-twentieth century, the most extensive historical weather series in the world, and the archive against which our monthly and annual temperatures are still compared.[9]

꙳

There was another keeper of records whose writing and thinking could not be contained in the grid recommended by the Royal Society or published in the *Gentleman's Magazine*. He published only one work, but it was the result of a lifetime's watching, and it became one of the best-loved books in the English language. The book was *The Natural History of Selborne* (1789); its author was Thomas Barker's friend and brother-in-law, Gilbert White. As a boy of fifteen, visiting Lyndon, Gilbert helped with the weather observations.[10] Later visits were few and far between, with Barker stubbornly refusing to leave his Rutland lookout and White reluctant to leave his Hampshire home at Selborne, so they relied on a regular correspondence in which their different priorities came to complement each other. Barker's observations over sixty years took the form of statistical tables, while

White's records translated the numbers on the barometer into sensuously precise descriptions of the world around him.

White's name is not immediately associated with the history of weather. He is better remembered for his observation of swifts or for some of the more startling episodes from the *Natural History*, like the excursion to examine a moose in a neighbouring parish. Eric Ravilious, who made engravings for the *Natural History* in the 1930s, loved the spare grandeur White could evoke merely by writing that 'there are bustards on the wide downs above Brighthelmstone'.[11] The importance that White attached to weather is clear in the six letters with which he concluded the *Natural History*: of all the subjects he might have chosen for his ending he devoted these letters to the climate of Selborne. They were written specifically for the book, but they looked back over four decades of weather-watching. The story of White's relationship with weather is a version of his life story.

When White first settled down at the family house, The Wakes, after a period of travel and uncertainty in his twenties, he made ambitious plans for its horticultural improvement. Gardening was his passion, and his weather during the 1750s was gardener's weather – more precisely melon-grower's weather. Melons in Hampshire needed coaxing. White was constantly out tending his hot beds, shovelling on quantities of steaming compost. His biographer Richard Mabey comments with fascination on this all-consuming task: 'White seems to have become locked in some personal struggle with the rigours and vagaries of the eighteenth-century climate'.[12] This kind of gardening was a precision art, a virtuoso exercise in temperature control.

White's hot beds and cold frames belonged to a tradition of experimental gardening in England. Francis Bacon had promoted the idea of perpetual spring – 'ver perpetuum' – in the garden, arguing that increased horticultural knowledge could produce bounty in every season. John Evelyn had taken up this idea in his own garden at Sayes Court. In his *Kalendarium Hortense* he listed plants for every month of the year, showing that there need never be a bare or droopy time in the border. All this was part of the seventeenth- and eighteenth-century delight in deploying human ingenuity to refine the habits of nature. Evelyn issued instructions for the care of exotics during the last frosts of March, and published designs for an advanced new form of heated greenhouse. Here was the ultimate in controllable mircroclimates, featuring an underground

stove, a fresh-air circulation system, and a porch to act as an insulating buffer between inside and out. It also featured a barometer in prime position: man was now not only measuring temperature but adjusting it to his requirements.[13]

Gilbert White inherited this spirit of microclimatic ambition, and it showed in his melon-growing. Gradually, however, he watched the weather as it affected birds rather than cantaloupes. He was amazed to see swallows appearing in the frost of early April and worried about what other migrating species would do. He noted that the swift is 'never so much alive as in sultry thundry weather'. 'In hot mornings several, getting together in little parties, dash round the steeples and churches'.[14] We can almost feel the tall, still air in which the restless swifts dash round.

White watched other animals, though birds would be the central passion of his life. With wry amusement he noted, over many years, the meteorological sensitivities of Timothy his tortoise, who proved hardier than Evelyn's. A warm autumn might prove too hot for the exertions of digging a 'hybernaculum', while a rainy day might send Timothy into hiding. White wrote it all down with patience, fondness, and scientific interest:

> No part of its behaviour ever struck me more than the extreme timidity it always expresses with regard to rain; for though it has a shell that would secure it against the wheel of a loaded cart, yet does it discover as much solicitude about rain as a lady dressed all in her best attire, shuffling away at the first sprinklings, and running its head up in a corner. If attended to it becomes an excellent weather-glass.

The weather-glass joke was important because White was interested both in the old rural prognostications and in the expanding range of new scientific instruments. He thought 'superstitious prejudices' were 'too gross for this enlightened age', but he was keen to test the scientific justification for some of the old lores. The tortoise, the pinecone, the swallow, the mercury tube: they were all nature's forecasters, if only one knew how to read them. White sometimes read them wrongly – thinking, for example, in line with the Aristotelian system of exhalations, that underground creatures like moles received early warning of 'warm vapours' coming up from deep in the earth. But if there was an approach likely to bring real advances in understanding it was White's mix of patient watchfulness, sensory immersion, and willingness to use all the tools at hand.[15]

Barometers and thermometers were much-prized members of the household at The Wakes. Instruments by different makers hung side by side for comparison. The very thought of his brother-in-law in Lyndon was tiring ('he rises at six and cannot sit still'), but White was assiduous too. He was up in the freezing dawn of 31 January 1776, scraping frost from the barometer glass to take a remarkable reading: 'just before sunrise, with rime on the trees and on the tube of the glass, the quicksilver sunk exactly to zero, being 32 degrees below the freezing point'.[16]

White could never be content with statistics alone. He also had to look and touch and smell the air to understand how his familiar environment was altered. From 1767 he used a *Naturalist's Journal* designed by his most frequent correspondent, Daines Barrington, preprinted with columns for daily recordings of flora and fauna, wind and weather.[17] White's column entries were a mixture of objective recording and evocative writing. He couldn't help noticing chamber pots: 'It freezes under people's beds'. Then the next day: 'Meat frozen so hard it can't be spitted'.[18] He needed the sensory and numerical measures side by side, the one giving meaning to the other.

Generations of readers have enjoyed White's prose while seeing in their minds' eye the woodcuts of Thomas Bewick, whose *History of British Land Birds* was published in 1797. Bewick was over thirty years younger, and very much a craftsman rather than a gentleman-scholar, but what they shared as pioneer ornithologists, and as playful, sensuously precise recorders of country life, was more important than their differences. Bewick came to love White's book, and the two have been associated ever since.[19] The tiny scenes which Bewick engraved on boxwood as tailpieces for his *British Birds* are lovingly particular about the movement of wayside grass in the wind and the stillness of bare trees against winter sky. As White observed with both scientific interest and practical good humour, so Bewick shows us just how a child's kite flutters on a breezy day, and how a coat flaps out, and water ripples, and trees blow in full summer leaf. All this happens in the sharp lines of the graver, where nothing can be fudged or smudged to give vague indications. In his vignettes of travellers, Bewick conveys by hunched shoulders precisely the force of the gale, and exactly how a man needs to balance his weight as he walks precariously across ice.

While Bewick cut into wood, White kept quiet watch over the garden and fields at Selborne. On a warm June day: 'fruit-walls in the sun are so hot that I cannot bear my hand on them'. What does this temperature feel

like, he is asking, how does it affect my world? In the wet: 'Tortoise scarce moves'; in fog: 'distorted shadows cast'. On a changeable April day: 'just enough rain to discolour the pavement'.[20]

~⟲~

It is unlikely that Gilbert White ever read, or met, William Cowper, the brilliant, charming, depressive, reclusive poet eleven years his junior. Neither writer could be persuaded to leave his home village in anything other than an acute emergency. Neither had enough money to keep up with new publications, so there is not much chance that a copy of *The Task and Other Poems* made its way to Selborne after its publication in 1785, or that the *Natural History* arrived at The Lodge in Weston Underwood after its publication in 1789. But these two men were thinking in common about nature, about the weather and the seasons, about inside and outside lives. They were read in common, too, by the Romantic generation who succeeded them.

Not many people today visit the house at Olney in Buckinghamshire where Cowper lived for nearly twenty years (before moving, in 1786, a mile up the road), though it is open as a museum and packed with objects he once knew intimately – his teacups, mahogany writing slope, white cloth cap, and leather waistcoat. The house fronted on to the marketplace, but Cowper preferred to be in the garden at the back, where – like White at Selborne – he made an enclosed horticultural paradise, the beds spilling over with perennials and with the much-tended melons that marked him out as a serious eighteenth-century gardener.

Cowper's writing and gardening got mixed up, since both centred on a tiny summerhouse with a steep tiled roof. There wasn't room for both the poet and his plants, so they took it in turns. 'When the plants go out, we go in', he told his cousin Harriet Hesketh, with whom he anticipated long conversations in the 'summer parlour'. It was a place where he could be both indoors and out, 'a cabinet of perfumes', 'fronted with carnations and balsalms, with mignionette and roses, with jessemine and woodbine'.[21] When out on his walks, Cowper always sought containment rather than openness. He loved groves and tree-lined paths; he lamented the felling of a poplar avenue as sadly as if he had lived in it. His favourite walk took him to a large 'alcove' on the Weston estate, an outdoor home from which he could look across the fields.

William Cowper's summer house at Olney: a 'cabinet of perfumes'.
From *The Rural Walks of Cowper*, 1822.

To the next generation this sheltering would look tame. 'He seldom launches out into general descriptions of nature', complained William Hazlitt in his 1818 lectures on English poets:

> he looks at her over his clipped hedges, and from his well-swept garden-walks; or if he makes a bolder experiment now and then, it is with an air of precaution, as if he were afraid of being caught in a shower of rain, or of not being able, in case of any untoward accident, to make good his retreat home.[22]

Hazlitt catches here precisely the temperament of Cowper's writing. Cowper *was* afraid; his life – dominated by periods of disabling depression – had given him reason to be cautious. His poetry of nature is not about the quest for wildness or sublime immersion often undertaken by writers whose lives are comfortable enough to seek danger. Cowper's depression made his life alarming enough as it was. He wrote about our ways of finding small delights and kind protection.

In the winter of 1780–81 he composed almost the entire contents of his first volume, *Poems*. He would refer to the collection as 'the produce of the last winter', as he might refer to a good cabbage crop. This spell of productivity surprised him. Shouldn't poets flourish most in spring? 'The season of the year which generally pinches off the flowers of poetry, unfolds mine, such as they are, and crowns me with a winter garland'. He knew that his winter writing made him different, and though he talked about it jokingly he knew that this difference mattered:

> In this respect, I and my contemporary bards are by no means upon a par. They write when the delightful influences of fine weather, fine prospects, and a brisk motion of the animal spirits, make poetry almost the language of nature; and I, when icicles depend from all the leaves of the Parnassian laurel, and when a reasonable man would as little expect to succeed in verse as to hear a blackbird whistle.

No one had bothered so much about the influence of weather on writing since Dr Johnson's articles in the *Idler* and his *Life of Milton*. Cowper had been reading *The Lives of the Poets* and was particularly struck by Johnson's mistreatment of Milton.[23]

The weather mattered to Cowper and, unlike Johnson, he wanted both to admit it and to write about it. All through the spring and summer

of 1783 he wondered and worried about the strange haze that refused to lift.[24] This was the year of the Laki eruption in Iceland, when volcanic ash hung in the atmosphere. At Selborne, Gilbert White wrote that the midday sun was 'as blank as a clouded moon, and shed a rust-coloured ferruginous light on the ground, and the floors of rooms'. The same disturbing rust-red light reflected dimly on the wooden floors at Olney. In the close, still, humid heat (the fog worked as an insulating greenhouse), Cowper tried to determine what he thought. In the marketplace people talked anxiously about what the weather might portend, and when in June 'two fire balls' struck close to the church, sending debris flying and smoke curling from the steeple, it was hard not share the mood of superstition. 'Misty however as I am, I do not mean to be mystical', wrote Cowper, trying to laugh. It was an 'unhealthy season' for everyone; so many people were ill by late summer that it was a struggle to gather the harvest. Cowper felt the same 'lassitude and disgust' as the cows who looked miserable in the fields around Olney.[25] He cheered himself with poems on a rose in the rain, an ink pot, the goldfinches who took up residence in his summerhouse; and then, when Lady Austen challenged him to write a poem about the very sofa she was sitting on, Cowper outstripped her small commission to write the six books of *The Task*.

Conceived in that disturbing summer, the poem makes its own peaceful and temperate spaces in 'a world that seems / To toll the death-bell of its own decease'. *The Task* is both a sequel to *Paradise Lost* and a prelude to the Book of Revelation, describing rural retreats and peaceful ways of life that can be made, temporarily and only approximately, into little earthly Edens. Cowper registered the signs of apocalypse that seemed to appear on every side ('Fires from beneath, and meteors from above'), and sounded like Donne in his apprehension of an 'old and crazy earth' given now to frequent 'shaking fits'. Cowper's pleas for the peace of nations and liberal respect between diverse people (pleas which sound contemporary today) are made in the context of fire and fog:

> Is it a time to wrangle, when the props
> And pillars of our planet seem to fail,
> And Nature with a dim and sickly eye
> To wait the close of all?[26]

Making a shelter beneath the falling pillars, Cowper celebrates 'Domestic happiness, thou only bliss / Of Paradise that has survived the fall!' He advises on how to protect blossoming trees through tentative spring weather, screening them from cold, but removing the screen to let them bask in any beams of early sun. For such a gardener the growing of cucumbers (the 'prickly and green-coated gourd') is a task worthy of epic. They require just the right level of heat in the fertilized soil, and moisture let in through the adjustable windows. This refined control of nature is an art: 'an art / That toiling ages have but just matured, / And at this moment unassay'd in song.' Snugly protected, the cucumbers can pretend they are in India, while the exotic blooms in Cowper's greenhouse 'Peep through their polish'd foliage at the storm, / And seem to smile at what they need not fear'.[27]

The fourth book of *The Task* is about that same sense of safety from the storm as it is experienced by humans indoors. The scene is set in the poet's parlour as dusk falls on a winter night. Cowper's anticipation of the warm, safe time ahead is a kind of ecstasy, and he sighs with grateful relief that the day's battles are done. In the happy reprieve of early darkness, he prepares his safe haven for the next few hours: 'Now stir the fire, and close the shutters fast, / Let fall the curtains, wheel the sofa round'. Here he is sheltered from the blast outside, though he never forgets that it is going on. The post-boy arrives as a 'herald of a noisy world', bringing news which seems to press in at the window like the gale. 'He comes! he comes!' wrote Thomson of the melancholy autumn spirit arriving on the breeze; 'He comes', writes Cowper of the post-boy, as if the evening papers were themselves a melancholy breeze gusting in from abroad.[28] 'Have our troops awak'd?' 'Is India free?' The British had at last been bloodily defeated in America, and in Mysore young lives were being lost in spurious imperial wars. Cowper wheeled the sofa round so that his back was to the marketplace, and took up the newspaper. 'I behold / The tumult and am still', he wrote, knowing also that his stillness allowed him to behold the tumult.[29]

Winter, which is violent outside, gives extended licence for stillness within. The long evenings concentrate the mind, 'fixing thought / Not less dispersed by day light and its cares'. Daylight demands movement and reveals distractions. Cowper found that he worked quite differently by the light of a lamp in an otherwise dark house. 'Composure is thy gift', says

Cowper of winter nights at Olney, allowing the phrase to embrace both self-composure and the act of poetic composition.[30]

The winter of 1783 was the most productive season of Cowper's life, though the long effort to keep himself safe and mentally stable did not always work. On 19 December a deep frost set in and stayed continuously for nine weeks. In the midst of this time Cowper became too ill to write. His melancholy overtook him, and even in the shuttered evenings he could feel no composure. That January of 1784, believing that he was consigned to frozen darkness, Cowper read the weather outside as 'an exact emblem' of his mind: 'A thick fog invelops everything, and at the same time it freezes intensely'. He was confident that the weather outside would change, but that his own internal condition was permanent: 'nature revives again, but a soul once slain, lives no more'. If he could only start to write again, however, he knew it would be an alternative kind of living. As the 'ice in [his] pen' and in his mind relented a little, he embarked on 'The Winter Morning Walk', to be followed by 'The Winter Walk at Noon', the last books of *The Task*.[31] By describing in this poem the beauty of low sun on snow, he was affirming the joys to be found even in winter cold. He was showing how, each morning, 'nature revives' – and *survives* – even without the coming of spring.

Cowper was one of the first poets to write with real pleasure about winter.[32] The snowy landscapes he inherited from Thomson were grandly scenic expressions of divine majesty. Cowper's winter was intimate, both indoors and out. Along his customary path, he watched a robin shake snow from a twig, and he paused to admire the shape of icicles around a waterfall:

> see where it has hung th'embroidered banks
> With forms so various, that no pow'rs of art,
> The pencil or the pen, may trace the scene!
> Here glitt'ring turrets rise, upbearing high
> (Fantastic misarrangement) on the roof
> Large growth of what may seem the sparkling trees
> And shrubs of fairy land.

Even on this frozen day he found nature expressing liberty. The icicles, in their 'thousand shapes / Capricious', show that nature itself, ordained by

God, is on the side of creative freedom. Roaming outwards in imagination, Cowper juxtaposes these free-forming icicles with a work of frostbound human tyranny: the ice palace built at the command of Empress Anna of Russia in 1740. It was meant to impress and entertain the crowds, but it was also a grotesque exercise of power. The empress ordered a dishonoured prince and his new wife to spend their wedding night in a bed carved from ice. This elaborate torture chamber became for Cowper an image of toxic rule, 'treach'rous and false'. His own poetry and politics followed the example of the icicles.[33]

Cowper did not probe the science of weather as Bacon or Hooke had done, or measure it like the diarists. His particular faith set him apart from the scientific revolution: 'God', he wrote in *The Task*, 'never meant that man should scale the heavens / By strides of human wisdom'. Yet at the same time his religious watchfulness brought him close to the work of Barker and White: he shared with them a devotion to observing the small daily wonders of one ever-changing patch of ground and sky. He believed winter to be a just punishment for man's disobedience, but not an annual work of divine vengeance. It was, after all, a season of surprising beauty. When noon comes in *The Task* the sun is shining on the snow in 'dazzling splendour'. Though 'inattentive man' took much for granted, though Cowper himself could sometimes see only darkness, he now looked about him in wonder: 'all we behold is miracle'.[34]

VI

And oh! that even now the gust were swelling,
And the slant night-shower driving loud and fast!

Samuel Taylor Coleridge,
'Ode: Dejection'

COLERIDGE AND THE STORM

May 1798. Dark clouds start massing over the north Devon coast, and the first thunder sounds in the distance. In the village of Lynton, high on the cliffs five hundred feet above Lynmouth, a round-faced figure in his middle twenties emerges excitedly from the door of an inn and runs into the street. He has not stopped to put on his hat, but he doesn't care. He has come out to feel the power of the storm.

This is Samuel Taylor Coleridge, a man mesmerized by weather. Any storm has its drama, but Coleridge knew the particular exhilaration of this place. The lane west from Lynton leads into a giant, irregular bowl of heathland known as the Valley of the Rocks. From the cramped streets of the village the walker is thrown out into an alien land where rocks stick up like injured bones from the earth. One outcrop, close to the sea, rises sheer above the scree bank, a castle on a defensive mound above the battered arena. Thousands of years ago these forms were carved by glaciers thawing and then freezing again: this was the southern limit of the ice that once covered Britain. You might think a natural amphitheatre like this would be sheltered, but no. On a calm day the wind in this valley is enough to drown out voices and make the eyes water; the ear canals ache with the pressure. Blowing in from the Bristol Channel, the north and north-west gales are funnelled into the bowl where they beat around furiously, trying to get free.

Coleridge wanted to be in the midst of it and set out at a run. His young friend Hazlitt watched him go. Years later Hazlitt recorded the moment for posterity, bemused and impressed by his hero's behaviour:

> A thunderstorm came on while we were at the inn, and Coleridge was
> running out bare-headed to enjoy the commotion of the elements in
> the *Valley of the Rocks*, but as if in spite, the clouds only muttered a few
> angry sounds, and let fall a few refreshing drops.[1]

By the time Hazlitt was writing this in the 1820s, he could see it was a little comical: the great poet runs out in search of a storm to be poetic in, and finds there is only a shower. This is the sort of thing poets are supposed to do: they rejoice in storms, they forget their hats. In 1798, however, this

was very far from what poets were expected to do. It is hard to imagine Pope or Johnson or Cowper running to hear the thunder echo in this most forbidding valley.[2]

The next morning, in the old-fashioned parlour where toast and honey was served for breakfast, Coleridge spotted a copy of Thomson's *Seasons* lying on a window seat. '*That* is true fame', he said.[3] Thomson was certainly famous, read and read again by families with only a handful of books on their shelves, and read – apparently – in the window seats of small inns in Devon. He had taught people to *see*, as Johnson said: to see the shimmer of leaves and the mist sinking down into a valley. Coleridge read him passionately, and liked to think of him as a neighbour. 'Thomson was born only ten minutes from the Borders', he noted later when he was living in the Lakes: 'the Air from Cumberland might easily have anglicised him'.[4]

For all this closeness, Coleridge knew that he wanted to do something very different. Nothing in Thomson expressed the fearful energy Coleridge experienced in storms, or the spirit that seemed on a summer evening to bind him to nature. Thomson said nothing of weather as a private sign language, and nothing of the guilty transactions between self and atmosphere that Coleridge was always secretly brokering. In contrast with the seasons of Thomson's uplifting public epic, Coleridge's apprehension of weather was personal, mystical and haunted. Sometimes it was terrifying, and just occasionally it was like a benediction.

Coleridge never wrote the series of 'hymns to the elements' he planned on a grand scale in 1796.[5] Nor did he write a history of the millennium in terms of 'progression in natural philosophy – particularly meteorology'. But much of his poetry was made from air, fire, water, earth, and he made his own progress in the science of airs and winds. He was drawn to the aerial and mobile, so that even when walking the bumpy ground along Hadrian's Wall he was less interested in the archaeology at his feet than in 'the divinely pearly whiteness' of the remote clouds above. His bodily presence could seem more aerial than solid. For all his corpulence, the effect he produced was diffuse; many of those drawn into his orbit responded to him as something more like a weather event than an earthbound human being. Hazlitt was aware of this from the time of their first walk together on a January morning in 1798. Coleridge's talk seemed 'to float in air, to slide on ice'. Returning from Germany a few years later, Coleridge was 'cometary, meteorous', burning through the sky as he re-entered the English atmosphere.[6]

Coleridge watched himself watching the weather. He wanted to know why he found certain conditions exhilarating. Why did the moon behind clouds haunt him? And how did his mood change what he saw? Such reflections filled his notebooks. On his thirtieth birthday, in October 1802, he noted the weather every few hours: 'great columns of misty sunshine travelling along the lake', followed by 'a shower-mist drunk and dazzling'. Is thunder sublime by association, he asked in 1804; what happens if we hear the rumble of a cart and think it's thunder? Long meditations are interleaved with sudden shards of vision. 'Blue *pierced* white', he noted one day at sea, and nothing more.[7]

He was drawn to the extremes of the earth and of weather. The magnetic poles worked irresistibly on his dreams, and the English places around him metamorphosed in their image. The hills and gorges of north Somerset became to him the land of Kubla Khan, with its caves of ice and sunless seas.[8] Dorothy Wordsworth recorded the occasion of a 'tour' with her brother William and Coleridge in November 1797, beginning with a walk across the Quantocks to the coast at Watchet, and then along to Porlock and Lynton.[9] They started out at half past four, when the day was close to darkness and other people were settling down indoors. Tramping miles across rough ground in the cold, they decided to compose a ballad. In Coleridge's mind the tale became a thing of blood and spectres, fire and ice. Wordsworth withdrew from the project and left him to it.

This ballad, begun in the Devon night, became 'The Rime of the Ancient Mariner', in which visions of the most hostile regions of the earth and the spirit are pressed on the attention of an Everyman, a wedding guest. It is a poem with no middle grounds. The Mariner's ship, blown off-course by a storm, is immediately in the land of ice:

> And now there came both mist and snow
> And it grew wondrous cold:
> And ice, mast-high, came floating by,
> As green as emerald.

The wind is all gone and in the still air the ice is audible, cracking and howling. Once a breeze sets the ship in motion again, complete change is immediate. In the gap between stanzas a hemisphere is crossed, so that the Mariner is next stranded in windless air at the equator, powerless

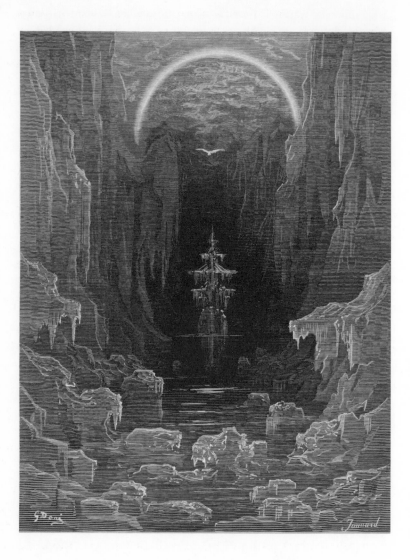

Gustave Doré, illustration for *The Rime of the Ancient Mariner*
by Samuel Taylor Coleridge, 1876

and motionless under the force of a 'bloody Sun'. It matters to Coleridge that there is nothing here so gradual as twilight: 'The Sun's rim dips; the stars rush out / At one stride comes the dark'. In this searing place, where the subtle language of twilights and misty forms belongs to wishful hallucination, the only mist is the vessel carrying Death-in-Life, a travesty of a ship. Moonlight too plays tricks. It looks cool and delicate on the water, reminding the desperate Mariner of a late spring frost: 'Her beams bemocked the sultry main, / Like April hoar-frost spread'. But this is indeed a mockery: there is no April here.[10]

Ice and fire keep doubling in processes of sublimation that miss all temperate middle states. The 'Rime' of the title is spelled for archaic effect, linking the poem with balladry, but this is also a work of rime ice.[11] The Mariner becalmed is both scorching and ice-numbed, subject to the twin torments of hell. He is saved by a breeze which is a form of the Holy Spirit, but for the rest of his life he is frozen into the spectral repetition of retelling his tale, becalmed on land with the tale 'burning' in his heart until periodically he can release it by talking. The breath of speech is the breeze that saves him, until the tale starts burning again.

Coleridge would always associate his own worst times with the 'dead swell of a dark and windless sea'. Calm in his poetry is often pent-up tension. He sets 'Christabel' on a night so still that one hears the beating of hearts. Eerier than the sounds of wind are sounds that are not wind:

> The night is chill; the forest bare;
> Is it the wind that moaneth bleak?
> There is not wind enough in the air
> To move away the ringlet curl
> From the lovely lady's cheek –
> There is not wind enough to twirl
> The one red leaf, the last of its clan,
> That dances as often as dance it can [...][12]

Such is the Beaufort Scale as Coleridge might have written it. These are his tests for the wind: a curl of hair seen vividly, sensually, touching and parting from skin, and the skittering dance of a leaf surviving beyond its time. This is the weather when the knowable world pauses; things happen here which would not show on any meteorological gauge.

It was in the stillness of February 1798 that Coleridge wrote his celebration of homely quietude, 'Frost at Midnight'. But even here the peacefulness feels precarious. The air is at first too calm for Coleridge's comfort. It 'disturbs / And vexes meditation with its strange / And extreme silentness'. Silence is for Coleridge an extreme condition, exceeding tranquillity to become a disturbance. This is a still-point of domestic happiness, but it is also taut and fragile, aware of all that lies beyond it. As Cowper closed fast the shutters in *The Task*, thinking of the wars he was shutting out, so Coleridge keeps much at bay from his midnight fireside. That same month he was working on 'France: An Ode', articulating his distress at the violence of Revolutionary France. All his work now felt like 'profitless endeavour'.[13] He had come to a halt. In 'Frost at Midnight' he strove to make that stopping-point benign. He eased the stillness with thoughts of future release, and placed hope in his son. The last stanza is a blessing and a prophecy for the infant Hartley who sleeps beside him.

The poem is a 'rondo', curving back and forward through time before regaining the equipoise of the silent night. Coleridge lets his mind travel so that it can return gratefully, and in awe, to the quiet frost. His wish that Hartley will wander 'like a breeze / By lakes and sandy shores' contains an image of Hartley wandering *in* the breeze, inspired by it and free to follow where it leads. It is Prospero's promise to Ariel: 'Thou shalt be as free / As mountain winds'. His imagining of Hartley's future life in all seasons is also a celebration of the scenes which had become dear to Coleridge over the last year in Somerset. Every line glistens with details of things observed. These are images which Coleridge has saved up in his notebooks, and which he now bequeaths to his son in a ceremony overseen by frost, the minister of nature's winter church:

> Therefore all seasons shall be sweet to thee,
> Whether the summer clothe the general earth
> With greenness, or the redbreast sit and sing
> Beneath the tufts of snow on the bare branch
> Of mossy apple-tree, while the nigh thatch
> Smokes in the sun-thaw; whether the eave-drops fall
> Heard only in the trances of the blast,
> Or if the secret ministry of frost
> Shall hang them up in silent icicles,
> Quietly shining to the quiet Moon.[14]

Coleridge made these wishes for Hartley because his own experience of weather was rarely a source of freedom. He loved it with a kind of compulsion, as he loved to see his children playing in the wind – not freely, but hypnotically, 'hair floating, tossing, a miniature of the agitated Trees [...] eddying half willingly, half by the force of the Gust – driven backward, struggling forward – both drunk with the pleasure, both shouting their hymn of Joy'. This is partly a charming description of delighted toddlers, but there is a disturbing intensity to it. There is enchantment at work here which holds the children involuntarily in its spell. Their hair recalls the flashing eyes and floating hair of Kubla Khan. It also recalls the unreachable, eternally dancing, eternally searching figure at the end of 'Christabel', 'A little child, a limber elf, / Singing, dancing to itself'.[15]

If wind was intoxicating, making children drunk with pleasure, Coleridge had a grown-up form of the addiction. Sometimes he longed for a high wind as one might long for a drink or a drug. His 'Ode: Dejection' traces a trajectory from becalmed non-feeling into wild visionary sorrow unleashed by a storm. The poem begins with a weather prognostication from one of the anonymous ballads collected in Thomas Percy's 1765 *Reliques*, 'The Ballad of Sir Patrick Spence':

> Late, late yestreen I saw the new Moon,
> With the old Moon in her arms;
> And I fear, I fear, my Master dear!
> We shall have a deadly storm.[16]

These words came to Coleridge's mind as he sat late at night in the study at Greta Hall, above the river in Keswick, in the heart of the Lake District, on 4 April 1802. He looked out at the strange phenomenon of a double moon, 'the new Moon / With the old Moon in her arms', caused by reflected light from the earth skimming the moon's night side. 'Well! If the Bard was weather-wise, who made / The grand old ballad of Sir Patrick Spence', tonight there will be a 'squally blast'.[17] Coleridge listened for the rising wind and cast an inward eye on his emotions. The poem he wrote that night was a cry of love for an unattainable woman, Sara Hutchinson, and distress at the loss of poetic creativity he felt. Over the following months he cut and disciplined the lines until he had made a poem which, for all its daylight revisions, holds us gripped in the tense night as the late hours tick away.

'Dejection' is a spring poem, written in April, invoking the tradition of April showers and 'peeping flowers'. It is related to those old *reverdies* in which a lamenting lover knows his mood to be out of kilter with the season, but April is almost always a month of spectral coldness in Coleridge. The horrors of 'Christabel' come in April, though the time is as unnameable as the rites enacted: ''Tis a month before the month of May / And the Spring comes slowly up this way'. The moon in 'Dejection' portends bad weather, and the poet waits for a storm rather than spring flowers. At Lynton he had rushed out hopefully to see the glory of the elements in commotion. He had been keenly responsive then, eager for all experience of sublimity. Now, sunk in 'dull pain', he wonders whether a squall will help rouse in him some feelings. 'Oh! that even now the gust were swelling, / And the slant night-shower driving loud and fast!'[18]

The difference here from Coleridge's days of contented inspiration is marked by an Aeolian harp in the window which lets out a 'scream' as it catches the rising wind. This is a charged sound because in Romantic poetry the Aeolian harp is the measure of harmonious relations with the natural world. The strings of the harp, pulled taut across a hollow wooden box, vibrate as the air passes over them so that the wind itself becomes the musician. The instrument was invented by the German polymath Athanasius Kircher in the seventeenth century, and first manufactured for the public in the 1740s. Thomson found its music sweet, sad, solemn, and divine, 'beyond each mortal touch the most refined'. In 1795 Coleridge had placed a harp in the cottage window at Clevedon in Somerset, and listened on balmy nights to the erotic courtship of strings and air:

> That simplest lute
> Placed lengthways in the clasping casement, hark!
> How by the desultory breeze caressed,
> Like some coy maid half yielding to her lover.[19]

This is a breeze laden with scent and sex, seducing Coleridge with its 'witchery of sound'. In a conceptual swelling-out from the harp to the universe, this wind-caress became an image for the one vast 'intellectual breeze' animating all life. The mind, in this expansive metaphor, is the harp to be played upon. The poet must hold himself exposed and receptive before nature. Instead of playing the harp as Orpheus had done, the poet is the harp to be played upon.

The harp in 'Dejection' makes a dreadful noise, or so it sounds to the mind at odds with the world. At the beginning of the poem the 'dull sobbing draft' of the night air 'moans and rakes / Upon the strings'. Later, with the force of the storm upon it, the lute sends out a scream 'of agony by torture lengthened out', and it is torturous to hear.[20] Pathetic fallacy (though he didn't know it by that name) had always seemed to Coleridge a tendency to be guarded against. The night-wandering man in 'The Nightingale', who hears the song of the bird as a lament because he happens to be melancholy at that moment, merely 'filled all things with himself'.[21] Nature could only echo back his own mood, and thus could never change it. Yet it is impossible for any of us to listen neutrally. Our relationship with nature is a fine balance between what we give and what we receive. These become the central terms of 'Dejection': 'O Lady! We receive but what we give, / And in our life alone does nature live'.[22]

A little before midnight the gale is raging outside. The bard of the old ballad *was* weather-wise; the storm has come. It has been going on for some time before the poet stops to listen, letting the wind free him from 'viper thoughts' writhing like the sea creatures the Mariner once saw in the deep. The storm does at least wake Coleridge from numbness. With wild cries and rapidly multiplying metaphors, he salutes the wind as 'Mad Lutanist', tragic actor, 'mighty Poet, e'en to frenzy bold!' The weather, crying and shouting around him, licences free expression in return. The ventilation of the storm allows him to vent passions long held within the muffled folds of his 'unimpassioned grief'. The wind carries the sounds of an outside world at war, 'the rushing of a host in rout': its noise triggers visions of troops in retreat, wounded and groaning.[23] This is a wind that connects Coleridge, in remote Keswick, with the continents over which it has travelled.[24] Then, as the wind drops, the wide aural landscape narrows and the echoing groans of war are replaced by the sound of a single child. Here is a returning ghost of the children Coleridge watched as they played outside, hair flying, drunk with pleasure. This is a sadder child, not dancing but frightened:

> a little child
> Upon a lonesome wild,
> Not far from home, but she hath lost her way.[25]

Her faint scream sounds beyond the limits of the poem.

This is what a storm can be in Coleridge's poetry. Someone else that night might have remarked on the direction of the wind, or the possibility of a tree falling into the greenhouse. In 'Dejection' we witness the storm as it flickers through mental space. Constantly changing form, the wind ('mighty Poet') writes an epic of rushing crowds, an age-old ballad, a lyric cameo of a terrified child. It wrenches feeling from blankness and guides it into the shape of an ode.

WORDSWORTH: WEATHER'S FRIEND

Coleridge's 'Dejection' was partly a response to a poem Wordsworth had begun that spring of 1802. In his 'Ode: Intimations of Immortality', Wordsworth worried about losing his responsiveness to nature. He stated the problem simply:

> Turn whereso'er I may,
> By night or day,
> The things which I have seen I now can see no more.

But Wordsworth rarely went very long without finding some sudden confirmation of his privileged relationship with a natural world that seemed to confide in him as a special friend. The very week that he wrote 'Intimations of Immortality', he was also overjoyed at the sight of a rainbow:

> My heart leaps up when I behold
> A Rainbow in the sky:
> So was it when my life began;
> So is it now I am a man [...][1]

He was always delighted when he could feel with the same wondering intensity he felt as a child. To Wordsworth it seemed a failing in Coleridge that he could find no reliably restorative powers in nature. The differences between them crystallized around a poem called 'Three Graves'. 'I gave him the subject', wrote Wordsworth, 'but he made it too shocking and painful, and not sufficiently sweetened by any healing views'.[2] It was the problem that had divided them when Coleridge, in the dark Quantocks, had begun the Mariner's tale.

Wordsworth told his own life story as a narrative of companionable weathers. He thought of his undergraduate life in Cambridge as 'a change in climate' from his Cumbrian boyhood, and his adult quest was to regain the weather of his youth in the Lakes. He returned there triumphantly with Dorothy in December 1799, and in his poem 'Home at Grasmere' this relocation is couched entirely in terms of weather. Brother and sister make a pilgrimage on foot through Yorkshire to Cumbria, undeterred by the 'bleak season', 'flying snows', and 'frosty wind'.³ For most people the business of moving house is distinguished by awkward attempts to carry heavy objects. For Wordsworth it has nothing to do with tea-chests and everything to do with an airy initiation, after which the mountain weather will be a generous host.

Wordsworth began *The Prelude*, his autobiographical epic, by receiving holy communion from the air. We are told in Genesis that God breathed into the nostrils of Adam the 'breath of life'. In the Vulgate text the etymological ties between spirit and breath are explicit: 'inspiravit in faciem eius spiraculum vitae'.⁴ This, in the Christian story, is the original moment of 'inspiration'. Wordsworth recast this first creation in his own terms, allowing a breath of wind to replace – or to represent – the breath of God:

> O there is blessing in this gentle breeze
> That blows from the green fields and from the clouds
> And from the sky: it beats against my cheek,
> And seems half-conscious of the joy it gives.
> O welcome messenger!

He wrote this invocation to the breeze, his muse, in mid-November 1799. It drew on ideas Wordsworth developed in his journal after a walk in November the year before, and in January 1804 he decided to use it as the overture to his grand poem on 'the growth of the poet's mind'. The story of his life, the story of imagination itself, would begin here. November 1798, November 1799, January 1804: this was winter work, though the cold gales seemed gentle to Wordsworth, who felt within him a 'corresponding mild creative breeze'.⁵

Wordsworth is on the brink of the journey which awaited Adam and Eve at the close of *Paradise Lost* when the world was 'all before them'. But he dispenses with Milton's 'Providence', which was to act as guide, and puts his faith in nature:

> should the guide I chuse
> Be nothing better than a wandering cloud,
> I cannot miss my way.

Wordsworth was announcing a whole philosophy of imagination. As the critic Peter Conrad observes, 'The Miltonic theology has evaporated into meteorology. Instead of ministering angels, Wordsworth's guide back to paradise is a "wandering cloud"'. The unpredictable course of air is Wordsworth's ideal structuring device. He uses it in both his epic poems: here in *The Prelude* and later in *The Excursion*, where the Poet and the Wanderer walk off together from their meeting point, not knowing where they will end up but submitting willingly to 'the changeful breeze of accident'. 'Wandering' was a tainted word in Milton's language: to wander is to err, straying from the appointed path. Wordsworth adopts and reforms it: his wanderings are not the sign of error but of creativity. They are divinely ordained, since it is the 'sweet breath of Heaven' which guides the cloud on its wandering way and in turn maps out the poet's path. The wind and the cloud are both symbols of a fallen world. In *Paradise Lost*, the winds and clouds were ordered into action as part of the punishment for man's disobedience, blowing away the temperate perfection of Eden. Milton described them with horror. Wordsworth's winds carry blessings. He has been elected to 'fellowship' with nature, which is its own kind of grace.[6]

⌒

Cumbria is now officially the rainiest county in England, dripping with twice as much rain as some other parts of the country. This didn't bother the Wordsworths. They were both phenomenally tough, able to walk for hours in steady rain, their woollen coats heavy with the wet, and still consider the experience pleasant. 'We walked on Butterlip How under the wind', wrote Dorothy on 2 March 1802; 'it rained all the while but we had a pleasant walk'. They disliked the continuous gloom of 'black drizzling days that blot out the face of things', but if there was any chance of seeing the face illuminated, and of hearing the rushing of streams after rain, 'when every brook is vocal', they wanted to take it.[7]

In his 1822 *Description of the Lakes*, Wordsworth gave lessons in seasonal appreciation. Tired of the influx of summer visitors, he argued for the unsurpassed beauty of the mountains in winter. He pointed to the

blending of withered fern with grey rock, and the fresh colours of moss and lichen. Yes, it is a rainy place, he observes, but there are harmonies in rain: 'Showers, darkening or brightening as they fly from hill to hill, are not less grateful to the eye than finely interwoven passages of gay and sad music are touching to the ear'. Though eighteenth-century poets, artists, and writers had almost always referred to Italy as the ideal, Wordsworth insisted that English skies were the ones to watch. 'The cerulean vacancy of Italy' was to him 'an unanimated and even a sad spectacle', compared with the swift, characterful, conversational, revelatory airs of the Lakes.[8]

Romantic composition was often an outdoor activity. Constable would paint outside in the rain. 'Large drops of rain falling on my palette', he once noted, untroubled, at the edge of a cloud study.[9] Wordsworth particularly liked the cold and dark. 'Starlight nights and winter winds are his delight', noted Dorothy; 'his mind I think is often more fertile in this season than at any other'. Early spring had its invigorating pleasures too. In March 1798 William and Dorothy took shelter during a hail-shower in a holly grove at Alfoxden. This was the kind of situation they both loved. William would write in *The Prelude* that 'Genius exists by interchange of peace and excitation'; under the sheltering holly he could experience the whirling wind while fostering 'happy stillness of the mind'. Dorothy, that day, sat watching how 'the withered leaves danced with the hailstones' – a ghoulish vision of ice bringing leaves back from the dead. Wordsworth meanwhile wrote 'A Whirl-Blast from Behind the Hill', in which those dead dancing leaves become a source of imaginative energy:

> O! grant me Heaven a heart at ease
> That I may never cease to find,
> Even in appearances like these
> Enough to nourish and to stir my mind![10]

The outdoor draft of a poem would usually be brought home for revision indoors, though not necessarily in the warm. On a February night at Alfoxden the Wordsworths 'sat with the window open an hour in the moonlight'. They had just walked back through a storm from Putsham, as the wind 'beat furiously' against them. Whether or not the trees were still 'roaring' in the darkness when they got home and opened the windows, the air must have been bitter. No matter: there was a full moon rising through the clouds. In February four years later, back north in Grasmere, they

were sitting again by the open window. Yesterday's snow was still on the ground, but there they sat, for 'a long time', with the 'windows unclosed', while William composed and Dorothy wrote out his verses by the light of a candle, which had to be kept out of the draught."

～

Most of us, after a walk, will talk about the weather having been grey, or bright, or raining off and on. Neither William nor Dorothy were much interested in such summaries. What mattered to them were very specific moments of transformation – when the sun suddenly strikes through cloud, for example, or when a figure is glimpsed through fog. Sometimes there will be an atmospheric event so dramatic as to stop them in their path, and sometimes they will congratulate each other on noticing a small incident – a flower lit up or the blurring of rain on a distant hill. In each case they respond to weather as an agent of revelation.

Dorothy described her favourite birch tree coming to life: 'it was yielding to the gusty wind with all its tender twigs, the sun drove upon it and it glanced in the wind like a flying sunshiney show [...] It was like a spirit of water'. This earth-rooted tree takes flight in air, dissolves into a water spirit, and glitters in the sun. Meteorological transitions are great subjects in William's poetry, not background scenery. A shepherd in the distance takes on heroic stature, 'ennobled' by the enlarging effects of fog or 'glorified / By the deep radiance of the setting sun'. In the ambient light of day one might have passed him by, but the weather, partly obscuring him, casts him in a more truthful light, signalling the grandeur of a man in his mountain home. The ingredients of the old miracle narratives are at work here: heavenly appearances in the mist, light irradiating the human form like a halo. But for Wordsworth these are natural miracles. For all the instability of their religious beliefs, the Wordsworths kept returning to ideas of a mobile, pervasive spirit linked with weather. William told an anecdote about what happened when his young son asked about the nature of God:

> I told him that God was a spirit, that he was not like his flesh which he could touch; but more like his thoughts in his mind which he could *not* touch. – The wind was tossing the fir trees, and the sky and light were dancing about in their dark branches, as seen through the window – Noting these fluctuations he exclaimed eagerly – 'There's a bit of him I see there!'[12]

The weather, this holy spirit, is no longer something to shut out. Nor, even, is it primarily to be looked at. It is to be felt; it is to be let into one's body and one's home. If possible, and this is an ideal Romantic state, one might reach the point of such immersion in the atmosphere as to feel inseparably part of it – as Dorothy Wordsworth felt, lying on Loughrigg Fell with her heart 'dissolved' in what she saw.[13] Warmth, or wind, or rain, or enveloping mist, could all prompt that loss of self which allowed the Wordsworths to feel for a moment united with their surroundings and part of a force larger than their human bodies.

Only Shakespeare had articulated such complicity of mind and sky. He had dared to make no distinction between the storm and the man who experiences it. Lear, as we hear before we see him on the heath, is 'minded like the weather'. Shakespeare gives the line casually to the anonymous 'first gentleman'; there is the hint of a joke. Romanticism is nonetheless latent in those words. Wordsworth knew it, and paid tribute by writing a Shakespearean storm scene into *The Excursion*. Where Lear's intimacy with the storm is the tragic fate of his old age, Wordsworth's is the joyous privilege of youth, and it is the sign of his inclusion not exile. The Wanderer in *The Excursion* exclaims in bliss:

> O! What a joy it were, in vigorous health,
> To have a Body [...]
> And to the elements surrender it
> As if it were a Spirit!

This is a memory of the youthful self-surrender Wordsworth described in *The Prelude*, recalling the times when he leant over crags to reach an eagle's nest, letting the wind support him. Here, in *The Excursion*, he writes of strong winds whipping round strong bodies:

> what a joy to roam
> An equal among mightiest energies;
> And haply sometimes with articulate voice,
> Amid the deafening tumult, scarcely heard
> By him who utters it, exclaim aloud,
> 'Rage on, ye elements!'[14]

That challenge to 'rage on' reprises Lear's manic goading of the heavens to do their worst. But the physical and psychological horror is all gone. Wordsworth recalls in ecstasy his youthful sensations of wild abandon. Lear's vision of the frail human form is replaced by Wordsworth's ideal of a body so energetic that it can match the force of the wind. And in Wordsworth, even when the body ages, the unfailingly agile mind allows the remembered elements to rage on.

A Flight: In Cloudland

On holiday by the sea at Ramsgate, in an unusually relaxed mood during the autumn of 1817, Coleridge let himself make pictures from the clouds. He saved up the sensations of this dreamy watching in a sonnet wonderfully named 'Fancy in Nubibus, or The Poet in the Clouds':

> O! it is pleasant, with a heart at ease
> Just after sunset, or by moonlight skies
> To make the shifting clouds be what you please [...]

He sends off his mind as a traveller, journeying weightlessly 'from mount to mount through CLOUDLAND, gorgeous land'.¹ Closing his eyes Coleridge imagines himself as blind Homer, hearing the sea, and conjuring from that sound the words of his epics. By analogy Coleridge conjures his poetry from clouds.

What made them so fertile a creative source? Their provisionality was part of it. Like a much redrafted poem there is no single authoritative version of a cloud. The cloud-form is constantly revised and never finished. For Coleridge here it is the suggestive vagueness that matters most: clouds give out the merest hint of a shape and then, as the perceiver imagines and projects more detail, they fill out the picture to represent quite convincingly whatever the observer thinks he sees. Coleridge is knowingly playing Hamlet, and claiming him as a Romantic.

The growth of nephology as a poetic subject had been predicted by Edmund Burke in his *Philosophical Enquiry* of 1757. His interest was not in clouds exactly, but in the aesthetics of obscurity. 'To see an object distinctly, and to perceive its bounds, is one and the same thing', he wrote, whereas when we cannot see distinctly, we know no bounds.² A hazy scene makes what Burke called 'some sort of approach towards infinity'. He recommended that painters include in their pictures some 'judicious obscurity' gesturing to unseen grandeur. Half a century later, for a new generation of artists and writers, mists and clouds were not merely an ingredient to be added. Clouds were the scene itself. They were both the source and the subject of art.

The most extravagant Romantic cloud scene is the one which forms the climax in Book 2 of *The Excursion*. Outdoing even Prospero,

Wordsworth builds in words the 'mighty city' suddenly revealed around and above the mountains:

> O, 'twas an unimaginable sight!
> Clouds, mists, streams, watery rock and emerald turf,
> Clouds of all tincture, rocks and sapphire sky,
> Confused, commingled, mutually inflamed,
> Molten together, and composing thus,
> Each lost in each, that marvellous array
> Of temple, palace, citadel, and huge
> Fantastic pomp of structure without name,
> In fleecy folds voluminous, enwrapp'd.[3]

It matters that this revelation comes as part of a narrative, though its relationship to that narrative refuses to be pinned down. The story is told by a disenchanted recluse to a pedlar and a poet. The Solitary (as Wordsworth calls him) has been up on the moors searching for an old man sent out by an uncaring housewife to gather turf for the fire. The old man has been out all night in a storm, but he is eventually found alive, 'snug' in a bed of protective turf he has built against the elements. He is carried down to safety by shepherds, and the Solitary follows on. It is on his descent from the moor that he is transported in a single step from dull mist to the amazing vista he describes. The old man, who made his own comfortable burial on the moor, has been resurrected to life. The landscape, too, undergoes a resurrection, emerging from mist to light.

Appearing after the violent night, the glinting cloud-city is wrought, says the Solitary, quoting Milton, 'Upon the dark materials of the storm'.[4] Wordsworth asks that we recall the realm of Chaos and Night in *Paradise Lost*, a confusion of those 'dark materials' from which worlds are made. Emerging from hell, Satan looks out over the 'wild abyss', which is rendered by Milton as the most terrifying of weather conditions. Satan flies up into the 'surging smoke' as if he were a deity in a seventeenth-century masque, hoisted from the stage 'in a cloudy chair'. But such clunky props are not built to brave this cosmic storm, nor are they adequate for Milton's vision of weather and the Romantic weather-writing that succeeds it. The makeshift cloud-chair collapses, Satan falls, and from now on literature will deal, not in painted wooden clouds, but in the drama of air and water. Satan is hurled up by the force of real weather, on a 'tumultuous cloud /

Instinct with fire and nitre'. He is a 'weather-beaten vessel' by the time he has crossed through the tempest and pauses to survey a jewelled heaven 'with opal towers and battlements adorned'.[5]

All this is reworked in Wordsworth's cloud vision. In *The Excursion* there is no Satan and there is no God. There is only nature, and human beings experiencing nature. The abyss and the empyreal heaven are relocated to the Lake District, since Wordsworth's scenes of revelation are always places on the map. Thomas De Quincey, who lived at Dove Cottage after the Wordsworths' departure, noticed the physical accuracy of what Wordsworth described in *The Excursion*. Just occasionally, he discovered, depending upon precise timing and conditions, the miraculous-seeming cloud-city was really *there*. De Quincey encountered it at four o'clock on a summer afternoon above Scor Crag, 'from which is descried the deep and gloomy valley of Great Langdale'. Looking down through the 'rents and openings' in a 'pendulous mass of vapour', he saw the familiar valley 'absolutely transfigured'. This, then, was not a singular marvel, but a repeated configuration, 'not evanescent', as De Quincey pointed out, 'but dependent upon fixed and recoverable combinations of time and weather'.[6] De Quincey, who had internalized Wordsworth's poetry, had been taught to see that vision. It had been 'wrought' in poetry first, created from the dark materials of human imagination and language. Who can say how much is 'there' in nature, and how much is made by our shape-imposing minds?

⤳

The exchange between minds and clouds has been going on for millennia. Already in 423 BC, when Aristophanes wrote his bawdy comic drama *Clouds*, there was a whole extravagant language of cloud-watching which was liable to be parodied. The play is full of mockery for writers of elaborate, unfathomable poetry and natural philosophers who talk a lot of hot air about the sky. 'You mean you never knew that they were goddesses?' asks Socrates in one scene; 'I thought they were mist, dew, vapour, that sort of thing', replies the earthier Strepsiades, dismissing a whole lexicon of cloudy poeticisms. Satirically portrayed by Aristophanes, Socrates is meant to expose his own highfalutin impracticality when he praises the clouds as the patron goddesses of philosophizing 'layabouts' like himself. Perhaps the audience in the Greek theatre laughed, but many artists would

take seriously the words with which Socrates welcomes to the stage the chorus of clouds: 'They are celestial Clouds, the patron goddesses of the lay-about. From them we get our intelligence, our dialectic, our reason, our fantasy and all our argumentative talents.'[7]

Though Aristophanes joked about the gullible tendency to see 'a cloud shaped like a centaur, or a leopard, or a wolf or a bull', there was nothing superficial about the best of the cloud visions to come.[8] The history of the human impulse to find legible forms in inchoate matter might fill many volumes.[9] Some artists have shaped their clouds into figures, so that the weasels and whales are permanently there, eerily looking back at us. The Italian art historian Chiara Frugoni has recently spotted a devil's face which has been looking out from the clouds of a Giotto fresco since the late thirteenth century; the cloud-rider on horseback in Mantegna's *St Sebastian* of 1458 has not taken the world quite so long to find.[10] Leonardo da Vinci recommended that artists in need of inspiration could find prompts merely by looking at a stain on a wall: all kinds of landscapes and figures might appear ('heads of men, diverse animals, battles, rocks, seas').[11] The promising stains on his wall were analogous, as he realized, to clouds in the sky: forms specific enough to jolt the mind into new thoughts, but vague enough to support fantastical interpretations. 'I have in the past seen clouds and wall stains which have inspired me to beautiful inventions'.

One of the most intriguing people in this history was the painter Alexander Cozens, an intense and eccentric figure around whom legends liked to gather. He started his life in Russia in the early 1700s, the son of a British shipbuilder (there were stories that he was an illegitimate son of Peter the Great), but he spent most of his career in London and played a significant part in establishing a tradition of English watercolour painting. He is best known for his advocacy of the 'blot method', and this is where he enters the history of form-finding. He explained his blots to an intrigued public in a 1785 treatise called *A New Method of Assisting the Invention in the Composition of Landscape*. The best way to paint an ideal landscape, Cozens thought, was to begin with an indeterminate blot. Take a broad brush and ink and splurge a general 'effect' on to the page. Study it, as Hamlet studied the cloud, until landscape forms emerge. Take a smaller brush and articulate these detailed forms. Summon out rocks and hills from the black seas of the blot, in formations you may never have imagined before.

It was a celebration of individual vision, valuing the creations of the inner eye over the representation of external scenes. 'One artificial blot will suggest different ideas to different persons; on which account it has the strongest tendency to enlarge the powers of invention'. Cozens loved the 'vague and indeterminate' nature of blots, their flirtation with chance and felicity.[12] Yet his own imagination was not much given to free wandering. His *New Method* was soothingly methodical; the point of the book was that you could follow the steps, like clockwork, to produce reliably imaginative pictures.[13] It was meant as a textbook, publicizing techniques that Cozens had long used as a teacher at Eton. With schoolmasterly clarity he gave numbered instructions, including a recipe for the blotting ink (made with lampblack and gum arabic). It was in keeping with previous textbooks in which he had recommended set formulae for drawing different types of face or species of tree. His friend William Beckford said that Cozens was 'almost as full of systems as the universe'.[14] The *New Method* was a curious, very eighteenth-century combination of things, licensing accident while also prescribing the stages by which it should be achieved.

Cozens associated blots with clouds from the first, taking as his epigraph the dislimning cloud vision from *Antony and Cleopatra*. He had advice for painting actual clouds as well. At the end of his book he reproduced a series of engravings showing twenty cloud formations, all guaranteed to give your picture a pleasing sky. Like the blotted landscapes, these clouds were both purposely vague and carefully classified so that you could choose your sky and make it your own. Sky-type 18: 'Streaky clouds at the top of the sky'. Sky-type 20: 'half closed half plain, the clouds darker than the plain or blue part, & darker at the top than the bottom'.

Cozens's blots and clouds lived in the minds of the English painters who saw them. In 1823 John Constable made patient copies of all twenty cloud plates in the *New Method*, using them as a measure against which to gauge what he saw for himself in the sky.[15] J. M. W. Turner studied at the academy of Dr Thomas Monro, who owned drawings by Cozens and was well versed in his methods. The blot would become for Turner more than it ever was for Cozens. The 'indeterminacy' valued by Cozens as a starting point would be Turner's goal; the cloud from which Cozens's firm land emerged would be for Turner the enveloping cloud into which the solid things of the world sank back. It is a remarkable story of artistic inheritance. These strange clouds of ink helped to shape the work of two

Top: Alexander Cozens, blots from *A New Method of Assisting
the Invention of Drawing Original Compositions of Landscape*, plate 13. *c.* 1784
Above: John Constable, *Cloud Study* (no. 9 of a series of 20 studies
of clouds after Cozens), *c.* 1822

great painters of the next generation, who would both, in their separate ways, put cloud painting at the very centre of their art.

<p style="text-align:center">⌁</p>

The copying of Cozens was only part of the ambitious course of training on which Constable enrolled himself. In his mid-forties, just at the moment when success as a painter finally looked possible, he decided that his skies were not good enough and that he must practise until he had mastered them. Starting in Salisbury in 1820, and continuing on Hampstead Heath in 1821–22, he made the cloud studies which are now among the most admired of his paintings. Sometimes he grounded the picture by sketching in the horizon line, or by letting us catch a glimpse of the mobile treetops. But mostly he painted sky. They are so free of narrative, these studies, that they appeal to the modern eye as some abstract paintings appeal. Yet they are far from abstract: Constable was painting precise conditions with all the fidelity he could. 'Skying' he called it, using a term which he may have borrowed from the Dutch painter Van de Velde the Younger (who was said to go 'skoying'), or from Turner (who certainly used the word in private), or which he may have invented himself for his invented task. 'I have done a good deal of skying', he told his friend John Fisher, 'for I am determined to conquer all difficulties, and that most arduous one among the rest.'[16]

Impressionistic clouds are one thing, but it is another matter to paint clouds accurately from nature with the attention one would give to a model in the life room. For one thing, the cloud-model kept moving. Constable had to commit to memory the shape of a cloud, so that he could keep painting after it had changed beyond recognition. Since clouds take their identity from process rather than permanence, he had to show in his static paintings that the clouds were mobile. Wondering how it could be done, he studiously copied the work of Dutch artists who had filled their canvases with the vast skies of the Low Countries, particularly Jacob van Ruisdael who had come closer than anyone to catching the life of clouds.[17] Constable understood exactly the challenge: the viewer must be able to see where the wind is coming from and what the cloud is about to become.

He achieved this with such accuracy that the precise timing of his paintings can now be gauged by reference to historical weather data. One study was labelled by Constable '31 Sepr. 10–11 o'clock morning looking Eastward a gentle wind to East'. Meteorologists checking it against the

records for 1822 have found that this formation of clouds would not have appeared over Hampstead until the next day, 1 October. We know that Constable got the date wrong because he got the clouds so right. This painting has a touch of the Rococo in its soft pinks and greys, but Constable's precision affirms that clouds depicted accurately are more beautiful than any dreamed-up approximation.

It took practical knowledge to parse the sky like this. The weather had been the currency of Constable's childhood: his father owned a group of windmills in Suffolk, which the young Constable visited regularly until he spent an entire year there as a miller's apprentice. The wind was his business; he needed to determine its direction so that the sails could be turned into it. He also learned some of the mariner's art of sky-reading when he spent a month on board a ship, never sailing far from the coast of England, but seeing 'all sorts of weather' even so: 'some the most delightful, and some as melancholy'.[18] The painter who sat on Hampstead Heath in the 1820s had an outdoor working life behind him. He could read the sky as a ploughman reads the field or a coachman the road ahead.

Carefully labelled with positions and dates, Constable's cloud studies formed a naturalist's journal in the manner of Thomas Barker and Gilbert White.[19] In the diary-keeping tradition, they were also a kind of scientific investigation, and Constable read up on the latest research. He annotated, for example, a copy of Thomas Forster's *Researches about Atmospheric Phenomena*, and what he found in this book were strenuous moves towards a systematization of cloud formations.

The 'modifications of clouds', as proposed by the young Quaker chemist Luke Howard in 1803, were all mapped out in Forster's book. Howard identified three basic cloud families, or 'modifications', which he called 'Cirrus', 'Cumulus', and 'Stratus'.[20] Telling the story of how Howard named the clouds, Richard Hamblyn observes the excitement among Howard's early readers: 'The world seemed suddenly to have been pulled more sharply, more richly, into focus.'[21] The whole idea of 'order' was changed: order need not be a static system, but – like the clouds – constantly moving. It is no surprise that Constable, who imagined heaven as a place where one might walk 'arm in arm with Milton and Linnæus', paid attention to the new taxonomy of clouds.[22]

For all this, Constable kept pulling away from objective observation towards what remained truly elusive. He did not adopt Howard's names in

his daily writing or in the annotation of his drawings; perhaps they did not help him very much. The language Constable really wanted to learn was the mood-language of weather. When he wrote to John Fisher about Gilbert White he said that 'the mind and feeling which produced the "Selborne" is such a one as I have always envied'. 'Mind and feeling' were what he cared about when he painted the sky. In another letter to Fisher, written in October 1821 after a long summer of work on Hampstead Heath, Constable reached for phrases that might convey the relationship between sky and feeling: 'It will be difficult to name a class of Landscape, in which the sky is not the *"key note", the standard of "Scale"*, and the chief *"Organ of sentiment"*'.[23] He was likening landscape to music and to the sentient body. He needed every analogy he could think of to explain things that no one seemed to have explained before. The sky is a tuning fork establishing the note, or it is the tonic chord, setting the key for the music of the whole scene. The sky is also a living 'organ'. Constable's quotation marks around 'Organ of sentiment' suggest that this was a familiar contemporary phrase. Phrenologists investigating the human brain at just this time were claiming to have identified organs for various brain functions: organs of knowledge, organs of propensity, and 'organs of sentiment'.[24] So if Constable is imagining the landscape as a living being, he may be analysing the dome of the sky as a phrenologist analyses the shape of a head, wanting to find the part of it that feels. The bodily analogy is richly ambiguous. Whose organs, whose sentiments? The sky is being named as a feeling organ, but the sentiments are surely those of the perceiver. Constable's skying was probing at the most mysterious emotional relations between man and his environment. Did he hear and approve the echo of 'scrying', the art of divination?

Constable's 'organ of sentiment' was capable of infinitely subtle variations. He could paint a cheerful Salisbury Cathedral as a wedding present for Bishop Fisher's daughter Elizabeth in 1822 ('I wish to have a more serene sky', wrote the bishop when he placed his order).[25] But when he painted that familiar scene again in *Salisbury Cathedral from the Meadows* (1831), the mixed weather became a complex narrative of changing moods. A storm is passing, and a clear summer afternoon may or may not emerge. The last of the lightning cracks around the cathedral spire, and the clouds are still agitated, whipped up by the staccato action of a palette knife, while in the foreground below every leaf and bramble is stirred by the wind. The rainbow which arches down over the Fishers' house has been called 'as

unpretty a rainbow as has ever been depicted [...] a wounded rebuke to Wordsworth's leaping heart'.²⁶ The expression of mood usurps the precise recording of nature. This is in fact an impossible rainbow, since the sun is to the side of the picture rather than behind us. 'The sky is wrong', writes the meteorologist John Thornes, 'But it is magnificent'.²⁷ All those years of skying had allowed Constable to create his own weather for the purposes of conveying, in meteorological language, imaginative truths. There was a laughing possessiveness in his letter to John Fisher of November 1823: 'You can never be nubilous' he wrote: 'I am the man of clouds'.²⁸

⤳

Clouds and inspiration go together in Romantic culture, but in many ways the association is counter-intuitive. It runs against our practical experience in Britain of blanket cloud which obscures the sun. John Keats, for one, looked about in disappointment. At the top of Ben Nevis there should be, surely, great visions to be had: something close to what Wordsworth experienced on Snowdon. Keats made the ascent in August 1818. He sat on the summit – 'a few feet from the edge of that fearful precipice', as his friend Charles Brown nervously observed – and wrote a sonnet. But it was not a sonnet of vision, because Keats found himself rendered 'blind in mist'. Cloud below him shrouded the earth; mist above him hid the sky. It was not a haunting mist of the kind the Wordsworths might have noted, but merely 'sullen'. 'Just so much I wist / Mankind doth know of hell', he wrote, and 'Even so much / Mankind can tell of heaven'. Perhaps divine infinity was made of this. For Keats this experience of blindness became symbolic of man's occluded mind:

> all my eye doth meet
> Is mist and crag, not only on this height,
> But in the world of thought and mental might!²⁹

This is a revelation of how nothing is clearly revealed. What is a 'thought', he asks, but more of this mist? Turning himself inside-out, Keats makes the cloud around him a projection of his own mind. If the cloud has besieged him from above and below, he responds by claiming those clouds as his vast mental space. Standing in the mist we are suddenly looking round at the great interior of Keats's brain.

In Germany, that same year of 1818, Caspar David Friedrich painted what would become one of the great icons of Romanticism, *Der Wanderer*

über dem Nebelmeer. The Wanderer stands on an elevated outcrop, gazing over the 'sea of fog' before him, commandingly portrayed as king of all he surveys. He stands in the place of God the Creator, as if at the beginning of time. 'Nebel' went up from the face of the earth in Luther's translation of Genesis (where the King James translators gave the more delicate 'dew'), so that Friedrich's 'Nebelmeer' seems to hold within it all the future contents of the world.[30] It is an exhilarated image of conquest, quite unlike Keats's quizzically underplayed sonnet of non-revelation.

Friedrich had no time for the dreariness of total cloud-cover. He painted clear air and sunlight above the fog. The sky, he thought, was the true image of infinity, and when our view of it is narrowed our minds are 'proportionately constrained and oppressed'.[31] Yet in Friedrich's painting the mind *is* cloud. The sea of fog is the outward expression of the Wanderer's mind. His hair, catching the wind, curls like the cirrus around him (the cloud named after wisps of hair). The mist seems to emanate from him. The Anglo-Saxons had once imagined thoughts being made from clouds, and accordingly prone to 'unstaðelfæstnes'.[32] Both Friedrich and Keats go further and suggest that mist is an accurate figuration of all mental life. To think is to walk among clouds.

Goethe had suggested that Friedrich make paintings to illustrate the 'modifications of clouds' as inventoried by Luke Howard. Friedrich was not impressed and responded with outrage. What Goethe suggested, he said, would undermine the very foundations of landscape painting.[33] Friedrich's imagination alone would shape the clouds in his art, for the clouds he painted were images of imagination itself. It was not to be ordered and given firm outline. Friedrich proposed that inside the human head is an infinite 'Nebelmeer'.

⌒

The cloud-mind could be glorious, and it could also be a nightmare. Thomas De Quincey described his mental landscape as a terrifying cloud structure bubbling up beyond control. The 'splendours' of his opium-induced dreams, he wrote in his *Confessions of an English Opium-Eater* (1821), were 'chiefly architectural', though it was a kind of architecture that belonged to clouds rather than to the earth: 'I beheld such pomp of cities and palaces as was never yet beheld by the waking eye, unless in the clouds'.[34] As a description of what he saw in sleep, De Quincey quoted in

full the cloud vision from *The Excursion* with all its 'alabaster domes, and silver spires'.

He built up an elaborate tracery of allusion so that the imprisoning structures of Piranesi's *Carceri* engravings were layered on to Wordsworth's cloud-city We re-experience that revelatory moment from *The Excursion*, now shadowed by Piranesi's tantalizing labyrinths, and seen not through the wondering eye of Wordsworth's Solitary, but in the drugged inner vision of De Quincey. In Wordsworth's poem the 'boundless depth' of the clouds, spreading far into the distance 'without end', is part of their splendour. Turned inwards by De Quincey, this endlessness is dreadful. The imagination generates more and more and more extravagant imagery. Thoughts multiply nauseously. 'Unstaðelfæstnes' becomes a torment.[35]

De Quincey was contrasting himself with Wordsworth, casting himself as the fallen Romantic in whose imagination the most luminous Wordsworthian visions turn bad. But clouds were troubling for Wordsworth, too. Though he was willing to elect a cloud as his guide through *The Prelude*, he could not really put his trust in such a detached and shifty thing. 'I wandered lonely as a Cloud', has come to sound like a statement of ideal freedom, but the trajectory of the poem is from the unworldliness of this wandering towards delight in the solid things of the earth.[36] Wordsworth's moment of ecstasy comes when the dancing daffodils wake him from drifting. He must be cloud-like in order to encounter such things, leaving himself receptively open to chance. But it is the rooted daffodils that are spiritual, appearing like a heavenly host as they dance in the breeze.

Even the cloud vision in *The Excursion* is suspect. The Solitary pauses a moment in the ecstasy of his tale before shrugging it off. The clouds, it seems, did not portend much after all: the old man's resurrection, he explains, lasted for only three weeks. After that he died, and was carried to his final burial. Was the Solitary foolish, then, to find the clouds beatific, and to suppose that they had meaning? Some of Wordsworth's most attentive readers have suggested, daringly, that 'The fantastic, pompous vision is a symptom of [the Solitary's] own sickness'.[37] Perhaps it is delusional to see the New Jerusalem in clouds.

Wordsworth kept wondering whether there was any satisfaction to be found in cloudland. A sonnet composed 'after a journey across the Hamilton Hills, Yorkshire' in 1802 describes the fantastic architecture seen in the clouds by moonlight, before making an effort to forget it. 'The

western sky did recompence us well / With Grecian Temple, Minaret, and Bower' – and Wordsworth's eye delights in them. Then the poem turns on itself with curious guilt:

> we felt, the while,
> We should forget them: they are of the sky,
> And from our earthly memory fade away.

He wrote another sonnet as a sequel, several years later, pursuing the subject and revising his views. No, he decided: he did not want to look at clouds. They are not stable, and stability means everything to Wordsworth:

> The Grove, the sky-built Temple, and the Dome,
> Though clad in colours beautiful and pure,
> Find in the heart of man no natural home:
> The immortal Mind craves objects that endure:
> These cleave to it; from these it cannot roam,
> Nor they from it: their fellowship is secure.[38]

This is the Wordsworth who carved in stone the names of those he loved. It is the Wordsworth who needed always to reach home after his wandering walks. The sky, for this reason, could not hold him in thrall in the way that it held the opium-addicted Coleridge, whose poetry kept building domes in air. Wordsworth built homelier things. Clouds, in the end, could only guide his imagination so far.

VII

Make me thy lyre ...

Percy Bysshe Shelley,
'Ode to the West Wind'

SHELLEY ON AIR

Shelley watched with envy everything that flew. As a student at Oxford in the Michaelmas term of 1810, he talked late at night about the possibility of balloons crossing the skies over Africa, carrying with them messages of democracy. He imagined with passionate conviction how a balloon would glide with the African sun straight above it, and how its shadow, as it passed over the land, would 'annihilate slavery forever'.[1] Wind-power, and the balloons which harnessed it, looked to Shelley like vehicles of revolution, transgressing all borders. He longed to use the wind as a messenger for his own ideas. It was all very well to publish works of atheist and democratic argument, but the means by which books and pamphlets were distributed seemed to him tediously slow and ineffectual. His words were earthbound. They had to be transported on coaches along rutted roads, sold by intermediaries, passed from hand to hand. If only they could be carried on the wind – the wind which could go anywhere and speak to anyone.

At Lynmouth in the summer of 1812, Shelley spent weeks with his wife Harriet Westbrook and his friend Bessie Hitchener sewing pieces of silk into balloon shapes. Then he suspended candles from the fabric and tied on copies of his 'Declaration of Rights', with its thirty-one propositions on liberty. In excitement he lit the wicks and launched these strange contraptions up into the air, sending his words into the world. None of these balloons has ever been found, so we do not know how far they went. The prevailing wind from the Atlantic took them, perhaps, a little way across the Bristol Channel.[2] The experiment was, in one sense, amateurish wishful thinking. But Shelley knew the power of a symbolic gesture, and he was right to anticipate that the future of communication would belong partly to the air. While the aeronautical scientists were working to make their professional balloons steerable, what Shelley valued most about his balloons was that they might go anywhere. His love of wind was always connected with its unpredictability: to surrender to it meant yielding to an invisible and unknowable force. His written words, like the breath from his lungs, became part of the atmosphere. So he let his balloons float up and off, dispersing the 'knowledge' of democratic reform wherever the wind took it.

He gave this knowledge to the sea as well. On the dark Lynmouth shingle, just below the cliffs where Coleridge had rushed out to see the commotion of elements, Shelley launched green bottles into the waves, each carrying a political text rolled up inside. He called on the wind to propel them along before washing them safely into receptive hands. 'May the breeze / Auspicious waft your dark green forms to shore'.[3] The wind, more than the water, is the force of change here, welcomed by Shelley as the agent of 'Liberty herself'. The west wind is best for such a task, associated not only with the new beginnings of spring but with the republican new world of the west: America.

Shelley's ambition was always to spread words rather than to hoard them, which is why he sanctified the apparently free movement of air. It was part of what made him so different from Coleridge, who chided himself for never wanting to throw anything away. The physicality of ink and paper was important for Coleridge because it signalled that the world's learning could be gathered and collated on the table in his study. Shelley by contrast was willing to let a new thought replace (dissolve, or set light to) an older one. No natural archivist, paper was to him merely the medium by which thoughts might travel, and if they could travel unfettered by earthly materials then so much the better. Every autumn he watched the little helicopters of sycamore seeds spinning through the air and landing in new places where young trees might grow. Winged seeds became, as Richard Holmes observes, one of Shelley's favourite symbols.[4] The balloons he had launched were homemade versions of these seeds. He was seed-like himself, but without ever pausing on the soil long enough to take root.

Sometimes he dealt with members of his family as if they too could fly as lightly and easily as the sycamore. It was not that he wanted to keep everyone in transit, but domestic and political developments seemed to require it. He felt that the whole household was impelled to keep moving like clouds across the sky. During the Shelleys' years in Italy, from 1818 to 1822, the weather moved them on even when events did not. They took remote country houses for the summer and moved back into the city when the winter came. Gripped by the rapid changes of the Tuscan sky, Shelley walked around Bagni de Lucca in summer 1818 watching 'the growth of the thunder showers with which the noon is overshadowed, & which break and fade away towards evening into flocks of delicate clouds'.[5] In Livorno he rented a house with a glass tower at the top, an

elevated sky-capsule in which he spent his days looking out across the bay.[6] The breaking of the weather at the end of summer was always an augury of change. Restlessly, the Shelleys would hang on into the last days of the season, packing and making plans while outside the winds began to rise. It was at just this time of breakage and anticipation, in the autumn of 1819, that Shelley walked in the woods near Florence and sensed on the wind the coming of revolution.

News had reached him in early September of the Peterloo Massacre. A peaceful gathering of thousands of workers outside Manchester on 16 August had turned to bloodshed when mounted militia carrying sabres went charging into the crowd. Protesters were crushed as they tried to get away, and, though the death toll was lower than originally reported, about five hundred people were wounded. It looked like a pivotal event; Shelley, alight with rage, immediately compared it with the beginnings of the Revolution in France. His language for what was happening was meteorological: 'These are, as it were, the distant thunders of the terrible storm which is approaching'. Walking by the River Arno on 25 October he felt an autumn storm building. There and then he wrote his 'Ode to the West Wind', addressing himself to the 'Wild Spirit, which art moving everywhere': 'Destroyer and Preserver; hear, O, hear!'[7] As the autumn wind acts violently, so does social revolution entail violence, but in both cases destruction opens the way to rebirth.

The 'Wild Spirit' seems to transcend any actual wind that might blow your umbrella inside-out in autumn, yet Shelley insisted on the topographical specificity of the poem's composition. He appended to the title a lengthy footnote describing how he conceived the poem in a wood by the Arno 'on a day when that tempestuous wind, whose temperature is at once mild and animating, was collecting the vapours which pour down the autumnal rains'.[8] The precise qualities of suddenness and animation in this wind are important, as is the fact that the west wind of autumn will be followed by the benevolent west wind of spring.

This very particular wind becomes a universal symbol of movement, liberty, inspiration, and the breath of language which will inspire the crowds. Shelley wants to become an Aeolian harp so that the wind can play its message on the receptive strings of his body and mind. 'Make me thy lyre', he asks, and then he goes further, envisaging a complete fusion: 'Be thou me'. Once poet and wind are one, the contents of the poet's head

can be carried in the air, dispersed like the 'winged seeds' he had long been watching, and scattered like autumn leaves.

·❧·

Shelley's meteorological writing is always concerned in some way with a fantasized escape from the constraints of a human body and skull-encased mind, and from the singleness of a face and name. 'So much for self', he wrote to his friend Leigh Hunt, asking that a poem be published anonymously: '*self*, that burr which will stick to one. I can't get it off yet'.⁹ He shook off the burr in 1820 by transforming himself into a cloud – not just wandering *like* it, but becoming it. In 'The Cloud' he speaks from the sky, before letting himself descend as rain into 'ocean and shores'. 'I bring fresh showers for the thirsting flowers', he begins, joining that long line of English poets who start with rain, but going so far this time as to be the rain itself. As Shelley shows us round his cloud-body, looking up to the 'towers' of his 'skiey bowers', up through his 'tent's thin roof', and down to his 'fleece-like floor', it is hard to believe he had seen nothing like the modern photographs taken by research scientists inside cloud systems.¹⁰

Shelley's dissolution of self was also a magnificently expansive replication of the self. He wanted to be a cloud, but he also wanted all clouds to be him. With his usual overreaching aspiration, Shelley flirted with becoming a version of that most powerful cloud-like being, the Holy Spirit. Shelley's cloud has wings suggestive of an angelic or spiritual presence. By the third stanza the invocation of Genesis and *Paradise Lost* is explicit: 'With wings folded I rest, on mine airy nest, / As still as a brooding dove'. The cloud-as-dove rests, perhaps, with folded wings, after the work of insemination described by Milton in those breathtaking lines addressed to a Spirit which was present before Creation itself:

> Thou from the first
> Wast present, and with mighty wings outspread
> Dove-like sat'st brooding on the vast Abyss
> And mad'st it pregnant.

All the future energy of the world is concentrated in the wings of that dove-like form. Harnessing the power of Milton's creation scene, Shelley emphasizes the potential energy of his cloud. And he was right to do so. Scientists now know that a cumulonimbus typically weighs more than

100,000 tonnes and can release 'the energy-equivalent of an atomic bomb every couple of minutes'.[11] Part of the fascination of clouds is the contrast between their apparent idleness as they drift fleecily about, and the giant potency we know them to contain. Shelley catches this precisely, resting with folded wings in the tense pause between the cloud's production of hail, lightning, and rain.

Shelley was freeing himself for a moment from his troubles on the ground. As he struggled to hold together his complex family circle, news arrived of the death of his ward Elena. The cloud was indifferent to such pains, carrying on far above them. In a personal letter at this time, Shelley envisaged himself and his household as cloud-like in a different way. 'As for us', he wrote, 'we are uncertain people who are chased by the spirit of our destiny from purpose to purpose, like clouds by the wind'.[12] He felt harried and pursued. In his poem, Shelley taught himself to love his cloud-like destiny by thinking of its power.

The cloud's greatest triumph, as it laughingly proclaims, is its immortality. It may fall to earth as water, but that water will evaporate and reconstitute a cloud. And so on – for as long as there is water on earth. Shelley replaces the death and resurrection of Christ with the miracle of the water cycle. Here is the cloud at the end of its poem, having dispersed itself as rain:

> I silently laugh at my own cenotaph,
> > And out of the caverns of rain,
> Like a child from the womb, like a ghost from the tomb,
> > I arise, and unbuild it again.[13]

Shelley mocks anything so solid as cenotaphs and tombs. His version of creativity is not construction with earthly materials, but a process of 'unbuilding' by which he frees himself again into the air.

�

As a teenager Shelley had loved sailing paper boats on ponds. His adult notebooks are full of boats, sketched around the edges of his poems and setting sail across pages. Perhaps each time he drew one he was mentally at the helm, skimming across water rather than paper. As in his sonnet 'On Launching some bottles filled with Knowledge into the Bristol Channel', it was the wind that mattered as much as the water. Shelley's passion for

Percy Bysshe Shelley's sketches
of sailing boats in a notebook of 1822.

sailing-boats (not rowing-boats), and for fast, agile sailing-boats at that, was the expression of his yearning to be at the mercy of the wind. On dry land our brain and legs between them insist on sensibly controlling our direction. Taking to the water and letting the air fill the sails, Shelley could surrender to the wind.

Sailing and flying were closely linked in his mind. For years he had been imagining airships that would allow him to sail through the 'the Ocean of Aether'. They were fast and powerful, magical improvements on his hand-stitched silk balloons. His 'Witch of Atlas' travels the world in such a vehicle, getting out sometimes to hitch a ride on a cloud 'like Arion on a dolphin's back / [...] singing through the shoreless air'.[14] For the sky-sailor, the air was a version of the sea but without the limitations of the coastline.

If Shelley couldn't have an airship, a boat would do – and he got one at the age of twenty-nine. His high-specification, twin-masted schooner arrived in May 1822. On the afternoon of 8 July he set out from Livorno, with his friend Edward Williams and boathand Charles Vivian, on his way north across the Gulf of La Spezia to Lerici further up the north-west Italian coast. His subsequent death at sea is one of the most famous stories in literary history. There are few clear facts and many competing accounts of what happened, but it is certain that the boat was caught in the storm that came up from the south-west that evening. It is certain too that when the boat sank its sails were still full. Why had they not been taken in? An Italian captain, out in the gulf that night, reported that he had offered to rescue the sailors, and shouted that they must at least reef their sails. The captain's account, narrated at second-hand, included a detail that has become part of the Shelley mythology: 'One of the gentlemen (Williams it is believed) was seen to make an effort to lower the sails – his companion seized him by the arm as if in anger'.[15] It is possible that Shelley's desperate need for the wind took, in the end, a fatal form.

THE STILLNESS OF KEATS

Two great autumn odes were written in 1819. Shelley wrote his poem to the wind rising along the Arno, scattering the leaves, dispersing thoughts, hurrying nature on through revolution and death into the new life of

spring. John Keats did almost precisely the opposite. He walked through the water meadows outside Winchester, basked in the late warmth, and wrote a poem about the still-point of the turning year. His ode 'To Autumn' makes time stop. Keats preserves the moment when nature, replete, seems to hold its breath. Romantic poetry may be remarkably 'ventilated', as critics have observed, but Keats protects both himself and his poetry from the wind.[1] He longs, not for the dispersal of ideas, but for concentration and accretion. He is the great English poet of stillness.

Portraits of Keats show him sitting, or propped up on chairs. Wordsworth was painted out on Helvellyn in the dark; Keats was painted by the window, indoors with a book. He loved walking – he had climbed Ben Nevis – but his walks were normally through flat fields or around the walls of an old city, and were preferably done in sunshine. There were practical reasons for Keats not to join in the storm-hunts and wind-worship of his contemporaries. In 1817, at the age of twenty-one, he became unwell with what was probably venereal disease. He avoided going out much that autumn because the cold air hurt his throat. He seems not to have been completely well again before much more serious symptoms appeared, spelling pulmonary tuberculosis.[2] From then on, his lungs were extremely sensitive. It was dangerous for him to brave the elements, even when he wished to. Bad weather therefore meant confinement and it brought him low.

In the spring of 1818 he went for an extended stay in Teignmouth, hoping to explore Devon. But it rained and rained. 'A splashy, rainy, misty, snowy, foggy, haily, floody, muddy, slipshod county', he deemed it after some miserable days in mid-March. Things did not improve: it rained all through April. 'No feel of the clouds dropping fatness', he noted wryly, disenchanted. Devon in the rain did not feel like the divinely watered country of the psalms, 'but as if the roots of the earth were rotten cold and drench'd'. Those roots seemed linked to the roots of Keats's nerves. He was the least weatherproof of men. Not only was his body susceptible to the damp, but his imagination seemed to let the water in. 'I lay awake last night – listening to the rain with a sense of being drown'd and rotted like a grain of wheat'.[3] This was a disturbing thing to be imagining in the small hours. The empathy which allowed him to inhabit a character from Shakespeare, or the body of a nightingale, meant that involuntarily he felt the rain as if he were out in it – and not just in it, but passively subjected

to it, overwhelmed by it like the corn. The roof of his bedroom could not keep him from the sensation of deluge.

<div align="center">⌒</div>

There was a great deal of bad weather in the teens of the nineteenth century. The year 1816 brought a series of meteorological anomalies similar to those experienced across Europe in 1783, though more extreme and extended. The cause, it turned out, was similar too. The eruption of Mount Tambora in 1815 sent 140 billion tonnes of volcanic dust into the atmosphere, blocking sunlight in the northern hemisphere, thousands of miles from where the volcano was still shuddering and spilling on its island in the East Indies.[4] Byron wrote a poem of climatic catastrophe called 'Darkness', a prophetic nightmare brought on by very real environmental conditions in the summer of 1816:

> Morn came and went – and came, and brought no day,
> And men forgot their passions in the dread
> Of this their desolation; and all hearts
> Were chilled into a selfish prayer for light [...][5]

Byron's vision of the 'seasonless' world, a 'lump' of clay, was a narrative of creation undone, a return to the original void. It was like the Norse myths of Ragnarök, which envisaged a deep winter lasting for years until the battle of the gods and the submersion of the earth in water.

This was the summer when Byron and the Shelleys were together at the Villa Diodati on Lake Geneva and set themselves the challenge of writing ghost stories. It was a task more appropriate to long winter nights, but this summer was a wintry season. The perpetual rain was depressing, and the storms were something else. Mary Shelley was enthralled by the spectacle:

> The thunder storms that visit us are grander and more terrific than
> I have ever seen before. We watch them as they approach from the
> opposite side of the lake, observing the lightning play among the
> clouds in various parts of the heavens, and dart in jagged figures upon
> the piny heights of Jura, dark with the shadow of the overhanging
> cloud, while perhaps the sun is shining cheerily upon us. One night we
> *enjoyed* a finer storm than I had ever before beheld. The lake was lit
> up – the pines on Jura made visible, and all the scene illuminated for

an instant, when a pitchy blackness succeeded, and the thunder came
in frightful bursts over our heads amid the darkness.[6]

These were young people who had grown up with ideas of the sublime, but still perhaps only Coleridge and Wordsworth had written so explicitly about the pleasures of a storm. Mary Shelley underlined the word 'enjoyed' as if she felt the perversity of it. The lightning fused in her mind with the galvanizing electric sparks she had seen used by scientists in pursuit of the life-spark. This was the lightning that shocked into life the novel which had long been germinating and which became *Frankenstein*. Where Byron saw lumpen deathliness that summer, Mary Shelley saw terrifying new forms of vitality.

The aberrant weather became part of the meteorological drama of Romanticism. On his honeymoon at Weymouth in Dorset that winter, Constable painted surging clouds so dark they throw the beach into nocturnal shadow, except for where a gleam of sun breaks through, more like lightning than daylight.[7] Turner painted sunsets of blazing redness in the years after Tambora, when the evening sunlight refracted through the ashen air really did appear blood-red. But Keats was longing for the sun to be warm again. Through the 'year without a summer' he watched and waited for temperate days which did not come. In late January 1817 Keats thought the air might be clearing at last:

> After dark vapours have oppressed our plains
> For a long dreary season, comes a day
> Born of the gentle South, and clears away
> From the sick heavens all unseemly stains.[8]

This is not about an ordinary winter giving way to early spring. The vaporous darkness and dreariness that Keats invokes here is something more disturbing than even a bad winter. The atmosphere itself is ill.

In imagination, Keats leapt forward to budding leaves, and then, in two lines of his sonnet, ran straight through the whole growing season to the point of ripeness: 'Leaves / Budding – fruit ripening in stillness – Autumn suns'. Here (in a poem written in January) we have the autumn imagery of 'ripening in stillness' that will dominate 'To Autumn'. Already Keats has fixed on autumn as a centre of gravity for his poetry. He races through the rest of the year so that he has time, in the last five lines of the sonnet, to gather in, like a harvest, its many associations:

Budding – fruit ripening in stillness – autumn suns
Smiling at eve upon the quiet sheaves –
Sweet Sappho's cheek – a sleeping infant's breath –
The gradual sand that through an hourglass runs –
A woodland rivulet – a Poet's death.[9]

The 'poet's death' here may allude to Thomas Chatterton, with whom Keats said he always associated autumn.[10] But by the following year he was expressing his own fears of death before autumn:

When I have fears that I may cease to be
Before my pen has glean'd my teeming brain
Before high-pilèd books, in charactery,
Hold like rich garners the full-ripen'd grain [...][11]

There was as yet (this was written in January 1818) little reason to think his time would be cut short. Yet Keats already feared that he would 'cease to be' in the spring or summer of his life, and he tried consciously to incorporate autumn into the early part of the year. At twenty-two, Keats established an urgent narrative for himself: he must reach the autumn of his career as a poet, bringing his mind to ripeness.

In February 1818 he wrote a letter fusing the imagery of spring and autumn. The beautiful morning had made him lazy; his laziness had heightened his sense of the morning's beauty. He sat still and opened himself to sensation: 'let us open our leaves like a flower and be passive and receptive'. Erotically expectant, he waited for pollination. In another mood and other weather this was the receptiveness that could make him feel exposed to the rain at night, rotting like the corn. Here the openness allows the warmth and sunlight in. He is both flower and woman, creating by receiving rather than by giving, by stillness rather than activity. Keats described his luxurious 'sense of Idleness', but his imagination was running ahead at top speed. He had to write furiously to keep up, preferring dashes to full stops because they were quicker (his dashes are speed-lines) and because each fertile thought points with an arrow to the next. Generating ideas so easily, Keats felt like a spider spinning. 'Almost any man', he wrote, 'may like the spider spin from his own inwards his own airy citadel – a tapestry empyrean'. In this image there is no need for pollination: the spider has all the materials it needs. Compared with the

springful flower, the spider's web is autumnal. This February letter evokes the glinting threads across paths in October. Keats imagined the words of a thrush after a long winter, bearing news of sun and stillness: 'To thee the spring will be a harvest-time'.[12]

Sometimes, it is true, Keats wrote about the wind. Sometimes his dreams whirled round in gusts, as when he seemed to have entered Dante's *Inferno* to be blown about like Paolo and Francesca, restless lovers in the whirlwind.[13] His imaginary architecture was sometimes made of shifting airs, as in the cool palace of 'Lamia', where 'sounds Aeolian' breathe from the door hinges and the roof is supported by nothing more solid than music.[14] But his most intense visions have a quality of stillness such that a stray breeze serves only to make palpable the lack of motion. Porphyro, in 'The Eve of St Agnes', watches his beloved Madeline in the silent night, knowing that careless movement will break the spell.

Keats's aesthetics of winter can be as mesmerizing as his poised autumn ripeness. It is striking that the images he most clearly inherits from Coleridge come, not from any of the restless storms, but from 'Frost at Midnight' and 'Christabel', poems of secret, static cold. Both are at work in 'The Eve of St Agnes':

> St Agnes' Eve – Ah, bitter chill it was!
> The owl for all his feathers, was a-cold;
> The hare limped trembling through the frozen grass,
> And silent was the flock in woolly fold:
> Numb were the Beadsman's fingers, while he told
> His rosary, and while his frosted breath,
> Like pious incense from a censor old,
> Seemed taking flight for heaven, without a death [...][15]

On a night like this, one sees details rather than wholes. The hare, the sheep, and the numb fingers are as distinct as in a picture by Dürer. Like Coleridge's ministering frost, the beadsman's frozen breath rising through the air seems part of a sacred ceremony.

This is the night on which Porphyro can steal into Madeline's dream. The spell lasts for as long as the stillness. Keats introduces a wind as a warning from the world outside: 'the frost-wind blows / Like love's alarum pattering the sharp sleet / Against the window-panes'. The rising gale is their ticking clock. As they leave the castle, 'the long carpets rose along the

gusty floor'. By the time they are outside, there is a storm to absorb them, sweeping them off into the night 'aye, ages long ago'.[16] Storms, for Coleridge, are the beginning of poetry. For Keats they mark the end.

In spring and summer 1819, good weather finally came, and stayed. The warmth relaxed Keats into those states of 'indolence' and 'idleness' that were his ideal receptive moods.[17] In May a series of odes came one after the next. He wrote all summer, first at Shanklin, on the Isle of Wight, and then in Winchester; and by the end of August he rejoiced in having had 'fair atmosphere to think in'. And still the weather held. 'I adore fine weather as the greatest blessing I can have', he wrote to his sister Fanny: 'our health, temperament and dispositions are taken more [...] from the air we breathe than is generally imagined'.[18]

On Sunday 19 September he took his customary walk out of Winchester and into the water meadows around the River Itchen. By Tuesday he had written a poem, 'To Autumn', and he told his dear friend John Reynolds about the weather feelings which prompted it:

> How beautiful the season is now – How fine the air. A temperate
> sharpness about it. Really, without joking, chaste weather – Dian skies
> – I never liked stubble fields so much as now – Aye, better than the
> chilly green of the spring. Somehow a stubble plain looks warm – this
> struck me so much in my Sunday's walk that I composed upon it.

He added a self-deprecating coda: 'I hope you are better employed than in gaping after weather. I have been at different times so happy as not to know what weather it was'.[19] Implicitly Keats connected his weather feelings with his anxiety and melancholy. He was physically ill, he was desperately lovesick for Fanny Brawne back in Hampstead, and he was worried (like Shelley, like everyone he knew) about political developments in the aftermath of Peterloo. His fretful mood deepened his feeling for the weather. Happiness can be so absorbing as to leave little room for anything outside, hence Keats's indifference to weather in times of personal joy. In our vulnerability, however, we are often more aware of external conditions. They become (as Woolf said of her lighthouse) 'deposits for one's own emotion'.[20]

Keats doubted whether his 'gaping' would be acceptable to any normally healthy, happy person with other things to do. But his doubts were only partly real, for this was the poem he had written:

Season of mists and mellow fruitfulness,
Close bosom-friend of the maturing sun;
Conspiring with him how to load and bless
With fruit the vines that round the thatch-eaves run;
To bend with apples the mossed cottage-trees,
And fill all fruit with ripeness to the core;
To swell the gourd, and plump the hazel shells
With a sweet kernel; to set budding more,
And still more, later flowers for the bees,
Until they think warm days will never cease;
For Summer has o'er-brimmed their clammy cells.

Who hath not seen thee oft amid thy store?
Sometimes whoever seeks abroad may find
Thee sitting careless on a granary floor,
Thy hair soft-lifted by the winnowing wind;
Or on a half-reaped furrow sound asleep,
Drowsed with the fume of poppies, while thy hook
Spares the next swath and all its twinèd flowers:
And sometimes like a gleaner thou dost keep
Steady thy laden head across a brook;
Or by a cider-press, with patient look,
Thou watchest the last oozings hours by hours.

Where are the songs of Spring? Ay, where are they?
Think not of them, thou hast thy music too –
While barrèd clouds bloom the soft-dying day,
And touch the stubble-plains with rosy hue:
Then in a wailful choir the small gnats mourn
Among the river-sallows, borne aloft
Or sinking as the light wind lives or dies;
And full-grown lambs loud bleat from hilly bourn;
Hedge-crickets sing; and now with treble soft
The redbreast whistles from a garden-croft;
And gathering swallows twitter in the skies.[21]

The year was at its equinox (which fell two days after Keats's walk, on 21 September) and everything in 'To Autumn' is poised. Action of many kinds is invoked, and then suspended. Autumn herself is sitting 'careless', or sound asleep. Where the figures in the 'labours of the months' were busy tying sheaves, and the months themselves in Spenser's 'Mutabilitie Cantos'

marched past with tools and heavy loads, Keats casts a sedative spell over his Autumn. The slight movement of air emphasizes the dream-inducing stillness, softly lifting Autumn's hair.

The symbolic accoutrements of Spenser's personification of September were, however, much in Keats's mind. September carries scales, alluding to the astrological sign of Libra in the second half of the month. Leigh Hunt had quoted this passage from *The Faerie Queene* in his monthly 'Calendar of Nature' column for the *Examiner*, and in an accompanying essay he reawakened the tired astrological imagery, giving it contemporary significance. Autumn was the time for the scales of justice, argued Hunt, in which the wealth of the season should be fairly weighed.[22] As always with Hunt, his generous appreciation of the natural scene was inseparable from his calls for democratic reform. He relished the serenity of September, but the chief appeal of the month was the democracy of the harvest: 'its noblest feature is a certain festive abundance for the supply of all creation'.[23]

The same issue of the *Examiner* (5 September 1819) was packed with commentary on Peterloo. Some of the banners held up by those who had met in St Peter's Field had borne the image of Justice with her scales, but the disproportionate force used against the crowd that day was an outrageous tipping of the balance.[24] Knowledge of such instability presses at the edge of Keats's poem, which is already, in Christopher Ricks's reading, sensuously replete with internal pressures:

> Pressure downwards, loading and bending the trees; pressure inwards,
> filling all fruit with ripeness to the core; pressure outwards, swelling
> the gourd and plumping the hazel shells [...] and at one with all these,
> the pressure of futurity and of approaching winter.[25]

The poem shapes a precarious calm in a season of violence, and it holds on to a fleeting moment of personal joy in which the 'ripeness' is Keats's own.

'Ripeness', as in 'ripeness to the core', is an augury of death: 'Men must endure / Their going hence even as their coming hither. / Ripeness is all'.[26] Keats soothes the pain of these words from *King Lear*. No one in Shakespeare's play is ripe for death: that is its tragedy. But in Keats's autumn the fruits of nature are ready to be plucked. Death, when combined with ripeness, he persuades himself, is not to be mourned, as long as the harvest is safely stored.

There was snow in October 1819 and winter started from there. Arranging to go out was a gamble with high stakes. Forced to live in constant wariness, Keats fussed over the possible chilliness of others, advising Reynolds before a voyage to keep on his coat and flannel and to keep under the hatches.²⁷ He survived the winter, but knew the doctors were right in saying that he would not make it through another one. September the next time was a season of mourning. He was due to sail for Italy, leaving Fanny Brawne behind. He felt he was dead already and said his goodbyes. He struggled on through the following winter of 1820–21, and died in February, the month he had once before imagined as his personal autumn.

CLARE'S CALENDAR

'Give my respects to *Keats* & tell him I am a half mad melancholy dog in this moozy misty country he has lately cast behind him'.This was John Clare writing to his publisher from his home in Northamptonshire. He had never met Keats; he cannot have known how desperately the dying man wanted to be back in misty England that January of 1821. There was conventional politeness in Clare's complaint about the English climate. But there was nothing conventional about Clare's feeling for the weather. Even in this tiny fragment of correspondence he was affirming his common interest with Keats, and marking out his difference. He paid his respects by fusing Keats's mistiness with his own local, colloquial, evocative 'moozy'.¹

Clare was the son of a farm labourer and worked for a time as a gardener himself, spending long days in the open. In all his writing he honoured the spoken language of those he knew and loved in Helpston. The dialect words, often onomatopoeically precise, are the words of people who have a daily need to distinguish between one kind of rain and another, and who know from the gait of a sheepdog in the distance just how cold it is outside. Clare's words are shaped out of physical experience. When raindrops 'dimp' the pool we see them in the very act of making dimples in the surface of the water. When ice 'crizzles' round the edge of a pond we visualize thin ice forming in shallow water near the banks.²

Clare watched harvesters in the fields, boys in the schoolroom, farmgirls coming down the lane. The barns he describes are full of work and noise, and even when no one is about there are 'Basking hens in

playfull rout' flapping in the dust while a cat eyes up a rat and a robin watches a fly.[3] Clare writes less about the weather itself than about the characteristic activities of those out in it, the shape of their bodies and the pace of their steps. We are there with the shepherd, picking our way as fast as possible across the puddled ruts of 'Winter Fields':

> and badly off
> Are those who on their pudgy paths delay
> There striding shepherd seeking driest way
> Fearing nights wetshod feet and hacking cough [...]

Or watching from a dry distance as 'croodling and thin to view / His loath dog follows – stops and quakes and looks / For better roads'.[4] Clare inhabits an outdoor working world that has good use for the word 'croodling' to describe a body shrinking from the cold.

His conversion to poetry came with his first reading of Thomson's *Seasons* when he was thirteen, and he loved to tell the story. A weaver in Helpston showed him a copy so battered that most of 'Winter' had fallen out, but the opening of 'Spring' made Clare's heart 'twitter' with delight. He pestered his father for a shilling and sixpence to buy his own copy from the bookshop in Stamford, and walked there the following Saturday (a round trip of about sixteen miles; you had to walk a long way to get a book in nineteenth-century Northamptonshire). He arrived to find that the shop was not open at the weekend, and in desperation he plotted a weekday scheme. Playing truant from his duties in the fields for a morning, he returned to Stamford, purchased his book and – because he couldn't wait to look at it – he jumped over the wall into Burghley Park so that he could read undisturbed. On a fine spring morning he sat obscurely in the grass near the great house where once, in different weather and another age, the windows had blazed for Queen Elizabeth. Clare wrote a poem of his own that same day.[5]

Thomson was his tutor in the art of landscape description, but Clare's experience of the seasons was different. He was less often surveying the view from a hill than standing on the ground with the sowers. He was a naturalist, keeping in mind the lives of birds, dogs, horses, bees, all going on in close proximity to human lives. Like Bewick, whose engravings he admired, Clare knew the wind not as an abstract element but as it scalds the face and sends a walker veering sideways across a path: a few lines cut in boxwood by Bewick can catch the shrinking movement of a croodling dog

and make us feel the chill. Although Thomson was the central inspiration for both men, showing how art could be made from the things they loved – fields, roads, and weather – they both turned away from his elevated style. They preferred to record the shouts of boys on their way home from school rather than imagining classical shepherds.[6]

The Shepherd's Calendar, published in 1827, tracing month by month the course of the rural year, was Clare's most fully formulated response to Thomson. Winter in Thomson was magnificent, and Clare sometimes found it magnificent too, but mostly he felt it to the bones, pinching the skin and hunching the shoulders. Skaters may shout excitedly, but those who have to work outside settle to quiet perseverance. This is why there is silence in 'February':

> The foddering boy forgets his song
> And silent goes wi' folded arms
> And croodling shepherds bend along
> Crouching to the whizzing storms.[7]

Many calendar traditions converged in Clare. He was a loving inheritor of the literary patterns of allusion he found in Spenser's *Shepherdes Calendar* and in Thomson's *Seasons*. But Thomson would never have thought to name the different weeds rooted up from the cornfields: poppies and thistles and pimpernels, each with characters and folklore of their own. Nor would he have made us feel the heat of a July afternoon by describing linnets trying to keep cool by splashing water, or the switch of the horses' tails as they flick away summer flies. Clare knew, as much as the villagers of Burnham Deepdale knew, what the tasks of the rural year entailed.[8]

Clare packed his poems full of busy-ness, and he marked the pauses in busy lives. He wrote about the September shower that might come as a welcome relief to harvesters who could find shelter and catch their breath. He had a particular feeling for protective places in which to pause and watch the world – and the weather – going by. He would crawl under a hedge, or prop himself against a wall, or climb into a hollow tree trunk. Langley Bush, an ancient whitethorn used for centuries as a moot place for the Langdyke Hundred, would often accommodate him in this way. It was a tree with an official function, standing at the meeting point of four parishes, but in his poem 'To Langley Bush' Clare celebrated first and foremost its unofficial role as 'the shepherds sacred shade'.[9]

English writers have had much to say about 'sacred shade', from Crusoe's careful crafting of his umbrella through to Cowper's deep love of his nearby poplar avenue and alcove. Sitting under a hedge, wet and muddy, Clare would have looked very different from Cowper with his cane and frock coat, sitting upright in the white-painted gazebo at Olney. But they have shade in common. Both kept to a narrow compass in their lives; both sought 'homes' among fields and trees, hunkering down in places where they could be outside and inside, exposed and secure at once.

'Sudden Shower', like many of Clare's poems, enacts the movement from a vulnerable position in the open to a safe retreat. The sonnet turns on an invitation:

> Aye, there some dropples moistened in my face
> And pattered on my hat – tis coming nigh
> Lets look about and find a sheltering place.

It is a natural instinct to find shelter, as Clare shows by allying his own movements with those of 'little things' like the bees hurrying back to the hive. The thick ivy that Clare finds to house both poet and reader is also housing someone else: 'That little wren knows well his sheltering bower / Nor leaves his dry house though we come so near'.[10] Birds' nests epitomized for Clare everything that a good shelter should be. He made a lifetime's study of the nests of different species, observing the snug fit between the needs of the birds and the mossily upholstered architecture of their nests. That a place of warmth and comfort could be created even in the teeth of the wind was a small miracle that Clare never tired of recording.

TURNER AND THE SUN

While staying in London in 1837, the Norwegian artist Thomas Fearnley made an oil sketch of Turner on 'varnishing day' at the Royal Academy. Turner was adding some finishing touches to a painting, but these were no ordinary tweaks. He was staging in public an extraordinary competition between sunlight and paint. The picture he was working on had already been exhibited once, ten years ago, but it was now at the centre of an experiment. Could white paint, applied to a canvas, inflamed by the

white-hot vision of an artist obsessed by light, be made to appear as radiant as the sun itself?

Fearnley and a group of other artists gathered round to watch. Some thought Turner was vulgar, or mad. Others wondered if they were watching a god at work. In Fearnley's picture, Turner stands on a bench to reach his canvas. He is a short, stout man in tailcoat and top-hat, but at the tip of his brush is a canvas blazing. Fearnley makes Turner's painting the light-source for the room. The floor beneath gleams as if it were a lake reflecting a winter sunset. The men standing round the picture are illuminated by it, and deep shadows are thrown behind them. Turner himself looks as if he were facing into a furnace, like the figures in paintings by Joseph Wright of Derby, whose intent faces are lit by molten iron lifted from a fire, or chemical reactions in an alchemist's phial. Here, however, the source of light is the white pigment of Turner's painted sun.

The picture was *Regulus*, now at Tate Britain. It appears to show the captured Roman general Regulus, barely visible on the palace stairs, about to depart from Rome to Carthage.[1] Really it shows light, prophesying the grotesque fate that awaited Regulus on his return. The Carthaginians' method of torture was to cut off his eyelids and force him to look directly at the sun until it blinded him. The mind revolts from the thought of it, as the eye turns instinctively from the sun. This is a painting about the physically violent interaction between light and power.

There is savagery in Turner's desire to blind the viewer with his painted light. He borrowed the seaport composition directly from Claude, though he was a kind of blazing Lucifer to Claude's evening star. Turner worshipped Claude as the master of atmospheric drama, a painter who saw history played out in the theatre of air, but Turner wanted none of Claude's gentle glowing.[2] On varnishing day at Somerset House, Turner applied yet more white paint, willing the sun to burn. It didn't matter that he was painting over the carefully rendered buildings underneath. He would have expunged the whole city if necessary. Turner's sunlight, like an acid, dissolves any solid matter in its path.

There were jokes about Turner's obsession with light. Towards the end of his life he was caricatured by Richard Doyle as a squat little man with a mop and a big bucket of yellow paint.[3] Doyle was making a joke, but also a statement about the artist's genius. For half a century Turner had been in pursuit of light, possessing little more than yellow paint

by the bucket-load, and yet never did the yellow in two paintings look the same.

Hazlitt found the pictures abstract and obscure, representing not 'the objects of nature' so much as the 'medium through which they are seen'. For Hazlitt, apparently, weather itself did not count as an 'object of nature', or at least not one worth depicting:

> The artist delights to go back to the first chaos of the world or to that
> state of things when the waters were separated from the dry land,
> and light from darkness, but as yet no living thing nor tree bearing fruit
> was seen upon the face of the earth. All is 'without form and void'.[4]

Turner himself may well have taken such remarks as a compliment. Hazlitt, for the wrong reasons, got him exactly right. He was the Old Testament God of his own paintings, with cosmic forces in his hands.

Earth ... world ... chaos ... void: Turner's art encourages us towards this universalizing language. At the same time it is topographically specific. Though in *Regulus* he painted the intensity of an Italian sun, most of Turner's light effects were English – and that local specificity mattered to him. Britain was generally thought to be a dim outpost of art in comparison with France and Italy, but Turner affirmed the lure of his native country as a home for painters. The new English landscape school came with the new appreciation of weather. No Englishman had made the atmosphere the subject of his art before, but if at last the extraordinary daily spectacle of air and water could be given space on the canvas, there was no better place for it than this country of low light and mists. Turner argued in a lecture around 1810 that 'an endless variety is on our side and opens a new field of novelty'.[5]

For an artist so attracted to the sun, this advocacy of English conditions was surprising. But Turner liked variation in his weather, and England provided enough for a lifetime. It could produce scenes as dramatic as anywhere on earth. In November 1810 Turner was working on the terrace at Farnley Hall in Yorkshire, looking out across Wharfedale towards the slope of Otley Chevin. In great excitement he called out to his friend Walter Fawkes's son (who would remember this moment all his life) to say that a storm was gathering. 'Come here! Look at this thunderstorm! Isn't it grand? – isn't it wonderful? – isn't it sublime?' Quickly he sketched the shape of the oncoming clouds and showed the drawing to the boy beside him: 'In two

years' time you will see this again, and call it Hannibal crossing the Alps'.[6] He was true to his word: his *Snow Storm: Hannibal and his Army Crossing the Alps*, painted on a canvas nearly eight feet wide, was exhibited in 1812.

The rapid translation of an English view to an epic scene from ancient history reminds us that Turner was a history painter, and never stopped identifying himself with narrative art. Yet his narratives are told through the battle of elements rather than in the tiny human forms he relegates to the edges of his canvases. In the *Hannibal* painting we can just make out the flailing bodies of exhausted soldiers straggling through the mountain pass on their battered way to the attempted conquest of Italy. The story, and the emotion, is all in the storm that inflicts on them a kind of cosmic persecution. Black cloud is sucked up and thrown out from the heavens in a great curving wave set to drown the shelterless men below. As ever, the sun is straight ahead of us. The trajectory of the viewer's gaze is from one weather-system into another, from the diabolical storm in the Alps to the sunlight of Italy.

Turner's elation in Wharfedale recalls Coleridge heading out to the Valley of the Rocks and Mary Shelley enjoying lightning in Switzerland. Turner did not in fact show much interest in the Lake Poets or even in the second-generation Romantic writers. But their feelings for air, wind, water, and dissolution, were nonetheless compellingly related. In the power of that storm gathering over Yorkshire, Turner had seen a whole history of power: the history of struggles between man and man, the giant struggle of all men combined against the elements, and the exhilarating imaginative power that the weather can stir in those who watch it. The upward arc of the storm surge is a shout of triumph and a leap of the heart.

Then, after the storm, there were the quiet consolations. Turner kept seeing, all around him, Milton's Eden, that country of 'mists and exhalations', where, if you watch for long enough, greyness will be lit up with gold. In the bleak cold of a rural wayside he watched the slow relief of dawn. His *Frosty Morning* caught the magic, crackling stillness of a winter sunrise, when the barren landscape softens moment by moment in the tawny glow. Constable was his only rival in the investigation of English light, as John Fisher knew when he compared their weathers. At the Royal Academy exhibition of 1813, Constable's landscape with two boys at Flatford Lock met face to face with Turner's *Frosty Morning*. Fisher studied in admiration Constable's rendering of a summer evening:

I only like one better – & that is a picture of pictures – the Frost of
Turner. But then you need not repine at this decision of mine; you are a
great man like Bonaparte & are only beat by a frost.[7]

⌒

In the late 1820s Turner watched the light change at Petworth House in
Sussex, looking due west across the park to the setting sun. In one of four
panoramic panels he made the land itself seem to curve up towards the
effulgent source of late warmth. The clouds, refracting light into deep
orange, bend down to meet the earth. Lord Egremont walks out across the
grass, followed keenly by a train of his dogs. With our eyes we follow him,
from the empty chair by the window and towards the sun. Turner makes
the land a reflective surface answering the sky: opaque, light-absorbing
grass inherits the light-emitting sheen of lying water. The statuesque deer
grazing in the foreground cast something more than shadows. Turner's
evening sunlight defies the solidity of the ground and changes it to water.

The picture was one of four commissioned to hang in the dining
room at Petworth, within exquisite scrolling frames carved years before
by Grinling Gibbons. Perhaps there was something unframeable about
Turner's view of the park, however, because Egremont asked him for a
revised version of the picture. The red of the sun was softened; the curve of
earth and sky was bent back to a flatter reality. The land reasserted itself as
more solid than the air; the composition settled back into something more
properly picturesque. The rejected first version survives, much admired,
in the Tate. In these Petworth landscapes Turner paints the English
atmosphere in its role as clement mediator between our eyes and the
blazing sun Regulus had to face in the cruelly cloudless Mediterranean sky.

Through the 1830s and 40s Turner's suns were capable of both
benign delicacy and terror. In Northumberland he watched the dawn over
the River Tweed and painted his late masterpiece *Norham Castle: Sunrise*
(*c.* 1845), in which early light is a filmy shroud over a peaceful world set to
brighten and warm as the morning goes on. The river and the mist between
them propose a fertile, refreshing dampness; the mirroring surface of
the water suggests the stillness of the air. Though the world is soft and
malleable in this extended moment, it is not uncreated. The horizon line
exerts its organizing force, positioned with almost classical precision one-
third of the way up the picture.

Yet in Turner there is always a tacit knowledge of nature's capacity for elemental violence. Storms might surge or rivers flood; fire might break out at the Houses of Parliament and burn on through the night. Among the most disturbing of his paintings is not a tempest or an avalanche but an interior. The picture now known as *Interior of a Great House* (*c.* 1830) shows white light surging into an elegant drawing room like an invading force. Mites of dust and debris are caught in its beams. This light has brought a storm with it, an indoor whirlwind that lifts the fabric and knocks a footstool on its side. Squinting into the bright shafts and the dim corners we begin to make out a scene of wreckage.

One of the first instincts of human beings is to build protective indoor spaces. Whatever goes on outside there will be calm within. We erect walls; we make watertight our roofs. The breaching of these barriers, against our will, is an assault on our concept of order. But in Turner's art the walls are flimsy, even when they are the walls of the grandest houses. Stout castles on the Tweed are to him no more solid than mirages in the distance. The stately homes of his patrons may have the finest classical proportions, but they cannot hold back the flood.

The painting of the drawing room was once thought to show Petworth Park, and it was given the dramatic subtitle *Apotheosis of Lord Egremont*. It was understood as a response to Egremont's death – and, knowing this, our eyes make out the shape on the right: a *coffin*, or rather an elaborate sarcophagus. Here is the house dying with its owner: the end of a cultural milieu. Or is it an unearthly resurrection scene? It is now thought to be none of these, and not Petworth either. It relates to interiors at East Cowes Castle, and it may have been intended as a sketch towards a history painting of the 'Sacking of the Temple in Jerusalem'.[8] For all these differing accounts of its setting, the real subject remains the same. Here is a picture in which an external force comes surging in. It does not show 'an interior', but the ruin of everything for which interiors stand.

VIII

... a scene of wet lawn and storm-beat shrub,
with ceaseless rain sweeping away wildly
before a long and lamentable blast ...

Charlotte Brontë,
Jane Eyre

COMPANIONS OF THE SKY

'No fresh air': that was part of what Charlotte Brontë disliked about the novels of Jane Austen. She read *Pride and Prejudice* in the winter of 1847–48, soon after the publication of *Jane Eyre*, and immediately set herself up in opposition. It was G. H. Lewes who had recommended Austen to her, and it was to Lewes that she wrote with her vehement response:

> What did I find? An accurate daguerreotyped portrait of a common-place face; a carefully-fenced, highly cultivated garden with neat borders and delicate flowers – but no glance of a bright vivid physiognomy – no open country – no fresh air – no blue hill – no bonny beck. I should hardly like to live with her ladies and gentlemen in their elegant but confined houses.[1]

She was describing Austen as the inverse of herself and her sisters. She was articulating in her critique of this powerful forbear all that she wanted to do differently. She would be a writer of open country and fresh air, a writer of the far blue hills rather than the well-kempt garden.

In a sense the opposition Charlotte set up was exaggerated. Jane Austen cared a great deal about fresh air in her novels, both literally and figuratively. The skies lighten and darken as her characters talk, and sudden showers catch them out; the reader of *Pride and Prejudice* could not fail to notice that its heroine Elizabeth Bennett insists on a brisk walk rather than a carriage ride, and shocks her neighbours by turning up with mud on her hem and high colour in her cheeks. Charlotte Brontë, conversely, was a superb writer of confinement – both its pleasures and constraints. 'There was no possibility of taking a walk that day', but the young Jane Eyre is glad of it, much preferring to stay indoors, draw the curtains round her window seat, and read Bewick's *History of British Birds*.[2] Though entrapment is Charlotte Brontë's recurring horror story, its opposite is not always the freedom of open country. Her moments of ecstasy are as likely to come in places of calm, quiet shelter. Still, the basic contrast will feel true to many readers. It is not that the two writers invoke different kinds of weather. There is sunshine on the Yorkshire moors as there is sunshine in Hampshire and Bath, and there is plenty of rain on

every side – in *Mansfield Park* it rains for months on end. The difference lies in the way these conditions are experienced.

Austen was sceptical about the cult of the sublime that made thunderstorms attractive to her more dramatically inclined contemporaries. She loved fresh air, but she gave no hint of being someone who might run out to see the lightning. While Byron and the Shelleys at Villa Diodati were responding to the strange summer of 1816 with apocalyptic narratives, Austen was looking out gloomily from her house in the Hampshire village of Chawton. 'We have had sad weather lately', she wrote to her young niece Caroline in March, 'I hope you have liked it. – Our Pond is brimfull & our roads are dirty & our walls are damp, & we sit wishing every bad day may be the last.' She implied that an eleven-year-old was more likely to enjoy bad weather. It did not seem to Jane Austen, watching the crops drown before harvest later that year, a very grown-up thing to do. She was herself in low spirits, as she told her nephew in July. 'It is really too bad, & has been too bad for a long time, much worse than anybody can bear, & I begin to think it will never be fine again'. For a moment she allowed herself to think (as Byron thought in 'Darkness') of a moribund world. But it was not a thought to dwell on. She quickly changed the tone: 'I have often observed that if one writes about the Weather it is generally completely changed before the Letter is read'.[3]

The contemporary liking for storms, which had been fostered by picturesque guides and gothic novels, came in for her playful satire in *Northanger Abbey* (1817). The picturesque code demanded that buildings be experienced in appropriate weather, and an abbey must of course come complete with a storm. So Catherine Morland is perplexed to arrive in weather which is simply wet. 'The breeze had not seemed to waft the sighs of the murdered to her; it had wafted nothing more than a thick mizzling rain.' At least it was raining, you might think, but the practicalities of rain make gothic appreciation difficult. 'A sudden scud of rain driving full in her face' prevents Catherine from seeing much at all. In the night she gets her recompense: a violent wind which slams distant doors and howls along passageways, making her feel 'for the first time that she was really in an Abbey'.[4] This is the night of trembling curtains, moaning chimneys, and hollow murmurs during which Catherine's heart is set racing by the discovery in a drawer of a manuscript of unknown antiquity which turns out – in the calm light of the next morning – to be a laundry list.

Catherine is overly excitable and uncritically taken in by narrative conventions, but Austen does not mock her for having an imagination. Austen understands, likewise, exactly why Marianne in *Sense and Sensibility* (1811) wants to take solitary walks in the twilight, luxuriating in her 'invaluable misery'. She also sees the self-dramatizing indulgence of such tastes and their liability to end in tears. Her portrait of Marianne in many weathers is a sympathetic investigation into what the developing weather-consciousness of eighteenth-century and Romantic art might mean for an enthusiastic reader. Austen knows full well the 'delightful sensations' of walking on a fresh, windy day, when you catch in your face 'the animating gales of a high south-westerly wind'. She appreciates as much as Marianne (and Wordsworth) the 'animating' effects of a breeze. But she also sees the dirtiness of the lanes and knows how cold cambric dresses get when they are damp. It is not silly of Marianne to appreciate autumn leaves – it is just that she cares so much more about her own 'transporting sensations' than about observing the leaves themselves.[5] 'Sensibility' is only excessive when it prevents one from clear observation of things beyond the self.

Though Marianne imagines that she is more sensitive than others, all Austen's characters are affected by weather. The wisest among them acknowledge this while also being able to separate out the moods of nature from their own. Practical, well-balanced Emma Woodhouse struggles melancholically through a long summer night of storms. Her sadness has a separate source from the weather, but 'the weather added what it could of gloom'. In the sunshine next morning she goes out 'seeking serenity', hoping that the weather will improve her mood. Mr Knightley arrives with the blue sky, they talk urgently in what is explicitly a clearing of the air, and Emma goes back indoors in an 'exquisite flutter of happiness'. Emma's mind is not governed by weather (she is far too self-contained for that), but she is perfectly aware of how the weather 'adds what it can' to her changing spirits.[6]

The narrative voice in Austen's fiction undertakes such knowing, patient weather-watching as might remind us of Gilbert White, whose life, as Austen knew, had been spent observing the subtle changes of nature at Selborne, just five miles down the road from Chawton.[7] Gilbert White recorded ordinary effects of weather, and Jane Austen gave weather a place in the daily fabric of fictional lives. Gothic novelists like Mrs

Radcliffe dealt in storms and dire meteorological events, but Austen was convinced that plain old wet days, being most of our lives, must be the stuff of fiction too. You would not know from reading her predecessors (Radcliffe, Richardson, Fielding) that the rhythms and moods of life can be governed by the chance of a shower; overcast skies seem too minor a fact to note when there is a plot to be getting on with and a skeleton falling out of a closet. Jane Austen, on the other hand, 'likes to make her plots turn on the weather'.[8] This is her acknowledgment that weather really does shape the plots of our lives.

Austen's interest is not quite in the weather itself but in what happens while people are avoiding it. She catches the fractious, steamed-up atmosphere of days when a whole household is kept indoors. Mr Palmer stomps about thinking everything disgusting on a rainy day in *Sense and Sensibility*.[9] The amateur dramatics at Mansfield Park are a way of keeping everyone diverted, and tensions run all the higher for the fact that no one can escape outside. Mary Musgrove in *Persuasion* writes bitterly to Anne Elliot comparing muddy Somerset with Bath:

> What dreadful weather we have had! It may not be felt in Bath,
> with your nice pavements; but in the country it is of some
> consequence. I have not had a creature call on me since the
> second week in January.[10]

Austen's own letters give glimpses of a life in which the threat of a shower is enough to scupper one's plans for the day, and in which prolonged rain could leave a household cut off from news and visitors for weeks. Austen was a robust walker, not easily detained at home, but in November 1800 the paths were 'too dirty even for such desperate Walkers as Martha & I to get out of doors'.[11] Compared with the redoubtable walking of the Wordsworths during the same years, Austen's characters are strikingly intimidated by the weather. The novels show them to be justified in their caution. The cold which necessitates Jane Bennett's stay at Netherfield is presented as the direct consequence of riding on a damp day. Marianne, with her taste for transcendence, hates to be hampered by trivial anxieties and so she walks determinedly towards the hills, 'attracted by the partial sunshine of a showery day'.[12] But her optimism proves misplaced. Running for home as the rain starts to pour, she slips and twists her ankle. If the

slip seems at first a fortunate fall, attracting the chivalrous attentions of Mr Willoughby, the incident proves regrettable in the end. Marianne will suffer still further for her all-weather commitment to nature, since so small a transgression as walking across wet grass is punished by an illness which almost kills her. This is a world in which, even for the affluent who can dry off quickly and who have access to doctors, dampness has a habit of being fatal.[13]

Heat can be a problem too. Part of Mrs Bertram's thoughtless cruelty in *Mansfield Park* is to make Fanny Price run errands in sunshine she would never go out in herself. Fanny is left weak with faintness and headaches.[14] Anne Elliot dreads the white glare of Bath in September (when the sun, to our modern eyes, does not tend to be punishingly strong).[15] Austen was writing in the first boom years of the British seaside, when the terraces of Brighton and Scarborough were laid out, but a trip to the coast in the 1790s and 1800s was about invigorating sea air rather than heat, and visitors hoped for a refreshing breeze. Austen, in any case, disliked the thought of brash, busy Weymouth and preferred to write about Lyme Regis out of season, when one could contemplate in peace the 'retired bay, backed by dark cliffs', and climb to woody Pinhay with its 'scattered forest trees and orchards of luxuriant growth'.[16]

For Austen's characters the priority on hot days is to find shade; hence, in *Mansfield Park*, the relief of reaching the 'wilderness' in the landscaped grounds at Sotherton after the open glare of the terrace. As much as Cowper, Austen knows the protective lure of an alcove or a shady avenue of trees. And like Cowper she is contemptuous of those who disregard these places. Mr Rushworth's felling of the Sotherton avenue to open up the 'prospect' is presented as a desecration. Both the feeling for shelter and the liking for temperate weather indicate values of moderation. So an 'uncommonly lovely' day is likely to be in gentle spring rather than summer. In Portsmouth on a March day which feels like April, Fanny takes pleasure in 'brisk soft wind, and bright sun, occasionally clouded for a minute'. Austen tells us about the 'sentiment and taste' which unite Fanny and Henry Crawford as they enjoy it. Her most appreciative natural descriptions are reserved for moderate autumn, 'that season of peculiar and inexhaustible influence on the mind of taste and tenderness'. Anne Elliot in *Persuasion* half quotes from Thomson's *Seasons* as she observes the 'last smiles of the year upon the tawny leaves

and withered hedges'.[17] It takes the wisdom of a mature heroine to find contentment in November.

⌒

Catherine and Heathcliff in Emily Brontë's *Wuthering Heights* (1847) do not deal in scenes and smiles, or say much of gentle autumn; they do not stand back to admire the view or bend close to admire a leaf. They understand themselves to be part of the land and the air, feeling with and through the weather rather than in response to it. The novel shares its imagery with the grand and furious panoramic paintings of John Martin, prints of which hung in the Brontës' parlour at Haworth Parsonage. Where Austen and her characters store up phrases from Thomson and Cowper, the Brontës inhabit imaginative landscapes shaped by Martin's giant waves, boulders falling as the earth shakes, lightning cracking over cliffs.

Shelter, in *Wuthering Heights*, is an obstacle. Since Catherine and Heathcliff must, for their basic human needs, submit to the containment of houses, windows are constantly being rattled or peered through, opened and closed. Houses are suffocating, especially when walls divide them not only from the wind but from each other. Heathcliff imagines smashing through the windows of the Grange to get Cathy out; years later he calls out from the window at the Heights, begging Cathy's ghost to come in. The houses they inhabit, made of stubborn slate and granite, would ideally deliquesce like Turner's castles; the plush rooms of Thrushcross Grange would ideally be blown apart, as in Turner's *Interior of a Great House*, their curtains and cushions thrown round in the gale. 'Open the window again wide: fasten it open!' is Cathy's repeated cry in her illness. The soft air of a spring morning is no good at all, and she asks Nelly to shut it out. But when the air is cold and wild she wants it: 'Do let me feel it—it comes straight down the moor—do let me have one breath!'[18]

Cathy's way of mourning Heathcliff's departure is to sit outside in a storm until midnight, refusing her shawl. It is a way of feeling closer to Heathcliff, since he is allied with wild weather. She is ritually surrendering herself to him as she allows the night to drench her, and she is claiming the weather as an expression of her grief, grander and more amplified than any merely personal gesture she can make. She is not a person of many words and prefers the weather to do her speaking. All this is adolescent melodrama; Brontë allows us a moment's smile at the

girl slumped soggily on the couch next morning. But there is no satiric distance here comparable with Austen's distance from the drenched Marianne. Catherine's night in the storm is to be respected as the potent expression of elemental feeling. It is Nelly in the end who sounds silly for fussing with a bonnet and shawl.

These characters are acutely conscious of defining themselves in relation to the weather. In describing abstract states of mind they reach for atmospheric conditions as the most evocative metaphors. Catherine's way of explaining the difference between herself and Edgar is to contrast lightning and a moonbeam. Her daughter, the younger Cathy, will come to express her relationship with the young Linton in terms of weather. Their conversation is remarkable for its insistence on identities being allied to climate: 'One time', remembers Cathy, 'we were near to quarrelling':

> He said the pleasantest manner of spending a hot July day was lying from morning till evening on a bank of heath in the middle of the moors, with the bees humming dreamily about among the bloom [...] mine was rocking in a rustling green tree, with a west wind blowing, and bright, white clouds flitting rapidly above [...] and the whole world awake and wild with joy. He wanted all to lie in an ecstasy of peace; I wanted all to sparkle and dance in a glorious jubilee. I said his heaven would be only half alive, and he said mine would be drunk; I said I should fall asleep in his; and he said he could not breathe in mine, and began to grow very snappish. At last, we agreed to try both, as soon as the right weather came.[19]

Their disagreement echoes the difference between moonbeams and lightning in the older generation, though their weathers are less sharply opposed. Both now imagine a temperate paradise rather than the storms inhabited by Catherine and Heathcliff or the silent moon of Edgar. They each have in their parentage both storm and calm, rival weathers which have mixed in the blood and tempered each other.

The novel is partly about this tempering.[20] The spring visions of the younger lovers stem from moral and emotional compromises which are Emily Brontë's most complex subject. But the extreme weather of Catherine and Heathcliff dominates to the end. Heathcliff dies with the window open so that the driving rain might soak him. It is easy to believe, as the locals believe, that the ghosts of the storm-lovers are sometimes seen to walk on wild and rainy nights.

As readers we all need different kinds of air; we are like Cathy, finding one sort claustrophobic and breathing in draughts of another like a vital dose. Charlotte Brontë found 'no fresh air' in *Pride and Prejudice*, but then G. H. Lewes thought there was 'a want of light and air' in *Wuthering Heights*.[21] Almost all the reviewers, whether they were impressed by it or not, responded to the novel as if it were an atmospheric disturbance. Its weather became part of the Brontë legend.

In her *Life of Charlotte Brontë* (1857), Elizabeth Gaskell would emphasize the remoteness and hostility of the landscape around Haworth, presenting the parsonage as a last outpost of civilization before the elements took over on the moor. 'Often, on autumnal or winter nights', she wrote, 'the four winds of heaven seemed to meet and rage together, tearing round the house as if they were wild beasts striving to find an entrance'. When Bill Brandt went up to Haworth nearly a century later, in 1944, intending to photograph it as one of a series of literary landscapes, he found he had made a miscalculation. The weather was not bad enough. It was summer; 'quite the wrong time of year'. Apparently he had not expected fair weather to exist in 'The Brontë Country'. He returned in the mist of November and eventually took his pictures after a snowstorm the following February, collaging one photograph of a thunderously dark sky with another showing the frozen land in a ghostly pale light.[22]

The artist Rebecca Chesney worked on 'The Brontë Weather Project' at Haworth Parsonage in 2011–12, researching the sisters' responses to weather and using her findings as the basis for art of her own. Her tally-charts showed that while wind is the most frequently mentioned weather in *Wuthering Heights*, sunshine comes a close second.[23] This was what Charlotte Brontë had tried to emphasize in her preface of 1850, when she pointed to the spots of 'clouded daylight'. But Charlotte always knew that *Wuthering Heights* would not be remembered as a novel of daylight. Its dominant climate is one of darkness and fire: 'in its storm-heated and electrical atmosphere, we seem sometimes to breathe lightning'. In private she acknowledged that 'every beam of sunshine is poured down through black bars of threatening cloud'.[24]

⌇

Charlotte Brontë, though she breathed the lightning of *Wuthering Heights* with a sense of awe, developed in the course of her life more conflicted

feelings about weather. As a young woman she associated the thundering winds at Haworth with the intense, furiously ambitious imaginative life she and her sisters shared at home. She realized this most acutely while away from the parsonage, miserably serving time as a teacher at Roe Head school, just turned twenty in 1836 and with no other prospects in sight. The pupils were recalcitrant, her hours were full, her energies were going to waste. 'What in all this is there to remind me of the divine, silent unseen, land of thought [...]?' Yet sometimes reminders came on the wind, which blew up the Calder valley and rattled the big sash windows. Listening to a high gale one October night, she made a desperate entry in her journal about this natural force which broke through into the confinement of her life. 'There is a voice', she wrote, 'there is an impulse which wakens up that dormant power which in its torpidity I sometimes think dead.' It was the voice of the elements at her window:

> That wind, pouring in impetuous current through the air, sounding wildly, unremittingly from hour to hour [...] That wind I know is heard at this moment far away on the moors at Haworth [...] O! It has wakened a feeling that it cannot satisfy! A thousand wishes rose at its call which must die with me, for they will never be fulfilled.[25]

Much of her future writing about the elements is already here in these frantic notes. There is the huge sense of her own power roused by nature's power, more an inner electric storm than Wordsworth's 'corresponding mild creative breeze'.[26] There is the trust in symbolic communication, which allows her to think of Emily thinking of her in the wind twenty miles away – as later it will allow Jane Eyre to hear Rochester calling her, from across England, through the cool darkness of a moonlit night. Most of all, there is the pain of excessive feeling – emotions unused, unsatisfied, out of place – which can only be avoided by learning not to feel the wind at all.

There is no tearing open of windows in Charlotte's novels. Bodies in *Jane Eyre* (1847) tremble vulnerably in weather that flays their skin and invades their lungs. If Emily Brontë's writing of Catherine is partly a wish-fulfilling fantasy of physical toughness (she recovers 'saucier than ever' after her wet night outdoors, while Mr and Mrs Linton die from the same fever), Charlotte writes instead about the mental toughness of those whose bodies suffer. Jane Eyre finds nothing sublime in chilblains at school. She is among the pale children huddling for shelter in the 'drizzling cold'. Her

physical sensitivity makes her sensitive to the hollow cough of Helen Burns, for whom icy air in tubercular lungs is nothing less than a death sentence. Jane sometimes dramatizes herself as a kindred spirit of the wintry world beyond the Lowood windows ('I wished the wind to howl more wildly, the gloom to deepen to darkness'), and in her adult life at Thornfield it is 'not without a certain wild pleasure' that she runs with the wind, delivering her troubles 'to the measureless air-torrent thundering through space'.[27] But there is a hint of self-conscious scepticism in these moments of surrender. Both occur when warmth and shelter are readily available.

The real duty of Charlotte Brontë's characters is not to imagine the weather as an extension of themselves but to watch and wait, holding themselves back. There are people who are not alert to the weather, but they are handicapped by their ignorance. Malone in *Shirley* has the full use of his eyes, but simply does not see the changes in 'the muffled, streaming vault, all black, save where, towards the east, the furnaces of Stilbro' iron-works threw a tremulous lurid shimmer on the horizon'. He does not notice nature's moods, and he is punished for it. Those who watch the weather acutely are drawn into intimacy. Caroline and Shirley are both attentive to the power of a storm – 'the sky was all cataract, the earth was all flood' – and to its consolatory aftermath.[28] It is part of their inheritance as Yorkshirewomen, and it is the mark of their kinship.

In *Villette* (1853), her later, sadder, novel about the continuous effort to keep emotion down, Charlotte Brontë thought back to the 'thousand wishes' let loose by the wind at Roe Head which then had to be suppressed. Her heroine Lucy Snowe knows her susceptibility to certain conditions and stands guard against them. She remembers how much she dreaded 'certain accidents of the weather': 'they woke the being I was always lulling, and stirred up a sort of craving cry I could not satisfy'. A thunderstorm excites in her a longing for another life, for something to lead her 'upwards and onwards'. All that longing must then be 'knock[ed] on the head' until Lucy is muted and deadened. She likens the bodily force of this necessary knocking-back to the grotesque murder of the biblical Sisera, his temples driven through with tent-pegs.[29] This is the excessive image she deploys in the task of holding down a dangerous body of emotion, a body which is left to bleed and, at intervals, to 'turn on the nail with a rebellious wrench'. Lucy's response to a storm, then, is not one of pleasure but of murderous suppression. Brontë goes far beyond the fashionable cultivation of

atmospheric sensitivity to write about a woman who must rein in her natural feelings for the sublime and who must cultivate instead a violently self-denying numbness.

There are other reasons to guard against the wind. Lucy Snowe learns to associate its articulate wailings with the coming of disease. 'Three times in the course of my life, events had taught me that these strange accents in the storm – this restless, hopeless cry – denotes a coming state of the atmosphere unpropitious to life'. It is the east wind which Lucy dreads, and which Charlotte Brontë too had learned to fear. Like Lucy she had entered 'that dreary fellowship with the winds and their changes, so little known, so incomprehensible to the healthy'. The young heroine of *Shirley* is untroubled by 'certain notes of the gale that plained like restless spirits'. But they are notes which, 'had [Shirley] not been so young, gay, and healthy, would have swept her trembling nerves like some omen, some anticipatory dirge'. In time she will recognize their sound. The 'trembling nerves' of tubercular patients and their carers are strung like Aeolian harps in the east wind. Caroline Helstone's illness is borne, 'probably', on the wind: 'probably in her late walk home, some sweet poisoned breeze, redolent of honey-dew and miasma, had passed into her lungs'. Charlotte Brontë knew that a cold night could bring on a chill that could end in consumption. The insistent headaches from which she suffered whenever the east wind blew may well have been related to the nervous tension of perceiving a fatal enemy at the door.[30]

After the death of her sisters, Charlotte found it painful to walk on the moors they had loved. Every knoll of heather, she said, reminded her of Emily, while 'the distant prospects were Anne's delight'. 'When I look around she is in the blue tints, the pale mists, the waves and shadows of the horizon'. The air moved with painful memories, though the changeful weather could still offer comfort. When Elizabeth Gaskell first came to know Charlotte in 1850, she was struck by her attentiveness to the sky: 'she read, as in a book, what the coming weather would be'. Asked about this, Charlotte spoke of feelings which went far deeper than those of the practical forecaster. She described a personal intimacy with the weather which was as powerful, though differently controlled, as that of Catherine and Heathcliff. She had known the 'dreary fellowship' with the winds that comes with nursing sufferers of tuberculosis, but the air brought other forms of fellowship. Gaskell recorded her words: 'She said [...] that I had no

idea what a companion the sky became to any one living in solitude, – more than any inanimate object on earth, – more than the moors themselves.'[31]

'DRIP, DRIP, DRIP'

Orlando, in the nineteenth century, finds herself in an atmosphere so moist that even when the sun shines its light is diluted. The moisture gets into the houses. 'Damp swells the wood, furs the kettle, rusts the iron, rots the stone.' The damp leads to chilliness so that even the hardiest men and women must take steps to keep out the cold. 'Rugs appeared; beards were grown; trousers were fastened tight under the instep.' Arriving in the country, Orlando finds the windows of her once airy house grown over with ivy, and the rooms inside so dark that a cat is mistaken for coals and shovelled on to the fire.' It is all in jest of course, but jokes like this only work when they contain elements of truth.

Edith Sitwell, who much preferred the eighteenth-century climate, complained in 1930 about 'the cold, damp mossiness' of Victorian taste which had cast a blight over England. Stevie Smith, more sympathetic to mossiness, produced a virtuoso parody of the Victorian atmosphere in her 1936 *Novel on Yellow Paper*. The narrator, Pompey, has been remembering childhood days spent reading in her grandfather's Lincolnshire library. The memories come oozing back to her, before breaking into flood:

> How richly compostly loamishly sad were those Victorian days, with a sadness not nerve-irritating like we have today. How I love those damp Victorian troubles. The woods decay, the woods decay and fall, The vapours weep their burthen to the ground, Man comes and tills the field and lies beneath, And after many a summer dies the swan. Yes, always someone dies, someone weeps, in tune with the laurels dripping, and the tap dripping, and the spout dripping into the water-butt, and the dim gas flickering greenly in the damp conservatory.

A few watery moments more and Pompey is in raptures about the 'wild wet days of the wild wet Lincolnshire of the younger Tennyson', and imagining herself – by means of a remembered painting – out in the desolation of a 'yellow brown seeping flood'.[2] Pompey's puddles are swollen by nostalgia, the gas flickers more dimly for being a distant memory, but her allusions

are specific and hers is a sensitively precise reading of literature she loves. Both these comic exercises in scene-setting must make us want to ask: how did the Victorians come to have so damp a reputation? Why were they so concerned with darkness? Are we just forgetting their light?

Pompey's reverie takes its atmosphere explicitly from Tennyson. She quotes 'Tithonus', his poem of weary immortality spoken by the man who wished for eternal life and found himself doomed to a state of lingering decay in a never-ending autumn. 'The woods decay, the woods decay and fall / The vapours weep their burthen to the ground'. All history mulches down in the undergrowth of those woods. Moisture dissolves burden's hard 'd' into a soft 'th'. We imagine not just one dripping woodland evening but dripping woodland evenings to the end of time. 'And after many a summer dies the swan' sounds the prolonged dying echo of Tennyson's earlier poem, 'The Dying Swan' (1830), in which water, land, sky and poetry are ecstatically merged. The landscape in which the swan sings its last is reminiscent of the Lincolnshire fenlands Tennyson had known all his life, where 'far through the marish green and still / The tangled watercourses slept'. In this low place of 'creeping mosses and clambering weeds' even the vegetation stays close to a ground that is mostly water, and the willow trees, 'hoar and dank', growing downwards, belong to the rivers more than the sky. 'The Dying Swan' has in common with 'Tithonus' an atmospheric lowering:

> The plain was grassy, wild and bare
> Wide, wild, and open to the air,
> Which had built up everywhere
> An under-roof of doleful grey.[3]

That 'under-roof' closes off the wildness; the building-up is really a claustrophobic lowering down of the ceiling of cloud. The skies into which Shelley had imaginatively launched himself were open and infinite, but Tennyson's skies roof one in.

Tennyson imagines the moment when his drowsily gurgling landscape of watercourses is overwhelmed by a 'death-hymn'. Where birdsong in Shelley soars upwards, unhindered, Tennyson's roofed-in swan-song must 'float about the under-sky'. The *Oxford English Dictionary* records no earlier use of 'under-sky'; it looks like a Tennysonian invention.[4] Sounds cannot travel up into the heavens, so the swan's notes of mourning echo on across the wide earth, spreading horizontally rather than ascending vertically.

John Everett Millais,
Autumn Leaves, 1855–56

Atkinson Grimshaw,
Liverpool Docks from Wapping, c. 1875

James Abbott McNeill Whistler, *Nocturne:*
Blue and Silver – Battersea Reach, 1870–75

Eric Ravilious,
Wet Afternoon, 1938

L. S. Lowry, *The Pond*, 1950

David Hockney, *My Mother, Bolton Abbey,*
Yorkshire, Nov. 1982

Howard Hodgkin, *Rain*, 1984–89

Benjamin Britten, composition draft
of *Noye's Fludde*, 1958,
showing the music for rain.

Moving more like water than air, this song is liquid under the banks of cloud. The landscape, which was already saturated, is now 'flooded over with eddying song'.

Air in Tennyson does not lift things up but weighs them down. The season which most disturbs and moves him is the time of rotting leaves, when summer's upward aspirations fall back to earth. Tennyson imagines a year-end spirit bowing down the stalks of 'mouldering flowers': 'Heavily hangs the hollyhock / Heavily hangs the tiger-lily'. Mariana's tears fall with the dew, so that the whole landscape of 'the glooming flats', 'the level waste', becomes part of her melancholy.[5] She can hardly bear to open the curtain, doomed as she is to see outside only a larger expanse of the psychic atmosphere she projects and endures within her moated grange. The moat was built to keep invaders out, but here it divides nothing from nothing. The stagnant water serves only to add to the damp in the air whose fertile creations ('blackest moss', rust on the nails, weed in the thatch) are further symbols of decay.

In a punishing climatic experiment, Tennyson wrote a sequel in which he translated Mariana to a hot, shuttered house in a southern country. Dust replaces damp, a dry riverbed runs in place of the moat. This contrasting environment manages to embody the same mood of desperate inertia. Heat is established as a sterile nightmare, in a way that anticipates *The Waste Land*. This aridity is worse than the English damp. Though Mariana cannot cry in either place, so enervated is her grief, at least the damp land offers a substitute for tears.

There are sparkling days in Tennyson's poetry, but it is the fate of his characters not to feel their freshness. The Lady of Shalott sees in her mirror the dazzling sun which shines from an unclouded sky as Lancelot appears, but such things can only be seen in the glass. The weather breaks with the breaking of the spell and the cracking of the mirror. Medieval chroniclers of Camelot (with the remarkable exception of the Gawain-poet) had said little of the air if they thought of it at all. For Tennyson it matters that the Lady breaks from eternity into time and weather. Going out into the world, she is met by 'the stormy east wind straining [...] / The broad stream in his banks complaining / Heavily the low sky raining'. The sun had been enchanted weather, held in the looking glass. The summer day ends with the Lady freezing to death in her boat on a rising river, under low clouds, in the rain.[6]

In his study of Victorian poetry, Valentine Cunningham collects some of the raindrops that fall in the work of other poets – Sydney Dobell, for example ('alas, alas, the drip-drop of the rain!'), and Theophilus Marzials, in whose poem 'A Tragedy' the 'grey drips drop' until a final, ridiculous 'Drop / Dead. / Plop, flop. / Plop'. More seriously, he makes sure that we hear, as the Victorians heard and as Stevie Smith heard later, the slow dripping sounds of *In Memoriam A. H. H.*, the steady rain-tears of Tennyson's elegy, which kept falling, and falling, and falling:

> In those sad words I took farewell:
> Like echoes in sepulchral halls,
> As drop by drop the water falls
> In vaults and catacombs they fell.[7]

⌒

Drop by drop the water falls, though it echoes differently through the vast humming mass of *Bleak House*, the novel Dickens began in the dark November of 1851 and finished the following year during three months of near-continuous rain. The heavy drops fall ('drip, drip, drip, upon the broad flagged pavement') when we first meet Lady Dedlock looking out blankly over a leaden landscape. 'The waters are out in Lincolnshire', and it rains for the first twelve chapters before pausing and raining again. Drops fall with the rhythm of footsteps as they might be heard on the haunted terrace, 'drip, drip, drip, by day and night', so that when Lady Dedlock has finally gone into the icy dark and Sir Leicester lies distraught, and the house waits in grey anticipation, there is one inevitable sound: 'It is falling still; upon the roof, upon the skylight, even through the skylight, and drip, drip, drip, with the regularity of the Ghost's Walk, on the stone floor below'.[8]

It was probably no coincidence that Dickens chose Lincolnshire, Tennyson's native county, as the setting for the dampest house in literature. Chesney Wold, seat of the Dedlocks, both honours and pastiches the loamish Tennyson of the early lyrics. Lady Dedlock, waiting out her fate in melancholy ennui, is an older and guiltier relative of Mariana.[9] Even when the rain stops, it is remembered in the rampant growth of the summer garden at Chesney Wold, mockingly profuse, with peaches basking by the hundred above heaps of marrows. Disused nails in the garden wall

FRONTISPIECE

'Phiz' (Hablot Knight Browne), frontispiece
for *Bleak House* by Charles Dickens, 1853

gesture to the rusty dereliction of Tennyson's moated grange where 'The rusted nails fell from the knots / That held the pear to the gable-wall'.[10] All year round the residual damp asserts itself in the smell of the church, in the 'cold sweat' of condensation on the pulpit (the sign of nerves as well as chill), in the rampant ivy and ferny undergrowth. 'Drip, drip': it is the novel's alternative to the tick, tock of clocktime, but more monotonous, not even varied to 'drip, drop'. Against the ticking clocks of progress in a country where the trains run to schedule, Tennyson and Dickens set up these other measures of time, achieving nothing, and with no promised end-points.

The weather which famously dominates *Bleak House* is not so much the rain in Lincolnshire but the concurrent fog in London. The whole novel is latent in the first two paragraphs, which make their virtuosic sweep over the city even while establishing its splashed, blackened, umbrella-jostled dreariness. The movement is expansively panoramic while burrowing into claustrophobic inner recesses. Dickens begins in the murky thick of things, while also beginning at the beginning, when dinosaurs roamed:

> London. Michaelmas Term lately over, and the Lord Chancellor sitting in Lincoln's Inn Hall. Implacable November weather. As much mud in the streets as if the waters had but newly retired from the face of the earth, and it would not be wonderful to meet a Megalosaurus, forty feet long or so, waddling like an elephantine lizard up Holborn Hill. Smoke lowering down from chimney-pots, making a soft black drizzle, with flakes of soot in it as big as full-grown snow-flakes – gone into mourning, one might imagine, for the death of the sun. [...]
>
> Fog everywhere. Fog up the river, where it flows among green aits and meadows; fog down the river, where it rolls defiled among the tiers of shipping and the waterside pollutions of a great (and dirty) city. Fog on the Essex marshes, fog on the Kentish heights. Fog creeping into the cabooses of collier-brigs; fog lying out on the yards, and hovering in the rigging of great ships; fog drooping on the gunwales of barges and small boats. Fog in the eyes and throats of ancient Greenwich pensioners, wheezing by the firesides of their wards [...][11]

This fog will seep its way into every crevice of the novel, becoming the setting, symptom, and symbol of all that occurs. It is the real fog of nineteenth-century London, leaving its grimy film on clothes and windows, itching at the back of the throat. It is also the fog of an obfuscatory legal

system which generates inky pages like so much sooty cloud around the long-lost truth of things. The fog lies at its thickest around the High Court of Chancery, where solicitors (Chizzle, Mizzle and Drizzle) lurk and slide in the dim back-alleys of Jarndyce and Jarndyce. In court even the simple address 'My lord' becomes 'Mlud' and threatens with every groggy repetition to become merely 'mud'.[12]

Dickens's fog and mud do strange things to the sense of time. It is 'as if the waters had but newly retired from the face of the earth', taking us back into a new-made world where discernible shapes are yet to be sculpted from the potter's clay and human life is yet to clamber from the bog. The mud-world, simultaneously, is very old, and *Bleak House* is about things which have gone on too long. Generations of birds have died in Miss Flite's room and generations of Jarndyce plaintiffs have turned to dust. This aged, tarnished, exhausted society seems too ill to go on much longer.

Perhaps, like Miss Flite expecting judgment, we must all expect a final doomsday. Flakes of soot as big as snowflakes come down in the smoky rain, as if the snow 'had gone into mourning for the death of the sun'. This is a vision of environmental catastrophe in a subclause. Scientists in the 1840s were proposing that the sun's warmth was finite, and were trying to determine how much longer it might last.[13] They knew its death was far in the future, but nevertheless it was eerie to contemplate the snuffing-out of the world's light. This version of apocalypse was not a spectacular final explosion of energy, but instead a gradual, inexorable cooling and ageing. As the sun got older the earth would turn grey; its geriatric terminus would be ice-bound. *Bleak House* is a stage on from the diminished people and pale summers lamented by John Donne in 'The First Anniversary'. Under the pall of London smoke, the sun really has lost its power and the rain pours down toxins rather than nourishment.

London smoke and fog had been mixing for a long time, though the word 'smog' was not used until 1905. Already in the seventeenth century John Evelyn had noticed that certain plants refused to grow in the polluted air and asked how long it would be before humans likewise expired. The smoke had grown very much worse since then, every new factory adding its freight to the air. In the 1830s and 40s Elizabeth Gaskell had struggled to find any flowering plants that would grow in the suburbs of Manchester, and she knew that human bodies could not long tolerate the conditions either. When Dickens was writing in 1851, chimneys were still emitting

unlimited fumes. The first legislation (the Smoke Nuisance Abatement Act) came in 1853, though by most accounts it made little difference. On autumn days a street of high houses really could be, as Dickens has it, 'an oblong cistern to hold the fog'.[14] No longer transparent, the air came in a range of opaque hues and a variety of consistencies. Later there would be 'pea-soupers', thick and tinged with green; in the 1850s there were 'London Particulars', as Esther is told in *Bleak House*. These were named, some said, after London Particular Madeira (fortified with extra brandy to suit the particularly alcoholic tastes of Londoners), or after long-fermented London stout. All ways round, the fog was particular, and dense with particulates that made it a potentially lethal brew.

Like a giant lung, London was subject to asthmatic constrictions. Streets seemed to contract; stumbling people and traffic blocked the way. Dickens, who lived and worked at efficient high speed, dreaded any clogging up. *Bleak House* is thick with such clogging; the whole novel can be read as a warning 'about the need to keep things moving if they are not to atrophy or explode'.[15] The congestion is so dense in places that explosion seems likely; Krook's spontaneous combustion, notoriously improbable, comes to seem the inevitable result of hoarding clutter and dust. As it lingers and thickens, the fog threatens to bring all London to a comparably grisly end.

Yet this weather which blocks up passageways is also capable of opening lines of connection since disparate people are united in the same murky cloud. The mud in the soaked park at Chesney Wold is also the mud which lies thick over the crossing which Jo sweeps. Weather is a go-between carrying messages from subplot to subplot. It is a symbol of what is toxic and contagious, and a symbol of our common fates. When he campaigned in lectures and essays for sanitary reform, Dickens stressed that the problems of the slums could not be contained. Infections would leach into the water or they would be carried in air. He argued that because the conditions of the urban poor were really the conditions of all England, everyone was implicated, and everyone would suffer. In a disturbing essay called 'A December Vision', which Dickens wrote for his periodical *Household Words* in 1850, he figured the poisoned air as a 'mighty Spirit' moving over the land, a perversion of the Holy Ghost. Laden with infection, the bad air or 'miasma' (in ancient Greece the word signified moral pollution or contagious power) manifested itself as a profane spirit, breeding and brooding.[16]

Illness bred in the fog and travelled on the wind. Dickens warned in a speech to the Metropolitan Sanitary Association that 'Air from Gin Lane will be carried, when the wind is Easterly, into May Fair'.[17] When there is a wind in *Bleak House*, it is almost always from the east. It was wind rather than fog which seemed to Dickens to define the novel: most of the possible titles he tried out were versions of 'Bleak House and the East Wind'. His autumnal easterlies were the opposite of the invigorating west winds of Shelley's 'Ode'. For Shelley the wind was a symbol of how knowledge might spread through the world, clarifying thought, and inspiring action. Dickens was interested in another kind of wind, one which disseminated fear and illness. The east wind was an automatic signifier of contagion. In southern England it threated to bring fenland air into the home counties: an easterly blowing through London had necessarily blown en route over the Kent marshes ('that dark flat wilderness' where Magwitch waits in the graveyard of *Great Expectations*) and on across the East End of the city, from which the West End understandably took flight.[18] The east wind that so perturbs John Jarndyce at home in Hertfordshire would carry the moral pollutants of Chancery, as well as the cholera and smallpox of the slums. If it blew north-east from Lincolnshire, it would carry, in addition to all this, the gothic airs of Chesney Wold.

The heroine of the novel, Esther Summerson, is named for her capacity to bring light. She is the fresh air in this book of many weathers. Jarndyce thinks of her in connection with the old nursery rhyme (a Victorian favourite, though it dated at least to the 1640s) about a washerwoman whose broom worked on the weather:

> Old woman, old woman, old woman, said I,
> Whither ah! whither, whither so high?
> Oh! I'm sweeping the cobwebs off the sky,
> And I'll be with you by and by.[19]

Metaphorically flying with her broom, Esther is the inverse of a witch. She calmly deals with the cobwebs of all England, from Chesney Wold to Krook's shop ('rust and must and cobwebs') to Temple itself. She is doubled with Jo the crossing-sweeper, whose broom is used on earth rather than air, clearing mud from the street where people will cross each other's paths.

Esther's housekeeping is deeply honoured in the novel as a force for moral good. Dickens, who had strong personal feelings about orderliness,

started *Bleak House* just after moving into a new London home; his study was freshly painted and he wrote the 'good' house in his novel, the home of John Jarndyce, as a place of pleasant tidiness. But his huge creative energy could not subsist in neatness.[20] The greatest passages in his novel are those of fog and flood. He needed to inhabit Krook's grimy shop and the Dedlocks' sinister corridors. Esther visits Chesney Wold in sunshine and looks across the park at a pleasant house, but few readers remember it in that light – perhaps fewer than remember the temperate days in *Wuthering Heights* for all Charlotte Brontë's insistence that we notice them. Reading the first instalments of *Bleak House* in 1852, Brontë found the sections narrated by Esther to be 'weak and twaddling'. It was the Chancery part that had power.[21]

Like Pope in *The Dunciad*, Dickens made his anarchic art from the darkness he condemned. His novel was a massive nineteenth-century sequel to Pope's poem. The thickest fog has moved from Grub Street to the Inns of Court where Dickens's lawyers go about their inky business; the throne occupied by Pope's Queen of Dulness is willingly taken by the Lord High Chancellor. Pope's attention was fixed on the streets around Fleet Ditch, though at the end of the poem 'universal darkness buries all'. Dickens takes up that all-consuming vision and asks what it might mean. He follows contagion as it spreads, seeing that darkness implicates everyone and really might 'bury all'.

Turner, the master of mists, died just a few weeks after Dickens began *Bleak House*. The difference between mist and fog is defined in the difference between these two artists. The deer in the park at Chesney Wold, 'looking sodden, leaving quagmires where they pass', are gloomy descendants of the deer who leave graceful pools of shadow in Turner's Petworth paintings.[22] Dickens deals in puddles, not pools. Turner's weather has centre and focus: his storms are vortices. Dickens the panoramic novelist, spanning the horizon, finds no single centre in his vision of society and revises his weather accordingly. Weather in Dickens spreads and seeps, connecting those it dampens, honouring no one and no place above another.

The years pass in *Bleak House*; it cannot always be November. But all seasons are melancholy or moribund. Midsummer heat causes the same dusty exhaustion as Tennyson's 'Mariana in the South'. July, a 'cobweb' of idleness, is no cleaner than November. Wafts of fresh air, which blow

through London and into Mr Tulkinghorn's sultry rooms, soon realize their mistake and blow out again. Tom-All-Alone's is still thick in mud.

The climax unfolds in snow as Lady Dedlock flees into frozen wastelands, like the wandering exiles of ten centuries before. But this snow is not white and it will not even stay frozen. Reaching the city burial ground, Lady Dedlock lies down to die among 'clogged and bursting gutters and water-spouts' and 'mounds of blackened ice and snow'.[23] The dirty thaw pours round her, in a flood which will take England full circle to its beginnings, when the waters were newly retired from the face of the earth and dinosaurs walked in the mud.

After *Bleak House*, the art and literature of gothic fog gathered thick and fast. The French artist Gustave Doré, staying in London in 1870 for the purpose of recording it, made engravings which show day to be indistinguishable from night. Darkness hangs over Houndsditch and Bluegate Fields; gas lamps cast the odd faltering glow, enough to pick out the bodies of people who may as well be ghosts. Dawn is meaningless in this night world, as Doré shows by drawing workers as they gather for morning coffee. A sun is palely visible, more like the moon, as the men take their breakfast in blackness.

Though the fog is drearily prolonged it specializes in sudden horrors. Who might emerge from a hidden door in a dark Soho street? Mr Hyde, perhaps, that murderous incarnation of pure evil imagined by Robert Louis Stevenson in 1886. If all that was dark in the human psyche were drained off, separated out from the civil and well-meaning parts, what monstrous being would be made? It would live, of course, in the murkiest inner recesses of London, where a 'chocolate-coloured pall' hangs over the streets at 9 a.m., and only a 'haggard shaft of sunlight' occasionally crosses the 'rich, lurid brown' of morning twilight. The fog is partly responsible for engendering Hyde. The city's darkness, its capacity for concealment, its stoking of gothic imagination, has made such division of the self a possibility. Like the 'shadow-stalker' Grendel, this creature of the mists is capable of gratuitous physical violence while also being rendered as a 'mere aura and effulgence'.[24] He can tread down a child as Grendel can rip limbs, though both can also be mere tricks of the light.

Hyde is the smoke from Jekyll's factory chimney, the waste matter from a cheerful daylit existence. Stevenson's parable draws attention to the fact that this smoke, though not always acknowledged, is part of the

make-up of western man. Dickens showed the smoke of London to be, likewise, part of the make-up of an industrial nation, though some might choose not to see it. *Bleak House* was Dickens's purposeful counter to all the glitter and pride on show at the Great Exhibition, which opened in the Crystal Palace in May 1851.[25] At the Exhibition inventions gleamed. The glass walls advertised cleanliness and transparency. But there were writers who insisted that England's soot must also be put on display. 'Progress' was the giant hydraulic press and the steam hammer, the Sheffield cutlery, Axminster carpets, and London carriages; but progress was also the bad air that hung over the factories of Manchester and the overcrowded back streets of London's East End. Progress was Tom-All-Alone's, the slum at the heart of *Bleak House*, deep in mud at the height of summer.

VARIETIES OF GLOOM

It is not surprising that dark weather should have been so symbolically charged for the Victorians. Darkness as an aesthetic choice, however, is a strange phenomenon, and there is no question that the Gothic Revival, which flourished as a national style for most of the nineteenth century, tended to be dark. Under its influence, life was dimly lit for preference even when not by necessity. The revival involved a willed reversion to the medieval, accompanied by ideas about how Britain might become a country of godliness, craftsmanship, chivalry, and national pride. It fantasized an escape from the industrial revolution, but rather than heading out into fresh air it fostered a variant kind of darkness. Even under the glass roof of the Great Exhibition, surrounded by new products and machines, a 'Medieval Court' designed by A. W. Pugin ushered visitors in between rich drapes and screens to inspect huge ornamental brasses and a tabernacle inlaid with amethysts. Pugin's churches and his interiors for the new Houses of Parliament were glittering twilight places of stencilling, panelling, carving, dogtooth mouldings, and escutcheons. They had a pungent weather of their own which resisted any encroachment from outside.

In private houses one entered the shadows of dim hallways, where deep-hued stained-glass windows revealed dark furniture against dark walls. At Tyntesfield, in Somerset, the walls were flock-papered in forest greens and russets. Cragside, in Northumberland, was equipped with all

the latest innovations including hydro-powered electric lights, but the bulbs must not shine out too brightly since the desired atmosphere was one of ancient English grandeur. The walls were wood-panelled, the floors thick-carpeted in ruby red and blues, and the shadows gathering in a corner were valued as much as the pools of steady modern light.

The Liverpool merchants who established themselves in the big houses around Sefton Park filled their drawing rooms with more plush fabric than could reasonably be accommodated. As well as the draped curtains, the draped tables, the upholstered couches, and the covered aviary in the corner, canopies of deep-pleated fabric were often suspended from the ceiling. There was warmth in all this cushioning, and the fire picked out the brightness of gilt edgings. There were practical benefits: the brown would not show up the ring of soot on the wall above the mounted candles, or the dust from the street around the window ledge. But the taste for brown went beyond expedience. Windows were generally larger than at previous times, so there should have been more light indoors. Instead, layers of netting intervened, framed by heavily lined curtains on either side and deep pelmets across the top so that light disappeared into absorbent recesses of plush velvet. There were curtains on the outside, too, in the form of the dark-leaved ivy that clung thickly, all year round, to the walls of Victorian England. It was a sunbeam of rare stamina that managed to penetrate these obstructions.

It was sunnier outside. Sefton Park itself was testament to the desire for fresh air. Victorian gardens and pleasure grounds across the country featured open lawns, terraces for strolling, carpets of annuals smiling brightly in their beds. But not far away there would be a path leading off into the shadows. Rhododendrons or laurels on each side made hedges of a glossy green that was almost black. The route wound down, perhaps, to a pinetum, or to a water-garden where huge gunneras grew unstoppably in the damp ground. More modest gardens comprised a shrubbery and conifers. The young Jane Eyre at Gateshead walks a full hour in the 'leafless shrubbery' when rain precludes going further afield.[1] It is hard to imagine anyone at Gateshead (or Thornfield), planting pansies for winter cheer.

The plants which most appealed to the Victorians were those most damp-loving species, the ferns. The fern craze ('pteridomania') was a phenomenon of the 1860s and 70s.[2] The huge public fernery which opened in Blackpool in 1878 was immediately a top visitor attraction. Across

Fern-mania in the damp-loving nineteenth century.
Illustrations from *British Wild Flowers*, after a work
by J. E. Sowerby and C. P. Johnson, 1876.

England tourists would seek, not holiday sunshine, but shady groves where unusual ferns might grow. Afternoons were spent with narrow fern-trowels, dislodging specimens from rocky crevices. 'We look in wonder', marvelled one enthusiast, 'upon a fairy, dreaming scene of clustering ferny forms in fascinating association with mossy rocks and flowing water'.[3] In some fern-hunting areas in Devon and Cumbria, stocks were so depleted that collecting had to be forbidden. In the great Victorian gardens the fernery was a showpiece. At Warden Park in Bedfordshire a whole landscape of dripping grottoes was created under glass as the ideal backdrop for fern planting; at Nash Court in Kent the giant fernery was a jungle of tree-ferns above moss-edged pools. At Stevenstone in Devon the smart classical orangery left over from the eighteenth century was redeployed as a fernery: the Mediterranean associations of citrus and warmth were exchanged for dripping fronds. Charlotte Brontë imagined that Jane Eyre and Rochester would find their ultimate happiness in a damp shaded valley, in a house called Ferndean.

~

The Pre-Raphaelites, in their mid-century paintings, revived the colours of medieval manuscript illumination and stained glass. But nothing in their pictures echoes the spring feeling of the medieval songbooks; their strenuously painted flowers and lambs do not suggest that 'Sumer is icumen in'. Their heavy, serious, saturated beauty has little to do with April light. In Arthur Hughes's *April Love* (1856) the young lovers are framed by ivy scrambling over old wood, evergreen sign of age and tenacity. If there was a spring it has passed, the flower petals are scattered on the ground, and these lovers are caught in some secret bond that consigns them to shadows.

The season of Pre-Raphaelitism is autumn, though perhaps only once or twice in a year is there such a light as Holman Hunt paints in *The Hireling Shepherd* (1851) and *Our English Coasts* (1852). It is the late afternoon of a September day, when the sky is its deepest blue. The light is low enough to be gold, and to fall at the raking angle which will throw each blade of grass into relief. Every leaf must be seen in its distinctiveness, every flower spotlit. There must be shadows on the verge of lengthening, but not yet shadowy enough to obscure detail. Such controlled conditions are essential to an art which is botany, elegy, and allegory in every inch. The ideal weather might last for an hour; the process of painting took

months, even years, and that double time becomes part of the meaning of the picture. Hunt worked intensively on *Our English Coasts* for five months from August to December 1852. He painted on the cliffs near Hastings, and though he started the picture in deep summer light, he had to go on with the blue sea and the luminous grass as winter overtook him. Through November he kept painting, creating hour after hour his lost moment of sun-gilded pastoral before the sheep wander over the edge of the cliff.

Autumn is Millais's season too. As Mariana yawns at her worktable, late sun lights the turning leaves seen through the window to the saturated yellow of tapestry thread. Millais rejects the 'under-sky' of Tennyson's Lincolnshire poetry because he needs brightness for his scrupulous studies. There must have been a quiver of a breeze to blow leaves in through an unseen open casement, but in the moment of the picture all is held still for examination. Even the mouse stops mid-scamper. Four years later, in *Autumn Leaves* (1855–56), Millais studied another kind of autumn weather. The season is later and cooler, the leaves are fallen, the trees nearly bare, and four girls stand around a bonfire, burning the remnants of summer as the sky clears to dusk-white and sulphur behind them in the moments before wintry dark. Though the material detail is again immersive, and Millais differentiates the individual leaves on the pile as if each were a life to be mourned, there are areas of obscurity in this canvas which set it apart from the unearthly clarity of *Mariana*. Wisps of smoke come from the bonfire and the distant hills are inky shadows. Ruskin called it the 'first instance existing of a perfectly painted twilight'.[4] The twilight required of Millais a new kind of naturalism, but the symbolic freighting he wanted could not be rendered through naturalism alone. The figures he paints in the fading light are emblems or icons. The child who has bitten into her apple, and the three girls on the verge of adolescence, appear separate and apart from the air they inhabit. Each is intent on some private inner melancholy and not one of them looks at the bonfire she tends. They are all in the spring of their lives: we might expect them to be kicking through the leaves in defiance of death. But the fall from innocence is so inevitable that autumn already bears in upon them. The season is already theirs.

Autumn-consciousness in Victorian art and literature is as pervasive as the spring-consciousness of the Middle Ages. The dying of the light continued long after the 1850s in the work of the next generation. John Atkinson Grimshaw began, self-taught, as a follower of Hunt and Millais.

A version of the moated grange, apparently deserted, is glimpsed through the trees in *The Old Mill: Autumn Glory* (1869). So crumbly are the bricks that any rusted nail might fall from its lodging in the mortar. Glory and dereliction are not opposites to be reconciled: the painting assumes sadness to be beautiful. When he painted his own grand house, Knostrop Hall in Leeds, it was always in an autumn gloaming or a winter dawn, silent, lonely, the house seen beyond the black etching of bare branches. Gradually he turned his eye from these lost places in the woods to the daily life of the northern cities.[5] He began a series of suburban 'lane' paintings, each similar in composition, varying only – but varying completely – in the season, the weather, and the time. Always there is a woman walking steadily away from us, and always we are invited either to follow or to become her. We must sidestep to miss a pothole, or pull a cloak more firmly round the shoulders. Grimshaw studies the texture of grit and mud across the road, the gleam of the puddled cart-tracks, the colours of moss and lichen on the high roadside wall. He favoured November dusks, and increasingly he waited until after dark to paint. He gave these pictures sentimentally poetic titles as if they were tales from the forest of romance: *Autumn Gold*, *Silver Moon*, *Where the Pale Moonbeams Linger*. But his patrons knew this kind of road, this avenue of bare trees, the slight anxiety behind the steady step of the late figure walking home. Grimshaw saw that the elegiac mood of the moated grange in the woods cast its slow-burn sorrow across the affluent suburbs of Halifax and Leeds.

It was there, too, right in the centre of the cities. He saw it on the wet street along Prince's Dock in Hull, where a woman pauses in the gaslight on the pavement, her umbrella closed because the night is clearing, though it has been raining hard. The melancholy stillness was there, even in the bustle of Boar Lane in Leeds and the waterfront in Liverpool, where yellow light blazes in the windows of jewelry shops and wine merchants, and gives a dun glow to the fog. Grimshaw looks at the broad northern streets as if he were looking across a wide heath or fen. He applies to the city all the knowledge of the landscape painter, since the city is as weathered as the land. He knows that the shops are bright shelters from which one sets out into lonely space.

In the early 1880s experiments were being made with electric street-lighting, and those who saw the giant arc lights shining white into dark corners of Paris realized immediately that the future would be differently

lit. It would be like the 'glare of permanent lightning' warned Robert Louis Stevenson, imagining the disappearance of those dim regions of Soho in which an Edward Hyde could exist.[6] For the time being, in the cities Grimshaw painted, the lamplighter still made his rounds. Nostalgia for gaslight set in well before it disappeared, along with nostalgia for the gaslit weather of which it was inseparably a part. Lamplit streets had a weather of their own, made from foggy haloes and smeared reflections, the verdigris green of long-damp copper, the sheen of cobbles, the oily spectrum of yellow and green-blue.

～

There had been a change, not so much in the air as in the art. Look back, and the contrast stands out. In the 1810s and 1820s, in a Regency England where classical colonnades were high style, artists had dreamed of clear light. It was one of the problems of being a painter in Britain: the weather was so often in the way. In 1820 the *Annals of the Fine Arts* had included a nice satire on the plight of a British artist wanting clear light for painting:

> Wake at half past seven; – remember this is the day you are to paint the head of your principal figure! [...] hope it may not rain; hope there may be no fog; lie still for five or ten minutes afraid to look out of the window, for fear of the consequences; at last seize the window curtain, – take a sort of peep with a beating heart, but no light appearing, fancy you have not moved the blind; – grapple for the blind, – find you have moved it; and what you mistake for an obstruction of the light *inside* your window, find to be a thorough-bred dark, dingy, heavy, wet, muggy, smoky, greasy, filthy, yellow London fog, of the true sort *outside!*[7]

It was some time before any major artist emerged who was willing to accept this fog as the background of a painting, let alone the subject. The fog-painting which became a phenomenon in the 1870s and 1880s was different, aesthetically and ideologically, from the toxic and claustrophobic fog-writing of *Bleak House*. Foul urban air, which had engendered so much Victorian debate about the immorality of filth, became the favourite subject of artists who wanted to separate art from ethics. The fog-painters were not examining a social problem or a gothic nightmare; they were not painting the underside of imperial progress. They were painting aesthetic effects.

James Whistler liked the fog best at night, or in the dawn, when he would take a boat on the Thames and sketch in the cool air with dark greasy water lapping around him. In the studio afterwards he would rearrange the composition, using quick long strokes to shade deep blue into grey. He thought of himself turning the city into music, harmonizing shapes and shades. He was improving on nature, he was sure, though he was taking his cue from the mists which unified disparate things and drained them of garish colours.

Nature, he thought, did not always have good taste in weather. 'The sun blares – and the wind blows from the East – the sky is bereft of cloud'. Such common daylight did little to inspire him; it was at dusk that Nature showed her subtlety, turning down the lights on the clutter of a teeming man-made city and covering it over with solemn beauty. The words of his 'Ten o'Clock' lecture in February 1885 would become famous, or infamous, among all those interested in art, air, and the city:

> When the evening mist clothes the riverside with poetry, as with a
> veil – and the poor buildings lose themselves in the dim sky – and the
> tall chimneys become campanile – and the warehouses are palaces in
> the night – and the whole city hangs in the heavens, and fairy-land is
> before us – then the wayfarer hastens home [...] and Nature, who, for
> once, has sung in tune, sings her exquisite song to the artist alone.

On this particular evening he had made his audience stay out late: the lecture began in Piccadilly at 10 p.m. The lateness showed that Whistler was the leader of a nocturnal cult, the showman-priest of illicit aesthetic rites. His arch-rival Ruskin rose early to see God-given morning clouds; Whistler held night vigils in the godless dark. He implied disdainfully that brightness was vulgar: 'The holiday-maker rejoices in the glorious day, and the painter turns aside to shut his eyes'.[8]

Whistler presented his dark wanderings along the riverbank as both seedy and sophisticated. He liked to behave distastefully while declaring himself the apogee of style. But there was a melancholy in him that went beyond sophistication. He may have recalled, in his image of the wayfarer hastening home, the last moments of *Paradise Lost*: the ghost of angels gliding, and the evening mist 'Risen from a river o'er the marish', gathering 'fast at the labourer's heel'. It is the job of the artist, said Whistler, to stay out and bear witness to those mists, reinterpreting the world which lay 'all

before them' as a 'fairy-land' of vaporous possibility. Atkinson Grimshaw, reading over his copy of the lecture, paused over the description of evening mist and underlined the words.⁹

Whistler was choosey about nature, and always redesigning it. Claude Monet wanted only to paint what he saw. At whatever time of day he loved the thick London air. Impressionism was an art of atmosphere. It reactivated the seventeenth-century use of the word 'impression' for atmospheric movements, pressing in on earth and skin, impressing scenes on the retina. In London the air was both palpable and visible; you could never forget you were looking at the solid things of the world through an atmosphere. When Monet first came to London in 1870, escaping the Franco-Prussian War, he responded immediately to the atmosphere. He painted the spires of Westminster as mere suggestions, faint grey silhouettes in the diffuse light. His friend Pissarro sat in Norwood, in the south London suburbs, painting clouds. They both studied the work of Turner, admiring his explosions of light on the Thames, and the sooty gusting splendour of *Rain, Steam, and Speed*.

'There may have been fogs for centuries in London,' wrote Oscar Wilde. 'I dare say there were. But no one saw them, and so we do not know anything about them. They did not exist until art had invented them'.¹⁰ This precocious statement comes as part of a dialogue Wilde imagined between two friends, Cyril and Vivian. Vivian is an intellectual poseur, always deploying his contrary logic to make the ridiculous sound obvious. But how ridiculous were his theories about art and nature, and his associated commentary on fogs? Wilde refused to judge. We have to give Vivian a hearing, even as he declares, outrageously, that nature has no ideas of her own and is merely an imitator of art.

Whatever artists paint, he says, nature keeps producing. So, when Turner painted sunsets, nature took it upon herself to follow the fashion. Sunsets kept blazing in the evening sky, boringly repetitive, and not even as good as the paintings. They were merely 'second-rate Turners'. Now, in this age of fog-painting, nature (having no autonomy) takes the shape the painters give it:

> Where, if not from the Impressionists, do we get those wonderful brown fogs that come creeping down our streets, blurring the gas-lamps and changing the houses into monstrous shadows? To whom,

if not to them and their master, do we owe the lovely silver mists that brood over our river, and turn to faint forms of fading grace curved bridge and swaying barge? The extraordinary change that has taken place in the climate of London during the last ten years is entirely due to a particular school of Art.[11]

Wilde revels in this absurdity. Of course the fogs had been there before Impressionism (ask the asthmatics and the tubercular patients). If the discussion is confined to aesthetics it is still absurd, since nature's fogs preceded and produced the art. Yet art shows us things in nature we had not recognized, and in doing so brings them into being for us. In this sense the nineteenth century made its own mists.

Monet returned to London in 1899, out of pleasure rather than necessity. He wanted to be in fog again. It was probably Whistler who suggested that he take a room at the Savoy, overlooking the Thames. Whistler had stayed there in 1896 with his dying wife, in a room on the fifth floor, where he sat at the riverside window and made frail, sensitized lithographs, balancing the delicate tracery of boats with spasms of smoke and shadow. Monet booked into the Savoy in September 1899. That autumn, and in the two winters following, and for years afterwards back in his studio at Giverny, Monet made his 'London Series', ninety-five canvases and about twenty pastel drawings of varying lights over the Thames.

His atmospheric observation was so precise that meteorologists have identified the times and positions of painting (measured to the nearest balcony at the Savoy).[12] Moment by moment he painted the light as it changed on the water, opalescent cloud as it half-consumed the Palace of Westminster, Charing Cross Bridge reduced to a few strokes. He loved to see the smoke from the steam trains on the bridge dispersing slowly in the already smoky air. In the early 1890s he had painted haystacks in sun and snow, midday and dusk, watching as apparently solid objects changed radically day by day. He had seen the stone of Rouen Cathedral turn into liquid and air and shadowy stalagmites and shimmering gold. Now it was London that metamorphosed before him, and the spectacle was so engrossing that he didn't even seem to mind much about contracting pleurisy in 1901.[13] The fog was where he needed to be. 'There wasn't a wisp of fog', he wrote one Sunday, 'it was appallingly clear'.[14]

Monet moved quickly between canvases, his method the opposite of Holman Hunt painting *Our English Coasts* through five long months.

But Monet, in his way, was the more assiduous realist. He showed in every painting that we see through weather and in weather. His art was a variant of St Paul's advice to the Corinthians that 'we see through a glass, darkly', except that Monet had no expectation of an ultimate seeing 'face to face'.[15] The present was for him what counted above all else, and certainly above the dubious promise of eternity. If the glass was analogous with weather, he wanted to look not only through it but at it.[16] To look at the weather was not for him to see 'darkly' or imperfectly. His fogs, on the contrary, were radiant visions, closer to heaven than earth. He ignored the ghosts of Victorian elegy and made the lowering sky transcendent. Perhaps it took a Frenchman to do so. Few English artists or writers, though they absorbed the lessons of Impressionism, could render the air over London quite so free from emotive association.

RUSKIN IN THE AGE OF UMBER

Every nineteenth-century thinker understood the darkness of the age in a different way. It was literal or figurative, local or universal, a matter of taste or a matter of God. Many individual stories might be told, but John Ruskin – who was born the same year as Queen Victoria, in 1819, and lived into the first days of 1900 – read the weather of his century and became its most dedicated interpreter. He wrote about the weather early on and to the end of his life. Eventually it would break his heart.

No one before Ruskin had ever declared such a passion for skies and clouds. It was so vast and verbose a passion as to be almost indecent, so extravagantly documented as to fill hundreds of pages on the 'Truth of Skies', the 'Truth of Clouds', 'Cloud-Flocks', 'Cloud-Balancings', 'Cloud-Chariots'. In these chapter titles from his *Modern Painters*, an epic study of landscape and landscape painting which eventually filled five volumes, Ruskin connected the 'truth of skies' with the truth of the Gospels and with the words of God in the Old Testament. 'Dost thou know the balancings of the clouds?' God asked of Job.[1] Ruskin was determined to demonstrate the wonder of the sky to people who seemed not to notice it. It was a moral imperative: he must teach people to see.

Ruskin's way of praising God was to observe divinely created nature. Winds and clouds might have their roles in the distribution of air

and water, but not the least of their purposes, in Ruskin's view, was the provision of aesthetic satisfaction to man. He understood the sky to be 'fitted in all its functions for the perpetual comfort and exulting of the heart, for soothing it and purifying it from the dross and dust'. God was asking us to look up, yet people walked with their eyes to the ground. Ruskin deeply regretted the failure of his contemporaries to share in this overwhelming sense of natural goodness. Even among artists, professional observers, the problem was endemic. Ruskin described the modern 'habit of mind' which perceived dimness where there should be light. 'Modern colour is on the whole eminently somber', he wrote, 'tending continually to grey or brown, and by many of our best painters consistently falsified, with a confessed pride in what they call chaste or subdued hints.' 'We paint our sky grey, our foreground black, and our foliage brown.'[2]

Ruskin compared the clarity of classical and medieval art with the dimness of modern pictures. The central cause for the change, he thought, was the modern loss of faith. The apprehension of divinity in nature was all gone. 'Whereas the Mediaeval never painted a cloud, but with the purpose of putting an angel in it', the nineteenth-century painter inhabited a merely material world: 'We have no belief that the clouds contain more than so many inches of rain or hail, and from our ponds and ditches expect nothing more divine than ducks and watercresses'. The Dark Ages had shimmered with brightness; it was modern society which lived in the dark. 'Theirs were the ages of gold; ours are the ages of umber.'[3]

The exception was Turner, who painted not in umber but yellow. As a boy Ruskin had dreamed of buying Turners as other boys dream of buying sweets. As a student he couldn't help being a little disappointed when his father bought him a Turner drawing with an uncharacteristically lacklustre sky.[4] In *Modern Painters* he venerated Turner as a tutor in sky appreciation. If anyone needed convincing about the accuracy of Turner, Ruskin recommended that they stand by the window with a book of his engravings.[5] To modern readers, and to many people at the time, this was a surprising way of looking at Turner. Wasn't his genius for indistinctness? 'All is "without form and void"', Hazlitt had said.[6] Turner was the Romantic who transcended topography and turned the world to air and water. With epic patience Ruskin remade him as a Victorian. Ruskin's Turner is attentive to every detail of the mist; he is a diligent student of obscurity.[7] What Ruskin meant by 'precision', however, was not

only empirical precision (though it was partly that). To be accurate about a sky you had to be imaginatively responsive to its particular expressions of divinity, and to represent that divinity in the painting. Other artists might render accurately the arrangement of clouds, but they could not infuse the painting with the spiritual power which Ruskin understood to be an essential part of its factual truth. This was Turner's gift.

The effort to describe blue sky, and to describe Turner describing blue sky, inspired in Ruskin prose of sensual intensity. Looking up into the blue, Ruskin saw 'not dead, flat colour, but a deep, quivering, transparent body of penetrable air'. Looking at blue in Turner, he saw 'breaking, mingling, melting hues [...] infinite and immeasurable'. Even Constable couldn't capture such divine expressiveness in his skies, or so Ruskin thought: 'the showery weather, in which the artist delights, misses alike the majesty of storm and the loveliness of calm weather; it is great-coat weather, and nothing more'.[8] Given that Constable paints a downpour on the beach as if the very heavens are collapsing, and sunlight after rain so that it seems to bring all nature back from the brink of death, Ruskin's dismissal is incomprehensible. But Constable seemed to Ruskin to have painted only the rain, whereas Turner painted the animated spirit of all nature. There was no evidence that Turner had believed in a Christian God, but Ruskin nevertheless made him a priest.

Ruskin was doing God's work too, and his rites of sky-watching were never over. One morning in the winter of 1859–60 Ruskin was up early as usual, watching the sunrise. He started to count the streets of high cirrus clouds: not just seven or eight, but 150 distinct streets. Sixty clouds in each row, he thought, on average. Nine thousand clouds in one rank, then, and about fifty thousand in the field of sight. He reported this in the fifth volume of his *Modern Painters*.[9] Interwoven with the myth-making and the overwhelming emotion in Ruskin's response to skies, there was always this desire to define.

In hundreds of watercolours Ruskin strained to preserve effects that eluded capture. To help with his drawings, and to demonstrate the geometrical orderliness of creation, he made diagrams of 'Cloud Perspectives', both 'rectilinear' and 'curvilinear', ruling cloud-lines with pen and protractor, drawing grid systems across the sky. Since clouds form in 'streets' it was logical to map them on a street plan, but Ruskin's diagrams are arrestingly incongruous. One critic has called them 'as schematic as

designs for iron bridges'.[10] There was a part of Ruskin that wanted the clouds to be as tangible as iron, and to last as long. He compared clouds with the solid, earthly things they refused to be: 'On what anvils and wheels is the vapour pointed, twisted, hammered, whirled, as the potter's clay? By what hands is the incense of the sea built up into domes of marble?' The overlapping metaphors build in the mind's eye an amazing concoction of ironmongery, carpentry and pottery rising to form an eastern temple and collapsing into air. Ruskin's father, a sherry merchant in partnership with the Domecq family, had laid down wine for future years. Ruskin bore this in mind when he painted, laying the sky down in his sketchbooks. He gestured to his drawings one day in a lecture and announced that he wanted to keep skies 'bottled', as his father kept his sherries.[11]

This bottling metaphor would become an irony. As Ruskin spoke, scientists were experimenting with the qualities of air, observing the behaviour of gases in test-tubes. In 1869 the chemist John Tyndall announced that he had replicated blue sky in a glass tube, using electric light to mimic the effects of the sun. It was a small miracle of laboratory creation: 'a bit of more perfect sky than the sky itself!'[12] Ruskin repeated those words bitterly. To his mind, nothing made in a test-tube could have the properties of sky. His riposte was a lecture on the mythology of Athena, 'Queen of the Air', in which he tried to awaken in his audience a sense of air being more than particles. For the Greeks, the sunrise had meant 'daily restoration to the sense of passionate gladness [...] the thrilling of new strength through every nerve'. They had understood the winds as divine gifts, hence the myth of Aeolus giving winds in a bag to Odysseus as if he were giving a purseful of treasure. They had seen the vital connection between air and inspiration, making Athena the goddess of both. 'Ah, masters of modern science', Ruskin pleaded in the preface to the published lecture, 'give me back my Athena out of your vials'.[13]

～

In Switzerland in May 1869 Ruskin could not feel his usual elation at being in the mountains. The air was 'defiled with languid coils of smoke'; the light was 'umbered and faint'. The brown world of contemporary painters had become reality. Ruskin's disgust was disturbing and physical: 'The light, the air, the waters, all defiled!' Back in London he carried on with work, but he was faltering at the edge of disabling depression. He observed

a strange 'plague-wind', blowing tremulously and agitatedly. Distracted from his writing, Ruskin watched its nervy motion in the trees. The wind brought with it a new kind of cloud which spread itself about formlessly, blocking the sun. This was what Woolf alluded to in *Orlando* when she set the scene of the nineteenth century with a restless dark cloud that came and went, wan sunlight emerging from a 'bruised and sullen canopy' and rain falling in 'fitful gusts'.[14] There was nothing comic about it for Ruskin. He was sure that a monstrous new weather had set in.

He kept hoping it would pass, but instead it got worse. 'I learn day by day', he wrote in January 1875 from Kirkby Lonsdale in Cumbria, 'of the cruelty and ghastliness of the *Nature* I used to think so divine'. Nothing remained immune from this weather. Indoors Ruskin found the daylight barely adequate for reading; outdoors the world was gone to seed and even the seeds were mouldy, as he recorded in an 1879 diary entry intensely evocative of Victorian despair:

> Looking over my kitchen garden, I found it one miserable mass
> of weeds gone to seed, the roses in the higher garden putrefied
> into brown sponges, feeling like dead snails; and the half-ripe
> strawberries all rotten at the stalks.[15]

Because he believed in the animus of the skies, he believed they had the power, and intention, to betray him. The 'corresponding breeze' was blowing, but where Wordsworth had felt it as the sign of ideal affinity between man and environment, Ruskin felt the correspondence as a torture.

The weather was indeed measurably bad. Every summer of the 1870s was abnormally wet, and Ruskin was not alone in feeling despair in 1879 when crops failed to ripen. Farmers were in a state of crisis, with wheat yields ruinously low and livestock disease spreading in the damp conditions.[16] The cloud was exacerbated by smoke: the furnaces of Barrow and Manchester affected the air in the Lake District and all over England. Modern statistics show that levels of sulphur dioxide in British air peaked in the 1880s.[17] Ruskin was surrounded by commentators worrying about air pollution and could easily have joined them. Instead he argued that this plague-cloud was more than 'mere' factory fumes:

> It looks partly as if it were made of poisonous smoke; very possibly
> it may be: there are at least two hundred furnace chimneys in a square

of two miles on every side of me. But mere smoke would not blow to
and fro in that wild way.[18]

Long ago, as an undergraduate, Ruskin had buoyantly told a sceptical
fellow student that 'there [is] no such thing as bad weather'.[19] He thought
all winds and rains were wonderful and wanted to be out in them. Now he
was confronted with conditions that were not only unpleasant but which
seemed to him purposely malign.

He thought there was something beyond measurement in the weather.
In 1884 he gave two extraordinary lectures at the London Institution and
published them as *The Storm-Cloud of the Nineteenth Century*. He looked
back to the 'old days' when fair weather was luxuriously fine and bad
weather stormed itself out and went away; 'it didn't sulk for three months
without letting you see the sun'. Searching through art and literature from
Homer to Byron, he could find no precedent for such sulky weather. He
made no mention of Donne's elegiac delineation of a world 'quite out
of joint', or Byron's 'Darkness'. All he could find was evidence of proper
storms and vivid sunsets. The central difficulty of his lectures, and their
central fascination, was that he was trying to prove the objective existence
of something amenable only to subjective registration. He could record
the strength of the wind, but there was no gauge for recording its mood.
The anemometer chart showed how often the instrument blew round,
but 'not at all whether it went round *steadily*, or went round *trembling*'.
This was why Ruskin felt human observation to be so crucial, and why he
thought contemporary science, for all its instruments, fell short. Professor
Tyndall, poring over his test-tubes, had not noticed the greatest climatic
change of all.[20]

All Ruskin's previous thinking was now thrown into question. He had
long sensed danger in the emphasis placed by contemporary thinkers on
subjective perception. The lessons of the Romantics, though he passionately
believed in them, were, he saw, open to lazy exploitation. Emphasis on the
purely personal was liable to encourage fanciful inventions about nature
rather than close observation. Ruskin policed that indulgence, stating
firmly in the third volume of *Modern Painters* that we see a gentian as
blue because blueness is part of its nature. We do not impose the blueness:
the blue belongs to the gentian and not to us. This was the starting point
for the famous chapter on 'pathetic fallacy' in which Ruskin analysed

the tendency of 'weak poets' to project their own emotions on to natural phenomena. Ruskin hated to hear waves described as 'remorseless' when they were just doing, without emotion, what waves do. If people kept projecting they would see nothing but themselves, missing the 'ordinary, proper and true appearances of things'. They could only be 'borne away, or over-clouded, or over-dazzled by emotion'.[21] And yet, if we feel at all, that feeling must affect the way we see the world. Ruskin, the most feeling of viewers, knew his own seeing to be deeply affected by emotion, and he valued this emotional viewing beyond objective physical analysis. What mattered was the sincerity of the emotion, and the individual's capacity to control it. The strong mind could elicit from pathetic fallacy the highest forms of imaginative truth.

What kind of truth was he offering when he described the 'storm-cloud of the nineteenth century'? The audience at the London Institution in February 1884 responded with a mix of puzzlement and condescension. Readers today, though they approach the lectures with seriousness and admiration, still differ over them.[22] What is certain is that Ruskin was prophesying a disastrous breakdown in the covenant between man and nature. He thought he saw something more than smoke, and stranger than anything recorded in the past. It was a nightmare revelation. In his most disturbing attempt to describe it, in 1871, he linked the cloud with the dead of the Franco-Prussian War, and conjured by extension a vision of the storm as a hideous grey afterlife of all the world he knew: 'It looks more to me as if it were made of dead men's souls'.[23]

RAIN ON A GRAVE

Thomas Hardy looked out at the weather in Dorset during the same years in which Ruskin saw spectres in the air. He observed nothing but emptiness in the sky. Ruskin watched apocalypse spelled out there; Hardy watched only the rain. He described approvingly in *The Return of the Native* (1878) the practicality with which his heroine Thomasin presses on across Egdon Heath on a foul wet night.

> To her there were not, as to Eustacia, demons in the air, and malice
> in every bush and bough. The drops which lashed her face were not

> scorpions, but prosy rain; Egdon in the mass was no monster whatever, but impersonal open ground.[1]

To accept the prosiness of rain seemed to Hardy sensible and necessary, but terribly hard. He wrote over and again about the sorrow of finding that the sky is an unanswering blank. Ruskin's prose tended towards a pitch of high rhetoric when he wrote about the weather, but Hardy insisted, just as sadly, that 'poetic' figurations are out of place because rain has no grand intention. There is no God in his sky and no providence.

Hardy's people like to feel they have been singled out for the weather's malice. But the rain which drowns Michael Henchard's crops in *The Mayor of Casterbridge* (1886), and makes a washout of his entertainments, is not casting judgment on anyone. Henchard is not fated; he is simply not very well prepared. His is a lowlier tragedy than any providential downfall.[2] Hardy knew that humans must make meaning from their world, but he also knew that rain does not deal in meanings. Rain on a grave was one of his symbols for nature's indifference to human lives. He made a grotesque emblem of it in *Far from the Madding Crowd* (1874). Sergeant Troy has attempted to make late reparations to the woman he abandoned by planting flowers on Fanny Robin's grave. It is done with frantic tenderness, though it is consoling only to Troy himself. He rests, exhausted, in the church porch, and as he sleeps the rain comes down. No one has realized that the new grave is positioned just where the water gushes from the leering mouth of a gargoyle, high on Weatherbury church tower. At first there is only a splattering; then 'the stream thickened in substance and increased in power, gradually spouting further and yet further from the side of the tower'. Under pressure, the water arcs outwards. Soon the soil is churned to mud and every plant uprooted.[3]

In the context of Victorian literature's many damp patches and dripping pipes, this is a caricaturist's masterly black joke. The tap of the heavens runs in a roaring torrent. It is as if every 'drip, drip' of the nineteenth century were channelled through that precisely angled spout. There is a parody here of all weeping elegy, and Troy deserves it. Natural justice seems to have been done, condemning past negligence and his inadequate last gesture. Troy certainly understands himself to have been judged. But for Hardy the truth is worse than any cosmic doomsday. The truth is that there is no connection at all between Troy's behaviour and the

gushing water. The gargoyles have expressions but they are only stone, just as the sky has expressions and is only air. They look to have malign intent, but neither the gargoyles nor the rain have agency. 'The persistent torrent from the gurgoyle's jaws directed all its vengeance into the grave', writes Hardy, knowing full well that vengeance has nothing to do with it.[4]

His poem of October 1904, 'An Autumn Rain-Scene', is a small, spare summary of human life under the weather. Hardy sketches, one by one with the briefest touch, the figures of six people out in the rain. Each is intent on his separate purpose. One herds animals to shelter; another keeps watch on a hill. Each has a pressing reason to be out on such a day.

> There trudges one to a merry-making
> > With a sturdy swing,
> On whom the rain comes down.
>
> To fetch the saving medicament
> > Is another bent,
> On whom the rain comes down.

There is a seventh in the poem: 'another knows nought of its chilling fall / Upon him at all'. To live is to toil through weather, herding, fetching, searching, watching. To be dead is to lie prone in rain and experience no chill. Among Hardy's elegies for his first wife Emma – many of them watery – would be another poem measuring in rain the distance between life and death. The living Emma would have run for shelter in a rainstorm. Now she is soaked and uncomplaining as 'Clouds spout upon her / Their waters amain / In ruthless disdain'. Life and death are both rained on, though the dead do not feel it any more.[5]

⌁

The First World War was a vast and bloodied scene of rain on a grave, a scene four years long in which rain churned a mass burial. In the lowlands of Belgium, where farmers would normally maintain a careful system of ditches to regulate the water level, trenches were dug for warfare rather than drainage. There was nowhere for rain to soak away, and soldiers had no means of getting dry after a night's downpour. It was common for battalions to live knee-deep in water. The 'great bog' was traversed by narrow duckboards, and off the duckboard track, as Wyndham Lewis

put it, 'conditions were frankly aquatic'.[6] Though there was 'water, water everywhere', it was toxic water, polluted with the combined waste of thousands of men and animals. Soldiers in the trenches could remain hidden from the enemy, but they were constantly exposed to the elements. For days and days, in this world of mud and sky, nothing happened – nothing except the shifting of sandbags and supplies, the vibration of shells hitting somewhere else, and the waiting to die. Nothing happened except the weather. 'But nothing happens', repeated Wilfred Owen in the refrain of 'Exposure', recalling Hardy's flat, invariable refrains. 'Our brains ache, in the merciless iced east winds that knive us.' He could not say what kept them there, the officer and his men, passive and powerless, as the 'mad gusts' tugged at the wire and another freezing day arrived. 'We only know war lasts, rain soaks, and clouds sag stormy.'[7]

At Hare Hall army camp outside London, Edward Thomas listened all night to the rain on the tin roof of hut number 51. He had often written about rain and said that at all times he loved it.[8] He loved it now, though it was also terrible. He remembered the rain that haunted him at night while he walked alone on the Icknield Way. Back then his thoughts had turned to prayer, though there was no God and only rain: 'The rain has been and will be for ever over the earth'.[9] Now, in January 1916, he repeated a prayer-like proverb: 'Blessed are the dead that the rain rains on'.[10] A folk belief had existed at least since the sixteenth century that rain on a coffin was a sign that the soul had departed for heaven. Thomas envied the community of the rained-on. His poem continued beyond the proverbial, in a single fluid sentence which moves out across the battlefields to pray that:

> none whom I once loved
> Is dying tonight or lying still awake
> Solitary, listening to the rain [...][11]

The offensive on the Somme was postponed because conditions were so wet in the early summer of 1916, but when the fighting began in July there were spells of perfect weather. One sergeant remembered how the bodies of men were tossed by exploding shells into a blue sky. 'It seemed so strange to be lying there on that lovely warm summer's day watching these bodies going up and down.' Soldiers were not treated to that kind of irony very often. It was soon raining again on the Somme, and through much of the following year it rained on Ypres. Wyndham Lewis, serving

Paul Nash, *Rain,*
Zillebeke Lake, Belgium, 1918

as an artillery officer, remarked on the 'subtly appropriate' suggestions of splashiness and passion that congregated in the word 'Passchendaele'. 'The moment I saw the name on the trench-map I knew intuitively what was going to happen'. Paul Nash was at Passchendaele in November 1917 and tried to articulate it:

> only the black rain of the bruised and swollen clouds all through the
> bitter black of night is fit atmosphere in such a land. The rain drives on,
> the stinking mud becomes more evilly yellow, the shell holes fill up with
> green-white water [...][12]

In his drawings those soaked craters became parodies of the refreshing dew ponds he had often drawn in English pasture land. Nash's lithographs of Zillebeke look out across many miles of rain, water streaking through the air like arrows. In moonlight, or in the half-light which penetrates the storm, the lake is a white blank and the stumps of blasted trees show that it was once bordered by woods. The last thing one notices, because they are so small as to seem incidental, are the troops moving in line along duckboards, bent forward into the oncoming rain.

⌇

Thomas Hardy seemed to have been writing about those men for years. He had not imagined the western front, but he had watched small figures toiling over heaths intent on missions which would make no difference in earth's scheme of things. He had expressed the repetitiveness with which nature brings all proud and individual lives to the same basic end. The poems of *Time's Laughingstocks* (1909) and *Satires of Circumstance* (1914) rhymed their way through the black jokes of love and loss; their tones of smiling, sardonic grief would become dominant tones of the war.[13]

'During Wind and Rain', published in 1917, was another elegy for Emma. This time it was a domestic poem about her whole family, but it was also about the anonymity of death. In four stanzas, written to a jaunty dance tune, Hardy tells the history of Emma's family as they sing their songs, tend the garden, breakfast outside in summer. The sixth line brings, always, the passage of time ('Ah, no; the years O!'), followed in the next by an image of aftermath: leaves sickening, a rose rotting. The last stanza works in the same way, busy at first with life and all its paraphernalia:

> They change to a high new house,
> He, she, all of them – aye,
> Clocks and carpets and chairs
> On the lawn all day,
> And brightest things that are theirs...
> Ah, no; the years, the years;
> Down their carved names the rain-drop ploughs.[14]

Whatever the lives and efforts of Hardy's people, this is how the story ends. He will never let us forget it, though his characters may forget it for a time. Whichever names are carved on the stone, rain is a disrespectful mourner, driving its furrow through them, unseeing and undiscerning. The clocks and chairs, which seemed so solid, are as nothing compared with it. This is Feste's wisdom – 'the rain it raineth every day' – though Hardy grieves more than the fool. He uses his dance tune ironically: no one would dance to this. There is less chance in Hardy's world than in Shakespeare's of banishing sadness with a jig.

IX

*Complicated feelings [...] come
to those who walk alone in the damp.*

Stevie Smith

BRIGHT NEW WORLD

Modern times were advertised with much rhetoric of brightness. Arriving in the twentieth century, Orlando puzzles over the disappearance of the Victorian cloud. It seems to have evaporated, leaving clear, dry air.

> The sky itself, she could not help thinking, had changed. It was no longer so thick, so watery, so prismatic now that King Edward [...] had succeeded Queen Victoria. The clouds had shrunk to a thin gauze; the sky seemed made of metal, which in hot weather tarnished verdigris, copper colour or orange as metal does in a fog [...] The dryness of the atmosphere brought out the colour in everything and seemed to stiffen the muscles in the cheeks. It was harder to cry now. Water was hot in two seconds. Ivy had perished or been scraped off houses. Vegetables were less fertile; families were much smaller.

Everything is more efficient now, so Orlando does not hang about. Her survey of pre-war England is rapidly succeeded by further time travel. As she comes up to date, speeding towards the present time of the novel, she is aware, more than anything, of light. 'The light went on becoming brighter and brighter, and she saw everything more and more clearly', until she discovers, with the striking of a clock, that it is ten in the morning on 11 October 1928. This, the 'present moment', is publication day for *Orlando*, the novel she inhabits: she could not be any more up to date.'

Woolf's cameos of twentieth-century weather are less emphatic about prevailing atmospheric conditions than her portraits of eighteenth- and nineteenth-century climates. She found her own times were harder to caricature. They had not yet been mythologized, or misremembered, or re-tinted with a Claude glass. The world outside the window is constantly changing and capable of anything. Woolf's modern sky is evoked in mixed terms: gauzy yet metallic; hot and dry, but also likened to what happens in a fog. The high and subtle cirrus is a more modern cloud than the cumulus with its Rococo plumpness or the extravagant cumulonimbus. The clear air shrinks distances and brings the world within reach, so that Orlando can see as far as the Highlands from underneath her oak tree in Kent. But Woolf is not ready to let go of romantic occlusions. At the end of a full day

Ice-cool style for Bright Young People: *Baba Beaton:
A Symphony in Silver*, by Cecil Beaton, 1925

in 1928 Orlando looks out across misty fields as the light fades. The novel ends in the dark – a cool, lunar, magical dark. The air is still, and then there is a rush of wind as Orlando's lover Shelmardine arrives in an aeroplane. As the first stroke of midnight sounds, Orlando feels in her face 'the cold breeze of the present'.[2]

All these weathers would become part of the imaginative climate of the twentieth century. Awareness of the present moment would strike with a cold gust of wind, inducing shivers of anticipation. For some thinkers cold was the ideal modern condition; others yearned for heat. Both could produce shimmering brightness, sharp outlines, a metallic glint. In all conditions, similar questions kept returning. How far could the English in the twentieth century generate the kinds of weather they wanted? And should modern lives be subject to the weather at all?[3]

⌒

Wyndham Lewis had firm ideas about the right sort of climate for a progressive country and progressive artists. In 1914, before going off to the great bog, he issued a meteorological manifesto. Launching his avant-garde movement Vorticism with a magazine called *Blast*, he listed things to be blasted and things to be blessed. Top of the list of things to be blasted, in the largest bold type, was the whole English climate.

> BLAST First (from politeness) ENGLAND
> curse its climate for its sins and infections
> DISMAL SYMBOL, set round our bodies,
> of effeminate lout within.

The dismal weather was a nineteenth-century hangover, better suited to gothic fiction. 'VICTORIAN VAMPIRE, the LONDON cloud sucks the TOWN's heart.' The climate of *Bleak House* and *Jekyll and Hyde* was no atmosphere for modern art. If only the cloud really had evaporated as Orlando thought.

The problem was to do with the mildness of England's in-between location. 'OFFICIOUS MOUNTAINS hold back DRASTIC WINDS.' Severe weather tried to blow at England, but topography repressed it. No drama, no action: Lewis wondered how anyone could be decisive when forced to breathe this air of compromise.

the flabby sky that can manufacture no snow, but
can only drop the sea on us in a drizzle like a poem by Mr. Robert Bridges.[4]

In 'London Snow', Robert Bridges's best-known poem, the snow falls silently, 'lazy' and 'muffling'. Lewis was never going to like such quiet descriptions: the poet laureate appeared to him about as ineffectual as the weather. The critic T. E. Hulme had recently been complaining about the sogginess of such 'romantic' poetry, and he was stern, too, about the sloppy values of readers for whom 'poetry that isn't damp isn't poetry at all'.[5] Lewis joined the campaign for an efficient mopping up.

If the climate itself could not be improved (even Lewis had to admit this would be hard), at least the energetic shouting in *Blast* might help to change the English *taste* in weather. Nineteenth-century feelings for drippiness must go, as must the liking for indistinct impressions. 'Our vortex rushes out like an angry dog at your Impressionistic fuss'. The ideal Vorticist weather was heroically assertive, ideally a blizzard. 'LET US ONCE MORE WEAR THE ERMINE OF THE NORTH.'[6] In the cold there is no dithering; people get on with the necessary acts. So 'the north' meant rigorous attitudes as well as crystalline forms. Definite weather (either a blizzard or not, no half-measures) stood for clearly demarcated times and actions, and preferably for clear emotions too.

The restless characters in D. H. Lawrence's *Women in Love* (1920) are similarly frustrated when they determine to leave England behind. 'I feel I could *never* see this foul town again', cries Gudrun on her last day in London, and in the next chapter she and Gerald, Ursula, and Birkin, are inhaling deeply the cool, clear air of the Tyrolean Alps.[7] The critic Philip Sidney, an astute reader of modernist cold, has shown how ideas of both numbness and rapture, sangfroid and froideur, are patterned right through the novel, pointing compass-like to the northern denouement.[8] Ice exercised a hold on Lawrence, as if it were the ultimate condition he must confront. Long before their journey to the mountains, Birkin comes to understand Gerald as

> one of these strange white wonderful demons from the north, fulfilled
> in the destructive frost mystery. And was he fated to pass away in
> this knowledge, this one process of frost-knowledge, death by perfect
> cold? Was he a messenger, an omen of the universal dissolution into
> whiteness and snow?[9]

Gerald may be, in this sense, a prophet of icy truths which lie ahead for everyone. Like the Anglo-Saxon poet of 'The Wanderer', who knows that what exists outside the transitory comforts and intimacies of the mead-hall is a heartless cold expanse, or like the Norsemen who looked ahead to Ragnarök, Lawrence proposes a frozen end-state which is grimly appealing in its simplicity. Beyond the human connectedness of the present with all its doubts and confusions, he apprehends an icy blank.

'My God, Jerry', cries Gudrun as they arrive at the end of the railway line, where the station gives on to endless snow: 'you've done it now'. Gerald's iciness seems actually to have created this world; his frost-knowledge makes him a Prospero of the mountains. Ursula finds the Alpine air 'bruisingly, frighteningly, unnaturally cold [...] It seemed conscious, malevolent, purposive in its intense murderous coldness'. It is violent, she knows, and it is wonderful: 'wonderful enough to make one cry aloud'. Cold, here, is a rebirth, shocking the nerves into sensitivity while also clearing out the old mess of history, memory, doubt. In the remote high snow, Ursula imagines that she might douse herself in 'a bath of pure oblivion, a new birth, without any recollections or blemish of a past life'.[10] Writing this novel during the Great War, Lawrence contrasted a language of murk and soiling, which was also the language of the trenches, with these extravagant dreams of purity.

But snow-birth ('in the perfect cradle of snow') is only an event on the way to snow-death. The end-point of cold is numb and silent. Gudrun, who has 'a diabolic coldness in her', is attracted to the coolly savage sculptor Loerke, who is carving a 'great granite frieze for a great granite factory in Cologne'.[11] The scene he represents is a fairground, a place of life and movement, but here it is frozen into a monument which is cool to the touch. Loerke's carved roundabout is purely mechanical and so is the fun. The sculpture offers a model of life without feeling. 'Forgetful snow' is the anaesthetic for which T. S. Eliot will be grateful in *The Waste Land*, willing the cruel spring not to melt it. Lawrence's ice messenger, Gerald, wishes to be alone, 'snow-burned, snow-estranged'. He dies anonymously into the whiteness and the corpse brought down from the mountain is 'cold, mute, material'.[12]

'The compass needle of the 1930s', writes Peter Davidson, 'pointed unequivocally northwards'.[13] W. H. Auden deemed coldness to be the challenging environment appropriate for modern heroes. Coming of age after

the war of lowland mud, the tough athletes of his early poems occupy high and lonely outposts. They run at night across Pennine valleys and some do not return home to the remote houses in which they are awaited. The besieged modern thinker waits out the storm: 'Nights come bringing the snow and the dead howl / Under the headlands in their windy dwelling'.[21] Summer and the south brought on in Auden a mood of exhausted dissipation; his allegiance was to a culture of 'precipices, glaciers, caves, heroic conquest of dangerous obstacles, whales, hot meat and vegetables, concentration and production, privacy'.[14] Frustrated at the lack of cold writing in English literature, he went back to its Anglo-Saxon beginnings, tuning his early poetry to the alliterative verse forms of *Beowulf* and the elegies. He read the icy sagas of the Norsemen with a sense of familial belonging, declaring affiliations that would remain strong into the last decade of his life, when he worked on translations from the Icelandic *Elder Edda*.

Auden dreaded times of sticky heat and sat them out behind closed curtains – or evaded them by going to Iceland, which was his destination with Louis MacNeice in the summer of 1936. He wasn't won over by Reykjavik and its environs ('scattered stacks surrounded by wire fencing, stockfish drying on washing lines and a few white hens'), and he grumbled about a head cold that flowed like a geyser, but he could hardly stop writing – about silent bus journeys through darkness, long nights of cards, corrugated huts, more fish drying under tarpaulins. Auden and MacNeice packed their observations into *Letters from Iceland*, an anthology, bibliography, and travel guide for the northern modernist, complete with notes on clothing (oilskin trousers, oilskin sou'wester, flannel pyjamas to wear underneath at all times). Auden would not idealize 'Sagaland' after this trip, though he never gave up on the prospect of retiring there. MacNeice concluded that 'We were happy while we watched / Ravens from their wall of shale / Cruise around the rotting whale'.[15]

An intellectual landscape of 'cold modernism' has been charted, in which cold is an attitude rather than a temperature.[16] Those who kept their cool – Hulme, Lewis, Ezra Pound, Mina Loy – aspired, at least in their writing, to the condition of unreactive metals. They cultivated scrupulous forms of 'impersonality' as the kind of armour necessary for survival in modern times. The warm-blooded human mammal, with its changeable moods and unruly desires, was desperately vulnerable in a ruthless world and needed to develop habits of detachment. Any licence given to emotion

risked a dangerous opening of the flank. Immunity was the safest option, though it was promoted as a kind of bravery.

Visions of cool modernity often came from North America, where cars, conveyor belts, and air conditioning were all a step ahead. The Carrier Corporation began cooling and dehumidifying factory workspaces in 1915, and soon it was advertising 'Manufactured Weather' to 'make any day a good day'. It was in America, too, that the future arrived in the shape of the domestic refrigerator. 'Make your ice-box a Frigidaire', ran the advertisements; 'The White Frost Refrigerator is beautiful as well as sanitary'.[17] When Virginia Woolf fantasized about American life (as she regularly did, rightly assuming that this was the shape of things to come), she always stressed the ubiquity of ice. 'A spring is touched; a refrigerator opens', she marvelled in an imaginary transatlantic visit: 'there is a whole meal ready to be eaten: clams on ice; ducks on ice; iced drinks in tall glasses; ice creams all colours of the rainbow.'[18] Nature was arrested; time could be paused according to human convenience. This was how modernity's cool dreams might come home: in the shiny metallic box of the refrigerator, its magical door revealing a space of electrically lit frost.

﹌

Other incarnations of the bright new world dazzled in hot sun rather than in snow. The sun was a surprising entry on the list of modernist discoveries; it had, after all, been around a long time. Yet for centuries people in northern Europe had been ambivalent about it. The sun in paintings had been a gentle Claudian light gilding the trees, or the blazing Turnerian sun which, though incendiary, stops curiously short of making us feel hot. Cowper, Clare, Austen and the people she wrote about, had all sought shade. The Victorians tended to shield themselves from a sun which pierced through into rooms, bleaching curtains and books, encroaching on the body, reddening a neck or a forehead, causing a headache. Blinds were lowered; parasols were raised.

The new solar culture of the early twentieth century went to the other extreme. Modern sunning was no brief sit in a deckchair: ideally the whole body would be exposed for hour after hour. The cult of fresh air and sun had begun in Germany, and it was recognized in England as an import. In some milieus, enthusiastic nudism followed quickly. The Sun Bathing Society was founded in 1927 and issued regular bulletins of the

Electric frost from across the Atlantic:
a refrigerator advertisement from the 1920s.

Sun Bathing Review; members met at Sun Lodge in Norwood, or at the growing number of naturist clubs around the country. The National Sun and Air Association had 2,500 members by 1939. The popularity of wearing nothing or not much in northern climates was a little strange, but there was clear appeal in free movement and sensual consciousness after so long spent bundled up. Many of the new seaside pavilions incorporated solaria where sunbathing carried on through the winter under ultraviolet lamps.[19] At Branksome Chine in Dorset, there was indoor sand and deck-chairs; the spa at Bridlington on the Yorkshire coast featured palm trees for a desert island feel.

Hospitals, too, were commonly equipped with solaria because sunbathing was recommended as a life-giving treatment for the sick and the healthy alike. Military infirmaries had used light treatment on infected wounds during the Great War, and by the 1920s heliotherapy was a standard treatment for conditions as disparate as pneumonia and neurasthenia. Physicians had been prescribing warmth for tuberculosis since the eighteenth century, but no one had expected patients to lie outside in fierce direct sun. Now, for the first time, tanned skin was more desirable than paleness. It was a change that would last well into the next century, establishing itself so unshakeably that understandings of skin cancer would only moderate rather than reverse the craze for bronzing. If there had been a 'golden afternoon' before the war, which stretched out in memory as a time of sepia glow diffused over dappled lawns, the ideal afternoon now involved a different order of sunshine.

D. H. Lawrence felt the lure of heat as much as snow. His desire for sun was part of what made him desperate to leave England, and his journey to Italy in 1919 was the start of a long exile from which he never returned. His 1925 story 'Sun' describes the religious conversion to sun-love of a neurotic New Yorker called Juliet who is sceptical, at first, about heliotherapy. She goes to Italy on the advice of her doctor, stepping uncertainly and fully clothed into a world of southern light. Then the sun starts to claim her as its own. Secretly at first, then proudly, she goes to lie naked under the cypress trees. Day after day Juliet offers her body to the sun, and this becomes the central relationship of her life. The white woman is transformed into a potent and rosy-gold new being. The eventual reunion with her husband is a pale comedy of irrelevance since there is no possibility of her returning home. Other people now seem lacking in Juliet's eyes: 'They

were so un-elemental. So un-sunned'.[20] Lawrence, looking around him at the majority of people, who did not lie naked for hours in the heat, felt the same. Leaving un-elemental England behind, he surrendered himself to the sun of Italy and then Mexico. The stories he sent back for publication (at least those which got past the censors) were postcards from a different life and they helped to foster the sun culture which was rapidly growing back in England.

There were those like Wyndham Lewis who thought sunbathing was a primitive aberration, embarrassingly regressive, not right for an advanced machine-age culture. Auden thought the time was past for basking: 'The chairs are being brought in from the garden', he wrote in 1929, feeling that the climate of the 1930s would be different: 'The summer talk stopped on that savage coast / Before the storms'.[21] He understood Europe to be entering its winter and advised his contemporaries to prepare accordingly. But other artists were now in league with the sun. The photographers Man Ray and Lee Miller experimented with techniques of solarization, reversing light and dark so that their subjects appeared radiant. Their nudes were exothermic bodies of light. Even Man Ray's name, invented by his parents in pre-war Brooklyn as an expedient contraction of the Jewish 'Emmanuel Radnitzky', now served as an aesthetic manifesto. He was pleased to be designated as a human sunbeam.

Sun-seeking was becoming a national preoccupation among the English, whether it was the winter exodus of the wealthy to the Riviera or the annual week at the seaside into which millions of families poured their hopes and their savings. Architects optimistically designed buildings for the sun, even when they were to be sited in Ruislip or Amersham. Maxwell Fry's 'Sun House' in Hampstead was an ocean liner on land, with expanses of terrace fit for a cruise. The Ideal Home Exhibition of 1934 featured prototypes for a 'Sunway House' and a 'Staybrite City', as well as a design by Wells Coates and David Pleydell-Bouverie for 'the home of tomorrow, with sunshine laid on'. Coates's 'Sunspan' house could not actually generate sun on a cloudy day, but the huge curving windows, carefully angled, would make the most of any rays. About twenty Sunspan houses were built and most of them can be seen today, still sunning themselves in Thames Ditton, New Malden, Thurrock, and Angmering.[22]

The appropriate flora for such houses were cacti and succulents: it was important to choose plants in expectation of heat. Damp-loving

creepers would be an aberration, and in any case they could not get a grip on smoothly rendered walls. As Orlando observed, 'the ivy had perished or been scraped off'. A Phoenix palm with its spiny leaves might rise from a gravelly bed (as at the Chertsey home of the garden designer Christopher Tunnard). Writing from Iceland, wrapped up in oilskins, Auden mocked this redesign of Britain as a province of the Mediterranean:

> The cult of salads and the swimming-pool
> Comes from a climate sunnieor than ours [...]
> The south of England before very long
> Will be no different from the Continong.[23]

International-style buildings, which looked their best in hard light, waited through dim English months for the few perfect days when recliners would be spread on the sun-decks, the aluminium windows thrown open, and the white walls seen fresh and luminous against blue sky. In winter, however, there was at least one mitigating factor for modernists: white buildings had a cool glamour to them and looked good in snow. When Berthold Lubetkin used concrete for the London Zoo penguin pool in 1934 he was acknowledging its snow-white Antarctic qualities. The spiral slopes looked like the right environment for penguins, being evocative of ice. And when the sun shone over London the penguins had a sun terrace of their own. Concrete excelled in the two most venerated modern conditions: deep cold and high heat.

\sim

For all their strong feelings about bodily immersion in ice and sun, many modernists were attracted by the idea of a machine age which would keep unwanted weather out. Art and life were both too leaky. 'Our vortex insists on water-tight compartments', wrote Wyndham Lewis. 'Dry hardness' was what T. E. Hulme wanted to see in poetry after a long phase of Romanticism (which he understood in liquid terms as 'spilt religion').[24] Ideas of the clear and watertight showed themselves in the painting and sculpture these arid Vorticists espoused. The figure in Jacob Epstein's *Rock Drill* (1913–15) is not a sensitive human prone to chills and spills, but an efficient, impervious part of the machine itself. It is easy to be fooled into thinking he bears a rueful expression, but we are only looking at his visor. David Bomberg made studies of the steam-baths at Whitechapel, culminating in his huge

Sun-bathing, by Tom Purvis,
London and North Eastern Railway poster, 1931

Vorticist painting *The Mud Bath* (1914). The subject matter was vaporous, but there was no mess in what he painted. The figures are geometric forms of clean white and blue, moving across a bright red-orange area superbly defined by a dark axis. The picture hung for a while outside the Chenil Gallery on the King's Road in Chelsea, serving as a billboard for the exhibition within. It was suited to the purpose, being bright and waterproof on the drizzliest day.

In the twentieth century more people than ever before could go through life without getting regularly soaked. The continued shift towards indoor work in towns, and away from agricultural labour, limited daily exposure. The quick dash across city streets from shop to shop, onto a tram or into the London Underground, was barely enough to merit a raincoat. Even farm-work was drier now that many jobs could be conducted more quickly on a tractor, and rural life was transformed wherever there was a car available. In a poem called 'A Wet Night' Hardy grumbled about the 'hardship' of a long walk in the rain, but then he stopped to consider that his forefathers, 'sires of mine now perished and forgot', would have thought such rain a trifle: they had trudged on in these conditions day after day.[25] Work had changed, transport had changed, and the short-term weather outlook was more certain too: forecasts appeared in the newspapers from 1879 and by the 1920s regional detail was available.[26] Shipping forecasts were issued daily on the radio from 1923. For the first time in history it was possible to plan with relative confidence for the weather of the day ahead. Perceptions of modern 'dryness' in the atmosphere (it is what first strikes Orlando) were in part related to this diminished necessity of spending time in the wet.

Edgar Hooley, civil engineer and county surveyor of Nottingham-shire, patented tarmacadam in 1902, right on time to inaugurate the twentieth century's assault on damp. The new tarred surfaces could withstand both high-speed traffic and the weather; Hooley's company, Tarmac Ltd, strained to meet overwhelming demand. At home, the air was getting drier and a little warmer. Damp-proof courses had been a legal requirement in houses constructed since 1875; techniques now improved rapidly and the purchasers of new homes in the 1920s had little to fear from rising damp. Heating apparatus was the subject of much experiment. Victorian engineers had developed elaborate piping systems: always unwieldy, occasionally dangerous, and far too expensive for the

average family home. Then, in the 1910s and 20s, domestic comfort was much improved by the introduction of moveable electric fires. These kept off the chill in the meantime while engineers made advances towards reliable central heating.[27]

Filippo Marinetti, the founder of Futurism, lectured at the London Lyceum Club in 1912 on the glories of a technological future fuelled by power stations and controlled by switches. He laughed at the 'lymphatic ideology of your deplorable Ruskin' (lymph glands and all bodily humours belonged to the same archaic culture as Ruskin's love of ageing stone), before prophesying a new age of climate control: 'heat, humidity and ventilation regulated by a brief pass of the hand'.[28] That flick of the switch was not in fact far off. Le Corbusier understood temperature regulation as one of the great challenges, and opportunities, for modern architects. Human beings, he thought, should ideally breathe 'pure air at a constant temperature and a regular degree of humidity', but instead they had to deal with the varying climates of the world. Speaking in Buenos Aires in 1929, he set out his vision for a single building that would suit all continents and which would allow people to spend their lives at a constant temperature, wherever they were. 'I propose: only one house for all countries. The house of *exact breathing*' ('respiration exacte'). The windows would be double glazed, creating a hermetically sealed environment in which the air-conditioning system could reign supreme. Whether in Russia or at Suez, explained Corbusier with brio, the temperature would be 18°C.[29] Few buildings in the 1930s achieved anything like this. Draughty windows and temperamental gas fires were the norm. But Le Corbusier looked ahead to a new era of thermometric control.

The revolving door at the entrance to a department store or a block of flats gave the impression of always being open. Really, of course, it was always closed, an ingenious valve ensuring that people could come and go without bringing the outside with them.[30] As for the roof, which might once have had solid eaves and a decent pitch for throwing off the water, this had disappeared altogether and been replaced by a gravelled garden or a sun-deck. Clothing expressed the new immunity. The change of ambient temperature and the possibility of dryness played their part in the most dramatic costume change for centuries – from bustles and underskirts, swathes of taffeta and wool, to light shirts, knee-length skirts, silk dresses for the evening and legs bare but for the thinnest stockings.

The variability of weather was missed as soon as it began to be eliminated. Auden loathed the idea of controls that promised to make all rooms blandly similar. Where could he find a cosy corner if everywhere felt the same? He mourned the pleasures of cooling down and warming up, knowing that variation provides more enjoyable sensations than constancy. The post-hearth age would be diffuse and unromantic. 'Lovers will gaze at an electric stove', he prophesied: 'Preserve me, above all, from central heating'.[31]

Stevie Smith was imaginatively attached, likewise, to cooler and damper times, hence Pompey's fantasies of Victorian drippiness in *Novel on Yellow Paper*, which gather like streams into floods of longing for the 'wild wet Lincolnshire of the younger Tennyson': 'And thinking of all this I have a great *nostalgie* for an open drain, like the flooded dykes they have there between the sodden fields'.[32] Smith sought out water at every opportunity. She was delighted to find an advert for clerical rainwear in a church outfitters' catalogue (what kind of outfit was she looking for, one wonders): 'A priestly garment, eminently suitable for conducting funeral services in inclement weather'.[33] This – and her habitual woollen overcoats – constituted her ideal clothing, permitting much more weather experience than fashionable thin dresses. To be cut off from water was her disaster. She once wrote of 'the tragedy of unwatered country', and the saddest moments of her close-pent poems are those in which neither rain nor feeling has free passage:

> In a shower of tears I sped my fears
> And lost my heavy pain
> But now my grief that knew relief
> Is sultried o'er again.[34]

The most influential poem of the century took dryness as its central motif. Among the enigmatic forces holding together the many pieces of *The Waste Land* (1922) is the mythic quest of a damaged king to restore fertility to his barren country. The poem invokes parched landscapes and it returns to dreams of water with the insistence of a thirsty man. With all its gathered images and sources, the poem is itself a handful of dust, dry grains that fall through the fingers. Written in the aftermath of the First World War, the

Stevie Smith in her preferred weather, with John Gale, 1969.
Photographed by Jane Bown.

poem is a search for meaning among rubble. The places and people of the waste land become emblematic of a worldwide cultural desiccation that is for Eliot the climate of modern times, though in the dust there remain many fragments that can be shored against our ruins.

The funeral service which begins the poem is performed over dusty ground (no need for priestly rain gear). A little vegetable life clings on, but inauspiciously. 'What are the roots that clutch, what branches grow / Out of this stony rubbish?' There will be no rich hummus or well-watered shade for the corpse buried here. The spade of a gravedigger would tap and scrape against the stones in this 'heap of broken images'. There was fertility once, for a tree grew, but now 'the dead tree gives no shelter, the cricket no relief'.[35]

Memories of water keep returning (as in the sensual recollection of the hyacinth girl, 'Your arms full, and your hair wet'), but the waters of the present are deathly. The tarot card of the 'drowned Phoenician sailor', dealt in the first section, leads to 'Death by Water' in the fourth. The sailor's bones on the sea-floor are picked at rather than washed smooth by the currents. 'Sweet Thames run softly til I end my song', wrote Edmund Spenser in the sixteenth century, linking the fertile union of marriage with the unending river. The people of the waste land are more likely to be found 'Fishing in the dull canal / On a winter evening round behind the gashouse'. The nymphs have now departed, and water in Eliot's London is not enlivening. The hot water can be programmed to come on at ten, and you may order, 'if it rains, a closed car at four'. The rain brings no relief for those who ride through it in a taxi.[36]

The aridity of London, damp and rheumy though it is, emerges from its juxtaposition with landscapes more reminiscent of the Middle East or the American South. English weather is disturbingly conflated with the dry airs of desert places. We are wandering on the sand where the sun beats, grateful to be ushered in 'under the shadow of this red rock'. The landscape of the poem's final section is a version of Gethsemane, an 'agony in stony places':

> Sweat is dry and feet are in the sand
> If there were only water amongst the rock
> Dead mountain mouth of carious teeth that cannot spit [...]

Cheated by the 'dry sterile thunder without rain', people snarl at the doors of 'mudcracked houses'. Fantasies rise like mirages, culminating in the song of the hermit-thrush: 'Drip drop drip drop drop drop drop / But there is no water'.[37] Eliot measures his distance from Dickens: his 'drip drop' is not the sound of abundant water which keeps the taps of narrative flowing, but the imagined call of a bird which does not make a watery sound at all.[38] Eliot measures, too, the difference between the tearful mourning of Tennyson's *In Memoriam* and his own dry elegy. Eliot himself thought the 'water-dripping song', as he called it, was the best part of his poem.[39] It was also the saddest, and it was about poetry running dry. It conjures the sound of 'voices singing out of empty cisterns and exhausted wells'. Spenser once looked to Chaucer as the 'pure well head of Poesie', and drew up nourishment for his own writing. Eliot looks into the well and finds it dry. The wellheads gape like open mouths and voices issue spectrally from the void.[40]

When the poem arrives, at last, at a version of the grail chapel, a damp gust promises rain. By the end the thunder has spoken, though we feel no raindrops. The Fisher King, having crossed the waste land, sits by the sea with the land behind him still unwatered. The ancient vegetation rites to which Eliot referred were ceremonies of regeneration, ending in the revival of the fertile ruler and the land he personified. Eliot's modern ceremony, played out in fractured verse, is less certain of its ending.[41]

Dryness would return in his poetry. In the 'dry cellar' of *The Hollow Men* (1925), stuffed effigies await incineration, whispering together in voices that sound like 'wind in dry grass'. 'A penny for the Old Guy' begs the epigraph, as if carrying the poem door-to-door through cool autumn air. But if the month is November the season is brittle and arid. 'This is the dead land', chant the hollow men, 'This is the cactus land'.[42] The nursery rhymes have to be rewritten, since there can be no more dancing round the lush, leafy mulberry bush, and the people of the cactus land circle instead round the prickly pear.

In America, F. Scott Fitzgerald wrote about a waste land just outside New York, a ready symbol for the desert he perceived at the centre of American life. It was a dumping-ground for Manhattan's refuse, a vast acreage of incinerated rubbish. Here was a grey version of Eliot's red sand, invoked in *The Great Gatsby* (1925) as another travesty of pastoral, a 'valley

of ashes – a fantastic farm, where ashes grow like wheat into ridges'. Later, in the apocalyptic years of the Dustbowl, when the American Mid-West turned to sand and blew in terrifying clouds across hundreds of miles, the dryness of *The Waste Land* sounded prophetic.[43]

꒜

Virginia Woolf, who wrote the weather of centuries in *Orlando*, insisted on its enlivening presence in all her fiction. Though modernity was sometimes associated with regulated environments – switches, thermostats, a solarium when you wanted it, sealants, valves, 'water-tight compartments', lights to override all darkness – Woolf defined her literary aesthetics in terms of weather that wafts in through doors. Her 1919 manifesto 'Modern Novels' proposes a difference between sealed books and those which let in the air. Her complaint about Arnold Bennett's fiction is that 'there is not so much as a draught between the frames of the windows, or a crack in the boards'. 'And yet – if life should refuse to live there?'[44]

'Life' in her own fiction is lived in the air and affected by it. Young James Ramsay can sail to the lighthouse 'if it's fine tomorrow'; Charles Tansley holds his bony fingers spread to test the direction of the wind. The conditional tense of Woolf's novels often rests on changeable weather. The pageant in *Between the Acts* (1941) will be performed outside if the afternoon stays fine and in the barn if it looks like rain. The forecast in the newspaper leaves the outlook uncertain: 'variable winds, fair average temperature, rain at times'. Everyone looks out at the variable day: 'it was green in the garden one moment; grey the next'. 'We can only pray', says Lucy, though it may be more practical, as Bartholomew suggests, to 'provide umbrellas'.[45]

Between the Acts begins and ends with people talking by a window as the evening air seeps into their conversation and shapes it. The way to write atmosphere, Woolf once observed, is to do it indirectly:

> set people talking in a room with their backs to the window, and then, as they talk about something else, let someone half turn her head and say 'A fine evening', when (if they have been talking about the right things) the summer evening is visible to anyone who reads the page, and is forever remembered as of quite exceptional beauty.

When she read the work of other writers, she often imagined them by a window like this, and noticed the moments in which they half turn their heads to register a change of light. Alert to the weather in the background of books, she felt sure, for example, that the room in which John Paston wrote his letters in the 1450s must have been draughty, with 'the wind lifting the carpet' and the wide bleak fens beyond the window.[46]

She knew, too, that the weather in which we read affects our understanding of a book, and that the book in turn influences the air around us. Her long 1919 essay 'Reading' begins with a chair by an open window on an August day. The words read in this chair seem, 'not printed, bound, or sewn up' in a book, 'but somehow the product of trees and fields and the hot summer sky'. De Quincey, she says in a very early review, is best read outside in the sunshine: 'Take us out of doors [his essays] seem to plead, supplement the printed page with draughts of generous sunlight'. It is not that De Quincey is a sunny garden sort of writer – quite the opposite. Summer was for him a season of mourning, and his cavernous prose is suggestive in Woolf's mind of 'dimly lighted [...] cathedrals'. There can be no simple equations between the weather evoked in a book and the weather in which it is best read. The relationship between reading and weather is less predictable and much more interesting than that. In the case of De Quincey it has to do with rhythm and expansiveness: because De Quincey is a writer who disregards the clock on the mantelpiece indoors, he is better read outside where time moves differently and where there is no separation between words and air:

> The generous reader, reading luxuriously in some sheltered garden where the view between hedges is of a vast plain sunk beneath an ocean of air, will find that a page of De Quincey is no mere sheet of bald signs, but part of the pageant itself. It will carry on the air and the sky, and, as words do, invest them with finer meaning.[47]

Vibrating on the air, eddying like 'rings of sound', De Quincey's words build shapes in a sky which is already alive and full of noises, built high with 'cloud-capp'd towers' of language like the 'insubstantial pageant' of *The Tempest*.[48] Literature becomes weather and the weather becomes literature. Words 'carry on' the air and the sky.

People and their books invest the sky with meaning. And yet it is also remote and apart from human life, unreachable and unconcerned.

Woolf writes about the periodic shocks with which we remember the sky's indifference to 'this little coloured earth'.[49] In this she is the great inheritor of Hardy, aware of our smallness under the empty heavens. Our lives rumble along more or less coherently and anthropocentrically, until suddenly we look up. Few writers have so frequently knocked their readers over backwards and made them take notice of the sky.

In *Jacob's Room*, when the children are safely sleeping in the orderly lodging house, we must go (at least in imagination) into the dark soaked garden, lie on the grass, where every inch is rained on, and look up into the tumult: 'Lying on one's back one would have seen nothing but muddle and confusion – clouds turning and turning, and something yellow-tinted and sulphurous in the darkness'. The novel is about Jacob's life, but this, too, is part of the story, this tremendous action in the sky which cares nothing for Jacob, or for the crab (brought home from a day at the seaside) which is left climbing and climbing the walls of a bucket. In the book's final scene, after Jacob's death, his friend Bonamy looks out at the London pavement on a gusty autumn day. 'Suddenly all the leaves seemed to raise themselves. '"Jacob! Jacob!" cried Bonamy, standing by the window. The leaves sank down again.'[50] In this wishful haunting, Shelley, Keats, and Jacob Flanders inhabit the wind, but only for a second. It is only a blowy autumn day in London.

The unregarding character of the wind and the sky both disturbs and delights Woolf. 'This then has been going on all the time without our knowing it!' she remarks in mock astonishment, again lying prone, this time on a sickbed, in her 1926 essay 'On Being Ill'. Who is it all for – 'this incessant making up of shapes and casting them down'? It is not for us. 'Divinely beautiful it is also divinely heartless. Immeasurable resources are used for some purpose which has nothing to do with human pleasure or human profit.'[51] The vacated central section of *To the Lighthouse* is left in the hands of these beautiful and heartless forces. Woolf fixes her gaze steadily on the Ramsays' empty house as the darkness pours down, the nights fill with 'wind and destruction', the 'stray airs bluster in'. Far away a young woman dies in childbirth and a young man dies at war, but the weather goes on regardless. The winds offer no answers. 'Almost it would appear that it is useless in such confusion to ask the night those questions as to what, and why, and wherefore'.[52]

Bernard in *The Waves* thinks of a stormy sky and sees the impossibility of these questions about shape and meaning. At the end of

the novel he sits at a table in a restaurant, hoping to find a way of summing up the pattern his life has made. But he knows that nature is resistant to neat stories told at tables. Abruptly he imagines himself in a ditch:

> Lying in a ditch on a stormy day, when it has been raining, then enormous clouds come marching over the sky, tattered clouds, wisps of cloud. What delights me then is the confusion, the height, the indifference and the fury. Great clouds always changing, and movement; something sulphurous and sinister, bowled up, helter-skelter; towering, trailing, broken off, lost, and I forgotten, minute, in a ditch. Of story, of design, I do not see a trace then.

It is a passage to stop us in our tracks. It is about stopping and pulling off the road. Lying in a ditch, one looks up at inhuman power, 'the height, the indifference and the fury'. 'Fury' in this context picks up an echo from *Macbeth* of life as a tale 'full of sound and fury / Signifying nothing'.[53] To Bernard the very thought is a release. He looks to the sky as a model for a narrative with no design and signifying nothing. What he sees, looking up, is not a story with beginnings and endings, but pure action, undirected.

Bernard's observation that the sky is all confusion comes in a novel which is intricately structured, designed around the movement of the sun through the sky and the progress through the seasons correlating to the stages of human life. Nothing could be more orderly. Woolf may have suppressed the section headings that appear in her first draft – spring, summer, autumn, winter – but *The Waves* still bears structural resemblance to the medieval books of hours or the 'labours of the months', asserting sequence and repetition over chaos.[54] As Bernard knows when he opens his notebook or starts to arrange words in sentences, part of the purpose of art is to seek out design in a world which resembles the confusion of clouds.

GREYSCALE

Though the twentieth century dreamed of brightness, it came to specialize in grey. G. K. Chesterton was an early advocate in an indulgently patriotic 1907 essay called 'The Glory of Grey', pointing out that grey skies might be steely or frosty or smoky, and that scarlet flowers against a dark sky look 'at once vivid and secret'. The effect of a grey day is not purely visual, he

thought, but moral and psychological as well. Grey 'suggests in some way the mixed and troubled average of existence'. It is 'a colour that always seems on the eve of changing to some other colour [...] So we may be perpetually reminded of the indefinite hope that is doubt itself.' In that same year the American poet and essayist Louise Imogen Guiney (now living in England) published in *Scribner's Magazine* a rhapsody on skies of 'pearl-grey', 'the most subtle and the least appreciated of lovely hues'. She made it clear that the truly refined Anglophile is one who appreciates the in-between weathers of February and March.[1]

Modern grey came in an almost limitless variety of tones and concentrations, bearing different histories and allegiances. There were, to begin with, clear, translucent greys that descended from the eighteenth century. The watercolourist Eric Ravilious loved the steady light he found in the eighteenth-century paintings of Paul Sandby and Thomas Girtin, bright enough to reveal details in the distance and sufficiently clouded to fall evenly across a view, holding everything in calm proportion. Ravilious inherited the weathers of the early landscape draughtsmen and brought to them a distinctively 1930s interest in ordinary places and unremarkable conditions. His Essex roads and fields, with leaning telegraph poles and the odd bit of parked machinery, show less obviously beautiful views and in greyer, rainier sorts of weather. Ravilious knew and respected the picturesque habits which make us wait instinctively (now as then) for a moment of brightness or a shapely cloud, but he preferred, in his lucid watercolours, to occupy the stretches of normal time in between. When he painted chalk paths across Sussex downland, or chalk figures carved on the hillsides, Ravilious liked them grey in steady cloud-light as much as he liked them sharp white in sun.

The icy extremes of the polar north attracted him, and his bookshelves filled with reports of polar expeditions long before he was posted as a war artist to Norway and Iceland in 1941. The crystalline drawings he made in the Arctic are among his most admired works: the bare, immaculate blue and purple forms of mountains and water are mapped in dry brushstrokes as if the watercolours themselves had frozen.[2] But all through the 1930s, while he lived in southern England, he trained his eyes on small gradations of land and weather that were far from sublime. Even in Wales, where he was happy to sit outside through rain and gales, he painted geese and chapels rather than mountains. There is a little ochre in the winter sky of

Wet Afternoon, the light is low but not dull, falling evenly on the tightly clipped holly hedges to either side of a sunken lane. With a slight shimmer on the evergreens and the faint suggestion of streaks through the sky, Ravilious makes us feel light sheets of rain blowing right to left over the sheltered path which runs down past the church.

His friend and contemporary John Piper was always glad of a grey day. The bright forms of seaside structures were at their best, he thought, when seen in gloom. Admiring the distinctiveness of 'nautical style', he painted the strong lines and bold stripes of lighthouses, beach huts, bollards, and boats, all of which stood out along the grey coast.[3] These were gestures of architectural assertion under doubtful skies. With a single brushstroke of red or yellow, Piper saluted the flags which flutter brightly against the monochromes of Dungeness. He was pleased to go to the seaside in the rain, painting Portland on days when the heavy sky was a darker hue than the pale, glimmering Portland stone. 'You seem to have very bad luck with your weather Mr Piper', said George VI as he surveyed a series of leaden-skied pictures.[4] But in Piper's eyes a clouded backdrop was the best foil both for the stripes of a lighthouse and for the worn frontages of old houses and churches. The heavy weather seemed to speak of all the time and experience that carved its way into bricks and stones.

Ravilious and Piper used their greys in a spirit of celebration, with a firm, fond sense of time and place. They both painted drizzly rain because they liked to be out in it. But grey without the cheerful flags or buoys could be an expression of alienated blankness. Hardy had established a modern chromatic scale in his poem 'Neutral Tones' (published 1898), where the 'pond edged with greyish leaves' is forever associated with a 'grin of bitterness', and where emotion is muted to the silent circles of white sun and ash-edged water.[5] There is no relieving flash of colour here. Nor is there anything so definite as black, which might allow for mourning. Where many Victorians with their black-edged letters and mourning weeds made fulsome use of black in negotiating sadness, the twentieth century bred more circumspect areas of grey. Orlando noticed that it was 'harder to cry' in the twentieth century than in the nineteenth, a passing observation which delineates a whole new era in the history of emotions.

Reading and rereading *In Memoriam*, Hardy was drawn to moments when Tennyson's flood of grief runs into emptiness. He marked in his copy the meaningless dawn on Wimpole Street where Tennyson's lost

friend Arthur Hallam had lived: 'And ghastly thro' the drizzling rain / On the bald street breaks the blank day'.⁶ 'Ghastly' stems from the same root as 'ghostly', but the ghost here is sickeningly absent. A history of modern blankness might be traced in the attentiveness of twentieth-century readers to these particular lines, which would be singled out repeatedly from the 133 cantos of the whole. T. S. Eliot quoted them in his 1936 essay 'In Memoriam' and let them haunt the derelict wartime dawn of his Blitz poem 'Little Gidding'. After a night of conversation with familiar ghosts, the morning is a lonely blank. 'The day was breaking. In the disfigured street / He left me'.⁷

～

Auden associated himself with deep cold, but the locations he sought were grey rather than white – and one had to visit them after dusk. His early poetry made dimly lit excursions into part-derelict northern mining country, where furtively he paused at 'the crux left of the watershed', looking down on 'dismantled washing-floors, / Snatches of tramline running to a wood'. He wrote about 'a world that has had its day', and long after daylight he operated in a secretive hinterland of late watchers and swift departures. The headlights of an unseen vehicle scour the wall of a lonely bedroom. 'Go home, now, stranger', these poems instruct, pushing us away even as they hint urgently at what is there to be seen.⁸

In the decade before 1939, Auden mapped England as a military zone. If civilian life here had 'had its day', if culture was worn out and the mining towns were expiring, folding in over their own secrets, the new efficiency belonged to undercover agents and the new poetry came in the form of diagrams and codes legible only to initiates. Auden made sorties into forbidden country and returned to analyse his evidence in the huddled, reclusive places from which he set the literary agenda of his time. Habitually he kept his curtains drawn all day, wanting to insulate his study or control room, guarding against interruptions from sunlight. Heavy blankets were helpful too, prolonging darkness well into the afternoon and constituting another form of defence against dangerous times. Auden occupied in his poetry some of the same coastal lookouts as John Piper in his paintings, but he raised no bright flag in the dim light along the harbour wall. The vessels he watched were not local fishing boats with fondly stencilled names but anonymous warships on classified missions.

Auden preferred, in any case, to imagine himself carrying out surveillance from above, detached and immune, looking down on England 'as the hawk sees it or the helmeted airman'.[9] When a rift in the clouds reveals the country laid out below, neither the hawk nor the airman is Romantic about it; both keep a cool eye on their targets.

Warlike operations take place quickly and decisively in Auden's poetry: there are sudden disappearances, or a train starts at night for the north.[10] Other kinds of life, meanwhile, grind slowly to a halt. Anxious stasis became the subject of Henry Green's 1939 novel *Party Going*, in which nobody is going anywhere. The title is wishful thinking: Auden's secret trains have long departed and at Victoria station all normal services are cancelled due to fog. We are back in the low visibility world of *Bleak House*, though without any sign of Esther Summerson and without the Dickensian expectation that hidden truths might eventually emerge. Pressing on to the station concourse, passengers wait for something to happen. A group of Bright Young People, who would normally be found glittering in silks with ice cubes chinking in their cocktails (and who are on their way to the bright lights of the Riviera), book in to the station hotel and survey the crowds from above. Though they have the luxury of a hot bath while they wait, they are detained by the fog just as irremediably as the thousands of commuters who are trying to get home from work. The novel is stuck from the outset and gets nowhere. Green lets the disoriented agitation of the late 1930s catch like particles in the thickening air of a November afternoon.

In the restricted space of a London terminus, Green is restlessly inventive. His sentences shift from foot to foot, with no certain place for the emphasis to fall. Both definite and indefinite articles are lost, leaving nouns to float, or sink. In the first line, 'bird that had been disturbed went flat into a balustrade and slowly fell, dead, at her feet'. Grammatically dislodged, the bird falls into a world where all logical relations are obscured. The fate of Romanticism in such conditions is, like everything else, uncertain. The bird in question is a pigeon rather than an albatross, falling not from polar mist but from the grimy rafters of a smoggy station. Romanticism is knocked out and falls flat, though for reasons that remain unclear an elderly Miss Fellowes carefully stows the pigeon in a paper bag for onward travel. There is no difference, in Green's fog, between the mundane and the mythic, a grimy rush hour and a haunted otherworld.

A stranger penetrates mysteriously through barriers, like a revenant on All Souls' Day passing between worlds. From above, we are told, the electric lights on the concourse 'might have looked like November sun striking through mist rising off water'.[11] The station is momentarily transfigured into a Turner painting, but the epiphany is missed, since the clerk who might have seen it from his high office window is busy calling the police.

The young aristocrats at their hotel windows see little sign of beauty. They look down as if from a besieged fortress onto a frightening concentration of human energy. But the massed people on the ground, if they are powerful and threatening, are also extremely vulnerable, and know it. Boredom keeps turning to alarm. 'What targets for a bomb', remarks someone in the crush, though no one sees exactly who.[12] The fog and not the crowd is really the besieging force, and as it thickens it seems more and more to carry the fears of 1938. Victoria station, this November night, is a preview of war. Green gives a panorama of peacetime life surging towards its terminus: the greyness seems to spread out over Europe even as the fog closes in, inducing claustrophobia, and allowing us to see only a few feet in front.

The paintings of L. S. Lowry are about how people carry on in the gloom, how work gets done and football is played. In the pictures of northern urban life he made consistently from the 1920s to the 1960s, he refused to make the smog symbolic. He made no analogy between air and thought; his sky was not a state of mind. Lowry was not even much interested in occlusion. He assumed blanket cloud, and smoke trapped beneath it, as the normal condition of city life. Monday to Friday, and at the weekends, this is the white-grey canvas across which his striving stick-people go on their way. In grey light they arrive at the factory gate; in grey light they leave it. Lowry's opaque skies are never about to change or clear. There will be no revelatory sun striking through mist rising off water, and not even much change from season to season. If there are highs and lows, they are made by the activities of people rather than weather.

Lowry's opacity is all the more striking because he was an admirer of Monet and Pissarro, and an inheritor of Impressionist translucence. He was taught in Manchester by Adolphe Valette, the Frenchman who exported nebular radiance to northern England. Lowry learned all a painter could know about mists and then rejected it, understanding that factory work is

not done in a haze of shifting luminosity but in a steady routine, knowing that a football match is a 'fixture', a landmark which holds the week, and the community, together. This was his argument with Impressionism. The mill and the town hall are not half-there in Lowry's paintings, forever changeable: they are really there, and must not be obscured because they are the basic building blocks of life.

As a sophisticated master of 'naive' flat-fronted streets scenes, Lowry honoured the shadowless light in which two dimensions are more real than three. He looked out over long perspectives, too, painting recessive miles of chimneys. Sometimes his grey looked as pretty as a snow scene. *The Pond* (1950) is like a seventeenth-century Dutch skating picture by Avercamp; everyone seems to be out in a wonderland. There is a memory here too of Brueghel's *Returning Hunters*, with its dark figures in a white world and the sweeping view from high ground into the frozen valley. But the visual allusions mark out a difference. Lowry's pond is not frozen. The mothers push their prams in a park which is merely reflecting the grey-white of the sky. It might well be the middle of June.

<center>〜〉</center>

In the years after the war, grey was the colour of austerity. Returning to England from Canada in 1945, Wyndham Lewis was more dismayed than ever by the failure of the weather to be modern. His flat in Notting Hill was infested with dry rot, the fungus which, despite its name, flourishes in damp. '[D]ry knot of Rotting Hill' mocked Ezra Pound from America. Lewis glumly wrote a book of short stories with this title, taking the rot and the rotten weather as symbols of British dereliction. 'The decay of which I write is not romantic', he began. He knew his Ruskin; almost certainly he knew John Piper's article on 'Pleasing Decay', exploring the picturesque possibilities of ruins in the context of post-war dereliction. Lewis refused to see any aesthetic potential in the gloom. People in *Rotting Hill* live in houses where the Ascot heaters fail to produce hot water, and they struggle drearily through 'attempted snow-storms' which fail to produce snow. One of them, a government bureaucrat, is sufficiently on-message to keep smiling, but harbours suspicions that the weather is compromising the official post-war rhetoric of England's 'brave new day'.[13]

Rotting Hill was published in 1951 as a scathing counter-narrative to the Festival of Britain. The South Bank extravaganza set an example of

airy lightness with its levitating Dome of Discovery and seaside bunting. Its centrepiece, the steel Skylon, an aerial insect poised for take-off, looked as if it might pierce any cloud which threatened it. But the Skylon was dismantled (and pieces of it recycled into souvenir ashtrays) before the Great Smog of December 1952, which included six minutes of near-total blackout. For days the air in London was thicker than at any time in living memory. The smog crept in everywhere: through revolving doors into shops and smart apartments, into bedrooms and wardrobes. At Sadler's Wells a performance of *La Traviata* was stopped because no one could see the stage; the air can have been no good for the singers' lungs.[14] Fog seeped into hospitals where asthmatics gasped and wheezed; smog-related deaths were estimated at four thousand. It was an affront to the pride of a modern city and – at last – the crisis precipitated action. The Clean Air Act of 1956 legislated for control of both industrial and domestic emissions.

England returned from paralysed gothic to the normality of greyness, and the grey had never before been written about so much. The post-war decades were the golden age, or the grey afternoon, of weather jokes. Flanders and Swann sang a 'Song of the Weather' in the tradition of medieval calendar rhymes:

> April brings the sweet spring showers
> On and on for hours and hours.
> Farmers fear unkindly May
> Frost by night and hail by day.

Their lyrics were based on an 1834 nursery rhyme by Sara Coleridge. 'Hot July brings cooling showers', she had written, 'Apricots and gillyflowers'. Flanders and Swann conceded that 'In July the sun is hot', but: 'Is it shining? No, it's not'.[15]

English writers and artists, born into grey, trained their eyes on its many tones and tuned their grammar to the minor key of its constrictions. Sylvia Plath, on the other hand, exiled from America, hated it with passion. In Devon, in November 1961, she was desperately frustrated by 'English dinge / Our sole indigenous art-form – depressionist!' She wanted to go somewhere that would cleanse the grime and free her from post-war utility meanness.[16] Ted Hughes told his version of what happened next in one of the saddest poems of *Birthday Letters*. He thought Woolacombe Sands would be the place to go for relief one afternoon, and though he had never

been there it was a good guess: it is one of the biggest beaches on the Devon coast, flat to the horizon, about as close as you get in England to the Atlantic stretches of Cape Cod. It might have worked in sun, or at sunset, but not in rain – not for Plath:

> It was dusk when we got there
> After a steamed-up hour of November downpour
> And black cars sploshing through pot-hole puddles.
> The rain had stopped. Three or four other cars
> Waited for walkers – distant and wrapped in their dowds.
> A car-park streetlamp made the whole scene hopeless.

There is no sublime possibility in the 'The blue-black heap of the West collapsing slowly'. It is not even worth getting out of the car.'' Sometimes we need a gift from the weather and are refused.

In London, the weather was a public examination taken by immigrants from sunnier places, a grim rite of passage into English life. West Indians on their third or fourth winter, having honed their own tactics for survival, scrutinized newcomers to see how they would manage. Part of Sir Galahad's mystique in Sam Selvon's *The Lonely Londoners* (1956) is his immunity to the English chill: he arrives from Trinidad without so much as an overcoat and carries on as if the weather is just fine. But this is a 'miracle of metabolism' and everyone else is leaning close to the gas fire and 'rattling with cold'. The grim South African exile in J. M. Coetzee's novel *Youth* watches muffled Trinidadians under the 'ghostly sodium lights' on the Kilburn High Road and wonders how they stand it. For himself, John won't admit to liking the weather but it conveniently exacerbates his misery; 'in misery he is still top of the class'. He could be running on Strandfontein beach under a great blue sky, but his ambition to be a great writer of cool, ascetic, impersonal poetry requires that he become an Englishman, or rather a steel-masked actor of Englishness. Through the legendarily bleak winter of 1962–63 he plays out the role in dismal rooms, putting his shilling in the gas meter and waking one morning to find that, a pipe having burst, he is surrounded by a sheet of ice. It is the inverse of the flaring eastern sunsets ('romance … glamour! … a flick of sunshine upon a strange shore!') in Joseph Conrad's story 'Youth', which gives Coetzee his title. The frozen mist of a western capital, hung with coal dust and sulphur, is the right weather in which to read disappointing novels by Ford Madox

Ford and fail to become a writer of poems about failure. *Youth* ends in grey silence, all narrative attenuated, with John clutching at his credo that 'poetry is not written out of warmth'.[18]

These were years in which to be thankful for small clemencies. Philip Larkin, in January 1962, felt 'A slight relax of air where cold was'. 'Relax' as a noun: an expansion, an easing, a release of winter's grip, though nothing so distinct as the first sign of spring. In Larkin's careful modulation of negatives, the 'dark ruinous light [...] withdraws'. His is a poem of less-dark light, marking a small shift on the monochrome scale. He surveys a landscape which might now be called Larkinesque: wet slates and railway banks beyond the net curtains, slippers, gas, and grate within. Then (with that abstract upward gaze for which he would become famous in 'High Windows') he looks up, or sees some other face look up:

> To see the sky over the aerials –
> Sky, absent paleness across which the gulls
> Wing to the Corporation rubbish ground.
> A slight relax of air. All is not dead.[19]

This is the year's resurrection. The sky may be an absence, but the word 'sky', repeated, has room to stretch; it is an out-breath, almost an exclamation. The flight of the gulls has grandeur, though they may be making for the dump. This view, delimited by roofs, is a descendant of Constable's cloud paintings, both abstract and precise, earthed by a few wire aerials as Constable would sketch in the top of a tree. Larkin, however, cannot allow in his sky the lively action of Constable's clouds: he needs the view from his high windows to be ascetically empty, a monastic blank giving on to infinity.

Penelope Fitzgerald admired the 'marvellous talent for the clearest possible everydayness' which Larkin combined with 'romantic vision'.[20] The characters in her own novel *Offshore*, published in 1979 and recalling her life in the early 1960s on a worn-out Thames barge moored off Battersea Reach, are in two minds about whether there is anything Romantic to be discovered in their damp days. Their leaky home rests flat-bottomed on the mudflats and grudgingly rises with the tide. The lonely mother Nenna, tired and disappointed at thirty-two, recites over to herself Whistler's 'Ten o'Clock Lecture', wondering if it has any relevance to her. Is she living in a Whistler painting? Is her makeshift, half-sunken world the same place

as his 'fairyland', 'when evening mist clothes the riverside with poetry, as with a veil [...], and the warehouses are palaces in the night, and the whole city hangs in the heavens'?[21] Whistler had been very sure of himself as he painted the dark city and lectured about it. Fitzgerald's Nenna is much less certain and more truly a figure of the half-light. She rebukes herself with Whistler's words, which remind her that she has failed to make poetry of her riverside life. She also offers his words in her defence, since they suggest that there is a life here worth living.

Fitzgerald finds it for Nenna where she can: in the V-shaped eddies beneath a transparent violet sky, or in the suspension between ebb and flow when the tide is on the turn. She pauses in these moments of transition, at tide-turn or daybreak, less to affirm their beauty than to register the sense of indecisiveness when time is at sea and 'the lighters swing at their moorings, pointing all ways, helpless without the instructions of the tide'. She knows the worth of 'small gains' (it is the name of a wrecked but un-sunk boat in the novel), and a small gain in light or warmth is enough to lift a scene from desolation to fragile hope. Fitzgerald makes an art very different from Whistler, refusing his formal confidence in order to write about Nenna's 'formless melancholy'.[22] He was a virtuoso of mists, bringing down the veil in order to paint Battersea with artistic detachment; she writes about how to 'manage pretty well' from day to day, trying not to trip on wet ladders or a ten-gallon tin of creosote. Nenna responds with ambivalence to the mist that comes off the water and to the corresponding blankness liable to permeate one's mind.

～

Lowry's industrial places had been packed with human liveliness: crowds of figures, someone loitering, someone pushing a pram against the flow. Lonelier greys emerged from a later and different kind of industrial England where the power station was not a community affair but an otherworld. Prunella Clough studied the faint tonal shifts of light on concrete and corrugated iron, and she used paints the colour of ferrous oxide, spreading like lichen across canvases of grey-white and grey-blue. Paul Farley and Michael Symmons Roberts have more recently been watching the effects of weather out of town, beyond the ring road, in depots, distribution sheds and other 'edgelands' less loved even than Larkin's 'mortgaged half-built edges'. 'Look at slant rain at night', they suggest, 'falling on a fenced-off yard

full of identically liveried vans or brand-new cars, lit by powerful security lights'; or look at the 'morning sun brushing the tops of willowherb, nettle, thistle, in the unkempt field behind the car-crushers'.[23]

The wide spaces of these edgelands (where cars have their identical beginnings and their crushed ends) have been opened up by road transport, and they share qualities with roads themselves as landscapes with weather of their own. Many modern lives entail hours spent every day in road weather; and more rain is seen through the windscreen, smeared then clarified by wipers, than is blown straight in the face. In the 1980s the architects Alison and Peter Smithson were so enthusiastic about the views from their Citroën DS that they compiled a car-shaped book of their Citroën-centred observations. Surrounded by glass they could see so much, and see it at speed. As Turner knew when he painted *Rain, Steam, and Speed*, weather can be awe-inspiring when you (or it) are moving quickly; the splash and spray of a rainstorm experienced in a car at sixty miles an hour has similar potential to be sublime. The Smithsons appreciated the smooth arc of a demisting window, the unfurling miles of wet tarmac at night, the 'ground mist' created by spray, the 'kindly lights' of the car in front, beckoning them on through darkness.[24] It may be that few people in practice have enjoyed a wet A-road so much as the Smithsons, but there can be little doubt that what we see in the twinned white cones of moving headlights are among the most characteristic weathers of our times.

⌖

English summers take their identity from the stretches of grey on either side. Days of sunshine and warmth do not come as standard but as gifts to be honoured and rejoiced in. This temporariness is responsible for summer rapture, and also for the pressures and disappointments that summer days can bring. Particularly in the decades after the war, when sun culture was well established but not habitual, when annual holidays involved beaches in England rather than southern Spain, heat had a tendency to generate unease.

For Sam Selvon in the 1950s, and the growing West Indian community he wrote about, summer was a blessed relief after 'the beast, winter'. July was a homecoming to warmth, so sweet after the cold that many fell in love with it and postponed their planned return to the perpetual green summers of Trinidad or Jamaica. This was the sexy time, the proud time,

the season for watching the world on the Bayswater Road, 'when all the fog and snow gone, and night stay long to come, when you could put on a hot jitterbug shirt and wear a light sharkskin pants, when them white girls have on summer frocks'. 'Everywhere you turn the English people smiling isn't it a lovely day as if the sun burn away all the tightness and strain'. The English, thought Selvon, looked 'as if they living for the first time'.[25]

They were living, but often warily. Larkin, 'though summer-born / And summer-loving', could not feel at home in the sun and expressed some of the complicated feelings that accompany the heat. Out of step with summer's confidence, he found the high point of the year was overwhelming:

> Too often summer days appear
> Emblems of perfect happiness
> I can't confront: I must await
> A time less bold, less rich, less clear:
> An autumn more appropriate.

He kept feeling he had blundered out of his grey element into a place not made for him. Blue skies were an aesthetic and, inseparably, a moral challenge, setting a standard beyond reach. But 'If the worst / Of perfect weather is our falling short', 'It may be that through habit these do best, / Coming to water clumsily undressed / Yearly'.[26] The annual seaside holidaymakers were doing the best that imperfect human beings could.

Larkin's summer poetry is barometric, registering the pressure of air and the weight of expectation which grows with it. The pressure of the sunlit Saturday in 'The Whitsun Weddings' (1958) intensifies with every stop of the train on the line down to London as the hopes of each young couple press in on the 'tall heat'. Anticipation builds like static on a long hot day, and what can come of it? Larkin takes his answer from meteorology, though there is no conclusive storm right overhead. The point of release, the breaking of the weather – not here but elsewhere – becomes the sidelong climax:

> there swelled
> A sense of falling, like an arrow-shower
> sent out of sight, somewhere becoming rain.[27]

The fall is really an ascent, a 'swelling'. The high-point of the poem is the invisible collapse back into grey, an offstage exhalation of relief.

Prolonged hot spells in England have tended in the past to arouse suspicion. Tensions rise, and agitation sets in. Heatwaves may well become a matter of course as our weather gets more extreme, but in the twentieth century they were distinct and memorable events. They pushed English lives out of their natural element, and that was what fascinated novelists. They offered forms of alluring strangeness comparable with what E. M. Forster's characters experience in Italy and India. A series of modern writers saw that heat could make home a foreign country.

L. P. Hartley in *The Go-Between* (1953) looked back to the high temperatures with which the century began. The summer of 1900 was record-breaking, and Hartley's twelve-year-old hero Leo (summer-born and summer-named) examines in daily excitement the thermometer hung under the yew tree in the grounds of Brandham Hall. Given the run of an aristocratic estate, thrilled by the attentions of glamorous Marian, Leo feels complicit with the summer. Last year, sick with a fever, he had loathed the sun; but that was in the nineteenth century. Now, in his new green summer suit, he is ready, or so he thinks, for the century so blazingly inaugurated. As an ageing Leo remembers, looking back, 'I was in love with the heat. I felt for it what the convert feels for his new religion. I was in league with it, and half believed that for my sake it might perform a miracle'. Young Leo does not yet know what sorts of miracle life has to offer, though the heat is revealing to him new possibilities. He carefully examines its effects on familiar things:

> In the heat, the commonest objects changed their nature. Walls, trees, the very ground one trod on, instead of being cool were warm to the touch: and the sense of touch is the most transfiguring of all the senses [...] The mind, the heart, the body, all told a different tale. One felt another person, one was another person.

The minimum and maximum levels on the thermometer mark out the limits of experience, and the mercury ('Ninety four!') is reaching new heights: 'I seemed to feel within me the world's tremendous meteorological effort to excel itself, to pass into a region of being which it had never attained before'.[28] Eagerly carrying love letters between Marian and Ted Burgess, Leo can imagine himself as the summer's protagonist, its controller and explorer, the one who knows its secrets. By the end of July he has learned that there are 'altitudes' of emotional temperature which might lead a man

to shoot himself. He has learned, too, that he has no magical relationship with the weather; the world's meteorological efforts are not 'within him' at all, but beyond control.

Leo is both Mercury and Icarus. 'You flew too near the sun, and you were scorched', he tells his younger self: 'This cindery creature is what you made me'. His encounter with burning emotion in that hot summer of his boyhood, we realize, has shaped the whole course of a life in which he has avoided passion. His own golden age was shot down in flames, and so too, he reflects, was the century, 'this hideous century we live in'. 'Ask yourself whether you have found everything so radiant as you imagined it. Ask yourself whether it has fulfilled your hopes'.[29] It is raining on the day in 1950 when he sits down to examine his past.

Ian McEwan, who first read *The Go-Between* 'spellbound' at thirteen, has been compelled by the disturbing effects of English heat since he began his first novel, *The Cement Garden*, in the heatwave of 1976, responding to Hartley with the story of another summer, another boy (a little older) finding out about sex and death, though in a place very far from Brandham Hall.[30] The expansive landscape of pastoral is reduced, in McEwan's novel, to a plaster cast of Pan on a small rockery in a suburban garden in a street where only a few houses are yet to be demolished. Jack's father had intended to cement over the lawn (the size of one of the baize card-tables they might have used at Brandham), but he died before he could lay more than a small path around the house. And so, when Jack's mother dies, on the last day of the summer term, there is enough cement left over for Jack to inter her body in the cellar.

By the time the schools broke up in mid-July 1976, it had already been hot for six weeks. The green England of the Hovis advertisements, seen from Gold Hill in Shaftesbury, was parched to straw as far as the eye could see. The friable soil, powdery as cement in places, evoked the handful of dust in Eliot's waste land. Fires broke out with frightening regularity. Road tarmac bubbled and streets were lined with dusty cars their owners were not allowed to wash because water was in short supply.[31] McEwan took the measure of national claustrophobia and dilapidation. Was England now a barren place comparable with Faulkner's American South, through which a dead mother is carried (and a broken leg clumsily cemented) in *As I Lay Dying*?

The cement of *The Cement Garden* is not the material of utopia but an agent of bungled gothic in the dismal surroundings of a grey and

burned-out suburb. The decomposing body downstairs refuses to be sealed in and plastered over. This is a summer of decay: meat festers in the kitchen, flies gather around unemptied dustbins. There are no pockets of natural shade, no trees offering dappled summer pleasures, though weeds push up through the asphalt around the derelict prefabs and Jack's sister Julie sunbathes stickily on the remaining patch of grass. The cement garden is the poor and grey relation of the modernist sun-decks where the concrete was always refreshingly white.

Flesh asserts itself in summer, among the living as well as the dead. While the corpse in McEwan's novel rots, living bodies sweat; arms and legs and backs and breasts are variously exposed. Jack spends his summer acutely conscious of Julie in her bikini, feeling sick as he rubs cream on to her hot, brown skin, repelled and attracted. His feelings merge indeterminately because he is not yet master of them, but also because the heat renders all apprehension hazy. 'The house seemed to have fallen asleep'. So has England, and Jack is a somnambulist in a suspended world, moving semi-consciously towards disoriented abandon on 'the hottest day since 1900' – the hottest day since Leo ran like Mercury – when police sirens at last break the awful spell.[32]

McEwan marked the new millennium by returning to *The Go-Between*. His mercurial message-carrier in *Atonement* (2001) is young Briony, who tells a lie on a stifling day in 1935 and lives for the rest of her life in the shadow of that moment. McEwan knows the comedy of a pre-war country-house England which was not used to heat or happy with it. Mrs Tallis lies prone upstairs with a migraine. The Victorian rooms are all wrong for the weather, the 'effect of suffocation' heightened by the dark panelling on the walls and the 'aroma of warmed dust' slowly emanating from the Persian carpets. The family sits down to a huge roast dinner which was clearly hell to cook and which nobody wants to eat. The elder son, Leon, feels a frisson of excitement at the transgressions licensed by the weather: at his club, he explains, 'if the temperature reaches ninety degrees before three o'clock, then jackets can be taken off in the upstairs bar the following day'. He needs no further proof that England in a heatwave is 'a different country' with different rules. We smile at the petty codes of the club and at Emily Tallis's recollection of her parents' quaint view that 'hot weather encouraged loose morals'. But the consequences become more serious when Briony, in her rage to restore order, loses her judgment. Like Leo in

The Go-Between, she flies too close to the sun and is not alone in being scorched.[33]

~

David Hockney, in California during the 1970s, painted places where sun-filled lives were normal. The bright light exposed no secrets around his shadowless poolsides or in the depthless blue of the glassy water. Acrylic was the right medium for planes without gradation. On his periodic returns home to Yorkshire he was all the more attentive to the relationship between character and damp. *My Mother* (1982) is a collage of photographs taken at Bolton Abbey in November. Turner painted Bolton's ruined arches soaring above the river; Hockney includes the abbey in the background, but prefers the slanting tombstones, dark with the damp, faintly reflecting the green-grey sky. An out-of-focus photo doubles as a puddle, or a memory of water on the lens. Hands pushed deep in raincoat pockets, his mother patiently poses for her son. Hockney's own glossy brogues, peeping in at the bottom edge, hint at a dandified artist less well equipped for the wet than this frail octogenarian.

Later, ageing himself, Hockney came home to the north and brought his acid pop-art colours with him. They worked differently in England. His winter landscapes were now luminous with yellows and purples, the hot-house colours sharpening, in a surprise alchemy, the sense of heavy silence in winter air. The reds and greens of the furrowed field in *Three Trees near Thixendale, Winter 2007* would be candy stripes in another context, but here, under the violet tracery of bare branches, with the hilly distance a frieze of ice-blue, the red is the red of cold bare soil. Hockney's colours expressed the exhilaration he found in greyscale country. All the entertainment he needed, he said, was within a few square miles of his home. 'I can find excitement, I admit, in raindrops falling on a puddle.'[34] *Rainy Night on Bridlington Promenade* sounds dreary enough, but for Hockney it is a carnival of bouncing drops, purple splashes, primrose lamplight.

~

'Welcome, kindred glooms!' cried out James Thomson in 1726, at a time when poetry said little of greyness. Almost three centuries later, gloom is a crowded field. The poems of Sean O'Brien are echo chambers for the past glooms of Auden, Eliot, and Larkin. In his 2011 collection *November*,

O'Brien welcomes his kindred weather:

> Come, then,
> Fog and drizzle, frost and cigarettes
> And dank austerity and blessed peace!

Grey weather defines the places he inhabits: 'In this world it rains and the winter / Is always arriving'. It rains on the leaf-clogged passageways, and it rains on 'the stuff that gets left in the gaps / Between houses': the unwanted settees and the mail-order catalogues 'turning to mush'. When winter actually arrives – silent, snowing, purifying – these places are capable of transfiguration, just as much as the 'draughty church at smokefall' in Eliot's *Four Quartets*. O'Brien ends his poem with a moment of wonder: 'the minute at nightfall / When rain turns to snow and is winter'.[35]

O'Brien's meteorology is rich with history. He feels for the particular qualities of modern rain in relation to rains gone by. His sodden northern topographies (Newcastle, Huddersfield, Holderness, 'the bus station's just-closing teabar', regional termini) are also period pieces, each phase of the past conjured through its distinctive sites of damp. So he goes back through the wet margins of his post-war childhood:

> Novembers, Decembers, you smoke-haunted Fifties: lead
> me The wrong way to school, by the drain and the tenfoot,
> The rain-rotted gate to the graveyard, the laurelled Victorian
> Dark of the ruinous gardens, the fogged-over bombsites [...]

He discerns the look and the smell of post-war rain on post-war rubble, and how you might turn a corner into the undergrowth of a derelict Victorian garden. He knows the suburban houses painted by Atkinson Grimshaw, the 'northern master' who 'understood belatedness', both the lateness of the hour and the lateness of nineteenth-century nostalgia. O'Brien understands himself in this tradition of lateness. The raindrops he shakes from the thick glossy leaves of an overgrown laurel hedge belong at once to the present, to his youth in the 1950s, and to the heyday of these large laurelled gardens in the 1860s. His poetry asks what narrative we make for ourselves if we say that 'Ours was just a period in the history of rain'.[36]

Daily, in our own period, we take stock of our history and our rain. The news and the weather are bound together in the papers and on

the television, so that the events of the day reach their conclusion in a picture of Britain overlaid with the lines and signs of the air. Since the first bulletins were broadcast on radio in the 1920s, and on television in the 1950s, the weather forecast has been a regular feature in our lives, a soothing institution, dependable in its timing even if the predictions it imparts are fallible and the weather itself is bad. The dramas of the wind and rain are contained within our most homely routines, watched from the sofa in the evening with the encouragement of kindly presenters who know themselves to be taking a version of school assembly for households across the country. Even for those who barely listen to the words, watching can be a form of ceremony as we bear witness to the moving isobars and hear this particular day's permutation of the old repeated phrases: rain clearing northwards, fog slow to lift.

The shipping forecast, delivered over the radiowaves in coded language and sober tones, has often prompted in listeners a sense of ritual. Broadcast in the hours of darkness, it is valued as a fixed beacon in the night and not only for those at sea. At 00.48 it is the voice of a late watcher, keeping guard outside so that those indoors may sleep, and at 05.20 it lays out the premise for the day ahead.[37] Listening, we think of others listening; the forecast makes a community of detached and separate people many miles apart. Most of them have no knowledge of shipping and what they hear is less a functional bulletin than the script for an imaginary offshore tour through dark waters they have never seen. Cold headlands appear, unvisited beaches, moving lights on black swell, a low groan and clang from a container ship, discs and dials in a small cabin, a flickering screen. These are versions of the images which appeared a thousand years ago to those who spoke or read 'The Wanderer' and 'The Seafarer', their thoughts travelling between warm rooms and lonely waters.

While the Wanderer gives no name to the seas he ploughs, however, the shipping forecast conducts an orderly tour of the national estate. The waters are measured and mapped, their weather corralled into named zones. The reading of 'reports from coastal stations' is a beating of the bounds, a version of the circular parish walks which used to take place each year at Rogation and which had both practical and ritual purposes. The forecast, too, is a thing of utility and sanctity. Carol Ann Duffy named some of the quotidian sounds which become, unexpectedly, the vessels

for things we cannot say: the 'Latin chant' of a passing train, overheard piano scales, and the shipping news at night: 'Darkness outside. Inside, the radio's prayer – / Rockall. Malin. Dogger. Finisterre.'[38]

~

Since the grimy days of *Rotting Hill* the English atmosphere has become a cause for celebration. Soft greys are now desirable indoors as well as out. It is possible to paint your sitting-room in 'Mizzle', a colour described by Farrow & Ball as 'a soft blue grey, reminiscent of a West Country evening mist'. You might use it in a colour scheme with 'Light Gray', 'French Gray', 'Blue Gray', or even with a lead grey called 'Down Pipe'.

There have been government campaigns to promote English weather as a tourist attraction, mainly on the basis that rainfall is lower than in Santander.[39] But English fogs are also worth a visit. An annual art installation on the North Sea coast at Whitley Bay recreates the effects of a 'haar' – a fog which forms rapidly in salt-laden air on the east coast. The first *Flash Fog* by Colin Priest rolled across the beach in November 2011, brilliantly spotlit, spectral white with brown stains curling through it. 'FOG' was spelled out in white neon, the pop-art tubular brightness softened and made ghostly by drifting smoke. In the cold and wind of a November night, visitors jumped and shouted. Children blew on foghorns which were really hooters and sounded, in chorus, more like the high wailing of gulls, joyous and plaintive at once – a fitting sound for grey.[40] *Flash Fog* makes you want to go to Whitley. You would go there in hope of a haar as you would go to the Arctic in hope of the aurora borealis.

Liverpool was supposed to have a larger piece of cloud-art. Anthony McCall envisaged a thin column of vapour rising far into the sky, bending in the wind, visible from all over Merseyside. Classical columns are solid and stable, good for holding things up, whereas this column was to be gaseous, held by the air. It was a confident gesture to local history: sixty years ago there was a cloud over Merseyside visible from miles around, as there were clouds over Manchester and Sheffield. They were brown, unwanted clouds, though they were the sign of essential industry. The new cloud column, clean and delicate, but with some of the old comedy and grand sense of scale, might have become the sign of the city's resurrection as a commercial and cultural centre. Except that it could not be made to work. McCall had imagined a line in the sky, but the sky resisted his

drawing. He had to give up, and *Column* exists only as an idea, a failed cloud, an artwork which consists of leaving the sky to itself.

TOO MUCH WEATHER

So much weather has been remembered and talked about, written, painted, and filmed, that it is daunting now to try the simplest description of a thunderstorm. The ready similes are worn through. A novelist ending with softly falling snow, or a filmmaker who wants a kiss in the rain as the credits roll, must tussle with hundreds of precedents.[1] Symbolic or emotionally freighted weather can drive a reader to weather-weariness. Wyndham Lewis was already feeling it when he complained about the poetry of Robert Bridges as a kind of drizzle, and many have felt it since.

Julian Barnes in the 1970s was sceptical about the use of 'significant weather' in novels.[2] Determining not to use the cheap trick in his own first book, he chose 'No Weather' as the working title and provided a stylish demonstration of the fact that long passages on the art of adolescent flâneurie could be written without mention of the weather in the streets. Charles Baudelaire, poet of 'l'existence brumeuse', would not have allowed this – but Barnes's Francophile youths are free from mists. The novel was published in 1980 as *Metroland*, the first title having seemed to Barnes 'a little coy'.[3]

He came up against the problem again in *Flaubert's Parrot* (1984). The fact of the matter, as Barnes recorded in his notebook, was that it was a 'cloudy, grouchy, rainy morning' when he went to Flaubert's house at Croisset and found there the second of the taxidermic parrots labelled as the one parrot Flaubert kept in his room. As Barnes looked at this second parrot, which might have been Flaubert's or which might equally have been an impostor, the sun came out. Barnes photographed the parrot in a shaft of light. 'It felt like a benign intervention by Gustave Flaubert, signalling thanks for my presence, or indicating that this was indeed the true parrot.' It was a literary epiphany, analogous with the finding of the grail or the true cross. A weather sign which might once have emanated from God was now a message from the great French writer who hoped to be godlike in his fiction, everywhere present and nowhere visible. The ray of light was a kindly benediction, gratefully received. But it also presented

a problem because significant weather is suspect when it gets into fiction. Barnes pared the incident down to a phrase, and then took it out – or thought he did – not wanting 'this obviously banal and sentimental piece of sunlight'.[4] He never actually deleted the words and was later surprised to find them still there.

Barnes has kept testing the degree to which life's coincidences and miracles must be edited out of art. He presents instances of significant weather as if to ask, 'What do we do with this?' A postcard arrives in *England, England* which is too comic to risk sentimentality, but which is all about sentimental feelings. It is a report of great sex in Carcassonne:

> A tremendous storm was brewing, like in an El Greco, and as the heavens went about their business, so did we, until the gap between the lightning and the thunder grew to nothing, and the storm was overhead, and all we seemed to be doing was following the guidance of the skies.[5]

This storm appears again in 'Carcassonne' (2010), which proffers the source for the fictional postcard. The lovers were friends of the novelist, one of whom told him about the storm. The episode is relayed as one of a series of lightning-bolt moments, the most literal *coup de foudre* in an essay (or is it a story?) concerned with the kinds of discernment we show in our emotional impulses. John Dowell says of Nancy in *The Good Soldier*, 'I just wanted to marry her as some people want to go to Carcassonne'; Barnes considers the essence of taste which says 'me, here, now, this, you'. Storm-heightened sex in a novel may not be in the best literary taste ('I put his words into a novel [...] with some hesitation about the accompanying weather'), but in life it may be absolutely right. Part of the point of the storm reprise in 'Carcassonne' is that it happened and was glorious and that weather matters and is still sending its signs. 'Life's astonishments are frequently literature's clichés', writes Barnes.[6] His originality has sometimes been in the avowal of the old clichéd magic.

Weather keeps astonishing us. Since it is new in every moment there can be no end to its representation. Howard Hodgkin's large painting *Rain* (1984–89) is a conjunction of weather and emotion. It immerses us in the very moment of a downpour, bright blue sweeping down out of thick grey, rain-light flashing salmon-pink in its wake. Then there is a joyous gesture to a rainbow, and the thick lush green of the world after rain. The picture

is both in rain and in the aftermath of rain. It is a weather memory, the expression of a residual feeling as much as a shower. The sudden sluicing is held in an image of long remembrance, its few fresh brushstrokes revisited by the artist over the course of at least five years.

Hodgkin's one-time tutor Peter Lanyon took up gliding as a way to immerse himself in weather. Lanyon liked to be towed fast in his glider to the edge of a cliff in his native Cornwall, hurtling to the edge and then floating out into air; *Silent Coast* (1957) allows us a visual plunge into blue which feels endless and holds us levitating in the smooth of a thermal. Hodgkin does not abandon himself to the air like this. He works in a white-painted studio without windows, his elements mediated by memory. But in a succession of astonishments – *After the Storm* (2000), *Fog* (2002), *Snow Cloud* (2009) – his pictures constitute weather of their own as paint slants in across the frames.

Hodgkin's first name required of him an interest in the weather. 'Howard' was after Luke Howard, a distant relation, the chemist who named the clouds. The painter paid tribute in his 1976 print *After Luke Howard*, which was made for John Constable's bicentenary and marked a double allegiance.' The cloud has the charm of a child's drawing, the satisfying cloud-shape of a cumulus. The sky becomes a deep frame, enveloping the cloud with the perfect melting fluffiness of a summer sky. Though he was thinking back through cloud history, Hodgkin's picture was one of free-floating innocence. Twenty years later, *Old Sky* (1997) is again about a long inheritance of weather representation. Centuries of painted sunsets are concentrated into this small panel of umbered orange. Claude is here, and Turner. Intensely worked and stippled it seems to bear the weight of thousands of varnishes and gilt frames. One feels that in Hodgkin's memory the light of those old skies flares out, both aged and immediate at once.

⟿

Ted Hughes assured listeners to BBC Schools Broadcasting in the 1960s that everyone could write about weather: 'One poetic experience which all of us go through […] is the hour by hour effect on us of the weather. Out of this almost everybody, at some time in their lives can produce poetry.' He advised young writers to concentrate on a particular weather experience and to think very precisely about how it looked and how it affected the body, since everybody is a 'natural barometer'. He wanted to bring

weather close, helping children, and adults, to think about how it affected them, or alternatively how little they noticed it.[8] Hughes's own weather poems startled readers increasingly detached from the natural world and forgetful of its power. They shook, too, all habits of picturesque weather appreciation. He was no writer of glowing tints seen through windows or picture frames. This was battle.

On a frozen morning a stopped tractor, ice on iron, defies the flesh that tries to mend it: 'hands are wounds already / Inside armour gloves'. This is the machine age and it is not a bright new world. It is hard and cold, though the reward of perseverance is a tractor 'raging and trembling and rejoicing'. The earth and sky divide power between them, and the most that Hughes can say for human efforts is that 'Between the weather and the rock / Farmers make a little heat'. Coming close, he watches what it takes to make that 'little heat', to make a buffer between rock and weather for just long enough to live out a life. Death is imminent from the moment of birth. Light thickens, and the crow does not make it to the rooky wood; his cry is as desolate as the sound of his death: 'As the dull gunshot and its after-râle / Among conifers in rainy twilight'.[9] Hughes's dusks and dawns are not for choruses. These are lonely times. Every bird to itself.

Summer comes to Hughes's country, but it has weaponry. 'Thistles spike the summer air / Or crackle open under a blue-black pressure.' The heat is electric and the thistles are metallic conductors. Even in the form of these summer weeds, the iron age returns, or the ice-world of Viking wars, each thistle 'a grasped fistful / Of splintered weapons and Icelandic frost thrust up'. In the early poem 'October Dawn', an autumn morning is golden, or 'marigold'. But golden ages are deceptive: a wine glass left out overnight has a little ice in the bottom, left over from the ice-age dreams which haunted it in the dark. Hughes saw residual ice-forms carved into the rock of Yorkshire, the warning lines of weather in the landscape. At Heptonstall he was surrounded in every direction by 'glaciated moorland', fossilizing in rock and peat the knowledge of ice ages which would one day come again. When he watched footballers out in a gale and plastered with rain, he saw them as 'brief figures in [a] gigantic archaic landscape'.[10]

A version of glacial time repeats itself with each year's seasons (Hughes's poems have no option but to be seasonal) and with each day's changes. Early morning may bring a convalescent pause after nocturnal onslaught: 'A daisy / Mud-plastered unmixed its head from the mud', a

calf is licked into life under a rainbow. Then the 'world blurred / And disappeared'.[11] This dawn pause is from *Moortown Diary* (1989), a record of nature's progress on a Devon farm. Hughes had moved down from the exposed Yorkshire moorland of Heptonstall to the more lenient country in the Taw valley between Dartmoor and Exmoor. Yet the climate of the poetry is hardly calming. We have moved from a blasted heath down into a slurping bog. Going from peat to loam the mud changes, and rural weather is as much in the mud as in the sky. Cattle churn their fields against their will. Rain hammers and pulverizes until it has got the last flesh off a fox's bones. Pleasantries sink back into the deep.

The naturalist Richard Mabey is on more sociable terms with both birds and weather. He watches their habits and checks up on progress like an old friend. He knows the weather's tendencies in certain places, and his address book is full of contact details for the hollow where fog settles or the exposed point where a spring gale comes from the west. Like Hardy's 'woodlander' Giles Winterbourne, who can identify a tree from the 'wind's murmur through a bough', Mabey carries in mind a sound-map of weather noises. In *Nature Cure* (2011), a book in which the battles are patient and psychological rather than bloody, Mabey described his move between the two great breeze-blocks of his life: the 'tree-top wind-gossip' in the Chiltern beeches and the blasts which arrive in East Anglia fresh from their trip across the North Sea.[12]

Mabey has long argued that 'how we experience and deal with [weather] depends on our moods and memories and powers of myth-making'.[13] The weather he writes is *his* weather, unique in its relationship to a private history of low-pressure dreariness and unexpected halcyon days. Being personal, it affects body and mind. Festive weather has him exuberantly *en fête*; other weathers will mock him or let him down. Mabey monitors with the acuity of any hospital instrument the interdependent rhythms of physical and emotional change.

Mabey is the curate of a meteorological parish; like Gilbert White he finds a great deal of weather on his home plot. Robert Macfarlane, on the other hand, goes out in search of more weather than will blow at him in Cambridge. He sets out into a headwind in the Cairngorms, or head-on into the 'mind-altering substances' of mist and mud on the sunken Broomway, where air is 'thick like gel in the nose and mouth'. On the ridge of the South Downs he patrols a 'frontier', where rain is military and time is measured

out in showers marching up and blowing over. Always interested in border-crossings from one kind of place to another, he sees that weather can 'reconfigure local geographies, leaving known places outlandish or quickened'. A sudden mist can make a familiar lane a wilderness. A version of the 'signal prickle' experienced by a mountaineer may be felt by anyone with goose-bumps before a thunderstorm. Macfarlane's method is one of constant defamiliarization. He describes places, not so that we will recognize them, but so that we will be in awe of their strangeness: raindrops might be 'candle-blacking dropped into water', and the puddles afterwards might 'flash gold, coined by the sun'.[14]

Such accounts of direct, sensual, even overwhelming weather experience are prized by readers increasingly regretful of their separation from natural places and natural processes. Many readers are grateful, too, for reminders of all those little landmarks in the cycle of the year which are too easily missed if the office looks the same each day and you travel home in the dark. At just the moment when the average diary looks less like a medieval almanac than ever, English culture has turned passionately seasonal. And in this critical period when climate change threatens to throw the seasons out of kilter, artists and writers have reaffirmed the wonders of the year's repeating stages.

Katherine Swift, who was a historian of medieval books before becoming a gardener, told the story of her Shropshire plot in the form of a book of hours, combining the canonical hours of the monastic day with the labours and festivals of the year. In June there is lawn-mowing at home and haymaking in the meadow. In November: storing, digging and planting. In December: feasting (and leftover tulip-planting by moonlight, at the eleventh hour, before the frost). Swift's February warming is a winter art, with birch leaping quickly into flame, alder slowing the fire down, dense tulip left to burn all night. The fire moves with the draughts blowing through the house, and it makes a close, wood-scented weather of its own.[15]

For the birdwatching writer Tim Dee, the seasons are bird-seasons. His red-letter days mark the arrival of wheatears and whitethroats from Africa, and their departure. *The Running Sky* (2009) was an almanac illuminated by nightjar plumage and puffin dances. *Four Fields* (2013) explored meadows across the world and four versions of the same Cambridgeshire fen, 'where the landscape is thin but the weather is wide'. 'There are no right angles in the seasons', he says, but there are 'corners' (as

on the font at Burnham Deepdale) which on certain days we seem to peer around. There will be a day, for instance, when the sky's 'lid' is lowered and one breathes the low constrictions of winter, or when the lid is lifted and a little light comes in. He follows the fenland labours, from the hay-mowers' first green haircut of the youthful year to the harvest and the peat-cutting which store up winter fuel.[16]

David Hockney in his late seventies is a carnival of seasons, though it is spring which most excites him and sustains his septuagenarian adolescence. In 2011 he made fifty iPad drawings of the same view down the same lane between Bridlington and Kilham as winter rounded the corner to spring. He was on high alert for 'action week' in early May when the cow parsley shoots up so fast the growth is visible if you stand to watch. Like Chaucer's spring ducks 'that slepen al the nyght with open ye', Hockney was all eyes and missing nothing. The *reverdie* is a contemporary art form. For plantsmen and birdwatchers, the year does not start in the lamplit hangover of January, but on the first day of spring, which cannot be predicted on the calendar and must be snuffed on the air. Richard Mabey waits all winter for this beginning-again, anticipating 'that day in early March when there is a kind of pre-Spring overture, when the light seems to open out'.[17] He has been known to give up waiting and walk west in search of spring. Tim Dee plans to outrun time by following the spring-line vertically around the globe, living a full year of springs.

⌒

The man-made environments of the last fifty years have often advertised light and air while achieving complete independence of the elements outdoors. Alison and Peter Smithson in the 1980s marvelled at how their car kept them insulated from the weather they drove through. 'We smell something only after it has passed through the ventilation system [...] we are wonderfully protected from the most violent of storms in the wildest of landscapes.'[18] The 'wonderful protection' has steadily increased since then, with air conditioning now fitted as standard. The 'man-made weather' first invented for sweltering factories in California is now deployed on mild days in Kent. The temperature is set on a dial, relegating to memory the breeze from the front window ('too windy for you'?) and the hopeful upward tilt of the sunroof. Aeroplanes take controlled immersion to extremes. Above the cloud-line, above weather, they fly into deeper blue than Lanyon in his

glider, the sun flaring on a metal wing-tip, the temperature averaging -50°C. Exhaust vapours condense into contrails of ice, a frosty sky-writing, while in the sealed cabin normality is performed with constant rounds of tea and coffee. No wonder the 'natural barometer' in many of us is going awry.

The orthodox modern ideal is to be in the sun while keeping one's cool. Large sunglasses have been in fashion since the 1960s because they make a desirable double statement: the wearer is in the weather, but aloof and in control, unwilling to be dazzled. Large windows are still the mainstay of modern buildings, making the same outward-looking gestures as Hardwick Hall, 'more glass than wall'. But now they come with automatic blinds and intelligent heat-responsive tinting: architecture's sunglasses. The glass-walled gamble can go wrong: the architects at 20 Fenchurch Street in London had their interiors well regulated, but paid less attention to what might happen on the outside. The building's concave glass frontage focused sunlight with such intensity as to warp the cars and fry the eggs of Eastcheap. The 'Walkie Scorchie' needed modern accessories and was duly equipped with a 'brise-soleil'.

There are signs of a large-scale return to the air. The 'Blur Building' which appeared on Lake Neuchâtel for Swiss Expo 2002 became an international model for new kinds of architecture with vaporous rather than solid aspirations.[9] The Blur was not really a building at all, but a cloud or mist that one might walk through, an environment made from the materials at hand: lake water below and air above. This was not a very practical suggestion for future homes or offices, which do as a minimum need to keep us dry. But it was a provocative symbol of the need to keep revaluating the relationship between buildings and the elements. Since most glass buildings rely on thermal control to counteract solar loss and gain, the possibility of feeling air through an open window demonstrates that the most advanced technology is in operation. A draught is the new sophistication.

Skyscrapers at their translucent best can become part of the sky, reflecting the clouds around them and so disguising their own multi-tonne solidity. Reflection is their apology for bulk. The Shard (2012) is a sky-mirror stretching up almost eight hundred feet, its glinting walls constructed from 'extra white' glass with a low iron content, variable enough in its hues to share the colours of the sky. With its opalescence, and its jagged summit reminiscent of an iceberg, the Shard is a giant enlargement of the

ice-splinters painted by Abraham Hondius when the Thames froze in 1677 and looked like an inner-city Arctic. But if it advertises itself as a weather event in one moment, it can also fade away into mist. The aim of the delicately tapered glass at the very top is that it will disappear. This self-effacement is combined with the gesture of unroofed ambition by which the building claims the endlessness of the sky itself.

Such manoeuvres towards airy vastness come naturally to a culture which conducts its most ordinary business via aerial signals. The virtual world of information technology is envious of weather and adopts its terms. Weightless, intangible, and all around us, information forms an additional atmosphere. Untethered from the earth, wireless streaming operates in the realm of 'AirPlay', a brand name that invokes the heady joy of flying. Our words and music, and our credit-card transactions, are held in a figurative 'cloud' which is cloud-like in its vast capacity, building and building as the vaporous particles of our data gather together in thin air.[20] Storage used to be heavy: there were boxes and filing cabinets. Now our stored information is ethereal. It is at once everywhere and nowhere, though we imagine that it is up in the sky because that is where our gods have traditionally belonged. We need a modern Shelley to interpret our predicament.

⌒

In 1979 the World Meteorological Organization judged it 'plausible that an increased amount of carbon dioxide in the atmosphere can contribute to a gradual warming of the lower atmosphere'. If this were the case, 'significant effects might be seen by the middle of the next century'.[21] Thirty-five years of intensifying research, debate, and diplomacy have elapsed. It is a very short time in the long history of people and weather, but probably the most momentous time of all.

There is nothing new about climate-related anxiety. In every century since 'The Wanderer' was copied into the Exeter Book, beliefs have existed that extreme change is imminent if not already underway. Meteoric marvels lit up the sky with messages of horror for providential readers. Donne watched the sun grow pale and Milton anticipated the terminal cooling of the world; Cowper recorded 'Fires from beneath, and meteors from above' as hour-markers on the ticking timepiece of the world's finite life. When Ruskin shuddered to see the trees agitated by a wind more restless than any he had known, he was both mistaken and prophetic. He

was mistaken in thinking that the climate of Europe had changed. Carbon levels in the atmosphere in the 1870s were not on a scale that could make a tangible difference to temperature and airflow. But he was right in his certainty that modern habits of disregard for nature, and particularly the disenchanted view of the sky he lamented in his contemporaries, had the power to cause serious environmental damage.

By November 2013 the Intergovernmental Panel on Climate Change, representing 195 countries, could announce the 95–100 per cent probability that human action was the dominant factor in producing the global warming observed 'on all continents and across the oceans'. In March 2014 the IPCC working group on 'Impacts, Adaptation and Vulnerability' reported negative impacts on crop yields, vulnerability of both ecosystems and human systems, and high confidence that 'increasing magnitudes of warming increase the likelihood of severe, pervasive and irreversible impacts'. The working group on 'Mitigation of Climate Change' laid out the urgent reduction in fossil fuel emissions necessary to avert the catastrophic changes consequent upon a 2°C increase in average global temperature.[22]

So human beings have agency after all; we can affect the way the rain comes down. We cannot significantly improve the weather, but we can make it radically worse. The small figures bent on their private purposes under Thomas Hardy's empty and regardless sky had within reach disastrous powers they did not imagine. Hardy's stubbornly immovable refrains were his bleak assessment that whatever happens in our lives the weather goes on just the same. 'Ah, no; the years, the years; / Down their carved names the rain-drop ploughs.'[23] The twenty-first century requires another kind of refrain, frightening not in its repetitions but in its alterations. There will not be a predictable chorus that keeps returning. The rain will not keep falling just the same. In some places, the IPCC data tells us, it will fall so torrentially as to drown whole nations, in others it will fall so little as to starve them. Things that Hardy could not know are now clear beyond all doubt. We may be small figures on the heath, but nonetheless we have changed the sky. We live now in the 'Anthropocene', the age made by man. But we are un-godlike makers, not fully in control and unable to see the whole creation.

Thousands of strenuously reached projections offer versions of the future, and though we cannot know which of the many possible sequences of physical events will actually occur, all of them forecast dramatically altered weather by the end of the century if carbon emissions continue

at the current rate. Orlando will get the shock of her long life if she leans out from a London window in 2080, or if she sits down under her oak tree in 2092 to continue with her poem. Where in the past she saw changes resulting from cultural sensitivities and tastes – the cut of a dress, the turn of a sentence – now she will experience the effects of measurable, undeniable, and perhaps intolerable physical transformations. The English have identified themselves with mildness of climate, but we may need to get used to extremes we have only experienced abroad for a week at a time, or to the wildness of a climate we do not yet know at all. The penultimate story in Helen Simpson's 2010 collection *In-Flight Entertainment* is written from the vantage point of 2040 in 'Southern England'. It is called 'Diary of an Interesting Year', but it is not much like Gilbert White's diary, or even Bridget Jones's. The salient features are malaria, typhoid, rats, rags, a few cans of tinned food you might use to barter with if you stop yourself from eating them, and the effort required to abort a child since the womb is a better place to die.

If warming is not averted, England is likely to be one of the last and least physically affected countries. But it will be an overcrowded lifeboat on the rising water with no guarantee of a new start after forty days and forty nights. Food shortage, or the violence that comes of short supplies, may deplete society well before the country is too hot or too wet to sustain a population. Since 2010 United Kingdom passports have been watermarked with national weather. The page for personal details features a weather map of Britain in the background, complete with an occluded front. The areas of the shipping forecast are spelled out in tiny letters: 'CROMARTYFORTIESFORTH'. Even the page numbers are printed in degrees Celsius, as if the passport were a travelling thermometer. It is done with wit and pride, but it raises questions. If our names and addresses and next-of-kin have been watermarked by the weather we know and pretend not to love, how will we know ourselves without it?

Logically, given the scientific evidence, we should be far more worried than we seem to be. The uncertainty of all meteorological prediction is part of the problem: there is no definite image to terrify us into action. Strange weather is, in any case, surprisingly hard to imagine. We can know the facts without feeling them in our nerves and bones. At Laughton Tower in December, where I looked out across the floods, I found postcards of the same place in summer and scarcely believed in its existence. Casually

I remarked on how difficult it is to imagine being hot when we are cold. A quirk of the human mind, but it strikes me now as potentially very dangerous. It makes it possible for us to stow our knowledge of the coming crisis in a mental pigeonhole while we get on with other things. It is difficult to pack for a holiday abroad because it is hard to visualize the reality of the temperatures stated in the guidebook. How much harder it is to prepare adequately for the future.

The social scientist Mike Hulme has long argued that, in our bid to understand climate, 'the role of story-telling needs elevating alongside that of fact-finding'.[24] Certainly it does. 'Climate fiction', for example, is emerging as a laboratory in which to experiment with visions of our warmed future.[25] What, for instance, if aerosol technology were used to control the balance of gases in the stratosphere? Who would we elect as the weather gods, or would they elect themselves? It is the dystopian end-point of the climate control questions raised by John Heywood in *The Play of the Weather* and by Dr Johnson in *Rasselas*. Would the representatives from Hartforde, Harwych, and Harrow on the hyll who appealed to Jupiter in the 1530s now have a vote alongside those from Manila and Montana? Fiction, like science, is good at testing out hypotheses.

But 'climate fiction', and climate art more widely, can be difficult because we do not like imagination to be compromised by insistence on a message. A work of art is not the place for lectures, even lectures as urgent as these. Helen Simpson tackled this difficulty by writing an assortment of intolerable lecturers into the stories of *In-Flight Entertainment*. Her worthy bores refuse air travel even in the name of love affairs. Or they take flights in their irresponsible old age while hectoring the young about the consequences. A smug old man blathers on as a plane makes an eerie unscheduled stop in the wastes of Labrador. Goose Bay: it is a name we know from the digital map on the headrest in front of us. It is a point on the transatlantic arc where nobody stops. Ah yes, warns the bore, don't think you'll escape global warming by moving to Goose Bay. There'll be none of it left because Americans 'are buying up real estate in this sort of area even now'.[26] Simpson has a magic touch at the intersection between tedium and weirdness, which is where we may need to spend a good deal of time.

The most powerful stories may not be those we expect. They may not be directly engaged with climate at all, and they may be much older than the period of global warming. Art, in any case, has no duty to tell cautionary

tales. It may be a form of mourning, it may celebrate pleasures past and present. It may be a kind of magical thinking. Simpson purposefully chose to conclude her collection not with the shocking diary of 2040 but with 'A Charm for a Friend with a Lump'. This grace note at the end is a personal midsummer rite, a charm spelled out in the garden of literature, taking its scents and soft fruits from Shakespeare and Tennyson. It is not global, and the weather is of a dusky June kind; this is about cancer and friendship, not climate change. Yet it speaks to the apocalypse imagined on the previous pages. It proposes (here, now, not in the projected future) a role for words written and read, for dreams and spells, for things of beauty remembered and anticipated.

The best of Ted Hughes's laureate poems was a 'Rain-Charm for the Duchy', a celebration of the first rain after months of drought in 1984. Gift-wrapped as a baptismal offering for Prince Harry, it was really a bardic prayer for a whole stretch of Devon, particularly its rivers and their salmon. The rain brought out a civic streak in the poet of lonely *Crow*. Drops come 'sploshing' down (there's a wellington skip in the child-like word) and thunder strikes up its brass band. Hughes imagines water surging into the county's network of dry rivers (Torridge, Taw, Tamar, Dart), each ceremonially named as at a baptism. The poem is a sequel to *The Waste Land*, marking a reprieve from the desert. After Eliot's vegetation rites, Hughes does not seriously propose ceremonial rain-making (though his riverside bracken waves its fronds in a rain-dance). But if his 'Charm' does not itself perform magic, it pays tribute to the water which does. Alice Oswald, nearly twenty years later, made the water the speaker of her long poem *Dart*, the poet of its own gurgling, babbling spell, which catches in its flow the sounds of fishermen, walkers, poachers, the movement of 'rain-making oaks', salmon, and seals. 'Who's this', asks the river, 'moving in the dark? Me / This is me, anonymous, water's soliloquy'.[27] A millennium after the Anglo-Saxon riddles, the elements are speaking again – though in Oswald's work they are not alien things to be caught and contained within the high banks of poetry, but shaping forces of our lives, gathering our voices into theirs.

～

The relations between literature and environmental activism are the subject of much discussion among a rapidly growing community of eco-critics,

who are asking not only what climate-conscious forms of contemporary art might look like, but how the art of the past might yield imaginative understandings of the natural world.[28] At the turn of the millennium Jonathan Bate expressed his amazement that ecology had not yet become a major strand in literary studies (like feminism or postcolonialism). Proposing that we take our reading out of doors, or let the weather in – allowing Keats's 'Ode: To Autumn', for example, to be a poem about a warm autumn after sunless years – he made an influential case for the reading and rereading of literature as a route to the 're-enchantment' of nature.[29]

At its best, ecologically minded criticism allows us to listen more attentively to what has been felt and said about our place in the natural world. It can run into trouble when polemic becomes its currency, and ethical judgment becomes its aim; to evaluate literature according to 'green' criteria, admiring a play for its environmental awareness rather than its language or form, entails a category error about the nature of art. The value of a great play or painting cannot be so schematically assessed as that. But certainly we keep revaluing, acquiring new tastes, needing one kind of writing more than another. The fourteenth-century almanac-buyer valued steady images of the repeating seasons, and pictures of firesides rather than snow. Appreciation of the sublime in the eighteenth century depended on contexts of relative warmth and comfort. It may be that even Turner's *Norham Castle*, so still and eternal, will look different to future generations; the dissolution of solid castle walls in the liquid vastness of river and sky may not seem to them to be an image of peace.

'A change in the weather', wrote Proust, 'is sufficient to recreate the world and ourselves'. Global warming will recreate the world in physical ways, and necessitate changes in ourselves – changes in practical life, but also in attitudes and aesthetics. Steve Rayner's addition is also worth remembering from this perspective: 'a change in ourselves is sufficient to recreate the weather'. Human actions are recreating weather in the objective, measurable ways that most concern us all. But at the same time our ways of looking and experiencing are changing, and perhaps we can shape them to our purposes. Like Proust's Marcel, waking on a cool Sunday morning to foggy ecstasy, we can become receptive, adaptable, ready to make something new from the new weather we have made ourselves.

Indoor temperatures provide a small example of how our weather tastes have changed and can change again. Less than a hundred years ago

the ideal temperature at home (at least in England and France) was deemed to be 18°C, hence Le Corbusier's plan for buildings in which exactly that temperature could be constantly maintained. Today 21°C is the average, and anything less starts to feel uncomfortable.[30] When outdoors, we tend to be sure that rain is miserable and that getting wet is bad. But there are poems and pictures that can alter our expectations and show us things we hadn't seen before. Gay's *Trivia*, Dorothy Wordsworth's journals and Atkinson Grimshaw's paintings can change our minds, even as we change our minds about them.

Is this period of global crisis really the time to read Parson Woodforde's mundane Norfolk diaries, or teach oneself Old English? I think so. In the rain recently I've been trying to listen. There is not much richness in my hearing yet, but I hope it will grow. There are characters in Thomas Hardy's fiction so knowledgeable in rain that they can find their way across dark country (even when drunk) by comparing the sound of the water on different crops:

> Sometimes a soaking hiss proclaimed that they were passing by a pasture, then a patter would show that the rain fell upon some large-leafed root crop, then a paddling plash announced the naked arable, the low sound of the wind in their ears rising and falling with each pace they took.[31]

Given the scale of international cooperation necessary to stabilize the global climate, it can feel irrelevant now to think in terms of the local and national. If Bangladesh is about to flood, why would we stop to notice that the tulips are a month later this year than last? Acute descriptions of the Anthropocene have emphasized its challenges to our sense of proportion and perspective, 'its bizarre kinds of action-at-a-distance, its imponderable scale, the collapse of distinctions between the trivial and the disastrous'.[32] It is a hard thing to think globally, as clearly we must, while also hunkering down and living locally, as sustainability requires. We have had to invent ways to make the confusing situation feel graspable. We try to imagine carbon emissions as 'footprints', for example, a metaphor which translates the global problem into human-sized units of impact, as small and touchingly personal as the footprints left in the mud at Happisburgh by our ancient ancestors.

Zadie Smith wondered whether it was alright to mourn a beloved pear tree which lost its grip in wet earth. 'You're not meant to mention the minor losses', she observed sadly in the drowned spring of 2014: 'They don't seem worth mentioning – not when compared to the visions of apocalypse conjured by climate scientists and movie directors.'[33] Science fiction can seem the only responsible kind of reading and writing.[34] But this is far from the case. Small alterations in familiar places can disturb us more than dystopian visions. The fallen pear tree may strike harder than the disaster movie. Smith started to compose her intimate elegies – for cold dry ground on fireworks night and for Boxing Day walks in winter glare. They were all things not quite gone yet, but in danger of going. We could each make lists of things to be savoured now and remembered later: certain plants in certain places, the light in the street after rain.

In the years to come, which may be the last years of English weather, our experience will be determined by memory and association, by the things we have read and looked at, by the places we have been to or imagined. We will draw on the great storehouse we each carry in mind. 'Hast thou seen the treasures of the hail?' asked God of Job. 'Treasures' here means 'treasuries', places where snow is stored up for future use. The words contain a note of threat: these treasure-stores are armouries, stockpiled with ammunition. At the same time they are luminous, conjuring for a moment what we cannot see: the door of a cupboard swung open to reveal a great gleaming wealth of hail. The weather in that storehouse is beyond the knowledge of Job, who is all of us. But it seems to me that the 'treasures of the hail' are also those that have been made by human beings through many centuries. These are forms of man-made weather we need not regret. The treasuries are piled high with the names we have found for the hail, the wind, and the mist, the traditions of the seasons, the myths, the measurements, the diary entries, the carvings, paintings, Frost Fairs, and riddles. In the sadness there is room for celebration.

Flood

Among the memories I carry into the future will be this one. In the early summer of 2013 I went to Tewkesbury to hear a performance in the abbey of Benjamin Britten's opera *Noye's Fludde*. Arriving in the afternoon, I caught the end of a last rehearsal. Noah's children were tweaking the choreography of their ark-building; cellists from Gloucestershire Youth Orchestra were practising a few bars in their makeshift pit. Paper fish stuck to the music stands showed that they were underwater, and that the ark-stage above them would, when the rains came, float on their sound.

The opera is based on a medieval mystery play which would have been performed in the streets of Chester as part of the Corpus Christi festival in June, as the *Second Shepherds' Play* was performed in Wakefield. All the mystery plays were acted out by workmen and their families; this particular part of the Chester Cycle, with its watery subject matter, was acted by the Guild of Waterleaders and Drawers of Dee.[1] Britten was drawn to the amateur and communal nature of these medieval plays, and his setting of *Noye's Fludde* is a model of inclusiveness. The lead adult parts (Mr and Mrs Noah, and God) are intended for professionals, but all the other roles are for children. Britten was keen that the audience should not be hidden by darkness, as in a theatre, but visible to each other and part of the action. The audience of this opera is a congregation, standing when prompted to join in the singing.

Noye's Fludde was first performed in 1958, in the church at Orford on the Suffolk coast where, in 1953, January floods had overwhelmed the small town. Tewkesbury is a watery place as well, an island between the rivers Severn and Avon. In July 2007, not for the first or last time in living memory, floodwater inundated the low-lying meadows meant to contain it, and washed right up to the abbey door. In aerial photographs, which will be remembered by anyone who watched the news that summer, the great stone abbey and two irregular streets stand out, alone and stranded, in a wide brown sea.

James Mayhew, the illustrator who designed the sets and costumes for this performance in Tewkesbury, has said that the abbey seems to float upon the landscape like a great ark.[2] That was never more true than in

2007. The water rose around the ark again in 2012 and would return in 2014. To perform the *Fludde* here would clearly be a mark of survival, and already there was a festive atmosphere all over town. I suspected that the performance would bring out darker feelings, mixed with the pleasure. The congregation would include people who had lost homes and who lived in dread of it happening again. This is the problem with the Disembarkation Treaty between God and Noah: 'The rainbow! Ha!' says the woodworm in Julian Barnes's *A History of the World in 10½ Chapters*. 'A very pretty thing to be sure', but 'was it legally enforceable?'[3] Not when man has his own part to play in creating wetter weather.

I walked round the town in the afternoon sun. On the Severn Ham, the area of common land between the rivers, there were signs saying that hay should be cropped by the end of the week. In the labours of the months it is the time for mowing. Heading out across the water meadows, I thought of the novelist Henry Green, who spent much of his childhood nearby at Forthampton Court. He could see the abbey from the bottom of the garden. Much later he remembered the bells in his autobiography, catching in his strange syntax the effulgence of atmosphere: 'always at any time the pealing bells would throw their tumbling drifting noise under thick steaming August hours and over meadows between, laying up a nostalgia in after years for evenings at home'.[4] That was written in 1939. Assuming he would soon be dead, Green wrote his memories of this place where time was a thing of substance, where both air and time were 'thick'. For him, Tewkesbury was a place of continuity. The moisture was soothing, the opposite of cataclysm.

The Hungarian poet George Szirtes, an affectionate observer of England, has done the un-English thing of imagining dramatic endings for the nation. His poem-sequence 'An English Apocalypse' (2001) involves a good deal of water. 'Death by Deluge' proposes as our end-point a tidal wave on an August day.

> The North Sea had been rough
> and rising and the bells of Dunwich rang
> through all of Suffolk. One wipe of its cuff
>
> down cliffs and in they went, leaving birds to hang
> puzzled in the air, their nests gone. Enormous
> tides ran from Southend to Cromer.

In the next lines we are high above England, higher than the aerial photographers and the homeless birds, watching the tide rush across Lincolnshire and the Wash, watching as it comes up the Thames valley, watching as it buries Dorset and Land's End. The medieval loss of Dunwich (after which the church bells, it was said, rang under the water) is gathered up into this future catastrophe. Time is justifiably concertinaed, for human history is small when seen from the apocalypse. Szirtes's best touch is right at the end. The deluge, it transpires, has created something very English, more Cotman than John Martin. '[A]ll was water-colour, / the pure English medium, intended for sky, cloud, / and sea'.[5]

In *Noye's Fludde* the deluge begins with raindrops, pattering musically while the strings start up the tune of 'Eternal Father, strong to save', the opera's central survival song, a resetting of the stout Victorian hymn sung by sailors and coastguards. 'Oh hear us when we cry to thee, / For those in peril on the sea.' Drip, drip, drip, the raindrops fall. The rain-makers are children, playing on 'slung mugs'. Imogen Holst suggested the mugs for percussive effect, and Britten loved the idea. He arranged mugs of all shapes and sizes, suspended by their handles, and played like a dangling xylophone.[6] It was a good 1950s sort of joke: not quite a storm in a teacup, but teacups creating the storm. So English rain and teatime are set to music. We all stood to sing our hymn very solemnly. Then, after the last raindrops, the dove was sent out.

There are no deaths in the opera. (Mrs Noah's drunken, gossiping friends presumably drown, but no one mentions it.) The emphasis is all on that which continues. The menagerie in the ark, with its assorted feathers, trunks, and tails, looks large and exuberant enough for the making of a new world. The 'congregation' has been saved from the flood as well, of course. That is part of the point. Leaving the church, funnelling out through the porch, we all had to walk two-by-two. In pairs we ducked under painted banners as if we were leaving the ark. We were graduates together of what Donne called 'that swimming college, and free hospital / Of all mankind'. We had left 'that floating park'.[7] As I went away into the calm summer evening, I glanced back at the chatting groups waiting in the churchyard: there were mothers sharing sighs of relief, and musicians packing up their instruments. A small boy still dressed as a crocodile was flitting in and out between them. He ran off to hide behind a yew tree, and then, for just a moment, I saw an octopus dancing over the graves.

SOURCES OF EPIGRAPHS
AND NOTES

Full publication details for works cited in
abbreviated form below can be found in the
Select Bibliography.

SOURCES OF EPIGRAPHS

Page 3: *Macbeth*, 3:3.

Page 7: Keats to J. H. Reynolds, 21 September 1819,
Selected Letters, 271.

Page 25: 'The Wanderer', in Crossley-Holland,
Anglo-Saxon World, 51.

Page 50: Ecclesiastes 3:1: Latin (Vulgate); English
(Douay-Rheims).

Page 86: *The Tempest*, 1:2.

Page 116: Donne, 'The First Anniversary' (1611), ll.
387–88, in *Major Works*, 216.

Page 160: James Thomson, *Seasons* (1730), '
Autumn', ll. 38–39.

Page 218: Coleridge, 'Dejection' (1802), in *Major
Works*, 114.

Page 248: Shelley, 'Ode to the West Wind' (1819),
in *Major Works*, 413.

Page 278: Brontë, *Jane Eyre* (1847), ch. 1, p. 13.

Page 328: Stevie Smith, 'Book of Verse: Thomas
Hood', radio broadcast 8 June 1946, quoted
in Frances Spalding, *Stevie Smith: A Critical
Biography* (Faber, 1988), 13.

NOTES

INTRODUCTION:
A MIRROR IN THE SKY

1 Judith Glover, *The Place Names of Sussex* (1975;
Batsford, 1986), 37; John Field, *Place-Names of
Greater London* (Batsford, 1980), 12; Richard
Hamblyn, 'Winter', in Jem Southam, *The River,
Winter* (Mack, 2012), n.p.

2 Tim Ingold, 'The Eye of the Storm: Visual
Perception and the Weather', *Visual Studies*,
20 (2005), 103: 'We do not touch the wind,
nevertheless things feel different when it is
windy compared with when it is calm. For
we touch *in* the wind'. Ingold argues that our
tendency to comprehend phenomena as either
material or immaterial has left no space for
understanding of weather, which is part of both
solid earth and immaterial sky. He advocates
new appreciation of the 'weather-world' in
which 'earth and sky are inextricably linked

within one indivisible field' (ibid., 104). See also
Tim Ingold, 'Earth, Sky, Wind, and Weather',
Journal of the Royal Anthropological Institute, 13
(special issue, 2007), 29, and Ingold, *Being Alive*,
115–35.

3 *Antony and Cleopatra*, 4:14; on Beaufort Scale
see Huler, *Defining the Wind*; Brontë, *Wuthering
Heights* (1847), vol. 1, ch. 1, p. 2.

4 Job 38:22–28 (King James version).

5 Job 37:18 (King James version). Coverdale gives
the sky as 'clear metal'.

6 Milton, *Paradise Lost* (1667), 10: 'the argument'
and ll. 650–707. The Bible leaves much room
for doubt about when, where, and how
weather began. Genesis 2:5–6, prior to the
creation of man, 'the Lord God had not caused
it to rain upon the earth, and there was not a
man to till the ground. But there went up a mist
from the face of the earth, and watered the
whole face of the ground' (King James version).
The next definite mention of weather is at the
Flood.

7 Michel Serres, *The Natural Contract* (1990), trans.
Elizabeth MacArthur and William Paulson
(University of Michigan Press, 2005), 27: 'By
chance or wisdom, the French language uses a
single word, "temps", for the time that passes
and the weather outside'. The etymology
suggests a history more interesting than
chance: Latin 'tempestas' meant, variously and
interrelatedly, 'period of time', 'season', 'period
of weather'.

8 *Solomon and Saturn*, in Cross and Hill, *Prose
Solomon and Saturn*, 26. Thanks to Andrew
Hamer. According to Cross and Hill, the
earliest known example of this theme ('Adam
Octipartite') is in the pseudepigraphic Book
of the Secrets of Enoch (date uncertain, but
c. first century AD), where man's intelligence
is made from 'the swiftness of angels and of
clouds'. Here the clouds are associated with the
heavenly angels rather than with instability.

9 *The Tempest*, 4:1.

10 Mabey, *Nice Again*, 58.

11 Marcel Proust, *The Guermantes Way* (1921), trans.
C. K. Scott Moncrieff and Terence Kilmartin,
rev. D. J. Enright (1992; Vintage, 1996), 398.
Proust understood memory, his great subject,
to be inseparable from weather. 'Atmospheric
changes, provoking other changes in the inner
man, awaken forgotten selves': *The Captive*
(1923), trans. C. K. Scott Moncrieff and Terence
Kilmartin, rev. D. J. Enright (1992; Vintage, 1996),
662. On weather, re-creation and rebirth see
Sedgwick, *Weather in Proust*, 1–42.

12 Steve Rayner, 'Domesticating Nature: Commentary on the Anthropological Study of Weather and Climate Discourse', in Strauss and Orlove, *Weather, Climate, Culture*, 289.

13 Woolf, *Orlando*, 215–16.

14 Monthly rainfall figures from the England and Wales precipitation series (EWP) are available at www.metoffice.gov.uk/hadobs/hadukp/data/simdownload.html. Lamb, *Climate, History*, remains a standard work of historical meteorology. See Lamb, 239–45, on the 'mixed bag' of Victorian weather.

15 Connor, *Matter of Air*, 175–76, writes that 'weather has no history'. 'Culture and weather', he rightly observes, 'seem to run on parallel tracks, each a metaphor for the other [...] connected only by mediations so vast and complex that no non-trivial determinations can really be established'. For these reasons I have not attempted to draw firm lines between weather causes and cultural consequences, or vice versa, but I do think it worth studying the parallel tracks and asking where they bend together in the same direction. I have been almost constantly indebted to Arden Reed's deft survey of cultural weather in the introductory chapter of his *Romantic Weather*.

16 Edward Thomas, *In Pursuit of Spring* (T. Nelson, 1914).

17 Pope, 'Epistle to Lord Burlington' (1731), in *Major Works*, 243; Angela Carter, 'Overture and Incidental Music for *A Midsummer Night's Dream*' (1982), in *Burning Your Boats: Collected Stories* (1995; Vintage, 2005), 274.

18 Woolf, 'The Art of Biography' (1939), in *Essays*, vol. 6, 186: 'Biography will enlarge its scope by hanging up looking glasses at odd corners'.

TESSERAE

1 Simon A. Parfitt et al., 'Early Pleistocene Human Occupation at the Edge of the Boreal Zone in Northwest Europe', *Nature*, 466 (2010), 229–33; Andrew P. Roberts and Rainer Grün, 'Early Human Northerners', *Nature*, 466 (2010), 189–90.

2 Nick Ashton et al., 'Hominin Footprints from Early Pleistocene Deposits at Happisburgh', *PLoS ONE* 9 (2014).

3 See Barry Cunliffe, *Britain Begins* (Oxford University Press, 2012). There are now known to have been at least twenty ice ages. Since the earliest human marks were made in Britain, there have been periods of ice lasting for 60,000 years, and then again for 150,000 years. Cunliffe,

102, on the return of human life to England in the early Holocene.

4 J. M. C. Toynbee, *Art in Roman Britain* (Phaidon, 1963), 11. For comparative context of season iconography throughout the Roman Empire see G. A. Hanfmann, *The Season Sarcophagus in Dumbarton Oaks* (Harvard University Press, 1951); Christine Kondoleon, *Domestic and Divine: Roman Mosaics in the House of Dionysos* (Cornell University Press, 1995), 87–99. There are no clear geographic differences in the pictures.

5 Sheppard Frere, 'The Bignor Villa', *Britannia*, 13 (1982), 135–95.

6 See Patricia Witts, *Mosaics in Roman Britain: Stories in Stone* (2005; The History Press, 2010), 78–92. Witts observes (79) that there are no convincing examples of male season busts in Roman Britain. There are, however, cupids – as at Chedworth.

7 Vitruvius, *Architecture*, book 6, ch. 1, p. 77. It would be well into the seventeenth century before such ideas were seriously revised.

8 Boia, *Weather*, 15, discusses Ovid and classical ideologies of climate.

9 Virgil, *Eclogues*, 1:66, quoted Charlotte Higgins, *Under Another Sky: Journeys in Roman Britain* (Jonathan Cape, 2013), 8; Tacitus, *Agricola*, ch. 12, trans. Harold Mattingly (1948; Penguin, 2009), 10.

10 Auden, 'Roman Wall Blues' (written for radio in 1937; Benjamin Britten set it to cabaret-style music), in *English Auden*, 289. Tungria, in modern Belgium, is not reliably much warmer than Northumbria, though the company would have helped.

11 Tablets 346 and 234. All the texts are available with translation and notes at www.vindolanda.csad.ox.ac.uk.

12 Diocletian, Edict on Prices, 301, cited Julian Bennett, *Towns in Roman Britain* (Shire, 2001), 42. Bennett estimates that the birrus cost about the same as five hundred litres of wine.

13 Vitruvius, *Architecture*, book 6, ch. 1, p. 76.

14 Joan Liversidge, *Britain in the Roman Empire* (Routledge & Kegan Paul, 1968), 43.

15 A line from the *Georgics* is written on the Vindolanda fragment with inventory number 02.38 A (d). The crane and calf weather-lore is *Georgics*, 1:374–76. See Britton, *Chronology*, for specific weather events in Roman Britain.

I

THE WINTER-WISE

1 'The Wanderer', in Crossley-Holland, *Anglo-Saxon World*, 50–53. Old English text in Gollancz, *Exeter Book*, 286–92.

2 Chen-Bo Zhong and Geoffrey J. Leonardelli, 'Cold and Lonely: Does Social Exclusion Literally Feel Cold?', *Psychological Science*, 19 (2008), 838–42; Claudia Sassenrath et al., 'Cool, but Understanding…Experiencing Cooler Temperatures Promotes Perspective-Taking Performance', *Acta Psychologica*, 143 (2013), 245–51.

3 Meaning respectively: having the bitterness of winter, a stream full in winter, wintry-cold, and a storm of snow and hail. Joseph Toller and T. N. Bosworth, eds, *An Anglo-Saxon Dictionary* (1898; Oxford University Press, 1973).

4 'Rodores candel' is a standard kenning, appearing e.g. in *Beowulf*, l. 1572.

5 'The Wanderer', in Crossley-Holland, *Anglo-Saxon World*, 51.

6 'Iceberg', in ibid., 242. Sound-recordings of 'singing icebergs' are available from the Alfred Wegener Institute: www.awi.de/en/news/background/palaoa_what_does_the_southern_ocean_sound_like/.

7 'The Anglo-Saxon Rune Poem', in Shippey, *Poems of Wisdom*, 81. Zwikstra, 'Wintrum Frod', 143, says that 'none of [the elegies'] evocations of winter is at all positive. Yet still there was an impulse to dwell on the visual effects of cold and make poetry from winter.

8 'The Wanderer', in Crossley-Holland, 52.

9 Jennifer Neville, 'The Seasons in Old English Poetry', in Leo Carruthers, ed., *La Ronde des Saisons* (Universities of Paris and Sorbonne, 1998), 37–50.

10 Zwikstra, 'Wintrum Frod', 142, translates the phrase as 'old with winters', and explores the relationship between wisdom, age, and winter. The phrase appears repeatedly, see e.g. *Beowulf*, l. 1724.

11 Gildas, *The Ruin of Britain*, chs. 3 and 8, ed. and trans. Michael Winterbottom (Phillimore, 1978), 16 and 18.

12 *Beowulf*, l. 1136 (trans. Heaney).

13 'The Seafarer', in Crossley-Holland, *Anglo-Saxon World*, 53. Neville, *Natural World*, 42, remarks on the irrelevance of fair weather to the higher reality in which the Seafarer believes. For more joy in sun see e.g. 'The Wonders of Creation', in Mackie, *Exeter Book*, 51.

14 Bede, 'Life of Cuthbert', in Farmer and Webb, *Age of Bede*, 58.

15 *Andreas*, ll. 372–75, in E. K. Gordon, ed., *Anglo-Saxon Poetry* (1926; Dent, 1976), 187–88. Carolyne Larrington remarks that the weather is 'quite gratuitous': *A Store of Common Sense: Gnomic Theme and Wisdom in Old Icelandic and Old English Wisdom Poetry* (Clarendon Press, 1993), 173n.

16 Lamb, *Climate, History*, 156–59.

17 Cuthbert, Abbot of Wearmouth, to Lul, Archbishop of Mainz, 764, trans. Dorothy Whitelock, in Crossley-Holland, *Anglo-Saxon World*, 184. For other records of cold see Britton, *Chronology*.

18 Brimblecombe, *Big Smoke*, 3–4.

19 Ælfric, 'Colloquy', in Crossley-Holland, *Anglo-Saxon World*, 221.

FORMS OF MASTERY

1 *Beowulf*, ll. 1358, 162, 703, 651, 710, 160 (trans. Heaney). Neville, *Natural World*, 2, shows that there is no distinction in Old English between natural and what we would call 'supernatural' phenomena.

2 Davidson, *Idea of North*, 153.

3 *Genesis B*, ll. 314–16, in Anlezark, *Old Testament Narratives*, 25.

4 Homily 17, 'Dedication of St Michael's Church', *The Blickling Homilies of the Tenth Century*, ed. and trans. Richard Morris (Early English Text Society, 1880), 209. Critics have disagreed about the relationship with *Beowulf*; some argue that both mere-visions are derived from the third-century *Visio S. Pauli* or from a lost Anglo-Saxon version of it.

5 See the discussion of walls and shelters in Neville, *Natural World*, 53–88.

6 Ezra Pound, *Cantos* (1925), 11:51, in *The Cantos of Ezra Pound* (New Directions, 1996), 78.

7 Neville, *Natural World*, 178–201, discusses 'literary enclosure of the natural world' as a sustained urge in Anglo-Saxon literature. Another kind of effort to master the elements is evident in the wealth of surviving Anglo-Saxon prognostication texts. Cesario, 'Weather Prognostics', examines the 'remarkable number' of manuscripts which offer weather forecasts by means of the *Revelatio Esdrae* (purporting to be the prophecies of the biblical Esdras).

8 'The Anglo-Saxon Rune Poem', in Shippey, *Poems of Wisdom*, 81–83.

9 'Enigmata', in *Aldhelm: The Poetic Works*, trans. Michael Lapidge and James Rosier (Brewer, 1985), 71.

10 Riddle 1, in Crossley-Holland, *Exeter Book Riddles*, 3, 5.

11 Monmonier, *Air Apparent*, 58.

12 Frisinger, *History of Meteorology*, gives a helpful outline of the early history.

IMPORTED ELEMENTS

1 'The Wanderer', in Gollancz, *Exeter Book*, 292.

2 Kevin Crossley-Holland, *The Norse Myths* (1980; Penguin, 1982), 3–4. See e.g. 'Vafthrudnir's Sayings' and 'Grimnir's Sayings' in *The Poetic Edda*, trans and ed. Carolyne Larrington (1996; Oxford University Press, 2008), 43, 57.

3 Genesis 2:7: 'And the Lord God formed man of the dust of the ground' (King James version).

4 'The Lay of Vafthrudnir', as translated by W. H. Auden and Paul B. Taylor, *Norse Poems* (Athlone Press, 1981), 229. This creation of the world from body parts is cognate with (but inverse to) the apocryphal Christian myth in which Adam's body is formed from the various constituents of the world. The associations between stone and bone, cloud and brain, are there in both the Christian and Norse schemes.

5 Robin Fleming, *Britain after Rome: The Fall and Rise, 400–1070* (2010; Penguin, 2011), 343–44; Lesley Abrams 'Conversion and Assimilation', in Dawn M. Hadley and Julian D. Richards, *Cultures in Contact: Scandinavian Settlement in England in the Ninth and Tenth Centuries* (Brepols, 2000), 135–54; Judith Jesch, 'The Norse Gods in England and the Isle of Man', in Daniel Anlezark, ed., *Myths, Legends and Heroes: Essays on Old Norse and Old English Literature* (University of Toronto Press, 2011), 11–24.

6 Bede, 'Lives of the Abbots', in Farmer and Webb, *Age of Bede*, 196.

7 B. K. Martin, 'Aspects of Winter in Latin and Old English Poetry', *JEGP*, 68 (1969), 380, argues that the Anglo-Saxon imagery is partly inherited from 'descriptions of the proverbial cold of Scythia, in formal passages on the seasons, and in Ovid's accounts of the miseries of his exile at Tomis'.

8 Enkvist, *Seasons*, 23.

9 In the 'Rune Poem' discussed above, hail is 'whitest grain'. The image was probably conventional and is no less powerful for that.

10 Earl R. Anderson, 'The Seasons of the Year in Old English', *Anglo-Saxon England*, 26 (1997), 231–63, and see his *Folk-Taxonomies in Early English* (Associated University Presses, 2003), ch. 6, on season words. The ancient Greeks understood the year in two seasons (cf. Persephone's binary year) or three (cf. three vegetation goddesses). Autumn emerged in later Greco-Roman times.

11 Alcuin, 'The Debate between Spring and Winter', in Peter Godman, ed. and trans., *Poetry of the Carolingian Renaissance* (Duckworth, 1985), 144–49.

12 Text and translation in Gollancz, *Exeter Book*, 200–41.

13 Enkvist, *Seasons*, 16.

14 Cf. Bede, *The Reckoning of Time*, ch. 15, trans. Faith Wallis (Liverpool University Press, 1999), 53–54, on the pagan months.

15 'The Old English Calendar Poem', Old English text in Elliott van Kirk Dobbie, ed., *The Anglo-Saxon Minor Poems* (Columbia University Press, 1942), 49–55, trans. Kemp Malone, in *Studies in Language, Literature, and Culture of the Middle Ages, and Later*, ed. E. Bagby Atwood and Archibald A. Hill (University of Texas Press, 1969), 193–99.

16 C. P. Biggam, *Grey in Old English: An Interdisciplinary Semantic Study* (Runetree Press, 1998), 73, observes that 'flint' can refer to rock generally, but concludes that the meaning here is dark grey.

17 *Genesis B*, ll. 808–12, in Anlezark, *Old Testament Narratives*, 61. Thanks to Andrew Hamer. Neville, *Natural World*, 172, argues that weather has already been created, but God, at the point of the Fall, ceases to protect Adam and Eve from it.

WEATHERVANE

1 Riddle 81, in Crossley-Holland, *Exeter Book Riddles*, 75. Craig Williamson, ed. and trans., *A Feast of Creatures: Anglo-Saxon Riddle-Songs* (University of Pennsylvania Press, 2011), 201, thinks that the riddler is making an analogy with Christ's passion.

2 See Mockridge, *Weathervanes*. Wind-vanes had existed in the classical world: in ancient Athens there had been a large bronze sculpture, half-man half-fish, which blew round on top of the famous Tower of the Winds.

3 Wulfstan, preface to his 'Life of St Swithin', trans. Michael Lapidge in his *Cult of St Swithun*, 389.

4 Mockridge, *Weathervanes*, 35, 57.

II

'WHAN THAT APRILL …'

1 From British Library MS Harley 2253, in Luria and Hoffman, *Middle English Lyrics*, 23.

2 The major work on the subject is Tuve, *Seasons and Months*. There is a helpful collection of Anglo-Norman work in translation: Douglas Gray, ed., *From the Norman Conquest to the Black Death: An Anthology of Writings from England* (Oxford University Press, 2011). For an evocative historical overview see Bartlett, *Norman and Angevin Kings*; and on the literary culture see Ian Short, 'Language and Literature', in Christopher Harper-Bill and Elisabeth van Houts, eds,
A Companion to the Anglo-Norman World (Boydell Press, 2003), 191–215.

3 Marie de France, 'Laüstic', in *The Lais of Marie de France*, trans. Glyn S. Burgess and Keith Busby (1986; Penguin, 1999), 94–96.

4 Quoted and trans. in H. J. Chaytor, *The Troubadours and England* (Cambridge University Press, 1923), 106.

5 In Walter Daniel, *The Life of Ailred of Rievaulx*, ed. and trans. F. M. Powicke (Clarendon Press, 1978), 13, cited Bartlett, *Norman and Angevin Kings*, 659.

6 Bartlett, *Norman and Angevin Kings*, 491. Tuve, *Seasons and Months*, 98, argues that spring in Middle English song was not inevitably linked with erotic love, as it was in French.

7 British Library MS Harley 978, in Luria and Hoffman, *Middle English Lyrics*, 4. The associations of the word 'cuccu' are discussed at length in G. H. Roscow, 'What Is "Sumer is Icomen In?"', *Review of English Studies*, 50 (1999), 188–95.

8 See Andrew Taylor, *Textual Situations: Three Medieval Manuscripts and Their Readers* (University of Pennsylvania Press, 2002), 93–111, on the book as a personal collection owned by William of Winchester, a monk accused of 'incontinence' in documents from the 1270s.

9 Pearsall and Salter, *Landscapes and Seasons*, 199.

10 On the names of the seasons, Enkvist, *Seasons*, 90, and appendix 2 (Enkvist's study began as a semantic exploration of the season words).

11 *The Legend of Good Women*, ll. 34–39, in *Riverside Chaucer*, 589; *Prologue to The Canterbury Tales*, ll. 1–12, in ibid., 23.

12 Paul B. Taylor, 'The Alchemy of Spring in Chaucer's General Prologue', *Chaucer Review*, 17 (1982), 1–4, makes the connection to the words of the Vulgate Genesis, 2:7: 'inspiravit in faciem eius spiraculum vitae'.

13 Groom, *Seasons*, 105.

14 British Library MS Harley 2253, in Luria and Hoffman, *Middle English Lyrics*, 6.

15 Ronald Hutton, *The Stations of the Sun: A History of the Ritual Year in Britain* (1996; Oxford University Press, 2001), 229; and see the chapters on Lent, The May, and May Games; also Groom, *Seasons*, 161–79.

16 British Library MS Harley 2253, in Luria and Hoffman, *Middle English Lyrics*, 6; Bodleian Library MS Rawlinson G22, in ibid., 7; British Library MS Royal Appendix 58, in Douglas Gray, ed., *The Oxford Book of Late Medieval Verse and Prose* (Clarendon Press, 1985), 178.

17 The variant readings are examined by Charles Frey, 'Interpreting "Western Wind"', *ELH*, 43 (1976), 259–78. Victorian and early twentieth-century editors often inserted 'that'. Virginia Woolf, thinking of these words in the 1920s, certainly associated them with spring. 'Small rain' appears in the 'Time Passes' section of *To the Lighthouse* (1927): 'softened and acquiescent, the spring with her […] flights of small rain'. Thanks to Anne Mathers-Lawrence and Hermione Lee.

18 Deuteronomy 32:2 (King James version). Vulgate: 'quasi imber super herbam, et quasi stillae super gramina'.

MONTH BY MONTH

1 Janet Backhouse, in Backhouse, D. H. Turner, and Leslie Webster, eds, *The Golden Age of Anglo-Saxon Art, 966–1066* (British Museum, 1984), 75, compares the Cotton Julius A.vi calendar drawings with the earliest work of the Harley Psalter and proposes a similar date in the 1010s.

2 Details from www.norfolkchurches.co.uk and Webster, *Labors*; labours sequences are compared in Colum Hourihane, *Time in the Medieval World: Occupations of the Months and Signs of the Zodiac in the Index of Christian Art*, (Department of Art & Archaeology, Princeton University, 2007). See also: Henisch, *Medieval Calendar Year*, and Collins and Davis, *Medieval Book of Seasons*.

3 William Blyth, *Historical Notices and Records of the Village and Parish of Fincham, in the County of Norfolk* (Thew & Son, 1863), 59–64.

4 British Library MS Lansdowne 383.

5 Fagan, *Ice Age*, 17.

6 *Annales Londonienses*, in William Stubbs, ed., *Chronicles of the Reigns of Edward I and Edward II* (Longman, 1882–83), vol. 1, 158.

7 Published records include J. Titow, 'Evidence of Weather in the Account Rolls of the Bishopric of Winchester, 1209–1350', *Economic History Review*, 12 (1960), 360–407.

8 Wood, *Story of England*, 186–89, drawing on the Merton manor rolls for Kibworth in Leicestershire.

9 Fagan, *Ice Age*, 39; Titow, 'Weather', 386.

10 Historians differ widely on the dating of the Little Ice Age. Fagan, *Ice Age*, sees the rains of the 1310s as the beginning of a cool and unstable period lasting to about 1850; the Little Ice Age of Lamb, *Climate, History*, begins later, in the sixteenth century. Astrid Ogilvie and Graham Farmer, 'Documenting the Medieval Climate', in Elaine Barrow and Mike Hulme, eds, *Climates of the British Isles: Past, Present and Future* (Routledge, 1997), 130, tell a different story again, collating evidence from documentary sources (as opposed to biological sources such as tree rings, pollen count, etc.) to suggest a 'long time-scale cooling *c.* 1240 to *c.* 1340'. In Britain the increased variability of precipitation and temperature seems to have been more significant than the drop in average temperature. Fagan, *Ice Age*, 44, explains that 'the moist, mild westerlies that had nourished Europe throughout the Medieval Warm Period now turned rapidly on and off' as a result of the North Atlantic Oscillation. Depopulation of northern farms is discussed Fagan, *Ice Age*, 39, and Lamb, *Climate, History*, 189.

11 Derek Vincent Stern, *A Hertfordshire Demesne of Westminster Abbey: Profits, Productivity and Weather*, ed. Christopher Thornton (University of Hertfordshire Press, 2000), 93–99.

12 Nicholas Comfort, *The Lost City of Dunwich* (Terence Dalton, 1994), 125, 131–32. David Jarman, letter to the *Guardian*, 22 February 2014, observes that the town was all but abandoned in the thirteenth century and stood unprotected against the storms of 1328 and after.

13 Henisch, *Medieval Calendar Year*, 30: 'The weather is always accommodating, always appropriate'. Histories of climate and culture have frequently linked the emergence of painted snow scenes (by Brueghel especially) in the mid-sixteenth century with the persistent cold of the Little Ice Age. See e.g. Behringer, *Cultural History*, 140. This seems dubious. There was plenty of snow to be painted before the 1560s had anyone

wanted to; the change which precipitated snow scenes was cultural not climatic.

14 Flemish book of hours, Walters Art Gallery, Baltimore, W.425.12R; Très Riches Heures du Duc de Berry, Musée Condé, Chantilly, MS 65, 'February'.

15 This is established as early as the Anglo-Saxon labours and goes through to the fifteenth century, e.g. in a stained-glass roundel from the parsonage of St Michael-at-Coslany in Norwich, now Burrell Collection, Glasgow, GLS 224041. A vivid early example is the twelfth-century line drawing in Bodleian Library MS Bodley 614 (reproduced Webster, *Labors*, fig. 97): bare legs, toes in the flames, boot held upside-down over the heat.

16 William Langland, *The Vision of Piers Plowman*, B-Text, XIV:161, ed. A. V. C. Schmidt (1978; Everyman, 2000), 236.

17 See Michelle P. Brown, *The World of the Luttrell Psalter* (British Library, 2006), and Michael Camille, *Mirror in Parchment: The Luttrell Psalter and the Making of Medieval England* (University of Chicago Press, 1998).

18 *Troilus and Criseyde*, 3:628, in *Riverside Chaucer*, 522. *Middle English Dictionary*, 'smok' adj (b). Thanks to Laura Ashe. Cf. John Lydgate, *The Troy Book* (1420), 2:6179, in *Lydgate's Troy Book*, ed. Henry Bergen (Early English Text Society, 1906), vol. 1, 321: 'þe blaknes of þe smoky rayn'.

19 *The Franklin's Tale*, l. 1245, in *Riverside Chaucer*, 184.

20 Tuve, *Seasons and Months*, 123.

21 Bodleian Library MS Digby 88, in Celia and Kenneth Sisam, eds, *The Oxford Book of Medieval English Verse* (Clarendon Press, 1970), 485.

SECRETS AND SIGNS

1 Lee in Aristotle, *Meteorologica*, xxv.

2 Aristotle, *Meteorologica*, 165.

3 On medieval science in Oxford (and not only the making of clocks) see J. D. North, *God's Clockmaker: Richard of Wallingford and the Invention of Time* (2005; Continuum, 2007). Bacon wrote his commentary on *Meteorologica* in about 1270. Janković, *Reading the Skies*, 16–19, gives a helpful summary of Aristotelian meteorology.

4 Steven J. Williams, *The Secret of Secrets: The Scholarly Career of a Pseudo-Aristotelian Text in the Latin Middle Ages* (University of Michigan Press, 2003). I have used a fifteenth-century English version of the text contained in

Bodleian Library MS Ashmole 396, printed as text 3 in Manzalaoui, *Secretum*, 18–113.

5 Tuve, *Seasons and Months*, 46–54, puts Chaucer's knowledge of the *Secreta* beyond doubt. Bacon recommended it as essential reading, and wrote an alchemical commentary on it.

6 Manzalaoui, *Secretum*, 58.

7 John B. Friedman, 'Harry the Haywarde and Talbat His Dog: An Illustrated Girdlebook from Worcestershire', in C. G. Fisher and K. L. Scott, eds, *Art and Life: Collected Papers from the Kresge Art Museum Medieval Symposia* (Michigan State University Press, 1995), 115–53. A comparable book in the possession of the Royal Society is discussed by Pamela Robinson in 'A "very curious Almanack": The Gift of Sir Robert Moray FRS, 1668', *Notes and Records of the Royal Society of London*, 62 (2008), 301–14.

8 On the Anglo-Saxon use of similar prognostications see Cesario, 'Weather Prognostics', 393. Anglo-Saxon and medieval people were also attentive to stranger omens, too erratic to be tabulated: fiery dragons (perhaps comets or meteors), for example, and rains of blood. See Paul Edward Dutton, 'Observations on Early Medieval Weather in General, Bloody Rain in Particular', in Jennifer R. Davis and Michael McCormick, *The Long Morning of Medieval Europe: New Directions in Early Medieval Studies* (Ashgate, 2008), 167–80.

9 Bodleian Library MS Digby 176. The text has been translated from Latin and published: *Merle's MS: Consideraciones temperiei pro 7 annis*, ed. and trans. G. J. Symons (Oxford, 1891). It is discussed in E. N. Lawrence, 'The Earliest Known Journal of the Weather', *Weather*, 27 (1972), 494–501. There is one earlier surviving diary, though a much slighter one, kept in Oxford from 1269 to February 1270 and now in the British Library. C. Long, 'The Oldest European Weather Diary?', *Weather*, 29 (1974), 233–37.

10 The death toll in England is also estimated at about 50 per cent: Rosemary Horrox, ed. and trans., *The Black Death* (Manchester University Press, 1994), 3.

A HOLLY BRANCH

1 Emphasis on seasonal ritual in the poem has been unfashionable since C. S. Lewis's essay 'The Anthropological Approach', in Norman Davis and C. L. Wrenn, eds, *English and Medieval Studies Presented to J. R. R. Tolkien on the Occasion of His Seventieth Birthday* (Allen & Unwin, 1962), 219–30. This is not a poem 'about' seasonal rites, and it certainly cannot be defined as a vegetation myth, but it does partake in the structures and rhythms of these things, holding them in tense relation to the rites of chivalry.

2 *Sir Gawain*, 1:206–7.

3 R. W. V. Elliott deploys local knowledge and sensitivity to regional dialect to map Gawain's journey in *The 'Gawain' Country* (University of Leeds School of English, 1984). On Gawain and nature see Gillian Rudd, *Greenery: Ecocritical Readings of Late Medieval Literature* (Manchester University Press, 2007).

4 *Sir Gawain*, 2:746–47, 731–32, 726–28.

5 Ibid., 3:1180, 4:2023–24.

6 Ibid., 4:2081.

7 Pearsall and Salter, *Landscapes and Seasons*, 147–52.

8 Knowledge of Old English in the Middle Ages was limited, though some writers knew and admired their English predecessors. See Seth Lerer, 'Old English and Its Afterlife', in David Wallace, ed., *The Cambridge History of Medieval Literature* (1999; Cambridge University Press, 2002), 7–34.

'WHY FARES THE WORLD THUS?'

1 Wakefield Master, *The Second Shepherds' Play*, ll. 1–5, 56–63, in Happé, *English Mystery Plays*, 266, 268.

2 The element of social complaint in the play links it with the well-established genre of political writing discussed in Wendy Scase, *Literature and Complaint in England, 1272–1553* (Oxford University Press, 2007).

3 *Boece*, in *Riverside Chaucer*, 399, 409, 423.

4 British Library MS Harley 2253, *Middle English Lyrics*, 181, 13.

5 Hoccleve, *My Compleint*, ll. 1–7, in *Selected Poems*, ed. Bernard O'Donoghue (Fyfield, 1982), 19.

6 Ibid., l. 21.

7 The book might have been by Boethius, but seems in this case to have been by Isidore of Seville.

III

SPLENDOUR AND ARTIFICE

1 Woolf, *Orlando*, 26.

2 Henry Howard, Earl of Surrey, 'Description of

Spring' (1557), in Amanda Halton and Tom MacFaul, eds, *Tottel's Miscellany: Songs and Sonnets of Henry Howard, Earl of Surrey, Sir Thomas Wyatt and Others* (Penguin, 2011), 7.

3 Alastair Fowler points out the double meaning of 'scales' in *Conceitful Thought: The Interpretation of English Renaissance Poems* (Edinburgh University Press, 1975), 24. With a light touch all the summer's life and growth is compressed as Pisces in March leads straight to Libra in September.

4 *Kalendar and Compost*, 4. Hundreds of almanacs and guides sustained calendar traditions through the sixteenth century, even in the face of post-Reformation curtailment of annual festivals. Thomas Tusser was especially influential, setting down the rhythms of life on his Suffolk estate in his *A Hundreth Good Pointes of Husbandrie* (1557), later enlarged to *Five Hundreth* (1573). In the *Georgic* tradition, he included much advice on anticipating and responding to the weather.

5 *Kalendar and Compost*, 111–12.

6 See Alan T. Bradford, 'Mirrors of Mutability: Winter Landscapes in Tudor Poetry', *English Literary Renaissance* 4 (1974), 3–39, on winter tropes evolving from *Tottel's Miscellany* through to Thomas Sackville's 1567 *Induction* to *A Mirror for Magistrates*, Spenser, and Shakespeare. 'The development of the stylized winter landscape as a recurrent *topos*', he writes, 'is not only a Renaissance phenomenon but also, it could be argued, a somewhat more characteristic expression of the Renaissance spirit – at least in England – than the more traditional spring or summer landscape' (7–8). Thanks to Jane Griffiths and Harriet Archer.

7 In 2010 a group of academics staged the play at Hampton Court. Recordings of the performance and associated research are at stagingthehenriciancourt.brookes.ac.uk.

8 Heywood, *Weather*, ll. 206–7, 274, 425, 1017.

9 Ibid., l. 1184. Richard Axton and Peter Happé, in *The Plays of John Heywood* (Brewer, 1991), 48, observe that control of the weather as a metaphor for political government had been a medieval commonplace, found e.g. in Manzalaoui, *Secretum*, 40. D. M. Bevington emphasizes the political implications of weather governance in 'Is John Heywood's *Play of the Weather* Really about the Weather?', *Renaissance Drama*, 7 (1964), 11–19.

10 Heywood, *Weather*, ll. 1239–40.

11 William Fulke, *A Goodly Gallerye* (William Griffith, 1563), t.p., 7, 10, 4.

12 Anon., 'The True Report of the Burning of the Steeple and Church of Paul's in London' (1561), in A. F. Pollard, ed., *Tudor Tracts 1532–1588* (Constable, 1903), 403–8.

13 Thomas Dekker, 'Paules Steeples Complaint', in *The Dead Tearme* (1608), in *The Non-Dramatic Works of Thomas Dekker*, ed. Alexander Grosart (privately printed, 1885), vol. 4, 42.

14 *Tamburlaine the Great, Part One*, 4:2, in *Complete Plays*, 126–27.

15 *Dr Faustus* (*c.* 1592, published 1604), scene 14, in ibid., 393. Heninger, *Renaissance Meteorology*, 172–78 reads Marlowe's imagery in the context of contemporary understandings of meteorological processes.

16 George Peele, 'Anglorum Feriae' (1595), quoted Lee and Fraser, *Rainbow*, 64.

17 Elizabeth was given a rainbow coat at the Harefield Fete in 1602. See ibid., 61–67; and on the iconography of Elizabeth more generally, Roy Strong, *The Cult of Elizabeth: Elizabethan Portraiture and Pageantry* (Thames & Hudson, 1977).

18 Spenser, 'April', in *The Shepherdes Calendar*, in *Shorter Poems*, 34.

19 Heninger, *Renaissance Meteorology*, 171. Fuseli's response is recorded in Allan Cunningham, *The Lives of the Most Eminent British Painters, Sculptors, and Architects* (John Murray, 1829–33), vol. 2, 326, and C. R. Leslie, *Memoirs of the Life of John Constable, R.A., Composed Chiefly of His Letters* (1843; Green & Longmans, 1845), 109.

20 Spenser, *Faerie Queene*, 1:1:6, 7:7:9. (I have modernized 'i' and 'u'.)

21 Ovid, *Metamorphoses*, 1:82–83; Virgil, *Georgics*, 2:325–27; Spenser, *Faerie Queene*, 4:4:47.

22 Ibid., 7:7:20.

23 Ibid., 7:7:58.

SHAKESPEARE: INSIDE-OUT

1 There is no record of the original painting, but it was certainly called the heavens, and the modern reconstruction takes cues from play-scripts which refer to sky and stars.

2 *Macbeth*, 1:1, 3:2, 2:3; *Cymbeline*, 3:3.

3 *Hamlet*, 3:2; Ludwig Wittgenstein, *Philosophical Investigations* (1953), trans. G. E. M. Anscombe, P. M. S. Hacker and Joachim Schulte (Wiley Blackwell, 2009), 204–5.

4 *Macbeth*, 1:1, and L. C. Knights, *Explorations: Essays in Criticism, Mainly on the Literature of the Seventeenth Century* (1946; New York

University Press, 1947), 23; *Much Ado about Nothing*, 1:1; *Two Gentlemen of Verona*, 1:3.

5 The seasonal references and Candlemas performances are considered by Roger Warren and Stanley Wells in their introduction to the play (1994; Oxford University Press, 2008), 4–8.

6 *A Midsummer Night's Dream*, 2:1.

7 Forman's notebooks are quoted and the weather discussed by Harold F. Brooks in his introduction to the play (1979; Arden, 2007), xxxvii. Alteration of the seasons occurs in Ovid's *Metamorphoses*, book 2, and Seneca's *Medea*, ll. 759–69.

8 *A Midsummer Night's Dream*, 2:1.

9 *OED*, 'Temperature', noun, 1a, 4, 5, and 6. The quotation is cited for 5b and is from Philip Barrough's *Methode of Phisicke* (1583).

10 *King Lear*, 3:4 (Quarto 11); Job 38:28 (this is the wording in the Coverdale translation used in all churches after the Reformation); *The Tempest*, 1:2; *King Lear*, 3:4 (Quarto 11). Quotations from *King Lear*, here and throughout, follow the 1608 Quarto text. Differences between this and the other versions of the play are minor for the passages quoted.

11 *Julius Caesar*, 1:3; *King Lear*, 1:3 (Quarto 2).

12 *King Lear*, 3:2 (Quarto 9). See Jones, 'Shakespeare's Storms', on the storm in the contexts of Renaissance performance.

13 *King Lear*, 3:2 (Quarto 9). 'The storm is without passion', wrote W. H. Auden, 'King Lear' (1947), in *Lectures on Shakespeare*, ed. Arthur Kirsch (Princeton University Press, 2000), 229.

14 *King Lear*, 3:4 (Quarto 11); *As You Like It*, 1:3.

15 Hardy, *Return of the Native*, book 5, ch. 8, p. 349; *King Lear*, 3:4 (Quarto 11).

16 *King Lear*, 2:4 (Quarto 8); 3:4 (Quarto 11); 2:4 (Quarto 7); 3:2 (Quarto 9).

17 *Macbeth*, 4:1. James I believed that witches had been responsible for the storm that nearly wrecked his ship in 1590. On the mythology of wind-knots see Davidson, *Idea of North*, 64.

18 Jones, 'Shakepeare's Storms', 29–37, studies the 'storms of separation' which divide characters.

19 *The Winter's Tale*, 4:1.

20 *King Lear*, 4:1 (Quarto 15).

21 *Richard II*, 4:1.

22 Bob Eckstein, in *The History of the Snowman: From the Ice Age to the Flea Market* (Spotlight Entertainment, 2007), 130, reports on 'The Miracle of 1511' in Brussels, which involved more than a hundred snowmen built across the city. Earlier snowmen are recorded in Italy, going back to a snow-sculpture of Hercules in Florence in 1408.

23 *Richard II*, 4:1; *OED*, 'Shiver', verb, 2, meaning 'tremble with cold', appears as early as 1250, though it does not yield a noun until the 1700s; 'Shiver', verb, 1, meaning 'splinter', is likewise thirteenth century, though the words do not seem to be etymologically related.

24 *Hamlet*, 1:2; *Antony and Cleopatra*, 4:14.

25 W. H. Auden, 'King Lear', in *Lectures on Shakespeare*, ed. Arthur Kirsch (Princeton University Press, 2000), 230; *Othello*, 5:1.

26 *Cymbeline*, 4:2; *As You Like It*, 2:7; *Love's Labours Lost*, 5:2.

27 *Twelfth Night*, 5:1. Since the eighteenth century this has customarily been sung to a melody attributed to Joseph Vernon, but which may have existed in the sixteenth century. David Lindley, *Shakespeare and Music* (Thomson Learning, 2006), 216.

28 Roger Warren and Stanley Wells, introduction to *Twelfth Night* (1994; Oxford University Press, 2008), 70–73.

29 *King Lear*, 3:2 (Quarto 9).

IV

TWO ANATOMISTS

1 Burton, *Anatomy*, partition 1, p. 220; 1:241.

2 Ibid., 2:34, 45–46; 60.

3 Ibid., 1:240, 239.

4 *King Lear*, 2:4 (Quarto 7).

5 Burton, *Anatomy*, 1:240.

6 Ibid., 2:65, 1:134.

7 Bacon, *Historia Ventorum*, 69. Bacon was deeply read in the classics he mistrusted, and Rees demonstrates in his introduction (xxxviii–xlvi) how much of the *Historia* relates directly to natural histories by Pliny and others.

8 Ibid., 55.

9 Ibid., 25.

10 Ibid., 27. Janković, in *Reading the Skies*, charts the later stages of this move towards dynamic meteorology.

11 Bacon, *Historia Ventorum*, 25, 45, 131.

12 Bacon, *New Atlantis*, in *Major Works*, 481.

13 Ibid., 488–89.

14 *OED*, 'Impression', noun, 5, obsolete, 'an atmospheric influence, condition, or phenomenon'.

15 John Aubrey, 'Francis Bacon', in *Brief Lives*, ed. Oliver Lawson Dick (1949; Penguin, 1987), 124.

16 Bacon to Earl of Arundel, undated, quoted in Lisa Jardine and Alan Stewart, *Hostage to*

Fortune: The Troubled Life of Francis Bacon (Gollancz, 1998), 504. Jardine and Stewart, 504–8, propose that Bacon had been inhaling nitre or opiates in the effort to prolong his life.

SKY AND BONES

1 Pepys, *Diary*, 26 December 1661, 20 July 1662, 15 July 1666; Swift, *Journal to Stella*, 24 February 1711, 13 January 1713.

2 *The Journeys of Celia Fiennes* (written 1702; Futura, 1983), 128, 290; Woolf, *Orlando*, 69.

3 Anthony van Dyck, *Charles I and Henrietta Maria with their two eldest children, Prince Charles and Princess Mary* (1632–33), Royal Collection, London.

4 Josselin, *Diary*, 25 April 1647, 31 December 1654. See Joyce Macadam, 'English Weather: The Seventeenth-Century Diary of Ralph Josselin', *Journal of Interdisciplinary History*, 43 (2012), 221–46.

5 *The Autobiography of Henry Newcome, M.A.*, ed. Richard Parkinson (Chetham Society, 1852), vol. 1, 161. With thanks to Kit Shepherd.

6 Ruskin, *The Art of England* (1883), in *Works*, vol. 33, 381.

7 Walton, *Compleat Angler*, 110, 108.

8 Ibid., 54.

9 Cotton, 'To My Dear and Most Worthy Friend Mr Izaak Walton', in *Poems*, 80–81.

10 Cotton, 'Winter, de Monsieur Marigny' and 'Evening Quatrains' (*c.* 1650s), in ibid., 69, 53.

11 Donne, 'A Nocturnal Upon St Lucy's Day' and 'The Sun Rising', in *Major Works*, 116–17, 92.

12 Hutchinson, 'Elegy 3, Another on the Sun Shine' (written *c.* 1665–70), printed as an appendix to Hutchinson, *Order*, 259. Elizabeth Scott-Baumann explores the relationship between these elegies and Donne's sonnet in *Forms of Engagement: Women, Poetry, and Culture, 1640–1680* (Oxford University Press, 2013), 125–35.

13 Hutchinson, *Order*, 20, 20–21.

14 Donne, 'The Anniversary', in *Major Works*, 102; Dekker, *Look Up*, 4; Thomas Browne, *Urne-Buriall*, in *Religio Medici and Hydriotaphia, or Urne-Buriall*, ed. Stephen Greenblatt and Ramie Targoff (New York Review Books, 2012), 134.

15 Hesiod, *Works and Days*, in *Theogony, and Works and Days*, trans. M. L. West (Oxford University Press, 1988), 40–41; Virgil, *Georgics*, 1:200; 'The Wanderer', in Crossley-Holland, *Anglo-Saxon World*, 51.

16 Du Bartas, 'The Second Day' (1578), ll. 509–603, in *The Divine Weeks and Works of Guillaume de Saluste, Sieur du Bartas*, trans. Josuah Sylvester, ed. Susan Snyder (Oxford University Press, 1979), 148; Donne, 'The First Anniversary', ll. 192, 203–4, in *Major Works*, 211, 212.

17 Ibid., ll. 355–56, 151–52, 213, in *Major Works*, 215, 210, 212. On cultural understanding of decay see Harris, *All Coherence Gone*.

18 Janković, *Reading the Skies*, 34.

19 Parker, *Global Crisis*, 13–16.

20 Ibid., 5, for Oglander, and throughout for causal relationship; John Oglander, *A Royalist's Notebook: The Commonplace Book of Sir Oglander of Nunwell*, ed. Francis Bamford (Constable, 1936), 119–20.

21 Parker, *Global Crisis*, xx. On the culture of 'oddity and excess' see Janković, *Reading the Skies*, 33–55.

22 Burton, *Anatomy*, 1:191.

23 Dekker, *Look Up*, 15; Anon., *A True Report of Certain Wonderfull Overflowings* (Edward White, 1607); Anon., *A Sign from Heaven* (T. Fawcett, 1642).

24 Anon., *A Report from Abbington […] with Exhortation for England to Repent* (William Bowde, 1641).

25 Charles Hammond, *A Warning-Peece for England* (Richard Burton, 1652), t.p., invoking Joel 2:30–31 (King James version). Janković gives an extensive list of pamphlets: *Reading the Skies*, 261–63.

26 Woolf, 'Rambling Round Evelyn' (1920), in *Common Reader*, 80.

27 Groom, *Seasons*, 80.

28 René Descartes, *Météores*, in *Discourse on Method, Optics, Geometry, and Meteorology*, trans. Paul J. Olscamp (1965; Hackett, 2001), 263.

29 Ibid., and see Martin, *Renaissance Meteorology*, 128–34.

30 David Norbrook, 'Milton, Lucy Hutchinson and the Lucretian Sublime', *Tate Papers*, 13 (2010), tate.org.uk/research/tateresearch/tatepapers.

31 Lucretius, *Nature of the Universe*, 6.86–89, p. 181, and see Janković, *Reading the Skies*, 43–46, on quasi-scientific authentication of wonders.

32 Lucy Hutchinson, *The Translation of Lucretius*, 2:123, 6:171–73, ed. Reid Barbour and David Norbrook (Oxford University Press, 2012), 91, 393.

33 Hutchinson's Dedication to the Earl of Anglesey, ibid., 7. Reid Barbour, *English Epicures and Stoics: Ancient Legacies in Early Stuart Culture* (University of Massachusetts Press, 1998), 264–68, weighs Hutchinson's 'condemnation of Lucretius' in her Dedication against her wish to preserve the translation.

MILTON'S TEMPERATURE

1 Jonathan Richardson, 'The Life of Milton' (1734), in Darbyshire, *Early Lives*, 203.

2 As reported by Henry Crabb Robinson, 7 January 1836, in Wittreich, *Romantics on Milton*, 138.

3 Milton, *Paradise Lost*, 5:185–9, in *Major Works*, 450.

4 Milton, 'Elegia Quinta, In Adventum Veris' (written c. 1629), in *Major Works*, 104; Edward Phillips, 'The Life of Mr John Milton' (1694), in Darbyshire, *Early Lives*, 73.

5 Milton, *History of Britain* (1670), in *Works of John Milton*, ed. Frank Allen Patterson (Columbia University Press, 1931–38), vol. 10, 325. Z. S. Fink, 'Milton and the Theory of Climatic Influence', *Modern Language Quarterly*, 2 (1941), 67–80, laid out the evidence for Milton at various points in his life accepting and rebuffing the theory of climatic influence. Thomas B. Stroup, 'Implications of the Theory of Climatic Influence in Milton', *Modern Language Quarterly*, 4 (1943), 185–89, linked this with Milton's thinking about humours, personal ageing, and cosmic decay.

6 Milton, 'Of Education', in *Major Works*, 230. Thanks to Kathryn Murphy.

7 Evelyn, *Diary*, 7 March 1658.

8 Milton, *Paradise Lost*, 9:44–46, in *Major Works*, 524.

9 Ibid., 4:152–59, in *Major Works*, 424.

10 Ibid., 4:264–65 and 5:394–95, in *Major Works*, 427, 456.

11 Ibid., 1:351–52, 2:1043, 10:564, in *Major Works*, 364, 401, 569.

12 Ibid., 10:665 and 704–5, in *Major Works*, 569, 570. Watson includes a comprehensive 'Dictionary of Winds' in *Heaven's Breath*.

13 Amy Lee Turner, 'Milton and Jansson's Sea Atlas', *Milton Quarterly*, 4 (1970), 36–39, argued that Milton used Jansson as a direct source, though Gordon Campbell, 'Milton's Catalogue of the Winds', *Milton Quarterly*, 18 (1984), 125–28, argues more credibly that Milton had no need of charts to tell him the names of winds he knew from Aristotle's *Meteorologica*.

14 Milton, *Paradise Lost*, 12:629–32, in *Major Works*, 618. Lewis, *Air's Appearance*, 36–41, argues for Milton's interest in 'aeriform message-bearing', and for the fall from the 'pure' air of Eden to 'other' airs as one of the poem's great subjects.

15 Dorothy Wordsworth to Catherine Clarkson, 12 November 1810, in Wittreich, *Romantics on Milton*, 123.

A PAUSE: ON FREEZELAND STREET

1 The name is used in the anonymous poem accompanying a commemorative woodcut, 'Great Britains Wonder: or, Londons Admiration', sold by Robert Walton and John Seller in 1684, reprinted in Rimbault, 'Old Ballads', 3.

2 Details from Currie, *Frosts*, 49–54.

3 Evelyn, *Diary*, 9 January 1684.

4 The contemporary evidence (or lack of it) for Roman and Anglo-Saxon frosts is scrutinized in Britton, *Chronology*.

5 Currie, *Frosts*, 1; John Stow, *Annales, or, A General Chronicle of London*, ed. Edmund Howes (Richard Meighen, 1631), 201.

6 *Annales Londonienses*, in William Stubbs, ed., *Chronicles of the Reigns of Edward I and Edward II* (Longman, 1882–83), vol. 1, 158: 'tanta frigiditas [...] quod panis in stramine vel alio velamine coopertus fuerat congelatus, quod non potuit comedi, nisi fuerit calefactus; et quod tanta fuit massa crustium glacierum in Thamisia, quod homines iter suum arripuerunt de Quenhethe in Suthworke, et de Westmonasterio usque Londoniam; et sic per multum tempus duravit quod populus duxit coream per medium ejus, juxta ignem quemdam ibidem factum, et luctaverunt, et leporum cum canibus ceperunt in medio Thamisiae'.

7 Bodleian Library MS Douce 5.

8 Raphael Holinshed, *Holinshed's Chronicles of England, Scotland and Ireland* (1577; J. Johnson, 1808), vol. 4, 228.

9 Dekker, *Great Frost*. A firm attribution has now been made on internal evidence: Doris Ray Adler, *Thomas Dekker: A Reference Guide* (G. K. Hall, 1983). Dekker often wrote about the symbolic climates of public events. See e.g. *The Wonderful Year 1603*, in *The Wonderful Year [...] and Selected Writings*, ed. E. D. Pendy (Edward Arnold, 1967), 32–40, with its extravagantly extended metaphor of spring.

10 Dekker, *Great Frost*, 80, 88.

11 Ibid., 82, 83, 88.

12 John Taylor, *The Cold Tearme: Or the Frozen Age: Or the Metamorphosis of the River of Thames* (London, 1621). 'Liquor' was a mix of wax, pitch and turpentine used to make boots waterproof. Simon Schama has a chapter on Taylor, a sort of aqua-biography of him, in *Landscape and Memory* (HarperCollins, 1995), 320–32.

13 Taylor, *Cold Tearme*, ll. 28, 69–70, 9–12, 73–74.

14 Evelyn, *Diary*, 1 December 1662; Pepys, *Diary*, 1 and 15 December 1662.

15 Evelyn, *Fumifugium*, in *Writings*, 127–58; *Diary*, 24 January 1684.

16 Taylor, *Cold Tearme*, l. 88; Dekker, *Great Frost*, 85; Evelyn, *Diary*, 24 January 1664.

17 Anon., 'Great Britains Wonder: or Londons Admiration', in Rimbault, 'Old Ballads', 1.

18 It had been intended to celebrate the anniversary of the Restoration, but Charles II died in February 1685 and the embryonic opera was left for several y ears unfinished.

19 Homer uses chattering teeth in the *Iliad*, 10:374, but they are chattering in fear. For cold see Lucretius, *Nature of the Universe*, 5:747, p. 158, where cold follows winter with chattering teeth; also Dante, *Inferno*, canto 32.

20 Woolf, *Orlando*, 32. Woolf would also have known the wintry *Induction* to *A Mirror for Magistrates* written by Vita Sackville-West's ancestor Thomas Sackville.

21 Mabey, *Nice Again*, 25.

22 Woolf, *Orlando*, 43; Paula Maggio, in *Reading the Skies in Virginia Woolf: Woolf on Weather in Her Essays, Diaries and Three of Her Novels* (Cecil Woolf, 2009), 31, points out that Orlando experiences an emotional spring while the outside world is frozen.

23 Thomas, Earl of Ailesbury, *Memoirs* (Roxburghe Club, 1890), vol. 1, 85; Woolf, *Orlando*, 61.

24 'The Thames Uncased, or, The Waterman's Song upon the Thaw', reprinted in Rimbault, 'Old Ballads', 38.

25 Evelyn, *Diary*, 24 January 1684. Charles's card is reproduced in Rimbault, 'Old Ballads', xviii; the baby was lost in a miscarriage. For Trump's card see Reed, *Frost Fairs*, 27.

V

METHOD AND MEASUREMENT

1 John Evelyn, 'An Abstract of a Letter [...] Concerning the Dammage Done to His Gardens by the Preceding Winter', in *Philosophical Transactions*, 14 (1684), 559–63. Evelyn's gardens are now lost, though many drawings survive to show how they were arranged.

2 Ibid., 561.

3 Ibid., 562. Other scholars were both mourning the loss of plants (official elegies were read at the Encaenia ceremony in Oxford) and trying to learn from it (see e.g. the findings of the Secretary of the Royal Society, Robert Plot, and the botanist Jacob Bobart in the same 1684 volume of *Philosophical Transactions*, 766–79).

4 Evelyn, *Diary*, 5 July 1691, 25 June 1699, 11 January 1690.

5 Robert Hooke, Preface to *Micrographia* (1665; John Martyn, 1667), n.p.

6 Hooke to Boyle, 6 October 1664, quoted in *The Works of the Honorable Robert Boyle* (J. and F. Rivington et al., 1772), vol. 6, 492.

7 Available in *The Works of Robert Boyle*, ed. Michael Hunter and Edward B. Davis (Pickering and Chatto, 2000), vol. 12, *Posthumous Publications, 1692–1744*.

8 Josselin, *Diary*, 25 November 1660.

9 Hooke, 'Method', 179.

10 Ibid. Thanks to Katy Hooper.

11 Almost sixty years later, in 1723, James Jurin, then Secretary of the Royal Society and a leading physician, recalled Hooke's 'Method' and issued another invitation to join a systematic effort of recording, which this time would have an international scope: 'Invitatio ad Observationes Meteorologicas Communi Consilio Instituendas', *Philosophical Transactions*, 32 (1722–23), 422–27. On the results, and more generally on the difficulties of standardizing measurement, see Frängsmyr, Heilbron and Rider, *Quantifying Spirit*, 147–50.

12 *'Observations of Weather': The Weather Diary of Sir John Wittewronge of Rothamsted*, ed. Margaret Harcourt Williams and John Stevenson (Hertfordshire Record Society, 1999), 15.

13 Diary of William Emes, Winchester College MS 16. Many thanks to Abigail Williams and Geoffrey Day.

14 An early seventeenth-century version of a rhyme which first appears in medieval Scots. *The Oxford Dictionary of Phrase and Fable*, ed. Elizabeth Knowles (Oxford University Press, 2003).

15 The shifting relations between feeling and rationality in response to weather are the subject of Golinski's *British Weather and the Climate of Enlightenment*. His first chapter examines the 1703 weather diary of a young man called Thomas Appletree, who wrote at great length and with metaphorical extravagance as he sought to articulate his intense emotional responses to weather. On the history and practice of weather diaries more widely, see ibid., 80–91.

16 'St Swithin's Day', Royal Meteorological Society website: www.rmets.org/weather-and-climate/weather/st-swithins-day.

17 William of Malmesbury, *Gesta Pontificum Anglorum: The History of the English Bishops*, trans. Michael Winterbottom (Clarendon Press, 2007), 257: 'ubi et pedibus praetereuntium et stillicidiis ex alto rorantibus esset obnoxius'.

18 Lapidge, *Cult of St Swithun*, 7–8, 48–49; Groom, *Seasons*, 196–98.

19 Wordsworth, 'A Slumber did my spirit steal' (*c.* 1798–99), in *Major Works*, 147.

20 As reported by Joseph Severn (who was with Keats) to John Taylor, 6 March 1821, in *Joseph Severn: Letters and Memoirs*, ed. Grant F. Scott (Ashgate, 2005), 138.

21 On the national debates precipitated by the storm, weighing 'naturalistic' readings of weather against fear of divine power, see Golinski, *British Weather*, 45–51.

22 Evelyn, *Diary*, 26 [27] November 1703; *Silva, or, A Discourse of Forest-Trees*, 4th edn (Robert Scott, 1706), 341; A Lady [Anne Finch], 'A Pindarick Poem upon the Hurricane in November 1703', in *Miscellany Poems, on Several Occasions* (1713), 230–47.

23 Finch, 'Upon the Hurricane', 235.

24 Defoe, *Storm*, 30, 26.

25 Ibid., 12.

26 Defoe, *The Lay-man's Sermon upon the Late Storm* (1704), in *Storm*, 187.

27 The link is made by Ilse Vickers, *Defoe and the New Sciences* (Cambridge University Press, 1996), 66–67, 108: 'Crusoe himself is of course unaware of the Society's guidelines but there can be little doubt that Defoe consciously followed their general rules'.

28 Defoe, *Robinson Crusoe*, 95.

29 Ibid., 70, 114–15.

30 Woolf, 'Daniel Defoe', in *Common Reader*, 86–94. Cf. Paul Fussell's observation in *Great War*, 52: 'those attentive to the history of taste know that sky awareness is a fairly late development. There is little of it, for example, in the eighteenth century, which felt no pressing need for such emblems of infinity as sea and sky'.

REASONING WITH MUD

1 Woolf, *Orlando*, 159–60.

2 Lamb, *Climate, History*, 233.

3 Pope, 'Epistle to Lord Burlington', in *Major Works*, 243.

4 Hawkes, *Architecture and Climate*, 96–122.

5 e.g. Walpole to George Montagu, 10 June 1765 and 21 July 1766, *The Yale Edition of Horace Walpole's Correspondence*, ed. W. S. Lewis (Yale University Press, 1937–83), vol. 10, 156, 222. He had not tired of spring verdure by 15 April 1791, writing to Miss Berry: 'England never saw such a spring since it was fifteen years old. The warmth, blossoms and verdure are unparalleled' (*Correspondence*, vol. 11, 247).

6 Janković, *Confronting the Climate*, 105: 'moral critique immediately drew upon the fact that the new dress's sexual freedom was a climatic perversity'. See also 96 on 'catching cold'.

7 Swift, *Journal to Stella*, 5 January 1713.

8 Woolf, *Orlando*, 215.

9 Pepys, *Diary*, 15 July 1666: '[I] walked only through to the park, and there, it being mighty hot, and I weary, lay down by the Canaille upon the grasse and slept awhile'.

10 Swift, *Journal to Stella*, 30 May, 5 June, 6 June 1711.

11 Defoe, *A Tour through the Whole Island of Great Britain* (1724–26), ed. Pat Rogers (1971; Penguin, 1986), 431, 434.

12 Swift, 'A Description of a City Shower', in Lonsdale, *Eighteenth-Century Verse*, 17.

13 Laura Brown, *Fables of Modernity: Literature and Culture in the English Eighteenth Century* (Cornell University Press, 2001), 23–24.

14 Gay, 'Advertisement' to *Trivia* (1716).

15 Martin C. Battestin's analysis of *Trivia*, and emphasis on Gay's artfulness, is particularly helpful: *The Providence of Wit: Aspects of Form in Augustan Literature and the Arts* (Clarendon Press, 1974), 126–39.

16 *Trivia*, 1:45–46, 60.

17 Ibid., 1:122–24.

18 Umbrellas in the 1710s were as yet ungainly whalebone contraptions, not very portable, and considered only (and rarely even then) for the protection of women. The umbrella-advocate Jonas Hanway was laughed at in the 1750s. By the 1780s, after refinements in design, umbrella usage was permissible. Details in Crawford, *History of the Umbrella*.

19 Pope, *The Rape of the Lock* (1712–14), canto 4, 'the cave of spleen', in *Major Works*, 92. Lewis, *Air's Appearance*, 61, understands the poem to be 'as fraught with weather as any gothic novel'; and see 61–91 for a detailed reading of Pope's airs and vapours linked to contemporary medical understanding of the body and atmosphere.

20 Pope, *Dunciad* (1742), 1:34–36, 2:361–64, in *Major Works*, 436, 486.

21 Pope, *Peri Bathous* (1727), in *Major Works*, 198–9. Thanks to Bethan Roberts.

22 Thomson, *Seasons*, 'Autumn', ll. 949–50; Pope, *Dunciad*, 4:629, 653–56, in *Major Works*, 551.

A LANGUAGE FOR THE BREEZE

1 Groom, *Seasons*, 219, observes that Thomson's *Seasons* went through over three hundred editions between 1750 and 1850.

2 Thomson, *Seasons*, 'Spring', ll. 18–21, 868–72; 'Winter', l. 5; 'Autumn', ll. 669–71.

3 For the context see Gerard Carruthers, 'James Thomson and Eighteenth-Century Scottish Literary Identity', in Richard Terry, ed., *James Thomson: Essays for the Tercentenary* (Liverpool University Press, 2000), 176.

4 *OED*, 'Breeze', noun, 2, 3.

5 Groom is among the fiercest critics, commenting in *Seasons*, 221, on Thomson's 'sinister vision'. The labouring poet John Clare, however, found Thomson an inspiration, far from sinister. See discussion of Clare below, p. 266.

6 Thomson, *Seasons*, 'Autumn', ll. 37–39, 989–90.

7 Ibid., ll. 1052–53, 701–2, 729–31, 718.

8 Patrick Murdoch, 'An Account of the Life and Writings of Mr James Thomson' (1762), in James Thomson, *The Seasons* (Robinson et al., 1799), xxv; Thomson, *Seasons*, 'Autumn', l. 1003.

9 Thomson, 'To the Memory of Sir Isaac Newton' (1727), in Lonsdale, *Eighteenth-Century Verse*, 190.

10 Cf. the discussion in Reed, *Romantic Weather*, 50–51, about whether Thomson intends the reader to look *through* weather to clarity or to look *at* weather.

11 Thomson, *Seasons*, 'Spring', l. 173.

12 Robert Shiels, in 1753, Johnson in his 'Life of Thomson', and John Gregory: all quoted in Ralph Cohen, *The Art of Discrimination: Thomson's The Seasons and the Language of Criticism* (Routledge, 1964), 86, 103, 172.

13 Woolf, 'Rambling Round Evelyn', *Common Reader*, 83.

14 Finch, 'Nocturnal Reverie' (1713), in Lonsdale, *Eighteenth-Century Verse*, 106–7; Addison, *Spectator*, 23 June 1712 and 31 May 1712; Pope, 'Windsor Forest', in *Major Works*, 50.

15 Thomson, *Seasons*, 'Summer', l. 900.

16 Barrell, *Idea of Landscape*, 12; John Dixon Hunt, *The Figure in the Landscape: Poetry, Painting, and Gardening in the Eighteenth Century* (Johns Hopkins University Press, 1976), 22.

17 Ruskin, *Modern Painters* 1 (1843), in *Works*, vol. 3, 184–85.

18 Thomas Gray, entry for 2 October in *Journal of a Visit to the Lake District in 1769* (1775), ed. William Roberts (Liverpool University Press, 2001), 39. Quoted by Malcolm Andrews in *The Search for the Picturesque* (Scolar Press, 1989), 69, and see the whole section on 'travelling knick-knacks'.

19 Addison, *Spectator*, 23 June 1712; John Dennis, writing in 1688, quoted in Emily Brady, *The Sublime in Modern Philosophy: Aesthetics, Ethics, and Nature* (Cambridge University Press, 2013), 14.

20 As reported e.g. in *The Monthly Visitor and Pocket Companion* (H. D. Symonds, 1799), 245; in a note to *The Dunciad*, Pope gives a different version: 'being once at a tragedy of a new author, he fell into a great passion [...] and cried "'Sdeath! That is *my* thunder"' (Pope, *Major Works*, 476). In the *Spectator* for 10 September 1714, Joseph Addison discussed a 'new set of meteors' being used 'to give the sublime to many modern tragedies'. He appreciated 'the new thunder, which is much more deep and sonorous than any hitherto made use of', 'lightnings made to flash more briskly', and clouds 'better furbeloved'.

21 Burke, *Philosophical Enquiry*, 75, 58. The link between obscurity and 'grander passions' was made across Europe in the mid-eighteenth century, and particularly in Germany where the title of Friedrich Klinger's 1776 play *Sturm und Drang* was adopted to define a whole movement.

22 Gopnik, *Winter*, 14.

23 Austen, *Northanger Abbey* (1818), vol. 1, ch. 14, p. 80.

24 Uvedale Price, *An Essay on the Picturesque as Compared with the Sublime and the Beautiful* (1794; J. Robson, 1796), 62.

25 'The Ruin', in Crossley-Holland, *Anglo-Saxon World*, 59.

26 Gainsborough to Lord Hardwicke, c. 1764, quoted in Amal Asfour and Paul Williamson, *Gainsborough's Vision* (Liverpool University Press, 1999), 192.

DR JOHNSON WITHSTANDS
THE WEATHER

1 Johnson, 'The Idler: 11', in *Yale Edition*, vol. 2, 37, 38.

2 Royal College of Psychiatrists, rcpsych. ac.uk/healthadvice/problemsdisorders/

seasonalaffectivedisorder. For twenty-first-century approaches to the study of circadian rhythm and clinical responses to SAD, see Timo Partonen and S. R. Pandi-Perumal, eds, *Seasonal Affective Disorder: Practice and Research* (2001; Oxford University Press, 2010).

3 *Hamlet*, 2:2.

4 See Janković, *Confronting the Climate*, on the medical history and physiological effects of 'airs' in the eighteenth century, especially on 'delicacy' and 'finer feelings' (27) and the 'obsessive concern with "environmental sensibility"' (36). Golinski, *British Weather*, 136–69, examines the relationship between 'climate susceptibility', pathology, and rationality. See also Castle, *Female Thermometer*, 21–43, on thermometers and barometers as metaphors for changeable emotion.

5 Swift, 'A Description of a City Shower', in Lonsdale, *Eighteenth-Century Verse*, 16; Addison, *Spectator*, 25 July 1712.

6 John Arbuthnot, *An Essay Concerning the Effects of Air on Human Bodies* (J. Johnson, 1733), 118.

7 Johnson, 'The Idler: 11', in *Yale Edition*, vol. 2, 38, 39.

8 Ibid., 39. The problem was well established in medical and philosophical discourse. See Janković, *Confronting the Climate*, 34: 'the morally astute demanded that society should not forfeit its accountability under the pressures of brute nature'.

9 Johnson, *Rasselas* (1759), in *Major Works*, 403, 405.

10 Ibid., 405.

11 Boswell, *Life of Johnson* (1791), 178, 226.

12 Samuel Johnson, 'Life of Milton' (1779), in *The Lives of the Most Eminent English Poets*, ed. Roger Lonsdale (Clarendon Press, 2006), vol. 1, 266, 267. On the place of weather in Johnson's wider reading of Milton see Christine Rees, *Johnson's Milton* (Cambridge University Press, 2010), 234.

13 Boswell, *Life of Johnson*, 401; Johnson, notes for 14 April 1775, in *Yale Edition*, vol. 1, 225; Johnson, 'Rambler: 80' (1750), in ibid., vol. 4, 56.

14 Johnson to Dr Charles Burney, 2 August 1784, quoted in Boswell, *Life of Johnson*, 963.

15 Richard Holmes, *The Age of Wonder: How the Romantic Generation Discovered the Beauty and Terror of Science* (Harper Press, 2008), 145; *Universal Magazine* (October 1810), 347.

DAY BY DAY

1 Janković, *Reading the Skies*, 78–90, examines a 'chorographically-shaped meteoric tradition' (81) established in the topographical and historical writing of Robert Plot, e.g. his *Natural History of Oxfordshire* (1677) and *Natural History of Staffordshire* (1686).

2 James Woodforde, *The Diary of a Country Parson, 1758–1802*, ed. John Beresford (1978; Canterbury Press, 1999), 5 September 1791, 28 January 1787.

3 See Gordon Manley, 'Constantia Orlebar's Weather Book, 1786–1808', *Journal of the Royal Meteorological Society*, 81 (1955), 622, and www.ectonvillage.co.uk/orlebarsisters. html.

4 A similar dial had been installed at Wallingford House in the 1690s and was still in working order in the Admiralty Board Room when Darwin installed his version at home in Lichfield.

5 Darwin, 'Frigorific Experiments on the Mechanical Expansion of Air [...] etc.' (1788), in *Essential Writings*, 191, 186; Desmond King-Hele, *Doctor of Revolution: The Life and Genius of Erasmus Darwin* (Faber, 1977), 118; Jenny Uglow, *The Lunar Men: The Friends Who Made the Future* (Faber, 2002), 370.

6 Darwin, *The Botanic Garden: A Poem, in Two Parts* (1788; Jones & Co., 1825), 109–16 (note 33). Darwin, 'Frigorific Experiments on the Mechanical Expansion of Air [...] etc.', in *Essential Writings*, 192.

7 Barker, *Weather Journals*, 45; Walpole to George Montagu, 14 January 1760, in *Letters from the Hon. Horace Walpole to George Montagu* (Rodwell and Martin, 1818), 188; John Mulso to Gilbert White, 13 December 1750 (on hearing that White's sister had married Barker), quoted in Barker, *Weather Journals*, 10. Golinski, *British Weather*, 86–91, considers the unusual temperament needed to keep these patient records, and points out that a 'diary' of this sort entails a thorough suppression of self.

8 Barker, *Weather Journals*, 20.

9 Manley, 'Central England Temperatures'.

10 Janković, *Reading the Skies*, 117.

11 Ravilious to Helen Binyon, undated, cited in Alan Powers, *Eric Ravilious: Imagined Realities* (Philip Wilson, 2003), 20.

12 Mabey, *Gilbert White*, 59.

13 Francis Bacon, 'Of Gardens' (1625), in *Major Works*, 431: the idea is from Virgil, *Georgics*, 2:149. Evelyn, 'A New Conservatory or Greenhouse',

appendix to *Kalendarium Hortense* (1664–69), in *Writings*, 399.

14 White, *Natural History*, 168.

15 Ibid., 140, 185, 255.

16 Gilbert White to Mary White, 27 August 1783, reprinted Rashleigh Holt-White, *The Life and Letters of Gilbert White of Selborne* (John Murray, 1901), vol. 2, 107. White, *Natural* History, 258.

17 Mabey, *Gilbert White*, 109.

18 White, *Journals*, 3–4 January 1768.

19 Jenny Uglow, *Nature's Engraver: A Life of Thomas Bewick* (Faber, 2006), 166.

20 White, *Journals*, 22 June 1790, 10 May 1780, 25 September 1777; Mabey, *Gilbert White*, 126.

21 Cowper to Lady Hesketh, 9 February, 1786, *Centenary Letters*, 102; Cowper to William Bull, 3 August 1784 (?), ibid., 78.

22 Hazlitt, 'On Thomson and Cowper', in *Round Table*, 250. Keats was in the audience.

23 Cowper to William Unwin, 1 May 1781, *Centenary Letters*, 39; Cowper to Joseph Hill, 9 May 1781, ibid., 40; Cowper to William Unwin, 31 October 1779, ibid., 18.

24 Tobias Menely examines the effect of the fog on Cowper's sense of time and eschatology: '"The Present Obfuscation": Cowper's *Task* and the time of Climate Change', *PMLA*, 127 (2012), 477–92. With thanks to Tony Seward and Vincent Newey for sending the article.

25 White, *Natural History*, 265; Cowper to William Unwin, 29 September 1783, *Centenary Letters*, 65.

26 *Task*, 2:50–51, 57, 59–60, 62–65.

27 *Task*, 3:41–42, 446, 450–51, 574–75.

28 *Task*, 4:36–37 and 4:5. I am indebted to Favret, *War at a Distance*, 59–60, which makes an emphatic connection between the post-boy and the weather. Favret's study asks how one experiences war when remote from it, and emphasizes the freighted qualities of air and weather in wartime; the 'Interlude', 98–116, is an extended reading of war and winter in Cowper.

29 *Task*, 4:99–100.

30 *Task*, 4:99–100, 137–38, 260.

31 Cowper to John Newton, 13 January 1784, in *The Letters and Prose Writings of William Cowper*, ed. James King and Charles Ryskamp (Clarendon Press, 1981), vol. 2, 200; Cowper to William Bull, 22 February 1784, *Centenary Letters*, 69.

32 Gopnik, *Winter*, 12, argues that Cowper 'announces a profound switch, a change of sensibility'.

33 *Task*, 5:107–113, 119-20, 176. See P. M. S. Dawson, 'Cowper and the Russian Ice Palace', *Review of English Studies*, 31 (1980), 440–43.

34 *Task*, 3:221–22; 6:64, 120, 132.

COLERIDGE AND THE STORM

1 Hazlitt, 'On My First Acquaintance with Poets' (1823), in *Selected Writings*, 62.

2 Cowper did write about storms, however, and his feelings about them, at least, might be compared with those of Coleridge. 'I was always an admirer of thunder-storms', he told William Bull (*c.* 3 August 1783), 'even before I knew whose voice I heard in them': *The Letters and Prose Writings of William Cowper*, ed. James King and Charles Ryskamp (Clarendon Press, 1981), vol. 2, 153.

3 Hazlitt, 'On My First Acquaintance with Poets', in *Selected Writings*, 62.

4 Marginalia, reprinted in *Coleridge's Responses: Selected Writings on Literary Criticism, the Bible and Nature*, ed. Seamus Perry (Continuum, 2008), vol. 1, 461.

5 John Livingston Lowes, *The Road to Xanadu: A Study in the Ways of the Imagination* (1927; Vintage, 1959), 75; Reed, *Romantic Weather*, 151.

6 Entry from the 1790s, and from August 1803, in *Notebooks*, ed. Perry, 3, 31; Hazlitt, 'On My First Acquaintance with Poets', in *Selected Writings*, 64.

7 Entry from 20 October 1802, in *The Notebooks of Samuel Taylor Coleridge*, ed. Kathleen Coburn (Routledge & Kegan Paul, 1957–), vol. 1, 525; entries from 14 May 1804 and *c.* 18 April 1804, in *Notebooks*, ed. Perry, 67, 62.

8 Richard Holmes, in *Coleridge: Early Visions* (Hodder & Stoughton, 1989), 164, relates the poem to the 'erotic, magical geography of Culborne Coombe'.

9 Dorothy Wordsworth recorded that they set out on Monday 13 November 1797, and that it was 'dark and cloudy'. Undated letter to Mary Hutchinson (?), in *Letters of William and Dorothy Wordsworth*, vol. 1, 194.

10 Coleridge, 'The Rime of the Ancient Mariner' (1798), in *Major Works*, 50, 52, 55, 57.

11 Reed, *Romantic Weather*, 148–55.

12 Entry from 1801 (?), in *Notebooks*, ed. Perry, 22; Coleridge, 'Christabel', in *Major Works*, 70.

13 Coleridge, 'Frost at Midnight' and 'France: An Ode' (1798), in ibid., 87, 92. 'France' was a recantation of Coleridge's support for the revolutionaries, who had betrayed his hopes with their campaigns of imperial aggression.

14 *The Tempest*, 1:2; Coleridge, 'Frost at Midnight', in *Major Works*, 89.

15 Entry from *c.* 28 September 1802, in *Notebooks*,

ed. Perry, 10; Coleridge, 'Christabel', in *Major Works*, 86.

16 Epigraph to 'Dejection', in ibid., 114. Coleridge would have found the anonymous, undated poem in Thomas Percy's *Reliques of Ancient English Poetry* (J. Dodsley, 1765). Coleridge revises (or misremembers) the ballad.

17 Coleridge, 'Dejection', in ibid., 114.

18 Ibid., 117; Coleridge, 'Christabel', in *Major Works*, 69; Coleridge, 'Dejection', in ibid., 114.

19 Thomson, 'The Castle of Indolence' (1748), canto 1, stanzas 40–41, in *Seasons*, 177; Coleridge, 'The Eolian Harp', in *Major Works*, 28.

20 Coleridge, 'Dejection', in ibid., 114, 116. Geoffrey Grigson thought the Aeolian harp more useful as a guide to Romanticism than any critical scholarship: see *The Harp of Aeolus and Other Essays on Art, Literature and Nature* (Routledge, 1948), 24–46. For a more recent study see Thomas L. Hankins and Robert J. Silverman, *Instruments of the Imagination* (Princeton University Press, 1999).

21 Coleridge, 'The Nightingale' (1798), in *Major Works*, 99. The comparison between 'Nightingale' and 'Dejection' is well made in Marshall Suther, *The Dark Night of Samuel Taylor Coleridge* (Columbia University Press, 1960), 148.

22 'Dejection', in *Major Works*, 115.

23 Ibid., 116, 117.

24 Mary Favret writes about weather in Romantic literature as part of 'a global system of communication, bearing if not news, then pulses of feeling, currents from abroad'. She argues that, in the late eighteenth century, with the broadening understanding of global air circulation came a 'change in the metaphorical currency of weather': *War at a Distance*, 119, 130; and see all of ch. 3. Thanks to Rowan Boyson.

25 Coleridge, 'Dejection', in *Major Works*, 117.

WORDSWORTH: WEATHER'S FRIEND

1 Wordsworth, 'Ode' (or, 'Intimations of Immortality') and 'My heart leaps up', in *Major Works*, 297, 246.

2 Wordsworth to Barron Field after Coleridge's death, quoted in Ernest de Sélincourt, *The Early Wordsworth* (Folcroft Library, 1936), 28.

3 Wordsworth, 'Home at Grasmere' (1800), in *Major Works*, 179.

4 Genesis 2:7 (Vulgate).

5 Wordsworth, *Prelude*, 1:1–5 and 43, in *Major Works*, 375, 376. All quotations are from the 1805 version of the poem.

6 Ibid., 1:17–19, in *Major Works*, 376; Conrad, *Cassell's History*, 413; Wordsworth, *Excursion* (1814), 2:87–88; Wordsworth, *Prelude*, 1:41 and 442, in *Major Works*, 376, 386.

7 Dorothy Wordsworth, *Journals*, 2 March 1802. Wordsworth, *Description of the Lakes*, 35; an earlier version of this text had appeared as an appendix to Wordsworth's 1820 sonnet sequence *The River Duddon*.

8 Wordsworth, *Description of the Lakes*, 35, 36.

9 Dated 3 September 1821, Victoria and Albert Museum.

10 Dorothy Wordsworth to Lady Beaumont, 29 November 1805, *Letters of William and Dorothy Wordsworth*, vol. 1, 547; Wordsworth, *Prelude*, 12:8–9 and 13, in *Major Works*, 569; Dorothy Wordsworth, *Journals*, 18 March 1798; Wordsworth, 'A Whirl-Blast from Behind the Hill' (*c.* 18 March 1798), in *Major Works*, 67 (Wordsworth later omitted these lines).

11 Dorothy Wordsworth, *Journals*, 1 February 1798, 12 February 1802.

12 Ibid., 24 November 1801; Wordsworth, *Prelude*, 8:404–5, in *Major Works*, 497; Wordsworth to Catherine Clarkson, January 1815, in *Letters of William and Dorothy Wordsworth*, vol. 2, 189.

13 Dorothy Wordsworth, *Journals*, 1 June 1800.

14 *King Lear*, 3:1 (Quarto 8); Wordsworth, *Excursion*, 4:508–13; ibid., revision adopted in 1845 edn at 4:536.

A FLIGHT: IN CLOUDLAND

1 Coleridge, 'Fancy in Nubibus', in *Major Works*, 134.

2 Burke, *Philosophical Enquiry*, 58.

3 Wordsworth, *Excursion*, 2:887–95.

4 Ibid., 2:881–2; Milton, *Paradise Lost*, 2:916, in *Major Works*, 398.

5 Milton, *Paradise Lost*, 2:930, 1043, 1049, in *Major Works*, 398, 401.

6 De Quincey, *Recollections of the Lakes and Lake Poets* (1834–40), ed. David Wright (Penguin, 1970), 164–65.

7 Aristophanes, *Clouds*, ll. 332–34, 316–19.

8 Ibid., ll. 344–45.

9 E. H. Gombrich explored part of it in *Art and Illusion*; Marina Warner expanded the story in *Phantasmagoria*. I am indebted to both in this section, which also follows the cloud canon mapped by Cozens in his *New Method*.

10 Gavin Pretor-Pinney, *The Cloudspotter's Guide* (London: Hodder & Stoughton, 2006), 124; and for Chiara Frugoni's

discovery, cloudappreciationsociety.org/
giotto-cloudspotter/.

11 Warner, *Phantasmagoria*, 110, and see Leonardo
da Vinci, *Notebooks* and his *Treatise on Painting*.
Gombrich, *Art and Illusion*, 90, finds the same
process at work in the naming of constellations;
Warner, 107–8, gives such related examples as
the carving of Mount Rushmore, and Paul Klee's
discovery of shapes in a marble tabletop.

12 Cozens, *New Method*, 11.

13 See Gombrich, *Art and Illusion*, 155–58, on
Cozens and Claude.

14 William Beckford, 'Red Copy Book' (1771–91), 81,
manuscript transcribed at www.beckford.c18.net.

15 John Gage, 'Clouds over Europe', in Morris,
Constable's Clouds, 127. Gombrich, *Art and
Illusion*, 151, discusses the importance for
Constable of the twenty cloud plates as a
taxonomic system: 'It matters little what filing
system we adopt but without some standard of
comparison we cannot grasp reality'.

16 Constable to John Fisher, 23 October 1821, in
Correspondence, vol. 6, 76. Turner seems to have
been using the word much earlier. Thornbury,
Life of Turner, quotes a note from about 1789
in which Turner instructed: 'If anybody calls I
can't be seen – I'm skying' (vol. 1, 139). Thornes,
Constable's Skies, points out a reference to
'skying' in William Gilpin's *Three Essays [...] to
Which Is Added a Poem, on Landscape Painting*
(R. Blamire, 1792), an important book for both
Constable and Turner. Gilpin wrote that no one
had studied skies with more attention than
'the younger Vandervelt' (Willem van de Velde,
1633–1707). A Thames waterman remembered
taking Vandervelt and his drawing materials up
and down the river, in fair weather and foul. The
artist called these expeditions 'going a skoying'
(Gilpin's notes to his 'On Landscape Painting: A
Poem', 34).

17 Thornes, *Constable's Skies*, 172–74.

18 Constable to John Dunthorne, 23 May 1803, in
Correspondence, vol. 2, 33.

19 This point is made by Timothy Wilcox in
'Keeping Time', in Morris, *Constable's Clouds*, 165.

20 Howard, *Modifications*, 2.

21 Hamblyn, *Invention of Clouds*, 36.

22 Constable to John Fisher, 9 May 1823, in
Correspondence, vol. 6, 117, imagining the
landscape painter Richard Wilson being happier
in heaven than on earth.

23 Constable to John Fisher, 1 April and 23 October
1821, in ibid., 66, 77. On the relationship between
clouds and feelings see Jacobus, *Romantic
Things*.

24 The anatomist John Barclay uses the phrase
in *An Inquiry into the Opinions Ancient and
Modern Concerning Life and Organization* (Bell
& Bradfute, 1822), 376, where he disputes the
theory of 'sentiments' advanced by George
Combe in his 1819 *Essays on Phrenology*. With
thanks to Kit Shepherd.

25 Bishop Fisher to Constable, in *Correspondence*, 3
August 1823, vol. 6, 125.

26 Antony Lane in Julia Marciari Alexander and
David Scrase, eds, *Howard Hodgkin: Paintings,
1992–2007* (Yale University Press, 2007), 64.

27 Thornes, *Constable's Skies*, 83.

28 Constable to John Fisher, 2 November 1823, in
Correspondence, vol. 6, 142.

29 Keats, 'Read me a lesson, Muse', in *Complete
Poems*, 270. The next day Keats wrote a comical
dialogue with Ben Nevis, upbraiding the
mountain for taking no notice of those who
work so hard to climb it: ibid., 270–72.

30 Joseph Leo Koerner, *Caspar David Friedrich and
the Subject of Landscape* (1990; Reaktion, 2009),
225.

31 See Oskar Bätschmann, introduction to Carl
Gustav Carus, *Nine Letters on Landscape
Painting, Written in the Years 1815–1824* (1831),
trans. David Britt (Getty Research Institute,
2002), 36.

32 *Solomon and Saturn*, in Cross and Hill,
Prose Solomon and Saturn, 26. See above,
'Introduction: A Mirror in the Sky'.

33 The story is told by Hamblyn, *Invention of
Clouds*, 221. See also Joseph Leo Koerner, *Caspar
David Friedrich and the Subject of Landscape*
(1990; Reaktion, 2009), 226.

34 De Quincey, *Confessions*, 71.

35 See Reed, *Romantic Weather*, 218–21, for a
detailed reading of this passage.

36 Wordsworth, 'I wandered lonely as a cloud'
(published 1807), in *Major Works*, 303–4.

37 Duncan Wu, *Wordsworth: An Inner Life*
(Blackwell, 2002), 203.

38 Wordsworth, 'Composed after a Journey across
the Hamilton Hills, Yorkshire', in *Major Works*,
287; Wordsworth, 'These words were uttered in
a pensive mood' (published 1807), in ibid., 287.
In 'Upon the sight of a beautiful picture' (1811),
Wordsworth longs for a cloud to be fixed and
'stayed'.

SHELLEY ON AIR

1 Thomas Jefferson Hogg, *The Life of Percy Bysshe Shelley* (Edward Moxon, 1858), vol. 1, 63.

2 Holmes, *Shelley*, 149. See Shelley's sonnet 'To a Balloon, Laden with Knowledge' (1812), in *Major Works*, 9.

3 Shelley, 'Sonnet: On Launching Some Bottles Filled with Knowledge into the Bristol Channel' (1812), in *Major Works*, 8.

4 Holmes, *Shelley*, 397n. Shelley uses the image in *Laon and Cynthia* in 1817 and later sketched seeds in his notebooks.

5 Shelley to Mrs Gisborne, 10 July 1818, quoted in Holmes, *Shelley*, 428.

6 Holmes, *Shelley*, 521.

7 Shelley to Thomas Love Peacock, 9 September 1819, quoted in Holmes, *Shelley*, 531; Shelley, 'Ode to the West Wind', in *Major Works*, 412.

8 Note published in *Prometheus Unbound* (1820), reprinted in *Major Works*, 762n.

9 Shelley to Leigh Hunt, 15 August 1819, in *The Letters of Percy Bysshe Shelley*, ed. F. L. Jones (Clarendon Press, 1964), vol. 2, 108–9. The image of the sticking burr is probably remembered from Keats's rejection in 'Sleep and Poetry' (1816) of 'the burrs and thorns of life'. William Keach in *Shelley's Style* (Methuen, 1984) helpfully examines the aesthetics of Shelley's 'melting, dissolving, erasing'.

10 Shelley, 'The Cloud', in *Major Works*, 461. Hamblyn, *Invention*, 216, reads the poem as an acknowledgment of Luke Howard's classification system, the stanzas variously invoking cumulus, cirrus, and cirro-stratus clouds which – as Howard showed – could mutate into each other.

11 Shelley, 'The Cloud', in *Major Works*, 462; Milton, *Paradise Lost*, 1:19–22, in *Major Works*, 356; Thornes, *Constable's Skies*, 18; Richard Hamblyn, *Extraordinary Weather: Wonders of the Atmosphere from Dust Storms to Lightning Strikes* (David & Charles, 2012), 14.

12 Shelley to the Gisbornes, undated, quoted in Holmes, *Shelley*, 599.

13 Shelley, 'The Cloud', in *Major Works*, 463.

14 Shelley to Henry Raveley, 17 November 1820, quoted in Holmes, *Shelley*, 561; Shelley, 'The Witch of Atlas' (1820), in *Major Works*, 501.

15 Shelley's friend John Taaffe gave this account of what the captain said, quoted in Holmes, *Shelley*, 729.

1 Abrams, 'Correspondent Breeze', 37.

2 Roe, *John Keats*, says that Keats was probably aware of symptoms in 1818, though it was not clear that he had consumption until January 1819.

3 Keats to Benjamin Bailey, 13 March 1818, in *Selected Letters*, 67; Keats to J. H. Reynolds, 9 April and 27 April 1818, in ibid., 81, 84.

4 The global effects of Tambora, from Yunnan to Bengal to Britain, are analysed in Wood, *Tambora*.

5 George Gordon, Lord Byron, 'Darkness', in *Lord Byron: The Major Works*, ed. Jerome J. McGann (1986; Oxford University Press, 2000), 272. The poem's relationship to the weather of 1816 was identified by Bate, *Song of the Earth*, 94–118. See also Wood, *Tambora*, 66–69.

6 Mary Shelley to Fanny Imlay, 1 June 1816, in *Letters of Mary Shelley*, ed. Betty T. Bennett (Johns Hopkins University Press, 1980), vol. 1, 20.

7 John Constable, sketch for *Weymouth Bay*, 1816, Victoria and Albert Museum, London.

8 Keats, 'After dark vapours have oppressed our plains', in *Complete Poems*, 96. I am indebted to Jonathan Bate's reading of 'To Autumn' in the context of bad weather: *Song of the Earth*, 102–18.

9 Keats, 'After dark vapours have oppressed our plains', in *Complete Poems*, 96.

10 Keats to J. H. Reynolds, 21 September 1819, in *Selected Letters*, 271.

11 Keats, 'When I have fears that I may cease to be', in *Complete Poems*, 221.

12 Keats to J. H. Reynolds, 19 February 1818, in *Selected Letters*, 63.

13 Keats to George and Georgiana Keats, 14 February–3 May 1819, in *Selected Letters*, 222–23.

14 Keats, 'Lamia' (1820), in *Complete Poems*, 424. Such airiness is apt for a story Keats first read in Burton's air-loving *Anatomy of Melancholy*.

15 Keats, 'The Eve of St Agnes' (1820), in *Complete Poems*, 312.

16 Ibid., 322–23.

17 On the fine spring and its relation to the odes see Roe, *John Keats*, 320–22. Robert Gittings, in *John Keats: The Living Year, 21 September 1818 to 21 September 1819* (William Heinemann, 1954), 132, described Keats working outside that summer in the garden at Wentworth Place in Hampstead. 'The weather itself can claim to have begotten much of these poems.'

18 Keats to Fanny Keats, 28 August 1819, in *Selected Letters*, 264.

19 Keats to J. H. Reynolds, 21 September 1819, in
 ibid., 271.
20 Virginia Woolf to Roger Fry, undated, in *The
 Letters of Virginia Woolf*, ed. Nigel Nicolson
 and Joanne Trautmann Banks (Hogarth Press,
 1975–80), vol. 3, 385.
21 Keats, 'To Autumn', in *Complete Poems*, 434–35.
22 Leigh Hunt, *Examiner*, 5 September 1819. The
 'Calendar of Nature' column is reprinted in
 Nicholas Roe, *John Keats and the Culture of
 Dissent* (Clarendon Press, 1997). Roe gives a
 political and historically contextualized reading
 on 250–67. See also Roe, *John Keats*, 354–55.
23 Leigh Hunt, quoted in Nicholas Roe, *John Keats
 and the Culture of Dissent* (Clarendon Press,
 1997), 259.
24 Ibid., 256, based on contemporary reports in the
 Champion and *Saturday Review*.
25 Christopher Ricks, *Keats and Embarrassment*
 (Clarendon Press, 1974), 208.
26 *King Lear*, 5:2 (Quarto 23).
27 Keats to J. H. Reynolds, 28 February 1820, in
 Selected Letters, 337.

CLARE'S CALENDAR

1 Clare to his publisher, John Taylor, 2 January
 1821, quoted in John Goodridge, *John Clare
 and Community* (Cambridge University Press,
 2012), 73. Goodridge calls this a 'delicate, elegiac
 homage' to Keats's 'To Autumn'. See his whole
 chapter on Keats and Clare, 59–82, for close
 readings of Clare's allusive relationship to Keats.
2 Clare, 'The Last of March' ('dimp'), and 'The
 Woodman' ('crizzle'), in *Major Works*, 95, 35.
3 Clare, 'September', in *Shepherd's Calendar* (1827),
 107.
4 Clare, 'Winter Fields', in *Major Works*, 198,
 199. The sonnet is discussed in Barrell, *Idea of
 Landscape*, 124, drawing attention to the local
 quality of Clare's writing in contrast with the
 generalizing and view-surveying tendency of
 landscape poets and artists in the eighteenth
 century.
5 Clare, 'Sketches in the Life of John Clare' (1821),
 in *John Clare's Autobiographical Writings*, ed.
 Eric Robinson (Oxford University Press, 1983),
 9–10. And see John Goodridge and Kelsey
 Thornton, 'John Clare: The Trespasser', in
 Hugh Haughton, Adam Phillips and Geoffrey
 Summerfield, eds, *John Clare in Context*
 (Cambridge University Press, 1994), 87–129.
6 On Bewick and Clare inheriting from Thomson
 see Jenny Uglow, *Nature's Engraver: A Life of
 Thomas Bewick* (Faber, 2006), 134, 315.
7 Clare, 'February', in *Shepherd's Calendar*, 28.
8 Mina Gorji, stressing Clare's knowing
 engagement with his literary inheritance, gives
 an account of how the calendar tradition
 evolved and survived after Spenser's time:
 John Clare and the Place of Poetry (Liverpool
 University Press, 2008), 77–96.
9 Clare, 'To Langley Bush', in *Major Works*, 30.
10 Clare, 'Sudden Shower', in ibid., 102.

TURNER AND THE SUN

1 John Gage argued that the viewer becomes
 Regulus in his last moments of sight: *Colour in
 Turner: Poetry and Truth* (Studio Vista, 1969), 143.
 On Turner's evolving response to sunlight and
 solar mythology see John Gage, 'J. M. W. Turner
 and Solar Myth', in Bullen, *Sun Is God*, 39–48.
2 Their relationship is explored in Ian Warrell, ed.,
 Turner Inspired: In the Light of Claude (National
 Gallery, 2012).
3 Richard Doyle, *Turner Painting One of His
 Pictures* (1846), National Portrait Gallery.
 On these jokes, and Turner's serious habit
 of looking at the sun, see James Hamilton,
 '"Earth's Humid Bubbles": Turner and the
 New Understanding of Nature, 1800–1850',
 in Westheider and Philipp, *Turner and the
 Elements*, 52–64, 65.
4 Hazlitt, 'On Imitation' (1816), in *Round Table*,
 78–79n, quoting Genesis 1:2 (King James
 version).
5 J. M. W. Turner, lecture manuscript, *c.* 1810,
 discussed by Barry Venning in Westheider and
 Philipp, *Turner and the Elements*, 75–76.
6 Quoted in Thornbury, *Life of Turner*, vol. 2,
 87–88.
7 Fisher to John Constable, 14 June 1813, in
 Correspondence, vol. 6, 21. Napoleon's army was
 forced into retreat from Russia and devastated
 during the bitter winter of 1812–13.
8 Andrew Wilton, letter to the *London Review
 of Books*, 26 April 2012. Wilton warns against
 overemphasizing the painting's abstraction.

VIII

COMPANIONS OF THE SKY

1 Charlotte Brontë to G. H. Lewes, 12 January 1848,
 in *Selected Letters*, 99.

2 Brontë, *Jane Eyre*, ch. 1, p. 13.

3 Jane Austen to Caroline Austen, 13 March 1816, and Jane Austen to James Edward Austen, 9 July 1816, in *Letters*, 324, 329.

4 Austen, *Northanger Abbey*, vol. 2, ch. 5, pp. 117, 121.

5 Austen, *Sense and Sensibility*, vol. 3, ch. 6, p. 229; vol. 1, ch. 9, p. 33; vol. 1, ch. 16, p. 67.

6 Austen, *Emma* (1816; Penguin, 1994), chs. 48–49, pp. 319–20.

7 Gilbert White was admired by Jane's brother James. The familiarity with White shown by the Austen household is noted by Peter Knox-Shaw, *Jane Austen and the Enlightenment* (Cambridge University Press, 2004), 27.

8 John Mullan, *What Matters in Jane Austen? Twenty Crucial Puzzles Solved* (Bloomsbury, 2012), 101: 'She is the first novelist to mark the small changes in the weather that anyone might notice on an ordinary day'. The 'airs' of eighteenth-century novels are subtly treated in Lewis, *Air's Appearance*; see especially 228–44 on Radcliffe.

9 Austen, *Sense and Sensibility*, vol. 1, ch. 20, p. 84.

10 Austen, *Persuasion*, vol. 2, ch. 6, p. 154.

11 Jane Austen to Cassandra Austen, 30 November–1 December 1800, in *Letters*, 64.

12 Austen, *Sense and Sensibility*, vol. 1, ch. 9, p. 31.

13 Janković, *Confronting the Climate*, 96, on 'catching cold'.

14 Austen, *Mansfield Park*, ch. 5, p. 71.

15 Austen, *Persuasion*, vol. 1, ch. 5, p. 32.

16 Ibid., ch. 11, p. 89.

17 Austen, *Mansfield Park*, ch. 42, p. 407; Austen, *Persuasion*, vol. 1, ch. 10, p. 78.

18 Brontë, *Wuthering Heights*, vol. 1, ch. 12, pp. 110–11.

19 Ibid., vol. 1, ch. 9, p. 71; vol. 2, ch. 24, p. 218.

20 Miriam Allott writes about this tempering in *Wuthering Heights: A Casebook* (Macmillan, 1992), 168. She sees the novel as posing this question: 'if storm values are dangerous or undesirable, what is the nature of the calm that one must try to accept?'

21 G. H. Lewes reviewing the novel in 1850, reprinted in ibid., 64.

22 Gaskell, *Life*, 49. Bill Brandt, 'A Statement' (1970), in *Bill Brandt: Selected Texts and Bibliography*, ed. Nigel Warburton (Clio Press, 1993), 31; the pictures appeared in *Lilliput*, May 1945, and subsequently in Bill Brandt, *Literary Britain* (Cassell, 1951).

23 Counting references to different kinds of weather in the novels, Chesney came to associate Emily Brontë with wind, Charlotte with rain, and Anne with sun. Rebecca Chesney, 'The Brontë Weather Project, 2011–2012', *Brontë Studies*, 39 (2014), 14–31.

24 Charlotte Brontë, preface to *Wuthering Heights*, 309; Charlotte Brontë to W. S. Williams, 27 September 1850, in *Selected Letters*, 177.

25 Charlotte Brontë, 'Roe Head Journal', October 1836, excerpted in the Brontës, *Tales of Glass Town, Angria, and Gondal: Selected Writings*, ed. Christine Alexander (Oxford University Press, 2010), 166.

26 Wordsworth, *Prelude*, 1:43, in *Major Works*, 376.

27 Brontë, *Jane Eyre*, vol. 1, ch. 5, p. 58, ch. 7, p. 71, ch. 6, p. 65; vol. 2, ch. 10, p. 309.

28 Brontë, *Shirley* (1849), vol. 1, ch. 2, p. 17; vol. 2, ch. 1, p. 177.

29 Brontë, *Villette*, ch. 12, pp. 109–10.

30 Ibid., ch. 4, p. 38, and ch. 24, p. 271; Brontë, *Shirley*, vol. 2, ch. 1, p. 189, and vol. 3, ch. 1,p. 351. Climate and health at Haworth are among Joanne Sarah Waugh's subjects in her thesis 'Talking about the Weather: Climate and the Victorian Novel'. She marks the distinction between tuberculosis in the Brontë family and contagious diseases like cholera and typhus which plagued the town. The precise connections between winds and disease were a matter of investigation among Victorian doctors. Vladimir Janković assesses the state of medical knowledge in 'Gruff Boreas, Deadly Calms: A Medical Perspective on Winds and the Victorians', *Journal of the Royal Anthropological Institute*, 13 (2007), 147–64.

31 Charlotte Brontë to G. H. Lewes, 22 May 1850, in *Selected Letters*, 163; Gaskell, quoting from her own letter to friends, in *Life*, 353.

'DRIP, DRIP, DRIP'

1 Woolf, *Orlando*, 217–18.

2 Edith Sitwell, *Alexander Pope* (Faber, 1930); Smith, *Yellow Paper*, 14.

3 Tennyson, 'Tithonus' (written 1833, revised 1859, published 1860) and 'The Dying Swan' (1830), in *Works*, 553, 32. The Lincolnshire qualities of Tennyson's poetry, including his 'long, liquid, even lines', are evoked by Drabble, *Writer's Britain*, 182–87.

4 Thanks to Gillian Rudd for pointing out a group of medieval references to various forms of flying 'under the sky'. See particularly *Cleanness*, l. 483, in *Sir Gawain*, 71, on the flight of the dove after flood: 'Ho skyrmez under skwe and skowtez aboute'.

5 Tennyson, 'Song' (1830) and 'Mariana' (1830), in *Works*, 24, 6–8. Longfellow reprised the weary grange in 'The Rainy Day' (1842): 'The vine still clings to the mouldering wall, / But at every gust the dead leaves fall, / And the day is dark and dreary'; but unlike Tennyson he worked through to an ending where his heart would 'cease repining' and a sun would be remembered behind the clouds.

6 Tennyson, 'The Lady of Shalott', in *Works*, 43–47.

7 Valentine Cunningham, *Victorian Poetry Now: Poets, Poems, Poetics* (Wiley-Blackwell, 2011), 89–90, 325; Sydney Dobell, 'Desolate', in *England in Time of War* (Smith, Elder, 1856), 1; Theophilus Marzials, 'A Tragedy', in *The Gallery of Pigeons* (Henry S. King, 1873), 85–87; Tennyson, *In Memoriam A. H. H.* (1849), canto 58, in *Works*, 316.

8 Dickens, *Bleak House*, ch. 2, p. 18; ch. 7, p. 95; ch. 58, p. 832.

9 The connection has been frequently made. Drabble, *Writer's Britain*, 187, points out that Dickens, 'the least enervating of writers, seems subdued by the [Lincolnshire scenery]' and produces 'dreariness that rivals the master's'. Lincolnshire would become the setting of Victorian literature's greatest flood. George Eliot thought it the most likely place for the catastrophic inundation with which she ends *The Mill on the Floss* (1860), overwhelming all the slow steps of mental effort with the undiscriminating surge of water. On Eliot's water see Waugh, 'Talking about the Weather', 111–43, and my 'Drip, drip, drip', *Guardian*, 14 February 2014.

10 Dickens, *Bleak House*, ch. 18, p. 266; Tennyson, 'Mariana', in *Major Works*, 6.

11 Dickens, *Bleak House*, ch. 1, p. 11.

12 Ibid., 15.

13 Gillian Beer gives details in 'The Death of the Sun: Victorian Solar Physics and Solar Myth', in Bullen, *Sun Is God*, 159–80.

14 Evelyn, *Fumifugium*, in *Writings*, 127–58; Jenny Uglow, *Elizabeth Gaskell: A Habit of Stories* (Faber, 1993), 84; Dickens, *Bleak House*, ch. 4, p. 46. On the history of air pollution see Brimblecombe, *Big Smoke*, 47–52.

15 Robert Douglas-Fairhurst, *Becoming Dickens: The Invention of a Novelist* (Belknap, 2011), 184. See also Robert Macfarlane, *Original Copy: Plagiarism and Originality in Nineteenth-Century Literature* (Oxford University Press, 2007), 55, on 'images of grease, fat, ooze and miasma'; and David Trotter, *Circulation: Defoe, Dickens, and the Economies of the Novel* (Macmillan, 1988).

16 Charles Dickens, 'A December Vision', in *A December Vision: His Social Journalism*, ed. Neil Philip and Victor Neuburg (Collins, 1986), 20.

17 Charles Dickens, speech to the Metropolitan Sanitary Association, May 1851, in Janice M. Allan, ed., *Charles Dickens' Bleak House: A Sourcebook* (Routledge, 2003), 37.

18 Charles Dickens, *Great Expectations* (1860–61), ed. Charlotte Mitchell (Penguin, 1996), ch. 1, p. 3.

19 This version from James Orchard Halliwell, ed., *The Nursery Rhymes of England* (1842; John Russell Smith, 1844), 90. Jarndyce quotes it and starts to call Esther 'Old Woman' in Dickens, *Bleak House*, ch. 8, p. 110.

20 See John Carey, *The Violent Effigy: A Study of Dickens' Imagination* (Faber, 1973), 31–34: 'the violent, anarchic side of Dickens despised neatness. He associated it with mean spirit, lack of ambition'.

21 Charlotte Brontë to George Smith, 11 March 1852, in *Selected Letters*, 200.

22 Dickens, *Bleak House*, ch. 2, p. 18.

23 Ibid., ch. 59, p. 844.

24 Robert Louis Stevenson, *The Strange Case of Dr Jeykll and Mr Hyde and Other Stories*, ed. Jenni Calder (Penguin, 1979), 48, 82.

25 Dickens called the Great Exhibition an 'enchanted ass', a 'big soapbubble': see Sabine Clemm, *Dickens, Journalism, and Nationhood: Mapping the World in Household Words* (Routledge, 2010), 16–47.

VARIETIES OF GLOOM

1 Brontë, *Jane Eyre*, ch. 1, p. 13.

2 Sarah Whittingham, *The Victorian Fern Craze* (Shire, 2009).

3 Francis George Heath, *The Fern World* (1877), quoted in ibid., 18.

4 Ruskin, *Academy Notes, 1856*, in *Works*, vol. 14, 67.

5 Robertson, *Atkinson Grimshaw*.

6 Robert Louis Stevenson, 'A Plea for Gas Lamps' (1881), in *Virginibus Puerisque and Other Papers* (Scribners, 1909), 262.

7 Anon., 'The Miseries of an Artist', in *Annals of the Fine Arts*, 4 (1820), 76. Many thanks to Maureen McCue for showing me this extract and allowing me to use it.

8 Whistler, 'Ten o'Clock', 143, 144.

9 Robertson, *Atkinson Grimshaw*, 118.

10 Oscar Wilde, 'The Decay of Lying' (1890), in *The Major Works*, ed. Isobel Murray (1989; Oxford University Press, 2008), 233.

11 Ibid., 233, 232.

12 John E. Thornes and Gemma Metherell, 'Monet's "London Series" and the Cultural Climate at the Turn of the Twentieth Century', in Strauss and Orlove, *Weather, Climate, Culture*, 154.

13 Jonathan Ribner, 'The Poetics of Pollution', in Lochnan, *Turner, Whistler, Monet*, 53.

14 Quoted in Sylvie Patin, 'The Return of Whistler and Monet to the Thames', in ibid., 180.

15 1 Corinthians 13:12 (King James version).

16 Cf. Connor, *Matter of Air*, 178: 'the very indistinctness of haze was, for a significant number of modernist artists, an objective, a vocation, and a provocation'.

RUSKIN IN THE AGE OF UMBER

1 Job 37:16 (King James version).

2 Ruskin, *Modern Painters* 1, in *Works*, vol. 3, 344; Ruskin, *Modern Painters* 3 (1856), in *Works*, vol. 4, 321.

3 Ruskin, *Modern Painters* 3, in *Works*, vol. 4, 321.

4 Dinah Birch traces Ruskin's lifelong commitment to the study of Turner in *Ruskin on Turner* (Cassell, 1990).

5 Ruskin, *Modern Painters* 1, in *Works*, vol. 3, 365.

6 Hazlitt, 'On Imitation', in *Round Table*, 79.

7 Conrad, *Cassell's History*, 491, argues that Ruskin elected Turner as 'an honorary pre-Raphaelite: a meticulous and myopic student of nature'; see also Conrad, *Victorian Treasure-House*, 115–16.

8 Ruskin, *Modern Painters* 1, *Works*, vol. 3, 348, 191.

9 *Modern Painters* 5 (1860), in *Works*, vol. 7, 146–47.

10 Ibid., plate 64; Jacobus, *Romantic Things*, 22. See Thornes, *Constable's Skies*, 194–96, on the ambitious but flawed meteorology involved.

11 Ruskin, *Modern Painters* 5, in *Works*, vol. 7, 140; aside in a lecture, recorded by E. T. Cook, *The Life of John Ruskin* (George Allen, 1911), vol. 2, 471.

12 John Tyndall, lecture, 'On Chemical Rays, and the Light of the Sun', January 1869, quoted by Ruskin in *The Queen of the Air: A Study of the Greek Myths of Cloud and Storm* (1869), in *Works*, vol. 19, 292; discussed Daniel Brown, *The Poetry of Victorian Scientists: Style, Science and Nonsense* (Cambridge University Press, 2013), 130–31.

13 Ruskin, *Queen of the Air*, in *Works*, vol. 19, 302, 294.

14 Ibid., 293; Woolf, *Orlando*, 217. In her fine essay on Woolf's relationship to Ruskin, Gillian Beer observes that 'she brings out the repressive humdrum "damp" to supplement and undermine the mythic, aggrandized account of Victorian weather in Ruskin': *Arguing with the Past: Essays in Narrative from Woolf to Sidney* (Routledge, 1989), 145.

15 Ruskin to Susan Beever, 21 January 1875, in *Works*, vol. 37, 154; diary entry from August 1879, used by Ruskin in *The Storm-Cloud of the Nineteenth Century: Two Lectures Delivered at the London Institution, February 4th and 11th, 1884*, in *Works*, vol. 34, 38.

16 Lamb, *Climate, History*, 254; Jonathan Brown, *Agriculture in England: A Survey of Farming, 1870–1947* (Manchester University Press, 1987), 1–6. Cattle herds were ravaged first by pleuropneumonia and then by foot-and-mouth. A government commission examining 'the depressed condition of the agricultural interest' ascribed the blame mostly to the weather, though with hindsight historians have understood the weather as an aggravating factor in long-term structural decline.

17 Douglas C. D. Pocock, ed., *Humanistic Geography and Literature: Essays on the Experience of Place* (Croom Helm, 1981), 39.

18 Ruskin, *Fors Clavigera: Letters to the Workmen and Labourers of Great Britain* (1871–73), letter 8, in *Works*, vol. 27, 133.

19 Ruskin had been showing the student one of his favourite pictures, a view by his old tutor, Copley Fielding, of a rainy Scottish hillside. 'After gazing blankly for a minute or two at the cheerless district through which lay the drover's journey, he turned to me and said "But, Ruskin, what is the use of painting such very bad weather?"' Ruskin told this story in his 1883 Slade lectures, *The Art of England*, in *Works*, vol. 33, 380–81, as part of his effort to convince students that the English atmosphere is more beautiful, and more of a gift for painters, than the monotonous sunshine of Greece and Italy.

20 *Storm-Cloud of the Nineteenth Century*, in *Works*, vol. 34, 39. On Ruskin and Tyndall in this context see Simon Grimble, *Landscape Writing and 'The Condition of England', 1878–1917* (Edwin Mellen, 2004), 59–60.

21 Ruskin, 'Of the Pathetic Fallacy', in *Modern Painters* 3, in *Works*, vol. 4, 204.

22 Anderson, *Predicting the Weather*, 228–32, places the lecture in the context of contemporary science. Timothy Hilton, *John Ruskin* (1985–2000; Yale University Press, 2002), 563, is clear about the evil wind being related to Ruskin's psychological state. Simon Grimble, *Landscape Writing and 'The Condition of England', 1878–1917* (Edwin Mellen, 2004), 62, sees a 'paranoid state of mind' being expressed,

in which the world as conjured by pathetic fallacy is held actually to exist. Fitch, *Poison Sky*, 2–42, reads the 1884 lectures not as the aberrant work of madness, but as the culmination of a lifetime's attention to the symbolism of skies.

23 Ruskin, *Fors Clavigera*, letter 8 (written 1 July 1871), excerpted in *Storm-Cloud of the Nineteenth Century*, in *Works*, vol. 34, 33.

RAIN ON A GRAVE

1 Hardy, *Return of the Native*, book 5, ch. 8, p. 349.
2 The novel's weather is discussed in detail by Waugh, 'Talking about the Weather', 147–90.
3 Thomas Hardy, *Far from the Madding Crowd* (1874), ed. Suzanne B. Falck-Yi (1993; Oxford University Press, 2002), ch. 46, pp. 306–12.
4 Ibid., 309.
5 Hardy, 'An Autumn Rain-Scene', in *Late Lyrics and Earlier* (1923), *Works*, 579–80; Hardy, 'Rain on a Grave', in *Satires of Circumstance* (1914), *Works*, 321.
6 Lewis, *Blasting*, 151. On Flanders mud see Harold A. Winters, *Battling the Elements: Weather and Terrain in the Conduct of War* (Johns Hopkins University Press, 1998), 41–46.
7 Owen, 'Exposure' (1918, recalling the winter of 1917), in Silkin, *First World War Poetry*, 190.
8 'At all times I love rain': Edward Thomas, *The South Country* (J. M. Dent, 1906), 274.
9 Edward Thomas, *The Icknield Way* (Constable, 1913), 282.
10 There are twinned phrases for marriage and burial: 'blessed is the bride whom the sun shines on; blessed is the dead whom the rain rains on'.
11 Thomas, 'Rain', in Silkin, *First World War Poetry*, 95.
12 Sergeant Norman Carmichael, quoted in Lyn Macdonald, *Somme* (1984; Penguin, 1993), 283; Lewis, *Blasting*, 151; Paul Nash to Margaret Nash, 16 November 1917, in *Outline: An Autobiography and Other Writings* (Faber, 1949), 210.
13 Fussell reads Hardy as a 'clairvoyant' of war in *Great War*, 3–7.
14 Hardy, 'During Wind and Rain', in *Moments of Vision* (1917), *Works*, 465–66.

IX

BRIGHT NEW WORLD

1 Woolf, *Orlando*, 282–84.
2 Ibid., 313.

3 Sidney, 'Literature of Cold', 145, understands Woolf's phrase as the expression of a whole 'structure of feeling': 'modernist authors used cold – as trope, as motif, as metaphor – as a way of stating and solving the problems of their age'.
4 Lewis, *Blast*, 11, 12. On modernist 'hostility towards the gaseous' see Connor, *Matter of Air*, 180–81, who goes on to identify a different 'nebular modernism'. Years later, considering the factors that had shaped his writing, Lewis again emphasized his loathing of the British weather, especially the 'incessant deluges of water that fall from the Britannic firmament' and 'the detestable Scotch mists that continually conceal everything, and which cause one to become a walking sponge'. Lewis claimed that he would rather have written *On an African Farm* than *Wuthering Heights*, 'because in order to write the latter one would have to exist for many years in a perpetual drizzle'. Adrian Alington et al., *Beginnings* (Thomas Nelson, 1935), 99, 100. Thanks to Paul Edwards.
5 Bridges, 'London Snow' (1890), in Caroline Blyth, ed., *Decadent Verse: An Anthology of Late Victorian Poetry, 1872–1900* (Anthem, 2009), 531; Hulme, 'Romanticism and Classicism' (1911), in *Speculations*, 127.
6 Lewis, *Blast*, 149, 12.
7 Lawrence, *Women in Love*, 402.
8 Sidney, 'Literature of Cold', 154–72, on Lawrence.
9 Lawrence, *Women in Love*, 264.
10 Ibid., 413, 423, 425.
11 Ibid., 423, 459, 439. Lawrence had seen a photograph of Mark Gertler's painting *The Merry-Go-Round* (1916), and wrote to Gertler that he found it 'horrifying and terrifying'.
12 Eliot, *Waste Land* (1922), l. 6, in *Complete Poems*, 61; Lawrence, *Women in Love*, 498.
13 Davidson, *Idea of North*, 83, and see the whole chapter on Auden and Ravilious, 83–109.
14 Auden, 'Taller to-day […]', in *English Auden*, 26, discussed Davidson, *Idea of North*, 18; Auden, 'I Like It Cold' (1947), in *Complete Works: Prose*, vol. 2, 335.
15 W. H. Auden and Louis MacNeice, *Letters from Iceland* (Faber, 1937), 25, 251. Later, in America, Auden loathed the heat of New York summers. His 'hottest memory' was of August 1944: 'I had money, friends, an electric fan, a shower, a refrigerator. I lay in a stupor wishing I were dead.' 'I Like It Cold', in *Complete Works: Prose*, vol. 2, 334.

16 See Jessica Burstein, *Cold Modernism: Literature, Fashion, Art* (Pennsylvania State University Press, 2012).

17 1921 advertisement for the Carrier Corporation quoted williscarrier.com/1915-1922.php; 1925 advertisement for the General Motors Frigidaire printed e.g. in *Saturday Evening Post*; 1914 advertisement for the White Frost printed in *Harper's* and *McLure's* magazines.

18 Woolf, 'America, which I have never seen [...]' (1938), *Essays*, vol. 6, 129.

19 Valentine Cunningham, *British Writers of the Thirties* (Oxford University Press, 1988), 183–85, on the sun cult and its political appropriation for both left and right.

20 D. H. Lawrence, 'Sun', in *Selected Short Stories*, ed. Brian Finney (1982; Penguin, 2000), 428.

21 Auden, 'It is time for the destruction of error [...]', in *English Auden*, 40.

22 Hawkes, *Architecture and Climate*, 200; Laura Cohn, *The Door to a Secret Room: A Portrait of Wells Coates* (Scolar Press, 1999), 152.

23 Auden, 'Letter to Lord Byron' (1936), in *English Auden*, 176.

24 Hulme, *Speculations*, 127; Lewis, *Blast*, 147.

25 Hardy, 'A Wet Night', in *Time's Laughingstocks* (1909), *Works*, 259.

26 Many scientific advances were celebrated at the Great Exhibition of 1851, but meteorological breakthroughs were lacking. The Yorkshire surgeon George Merryweather displayed a 'Tempest Prognosticator' involving leaches and a bell. The excitement this caused was a gauge of desperation. The next decade, however, would be pivotal. The Meteorological Office was founded in 1854, under the leadership of Vice-Admiral Robert FitzRoy, who began issuing forecasts in 1861. Public complaints about the inaccuracy of these forecasts may have contributed to FitzRoy's suicide in 1865. Newspapers returned to printing yesterday's weather, and would not carry predictions again until 1879. On Victorian meteorology see Anderson, *Predicting the Weather*.

27 See Banham, *Environment*; Hawkes, *Architecture and Climate*. Gopnik, *Winter*, 27, gives due credit to the Victorian engineers who deployed steam-engine technology for static buildings.

28 Marinetti, lecture of March 1912, published in *Futurisme* (1912), quoted in Banham, *Environment*, 125.

29 Le Corbusier published his Buenos Aires lectures as *Précisions* (1930). 'Exact breathing' comes at the end of the second lecture, 'Techniques are the very basis of poetry': *Precisions: On the Present State of Architecture and City Planning*, trans. Edith Schreiber Aujame (MIT Press, 1991), 66.

30 See Banham, *Environment*, 74.

31 Auden, 'Letter to Lord Byron', in *English Auden*, 176, discussed Sidney, 'Literature of Cold', 149. Connor, 'Thermotaxis', explores the ideal 'fluctuation between limits'.

32 Smith, *Yellow Paper*, 14.

33 She cites this as the inspiration for 'Silence and Tears' (1938), in *Collected Poems*, 117.

34 Smith, 'Brickenden, Hertfordshire' (1938), and '... and the clouds return after the rain' (1938), in *Collected Poems*, 121, 160.

35 Eliot, *Waste Land*, ll. 19–20, 22–23, in *Complete Poems*, 61.

36 Spenser, 'Prothalamion' (1596), in *Shorter Poems*, 190–95; Eliot, *Waste Land*, ll. 38, 189–90, 135–36, in *Complete Poems*, 62, 67, 65.

37 Ibid., ll. 26, 324, 337–89, 342, 345, 358–59, in *Complete Poems*, 61, 72, 73.

38 On the thrush which doesn't sound like water: Jim McCue, 'Did Eliot Mis-Ascribe the "Water-Dripping Song" in *The Waste Land*?', *Notes & Queries*, 61 (2014), 118–19.

39 Eliot to Ford Madox Ford, 4 October 1923, in *Letters of T. S. Eliot*, ed. Valerie Eliot and Hugh Haughton (Faber, 2009), vol. 2, 240. On 14 August (ibid., 188) he had given Ford a challenge: 'There are, *I* think, about 30 good lines in *The Waste Land*. Can you find them: the rest is ephemeral.'

40 Eliot, *Waste Land*, l. 385, in *Complete Poems*, 73; Spenser, *Faerie Queene*, 7:7:9.

41 See James Frazer, *The Golden Bough* (1890), one-volume edition (Macmillan, 1922), ch. 5, 'The Magical Control of Rain', and ch. 6, 'Magicians as Kings'; and Jessie Weston on 'The Freeing of the Waters' in Aryan mythology as an ancestor of the grail legend, *From Ritual to Romance* (1920; Doubleday, 1957), 26.

42 Eliot, 'The Hollow Men', in *Complete Poems*, 83, 84.

43 F. Scott Fitzgerald, *The Great Gatsby* (1925; Scribner, 2004), ch. 2, p. 23. The connections between *The Waste Land* and ecological crisis are well made by Elizabeth Harris, '"The Earth-Haunted Mind": The Search for Reconnection with Nature, Place and the Environment in the Poetry of Edward Thomas, T. S. Eliot, Edith Sitwell and Charlotte Mew', PhD thesis, Manchester Metropolitan University, 2013.

44 Woolf, 'Modern Novels', in *Essays*, vol. 3, 32, and revised as 'Modern Fiction', in Common Reader, 147.

45 Woolf, *To the Lighthouse*, 13; Woolf, *Between the Acts*, 17.

46 Woolf, 'Mr Kipling's Notebook' (1920), in *Essays*, vol. 3, 239; Woolf, 'The Pastons and Chaucer' (1925), in *Common Reader*, 11.

47 Woolf, 'Reading', in *Essays*, vol. 3, 142; Woolf, 'The English Mail Coach' (1906), in *Essays*, vol. 1 (appendix), 366, 367, 368.

48 Ibid., 367; *The Tempest*, 4:1.

49 Woolf, *Between the Acts*, 16.

50 Virginia Woolf, *Jacob's Room* (1922) ed. Kate Flint (Oxford University Press, 1992), 13, 173.

51 Woolf, 'On Being Ill', in *Essays*, vol. 4, 321. See Hermione Lee's discussion of the passage, linking Woolf's cloudscapes with those of Shakespeare, Wordsworth and De Quincey, in 'On Being Ill', in *Body Parts: Essays on Life-Writing* (Chatto & Windus, 2005), 86–99.

52 Woolf, *To the Lighthouse*, 140.

53 Virginia Woolf, *The Waves* (1931), ed. Gillian Beer (Oxford University Press, 1992), 200; *Macbeth*, 5:5.

54 Virginia Woolf, *The Waves: The Two Holograph Drafts*, ed. by J. W. Graham (Hogarth Press, 1976).

GREYSCALE

1 G. K. Chesterton, 'The Glory of Grey', in *Alarms and Discursions* (1910; Methuen, 1927), 119, 120; Louise Imogen Guiney, 'English Weather', *Scribner's Magazine* (November 1907), 631. Thanks to Alex Murray.

2 On Ravilious and the Arctic see Davidson, *Idea of North*, 101–9 and 261n, also Macfarlane, *Old Ways*, 294–302. Both are more interested in him as an icy rather than temperate painter.

3 John Piper, 'The Nautical Style', *Architectural Review*, 83 (1938), 1–14.

4 Reported by James Lees-Milne in *Prophesying Peace* (Chatto & Windus, 1977), 211–12.

5 Hardy, 'Neutral Tones', in *Wessex Poems* (1898), *Works*, 9.

6 Helen Small, 'Hardy's Tennyson', in Robert Douglas-Fairhurst and Seamus Perry, eds, *Tennyson among the Poets: Bicentenary Essays* (Oxford University Press, 2009), 367.

7 T. S. Eliot, *'In Memoriam'* , in *Essays Ancient and Modern* (1932; Harcourt Brace, 1936), 195; Eliot, 'Little Gidding' (1942), in *Complete Poems*, 195. See also Tom Paulin, *The Secret Life of Poems: A Poetry Primer* (Faber, 2008), 102–6. With thanks to Benjamin Markovits, who admires the image.

8 Auden, 'Who stands, the crux left of the watershed' (1927), in *English Auden*, 22; Auden,

'The month was April' (1932), in ibid., 131; 'Who stands [...]', in ibid., 22.

9 Auden, 'Consider this, and in our time' (1930), in *English Auden*, 46.

10 Auden, 'I have a handsome profile' (1932), in *English Auden*, 125; and for the train see e.g. Auden, 'The Orators', Ode 5, in ibid., 109.

11 Green, *Party Going*, 1, 14.

12 Ibid., 109; Reed, *Romantic Weather*, 16, discusses crowds as the urban version of clouds.

13 Ezra Pound to Wyndham Lewis, 3 February 1948, in *Pound/Lewis: The Letters of Ezra Pound and Wyndham Lewis*, ed. Timothy Materer (Faber, 1985), 239; Wyndham Lewis, *Rotting Hill* (Methuen, 1951), xii; John Piper, 'Pleasing Decay', *Architectural Review*; 102 (1947), 85–94; Lewis, 'Time the Tiger', in *Rotting Hill*, 170. Lewis's health, as well as his home, was in decay. His brain tumour affected the regulation of his body temperature, and in winter 1949 he found that the thickening fog around him was in fact the result of failing eyesight. In 'The Sea-Mists of Winter', *Listener*, 45 (1951), 765, he described the encroaching mists of blindness. Many thanks to Paul Edwards.

14 Ian Currie, in 'Strange Weather Days', BBC Radio 7 / Radio 4 Extra, 8 March 2010.

15 'Song of the Weather', from the show *At the Drop of the Hat*, 1956; Sara Coleridge, 'The Months', in *Pretty Lessons in Verse for Good Children* (1834; John W. Parker, 1839), 7.

16 Ted Hughes, 'The Beach' (1998), in *Collected Poems*, 1144.

17 Ibid.

18 Selvon, *Lonely Londoners*, 117; J. M. Coetzee, *Youth* (Secker & Warburg, 2002), 104; Joseph Conrad, 'Youth: A Narrative' (1902), in *Selected Short Stories* (Wordsworth, 1997), 94; Coetzee, *Youth*, 102, 168.

19 Larkin, 'A Slight Relax of Air', in *Collected Poems*, 142. Anthony Thwaite observes that the poem gives a sense of how Larkin might have written a modern version of Thomson's *The Seasons*, an idea that interested him: note to a letter of 26 September 1971, in Philip Larkin, *Letters to Monica* (2010; Faber, 2012), 425.

20 Penelope Fitzgerald, 'Really one should burn everything', in *New Criterion*, 11 (1993), 68.

21 Fitzgerald, *Offshore*, 38; see Hermione Lee, *Penelope Fitzgerald: A Life* (Chatto & Windus, 2013), 152.

22 Fitzgerald, *Offshore*, 27, 133.

23 Larkin, 'Here' (1961), in *Collected Poems*, 136; Paul Farley and Michael Symmons Roberts, *Edgelands* (Jonathan Cape, 2011), 257.

24 Smithson, *AS in DS*, 104. Thanks to Kevin Brazil for lending me the book.

25 Selvon, *Lonely Londoners*, 110, 115, 121.

26 Larkin, 'Mother, Summer, I' (1953) and 'To the Sea' (1974), in *Collected Poems*, 68, 174.

27 Larkin, 'The Whitsun Weddings', in ibid., 116.

28 Hartley, *Go-Between*, 76, 77.

29 Ibid., 20, 279.

30 Ian McEwan, 'When Faith in Fiction Falters', *Guardian*, 16 February 2013.

31 Memories of family and friends; Dominic Sandbrook, *Seasons in the Sun: The Battle for Britain, 1974–1979* (Allen Lane, 2012), 596–622.

32 McEwan, *Cement Garden*, 71, 122.

33 Ian McEwan, *Atonement* (2001; Vintage, 2002), 125, 128.

34 Hockney in Martin Gayford, *A Bigger Message: Conversations with David Hockney* (Thames & Hudson, 2011), 101.

35 O'Brien, 'Novembrists' (2011) and 'After Laforgue' (1991), in *Collected Poems*, 436, 152. And see Davidson's appreciation of O'Brien's work, and these last lines in particular, *Idea of North*, 229.

36 O'Brien, 'Poem Written on a Hoarding' (1995), 'Grimshaw' (2007) and 'Praise of a Rainy Country' (2007), in *Collected Poems*, 173, 395, 403.

37 Forecasts at 00.48 and 05.20 are broadcast on BBC Radio 4 FM and LW. There are also two daytime bulletins, broadcast at 12.01 (LW only) and 17.54 (LW weekdays; LW and FM weekends).

38 Carol Ann Duffy, 'Prayer', *Mean Time* (Anvil Press, 1993). 'Finisterre' has now been renamed 'FitzRoy'. Other responses include 'The Shipping Forecast' by Seamus Heaney, watercolours of each area by Peter Collyer, photographs by Mark Power, and Charlie Connelly's *Attention All Shipping: A Journey Round the Shipping Forecast* (Little, Brown, 2004).

39 See e.g. Vanessa Barford, 'Can you advertise British weather to tourists?', 13 February 2012, www.bbc.co.uk/news/magazine-16963717.

40 Colin Priest, *Flash Fog*, 2011–13.

TOO MUCH WEATHER

1 McKim, *Cinema as Weather*, explores a century of weather on film.

2 Julian Barnes, '*Metroland* – with Annotations', *Guardian*, 18 May 2013: 'I was going to put absolutely no references to the weather into [the novel], having long held a readerly prejudice about "significant" weather (storms, bright spells, rainbows) in fiction'.

3 'No Weather' discussed in Julian Barnes, *Nothing to be Frightened Of* (Jonathan Cape, 2008), 148. Charles Baudelaire, 'Elévation' (1857), in *Les Fleurs du Mal et Oeuvres Choisies*, ed. and trans. Wallace Fowlie (Bantam, 1964), 26; and see Reed, *Romantic Weather*, 70–77.

4 Notebook entries 1981, read in conversation with Vanessa Guignery in 2002, transcribed in Vanessa Guignery and Ryan Roberts, eds, *Conversations with Julian Barnes* (University Press of Mississippi, 2009), 104.

5 Julian Barnes, *England, England* (Jonathan Cape, 1998), 90.

6 Julian Barnes, 'Carcassonne', in *Pulse* (Jonathan Cape, 2011), 192; Ford Madox Ford, *The Good Soldier* (1915), ed. Thomas C. Moser (Oxford University Press, 1990), 143.

7 Colour lithograph published in the portfolio *For John Constable* (Bernard Jacobson, 1976).

8 Ted Hughes, 'Wind and Weather', in *Poetry in the Making: A Handbook for Writing and Teaching* (1967; Faber, 2008), 33.

9 Hughes, 'Tractor' (1989), 'Crow Hill' (1960) and 'Dawn's Rose' (1970), in *Collected Poems*, 511, 62, 239.

10 Hughes, 'Thistles' (1967) and 'October Dawn' (1957), in *Collected Poems*, 147, 37; Hughes to Nick Gammage, 29 November 1989, in *The Letters of Ted Hughes*, ed. Christopher Reid (Faber, 2007), 571.

11 Hughes, 'Birth of a Rainbow' (1989), in *Collected Poems*, 521.

12 Thomas Hardy, *The Woodlanders* (1887), ed. Dale Kramer (1985; Oxford University Press, 2005), ch. 44, p. 298; Mabey, *Nice Again*, 16.

13 Mabey, *Nice Again*, 75.

14 Macfarlane, *Old Ways*, 74, 66, 307, 78, 196, 308.

15 Swift, *Morville Hours*, 58–62, on February warming. And for a polemic advocacy of seasonal culture see Groom, *Seasons*.

16 Dee, *Four Fields*, 89, 254.

17 *Prologue* to *The Canterbury Tales*, l. 10, in *Riverside Chaucer*, 23; Richard Mabey, 'Where Two Kinds of Wildness Collide', *New Statesman*, 3 April 2012.

18 Smithson, *AS in DS*, 17.

19 Designed by the New York-based firm Diller + Scofidio.

20 Esther Leslie considered the 'thought-clouds' of an IT age in 'Head in the Clouds', *The Essay*, BBC Radio 3, 26 February 2009.

21 Declaration of the WMO at the World Climate Conference, 1979, quoted Matthew Paterson, *Global Warming and Global Politics* (Routledge, 1996), 28.

22 IPCC Assessment Report 5, 2013–14: separate
reports and summaries for policymakers issued
by working groups 1, 2, and 3.

23 Hardy, 'During Wind and Rain', in *Moments of
Vision* (1917), *Works*, 466.

24 Mike Hulme, 'Meet the Humanities', in *Exploring
Climate Change*, 107.

25 Writers test the waters of 'climate fiction' in
Gregory Norminton, ed., *Beacons: Stories for
Our Not So Distant Future* (Oneworld, 2013),
and Gordon Van Gelder, ed., *Welcome to the
Greenhouse: New Science Fiction on Climate
Change* (OR Books, 2011).

26 Simpson, 'In-Flight Entertainment', in
In-Flight, 15.

27 Hughes, 'Rain-Charm for the Duchy' (1984), in
Collected Poems, 803–5; Alice Oswald, *Dart*
(Faber, 2002), 16, 48.

28 The journal *ISLE: Interdisciplinary Studies in
Literature and Environment*, published by the
Association for the Study of Literature and
Environment (ASLE), is a forum for this work.

29 Bate, *Song of the Earth*, 72, 79.

30 The World Health Organization views 18°C
as appropriate for healthy people. Public
Health England's document *Minimum Home
Temperature Thresholds for Health in Winter:
A Systematic Literature Review* (Public Health
England, 2014), 60, concludes: 'There is good
evidence to show that indoor temperatures
in homes have increased steadily in recent
decades, with recent estimates suggesting that
average indoor temperatures have increased by
about 5–6°C since the 1970s to around 17–21°C'.

31 Thomas Hardy, *Desperate Remedies* (1871), ed.
Patricia Ingham (Oxford University Press, 2003),
303.

32 Timothy Clark, 'Nature, Post-Nature', in
Westling, ed. *Cambridge Companion*, 81. See
also Clark's essay 'Scale' in Tom Cohen, ed.,
*Telemorphosis: Theory in the Era of Climate
Change* (Open Humanities Press, 2012), 148–66,
and Robert Markley, 'Time', in the same volume,
43–64.

33 Zadie Smith, 'Elegy for a Country's Seasons',
New York Review of Books, 3 April 2014.

34 Visions of ecological disaster have long been a
key strand of science fiction. J. G. Ballard, *The
Drowned World* (Gollancz, 1962), has been an
inspiration for writers in the climate-change
era. Kim Stanley Robinson has written a climate-
change trilogy, starting with *Forty Signs of Rain*
(HarperCollins, 2004). Maggie Gee projected a
frozen English future in *The Ice People* (Richard
Cohen, 1998).

FLOOD

1 See *Noah*, in Happé, *English Mystery Plays*,
118–32. Britten read the play in his copy of the
1927 edition of A. W. Pollard, ed., *English Miracle
Plays, Moralities and Interludes: Specimens
of the Pre-Elizabethan Drama* (1890).

2 James Mayhew, 'Designs on Britten', *Guardian*,
1 July 2013.

3 Julian Barnes, *A History of the World in 10½
Chapters* (Jonathan Cape, 1989), 27.

4 Henry Green, *Pack My Bag: A Self-Portrait*
(1940; Vintage, 2011), 2.

5 George Szirtes, 'Death by Deluge', in *An English
Apocalypse* (Bloodaxe, 2001), 140.

6 Neil Powell, *Benjamin Britten: A Life for Music*
(Hutchinson, 2013), 345–46.

7 Donne, 'The Progress of the Soul' (1612), in
Major Works, 72.

Works quoted in the text but not appearing in the bibliography are cited with full publication details in the Notes. What follows is intended as an indicative list of major sources.

I. PRIMARY SOURCES

Addison, Joseph, et al., *The Spectator* (1711–14), ed. Donald F. Bond, 5 vols (Clarendon Press, 1965)

Anlezark, Daniel, ed. and trans., *Old Testament Narratives* (Harvard University Press, 2011)

Aristophanes, *Clouds*, in *Lysistrata and Other Plays*, trans. Alan Sommerstein (1973; Penguin, 2002)

Aristotle, *Meteorologica*, trans. H. D. P. Lee, Loeb Classical Library (Harvard University Press, 1952)

Auden, W. H., *Complete Works: Prose*, ed. Edward Mendelson, 4 vols (Princeton University Press, 1996–2002)

— *The English Auden: Poems, Essays and Dramatic Writing, 1927–1939*, ed. Edward Mendelson (1977; Faber, 1986)

Austen, Jane, *Jane Austen's Letters*, ed. Deidre Le Faye (2011; Oxford University Press, 2014)

— *Mansfield Park* (1814; Wordsworth, 1992)

— *Northanger Abbey* (1818), ed. John Davie (1980; Oxford University Press, 2008)

— *Persuasion* (1818), ed. Gillian Beer (Penguin, 1998)

— *Sense and Sensibility* (1811), ed. James Kinsley and Claire Lamont (Oxford University Press, 2004)

Bacon, Francis, *Historia Ventorum* (1622), in *The Oxford Francis Bacon*, vol. 12, ed. Graham Rees with Maria Wakely (Clarendon Press, 2007), 19–131

— *The Major Works*, ed. Brian Vickers (1996; Oxford University Press, 2008)

Barker, Thomas, *The Weather Journals of a Rutland Squire*, ed. John Kington (Rutland Record Society, 1988)

Beowulf: A New Verse Translation (Bilingual Edition), trans. Seamus Heaney (Faber, 2007)

Boswell, James, *The Life of Samuel Johnson* (1791), ed. David Womersley (Penguin, 2008)

Brontë, Charlotte, *Jane Eyre* (1847), ed. Michael Mason (Penguin, 1996)

— *Selected Letters*, ed. Margaret Smith (2007; Oxford University Press, 2010)

— *Shirley* (1849), ed. Herbert Rosengarten and Margaret Smith (1979; Oxford University Press, 2008)

— *Villette* (1853), ed. Margaret Smith and Herbert Rosengarten (1984; Oxford University Press, 2008)

Brontë, Emily, *Wuthering Heights* (1847), ed. Ian Jack (1976; Oxford University Press, 2009)

Burke, Edmund, *A Philosophical Enquiry into the Origin of Our Ideas of the Sublime and Beautiful* (1757), ed. Adam Phillips (Oxford University Press, 1990)

Burton, Robert, *The Anatomy of Melancholy* (1621; revised edition 1651), ed. Holbrook Jackson (1932; New York Review Books, 2001)

Chaucer, Geoffrey, *The Riverside Chaucer*, general ed. Larry D. Benson (Oxford University Press, 1987)

Clare, John, *Major Works*, ed. Eric Robinson and David Powell (1984; Oxford University Press, 2004)

— *The Shepherd's Calendar* (1827), ed. Eric Robinson, Geoffrey Summerfield and David Powell (Oxford University Press, 1993)

Coleridge, Samuel Taylor, *Coleridge's Notebooks: A Selection*, ed. Seamus Perry (Oxford University Press, 2002)

— *The Major Works*, ed. H. J. Jackson (1984; Oxford University Press, 2000)

Constable, John, *John Constable's Correspondence*, ed. Ronald Brymer Beckett, 6 vols (Suffolk Records Society, 1962–68)

Cotton, Charles, *Poems of Charles Cotton, 1630–1687*, ed. John Beresford (Richard Cobden-Sanderson, 1923)

Cowper, William, *The Centenary Letters*, ed. Simon Malpas (Fyfield, 2000)

— *The Task* (1785), in *The Poems of William Cowper*, vol. 2, ed. John D. Baird and Charles Ryskamp (Clarendon Press, 1995)

Cozens, Alexander, *A New Method of Assisting the Invention in Drawing Original Compositions of Landscape* (1785; Paddington Press, 1977)

Cross, James E., and Thomas D. Hill, ed. and trans., *The Prose Solomon and Saturn, and Adrian and Ritheus* (University of Toronto Press, 1982)

Crossley-Holland, Kevin, ed. and trans., *The Anglo-Saxon World: An Anthology* (1982; Oxford University Press, 2009)

— trans., *The Exeter Book Riddles* (1979; Enitharmon Press, 2008)

Darbishire, Helen, ed., *The Early Lives of Milton* (Constable, 1932)

Darwin, Erasmus, *The Essential Writings of Erasmus Darwin*, ed. Desmond King-Hele (MacGibbon and Kee, 1968)

Dee, Tim, *Four Fields* (Jonathan Cape, 2013)

Defoe, Daniel, *Robinson Crusoe* (1719), ed. Thomas Keymer (1983; Oxford University Press, 2008)
—— *The Storm* (1704), ed. Richard Hamblyn (2003; Penguin, 2005)
Dekker, Thomas, *The Great Frost: Cold Doings in London, Except It Be at the Lottery* (1608), in Edward Arber, ed., *An English Garner: Ingatherings from Our History and Literature*, vol. 1 (Edward Arber, 1877), 77–100
—— *Look Up and See Wonders* (Roger Michell, 1628)
De Quincey, Thomas, *Confessions of an English Opium-Eater* (1821), ed. Grevel Lindop (1985; Oxford University Press, 2008)
Dickens, Charles, *Bleak House* (1852–53), ed. Stephen Gill (1996; Oxford University Press, 2008)
Donne, John, *The Major Works*, ed. John Carey (1990; Oxford University Press, 2000)
Eliot, T. S., *The Complete Poems and Plays of T. S. Eliot* (Faber, 1969)
Evelyn, John, *The Diary of John Evelyn*, ed. E. S. de Beer, 6 vols (Clarendon Press, 1955)
—— *The Writings of John Evelyn*, ed. Guy de la Bédoyère (Boydell Press, 1995)
Farmer, D. H., ed., and J. F. Webb, trans., *The Age of Bede* (1965; Penguin, 2004)
Fitzgerald, Penelope, *Offshore* (1979; HarperCollins, 2009)
Gaskell, Elizabeth, *The Life of Charlotte Brontë* (1857), ed. Angus Easson (1996; Oxford University Press, 2001)
Gay, John, *Trivia, or, The Art of Walking the Streets of London* (1716), in *John Gay: Poetry and Prose*, vol. 1, ed. Vinton A. Dearing with Charles E. Beckwith (Clarendon Press, 1974), 134–81
Gollancz, Israel, ed. and trans., *The Exeter Book*, part 1 (Early English Text Society, 1895)
Green, Henry, *Party Going* (1939; Vintage, 2000)
Happé, Peter, ed., *English Mystery Plays: A Selection* (1975; Penguin, 1985)
Hardy, Thomas, *The Return of the Native* (1878), ed. Simon Gatrell (1990; Oxford University Press, 2008)
—— *The Works of Thomas Hardy* (Wordsworth, 1994)
Hartley, L. P., *The Go-Between* (1953; Penguin, 1958)
Hazlitt, William, *The Round Table and Lectures on the English Poets*, ed. Duncan Wu (Pickering and Chatto, 1998)
—— *Selected Writings*, ed. Ronald Blythe (1970; Penguin, 1985)
Heywood, John, *The Play of the Weather* (1533; Malone Society, 1977)
Hooke, Robert, 'Method for Making a History of the Weather', in Thomas Sprat, *The History of the Royal Society of London* (1667), ed. Jackson I.

Cope and Harold Whitmore Jones (Routledge & Kegan Paul, 1959), 173–79
Howard, Luke, *Essay on the Modifications of Clouds* (1803; John Churchill & Sons, 1865)
Hughes, Ted, *Collected Poems*, ed. Paul Keegan (Faber, 2003)
Hunt, Leigh, *The Months* (1821; revised from *The Calendar of Nature*, 1819) (Ingpen & Grant, 1929)
Hutchinson, Lucy, *Order and Disorder*, ed. David Norbrook (Blackwell, 2009)
Johnson, Samuel, *The Major Works*, ed. Donald Greene (1984; Oxford University Press, 2008)
—— *The Yale Edition of the Works of Samuel Johnson*, general ed. A. T. Hazen, 23 vols (Yale University Press, 1958–2012)
Josselin, Ralph, *The Diary of Ralph Josselin*, ed. Alan Macfarlane (Oxford University Press, 1976)
The Kalendar and Compost of Shepherds (1503; revised edition 1518), ed. G. C. Heseltine (Peter Davies, 1930)
Keats, John, *The Complete Poems*, ed. John Barnard (1973; Penguin, 2003)
—— *Selected Letters*, ed. Robert Gittings and Jon Mee (Oxford University Press, 2002)
Larkin, Philip, *Collected Poems*, ed. Anthony Thwaite (Faber, 1988)
Lawrence, D. H., *Women in Love* (1920), ed. David Bradshaw (Oxford University Press, 1998)
Lewis, Wyndham, *Blasting and Bombardiering* (1937; University of California Press, 1967)
—— ed., *Blast 1* (1914; Black Sparrow Press, 1981)
Lonsdale, Roger, ed., *The New Oxford Book of Eighteenth-Century Verse* (1984; Oxford University Press, 2009)
Lucretius, *On the Nature of the Universe*, trans. Ronald Melville, ed. Don and Peta Fowler (1997; Oxford University Press, 1999)
Luria, Maxwell S., and Richard L. Hoffman, eds, *Middle English Lyrics: Authoritative Texts, Critical and Historical Backgrounds, Perspectives on Six Poems* (Norton, 1974)
Macfarlane, Robert, *The Old Ways: A Journey on Foot* (Hamish Hamilton, 2012)
Mackie, W. S., ed. and trans., *The Exeter Book*, part 1 (Early English Text Society, 1934)
Manzalaoui, M. A., ed., *Secretum Secretorum: Nine English Versions* (Oxford University Press for the Early English Text Society, 1977)
Marlowe, Christopher, *The Complete Plays*, ed. Frank Romany and Robert Lindsey (Penguin, 2003)
Martin, Andrew, ed., *Scotland's Weather: An Anthology* (National Museums of Scotland, 1995)
McEwan, Ian, *The Cement Garden* (1978; Vintage, 1997)

Milton, John, *The Major Works*, ed. Stephen Orgel and Jonathan Goldberg (1991; Oxford University Press, 2003)

O'Brien, Sean, *Collected Poems* (Picador, 2012)

Pepys, Samuel, *The Diary of Samuel Pepys: A New and Complete Transcription*, ed. Robert Latham and William Matthews, 11 vols (G. Bell, 1970–83)

Pope, Alexander, *The Major Works*, ed. Pat Rogers (1993; Oxford University Press, 2006)

Rimbault, Edward F., ed., 'Old Ballads Illustrating the Great Frost of 1683–4 and the Fair on the River Thames', in *Early English Poetry, Ballads, and Popular Literature of the Middle Ages*, vol. 9 (Percy Society, 1844)

Ruskin, John, *The Works of John Ruskin*, ed. E. T. Cook and Alexander Wedderburn, 39 vols (George Allen, 1903–12)

Selvon, Sam, *The Lonely Londoners* (Allan Wingate, 1956)

Shelley, Percy Bysshe, *The Major Works*, ed. Zachary Leader and Michael O'Neill (Oxford University Press, 2003)

Shippey, T. A., ed. and trans., *Poems of Wisdom and Learning in Old English* (D. S. Brewer, 1976)

Silkin, Jon, ed., *The Penguin Book of First World War Poetry* (1979; Penguin, 1996)

Simpson, Helen, *In-Flight Entertainment* (Jonathan Cape, 2010)

Sir Gawain and the Green Knight; Pearl; Cleanness; Patience, ed. J. J. Anderson (1976; Everyman, 1996)

Smith, Stevie, *The Collected Poems and Drawings of Stevie Smith*, ed. Will May (Faber, 2015)

— *Novel on Yellow Paper* (1936; Virago, 1980)

Smithson, Alison and Peter, *AS in DS: An Eye on the Road* (1983; Lars Müller, 2001)

Spenser, Edmund, *The Faerie Queene* (1590–1609), ed. Thomas P. Roche, Jr, with C. Patrick O'Donnell, Jr (Penguin, 1978)

— *Shorter Poems: A Selection*, ed. John Lee (1988; Everyman, 1998)

Swift, Jonathan, *Journal to Stella*, ed. J. K. Moorhead (J. M. Dent, 1940)

Tennyson, Alfred, Lord, *The Works of Alfred Lord Tennyson* (Wordsworth, 1994)

Thomson, James, *The Seasons* (1730; revised edition 1746), ed. James Sambrook (Clarendon Press, 1972)

Virgil, *Georgics*, trans. Peter Fallon, ed. Elaine Fantham (Oxford University Press, 2006)

Vitruvius, *The Ten Books on Architecture*, trans. Ingrid D. Rowland, ed. Thomas Noble Howe, Ingrid D. Roland and Michael J. Dewar (Cambridge University Press, 1999)

Walton, Izaak, *The Compleat Angler* (1653; revised edition 1676) (1935; Oxford University Press, 1982)

Whistler, James Abbott McNeill, 'Mr Whistler's Ten o'Clock' (1885), in *The Gentle Art of Making Enemies* (1892; Dover Publications, 1967)

White, Gilbert, *Gilbert White's Journals*, ed. Walter Johnson (1931; David & Charles, 1970)

— *The Natural History of Selborne* (1789), ed. Richard Mabey (1977; Penguin, 1987)

Wittreich, Joseph A., ed., *The Romantics on Milton: Formal Essays and Critical Asides* (Press of Case Western Reserve University, 1970)

Woolf, Virginia, *Between the Acts* (1941), ed. Gillian Beer (Penguin, 1992)

— *The Common Reader* (1925), ed. Andrew McNeillie (Vintage, 2003)

— *The Common Reader: Second Series* (1932), ed. Andrew McNeillie (Vintage, 2003)

— *The Essays of Virginia Woolf*, vols 1–3 ed. Andrew McNeillie, vols 4–6 ed. Stuart N. Clarke (Hogarth Press, 1986–2011)

— *Orlando: A Biography* (1928), ed. Rachel Bowlby (Oxford University Press, 1992)

— *To the Lighthouse* (1927), ed. Hermione Lee and Stella McNichol (Penguin, 1992)

Wordsworth, Dorothy, *The Grasmere and Alfoxden Journals*, ed. Pamela Woof (Oxford University Press, 2002)

Wordsworth, William, *A Description of the Scenery of the Lakes in the North of England* (1822; Woodstock Books, 1991)

— *The Excursion* (1814), ed. Sally Bushell, James A. Butler and Michael C. Jaye (Cornell University Press, 2007)

— *The Major Works*, ed. Stephen Gill (1984; Oxford University Press, 2000)

Wordsworth, William and Dorothy, *The Letters of William and Dorothy Wordsworth*, ed. Ernest de Sélincourt, rev. Chester L. Shaver et al., 8 vols (1935–39; Clarendon Press, 1967–93)

II. SECONDARY SOURCES

Abrams, M. H., 'The Correspondent Breeze: A Romantic Metaphor', in M. H. Abrams, ed., *English Romantic Poets: Modern Essays in Criticism* (Oxford University Press, 1960)

Ackroyd, Peter, *Albion: The Origins of the English Imagination* (Chatto & Windus, 2002)

Anderson, Katherine, *Predicting the Weather: Victorians and the Science of Meteorology* (University of Chicago Press, 2005)

Aplin, Karen L., and Paul D. Williams,

'Meteorological Phenomena in Western Classical Orchestral Music', *Weather*, 60 (2011), 300–6

Banham, Reyner, *The Architecture of the Well-Tempered Environment* (1969; Architectural Press, 1984)

Barrell, John, *The Idea of Landscape and the Sense of Place, 1730–1840: An Approach to the Poetry of John Clare* (Cambridge University Press, 1972)

Bartlett, Robert, *England under the Norman and Angevin Kings, 1075–1225* (Oxford University Press, 2000)

Bate, Jonathan, *The Song of the Earth* (Picador, 2000)

Behringer, Wolfgang, *A Cultural History of Climate* (2007), trans. Patrick Camiller (Polity, 2010)

Boia, Lucian, *The Weather in the Imagination*, trans. Roger Leverdier (Reaktion, 2005)

Brimblecombe, Peter, *The Big Smoke: A History of Air Pollution in London since Medieval Times* (1987; Routledge, 1988)

Britton, C. E., *A Meteorological Chronology to AD 1450* (H. M. Stationery Office, 1937)

Bullen, J. B., ed., *The Sun Is God: Painting, Literature and Mythology in the Nineteenth Century* (Clarendon Press, 1989)

Castle, Terry, *The Female Thermometer: Eighteenth-Century Culture and the Invention of the Uncanny* (Oxford University Press, 1995)

Cathcart, Brian, *Rain* (Granta, 2002)

Cesario, Marilina, 'Weather Prognostics in Anglo-Saxon England', *English Studies*, 93 (2012), 391–426

Collins, Marie, and Virginia Davis, *A Medieval Book of Seasons* (Sidgwick & Jackson, 1991)

Connelly, Charlie, *Bring Me Sunshine: A Windswept, Rain-Soaked, Sun-Kissed, Snow-Capped Guide to Our Weather* (Little, Brown, 2012)

Connor, Steven, *The Matter of Air: Science and Art of the Ethereal* (Reaktion, 2010)

— 'Thermotaxis', 2005, www.stevenconnor.com/thermotaxis/

Conrad, Peter, *Cassell's History of English Literature* (1985; Weidenfeld & Nicolson, 2006)

— *The Victorian Treasure-House* (Collins, 1973)

Crawford, T. S., *A History of the Umbrella* (David & Charles, 1970)

Currie, Ian, *Frosts, Freezes and Fairs: Chronicles of the Frozen Thames and Harsh Winters in Britain since 1000* (Frosted Earth, 1996)

Damisch, Hubert, *A Theory of Cloud: Toward a History of Painting* (1972), trans. Janet Lloyd (Stanford University Press, 2002)

Davidson, Peter, *The Idea of North* (Reaktion, 2005)

Drabble, Margaret, *A Writer's Britain* (1979; Thames & Hudson, 2009)

Egan, Gabriel, *Green Shakespeare: From Ecopolitics to Ecocriticism* (Routledge, 2006)

Enkvist, Nils Erik, *The Seasons of the Year: Chapters on a Motif from* Beowulf *to* The Shepherd's Calendar (Societas Scientarum Fennica, 1957)

Fagan, Brian, *The Little Ice Age: How Climate Made History, 1300–1850* (Basic Books, 2000)

Favret, Mary A., *War at a Distance: Romanticism and the Making of Modern Wartime* (Princeton University Press, 2010)

Fitch, Raymond E., *The Poison Sky: Myth and Apocalypse in Ruskin* (Ohio University Press, 1982)

Fleming, James Roger, Vladimir Janković and Deborah R. Coen, eds, *Intimate Universality: Local and Global Themes in the History of Weather and Climate* (Science History Publications, 2006)

Fort, Tom, *Under the Weather* (2006; Arrow Books, 2007)

Frängsmyr, Tore, J. L. Heilbron and Robin E. Rider, eds, *The Quantifying Spirit in the Eighteenth Century* (University of California Press, 1990)

Frisinger, H. Howard, *The History of Meteorology to 1800* (Science History Publications, 1977)

Fussell, Paul, *The Great War and Modern Memory* (1975; Oxford University Press, 2000)

Golinski, Jan, *British Weather and the Climate of Enlightenment* (University of Chicago Press, 2007)

Gombrich, E. H., *Art and Illusion: A Study in the Psychology of Pictorial Representation* (1960; Phaidon, 1972)

Gopnik, Adam, *Winter: Five Windows on the Season* (2011; Quercus, 2012)

Groom, Nick, *The Seasons: An Elegy for the Passing of the Year* (Atlantic Books, 2013)

Hamblyn, Richard, *The Invention of Clouds: How an Amateur Meteorologist Forged the Language of the Skies* (Picador, 2001)

Harris, Victor, *All Coherence Gone: A Study of the Seventeenth-Century Controversy over Disorder and Decay in the Universe* (1949; Frank Cass, 1966)

Hawkes, Dean, *Architecture and Climate: An Environmental History of British Architecture, 1600–2000* (Routledge, 2012)

Head, Mrs Henry, *The Weather Calendar; or, A Record of the Weather for Every Day of the Year* (Clarendon Press, 1917)

Heninger, S. K., *A Handbook of Renaissance Meteorology, with Particular Reference to Elizabethan and Jacobean Literature* (Duke University Press, 1960)

Henisch, Bridget Ann, *The Medieval Calendar Year* (Pennsylvania State University Press, 1999)

Hill, Jonathan, *Weather Architecture* (Routledge, 2012)

Holmes, Richard, *Shelley: The Pursuit* (1974; Harper Perennial, 2005)

Huler, Scott, *Defining the Wind: The Beaufort Scale, and How a Nineteenth-Century Admiral Turned Science into Poetry* (2004; Three Rivers Press, 2005)

Hulme, Mike, *Exploring Climate Change through Science and in Society: An Anthology of Mike Hulme's Essays, Interviews and Speeches* (Routledge, 2013)

Hulme, T. E., *Speculations: Essays on Humanism and the Philosophy of Art*, ed. Herbert Read (Routledge & Kegan Paul, 1924)

Ingold, Tim, *Being Alive: Essays on Movement, Knowledge and Description* (Routledge, 2011)

Jacobus, Mary, *Romantic Things: A Tree, a Rock, a Cloud* (Chicago University Press, 2012)

Janković, Vladimir, *Confronting the Climate: British Airs and the Making of Environmental Medicine* (Palgrave Macmillan, 2010)

— *Reading the Skies: A Cultural History of English Weather, 1650–1820* (Manchester University Press, 2000)

Jeffery, Reginald W., 'Was It Wet or Fine? Being an Account of English Weather from Chronicles, Diaries and Registers', unpublished manuscript, 1933, lodged at the National Meteorological Library and Archive

Jones, Gwilym, 'Shakespeare's Storms', PhD thesis, University of Sussex, 2010

Klein, Naomi, *This Changes Everything: Capitalism vs. the Climate* (Allen Lane, 2014)

Lamb, H. H., *Climate, History and the Modern World* (1982; Routledge, 1995)

Lapidge, Michael, *The Cult of St Swithun* (Oxford University Press, 2003)

Lee, Raymond L., Jr, and Alistair B. Fraser, *The Rainbow Bridge: Rainbows in Art, Myth, and Science* (Pennsylvania State Press, 2001)

Le Roy Ladurie, Emmanuel, *Times of Feast, Times of Famine: A History of Climate since the Year 1000*, trans. Barbara Bray (Allen and Unwin, 1971)

Lewis, Jayne Elizabeth, *Air's Appearance: Literary Atmosphere in British Fiction, 1660–1794* (University of Chicago Press, 2012)

Lochnan, Katharine, ed., *Turner, Whistler, Monet* (Tate Publishing, 2004)

Mabey, Richard, *Gilbert White: A Biography of the Author of* The Natural History of Selborne (1986; Profile Books, 2006)

— *Turned Out Nice Again: On Living with the Weather* (Profile Books, 2013)

Manley, Gordon, 'Central England Temperatures: Monthly Means, 1659–1973', *Quarterly Journal of the Royal Meteorological Society*, 100 (1974), 389–405

— *Climate and the British Scene* (1952; Collins, 1971)

Martin, Craig, *Renaissance Meteorology: Pomponazzi to Descartes* (Johns Hopkins University Press, 2011)

McKim, Kristi, *Cinema as Weather: Stylistic Screens and Atmospheric Change* (Routledge, 2013)

Mockridge, Patricia and Philip, *Weathervanes of Great Britain* (Hale, 1990)

Monmonier, Mark, *Air Apparent: How Meteorologists Learned to Map, Predict, and Dramatize Weather* (University of Chicago Press, 1999)

Morris, Edward, ed., *Constable's Clouds: Paintings and Cloud Studies by John Constable* (National Galleries of Scotland and National Museums and Galleries on Merseyside, 2000)

Neville, Jennifer, *Representations of the Natural World in Old English Poetry* (Cambridge University Press, 1999)

Parker, Geoffrey, *Global Crisis: War, Climate Change and Catastrophe in the Seventeenth Century* (Yale University Press, 2013)

Pearsall, Derek, and Elizabeth Salter, *Landscapes and Seasons of the Medieval World* (University of Toronto Press, 1973)

Reed, Arden, *Romantic Weather: The Climates of Coleridge and Baudelaire* (University Press of New England for Brown University Press, 1983)

Reed, Nicholas, *Frost Fairs on the Frozen Thames* (Lilburne Press, 2002)

Robertson, Alexander, *Atkinson Grimshaw* (Phaidon, 1988)

Roe, Nicholas, *John Keats: A New Life* (Yale University Press, 2012)

Sedgwick, Eve Kosofsky, *The Weather in Proust* (Duke University Press, 2011)

Sidney, Philip, 'Scott's Last Expedition and the Literature of Cold', PhD thesis, University of Cambridge, 2014

Spufford, Francis, *I May Be Some Time: Ice and the English Imagination* (1996; Faber, 2003)

Stemp, Richard, *Painting the Weather* (BBC Adult Learning, 2002)

Strauss, Sarah, and Ben Orlove, eds, *Weather, Climate, Culture* (Berg, 2003)

Swift, Katherine, *The Morville Hours* (Bloomsbury, 2008)

Taub, Liba, *Ancient Meteorology* (Routledge, 2003)

Thornbury, G. W., *The Life of J. M. W. Turner, R.A.*, 2 vols (Hurst and Blackett, 1862)

Thornes, John E., *John Constable's Skies: A Fusion of Art and Science* (University of Birmingham Press, 1999)

Tuve, Rosemond, *Seasons and Months of the Medieval Year* (1933; D. S. Brewer, 1974)

Warner, Marina, *Phantasmagoria: Spirit Visions, Metaphors, and Media into the Twenty-First Century* (Oxford University Press, 2006)

Watson, Lyall, *Heaven's Breath: A Natural History of the Wind* (Hodder & Stoughton, 1984)

Waugh, Joanne Sarah, 'Talking about the Weather: Climate and the Victorian Novel', PhD thesis, University of York, 2008

Webster, J. Carson, *The Labors of the Months in Antique and Mediaeval Art to the End of the Twelfth Century* (Northwestern University Press, 1938)

Westheider, Ortrud, and Michael Philipp, eds, *Turner and the Elements* (Hirmer Verlag, 2011)

Westling, Louise, ed., *The Cambridge Companion to Literature and the Environment* (Cambridge University Press, 2014)

Wood, Gillen D'Arcy, *Tambora: The Eruption That Changed the World* (Princeton University Press, 2014)

Wood, Michael, *The Story of England* (Viking, 2010)

Zwikstra, Corey J., '"Wintrum Frod": Frod and the Aging Mind in Old English Poetry', *Studies in Philology*, 108 (2011), 133–64

ACKNOWLEDGMENTS

I am deeply grateful to the Leverhulme Trust for a Research Fellowship that allowed me to write the first half of this book in 2011 and 2012. The University of Liverpool granted me an invaluable semester of leave and has been generously flexible in its support throughout my time in the Department of English.

I could not have undertaken this project without excellent libraries. Thanks to the staff at the Sydney Jones Library in Liverpool and the Bodleian in Oxford. I am particularly grateful to Sue Usher and her staff for allowing me to adopt Oxford's English Faculty Library as a second home while I read my way clockwise around its shelves.

Thanks to the many colleagues and friends who have shared their expertise, saved up weather news, translated thunder prognostications, and inspired me with their own work: Laura Ashe, Harriet Archer, Paul Baines, Scarlett Baron, Joe Birch, Chloë Blackburn, Matthew Bradley, Peter Conrad, Nandini Das, Tim Dee, Paul Edwards, Elizabeth Garrett, Jane Griffiths, Richard Hamblyn, Andrew Hamer, Clare Hickman, Katy Hooper, Vladimir Janković, Ros Lacey, Jane Lewis, Greg Lynall, Richard Mabey, Robert Macfarlane, Maureen McCue, Fiona McLean, Michèle Mendelssohn, Kathryn Murphy, Alex Murray, Jennifer Neville, Danny O'Connor, Jill Rudd, Bethan Roberts, Philip Sidney, Paul Simons, Frances Spalding, Frances Twinn, Jenny Uglow, Christopher and Susan Venning, Abigail Williams, Matthew Wright.

Warm thanks to my agent, Caroline Dawnay, for being so ambitious on my behalf, and to Sophie Scard for her help. I am fortunate to have worked with a superb publishing team at Thames & Hudson. Thanks to Julia MacKenzie for her careful oversight of the editorial process, Maria Ranauro for all the pictures, and Lisa Ifsits for the design. Kit Shepherd brought his extraordinary historical and bibliographical knowledge to bear on my text; it was a privilege to be edited by him. This is, alas, the last book of mine to be commissioned by Jamie Camplin before his retirement. I give him my affectionate and lasting thanks.

I am sincerely grateful to those who have read and discussed drafts. Ben Morgan, as usual, grasped my point before I'd made it. Kevin Crossley-Holland and Anne Mathers-Lawrence generously read my chapters on early weather. Felicity James took my clouds to Tenerife and found new shapes in them; Elizabeth Scott-Baumann dealt with much seventeenth-century

weather in Gibraltar. John Barnard responded with exceptional insight and kindness to my chapters on Romanticism; he also arranged for my study to be rebuilt when the rain came in. Lara Feigel made even the hardest sections feel manageable and read the whole book with great acuity. Daisy Hay has been a constant touchstone, and her comments on the whole text taught me a good deal about writing. Will May and Andrew Blades were there in flooded Sussex at the beginning, and there in Oxford at the end, reading chapters at the last minute around the dinner table. Love and thanks to all.

I thank Dinah Birch for her support, and my dear friends Caroline and Steven Martin for help of many kinds. I am profoundly grateful to my father, Robert Harris, for his love, wisdom and extreme patience. The book is dedicated to Hermione Lee, the best reader and teacher I can imagine.

Some of my writing on rain first appeared in the article 'Drip, drip, drip, by day and night', *Guardian*, 15 February 2014. I am extremely grateful to Lisa Allardice, Claire Armitstead and Paul Laity at the *Guardian* for their support and their interest in my weather.

Parts of the section on Milton first appeared in *Where We Fell to Earth: Writing for Peter Conrad*, eds Michael Dobson and James Woodall (Christ Church, Oxford, 2011).

Quotations from the work of Julian Barnes, Kevin Crossley-Holland and George Szirtes are used by kind permission of the authors.

'Consider this...' © 1934 W. H. Auden, renewed 1962, 'Letter to Lord Byron' © 1937 W. H. Auden, 'Roman Wall Blues' © 1940 W. H. Auden, renewed, 'Taller to-day...', 'Who stands...', 'It is time...' and 'The month was April' are from *The English Auden*, ed. Edward Mendelson (Faber and Faber, 1977), © 1977 Estate of W. H. Auden, renewed, and reprinted by permission of Curtis Brown Ltd. Words from 'I like it Cold' are from *Complete Works: Prose* by W. H. Auden, ed. Edward Mendelson (Princeton University Press, 2002), © 2002 Estate of W. H. Auden, renewed, and reprinted by permission of Curtis Brown Ltd. Words from *Letters from Iceland* by W. H. Auden and Louis MacNeice (Faber and Faber, 1937) © 1937 W. H. Auden, renewed, and reprinted by permission of Curtis Brown Ltd.

Extracts from *The Waste Land* and *The Hollow Men* from *The Complete Poems and Plays*, T. S. Eliot (Faber and Faber, 1969) © Estate of T. S. Eliot and reprinted by permission of Faber and Faber Ltd.

Excerpt from *The Hollow Men* from *Collected Poems 1909–1962* by T. S. Eliot © 1936 Houghton Mifflin Harcourt Publishing Company, © renewed 1964 by Thomas Stearns Eliot. Reprinted by permission of Houghton Mifflin Harcourt Publishing Company. All rights reserved.

'Song of the Weather' quoted by permission of the Estates of Michael Flanders and Donald Swann.

Quotations from *The Go-Between* by L. P. Hartley (Hamish Hamilton, 1953; Penguin Books, 1958, 1997, 2000), pp. 20, 76, 77, 276, © 1953 L. P. Hartley, Penguin Books; 1997, 2000 editions © Douglas Brooks-Davies 1997; reprinted by permission of Penguin Books Ltd, with thanks to Alexander Bradshaw, and The Society of Authors, thanks to Lisa Dowdeswell.

Words from *Beowulf: Bilingual Edition*, translated by Seamus Heaney (Faber and Faber, 2007), © Estate of Seamus Heaney and reprinted by permission of Faber and Faber Ltd.

Extracts from 'The Beach', 'Birth of a Rainbow', 'Crow Hill', 'Dawn's Rose', 'October Dawn', 'Rain-Charm for the Duchy', 'Thistles' and 'Tractor' are taken from *Collected Poems* by Ted Hughes (Faber and Faber, 2003) © Estate of Ted Hughes and reprinted by permission of Faber and Faber Ltd, and Farrar, Straus and Giroux, LLC.

Extracts from 'A slight relax of air...', 'Mother, Summer, I', 'To the Sea' and 'The Whitsun Weddings' are taken from *Collected Poems* by Philip Larkin (Faber and Faber, 1988) © Estate of Philip Larkin and reprinted by permission of Faber and Faber Ltd.

Excerpts from 'January', 'Mother, Summer, I', 'To the Sea', and 'The Whitsun Weddings' from *The Complete Poems of Philip Larkin*, ed. Archie Burnett © 2012 The Estate of Philip Larkin. Reprinted by permission of Farrar, Straus and Giroux, LLC.

Quotations from the work of Wyndham Lewis are used by permission of the Wyndham Lewis Memorial Trust, a registered charity; thanks to Paul Edwards.

Quotations from *The Cement Garden* © 1978 Ian McEwan and *Atonement* © 2001 Ian McEwan, reproduced by permission of the author c/o Rogers, Coleridge & White Ltd, 20 Powis Mews, London, W11 1JN.

Lines from the following works in *Collected Poems* by Sean O'Brien (Picador, 2012) © Sean O'Brien 1991, 1995, 2007, 2011, reprinted by permission of Picador: 'After Laforgue', 'Grimshaw', 'Poem Written on a Hoarding', 'Praise of a Rainy Country' and 'Novembrists'.

Quotations from the work of Stevie Smith are used by permission of the Estate of James MacGibbon; thanks to Hamish MacGibbon, Faber and Faber Ltd and Will May.

SOURCES OF ILLUSTRATIONS

Measurements are given in cm (inches), height before width. a = above; b = below

Cover John Constable, *Cloud Study* (detail), 1821. Oil on paper laid on panel, 21.3 × 29.2 (8⅜ × 11½). Yale Center for British Art, Paul Mellon Collection (B1981.25.147)

4 William Kent, 'Spring' for James Thomson's *The Seasons*, 1730. Etching and engraving. British Museum, London (1874,0613.1303)

21 'Winter', mosaic. Photo Bignor Roman Villa, West Sussex

33 Bede, *Life of St. Cuthbert*, late 12th century. Ink and gold on parchment, 13.5 × 9.5 (5⅜ × 3¾). British Library, London. Yates Thompson MS 26 (Add. MS 39943), f. 24r/TopFoto

47 Scene from the Bayeux Tapestry, late 11th century. Embroidered cloth. The Bayeux Tapestry Museum, Normandy

53 Musical miscellany, *c.* 1261–65. Ink on parchment, 19 × 13.5 (7½ × 5⅜). British Library, London. Harley 978, f. 11v

60 Font, 12th century. St Mary's church, Burnham Deepdale, Norfolk. Photo George Plunkett

68 The Luttrell Psalter, Psalm 94, *c.* 1325–35. Ink and gold on parchment, 35 × 24.5 (13¾ × 9⅝). British Library, London. Ms Add. 4213/Scala, Florence

97 'Winter', mosaic, Chedworth Roman Villa, Gloucestershire. Photo © National Trust Images/ Ian Shaw

98 Anglo-Saxon miscellany, *c.* 1040. Ink on parchment mounted on paper, *c.* 36 × 30 (14⅛ × 11¾). British Library, London. Cotton Tiberius B.v, Part 1, f. 6v/TopFoto

99a The 'Shaftesbury Psalter', early to mid-12th century. Ink and gold on parchment. British Library, London. Lansdowne 383, f. 3v

99b The Gregory-Hood Cartulary, mid-14th century. Ink and gold on parchment. Shakespeare Centre Library and Archive, Stratford upon Avon. By permission of the Shakespeare Birthplace Trust

100 Astrological and ecclesiastical calendar, late 14th century. Ink on parchment. The Art Archive/ Bodleian Libraries, The University of Oxford, MS. Rawl. D. 939/3

101 John Lydgate, *The Siege of Thebes*. Illumination attributed to Gerard Horenbout, *c.* 1457–60. Ink on parchment. British Library, London. Ms Royal 18 D II, f. 148

102 Marcus Gheeraerts the Younger, *Queen Elizabeth I ('The Ditchley portrait')*, *c.* 1592. Oil on canvas, 241.3 × 152.4 (95 × 60). National Portrait Gallery, London

103 Anthony van Dyck, *Charles I and Henrietta Maria with their two eldest children, Prince Charles and Princess Mary*, 1631–32. Oil on canvas, 303.8 × 256.5 (119⅝ × 101). Royal Collection, London

104 Izaak Walton memorial window, installed 1914, Winchester Cathedral, Hampshire. Photo © Angelo Hornak/Alamy

108 Henry Fuseli, *Macbeth, Banquo and the Witches*, 1793–94. Oil on canvas, 168 × 135 (66⅛ × 53⅛). Petworth House, Sussex/The Egremont Collection/ National Trust Photographic Library/Derrick E. Witty/Bridgeman Images

133 'The wonders of this windie winter', London, 1613. Woodcut. Folger Shakespeare Library, Washington, DC

134 'A true report of certaine wonderfull ouerflowings', 1607. Woodcut. Special Collections and Archives, Cardiff University

143 Jan Janssonius, *Tabula Anemographica seu Pyxis Nautica Ventorum Nomina Sex Linguis Repraesentans*, 1650. Engraving. Private collection

147 Abraham Hondius, *The Frozen Thames*, 1677. Oil on canvas, 107.8 × 175.6 (42½ × 69⅛). Photo Museum of London/Heritage Images/Getty Images

148 *The Frost Fair Print: An A–Z of the frozen Thames'*, 1684. Engraving. British Library, London. Maps K.Top.27.39

151 Anon. possibly Thomas Dekker, 'Cold Doings', 1608. Woodcut. Houghton Library, Harvard University, Cambridge, MA

163 *The Triple Weather Glass*, 1759. Engraving. Photo Wellcome Library, London

166 Robert Hooke's 'Scheme', from Thomas Sprat, *History of the Royal Society*, London, 1667, p. 179

168 Diary of William Emes, late 17th century. Winchester College Fellows' Library MS 16. By permission of the Warden and Fellows of Winchester College

171 William Hogarth, *A Rake's Progress: pl. 4*, 1735. Etching and engraving. National Gallery of Art, Washington, DC. Rosenwald Collection (1944.5.31)

192 Thomas Trotter, *Dr Johnson in his Travelling Dress*, 1786. Engraving. Private collection

201a John Wootton, *A View of Cassiobury Park*, *c.* 1748. Oil on canvas, 71.1 × 127 (28 × 50). Courtesy Watford Museum, Hertfordshire

201b Richard Wilson, *The Valley of the Dee, with Chester in the Distance*, *c.* 1761. Oil on canvas, 148 × 193.5 (58¼ × 76⅛). National Gallery, London/ Scala, Florence

202 Thomas Rowlandson, *An Artist Travelling in Wales*, 1799. Aquatint, 35 × 41 (13¾ × 16⅛). British Museum, London (1938,0613.11)

203 Thomas Gainsborough, *Mrs Richard Brinsley Sheridan*, 1785–87. Oil on canvas, 219.7 × 153.7

(86½ × 60½). National Gallery of Art, Washington, DC. Andrew W. Mellon Collection (1937.1.92)
204 John Constable, *Study of Cumulus Clouds*, 1822. Oil on paper laid on panel, 28.6 × 48.3 (11¼ × 19). Yale Center for British Art, New Haven, CT. Paul Mellon Collection (B1981.25.116)
205a John Constable, *Weymouth Bay*, 1816. Oil on canvas, 20.3 × 24.7 (8 × 9¾). Victoria & Albert Museum, London. Photo The Art Archive/DeA Picture Library
205b John Constable, *Seascape with Rain Cloud*, c. 1824–28. Oil on paper laid on canvas, 23.5 × 32.6 (9¼ × 12⅞). Royal Academy of Arts, London
206 Thomas Fearnley, *Turner on Varnishing Day*, 1837. Oil on canvas, 23 × 23.5 (9 × 9¼). Private collection. Photo O. Vaering
207 J. M. W. Turner, *Regulus*, 1828, reworked 1837. Oil on canvas, 89.5 × 123.8 (35¼ × 48¾). Tate, London
208a J. M. W. Turner, *Petworth Park: Tillington Church in the Distance*, c. 1828. Oil on canvas, 60 × 145.7 (23⅝ × 57⅜). Tate, London
208b J. M. W. Turner, *Interior of a Great House*, c. 1830. Oil on canvas, 91 × 122 (35¾ × 48). Tate, London
214 Plate 14, *The Rural Walks of Cowper Displayed in a Series of Views near Olney Bucks*, London, 1822. Photo Tony Lamming/Trustees of the Cowper & Newton Museum
224 Gustave Doré, illustration for *The Rime of the Ancient Marine* by Samuel Taylor Coleridge, New York, 1876
242a Alexander Cozens, *A New Method of Assisting the Invention of Drawing Original compositions of Landscape*, pl. 13, c. 1784. Aquatint, 24 × 31.5 (9½ × 12¾). British Museum, London
242b John Constable, *Cloud Study*, c. 1822. Graphite on paper, 9.3 × 11.5 (3⅝ × 4½). Samuel Courtauld Trust, The Courtauld Gallery, London
256 Percy Bysshe Shelley, sketches of sailing boats, 1822. Ink on paper. Bodleian Library, University of Oxford, MS. Shelley adds. E. 18, p. 106 rev.
289 John Everett Millais, *Autumn Leaves*, 1855–56. Oil on canvas, 104 × 73.7 (41 × 29). City of Manchester Art Galleries
290 John Atkinson Grimshaw, *Liverpool Docks from Wapping*, c. 1875. Oil on canvas, 59.7 × 88.9 (23½ × 35). Private collection/Photo Christie's Images/Bridgeman Images
291 James Abbott McNeill Whistler, *Nocturne: Blue and Silver – Battersea Reach*, 1870-75. Oil on canvas, 49.9 × 72.3 (19⅝ × 28½). Freer Gallery of Art, Smithsonian Institute, Washington, DC
292 Eric Ravilious, *Wet Afternoon*, 1938. Watercolour, 43.2 × 50.8 (17 × 20). Private collection

293 L. S. Lowry, *The Pond*, 1950. Oil on canvas, 114.3 × 152.4 (45 × 60). Tate, London. © The Estate of L. S. Lowry. All Rights Reserved, DACS 2015
294 David Hockney, *My Mother, Bolton Abbey, Yorkshire, Nov. 1982*. Photographic collage, 36.2 × 69.9 (14¼ × 27½). Edition of 20. © David Hockney. Photo Richard Schmidt
295 Howard Hodgkin, *Rain*, 1984–89. Oil on composite panel, 164 × 179.5 (64⅝ × 70⅝). Tate, London. © Howard Hodgkin
296 Benjamin Britten, composition draft of *Noye's Fludde*, 1958, bars leading to Figure 69 – rain. Image provided by the Britten-Pears Foundation (www.brittenpears.org). © 1958 by Hawkes & Son (London) Ltd. Reproduced by permission of Boosey & Hawkes Music Publishers Ltd
299 'Phiz' (Hablot Knight Browne), frontispiece, Charles Dickens, *Bleak House*, London, 1853. Photo © Classic Image/Alamy
308 Illustration from *British Wild Flowers*, after a work by J. E. Sowerby and C. P. Johnson, London, 1876. Photo Universal History Archive/UIG via Getty Images
326 Paul Nash, *Rain, Zillebeke Lake, Belgium*, 1918. Lithograph, 25.4 × 36.2 (10 × 14¼). Private collection. © Tate
331 Cecil Beaton, *Baba Beaton: A Symphony in Silver*, 1925. Bromide, 26.4 × 17.1 (10⅜ × 6¾). © Cecil Beaton Archive, Sotheby's London
337 Frigidaire advert, mid-1920s. Courtesy The Advertising Archives
341 Tom Purvis, *Sun-bathing*, LNER poster, 1931. NRM/Pictorial Collection/Science & Society Picture Library. All rights reserved.
345 Stevie Smith with John Gale, 1969. © Jane Bown/The Observer